S0-ABR-437

The Butler Institute of American Art
Index of the Permanent Collection

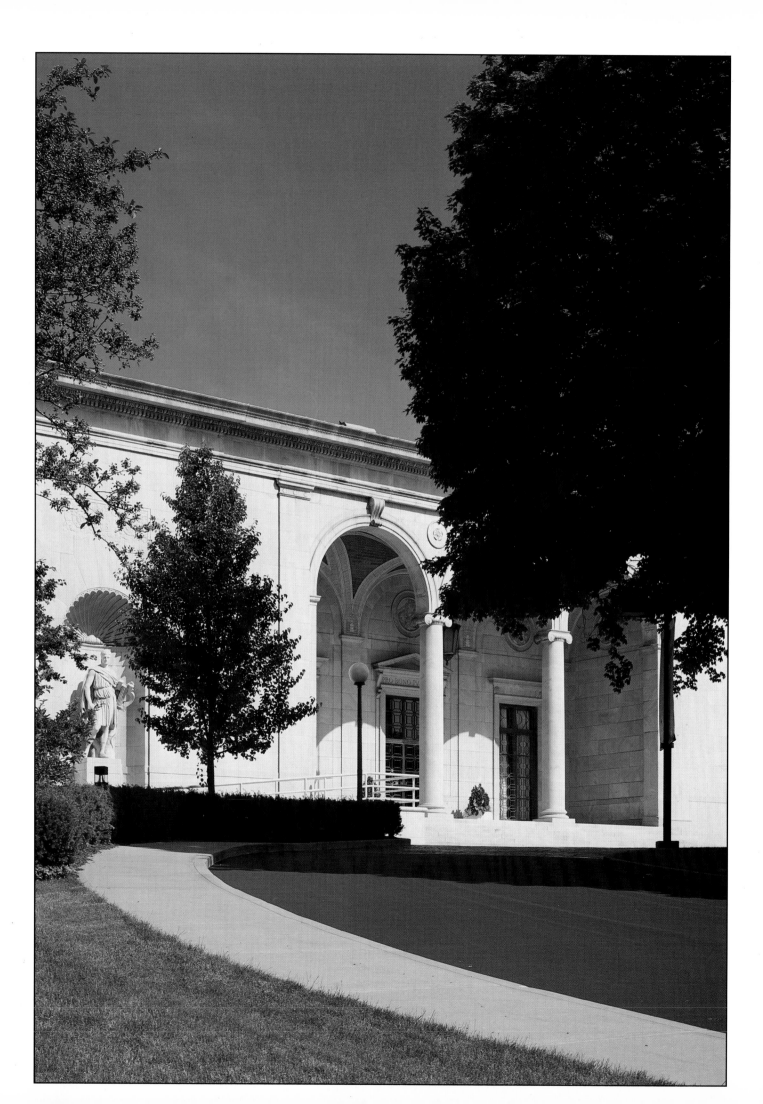

The Butler Institute of American Art
Index of the Permanent Collection

Irene S. Sweetkind
Editor

Louis A. Zona
Director of the Institute

Assisted by

Martha Menk
Barbara A. Sollenberger

Published by
The Butler Institute of American Art
Youngstown, Ohio

Research, editorial, and technical assistance by M. Melissa Wolfe, Thomas K. Zajac, Rebecca A. Davis, Mark A. Mavrigian, and Ken Platt, Registrar

Design consultant: Ronald Heames

Front Cover: Adolph Gottlieb, *Seer*, 1947

Back Cover: Jacob Lawrence, *The Street*, 1957

Photographs by Dennis Ryan—The Art Farm

Page ii
The Butler Institute of American Art, designed by McKim, Mead, and White, 1919

Page vii
Sculpture Garden and Plaza, photography by Sarah Strouss©

Photography by Dennis Ryan—The Art Farm, Rudenic & Associates, and The Butler Institute of American Art

Publication of the *Index of the Permanent Collection* has been partially funded by the Williamson Family Fund, the Irving Burger Memorial Fund, and the Drs. Paul and Laura Mesaros Acquisition Fund.

ISBN 1-882790-15-4
Copyright © 1997 Board of Trustees, The Butler Institute of American Art

Published in 1997 by The Butler Institute of American Art, Youngstown, Ohio
All rights reserved. No part of the contents of this book may be reproduced without the written permission of the publisher.

Printed by Youngstown Lithographing Company, Youngstown, Ohio

 Accredited by the American Association of Museums

 The Ohio Arts Council helped fund this program with state tax dollars to encourage economic growth, educational excellence, and cultural enrichment for all Ohioans.

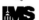 A portion of the museum's general operating funds for this fiscal year has been provided through a grant from The Institute of Museum Services, a federal agency that offers general operating support to the nation's museums.

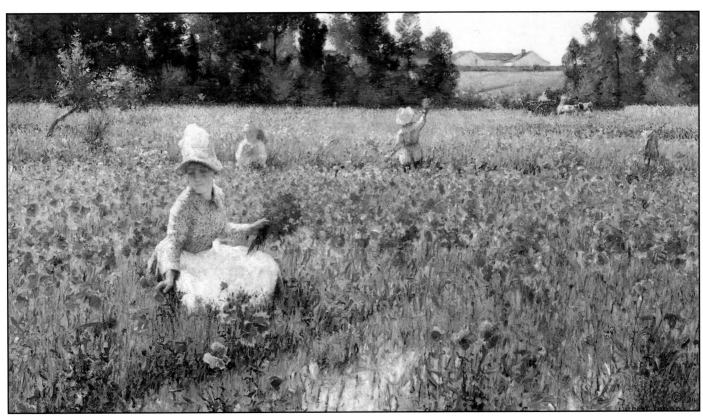

Robert Vonnoh - In Flanders Field—Where Soldiers Sleep and Poppies Grow (919-O-114)

Contents

William McGregor Paxton - The Beach at Chatham (977-O-105)

The *Index of the Permanent Collection* is dedicated to the collectors, artists, galleries,
and other patrons who through their generosity over the decades
have enhanced this great collection of American art

Format of the *Index of the Permanent Collection*

The purpose of this Index is to document the permanent collection of The Butler Institute of American Art, serve as a resource and guide for artists, scholars, and museum visitors, and to complement the catalog of the permanent collection *Master Paintings from The Butler Institute of American Art*. The Index contains information on more than 6,000 works of art; paintings and works on paper, sculpture, ceramics, and works in special collections. Within each section the Index is arranged alphabetically by the artist's name. In the section "Paintings and Works on Paper" the artist's works are listed by medium in alphabetical order. (Paintings included in *Master Paintings from The Butler Institute of American Art* are listed as the first entry under the artist's name.) Each artist entry includes name, birth and death dates (if known), title and date of work (if known), medium and measurements of the work, signature and location information, and accession number. All measurements are given in inches and centimeters with height preceding width except for the sculpture and ceramic entries where, as a rule, only the largest dimension is given. The first three figures of the accession number indicate the year the work entered the collection, followed by a letter indicating medium, the last three numbers indicate the order within that particular year the work entered the collection.

There are various collections within the Butler Institute's holdings that vary from this accession number practice. The marine paintings acquired by the Institute in 1928-29 are indicated by S28 and S29. The extensive collections of works by Irving Amen, Henry Keller, and Howard Worner have an initial(s) preceding the first three digits. Because of the size of the collection and given the space limitations of this volume not all works have a complete, separate entry but are instead grouped when enough similarities such as medium, size, or acquisition information support such abbreviations. Further information about the collection may be obtained from the Registrar and Curators of The Butler Institute of American Art and at http://www.butlerart.com on the Internet.

A History of The Butler Institute of American Art

In 1917, Joseph G. Butler, Jr. (1860–1927), a Youngstown industrialist, hired the architectural firm of McKim, Mead, and White to design a building to house his collection of American art. Butler, at the dedication of the building, stated, "In erecting this building and organizing the Butler Art Institute, I have sought to provide for the people of this city an opportunity to enjoy the best work of American artists . . . and have limited the canvases permanently hung in its galleries to those by American painters."

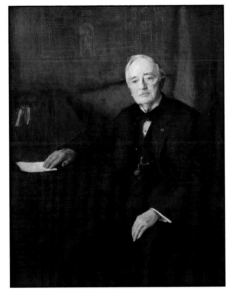

Olinsky - Portrait of Joseph G. Butler, Jr.

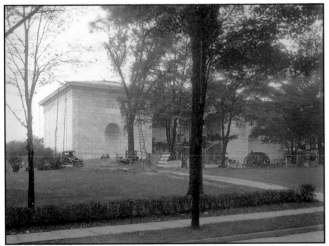

The Butler Institute of American Art - designed by McKim, Mead, and White - Construction, 1918

Mr. Butler's first collection, begun when he was in his early twenties, included both European and American works. It was destroyed in a fire that enveloped the third floor gallery of his home. His second collection, assembled between 1917 and 1919, was conditioned by his interest in trends and styles in American art. The Inaugural Exhibition included pieces that today still attest to Mr. Butler's aesthetic acumen: *Snap the Whip, Roadside Meeting, Red and Gold, Fiesta Day, Twilight, In Flanders Field*, and others.

In 1919 the Institute's Articles of Incorporation were finalized and the Institute was chartered by the State of Ohio with a self-perpetuating Board of Trustees. Upon the death of Joseph G. Butler, Jr. in 1927, the Presidency of the

The Central Hall, designed by McKim, Mead, and White

Board was assumed by his son, Henry Audubon Butler. In 1931 the original building was expanded with the addition of two lower level wings. Upon the death of Henry A. Butler in 1934, Joseph G. Butler, III assumed the duties of Director of the Institute.

The Institute inaugurated The Annual New Year Exhibition in 1935. This juried exhibition was expanded to include nationwide entrants in 1951 and became The Annual National Midyear Exhibition. In 1942 the Institute initiated public membership and encouraged volunteer efforts. The Institute's original galleries were renovated and second floor galleries over the original structure were created in 1952. The McKim, Mead, and White structure was placed on the National Register of Historic Places in 1967. In 1968 the Institute was again expanded with the addition of second floors to the wings built in 1931.

In 1979 the Institute published two volumes, *Index of the Permanent Collection* and *Selections from the Permanent Collection of the Butler Institute*, to celebrate sixty years as a museum of American art. During those sixty years the collection expanded dramatically with masterpieces; *The Little Dancer, In My Garden, The Lady Anne, Ship Starlight, Mrs. Knowles and Her Children, Chilmark, Geraldine Lee #2, Italian Landscape, The Oregon Trail, Seer, Pennsylvania Coal Town, Steam Turbine, After the Hunt, Salt Marsh Hay, The Cafe Francis, On the Wing, Bridal Veil Falls, Yosemite*, and *The Trysting Tree*, among many others.

The Watson Gallery, designed by Paul Boucherle, 1931

The Cushwa and Watson Galleries, designed by Paul Boucherle, 1931

Joseph G. Butler, III died in 1981 and Louis A. Zona was appointed Director of the Institute. The Institute completed the installation of a comprehensive climate control system in 1983. In 1985 the Institute, with the assistance of a community-wide group of volunteers, launched a Capital Campaign to fund the physical expansion of the museum. The West Wing addition was completed in 1987 doubling the size of the Institute to 72,000 square feet. This Post Modern design addition was successfully incorporated in the classic Italian Renaissance Revival building designed by McKim, Mead, and White. With this additional space the Institute was able to open to the public The Hopper Research Library, Sweeney Children's Gallery, Donnell Gallery of Sports Art,

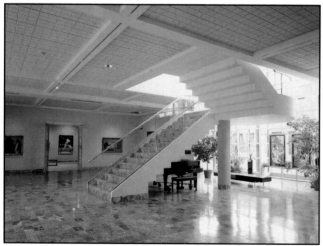

The West Wing, designed by Buchanan, Ricciuti and Balog, 1987, including the Burger Gallery, the Sidney Moyer Sculpture Area, and the Cynthia R. Debartolo Gallery

and Beecher Court. Shortly thereafter the Mesaros Print Gallery, built to house the Institute's collection of over 4,000 prints and drawings, was completed and opened for exhibition and study purposes. The Butler Institute received professional accreditation from the American Association of Museums in 1989.

In the 1990s the Butler Institute began a five year program of renovation of the original building and those galleries that were added in the 1930s and 1950s. Floors were replaced with marble and inlaid wood, lighting was upgraded, walls were refurbished, brass doors were cleaned and sealed, and Central Hall, the "historic heart" of the Institute, with its limestone and marble walls, beamed and stenciled ceiling, and mosaic floor, were restored to their original grandeur.

The Butler Institute opened a branch museum in Salem, Ohio in 1991 and in 1996 a branch museum was opened in Howland, Ohio, both in neighboring counties. The

outdoor Sculpture Garden and Plaza was completed in 1993 adding to the Institute a beautiful outdoor space where large three dimensional works could be displayed.

In 1994 the Butler Institute celebrated its seventy-fifth anniversary with the publication, in conjunction with Harry N. Abrams, Inc., New York, of its first scholarly catalog *Master Paintings from The Butler Institute of American Art.*

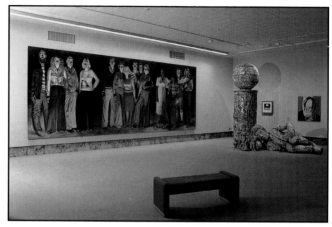

The Dennison Gallery - designed by McKim, Mead, and White - 1919, on exhibition Alfred Leslie - *Americans: Youngstown, Ohio* (on extended loan from the artist), Viola Frey - *Column/World/Man,* 1993 (on loan courtesy of the Nancy Hoffman Gallery)

The Butler Institute continued to expand the collection adding during the 1980s and 1990s masterworks by Blakelock, Bearden, Lawrence, Schnabel, Rivers, Levine, Curry, Kensett, Potthast, Gilliam, O'Keeffe, Ferrer, Roesen, and Motherwell.

As illustrated in this *Index of the Permanent Collection* of The Butler Institute of American Art, the Institute's collection is a virtual survey of the work of Americans in the field of visual art. The Institute contains an outstanding collection of American Impressionism, a broad collection of American marine painting, masterpieces from

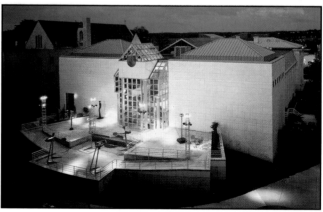

Sculpture Garden and Plaza, designed by Buchanan, Ricciuti and Balog, architects, 1993

"The Eight" and the "Hudson River School" as well as a comprehensive collection of art of the American West. The Butler Institute's collection of works on paper range from early eighteenth century works by Benjamin West, to works by Marin, Burchfield, Wyeth, Maurer, Lawrence, and Schnabel, and includes an important collection of drawings and works on paper by Raphael Soyer. In 1997, the Institute published the *Index of the Permanent Collection.*

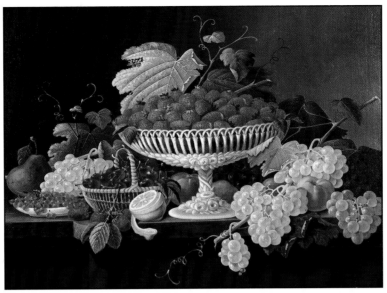

Severin Roesen - Still Life with Strawberries (993-O-119)

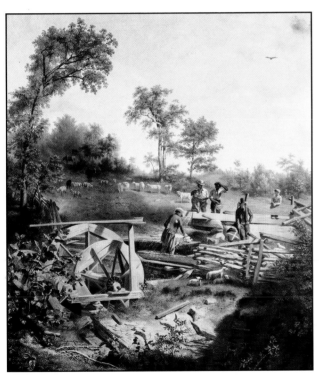

Allan Smith, Jr. - Sheep Washing in the Reserve (996-O-101)

Georgia O'Keeffe - Cottonwood III (990-O-111)

Romare Bearden - Hometime (990-W-103)

Selected Recent Acquisitions

Davies - Angled Beauty (995-P-102)

Alfred Maurer - Flowers in a Green Vase (996-W-101)

Motherwell - Mexican Past (994-W-101)

Nassos Daphnis - Three Graces 3—F—51 (993-O-118)

Audrey Flack - Davey Moore (993-O-103)

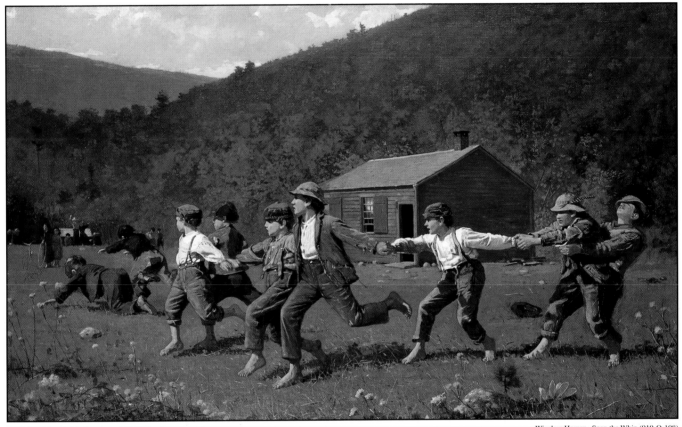

Winslow Homer - Snap the Whip (919-O-108)

Paintings and Works on Paper

William Merritt Chase - Did You Speak To Me? (921-O-102)

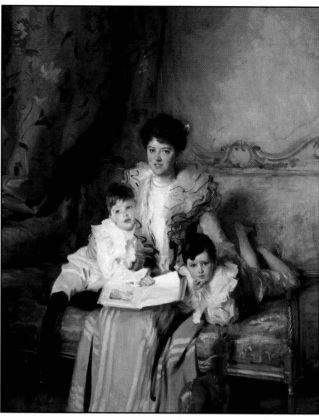

John Singer Sargent - Mrs. Knowles and Her Children (929-O-104)

Robert S. Duncanson - Fall Fisherman (969-O-105)

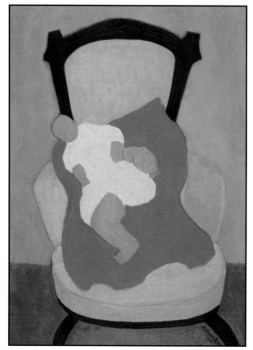

Milton Avery - The Baby (955-O-103)

William Michael Harnett - After the Hunt (954-O-120)

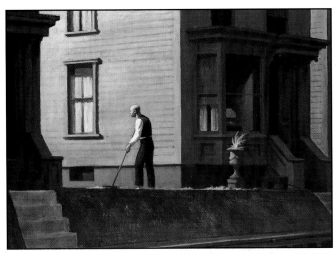

Edward Hopper - Pennsylvania Coal Town (948-O-115)

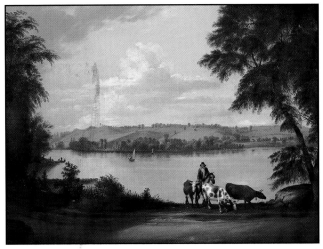

Alvan Fisher - View Near Springfield, Massachusetts (979-O-116)

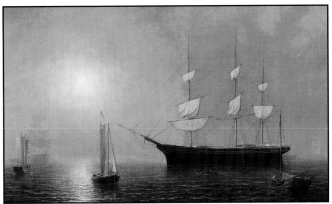

Fitz Hugh Lane - Ship: Starlight (S28-O-127)

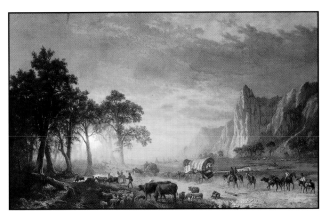

Albert Bierstadt - The Oregon Trail (946-O-101)

Reginald Marsh - The Normandie (962-W-115)

George Luks - The Cafe Francis (960-O-105)

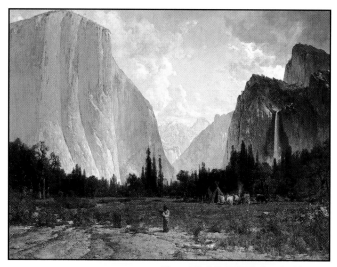

Thomas Hill - Bridal Veil Falls, Yosemite (969-O-109)

Joseph Raffael - Paper Mill (992-O-112)

George Wesley Bellows - Geraldine Lee #2 (941-O-101)

Raphael Soyer - My Friends (963-O-103)

Marsden Hartley - Birds of the Bagaduce (957-O-113)

Horace Pippin - Zachariah (951-O-120)

William Victor Higgins - Fiesta Day (920-O--506)

Maurice Brazil Prendergast - Sunset and Sea Fog (955-O-128)

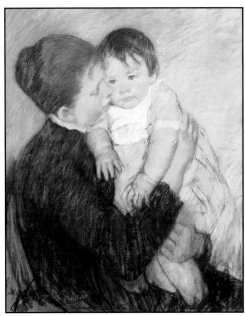

Mary Cassatt - Agatha and Her Child (947-W-102)

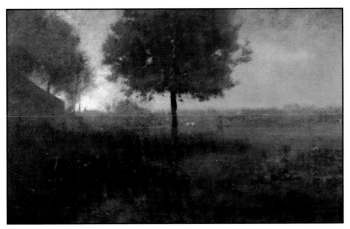

George Inness - Hazy Morning, Montclair, New Jersey (928-O-101)

Arthur Dove - Ice and Clouds(961-O-134

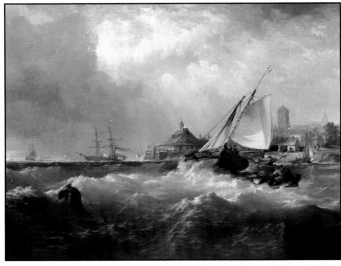

Edward Moran - New Castle on the Delaware (976-O-113)

Rafael Ferrer - El Sol Asombra (990-O-106)

Abbey - The Lady Anne

Abbey - Abingdon

Abrahamson - Interaction 94

Wayman Adams - Portrait of Irwin Shrewsbury Cobb and Daughter

Ahlgren - Desert Icon I (page 7)

Fritzie ABADI, (1915–)

December Dream
Oil on canvas, 36 x 45" (91.44 x 114.30 cm.)
Signed, Fritzie Abadi, lower right
Gift of Mr. and Mrs. Nahum Tschacbasov, 1955
955-O-101

Edwin Austin ABBEY, (1852–1911)

The Lady Anne, 1899
Oil on canvas, 48 x 24" (121.92 x 60.96 cm.)
Unsigned
Museum purchase, 1923
923-O-101

Abingdon
Watercolor wash on paper, 9 x 11.5" (22.86 x 29.21 cm.)
Signed, E. A. Abbey, lower right
Gift of Joseph G. Butler, III, 1978
978-D-109

Summer Landscape, 1898
Watercolor on paper, 14 x 22" (35.56 x 55.88 cm.)
Unsigned
Museum purchase, 1924
924-W-101

Tracking Rabbits
Wood engraving on paper, 9 x 13.75" (22.86 x 34.93 cm.)
Unsigned
Anonymous gift, 1963
963-P-103

The following six drawings on paper are a museum purchase, 1921, 1922

An Elizabethan Manor
8 x 11" (20.32 x 27.94 cm.)
921-D-101

Corinna Goes a Maying
8 x 13" (20.32 x 33.02 cm.)
922-D-101

Jolly Sailors
11 x 13" (27.94 x 33.02 cm.)
921-D-105

Landscape Drawing
14.5 x 21.5" (36.83 x 54.61 cm.)
921-D-106

Punting on the Thames
14 x 10" (35.56 x 25.40 cm.)
921-D-104

The Constant Maid of Ockley
14 x 11" (35.56 x 27.94 cm.)
921-D-103

Sigmund ABELES, (1934–)

Gina Still Smokes
Etching on paper, (3/12), 9.75 x 6" (24.77 x 15.24 cm.)
Signed, S. Abeles, lower right
Museum purchase, 1967
967-P-134

M. ABRAHAMSON, (active late 20th century)

Interaction 94, 1994
Color lithograph on paper, 19 x 24" (48.26 x 60.96 cm.)
Signed, M. Abrahamson, on reverse
Gift of Drs. Paul and Laura Mesaros, 1994
994-P-217

Israel ABRAMOFSKY, (1888–1975)

Grief
Charcoal and ink on paper, 25 x 10.5" (63.50 x 26.67 cm.)
Signed, I. Abramofsky, lower right
Gift of the Akron Art Museum, 1962
962-D-156

Ray ACAMPORA, (1926–)

Mexicans, 1965
Oil on canvas, 36 x 40" (91.44 x 101.60 cm.)
Signed, R. Acampora, lower right
Museum purchase, 1965
965-O-151

Seated Figure, 1964
Pen and ink on paper, 11.5 x 8.5" (29.21 x 21.59 cm.)
Unsigned
Museum purchase, 1965
965-D-133

Alice Stanley ACHESON, (1895–1996)

War Time Washington, 1945
Oil on masonite, 29.5 x 37.5" (74.93 x 95.25 cm.)
Signed, Alice Acheson, lower left
Museum purchase, 1975
975-O-125

Ed ADAMS, (active mid-19th century)

The following two unsigned oils on canvas, 24 x 36" (60.96 x 91.44 cm.), are a museum purchase, 1928

Ship: *Charles M. Watts*
S28-O-121

Ship: *Red Jacket*, 1854
S28-O-120

Wayman ADAMS, (1885–1959)

Portrait of Irwin Shrewsbury Cobb and Daughter, 1920
Oil on canvas, 49.5 x 39.5" (125.73 x 100.33 cm.)
Unsigned
Museum purchase, 1920
920-O-101

Lee ADLER, (1934–)

Discussion Group
Oil on canvas, 24 x 36" (60.96 x 91.44 cm.)
Signed, Lee Adler, lower left
Museum purchase, 1967
967-O-125

Samuel M. ADLER, (1898–1979)

Reverie No. 2
Oil on canvas, 24 x 18" (60.96 x 45.72 cm.)
Signed, S. Adler, lower right
Gift of Louis Held, 1965
965-O-110

Male Figure, 1962
Ink and crayon on paper, 22.25 x 14.25" (56.52 x 36.20 cm.)
Signed, S. Adler, lower right
Gift of Samuel Adler, 1963
963-D-106

Going to Church
Lithograph on paper, 10.5 x 6.5" (26.67 x 16.51 cm.)
Signed, Samuel M. Adler, lower right
Museum purchase, 1967
967-P-131

Barbara ADRIAN, (1931–)

Judgment of Heracles, 1966
Oil on canvas, 60 x 45" (152.40 x 114.30 cm.)
Signed, Adrian, lower right
Museum purchase, 1966
966-O-119

Roy AHLGREN, (1927–)

Infinity, 1970
Serigraph on paper, 13 x 13" (33.02 x 33.02 cm.)
Signed, Roy Ahlgren, lower right
Museum purchase, 1971
971-P-122

Homage to the Cross I
Silkscreen on paper, 20.5 x 20.5" (52.07 x 52.07 cm.)
Signed, Ahlgren, lower right
Gift of Roy and Martha Ahlgren, 1993
993-P-124

The following four signed serigraphs on paper, 20 x 20" (50.80 x 50.80 cm.), are a museum purchase, 1973

Desert Icon I, 1968–69
973-P-120

Desert Icon II, 1968–69
973-P-121

Desert Icon IV, 1968–69
973-P-122

Desert Icon VI, 1968–69
973-P-123

The Butler Institute's collection includes forty-three signed lithographs on paper which are the gift of Roy and Martha Ahlgren, 1993
993-P-101 — 993-P-143

Alexander AITKENT, (active late 20th century)

(Untitled)
Portfolio of 53: Rip Off on the Last Millennium
Print on paper, 8.5 x 11" (21.59 x 27.94 cm.)
Imprinted, Alexander Aitkent, on reverse
Gift of the William Busta Gallery, 1990
990-P-111.6

David ALBAN, (active late 20th century)

(Untitled)
Portfolio of 53: Rip Off on the Last Millennium
Print on paper, 8.5 x 11" (21.59 x 27.94 cm.)
Signed, David Alban, lower right
Gift of the William Busta Gallery, 1990
990-P-111.27

Josef ALBERS, (1888–1976)

Formulation: Articulation
Two portfolios, 127 prints in each volume
(Vol. I 312/1000, Vol. II 33/1000)
Serigraphs on paper, 15 x 20.5" (38.10 x 52.07 cm.)
Unsigned
Gift of Arthur Feldman, 1992
992-P-118

Squares, 1965
Silkscreen on paper, 25 x 25" (63.50 x 63.50 cm.)
Signed, Albers, '65, lower right
Museum purchase, 1967
967-P-151

White Line Squares #2, 1966
Lithograph on paper, (76/125), 20.75 x 20.75" (52.71 x 52.71 cm.)
Signed, Albers, '66, lower right
Museum purchase, 1966
966-P-144

James ALBERTSON, (active late 20th century)

Dream Series
Pen and ink on paper, 14.75 x 20.12" (37.47 x 51.12 cm.)
Unsigned
Gift of Erle L. Flad, 1992
992-D-103

Ivan Le Lorraine ALBRIGHT, (1897–1983)

Self Portrait in Georgia, 1967, 1967–68
Oil on panel, 20 x 16" (50.80 x 40.64 cm.)
Signed, Ivan Albright, lower right
Museum purchase, 1969
969-O-150

Country House, 1930
Watercolor on paper, 8.5 x 11.5" (21.59 x 29.21 cm.)
Signed, Ivan Albright, lower left
Gift of Mr. and Mrs. Nahum Tschacbasov, 1979
979-W-113

The Harbor of Dreams, 1941
Watercolor on paper, 13 x 19" (33.02 x 48.26 cm.)
Signed, Ivan Le Lorraine Albright, lower right
Museum purchase, 1946
946-W-101

Follow Me
Lithograph on paper, 14 x 9" (35.56 x 22.86 cm.)
Signed, Ivan Le Lorraine Albright, lower right
Gift of Louis Held, 1965
965-P-182

Show Case Doll
Lithograph on paper, 20 x 28" (50.80 x 71.12 cm.)
Signed, Ivan Albright, lower right
Museum purchase, 1974
974-P-105

Fred ALEXANDER, (1914–1982)

The following two watercolors on paper are the gift of the Friends of American Art, 1945, 1969

Black Narcissus, 1948
19 x 27" (48.26 x 68.58 cm.)
969-W-101

Interurban
19 x 28" (48.26 x 71.12 cm.)
945-W-101

John E. ALEXANDER, (1945–)

Macedonia, 1964
Woodcut on paper, (153/210), 15 x 22.25" (38.10 x 56.52 cm.)
Unsigned
Museum purchase, 1966
966-P-129

Albers - Squares

Albright - Self Portrait in Georgia, 1967

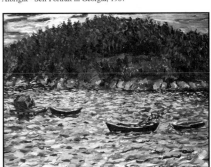
Albright - The Harbor of Dreams

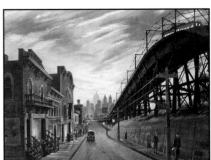
Fred Alexander - Interurban

John White Alexander - Portrait of a Lady (page 8)

Altman - Seated Figure

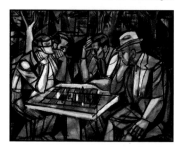

Amen - Chess Game

Amenoff - Mnemosyne

American Bank Note Company - Centennial-Dwight Company

Benny Andrews - Flowers and the Trees

John White ALEXANDER, (1856–1915)

Portrait of a Lady, 1900
Oil on unsized jute canvas, 40 x 22" (101.60 x 55.88 cm.)
Signed, J. W. Alexander, lower left
Museum purchase, 1920
920-O-102

Mel ALEXENBERG, (1937–)

Digitized Homage to Rembrandt: Night Angels, 1986
Lithograph on paper, 30 x 22.25" (76.20 x 56.52 cm.)
Signed, Alexenberg, lower left
Gift of Mel Alexenberg, 1986
986-P-112

James E. ALLEN, (1894– ?)

Blast Furnace
Etching on paper, 15 x 12.5" (38.10 x 31.75 cm.)
Signed, James E. Allen, lower right
Gift of Albert E. Hise, 1979
979-P-141

Spring Plowing
Lithograph on paper, 9 x 12" (22.86 x 30.48 cm.)
Signed, James E. Allen, lower right
Anonymous gift, 1943
943-P-101

B. Warren ALLIN, (1930–)

Edge of Town
Oil on canvas, 24 x 36" (60.96 x 91.44 cm.)
Signed, Allin, lower right
Museum purchase, 1970
970-O-103

Deborah ALMEIDA, (active late 20th century)

Red Smash, 1975
Acrylic on canvas, 72 x 85" (182.88 x 215.90 cm.)
Unsigned
Gift of Leonard Bocour, 1976
976-O-112

Charles H. ALSTON, (1907–1977)

Night People
Oil on canvas, 30 x 40" (76.20 x 101.60 cm.)
Signed, Alston, lower left
Museum purchase, 1955
955-O-102

Harold ALTMAN, (1924–)

Seated Figure
Etching on paper, 16 x 19.5" (40.64 x 49.53 cm.)
Signed, Altman, lower right
Museum purchase, 1965
965-P-258

Irving AMEN, (1918–)

Chess Game
Oil on canvas, 24 x 30" (60.96 x 76.20 cm.)
Signed, Amen, lower right
Gift of the Irving Amen Studio, 1982
A982-O-106

Sentinel, 1960
Oil on canvas, 36 x 46" (91.44 x 116.84 cm.)
Signed, Amen, lower right
Gift of Irving Amen Studio, 1980
980-O-114

Flute Player and Dog #1
Color woodblock on paper, (63/100), 29.25 x 14" (74.30 x 35.56 cm.)
Signed, Amen, lower right
Museum purchase, 1966
966-P-125

The Butler Institute's collection includes seventy-seven oils on canvas, two watercolors on paper, and sixty-five lithographs and woodblocks on paper which are the gift of the Irving Amen Studio, 1980

Gregory AMENOFF, (1948–)

Mnemosyne, 1988
Color woodcut on paper, (9/35), 64 x 37.25" (162.50 x 94.62 cm.)
Signed, Amenoff, 88, 9/35, lower right
Museum purchase, 1989
989-P-105

AMERICAN BANK NOTE COMPANY

Centennial-Dwight Company, ® 1876
Engraving on paper, 8.5 x 9.75" (21.50 x 24.77 cm.)
Unsigned
Museum purchase, 1975
975-P-126

Robert AMFT, (1916–)

Landscape
Oil on canvas, 25 x 30" (63.50 x 76.20 cm.)
Signed, Amft, lower right
Museum purchase, 1958
958-O-122

Edward A. ANDERSON, (active mid-19th century)

Delta Queen and Packet *Whisper*
Watercolor on paper, 16 x 28" (40.64 x 71.12 cm.)
Signed, Edward A. Anderson, lower left
Museum purchase, 1955
955-W-101

Frank H. ANDERSON, (1890–1947)

Church Supper
Woodblock on paper, 11 x 14" (27.94 x 35.56 cm.)
Unsigned
Anonymous gift, 1943
943-P-102

Benny ANDREWS, (1930–)

Flowers and the Trees, 1964
Oil on canvas, 37 x 24" (93.98 x 60.96 cm.)
Signed, Benny Andrews, 64, lower right
Gift of Emil Arnold, 1967
967-O-110

New York Cafe
Lithograph on paper, (64/250), 10.5 x 14.25" (26.67 x 36.20 cm.)
Signed, Benny Andrews, lower right
Anonymous gift, 1967
967-P-146

J. Winthrop ANDREWS, (1879– ?)

Phoebe Lord
Oil on canvas, 30.25 x 24" (76.84 x 60.96 cm.)
Unsigned
Gift of Mrs. Fred S. Coombs, Jr. in memory of Dr. Fred S.
Coombs, Jr., 1977
977-O-108

Garo ANTREASIAN, (1922–)

Shield, 1965
Color lithograph on paper, 27 x 19" (68.58 x 48.26 cm.)
Signed, G. Antreasian, lower right
Museum purchase, 1966
966-P-120

(Untitled) "Silver Suite," 1968
Lithograph on paper, 22.62 x 20.63" (57.47 x 52.40 cm.)
Signed, G. Antreasian, '68, lower right
Museum purchase, 1969
969-P-118

Richard ANUSZKIEWICZ, (1930–)

Bisected Red Violet, 1977
Acrylic on canvas, 60 x 72.25" (152.40 x 183.52 cm.)
Unsigned
Gift of Mr. and Mrs. J. J. Cafaro, 1983
983-O-105

Orange Bound, 1972
Acrylic on canvas, 48.25 x 36.25" (122.56 x 92.08 cm.)
Unsigned
Museum purchase, 1973
973-O-120

Movies are Better than Ever, 1952
Watercolor on paper, 13.5 x 22.5" (34.29 x 57.15 cm.)
Signed, R. Anuszkiewicz, '52, lower right
Museum purchase, 1955
955-W-102

Red Serigraph
Serigraph on paper, 22 x 22" (55.88 x 55.88 cm.)
Unsigned
Museum purchase, 1965
965-P-289

Yellow Reversed, 1970
Lithograph on paper, (23/100), 17 x 11.12" (43.18 x 28.26 cm.)
Signed, Anuszkiewicz, lower right
Gift of Arthur Feldman, 1991
991-P-184

D. Craig ARENTH, (active 20th century)

(Untitled)
Oil on panel, 30 x 24" (76.20 x 60.96 cm.)
Signed, Arenth, lower right
Gift of Alexander Pendleton, 1994
994-O-109

Pierre ARMAN, (1928–)

Boom–Boom
New York International: Portfolio of Ten Prints, (210/225)
Serigraph on paper, 17 x 22" (43.18 x 55.88 cm.)
Signed, Arman, lower right
Museum purchase, 1966
966-P-137.8

John Taylor ARMS, (1887–1953)

The following two signed etchings on paper are a
museum purchase, 1963

Gloria, 1937
14 x 8.5" (35.56 x 21.59 cm.)
963-P-145

Puerta del Obispo, Zamora, 1933
12.5 x 7" (31.75 x 17.78 cm.)
963-P-144

Paul ARNOLD, (1918–)

Pheasant
Color etching on paper, 12 x 18" (30.48 x 45.72 cm.)
Unsigned
Museum purchase, 1955
955-P-101

Margaret ARTHUR, (active late 20th century)

Perpetual Motion Machine
Portfolio of 53: Rip Off on the Last Millennium
Print on paper, 8.5 x 11" (21.59 x 27.94 cm.)
Signed, M. Arthur, lower right
Gift of the William Busta Gallery, 1990
990-P-111.13

Revington ARTHUR, (1908–1986)

Clown Blowing His Horn
Oil on canvas, 14 x 10" (35.56 x 25.40 cm.)
Signed, Arthur, lower left
Gift of Louis Held, 1965
965-O-118

Mary ASCHER, (1901–ca. 1993)

At the Beach–Provincetown
Oil on canvas, 20 x 24" (50.80 x 60.96 cm.)
Signed, Ascher, lower right
Gift of Mr. and Mrs. William A. Mollard, 1977
977-O-109

Ray J. ASHDOWN, (1915–)

Trees, 1964
Oil on canvas, 32 x 18" (81.28 x 45.72 cm.)
Unsigned
Gift of Louis Held, 1965
965-O-165

The following two watercolors on paper are the
gift of Louis Held, 1965

Village, 1953
6.5 x 20.5" (16.51 x 52.07 cm.)
965-W-138

Counterman
20 x 14" (50.80 x 35.56 cm.)
965-W-112

Maggy ASTON, (active 20th century)

Cartesian Rainbow
Color lithograph on paper, 27.75 x 17.25" (70.49 x 43.82 cm.)
Signed, Maggy Aston, lower right
Gift of Drs. Paul and Laura Mesaros, 1994
994-P-212

John ATHERTON, (1900–1952)

Barn Detail
Oil on canvas, 15 x 12" (38.10 x 30.48 cm.)
Unsigned
Gift of Mr. and Mrs. Milton Lowenthal, 1954
954-O-101

Anuszkiewicz - Bisected Red Violet

Anuszkiewicz - Orange Bound

Arman - Boom–Boom

Arms - Gloria

Revington Arthur - Clown Blowing His Horn

Aston - Cartesian Rainbow

Audubon - Fox and Goose

Audubon - Ruffled Grouse

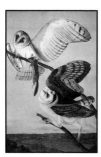

Audubon - Barn Owl

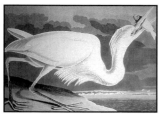

Audubon - Great White Heron

Ault - Sculpture on a Roof

Avery - The Baby

David ATKINS, (1910–)

Sails Fantasia
Oil on canvas, 24 x 30" (60.96 x 76.20 cm.)
Unsigned
Gift of H. M. Levy, 1967
967-O-152

John James AUDUBON, (1785–1851)

Fox and Goose, ca. 1835
Oil on canvas, 21.5 x 33" (54.61 x 83.82 cm.)
Signed, J. J. Audubon, 183-, lower right
Gift of Mrs. Arthur McGraw, 1940
940-O-101

Ruffled Grouse
Hand colored lithograph on paper, 25 x 38" (63.50 x 96.52 cm.)
Unsigned
Gift of Mary Wick Thompson, 1970
970-P-170

The following three hand colored lithographs on paper, Bien Edition, Elephant Folio, are the gift of Mrs. Oscar Gayton and Louise Fordyce, 1942

Barn Owl
37 x 24" (93.98 x 60.96 cm.)
942-P-102

Pigeon Hawk
30 x 22" (76.20 x 55.88 cm.)
942-P-101

Red-tailed Hawk
37 x 25" (93.98 x 63.50 cm.)
942-P-103

The following eight unsigned hand colored lithographs on paper, Havell Edition, Elephant Folio, are a museum purchase, 1942, 1943, 1947, 1969

American Crow
37 x 25" (93.98 x 63.50 cm.)
947-P-101

American Robin
37 x 25" (93.98 x 63.50 cm.)
943-P-105

Birds
21.63 x 30.25" (54.94 x 76.84 cm.)
969-P-103

Blue Jay
26 x 21" (66.04 x 53.34 cm.)
947-P-102

Carbonated Warbler
20 x 13" (50.80 x 33.02 cm.)
943-P-103

Great White Heron
25 x 37" (63.50 x 93.98 cm.)
942-P-104

Ruby-throated Humming Bird
27 x 22" (68.58 x 55.88 cm.)
943-P-104

Winter Hawk
25 x 38" (63.50 x 96.52 cm.)
942-P-105

The following five unsigned colored engravings on paper are the gift of Joseph G. Butler, III, 1976

Clay-colored Finch, Lazuli Finch, Oregon Snow Finch, 1837
22 x 14" (55.88 x 35.56 cm.)
976-P-121

Connecticut Warbler, 1832
21 x 14" (53.34 x 35.56 cm.)
976-P-123

Indigo-bird, 1829
22 x 14" (55.88 x 35.56 cm.)
976-P-120

Orchard Orioles, 1828
28 x 22" (71.12 x 55.88 cm.)
976-P-119

Townsend's Warbler, Arctic Bluebird, Western Bluebird, 1837
22 x 14" (55.88 x 35.56 cm.)
976-P-122

The following two unsigned colored engravings on paper are a museum purchase, 1957

Great Tern
17 x 13.5" (43.18 x 34.29 cm.)
957-P-101

Ivory Billed Woodpecker
38 x 25" (96.52 x 63.50 cm.)
957-P-102

Louise AUGUST, (1932–)

The Patriarch, 1963
Monotype on paper, 17.5 x 12.5" (44.45 x 31.75 cm.)
Signed, Louise August, '63, lower right
Gift of John Murray Butler, 1963
963-P-148

George AULT, (1891–1948)

Sculpture on a Roof, 1945
Oil on board, 16 x 12" (40.64 x 30.48 cm.)
Unsigned
Gift of Mrs. George Ault, 1961
961-O-131

Darrel AUSTIN, (1907–1994)

Woman Seated in a Garden, 1938
Oil on material, 20 x 18" (50.80 x 45.72 cm.)
Unsigned
Gift of Mr. and Mrs. Nahum Tschacbasov, 1979
979-O-122

Robert AUSTIN, (1895–1973)

The Plough, 1922
Etching on paper, 8.5 x 10.5" (21.59 x 26.67 cm.)
Signed, Robert Austin, lower center
Gift of Albert E. Hise, 1979
979-P-125

Milton AVERY, (1893–1965)

The Baby, 1944
Oil on canvas, 44 x 32" (111.76 x 81.28 cm.)
Signed, Milton Avery, 1944, lower right
Gift of Mr. and Mrs. Milton Lowenthal, 1955
955-O-103

The Blue Brook, Vermont, 1940
Oil on canvas, 23.5 x 35" (59.69 x 88.90 cm.)
Signed, Milton Avery, lower right
Gift of Roy Neuberger, 1949
949-O-101

The Rooster
Gouache on paper, 22 x 30" (55.88 x 76.20 cm.)
Signed, Milton Avery, lower right
Gift of Mr. and Mrs. Milton Lowenthal, 1954
954-W-101

Trees
Watercolor on paper, 16 x 23" (40.64 x 58.42 cm.)
Signed, Milton Avery, lower right
Gift of Joseph H. Hirshhorn, 1947
947-W-101

Child Cutting, 1936
Etching on paper, (28/100), 5 x 6.75" (12.70 x 17.15 cm.)
Signed, Milton Avery, 1936, lower right
Museum purchase, 1967
967-P-149

Mother and Child
Drypoint on paper, 9 x 7" (22.86 x 17.78 cm.)
Signed, Milton Avery, lower right
Gift of Louis Held, 1965
965-P-163

Reclining Nude, 1960
Woodblock on paper, 4 x 11" (10.16 x 27.94 cm.)
Signed, Milton Avery, 1960, lower left
Anonymous gift, 1962
962-P-103

Manuel AYASO, (1934–)

The Orbiters
Oil on canvas, 24 x 20" (60.96 x 50.80 cm.)
Signed, Ayaso, lower left
Gift of The Ford Foundation, 1964
964-O-101

Norio AZUMA, (1928–)

Autumn, 1961
Oil on canvas, 58 x 76" (147.32 x 193.04 cm.)
Signed, N. Azuma, 1961, lower right
Museum purchase, 1961
961-O-119

Winter #5
Silkscreen on paper, (2/20), 24 x 18" (60.96 x 45.72 cm.)
Signed, Norio Azuma, lower right
Museum purchase, 1962
962-P-119

Alice BABER, (1928–1982)

Circle of the Phoenix, 1968
Oil on canvas, 30 x 50" (76.20 x 127.00 cm.)
Signed, Baber, lower right
Gift of Dr. Herbert Meadow, 1974
974-O-115

Barbara BACHTELL, (active late 20th century)

Birth of Perestroika
Portfolio of 53: Rip Off on the Last Millennium
Print on paper, 8.5 x 11" (21.59 x 27.94 cm.)
Signed, Barbara Bachtell, lower left
Gift of the William Busta Gallery, 1990
990-P-111.38

Peggy BACON, (1895–1987)

Witchcraft, 1945
Pastel on paper, 17 x 24" (43.18 x 60.96 cm.)
Signed, Peggy Bacon, 1945, lower left
Museum purchase, 1946
946-W-102

Wending Her Way
Drawing on paper, 9.5 x 7.5" (24.13 x 19.05 cm.)
Signed, P. B., lower left
Gift of Louis Held, 1965
965-D-136

Witchcraft
Lithograph on paper, 8 x 11" (20.32 x 27.94 cm.)
Signed, Peggy Bacon, lower right
Museum purchase, 1946
946-P-101

The following two signed lithographs on paper
are the gift of Louis Held, 1965

Mayor LaGuardia, 1934
14.5 x 10.5" (36.83 x 26.67 cm.)
965-P-145

Where to Look?
8.5 x 12" (21.59 x 30.48 cm.)
965-P-193

Joseph BADGER, (1708–1765)

Portrait of Mr. Daniel Rea, ca. 1757
Oil on canvas, 49 x 39" (124.46 x 99.06 cm.)
Unsigned
Museum purchase, 1947
947-O-101

Howard A. BAER, (1907–)

Roping the Bull, 1942
Watercolor on paper, 10 x 15" (25.40 x 38.10 cm.)
Signed, Howard A. Baer, lower left
Museum purchase, 1943
943-W-101

William BAILEY, (1930–)

(Untitled), 1982
Etching, aquatint on paper, 27.5 x 22.25" (69.85 x 56.52 cm.)
Signed, Bailey, lower right
Museum purchase, 1983
983-P-145

Grant BAILIE, (active late 20th century)

(Untitled)
Portfolio of 53: Rip Off on the Last Millennium
Print on paper, 8.5 x 11" (21.59 x 27.94 cm.)
Unsigned
Gift of the William Busta Gallery, 1990
990-P-111.19

Tom BALBO, (active 20th century)

(Untitled)
Lithograph on paper pulp, 21 x 27" (53.34 x 68.58 cm.)
Signed, T. Balbo, lower right
Gift of Ana and Eric Baer, 1991
991-P-199

Avery - The Rooster

Avery - Trees

Azuma - Autumn

Bacon - Witchcraft

Bacon - Mayor LaGuardia

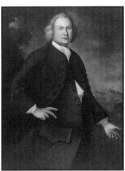
Badger - Portrait of Mr. Daniel Rea

Bailey - (Untitled) (page 11)

John Barber - Mexican Public Fountain

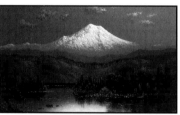

Barchus - Mt. Hood, Oregon

Barlow - The Home of Washington

Barnet - Stairway to the Sea

Barnet - Bluffing

Jerry BALLAINE, (active 20th century)

(Untitled), 1969
Silkscreen on paper, 22.5 x 22.5" (57.15 x 57.15 cm.)
Signed, J. Ballaine, lower right
Gift of Reese and Marilyn Arnold Palley, 1991
991-P-164

Hugo BALLIN, (1879–1956)

The Deposition
Oil on canvas, 46 x 66" (116.84 x 167.64 cm.)
Signed, Hugo Ballin, lower right
Gift of the Hugo Ballin Collection, 1958
958-O-160

Thomas BANG, (1938–)

Parade, 1959
Oil on canvas, 40 x 34" (101.60 x 86.36 cm.)
Signed, Ths. Bang, 59, lower right
Museum purchase, 1959
959-O-124

Ronnie Warner BANSBACH, (active late 20th century)

Going East
Silkscreen on paper, 21.5 x 29" (54.61 x 73.66 cm.)
Signed, Ronnie Bansbach, lower right
Gift of Ronnie Warner Bansbach, 1978
978-P-128

Robert BARBEE, (1921–)

Pool Room, 1961
Oil on canvas, 60 x 50" (152.40 x 127.00 cm.)
Signed, R. Barbee, 61, lower right
Museum purchase, 1962
962-O-127

John BARBER, (1898–1965)

Mexican Public Fountain, 1949
Oil on canvas, 18.12 x 15" (46.04 x 38.10 cm.)
Signed, Barber, lower left
Gift of Bruce C. Bachman, 1983
983-O-111

Study for Mexican Public Fountain, 1949
Pencil and ink on paper, 15 x 12" (38.10 x 30.48 cm.)
Signed, Barber, lower left
Gift of Bruce C. Bachman, 1983
983-D-102

John Jay BARBER, (ca. 1840–1905)

Cow and Calf
Oil on canvas, 12 x 20" (30.48 x 50.80 cm.)
Signed, J. Jay Barber, lower left
Gift of Mrs. Bowe Smiley Butler, 1970
970-O-118

Eliza BARCHUS, (1857–1959)

Mt. Hood, Oregon
Oil on canvas, 21.25 x 35.25" (53.98 x 89.54 cm.)
Signed, Barchus, lower right
Gift of Mr. and Mrs. Joseph Erdelac, 1990
990-O-103

Thomas Oldham BARLOW, (active 19th century)

The Home of Washington
Steel engraving on paper, 28 x 40" (71.12 x 101.60 cm.)
Unsigned
Museum purchase, 1975
975-P-125

Will BARNET, (1911–)

Stairway to the Sea, 1973
Oil on canvas, 67.75 x 65" (172.09 x 165.10 cm.)
Signed, Will Barnet, lower left
Gift of Henry Kaufman, 1991
991-O-104

Bluffing, 1985
Oil on canvas, 36.5" dia. (92.71 cm.)
Signed, Will Barnet, 85, lower left
Gift of Dr. and Mrs. Albert B. Cinelli, 1993
993-O-110

The Doorway, 1971
Oil on canvas, 95.5 x 51" (242.57 x 129.54 cm.)
Signed, Will Barnet, lower left
Gift of Will Barnet, 1993
993-O-111

Dialogue in Green
Color lithograph on paper, 25 x 39.25" (63.50 x 99.70 cm.)
Signed, Will Barnet, lower right
Gift of Mr. and Mrs. C. Gilbert James, Jr., 1972
972-P-120

Reflection
Silkscreen on paper, 14.37 x 22.5" (36.51 x 57.15 cm.)
Signed, Will Barnet, lower right
Gift of Robert L. and Linda K. Kurtz, 1991
991-P-121

Under the Table
Aquatint on paper, 6 x 8" (15.24 x 20.32 cm.)
Signed, Will Barnet, lower right
Museum purchase, 1946
946-P-102

Way to the Sea, 1981
Lithograph, silkscreen on paper, (85/300), 46.25 x 36" (117.48 x 91.44 cm.)
Signed, Will Barnet, lower right
Gift of Marc A. Wyse, 1983
983-P-111

The following ten signed silkscreens on paper are the gift of Will Barnet, 1993

Ariadne, 1980
(artist's proof), 31.5 x 23.5" (80.01 x 59.69 cm.)
993-P-157

Circe II, 1980
(30/50), 31.5 x 23.5" (80.01 x 59.69 cm.)
993-P-155

Interlude, 1982
(artist's proof), 25.75 x 42.75" (65.41 x 108.59 cm.)
993-P-161

Persephone, 1982
(231/250), 40.5 x 22.5" (102.87 x 57.15 cm.)
993-P-160

Peter Grimes, 1983
(artist's proof), 30.5 x 22.25" (77.47 x 56.52 cm.)
993-P-159

The Bannister, 1981
(4/300), 35.75 x 26.5" (90.81 x 67.31 cm.)
993-P-158

Totem, 1982
(102/112), 47 x 24" (119.38 x 60.96 cm.)
993-P-153

Way to the Sea, 1981
(61/300), 46.25 x 36" (117.48 x 91.44 cm.)
993-P-154

Woman Reading
(81/300), 41 x 29.5" (104.14 x 74.93 cm.)
993-P-156

Woman Reclining, 1982
(9/300), 33 x 41" (83.82 x 104.14 cm.)
993-P-152

Earl D. BARNETT, (1917–)

Silent Salesman, 1967
Oil on canvas, 32 x 42" (81.28 x 106.68 cm.)
Signed, Earl Barnett, lower left
Gift of Mrs. Edward W. Powers, 1984
984-O-104

The Horn and Bell at South Haven, 1965
Oil on canvas, 48 x 28" (121.92 x 71.12 cm.)
Signed, Earl Barnett, 65, lower left
Museum purchase, 1965
965-O-152

Jack BARNETT, (active 20th century)

Epithelium II
Oil on canvas, 60 x 42" (152.40 x 106.68 cm.)
Unsigned
Museum purchase, 1976
976-O-132

Bill BARRON, (active late 20th century)

Somalia, 1979
Collage on paper, 22 x 16" (55.88 x 40.64 cm.)
Signed, Barron, lower right
Museum purchase, 1979
979-D-120

W. H. BARTLETT, (1809–1854)

Boston and Bunker Hill
Engraving on paper, 5 x 7.12" (12.70 x 18.10 cm.)
Signed, W. H. Bartlett, lower left, Dick, lower right
Museum purchase, 1968
968-P-307

John Murray BARTON, (1921–)

Portrait with Flowers, 1963
Woodcut on paper, 17 x 13" (43.18 x 33.02 cm.)
Signed, John Barton, 1963, lower right
Gift of Louise August, 1963
963-P-149

Charles BASHAM, (active late 20th century)

Morning of the First Snow, 1988
Pastel on paper, 22 x 30" (55.88 x 76.20 cm.)
Signed, Basham, lower left
Gift of Jerald Melberg Gallery, Inc., 1991
991-W-102

Leonard BASKIN, (1922–)

Figure, 1962
Woodcut on paper, 7.75 x 4.5" (19.69 x 11.43 cm.)
Unsigned
Museum purchase, 1962
962-P-110

Self Portrait, 1985
Lithograph on paper, 10 x 14" (25.40 x 35.56 cm.)
Signed, Baskin, lower right
Gift of Ana and Eric Baer, 1991
991-P-202

Thomas Eakins
Etching on paper, 18 x 13" (45.72 x 33.02 cm.)
Signed, Baskin, lower right
Museum purchase, 1963
963-P-141

The following two signed etchings on paper are a
museum purchase, 1967

Bird, 1966
(21/50), 12.5 x 9" (31.75 x 22.86 cm.)
967-P-197

Eagle
9 x 12.5" (22.86 x 31.75 cm.)
967-P-196

The following three signed wood engravings on
paper are the gift of William and Margaret
Kinnick, 1986

Leper, 1956
10.75 x 5.5" (27.31 x 13.97 cm.)
986-P-109

Merlin
31.5 x 21.5" (80.01 x 54.61 cm.)
986-P-108

Sage
5.75 x 5.75" (14.61 x 14.61 cm.)
986-P-106

Wallace BASSFORD, (active 1925–1950)

Model
Drawing on paper, 24 x 20" (60.96 x 50.80 cm.)
Signed, Bassford, lower right
Gift of Dr. John J. McDonough, 1972
972-D-103

Betsy BATES, (1924–)

Victorian Window, 1970
Acrylic on canvas, 46 x 23.5" (116.84 x 59.69 cm.)
Signed, Betsy, 1970, lower right
Museum purchase, 1970
970-O-104

Mary BAUERMEISTER, (active 20th century)

Sketch for Tanglewood Press
New York International: Portfolio of Ten Prints, (210/225)
Mixed media on paper, 17 x 22" (43.18 x 55.88 cm.)
Unsigned
Museum purchase, 1966
966-P-137.10

Basham - Morning of the First Snow

Baskin - Figure

Baskin - Thomas Eakins

Baskin - Bird

Bauermeister - Sketch for Tanglewood Press

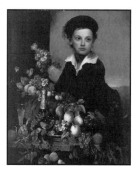

Charles Baum - Boy with Still Life

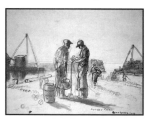

Gifford Beal - Fisherman, East Stone Cove

Bearden - Hometime

Bearden - Agony of Christ

Beaux - The Dreamer

Bechtle - September Toys

The following two signed offset lithographs on paper are the gift of Dana Seman, 1980

An Investment Report, 1973
26 x 19" (66.04 x 48.26 cm.)
980-P-117

Rainbow, 1973
18 x 25" (45.72 x 63.50 cm.)
980-P-116

Charles BAUM, (1812–1877)

Boy with Still Life, 1850s or 1860s
Oil on canvas, 40 x 30" (101.60 x 76.20 cm.)
Signed, Baum, lower right
Museum purchase, 1958
958-O-114

Walter Emerson BAUM, (1884–1956)

The Woods, 1925
Oil on canvas, 23 x 30" (58.42 x 76.20 cm.)
Signed, W. E. Baum, lower left
Gift of Sydna Smith, 1975
975-O-101

Harold BAUMBACH, (1905–)

The Flowers
Lithograph on paper, 34.25 x 23.5" (87.00 x 59.69 cm.)
Unsigned
Gift of Samuel S. Mandel, 1986
986-P-141

Cecil Gray BAZELON, (active 20th century)

Sagaponack
Silkscreen on paper, (30/56), 11.5 x 28.5" (29.21 x 72.39 cm.)
Signed, Cecil Gray Bazelon, lower right
Gift of Cecil Gray Bazelon, 1978
978-P-134

Gifford BEAL, (1879–1956)

Fisherman, East Stone Cove
Drawing on paper, 14 x 19" (35.56 x 48.26 cm.)
Signed, Gifford Beal, lower right
Museum purchase, 1959
959-D-106

Bareback Act, Old Hippodrome
Lithograph on paper, 6.5 x 9.75" (16.51 x 24.77 cm.)
Signed, Gifford Beal, lower right
Museum purchase, 1967
967-P-107

Jack BEAL, (1931–)

Trout, 1976–77
Lithograph on paper, (19/102), 25 x 30.5" (63.50 x 77.47 cm.)
Signed, Jack Beal, lower right
Museum purchase, 1988
988-P-103

Reynolds BEAL, (1867–1951)

USS *Constitution*, 1900
Etching on paper, 10 x 14" (25.40 x 35.56 cm.)
Signed, Reynolds Beal, lower middle
Museum purchase, 1965
965-P-283

Howard BEAR, (active 20th century)

Still Life
Oil on canvas, 17 x 21" (43.18 x 53.34 cm.)
Signed, Howard Bear, lower right
Gift of Elizabeth P. Osgood, 1992
992-O-118

Phyllis BEARD, (active late 20th century)

Dave Dravecki, 1991
Pencil on paper, 28.5 x 21.25" (72.39 x 53.98 cm.)
Signed, Phyllis Beard, lower left
Gift of Phyllis Beard, 1991
991-D-138

Romare BEARDEN, (1914–1988)

Hometime, 1970
Watercolor collage on board, 26.25 x 45.62" (66.68 x 115.89 cm.)
Signed, Romare Bearden, lower left
Museum purchase, 1990
990-W-103

Agony of Christ
Watercolor on paper, 18 x 24" (45.72 x 60.96 cm.)
Signed, Bearden, upper left
Gift of Mr. and Mrs. Milton Lowenthal, 1945
945-W-106

Tidings, 1973
Offset lithograph on paper, 22 x 29" (55.88 x 73.66 cm.)
Signed, Romare Bearden, lower right
Gift of Dana Seman, 1980
980-P-110

Cecilia BEAUX, (1855–1942)

The Dreamer, 1894
Oil on canvas, 33 x 25" (83.82 x 63.50 cm.)
Signed, Cecilia Beaux, lower left
Museum purchase, 1929
929-O-101

C. Ronald BECHTLE, (1924–)

September Toys
Watercolor on paper, 22 x 16" (55.88 x 40.64 cm.)
Signed, Bechtle, lower left
Gift of C. Ronald Bechtle, 1980
980-W-101

Bernard BECK, (1944–)

Mr. and Mrs. Elmer Beck
Oil on canvas, 36 x 65" (91.44 x 165.10 cm.)
Unsigned
Museum purchase, 1972
972-O-121

David BECKER, (1937–)

Mother and Child, 1967
Opaque watercolor and varnish on paper, 15 x 21.5" (38.10 x 54.61 cm.)
Signed, David Becker, lower right
Museum purchase, 1967
967-W-108

Maurice BECKER, (1889–1975)

Bull Fighter
Oil on panel, 10 x 8" (25.40 x 20.32 cm.)
Unsigned
Gift of Louis Held, 1967
967-O-104

The following five watercolors on paper are the gift of Louis Held, 1965, 1966, 1977

Beach Abstraction
5.5 x 10" (13.97 x 25.40 cm.)
966-W-120

Cows and Ducks, 1943
Two panels, each 3.5 x 5.5" (8.89 x 13.97 cm.)
965-W-124

Highway, 1948
10.5 x 14.5" (26.67 x 36.83 cm.)
965-W-123

Mexican Women, 1922
11.25 x 8.25" (28.58 x 20.96 cm.)
977-W-116

Sailboat–Maine, 1944
13 x 18" (33.02 x 45.72 cm.)
977-W-115

The following four drawings on paper are the gift of Louis Held, 1965, 1966

"Big Bill" Haywood, 1919
9 x 7" (22.86 x 17.78 cm.)
966-D-111

Card Party, 1915
8.5 x 8" (21.59 x 20.32 cm.)
966-D-110

Rev. J. H. Holmes, 1959
11.5 x 7.5" (29.21 x 19.05 cm.)
965-D-128

Three Men, 1913
10 x 6" (25.40 x 15.24 cm.)
966-D-109

Robert S. BECKMAN, (active late 20th century)

(Untitled)
Portfolio of 53: Rip Off on the Last Millennium
Prints on paper, (2), 8.5 x 11" (21.59 x 27.94 cm.)
Signed, R. S. B., on reverse
Gift of the William Busta Gallery, 1990
990-P-111.50 — 990-P-111.51

Arthur O. BEERY, (1930–)

Radiance in Space, 1968
Oil on canvas, 60 x 44" (152.40 x 111.76 cm.)
Signed, A. Beery, lower left
Museum purchase, 1973
973-O-118

Peter H. BEGLEY, (active late 20th century)

Roman Motif II, 1992
Acrylic, oil, and, wax paper on linen, two panels, each 37 x 70" (93.98 x 177.80 cm.)
Signed, P. H. B., 92, lower right
Gift of Peter H. Begley, 1993
993-O-101

Wayne E. BEGLEY, (1937–)

Tod Fliehend
Oil on canvas, 60 x 48" (152.40 x 121.92 cm.)
Unsigned
Museum purchase, 1959
959-O-113

Arnold BELKIN, (1932–)

Man with Bird, 1971
Lithograph on paper, 17 x 13" (43.18 x 33.02 cm.)
Signed, Belkin, lower right
Museum purchase, 1971
971-P-121

Cecil BELL, (1906–1970)

Hudson River, Moonlight
Gouache on paper, 6 x 8.5" (15.24 x 21.59 cm.)
Signed, C. Bell, upper left
Gift of Louis Held, 1965
965-W-122

Clara Louise BELL, (1886– ?)

The Pink Bow, 1922
(Portrait of Helen Elaine Wilkinson)
Watercolor on paper, 12.25 x 9.25" (31.12 x 23.50 cm.)
Signed, Clara Louise Bell, 1922, lower left
Gift of Clara Louise Bell, 1968
968-W-143

George Wesley BELLOWS, (1882–1925)

Geraldine Lee #2, 1914
Oil on panel, 38 x 30" (96.52 x 76.20 cm.)
Signed, Geo. Bellows, lower right
Museum purchase, 1941
941-O-101

Stag at Sharkey's
Lithograph on paper, (no. 11), 19 x 24" (48.26 x 60.96 cm.)
Signed, Geo. Bellows, lower right
Anonymous gift, 1958
958-P-104

The Odalisque
Crayon on paper, 11 x 14" (27.94 x 35.56 cm.)
Signed, Geo. Bellows, lower left
Museum purchase, 1957
957-D-101

The following eight signed lithographs on paper are the gift of Carl Dennison, 1975

Between the Rounds #2, 1923
20 x 17" (50.80 x 43.18 cm.)
975-P-110

Counted Out #1, 1921
15 x 14" (38.10 x 35.56 cm.)
975-P-107

Dempsey and Firpo, 1924
20 x 24" (50.80 x 60.96 cm.)
975-P-105

Introducing George Carpentier, 1921
17 x 23" (43.18 x 58.42 cm.)
975-P-108

Introducing John L. Sullivan, 1916
23 x 23" (58.42 x 58.42 cm.)
975-P-106

Preliminaries to the Big Bout, 1916
18 x 22" (45.72 x 55.88 cm.)
975-P-109

River Front, 1924
17 x 23" (43.18 x 58.42 cm.)
975-P-111

Clara Louise Bell - The Pink Bow

Bellows - Geraldine Lee #2

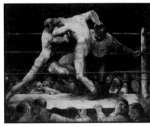
Bellows - Stag at Sharkey's

Bellows - The Odalisque

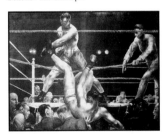
Bellows - Dempsey and Firpo

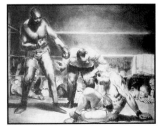
Bellows - The White Hope (page 16)

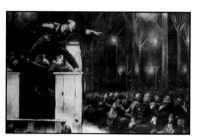

Bellows - Billy Sunday

Benedetto - Homage to Hockney

Benninger - Aftermath

Benson - Red and Gold

Benson - Metcalf Sketching

Benton - Chilmark

The White Hope, 1921
18 x 21" (45.72 x 53.34 cm.)
975-P-104

The following six signed lithographs on paper
are a museum purchase, 1952, 1965, 1968, 1980

Artist Drawing
11.5 x 8.5" (29.21 x 21.59 cm.)
965-P-120

Billy Sunday
9 x 16" (22.86 x 40.64 cm.)
952-P-101

Legs of the Sea, 1921
10.75 x 8.5" (27.31 x 21.59 cm.)
968-P-243

Life Study: Nude Woman Seated, 1917
17.5 x 13" (44.45 x 33.02 cm.)
980-P-129

The Journey of Youth, 1923–24
9.5 x 20" (24.13 x 50.80 cm.)
980-P-130

The Jury, 1916
16.25 x 12" (41.28 x 30.48 cm.)
968-P-244

Susanna BELTRANDI, (active 20th century)

Dancing Shadows
Acrylic on canvas, 32 x 40" (81.28 x 101.60 cm.)
Unsigned
Museum purchase, 1992
992-O-117

Anthony BENEDETTO, (Tony Bennett),
(1925–)

Homage to Hockney
Oil on canvas, 36 x 24" (91.44 x 60.96 cm.)
Signed, Benedetto, lower right
Gift of Anthony Bennett, 1994
994-O-123

Gerrit A. BENEKER, (1882–1934)

Old Fisherman, 1917
Oil on canvas, 20 x 16" (50.80 x 40.64 cm.)
Signed, Gerrit A. Beneker, 1917, lower left
Museum purchase, 1919
919-O-101

Ben BENN, (1884–1983)

Apples and Lemons in Red Bowl, 1948
Oil on canvas, 16 x 20" (40.64 x 50.80 cm.)
Signed, Benn, 48, lower left
Museum purchase, 1954
954-O-102

Flowers
Watercolor on paper, 12 x 15" (30.48 x 38.10 cm.)
Signed, Ben Benn, lower right
Gift of Mr. and Mrs. Nahum Tschacbasov, 1972
972-W-102

Bronx Park, 1941
Charcoal and red chalk on paper, 13.5 x 17.5" (34.29 x 44.45
cm.)
Signed, Benn, 41, lower left
Gift of Joseph G. Butler, III, 1960
960-D-107

John BENNETT, (1942–)

Closet the Skirting
Portfolio of 53: Rip Off on the Last Millennium
Print on paper, 8.5 x 11" (21.59 x 27.94 cm.)
Signed, John Bennett, lower left
Gift of the William Busta Gallery, 1990
990-P-111.33

Rainey BENNETT, (1907–)

The Moth, 1962
Watercolor on paper, 19.5 x 15" (49.53 x 38.10 cm.)
Signed, Rainey Bennett, lower right
Museum purchase, 1962
962-W-114

J. J. BENNINGER, (1908–)

Aftermath, 1955
Watercolor on paper, 18 x 24" (45.72 x 60.96 cm.)
Signed, Benninger, lower right
Museum purchase, 1957
957-W-101

Frank Weston BENSON, (1862–1951)

Red and Gold, 1915
Oil on canvas, 31 x 39" (78.74 x 99.06 cm.)
Signed, F. W. Benson, lower left
Museum purchase, 1919
919-O-102

Metcalf Sketching, 1921
Pencil on paper, 10 x 8.5" (25.40 x 21.59 cm.)
Signed, F. W. B., lower left
Museum purchase, 1964
964-D-104

Lone Yellow Legs
Drypoint on paper, 16 x 10.5" (40.64 x 26.67 cm.)
Signed, Frank W. Benson, lower left
Gift of Mr. and Mrs. Albert Cohen, 1985
985-P-105

Three Flying Geese
Etching on paper, 8 x 14.62" (20.32 x 37.15 cm.)
Signed, Frank Benson, lower left
Gift of John R. Tarantine, 1989
989-P-116

Thomas Hart BENTON, (1889–1975)

Chilmark, 1938
Watercolor on paper, 13 x 17" (33.02 x 43.18 cm.)
Signed, Benton, lower left
Museum purchase, 1938
938-W-101

Instruction
Lithograph on paper, 10.5 x 12.5" (26.67 x 31.75 cm.)
Signed, Benton, lower right
Museum purchase, 1967
967-P-193

Kansas Farmyard
Lithograph on paper, 10.5 x 16" (26.67 x 40.64 cm.)
Signed, Benton, lower right
Museum purchase, 1962
962-P-114

Morning Train
Lithograph on paper, 12 x 16" (30.48 x 40.64 cm.)
Signed, Benton, lower right
Gift of Albert E. Hise, 1979
979-P-158

New England Farm, 1951
Lithograph on paper, 9 x 14" (22.86 x 35.56 cm.)
Signed, Thomas H. Benton, lower right
Gift of Mrs. Albert L. Pugsley, 1968
968-P-252

Portrait of Old Man
Lithograph on paper, 13 x 19.5" (33.02 x 49.53 cm.)
Signed, Benton, lower right
Museum purchase, 1967
967-P-182

Woodpile
Lithograph on paper, 8.12 x 10.87" (20.64 x 27.62 cm.)
Signed, Benton, lower right
Gift of Mr. and Mrs. Edward E. Ford, 1970
970-P-109

The following two signed lithographs on paper
are a museum purchase, 1979

Island Hay, 1945
11.5 x 14.5" (29.21 x 36.83 cm.)
979-P-111

Old Man Reading
10 x 12" (25.40 x 30.48 cm.)
979-P-163

Dimitri BEREA, (active 20th century)

Landscape, 1976
Lithograph on paper, 30 x 23.25" (76.20 x 59.06 cm.)
Signed, Berea, lower right
Gift of Samuel S. Mandel, 1986
986-P-161

David BERGER, (1920–)

Red Equestrian
Oil on canvas, 35 x 43" (88.90 x 109.22 cm.)
Signed, D. Berger, lower right
Museum purchase, 1955
955-O-104

Jane Sari BERGER, (active late 20th century)

(Untitled)
Portfolio of 53: Rip Off on the Last Millennium
Print on paper, 8.5 x 11" (21.59 x 27.94 cm.)
Signed, Jane Sari Berger, lower right
Gift of the William Busta Gallery, 1990
990-P-111.4

Jack BERGHOFF, (1928–)

Nardin Park
Oil on canvas, 32 x 24" (81.28 x 60.96 cm.)
Signed, Berghoff, lower left
Museum purchase, 1953
953-O-101

Jerry BERNECHE, (1932–)

Two Young Women, 1964
Oil on canvas, 48 x 48" (121.92 x 121.92 cm.)
Unsigned
Museum purchase, 1964
964-O-108

Louis BERNEKER, (1872–1937)

Park in Winter
Oil on canvas, 11.5 x 15.5" (29.21 x 39.37 cm.)
Signed, Berneker, lower left
Museum purchase, 1965
965-O-164

Joanne BERNESHE, (1938–)

Winter, 1964
Watercolor on paper, 21 x 29" (53.34 x 73.66 cm.)
Unsigned
Museum purchase, 1964
964-W-106

Oscar E. BERNINGHAUS, (1874–1952)

Braves of the Taos Mountains
Oil on board, 16 x 20" (40.64 x 50.80 cm.)
Signed, O. E. Berninghaus, Taos, N.M., lower right
Museum purchase, 1970
970-O-104

Sylvia BERNSTEIN, (1918–1990)

Yesteryear's Bouquet
Watercolor on paper, 23.5 x 38" (59.69 x 96.52 cm.)
Signed, Sylvia Bernstein, lower left
Gift of Sylvia Bernstein, 1959
959-W-112

Theresa BERNSTEIN, (1898– ?)

New York Street
Oil on canvas, 30 x 40" (76.20 x 101.60 cm.)
Signed, Bernstein, lower right
Gift of Theresa Bernstein, 1974
974-O-103

On the Beach
Oil on paper, 14 x 20" (35.56 x 50.80 cm.)
Signed, Bernstein, lower middle
Gift of Louis Held, 1965
965-O-114

Donald BERRY, (active 20th century)

New Hampshire Indian, 1960
Wash on paper, 11 x 7" (27.94 x 17.78 cm.)
Signed, Donald Berry, 1960, lower right
Gift of Mr. and Mrs. Irving White, 1961
961-D-117

The following three drawings, ink wash on
paper, 21 x 15" (53.34 x 38.10 cm.), are an
anonymous gift, 1961

Abstraction #3, 1960
961-D-111

Abstraction #4, 1960
961-D-110

Abstraction #9, 1960
961-D-112

William BERSTRESSER, (1891– ?)

Kennerdell Festival, 1960
Oil on canvas, 24 x 30" (60.96 x 76.20 cm.)
Unsigned
Museum purchase, 1960
960-O-121

Johann BERTHLESEN, (1883–1969)

Winter Scene, Times Square
Oil on canvas, 30 x 25" (76.20 x 63.50 cm.)
Signed, Berthlesen, lower left
Gift of Dr. and Mrs. Robert V. C. Carr, 1988
988-O-102

Benton - Morning Train (page16)

Berninghaus - Braves of the Taos Mountains

Theresa Bernstein - On the Beach

Berthlesen - Winter Scene, Times Square

Bertolini - Figure Study (page 18)

Louis Betts - Frances and Judy (page 18)

George M. Biddle - Lilies

Bidner - 6-8-10 Great Jones Street

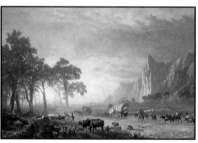
Bierstadt - The Oregon Trail

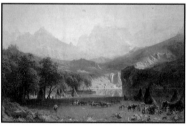
Bierstadt - Rocky Mountains

Bilicki - Work Table (page 19)

Mario BERTOLINI, (1925–)

Curvilinear and Rectilinear
Oil on canvas, 36.5 x 56.5" (92.71 x 143.51 cm.)
Signed, Mario Bertolini, lower right
Museum purchase, 1970
970-O-113

Figure Study, 1953
Drawing on paper, 24 x 10" (60.96 x 25.40 cm.)
Signed, Mario Bertolini, 1953, lower right
Museum purchase, 1956
956-D-101

Edward Howard BETTS, (1920–)

Coastal Landscape
Oil on canvas, 18 x 50" (45.72 x 127.00 cm.)
Signed, Betts, lower right
Museum purchase, 1957
957-O-101

Storm Tide, 1952
Oil on canvas, 28 x 40" (71.12 x 101.60 cm.)
Signed, Betts, lower right
Museum purchase, 1953
953-O-102

Fishing Shack
Watercolor on paper, 15 x 27.5" (38.10 x 69.85 cm.)
Unsigned
Museum purchase, 1958
958-W-112

Louis BETTS, (1873–1961)

Frances and Judy
Oil on canvas, 30 x 25" (76.20 x 63.50 cm.)
Unsigned
Gift of Zara Symons Betts, 1945
945-O-101

Edward BIBERMAN, (1904–1986)

Nude, 1930
Oil on canvas, 25 x 35" (63.50 x 88.90 cm.)
Signed, Biberman, lower right
Gift of Mrs. Charles F. Sampson, 1955
955-O-105

Grieving Woman
Lithograph on paper, 21 x 16" (53.34 x 40.64 cm.)
Signed, Edward Biberman, lower right
Gift of J. J. Benninger, 1971
971-P-109

William H. W. BICKNELL, (1860– ?)

Wharf Scene, ca. 1941
Etching on paper, 5 x 7" (12.70 x 17.78 cm.)
Signed, W. H. W. Bicknell, lower right
Gift of J. J. Benninger, 1968
968-P-218

George M. BIDDLE, (1885–1973)

Lilies, 1931
Oil on canvas, 30 x 25" (76.20 x 63.50 cm.)
Signed, Biddle, 1931, lower right
Gift of Drs. James and Nina Rudel, 1955
955-O-106

Here We Part, 1939
Watercolor on paper, 20 x 29" (50.80 x 73.66 cm.)
Signed, Geo. Biddle, 39, lower right
Museum purchase, 1941
941-W-101

Carnival in Rio, 1947
Lithograph on paper, 10.5 x 11.5" (26.67 x 29.21 cm.)
Signed, George Biddle, 1947, lower right
Museum purchase, 1967
967-P-106

Michael BIDDLE, (1934–)

Cheetah
Etching on paper, (66/250), 8.75 x 11.25" (22.23 x 28.58 cm.)
Signed, Michael Biddle, lower right
Museum purchase, 1967
967-P-147

Robert BIDNER, (1903–1983)

6-8-10 Great Jones Street
Oil on canvas, 48 x 66" (121.92 x 167.64 cm.)
Signed, Bidner, lower right
Museum purchase, 1975
975-O-119

Four Nudes Ascending Escalator
Acrylic on canvas, 48.5 x 32.5" (123.19 x 82.55 cm.)
Unsigned
Museum purchase, 1973
973-O-119

Plant Entrance
Oil on canvas, 28.5 x 49" (72.39 x 124.46 cm.)
Signed, Bidner, upper right
Museum purchase, 1953
953-O-103

(Untitled)
Oil on masonite, 22.12 x 17.12" (56.20 x 43.50 cm.)
Signed, Bidner, lower left
Gift of Gertrude Hobart, 1990
990-O-110

The following two lithographs on paper are an anonymous gift, 1980

Brooklyn Museum
23 x 29.5" (58.42 x 74.93 cm.)
980-P-160

Flying Rolls
23 x 31" (58.42 x 78.74 cm.)
980-P-161

Albert J. BIERSTADT, (1830–1902)

The Oregon Trail, 1869
Oil on canvas, 31 x 49" (78.74 x 124.46 cm.)
Signed, A. Bierstadt, 1869, lower right
Gift of Joseph G. Butler, III, 1946
946-O-101

Rocky Mountains, 1866
Steel engraving on paper, 16.5 x 28" (41.91 x 71.12 cm.)
Signed, Bierstadt, lower left and lower right
Museum purchase, 1970
970-P-168

Steven BIGLER, (active 20th century)

Seated Figure and Plant
Oil on canvas, 30 x 36" (76.20 x 91.44 cm.)
Unsigned
Gift of the Friends of American Art, 1980
980-O-108

John BILICKI, (1929–)

Work Table, 1959
Oil on canvas, 44 x 16" (111.76 x 40.64 cm.)
Signed, Bilicki, 59, lower left
Museum purchase, 1959
959-O-125

G. and F. BILL, (active mid-19th century)

Bird's-eye View of Mt. Vernon, 1859
Hand tinted lithograph on paper, 12 x 15" (30.48 x 38.10 cm.)
Unsigned
Anonymous gift, 1976
976-P-117

H. BILLINGS, (1816–1874)

Washington Portrait
(American Banknote)
Engraving on paper, 3.12 x 3" (7.94 x 7.62 cm.)
Unsigned
Museum purchase, 1968
968-P-303

Moses BILLINGS, (1809–1884)

Girl in White
Oil on canvas, 60 x 48" (152.40 x 121.92 cm.)
Unsigned
Museum purchase, 1977
977-O-156

Julien BINFORD, (1908–)

Still Life with Girl Reading, ca. 1945
Oil on canvas, 28 x 36" (71.12 x 91.44 cm.)
Unsigned
Gift of Harry Lewis Stone, 1962
962-O-102

George Caleb BINGHAM, (1811–1879)

James Harrison Cravens, 1842
Oil on canvas, 27 x 22" (68.58 x 55.88 cm.)
Unsigned, inscription by Cravens family, on reverse
Museum purchase, 1966
966-O-126

The County Election, 1854
Engraving on paper, 22.25 x 29.75" (56.52 x 75.57 cm.)
Unsigned
Museum purchase, 1979
979-P-101

The Jolly Flat Boat Men, 1847
Engraving on paper, 22.5 x 26.5" (57.15 x 67.31 cm.)
Unsigned
Museum purchase, 1978
978-P-117

Thomas BIRCH, (1779–1861)

Ship: *Houqua*, 1861
Oil on canvas, 24 x 31" (60.96 x 78.74 cm.)
Signed, T. Birch, 1861, lower right
Museum purchase, 1928
S28-O-101

Capture of the British Frigate *Currier*
by the US Frigate *Constitution*
Engraving on paper, 5.12 x 7.37" (13.01 x 18.73 cm.)
Unsigned
Museum purchase, 1969
969-P-129

George K. BISHOP, (active 20th century)

Self Portrait
Oil on canvas, 24 x 18" (60.96 x 45.72 cm.)
Unsigned
Gift of the estate of George K. Bishop, 1988
988-O-106

Isabel BISHOP, (1902–1988)

Laughing Head, 1938
Mixed media on panel, 13 x 12" (33.02 x 30.48 cm.)
Signed, Isabel Bishop, lower right
Museum purchase, 1940
940-O-104

Laughing Girl, 1938
Etching on paper, 5 x 4" (12.70 x 10.16 cm.)
Signed, Isabel Bishop, lower left
Museum purchase, 1967
967-P-174

Outdoor Lunch Counter
Etching on paper, 7 x 5" (17.78 x 12.70 cm.)
Signed, Isabel Bishop, lower right
Gift of Louis Held, 1965
965-P-162

Two Girls
Photo enlargement with pastel and tempera, 17 x 23" (43.18 x 58.42 cm.)
Unsigned
Museum purchase, 1942
942-D-101

The following four works on paper are a
museum purchase, 1965

Girls Outdoors
Etching on paper, 7.5 x 5" (19.05 x 12.70 cm.)
965-P-277

Ice Cream Cones #1
Ink on paper, 8 x 5" (20.32 x 12.70 cm.)
965-D-130

In the Subway
Etching on paper, 9.5 x 10.5" (24.13 x 26.67 cm.)
965-P-278

Small Nude
Aquatint on paper, 5.5 x 5" (13.97 x 12.70 cm.)
965-P-279

Wendell BLACK, (1919–1972)

Mountainscape, 1956
Engraving on paper, 21 x 27" (53.34 x 68.58 cm.)
Signed, W. Black, 56, lower right
Museum purchase, 1956
956-P-101

Morris A. BLACKBURN, (1902–1980)

Nets and Boats
Oil on canvas, 24 x 32" (60.96 x 81.28 cm.)
Signed, Morris Blackburn, lower right
Museum purchase, 1953
953-O-104

Moses Billings - Girl in White

Bingham - James Harrison Cravens

Bingham - The County Election

Bingham - The Jolly Flat Boat Men

Birch - Ship: *Houqua*

Isabel Bishop - Laughing Head

Isabel Bishop - Outdoor Lunch Counter

Phyllis E. Blair - Manhattan, Midtown

Blake - Tattooed Man

Blakelock - Twilight

Blakelock - Landscape with Cows

Blythe - Street Urchins (page 21)

Blythe - Portrait of Silas Gault (page 21)

Blue Floats, 1954
Watercolor on paper, 20 x 26" (50.80 x 66.04 cm.)
Signed, Morris Blackburn, lower left
Museum purchase, 1955
955-W-103

Old Philadelphia Street
Watercolor on paper, 13.5 x 17.5" (34.29 x 44.45 cm.)
Signed, Morris Blackburn, lower right
Gift of Louis Held, 1965
965-W-111

Harriet BLACKSTONE, (1864–1939)

Portrait of Louise M. Truesdale
Oil on canvas, 38 x 30" (96.52 x 76.20 cm.)
Unsigned
Gift of Phoebe Truesdale Smith, 1958
958-O-129

Allen BLAGDEN, (1938–)

Steamers
Watercolor on paper, 10.5 x 13.5" (26.67 x 34.29 cm.)
Signed, Allen Blagden, lower right
Gift of Frank K. M. Rehn, Inc., 1978
978-W-117

Jeanette BLAIR, (1912–)

Spring
Watercolor on paper, 22 x 30" (55.88 x 76.20 cm.)
Signed, Jeanette Blair, lower left
Museum purchase, 1954
954-W-102

Phyllis E. BLAIR, (active late 20th century)

Manhattan, Midtown, 1975
Oil on canvas, 48 x 36.25" (121.92 x 92.08 cm.)
Signed, P. E. Blair, lower left
Gift of Phyllis E. Blair, 1983
983-O-107

Slow Rise, 1974
Acrylic on canvas, 48 x 28.5" (121.92 x 72.39 cm.)
Signed, P. E. Blair, lower right
Gift of Phyllis E. Blair, 1983
983-O-108

Robert N. BLAIR, (1912–)

Light and Shade, ca. 1952
Watercolor on paper, 30 x 40" (76.20 x 101.60 cm.)
Signed, Robert N. Blair, lower right
Museum purchase, 1953
953-W-101

Peter BLAKE, (active 20th century)

The following five wood engravings on paper, 10.5 x 8.5" (26.67 x 21.59 cm.), are the gift of Mr. and Mrs. Nelson E. Oestreich, 1992

Side Show–Portfolio, (74/100)
992-P-101.1 — 992-P-101.5

Bearded Lady

Fat Boy

Giant

Midget

Tattooed Man

Ralph A. BLAKELOCK, (1847–1919)

Twilight, ca. 1898
Oil on canvas, 20 x 30" (50.80 x 76.20 cm.)
Signed, R. A. Blakelock, lower right
Gift of H. H. Stambaugh, 1919
919-O-103

Landscape with Cows
Oil on canvas, 18 x 32" (45.72 x 81.28 cm.)
Signed, R. A. Blakelock, lower left
Gift of Mr. and Mrs. John Tyler and Mr. and Mrs. William T. Deibel in memory of Mrs. C. P. Deibel, 1982
982-O-109

Arnold BLANCH, (1896–1968)

Vase Forms, 1958
Casein on paper, 20.5 x 27" (52.07 x 68.58 cm.)
Signed, Arnold Blanch, 58, lower right
Museum purchase, 1958
958-W-114

Backyards
Watercolor on paper, 14 x 19.5" (35.56 x 49.53 cm.)
Signed, Arnold Blanch, lower right
Museum purchase, 1941
941-W-103

Flowers, 1951
Lithograph on paper, 18 x 12" (45.72 x 30.48 cm.)
Signed, Arnold Blanch, 1951, lower right
Museum purchase, 1951
951-P-101

Girl with Vase of Flowers, 1968
Silkscreen on paper, 14 x 10" (35.56 x 25.40 cm.)
Signed, Arnold Blanch, lower right
Museum purchase, 1968
968-P-254

Lucille BLANCH, (1896–1981)

Intended Flight
Lithograph on paper, 14 x 10" (35.56 x 25.40 cm.)
Signed, Lucille Blanch, lower right
Museum purchase, 1955
955-P-102

Al BLAUSTEIN, (1924–)

Studio Interior
Oil on canvas, 48 x 62" (121.92 x 157.48 cm.)
Signed, A. Blaustein, lower right
Museum purchase, 1961
961-O-118

The following two etchings on paper are a museum purchase, 1962

Sessions of Sweet Silent Thought V
(21/25), 16 x 19.5" (40.64 x 49.53 cm.)
962-P-109

The Recluse
(18/25), 18 x 15" (45.72 x 38.10 cm.)
962-P-121

Frances BLOCH, (1921–)

Sonia and Still Life
Oil on canvas, 40 x 30" (101.60 x 76.20 cm.)
Signed, Frances Bloch, lower left
Museum purchase, 1966
966-O-118

William J. BLOOM, (1935–)

Spirit of America, 1961
Oil on canvas, 36 x 24" (91.44 x 60.96 cm.)
Signed, William Bloom, lower middle
Museum purchase, 1961
961-O-126

Zevi BLUM, (1933–)

Samson, 1966
Ink and watercolor on paper, 28.5 x 40" (72.39 x 101.60 cm.)
Unsigned
Museum purchase, 1966
966-W-115

Fannie BLUMBERG, (active 20th century)

Detura
Oil on canvas, 29 x 32" (73.66 x 81.28 cm.)
Signed, Blumberg, lower right
Anonymous gift, 1955
955-O-127

Yuli BLUMBERG, (1894–1964)

Self Portrait
Oil on canvas, 37 x 23" (93.98 x 58.42 cm.)
Signed, Blumberg, lower left
Gift of the Cohen-Snower Foundation, 1958
958-O-115

David Gilmour BLYTHE, (1815–1865)

Street Urchins, ca. 1856–58
Oil on canvas, 26.75 x 22" (67.95 x 55.88 cm.)
Signed, Blythe, lower right
Museum purchase, 1946
946-O-102

Portrait of Silas Gault, ca. 1855
Oil on canvas, 27 x 22" (68.58 x 55.88 cm.)
Unsigned
Museum purchase, 1965
965-O-148

The following two unsigned oils on canvas, 27 x 22" (68.58 x 55.88 cm.), are a museum purchase, 1948

Portrait of James McDonald, 1855
948-O-106

Portrait of Julianne Cooke McDonald, 1855
948-O-105

Lowell BOBLETER, (1902–1973)

Grandfather's House
Drypoint on paper, 8 x 10" (20.32 x 25.40 cm.)
Signed, Lowell Bobleter, lower right
Gift of Louis Held, 1965
965-P-176

Frank M. BOGGS, (1895–1926)

Le Pont-Neuf
Gouache on paper, 10.5 x 16" (26.67 x 40.64 cm.)
Signed, Frank Boggs, lower right
Museum purchase, 1967
968-W-120

Max BOHM, (1868–1923)

Self Portrait, 1896
Oil on canvas, 18 x 15" (45.72 x 38.10 cm.)
Signed, Max Bohm, upper right
Museum purchase, 1967
967-O-143

Aaron BOHROD, (1907–)

The Mormons, 1957
Oil on canvas, 20 x 16" (50.80 x 40.64 cm.)
Signed, A. B., middle right
Museum purchase, 1959
959-O-127

Still Life with Ferdinand
Oil on panel, 31 x 23" (78.74 x 58.42 cm.)
Signed, Aaron Bohrod, lower left
Gift of Drs. Paul and Laura Mesaros, 1992
992-O-115

East Liverpool, ca. 1939
Gouache on paper, 10.25 x 13.25" (26.04 x 33.66 cm.)
Signed, Aaron Bohrod, lower right
Museum purchase, 1992
992-W-101

Street in Peoria
Watercolor on paper, 14 x 18" (35.56 x 45.72 cm.)
Signed, Aaron Bohrod, lower left
Museum purchase, 1941
941-W-104

Country Church
Lithograph on paper, 9 x 12.5" (22.86 x 31.75 cm.)
Signed, Aaron Bohrod, lower right
Gift of Louis Held, 1965
965-P-184

New Orleans Vista
Lithograph on paper, 9.75 x 13.75" (24.77 x 34.93 cm.)
Signed, Aaron Bohrod, lower right
Museum purchase, 1967
967-P-105

Self Portrait, 1932
Lithograph on paper, 12 x 9" (30.48 x 22.86 cm.)
Signed, Aaron Bohrod, lower right
Museum purchase, 1972
972-P-110

Hannes BOK, (active 20th century)

The following four lithographs on paper, 14 x 10" (35.56 x 25.40 cm.), are the gift of Louis Held, 1965
965-P-128 — 965-P-131

The White Powers

The Black Powers, 1944

The Primal Powers

The Gray Powers

Ilya BOLOTOWSKI, (1907–1981)

Orange Tondo, 1973
Offset lithograph on paper, 29 x 29" (73.66 x 73.66 cm.)
Signed, Ilya Bolotowski, lower right
Gift of Dana Seman, 1980
980-P-108

Boggs - Le Pont-Neuf

Bohm - Self Portrait

Bohrod - The Mormons

Bohrod - Still Life with Ferdinand

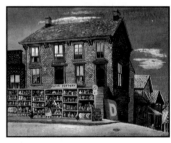

Bohrod - East Liverpool

Bolotowski - Orange Tondo

Bontecou- (Untitled)

Borgenight - Landscape in Green and Sienna

Bosa - Head

Bosa - Monks Fishing, Venice

Bosa - New York Subway

Boston - The Silver Moonlight

Carmen BONANNO, (active 20th century)

The Mates
Etching on paper, 9.62 x 7.87" (24.45 x 19.98 cm.)
Signed, Carmen Bonanno, lower right
Gift of Mr. and Mrs. Edward E. Ford, 1970
970-P-110

Lee BONTECOU, (1931–)

(Untitled)
Serigraph on paper, 9 x 12" (22.86 x 30.48 cm.)
Signed, Bontecou, lower right
Gift of Steven Feinstein, 1983
983-P-173

Samuel BOOKATZ, (1910–)

Gate Watch
Watercolor on paper, 20 x 31" (50.80 x 78.74 cm.)
Signed, Samuel Bookatz, lower right
Museum purchase, 1958
958-W-103

Jack BOOKBINDER, (1911–1990)

Cargador, 1964
Lithograph on paper, 20 x 17" (50.80 x 43.18 cm.)
Signed, Jack Bookbinder, lower right
Anonymous gift, 1973
973-P-138

Cameron BOOTH, (1892–1980)

Feb. 9, 15, 16, 1960, 1960
Acrylic on canvas, 60 x 48" (152.40 x 121.92 cm.)
Signed, Cameron Booth, 1960, lower right
Gift of Cameron Booth, 1969
969-O-160

Horse Feeding, 1963
Oil on canvas, 48 x 60" (121.92 x 152.40 cm.)
Signed, B., 1963, lower right
Museum purchase, 1965
965-O-106

Two Farm Horses, 1963
Oil on canvas, 54 x 72" (137.16 x 182.88 cm.)
Signed, B., 1963, lower right
Gift of Cameron Booth, 1972
972-O-103

Winter, Rich Valley Farm, 1974
Oil on canvas, 24 x 42" (60.96 x 106.68 cm.)
Signed, C. B., 74, lower right
Gift of Cameron Booth in memory of his brother Paul Booth, 1974
974-O-118

Grace BORGENIGHT, (1915–)

Landscape in Green and Sienna
Watercolor on paper, 16.5 x 21.5" (41.91 x 54.61 cm.)
Signed, Grace Borgenight, lower right
Gift of Louis Held, 1965
965-W-107

Louis BOSA, (1905–1981)

Head
Oil on canvas, 9.5 x 7.5" (24.13 x 19.05 cm.)
Unsigned
Gift of Louis Held, 1965
965-O-138

Monks Fishing, Venice
Oil on canvas, 30 x 40" (76.20 x 101.60 cm.)
Signed, Bosa, lower right
Museum purchase, 1960
960-O-106

New York Subway, 1947
Oil on canvas, 34 x 58" (86.36 x 147.32 cm.)
Signed, Bosa, lower right
Gift of the friends of Louis Bosa, 1979
979-O-113

Self Portrait
Oil on board, 7 x 5" (17.78 x 12.70 cm.)
Unsigned
Gift of the friends of Louis Bosa, 1979
979-O-114

The following three drawings, ink on paper, are the gift of the friends of Louis Bosa, 1979

Procession
9 x 12.25" (22.86 x 31.12 cm.)
979-D-103

Uchello
(Series of eight separate drawings)
4.75 x 3.75" (12.06 x 9.53 cm.)
979-D-104

Venezia, 1966
9.5 x 13.25" (24.13 x 33.66 cm.)
979-D-102

Thomas BOSTELLE, (1921–)

Theater Fragments, 1970
Paint on wood, 39.5 x 29.5" (100.33 x 74.93 cm.)
Signed, Bostelle, 1970, lower right
Gift of Lewis M. Helm, 1976
976-O-143

Joseph H. BOSTON, (1860–1954)

The Silver Moonlight, 1915
Oil on canvas, 35 x 48" (88.90 x 121.92 cm.)
Signed, Joseph H. Boston, lower left
Museum purchase, 1918
918-O-101

Henry BOTKIN, (1896–1983)

Boy with Bird, 1959
Oil on canvas, 25 x 21" (63.50 x 53.34 cm.)
Signed, Botkin, 59, lower left
Gift of Dr. Bernard Brodsky, 1959
959-O-103

September
Oil on board, 4.25 x 6" (10.80 x 15.24 cm.)
Signed, Botkin, lower left
Gift of Jack M. Hockett, 1977
977-O-152

Otto BOTTO, (1903–1968)

Anneli with Flowered Hat, 1967
Oil on masonite, 34.75 x 24" (88.27 x 60.96 cm.)
Signed, O. Botto, lower right
Gift of Sharon Hockett, 1985
985-O-111

Bouquet
Oil on canvas, 20 x 17.5" (50.80 x 44.45 cm.)
Signed, O. Botto, lower right
Museum purchase, 1968
968-O-160

Seated Nude with Flowers
Oil on panel, 48 x 24" (121.92 x 60.96 cm.)
Signed, O. Botto, lower left
Gift of Jack M. Hockett, 1977
977-O-110

The following three signed watercolors on paper are the gift of Louis Held, 1968

Landscape with Bird, 1959
11.5 x 9" (29.21 x 22.86 cm.)
968-W-128

Man, 1964
10 x 7" (25.40 x 17.78 cm.)
968-W-127

Portrait of Noble Man, 1959
11.5 x 8.5" (29.21 x 21.59 cm.)
968-W-126

The following two signed drawings, ink on paper, are the gift of Louis Held, 1968

Central Park, 1964
6 x 9" (15.24 x 22.86 cm.)
968-D-118

Dr. D, 1964
7 x 5" (17.78 x 12.70 cm.)
968-D-119

Louis BOUCHÉ, (1896–1969)

Self Portrait with Helmet, 1959
Oil on canvas, 24 x 20" (60.96 x 50.80 cm.)
Signed, L. Bouché, upper left
Museum purchase, 1965
965-O-170

Man Reading
Ink on paper, 13.5 x 9" (34.29 x 22.86 cm.)
Signed, L. Bouché, lower right
Gift of Louis Held, 1965
965-D-121

The following two signed drawings, ink on paper, are a museum purchase, 1959

Figure in Interior
15.5 x 12" (39.37 x 30.48 cm.)
959-D-113

Study for High Street Bus Barn
9 x 13.5" (22.86 x 34.29 cm.)
959-D-114

J. T. BOWEN, (active mid 19th century)

The following two lithographs on paper, published in 1841, are the gift of Albert E. Hise, 1979

Ka-Ta-Wa-Be-Da, A Chippeway Chief
21.5 x 15" (54.61 x 38.10 cm.)
979-P-122

Wa-Kahn, A Winnebago Chief
21.25 x 15.5" (53.98 x 39.37 cm.)
979-P-123

Alexander BOWER, (1875–1952)

On a Rising Tide
Watercolor on paper, 20 x 27" (50.80 x 68.58 cm.)
Signed, Alexander Bower, lower right
Museum purchase, 1945
945-W-102

Dorothy BOWMAN, (1927–)

City Edge #2, 1961
Silkscreen on paper, 34 x 20" (86.36 x 50.80 cm.)
Signed, Dorothy Bowman, 61, lower right
Museum purchase, 1965
965-P-253

Gustave BOWMAN, (active 20th century)

Punch Hunting Chipmunks
Woodblock on paper, 12.75 x 15.25" (32.39 x 38.74 cm.)
Signed, Gustave Bowman, lower right
Gift of Drs. Paul and Laura Mesaros, 1993
993-P-163

Martin BOYLE, (active late 20th century)

Guardian
Portfolio of 53: Rip Off on the Last Millennium
Print on paper, 8.5 x 11" (21.59 x 27.94 cm.)
Signed, M. Boyle, lower right
Gift of the William Busta Gallery, 1990
990-P-111.18

James W. BOYNTON, (1928–)

Sun Trap
Oil on canvas, 46 x 74" (116.84 x 187.96 cm.)
Unsigned
Museum purchase, 1957
957-O-102

Daniel BOZA, (1911–)

Death of Arthur, 1929
Oil on board, 46.25 x 32" (117.48 x 81.28 cm.)
Signed, Boza, 29, lower left
Gift of Charles R. Walker, 1990
990-O-117

Oliver BOZA, (active 20th century)

Ohio Flood, 1937
Oil on canvas, 36 x 48" (91.44 x 121.92 cm.)
Signed, Oliver Boza, 1937, lower right
Gift of Joseph G. Butler, III, 1938
938-O-101

Robert BRACKMAN, (1898–1980)

Arrangement in a Morning Light
Oil on canvas, 36 x 30" (91.44 x 76.20 cm.)
Signed, Brackman, lower left
Gift of Dr. and Mrs. John J. McDonough, 1967
967-O-145

Steven P. BRADFORD, (active late 20th century)

The following two signed prints on paper, 8.5 x 5.5" (21.59 x 13.97 cm.), are the gift of the William Busta Gallery, 1990

(Untitled)
Portfolio of 53: Rip Off on the Last Millennium
990-P-111.24 and 990-P-111.30

Bouché - Self Portrait with Helmet

Bouché – Man Reading

Bowen - Ka-Ta-Wa-Be-Da, A Chippeway Chief

Gustave Bowman - Punch Hunting Chipmunks

Brackman - Arrangement in a Morning Light

William Bradford - Afternoon on the Labrador Coast

Breckner - Mill Entrance

Breer - (Untitled)

Brenneman - Summer

Breverman - Two Friday Nights

William BRADFORD, (1830–1892)

Afternoon on the Labrador Coast, 1878
Oil on canvas, 28 x 48" (71.12 x 121.92 cm.)
Signed, Wm. Bradford, 78, lower right
Museum purchase, 1975
975-O-136

Don BRADLEY, (1935–)

Round Round #2, 1966
Rhroplex 33 impasto on canvas, 30 x 30" (76.20 x 76.20 cm.)
Signed, Bradley, 66, lower right
Museum purchase, 1966
966-O-109

Glenn R. BRADSHAW, (1922–)

Monument I, 1967
Oil collage on masonite, 48 x 48" (121.92 x 121.92 cm.)
Signed, Bradshaw, lower left
Museum purchase, 1968
968-O-214

Resurgent Shore
Watercolor on paper, 25 x 38" (63.50 x 96.52 cm.)
Signed, Bradshaw, lower left
Museum purchase, 1961
961-W-103

W. C. BRAMWELL, (active 19th century)

The *Great Eastern*, 1873
Ink and watercolor on paper, 17.5 x 28.5" (44.45 x 72.39 cm.)
Unsigned
Museum purchase, 1967
967-D-113

Frank C. BRAYNARD, (1916–)

The Eagle
Felt tip pen on paper, 16.5 x 11.75" (41.91 x 29.85 cm.)
Signed, F. C. B., lower left
Museum purchase, 1980
980-D-102

George BRECKNER, Jr., (1914–)

Mill Entrance, 1953
Oil on canvas, 30 x 40" (76.20 x 101.60 cm.)
Signed, George Breckner, 53, lower right
Museum purchase, 1954
954-O-104

Derelict at Spruce Head, 1965
Watercolor on paper, 22 x 30" (55.88 x 76.20 cm.)
Signed, George Breckner, lower right
Museum purchase, 1966
966-W-102

November Dune, Provincetown, Cape Cod, 1977
Watercolor on paper, 25 x 39" (63.50 x 99.06 cm.)
Signed, Breckner, lower right
Gift of the Friends of American Art, 1977
977-W-119

Stop Signal
Drawing on paper, 16.5 x 22" (41.91 x 55.88 cm.)
Unsigned
Museum purchase, 1951
951-D-101

Harry Frederick BREEN, Jr., (1930–)

Illinois Prairie: The Washout, 1961
Oil on canvas, 30 x 50" (76.20 x 127.00 cm.)
Signed, Breen, 61, lower right
Museum purchase, 1962
962-O-115

Robert BREER, (1926–)

(Untitled)
Lithograph on paper, 9 x 12" (22.86 x 30.48 cm.)
Signed, Robert Breer, lower right
Gift of Steven Feinstein, 1983
983-P-146

Raymond BREININ, (1910–)

At Golgotha, 1941
Oil on canvas, 48 x 30" (121.92 x 76.20 cm.)
Signed, Breinin, 41, lower left
Gift of Mr. and Mrs. Milton Lowenthal, 1954
954-O-105

Rosemary BRENNAN, (1942–1985)

Man: A Finite Moment in Time, 1979
Acrylic on paper, 20.5 x 26.5" (52.07 x 67.31 cm.)
Signed, Rosemary Brennan, lower right
Museum purchase, 1979
979-W-111

George W. BRENNEMAN, (1856–1906)

Summer
Mixed media on canvas, 12 x 18" (30.48 x 45.72 cm.)
Signed, G. W. Brenneman, lower left
Gift of Berry-Hill Galleries, Inc., 1968
968-O-209

Harvey BREVERMAN, (1934–)

Portrait of Philip, 1962
Oil on canvas, 48 x 36" (121.92 x 91.44 cm.)
Signed, Breverman, 62, upper right
Gift of Joseph G. Butler, III, 1968
968-O-200

Two Friday Nights, 1962
Oil on canvas, 52 x 48" (132.08 x 121.92 cm.)
Signed, Breverman, 62, lower right
Museum purchase, 1962
962-O-114

Brooding Figure, 1968
Etching on paper, 24" dia. (60.96 cm.)
Signed, Harvey Breverman, lower right
Museum purchase, 1968
968-P-235

The Draftsman, (Self Portrait), 1977
Lithograph on paper, 22 x 30" (55.88 x 76.20 cm.)
Signed, Breverman, lower right
Gift of Mrs. Harvey Breverman, 1980
980-P-107

The following two etchings on paper are a museum purchase, 1968

Dutchman III, 1968
10.75 x 10.75" (27.31 x 27.31 cm.)
968-P-212

Dutchman V, 1968
21.75 x 28" (55.25 x 71.12 cm.)
968-P-234

Nicholas R. BREWER, (1857–1949)

James A. Campbell
Oil on canvas, 34 x 44" (86.36 x 111.76 cm.)
Signed, N. R. Brewer, lower right
Gift of Louis J. Campbell, 1940
940-O-103

Rebecca Campbell Stambaugh and Her
Daughters, Nancy and Carol, 1920
Oil on canvas, 38.5 x 54.5" (97.79 x 138.43 cm.)
Signed, N. R. Brewer, 1920, lower right
Gift of Mrs. Stefano Passigli, 1968
968-O-170

George Douglas BREWERTON, (1820–1901)

Gorge in Rocky Mountains, 1854
Oil on canvas, 30 x 44.25" (76.20 x 112.40 cm.)
Signed, G. Douglas Brewerton, lower left
Museum purchase, 1966
966-O-132

Anna Richards BREWSTER, (1870–1952)

Coast View
Oil on canvas and board, 4.5 x 25.5" (11.43 x 64.77 cm.)
Unsigned
Gift of Dorothy Dennison Butler, 1980
980-O-111

Landscape Sketch
Oil on canvas, 12 x 12.5" (30.48 x 31.75 cm.)
Unsigned
Gift of Dr. William T. Brewster, 1970
970-O-112

The following ten signed oils on canvas and
watercolors on paper of various sizes are the gift
of Dr. William T. Brewster, 1954

5th Avenue at 57th Street, ca. 1918
954-O-152

An Old-fashioned Posey, ca. 1939
954-O-148

Cedar Swamp Pond
954-O-149

Clovelly, ca. 1895
954-O-151

Dunes on Narragansett Bay
954-O-150

Florence from San Miniato, ca. 1926
954-O-147

Portrait of William T. Richards, ca. 1895
954-O-106

Cheyne Walk, Chelsea London, ca. 1900
954-W-104

Clovelly Beach, 1897
954-W-123

Cottage in Sierra, Clovelly, Devon, ca.
1896
954-W-121

Alfred Thompson BRICHER, (1837–1908)

The Landing at Bailey Island, Maine, ca.
1907
Oil on canvas, 15 x 32" (38.10 x 81.28 cm.)
Signed, A. T. Bricher, lower right
Museum purchase, 1976
976-O-146

Rocky Shore
Watercolor on paper, 10.5 x 15" (26.67 x 38.10 cm.)
Signed, A. T. Bricher, lower left
Museum purchase, 1968
968-W-124

Alfred BRIGHT, (1940–)

Love Letter to My Wife Pat, 1968
Oil on canvas, 42.75 x 46" (108.59 x 116.84 cm.)
Signed, A. Bright, lower right
Gift of the Youngstown Chapter of Links, Inc., 1984
984-O-103

Frank D. BRISCOE, (1844–1903)

Backing for the Pilot
Oil on canvas, 24 x 42" (60.96 x 106.68 cm.)
Signed, Frank D. Briscoe, lower right
Museum purchase, 1948
948-O-101

Ann BROCKMAN, (1899–1943)

Twin Lights
Watercolor on paper, 15 x 22" (38.10 x 55.88 cm.)
Signed, Ann Brockman, lower left
Museum purchase, 1941
941-W-105

June BROCKWAY, (? –1940)

Polar Expedition, 1899, 1899
Oil on canvas, 16.75 x 26" (42.55 x 66.04 cm.)
Signed, June Brockway, lower right
Museum purchase, 1968
969-O-141

Virginia BRODERICK, (active 20th century)

The Bible and Theological Virtues
Acrylic on canvas, 24 x 18" (60.96 x 45.72 cm.)
Signed, Virginia Broderick, lower right
Gift of Virginia Broderick, 1973
973-O-112

Robert BRONER, (1922–)

Power Plant, 1967
Etching on paper, 10.5 x 17.5" (26.67 x 44.45 cm.)
Signed, Robert Broner, 1967, lower right
Museum purchase, 1967
967-P-184

Alexander BROOK, (1898–1980)

Southern Girl
Oil on canvas, 36 x 30" (91.44 x 76.20 cm.)
Signed, A. Brook, lower left
Museum purchase, 1974
974-O-116

Blondy
Oil on canvas, 13 x 10" (33.02 x 25.40 cm.)
Signed, A. Brook, lower right
Gift of Emil J. Arnold, 1958
958-O-154

Brewerton - Gorge in Rocky Mountains

Brewster - 5th Avenue at 57th Street

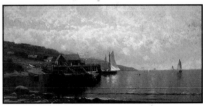
Bricher - The Landing at Bailey Island, Maine

Bright - Love Letter to My Wife Pat

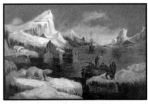
Brockway - Polar Expedition, 1899

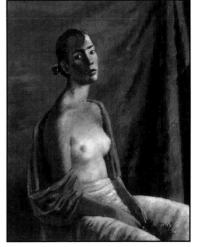
Brook - Southern Girl

Brooks - Green and Black Abstract

Harrison Bird Brown - Grand Manan Isalnd

John George Brown - Perfectly Happy

Browne - Trumpet Player

Browning - Telephones

Browning - Start

La Touche, 1938
Oil on canvas, 60 x 40" (152.40 x 101.60 cm.)
Signed, A. Brook, lower right
Gift of the estate of Alexander Brook, 1980
980-O-104

Remnants, 1952
Oil on canvas, 60 x 34" (152.40 x 86.36 cm.)
Signed, A. Brook, lower right
Gift of the estate of Alexander Brook, 1980
980-O-105

In the Studio
Lithograph on paper, 11.5 x 8.5" (29.21 x 21.59 cm.)
Signed, A. Brook, lower right
Museum purchase, 1967
967-P-104

James BROOKS, (1906–1992)

Green and Black Abstract
Watercolor on paper, 10 x 13.5" (25.40 x 34.29 cm.)
Signed, J. Brooks, lower right
Gift of Louis Held, 1965
965-W-120

Harry BRORBY, (1927–)

The Bird Watchers
Watercolor on paper, 26 x 39" (66.04 x 99.06 cm.)
Unsigned
Museum purchase, 1961
961-W-104

George Elmer BROWINE, (active 20th century

The Bailers
Etching on paper, 6.87 x 10.37" (17.46 x 26.35 cm.)
Signed, George Elmer Browine, N.E., lower right
Gift of Paul Burke, 1993
993-P-166

Anita BROWN, (1916–)

Portrait of Penelope
Oil on canvas, 25 x 33" (63.50 x 83.82 cm.)
Signed, Anita Brown, lower right
Gift of Leonard Bocour, 1975
975-O-110

Bolton BROWN, (1865–1936)

The Crooked Tree
Lithograph on paper, 10 x 10" (25.40 x 25.40 cm.)
Signed, Bolton Brown, lower left
Gift of Lenore Spiering, 1962
962-P-104

George Loring BROWN, (1814–1889)

The Hudson at Bear Mountain, ca. 1850
Oil on canvas, 30 x 48" (76.20 x 121.92 cm.)
Unsigned
Museum purchase, 1967
967-O-136

Harrison Bird BROWN, (1831–1915)

Grand Manan Island
(formerly "Coast of Maine")
Oil on canvas, 13 x 23" (33.02 x 58.42 cm.)
Signed, H. Brown, lower left
Gift of Joseph G. Butler, III, 1967
967-O-126

John George BROWN, (1831–1913)

Perfectly Happy, 1885
Watercolor on paper, 20 x 13" (50.80 x 33.02 cm.)
Signed, J. G. Brown, N.A., 1885, lower left
Museum purchase, 1967
967-W-118

Business Neglected, ca. 1885
Etching on paper, 20 x 14" (50.80 x 35.56 cm.)
Signed, J. G. Brown, lower right
Gift of Mrs. W. J. Sampson, 1977
977-P-114

Robert G. BROWN, (1939–)

Football Gridiron
Enamel on copper, 55 x 48" (139.70 x 121.92 cm.)
Signed, Robert G. Brown, lower left
Museum purchase, 1966
966-O-112

Byron BROWNE, (1907–1961)

Trumpet Player, 1946
Oil on canvas, 30 x 24" (76.20 x 60.96 cm.)
Signed, Byron Browne, lower right
Museum purchase, 1949
949-O-102

Clown, 1948
Watercolor on paper, 25.5 x 19.5" (64.77 x 49.53 cm.)
Signed, Byron Browne, lower right
Gift of Louis Held, 1965
965-W-106

Painting Satyr, 1954
Ink and watercolor on paper, 19.5 x 24.5" (49.53 x 62.23 cm.)
Signed, Byron Browne, lower left
Museum purchase, 1965
965-W-144

Harlequin Family
Casein tempera and India ink on paper, 17.87 x 16.37" (45.40 x 41.59 cm.)
Signed, Byron Browne, lower right
Gift of Stephen Bernard Browne, 1992
992-D-102

Colleen BROWNING, (1929–)

Telephones, 1954
Oil on plywood, 14 x 32.5" (35.56 x 82.55 cm.)
Signed, Colleen Browning, lower left
Museum purchase, 1955
955-O-107

Backstage
Oil on canvas, 37.5 x 57" (95.25 x 144.78 cm.)
Unsigned
Museum purchase, 1969
969-O-120

Start
Oil on canvas, 39 x 57.5" (99.06 x 146.05 cm.)
Signed, Colleen Browning, upper left
Museum purchase, 1992
992-O-109

Irish Landscape
Oil on canvas, 19 x 33" (48.26 x 83.82 cm.)
Signed, Browning, lower left
Museum purchase, 1962
962-O-113

Film Studio
Watercolor on paper, 18.25 x 28.5" (46.35 x 72.39 cm.)
Signed, Browning, upper right
Museum purchase, 1989
989-W-101

Figure
Chalk on paper, 12.5 x 10.5" (31.75 x 26.67 cm.)
Signed, Colleen Browning, lower left
Museum purchase, 1964
964-D-101

June BROZIO, (1945–)

Woman on Bus
Watercolor on paper, 19.5 x 12.5" (49.53 x 31.75 cm.)
Unsigned
Gift of the Friends of American Art, 1967
967-W-110

Edmund BRUCKER, (1912–)

Progress
Oil on canvas, 26 x 38" (66.04 x 96.52 cm.)
Signed, E. Brucker, lower left
Museum purchase, 1950
950-O-101

George DeForest BRUSH, (1855–1941)

Thea, ca. 1910
Oil on panel, 16 x 12" (40.64 x 30.48 cm.)
Signed, George DeForest Brush, lower right
Museum purchase, 1920
920-O-103

Rose Mary BUCHMAN, (active late 20th century)

Resting, 1991
Pastel on paper, 25 x 30" (63.50 x 76.20 cm.)
Signed, R. M. Buchman, lower left
Gift of Rose Mary Buchman, 1991
991-D-136

Howard BUCHWALD, (active 20th century)

(Untitled), 1981
Oil on canvas, 68 x 79" (172.72 x 200.66 cm.)
Unsigned
Gift of the Hoffman/Greenwald Family, 1991
991-O-102

Malcolm Roderick BUCKNALL, (1935–)

Girl with Fishes, 1968
Oil on canvas, 44.5 x 42.5" (113.03 x 107.95 cm.)
Unsigned
Museum purchase, 1968
968-O-182

Alice Standish BUELL, (ca. 1895– ?)

Noon Hour
Line etching on paper, 9 x 12" (22.86 x 30.48 cm.)
Signed, Alice Standish Buell, lower right
Museum purchase, 1943
943-P-109

Randi K. BULL, (1915–)

City Dock, 1963
Woodblock on paper, (32/35), 24.5 x 17" (62.23 x 43.18 cm.)
Signed, Randi K. Bull, 63, lower right
Museum purchase, 1967
967-P-199

Louis BUNCE, (1907–1983)

The Sea Beyond
Oil on canvas, 32 x 49" (81.28 x 124.46 cm.)
Signed, L. Bunce, lower left
Gift of Sidney Freedman and Samuel N. Tonkin, 1954
954-O-107

William Gedney BUNCE, (1840–1916)

Venezia
Oil on wood, 14.5 x 25" (36.83 x 63.50 cm.)
Signed, Gedney Bunce, lower left
Gift of Franklin Biggs, 1976
976-O-129

Elbridge Ayer BURBANK, (1858–1949)

Snake Dance, 1909
Oil on canvas, 30 x 40" (76.20 x 101.60 cm.)
Signed, E. A. Burbank, 1909, lower right
Museum purchase, 1916
916-O-501

Chief Geronimo, (Apache, Chiricahua, Fort Sill, OT), 1899
Oil on canvas, 13 x 9" (33.02 x 22.86 cm.)
Signed, E. A. Burbank, Fort Sill, OT, lower left
Museum purchase, 1912
912-O-582

Chief Joseph, (Nez Percé), 1899
Oil on canvas, 13 x 9" (33.02 x 22.86 cm.)
Signed, E. A. Burbank, lower left
Museum purchase, 1912
912-O-515

Holds the Enemy, (Crow, St. Xavier, MT), 1897
Oil on canvas, 18 x 11" (45.72 x 27.94 cm.)
Signed, E. A. Burbank, lower left
Museum purchase, 1912
912-O-594

Gi-aum-e-hon-o-me-tah, (Kiowa)
Oil on canvas, 12 x 9" (30.48 x 22.86 cm.)
Signed, E. A. Burbank, lower left
Museum purchase, 1912
912-O-577

She Rides a Plain Horse, (Crow, St. Xavier, MT), 1897
Oil on canvas, 10 x 6" (25.40 x 15.24 cm.)
Signed, E. A. Burbank, lower left
Museum purchase, 1912
912-O-508

Kuehl-lah-y-e-mah, 1905
Crayon on paper, 14 x 10" (35.56 x 25.40 cm.)
Signed, E. A. Burbank, lower right
Gift of Douglas Worcester, 1973
973-D-102

The following nine signed oils on canvas, 20 x 14" (50.80 x 35.56 cm.), are a museum purchase, 1912

Bon-i-ta, (Comanche, Fort Sill, OT), 1897
912-O-606

Bonita, (Comanche, Fort Sill, OT), 1897
912-O-610

Chasing Alone, (Sioux, Standing Rock Agency), 1897
912-O-607

Brush - Thea

Buchman - Resting

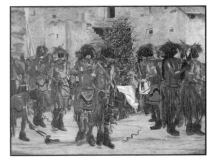
Burbank - Snake Dance

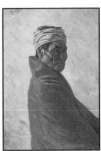
Burbank - Chief Geronimo

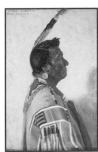
Burbank - Chief Joseph

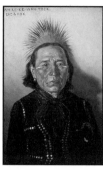

Burbank - Ah-ke-ke-wah-tock

Burbank - Ah-kis-kuck

Burbank - Black Man

Burbank - Chief American Horse

Burbank - Chief Red Wolf

Chasing Alone, (Sioux, Standing Rock Agency), 1897
912-O-607

Chosequah, (Comanche, Fort Sill, OT), 1897
912-O-605

Eagle Claw, (Crow)
912-O-608

Sees a White Horse, (Crow, St. Xavier, MT), 1897
912-O-611

Tan-quoodle-teh, (Kiowa, Fort Sill, OT)
912-O-609

Ton-hadle-ico, (Kiowa, Fort Sill, OT), 1897
912-O-604

The following seventy-five oils on canvas, 13 x 9" (33.02 x 22.86 cm.), are a museum purchase, 1912

Ah-all-tah-kone-ine, (Umatilla, Nes Pilem, WA)
912-O-589

Ah-guy-ah, (Moqui, Keams Canyon, AZ), 1898
912-O-588

Ah-ke-ke-wah-tock, (Sac and Fox, Fox Agency, OT), 1900
912-O-551

Ah-kis-kuck, (Kickapoo, Shawnee, OT), 1900
912-O-584

Black, (Arapahoe, Darlington, OT), 1898
912-O-580

Black Man, (Arapahoe, Darlington, OT), 1899
912-O-558

Bob-Tailed Coyote, (Southern Cheyenne, Darlington, OT), 1898
912-O-557

Chief American Horse, (Sioux, Pine Ridge, SD), 1899
912-O-567

Chief Antonio, (Apache, San Carlos, AZ), 1898
912-O-539

Chief Black Coyote, (Arapahoe, Darlington, OT), 1901
912-O-555

Chief Burnt-all-over, (Southern Cheyenne, Darlington, OT), 1898
912-O-549

Chief Chat-O, (Apache, Darlington, OT), 1899
912-O-585

Chief Chief Killer, (Southern Cheyenne, Darlington, OT), 1899
912-O-598

Chief Chi-hua-hua, (Apache, Fort Sill, OT), 1898
912-O-575

Chief Chiquito, (Apache, San Carlos, AZ), 1898
912-O-563

Chief Flat Iron, 1899
912-O-516

Chief Gabe-bit-yo, (Mojave, San Carlos, AZ)
912-O-595

Chief Geronimo, (Apache, Chiricahua, Fort Sill, OT)
912-O-559

Chief Keokuk, (Sac and Fox Agency), 1900
912-O-587

Chief Law-low-she-us, (Modoc, Seneca, MO), 1901
912-O-520

Chief Little Wound, (Sioux, Ogalalla, Pine Ridge, SD), 1898
912-O-583

Chief Loco, (Apache), 1899
912-O-545

Chief Lo-waine-wag-she-kah, (Shawnee), 1900
912-O-513

Chief Mah-ing-gah, (Ottawa, Sac and Fox Agency, OT), 1901
912-O-554

Chief Man-gus, (Apache, Chiricahua), 1899
912-O-602

Chief Medicine Grass, (Arapahoe), 1898
912-O-600

Chief Naiche, (Apache, Chiricahua), 1898
912-O-552

Chief Naiche, (Apache, Chiricahua), 1899
912-O-573

Chief Nah-kuh-mah-time, (Southern Cheyenne, Darlington, OT), 1898
912-O-548

Chief Naw-quag-ke-shick, (Ottawa), 1901
912-O-553

Chief Red-Fly, (Ogalalla Sioux, Pine Ridge, SD), 1899
912-O-586

Chief Red Wolf, (Arapahoe, Darlington, OT), 1901
912-O-543

Chief Severo, (Southern Ute, Ignacio, CO), 1898
912-O-502

Chief Spotted Elk, (Ogalalla Sioux), 1899
912-O-517

Chief Starving Elk, (Southern Cheyenne, Darlington, OT), 1901
912-O-509

Chief Stinking Bear, (Sioux), 1899
912-O-560

Chief Striking Back, (Arapahoe)
912-O-507

Chief Tal-klai, (Apache, San Carlos, AZ), 1898
912-O-578

Chief Tja-yo-ni, (Navaho, Ganado, AZ), 1897
912-O-581

Chief War Path, (Arapahoe), 1898
912-O-541

Chief Yellow Hammer, (Modoc, Quaw Paw Agency), 1901
912-O-591

Eagle Nest, (Southern Cheyenne, Darlington, OT), 1898
912-O-519

E-Ney, (Apache, Fort Sill, OT), 1898
912-O-546

Has-kin-es-tee, (Apache, San Carlos, NM), 1898
912-O-514

Ho-mo-vi, (Moqui, Keams Canyon, AZ), 1898
912-O-593

Ho-mo-vi, (Hopi, Polacca, AZ), 1904
912-O-592

Hong-ee, (Moqui, Keams Canyon, AZ), 1898
912-O-564

Hush-low, (Palouse), 1899
912-O-570

Iron Crow, (Sioux), 1899
912-O-511

It-say-ya, (Zuni, Zuni Pueblo, NM), 1898
912-O-571

Kicking Bear, (Sioux), 1899
912-O-569

Lap-hi, (Columbia, Nes Pilem, WA), 1899
912-O-612

Mac-ke-puck-e-the, (Kickapoo, Shawnee, OT), 1900
912-O-572

Medicine Woman, (Southern Cheyenne, Darlington, OT), 1899
912-O-590

Nad-kah, (Apache, San Carlos, NM), 1898
912-O-579

Na-goze de-tah, (Apache, San Carlos, NM), 1898
912-O-568

No-Flesh, (Sioux, Pine Ridge, SD), 1898
912-O-562

O-bah, (Moqui, Keams Canyon, AZ), 1898
912-O-566

Pah-bah-ah-gut and Pagosa, (Southern Ute, Ignacio, CO), 1899
912-O-597

Pay-tah, (Moqui, Keams Canyon, AZ), 1898
912-O-544

Quim-cha-ke-cha, (Southern Ute, Ignacio, CO), 1898
912-O-601

Red Wolf, (Arapahoe, Darlington, OT), 1898
912-O-603

Red Woman, (Southern Cheyenne, Darlington, OT), 1899
912-O-518

She-Comes-Out-First, (Sioux), 1899
912-O-510

Short Teeth, (Southern Cheyenne, Chincasse, OT), 1898
912-O-512

Sin-sin, (Columbia, Nes Pilem, WA), 1899
912-O-565

Standing Bull, (Southern Cheyenne, Darlington, OT), 1898
912-O-561

Standing Soldier, (Sioux), 1899
912-O-596

Tah-ah-rah and Juane, (Ute, Ignacio, CO), 1898
912-O-599

Tah-bo-ho-ya, (Moqui, Keams Canyon, AZ), 1898
912-O-556

Weasel Tail, (Southern Cheyenne, Darlington, OT), 1898
912-O-540

Woide-yah, (Laguna Pueblo, Pueblo, NM), 1898
912-O-550

Yat-tah-mosh-yet, (Yackima, Nes Pilem, WA), 1899
912-O-576

Zuquish, (Laguna Pueblo, Pueblo, NM), 1900
912-O-542

Zuquish, (Laguna Pueblo, Pueblo, NM)
912-O-574

The following twenty-four oils on canvas and oils on wood panel, 8 x 6" (20.32 x 15.24 cm.), are a museum purchase, 1912

Ah-ge-pah, (Navaho, Ganado, AZ), 1897
912-O-537

Ah-ge-pah, (Navaho, Ganado, AZ), 1898
912-O-538

Baratchia, (Ute, Ignacio, CO), 1898
912-O-527

Chief Medicine Crow, (Crow), 1897
912-O-501

Chief Severo, (Ute)
912-O-547

E-wa, (Apache), 1878
912-O-523

Gleh-so, (Moqui, Keams Canyon, AZ)
912-O-506

Has-teen-e-ashe-ee, (Navaho, Ganado, AZ), 1899
912-O-532

Has-tin-nez, (Navaho, Ganado, AZ), 1897
912-O-522

Ki-you-see, (Laguna Pueblo, Laguna, NM)
912-O-503

Burbank - Chief Yellow Hammer

Burbank - Ho-mo-vi (912-O-593)

Burbank - Lap-hi

Burbank - O-bah

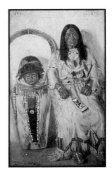

Burbank - Pah-bah-ah-gut and Pagosa

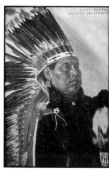

Burbank - Short Teeth (page 29)

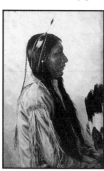

Burbank - Weasel Tail (page 29)

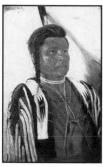

Burbank - Yat-tah-mosh-yet (page 29)

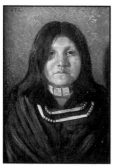

Burbank - Baratchia (page 29)

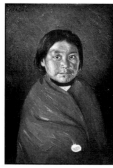

Burbank - E-wa (page 29)

Koe-ah-di, (Moqui, Keams Canyon, AZ)
912-O-534

Lot-si-te-sah, (Zuni, Zuni Pueblo, NM), 1898
912-O-524

Ma-u-rita, (Zuni, Zuni Pueblo, NM), 1898
912-O-526

Nat-ze-nie, (Zuni, Zuni Pueblo, NM)
912-O-504

Nun-aw-re-tah, (Ute, Ignacio, CO)
912-O-535

O-koon-sey, (Moqui, Keams Canyon, AZ)
912-O-533

O-kus-ah-yeah-ha, (Apache)
912-O-525

One Feather, (Ottawa, Fort Sill, OT)
912-O-505

Red Hawk, (Sioux, Standing Rock, ND)
912-O-536

Sah-ah-lock-o, (Moqui, Keams Canyon, AZ), 1899
912-O-521

Scah-e-ah, (Apache), 1898
912-O-530

Tli-ich-na-pa, (Navaho, Ganado, AZ), 1899
912-O-531

Ton-had-dle, (Kiowa, Fort Sill, OT)
912-O-529

Tre-re-kah, (Mojave), 1898
912-O-528

The following one hundred forty-six signed crayon drawings on paper, 14 x 10" (35.56 x 25.40 cm.), are a museum purchase, 1912

Ach, (Mojave, Needles, CA), 1906
912-D-534

Antonio Martiney, (Desert Cahuilla, Coachella, CA), 1905
912-D-561

Ap-Kaw, (Pima, Sacaton, AZ), 1905
912-D-559

A-Vah, (Yuma Apache, Aqua Caliente, AZ), 1905
912-D-613

Be-Tow, (Temecula, Pichanga, CA), 1905
912-D-606

Ben-a-la-chah-ah, (Aqua Caliente, Pala, CA), 1905
912-D-640

Blah-se-dah, (Soboda, San Jacinto, CA), 1905
912-D-596

Cal-lah-hob-nah, (Ukiah, Ukiah,CA), 1906
912-D632

Calp-ah-day-o, (Poma, Ukiah, CA), 1906
912-D-510

Chat-ah, (Chimevava, Coachella, CA), 1905
912-D-571

Chat-ah, (Chimevava, Coachella, CA), 1905
912-D-629

Che-kah, (Tejon, Tejon Ranch, Kern, CA), 1906
912-D-540

Cheney, (Pomo, Ukiah, CA), 1906
912-D-548

Chief Po-ka-gon, (Pottawattamie)
912-D-575

Chief Wee-te-luck, (Nomelackie, Elk Creek, CA), 1906
912-D-647

Chief Whan, (Pima, Sacaton, AZ) 1905
912-D-550

Cle-o-vah, (Aqua Caliente, Pala, CA), 1905
912-D-556

Concepciona-calac, (San Luis Rey, Valley Center, CA), 1906
912-D-513

Concow, (Covelo, CA), 1906
912-D-637

Concow, (Covelo, CA), 1906
912-D-560

Concow, (Covelo, CA), 1906
912-D-580

Concow, No.1 Woman, (Covelo, CA), 1906
912-D-600

Delaris-lachap, (Digeno, Mesa Granda, CA), 1906
912-D-529

Do-min-ga, (Tejon, Tejon Ranch, Kern County, CA), 1906
912-D-612

Downsen, (Meuwock, Groveland, CA) , 1906
912-D-573

E-lanar, (Desert Cahuilla, Coachella, CA) 1906
912-D-589

Ech-o-ney, (Ukie, Covelo, CA), 1906
912-D-531

Es-pran-sah, (San Luis Rey, Valley Center, CA), 1906
912-D-644

Fo-e-nah, (Meteneck, Elk Creek, CA), 1906
912-D-532

Francisco, (Sobaba, San Jacinto, CA), 1905
912-D-567

Gah-kah-che, (Washoe, Carson City, NV), 1906
912-D-570

Gailey, (Hopi, Polacca, AZ), 1905
912-D-635

Hah-re-naldo, (Tejon, Tejon Ranch, Kern, CA), 1906
912-D-585

Hey-dahm, (Ukiah, CA), 1906
912-D-568

Ho-say-da-loris-cap-is-trano, (San Felippo Pala, CA), 1905
912-D-564

Ho-say-domingo, (Cahuilla, Banning, CA), 1905
912-D-581

Ho-say-pah, (San Luis Rey, Pala, CA), 1905
912-D-623

Ho-seph-ah, (Desert Cahuilla, Coachella, CA), 1905
912-D-557

Hole-kid-ney, (Navaho, Ganado, AZ), 1908
912-D-514

Hoopa, (Hoopa, CA), 1906
912-D-525

Hoopa, (Hoopa, CA), 1906
912-D-503

Hoopa, (Hoopa, CA), 1906
912-D-553

Hoopa, (Hoopa, CA), 1906
912-D-638

Hoopa, (Hoopa, CA), 1906
912-D-584

Hoopa, (Hoopa, CA), 1906
912-D-583

Hoopa, (Hoopa, CA), 1906
912-D-593

Hub-bah, (Pomo, Ukiah, CA), 1906
912-D-549

Hul-kush, (Kobahlmem, Elk Creek, CA), 1906
912-D-639

Im-who-che-che, (Shoshoni, Elk Creek, CA), 1906
912-D-617

Jau-ro, (Cahuilla, San Jacinto, CA), 1905
912-D-610

Jose Carac, (San Luis Rey, Valley Center, CA), 1906
912-D-537

Jose, (South Fork Paiute, Onyx, CA), 1906
912-D-546

Juan-roman, (Serrano, Banning, CA), 1905
912-D-630

K-lum-pah, (Kabahlmen, Elk Creek, CA), 1906
912-D-522

Ka-kah-simm, (Napa, Ukiah, CA), 1906
912-D-574

Kahl-bah, (Poma, Ukiah, CA), 1906
912-D-544

Kal-tah-had-dah, (Coo-koo-lah, Ukiah, CA), 1906
912-D-619

Kar-nah-co-nah, 1905
912-D-650

Karlabie, (Nomelacki, Elk Creek, CA), 1906
912-D-577

Katl-le-got, (Wylackie, Covelo, CA), 1906
912-D-586

Ki-e-tah, (South Fork Paiute, Onyx, CA), 1906
912-D-533

Kisc-see, (Wylackie, Covelo, CA), 1906
912-D-547

Ko-see-yah, (Kabahlmen, Elk Creek, CA), 1906
912-D-634

Lah-gah-wood-ey, (Mad River, Arcata, CA), 1906
912-D-641

Lah-see, (Tule River, Porterville, CA), 1906
912-D-601

Le-van-us, (Soboba, San Jacinto, CA), 1905
912-D-519

Le-van-us, (Soboba, San Jacinto, CA), 1905
912-D-642

Le-vra-do, (Soboba, San Jacinto, CA), 1905
912-D-649

Little Lake Man, (Covelo, CA), 1906
912-D-646

Little Lake Girl, (Covelo, CA), 1906
912-D-621

Little Lake Woman, (Covelo, CA), 1906
912-D-555

Low-ste, (Pima, Sacaton, AZ), 1905
912-D-643

Lower Klamath, (Hoopa, CA), 1906
912-D-598

Lu-is Subrano, (Pala Pala, CA), 1905
912-D-551

Lu-ise-ah, (Papago, Sacaton, AZ), 1905
912-D-538

Mad-dy, (Washoe, Carson City, NV), 1906
912-D-590

Mah-so-lin-a quasis, (San Luis Rey, Pala, CA), 1905
912-D-608

Mah-tel-lo, (Mojave, Needles, CA), 1906
912-D-539

Maidu, (Chico, CA), 1906
912-D-505

Maidu, (Chico, CA), 1906
912-D-636

Meuwocw, (Groveland, CA), 1906
912-D-595

Morongo, (Seranno, Banning, CA), 1905
912-D-509

Mu-lack, (Digger, Colfax, CA), 1906
912-D-633

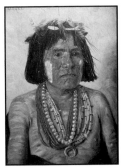

Burbank - Gleh-so (page 29)

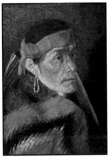

Burbank - Has-tin-nez (page 29)

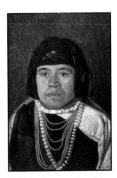

Burbank - Ki-you-see (page 29)

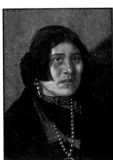

Burbank - Koe-ah-di (page 30)

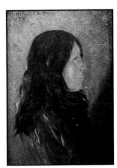

Burbank - Nun-aw-re-tah (page 30)

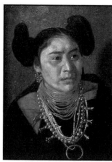

Burbank - O-koon-sey (page 30)

Burbank - O-kus-ah-yeah-ha (page 30)

Burbank - Red Hawk (page 30)

Burbank - Ton-had-dle (page 30)

Burchfield - September Wind and Rain (page 33) (953-W-102)

Na-gay-rooch, (Digger, Colfax, CA), 1906
912-D-591

Nache-luch-pe, (Napo, Ukiah, CA), 1906
912-D-552

Nah-hahn-trum, (Tejon, Tejon Ranch, Kern, CA), 1906
912-D-594

Nar-see-so-lapacha, (Diegueno, Mesa Grande, CA), 1906
912-D-609

Navol, (Tejon, Tejon Ranch, Kern, CA), 1906
912-D-597

Ooch-uha-wah, (Mojave, Needles, CA), 1906
912-D-528

Orleans, (Hoopa, CA), 1906
912-D-563

Orleans, (Hoopa, CA), 1906
912-D-524

Pah-ute, (Reno, NV), 1906
912-D-506

Pah-ute, (Carson City, NV), 1906
912-D-592

Pay-trah, (Telecula, Pichanga, CA), 1905
912-D-576

Peck-an-billie, (Lower Klamath, Hoopa, CA), 1906
912-D-622

Pitt River Girl, (Covelo, CA), 1906
912-D-512

Pomo, (Ukiah, CA), 1906
912-D-521

Ponc-te-mah, (Hopi, Polacca, AZ), 1905
912-D-645

Pu-el-we-tah, (Sun Pum, Elk Creek, CA), 1906
912-D-605

Pum-ah-o-key-wah, (Mojave, Needles, CA), 1906
912-D-507

Quie-ithas-ha, (Navaho, Ganado, AZ), 1907
912-D-579

Ramona, (Desert Cahuilla, Coachella, CA), 1905
912-D-631

Rap-a-hoe, (Yuma Apache, Aqua Caliente, AZ), 1905
912-D-624

Red Wood, (Hoopa, CA), 1905
912-D-504

Ro-sin-da, (Aqua Caliente, Pala, CA), 1905
912-D-607

Saiaz, (Hoopa, CA), 1906
912-D-515

Sal-va-zor, (Warner Ranch, Pala, CA), 1905
912-D-588

Say-kah-wee-ah, (Maidu, Digger, Chico, CA), 1906
912-D-558

Schlah-asch-she, (Mad River, Arcato, CA), 1906
912-D-611

Se-pran-sah, (San Luis Rey, Valley Center, CA), 1906
912-D-625

Se-te-ah-kah, (San Luis Rey, Valley Center, CA), 1906
912-D-523

Se-var-i-o Ne-vas-ky, (Yaqui, Pala, CA), 1906
912-D-562

See-he-nach-ee, (Papago, Sagaton, AZ), 1905
912-D-536

Shock-o-wah, (Ukiah, CA), 1906
912-D-614

Shoe-my-nie, (Maidu, Chico, CA), 1906
912-D-565

Sky-two-bem-deh, (Coo-koo-lah, Ukiah, CA), 1906
912-D-508

Skoung-o-vah, (Hopi, Polacco, AZ), 1905
912-D-501

Skoung-o-vah, (Hopi, Polacco, AZ), 1906
912-D-527

So-li-da, (Sobaba, San Jacinto, CA), 1905
912-D-572

South Fork Paiute #2, (Onyx, CA), 1906
912-D-628

South Fork Paiute, (Onyx, CA), 1906
912-D-620

Su-sah-lie, (Ceranno, Banning, CA), 1905
912-D-615

Tehachapi, (Paiute, CA), 1906
912-D-569

Tehachapi, (Paiute, CA), 1906
912-D-502

Tehachapi, (Paiute, CA), 1906
912-D-627

Tehachapi, (Paiute, CA), 1906
912-D-535

Ter-e-sa, (San Ignagio, San Jacinto, CA), 1905
912-D-582

Tla-i-ashi, (Navaho, Ganado, AZ), 1908
912-D-518

Tlo-bi-nelli, (Navaho, Ganado, AZ), 1907
912-D-599

Toc-b-bee-ah-kigh-ah, (Ukiah, Ukiah, CA), 1906
912-D-616

Toc-chu-chu, (Tule River, Porterville, CA), 1906
912-D-542

Tomah-sah, (South Fork Paiute, Onyx, CA), 1906
912-D-618

Tow-mas Cisco, (Seranno, Banning, CA), 1905
912-D-545

Ukiah, (Ukiah, CA), 1906
912-D-530

Ukiah, (Ukiah, CA), 1906
912-D-648

Ukiah, (Ukiah, CA), 1906
912-D-511

Ukie, (Covelo, CA), 1906
912-D-541

Ukie, (Covelo, CA), 1906
912-D-626

Wah-kane, (Panamint, Ballarat, CA), 1906
912-D-587

Whanah, (Desert Cahuilla, Coachella, CA), 1905
912-D-543

Wong-ge-tow-ee, (Chimevave, Coachella, CA), 1905
912-D-554

Wylackie, (Covelo, CA), 1906
912-D-517

Yam-wee, (Maidu, Chico, CA), 1906
912-D-526

Zahn-eh, (Navaho, Ganada, CA), 1907
912-D-602

Claire R. BURCH, (1935–)

The Earth Was Probably Created, 1960
Oil on paper, 28 x 17" (71.12 x 43.18 cm.)
Signed, Claire Burch, '60, lower left
Gift of Claire R. Burch, 1962
962-O-104

Charles E. BURCHFIELD, (1893–1967)

September Wind and Rain, 1949
Watercolor on paper mounted on board, 22 x 48" (55.88 x 121.92 cm.)
Signed, C. E. B., lower right
Museum purchase, 1953
953-W-102

Late Winter Radiance, 1961–62
Watercolor on paper, 44 x 26.5" (111.76 x 67.31 cm.)
Signed, C. B., 1961–62, lower left
Museum purchase, 1962
962-W-113

Town Hall
Watercolor on paper, 14 x 10" (35.56 x 25.40 cm.)
Signed, B., 224, lower right
Gift of the Burchfield Foundation, 1993
993-W-101

Fantasy
Pencil on paper, 10.5 x 16" (26.67 x 40.64 cm.)
Unsigned
Gift of Mortimer Spiller, 1971
971-D-105

September Wind and Rain
Ink and conte on paper, 5.5 x 13.5" (13.97 x 34.29 cm.)
Signed, C. B., lower right
Museum purchase, 1958
958-D-104

(Untitled)
Pencil on paper, 5.75 x 7.75" (14.61 x 19.69 cm.)
Signed, C. E. B., lower right
Gift of H. F. Hoprich, 1992
992-D-104

Autumn Wind, 1951
Lithograph on paper, 7.5 x 13.5" (19.05 x 34.29 cm.)
Signed, Charles Burchfield, lower right
Museum purchase, 1958
958-P-107

(Untitled), (Christmas Card)
Print on paper, 5.5 x 8" (13.97 x 20.32 cm.)
Unsigned
Gift of H. F. Hoprich, 1992
992-P-127

Crows—March
Lithograph on paper, 13.5 x 10" (34.29 x 25.40 cm.)
Signed, Charles E. Burchfield, lower right
Museum purchase, 1958
958-P-108

Wallpaper (three pieces)
Print on paper, 22 x 23" (55.88 x 58.42 cm.), 31 x 19.5" (78.74 x 49.53 cm.), 22 x 31" (55.88 x 78.74 cm.)
Unsigned
Gift of Marion Cox, 1985
985-P-101

The Butler Institute's collection contains six wallpapers of various sizes which are the gift of Edna M. Lindemann, 1992
992-P-107 — 992-P-112

Robert BURKE, (1923–)

Inheritance of Many Generations, 1961
Oil on canvas, 36 x 48" (91.44 x 121.92 cm.)
Signed, Burke, lower right
Gift of Robert Tornello, 1961
961-O-135

Robert Randall BURKERT, (1930–)

Night Ride, 1965
Oil on masonite, 48 x 66" (121.92 x 167.64 cm.)
Signed, Robert Burkert, lower right
Museum purchase, 1965
965-O-153

Spring Thaw
Color serigraph on paper, (28/50), 20 x 32" (50.80 x 81.28 cm.)
Signed, Robert Burkert, lower right
Museum purchase, 1965
966-P-290

Emerson C. BURKHART, (1905–1969)

Spiritual Decay
Oil on canvas, 36 x 48" (91.44 x 121.92 cm.)
Signed, Emerson C. Burkhart, lower right
Gift of the Friends of American Art, 1949
949-O-103

Paul BURLIN, (1886–1969)

Merchant of Pearls, 1943
Oil on canvas, 13 x 18" (33.02 x 45.72 cm.)
Signed, Paul Burlin, lower left
Gift of Mr. and Mrs. Milton Lowenthal, 1954
954-O-108

Burchfield - Late Winter Radiance

Burchfield - Crows March

Burchfield - September Wind and Rain (958-D-104)

Burchfield - Autumn Wind

Burlingham - River Bend

Burliuk - Blue Horse

Buttersworth - Ship: *Valparaiso*

Cadmus - Reclining Nude (page 35)

Composition, 1953
Watercolor on paper, 22 x 30" (55.88 x 76.20 cm.)
Signed, Paul Burlin, 1953, lower left
Gift of Mr. and Mrs. Milton Lowenthal, 1965
965-W-101

Martha BURLINGHAM, (1889–1981)

River Bend, 1961
Oil on canvas, 18 x 24" (45.72 x 60.96 cm.)
Signed, Martha Burlingham, lower right
Museum purchase, 1961
961-O-136

This Ole House, 1963
Oil on masonite, 12 x 16" (30.48 x 40.64 cm.)
Signed, M. Burlingham, lower right
Gift of Louis Held, 1965
965-O-163

David BURLIUK, (1882–1967)

The following two signed oils on canvas are the
gift of Joseph H. Hirshhorn, 1948

Blue Horse
16 x 20" (40.64 x 50.80 cm.)
948-O-108

Woman with Hen
12 x 12" (30.48 x 30.48 cm.)
948-O-107

Mare and Foal, 1950
Oil on canvas, 9 x 12" (22.86 x 30.48 cm.)
Signed, Burliuk, 1950, lower left
Gift of Louis Held, 1965
965-O-142

The White Horse
Watercolor on paper, 11 x 14.5" (27.94 x 36.83 cm.)
Signed, Burliuk, lower right
Gift of Louis Held, 1965
965-W-103

Landscape
Mixed media on paper, 10.5 x 15" (26.67 x 38.10 cm.)
Signed, Burliuk, lower left
Gift of Mr. and Mrs. Nahum Tschacbasov, 1979
979-W-114

Edward R. BURROUGHS, (1902–)

Lynnhaven Inlet, 1939
Watercolor on paper, 19 x 27" (48.26 x 68.58 cm.)
Signed, Edward R. Burroughs, '39, lower right
Museum purchase, 1948
948-W-101

Peter BUSA, (1914–1983)

Abstraction
Oil on canvas, 30 x 36" (76.20 x 91.44 cm.)
Signed, Busa, lower right
Gift of Emil Arnold, 1967
967-O-112

(Untitled)
Oil on canvas, 30 x 20" (76.20 x 50.80 cm.)
Signed, Busa, lower right
Gift of Mr. and Mrs. Nahum Tschacbasov, 1972
972-O-112

(Untitled), 1942
Watercolor on paper, 12.5 x 8" (31.75 x 20.32 cm.)
Signed, Busa, upper right
Gift of Mr. and Mrs. Nahum Tschacbasov, 1972
972-W-103

Sidney BUTCHKES, (1922–)

Tour #1
Silkscreen on paper, 29.5 x 23.5" (74.93 x 59.69 cm.)
Signed, Butchkes, lower right
Gift of Sidney Butchkes, 1978
978-P-131

Andrew R. BUTLER, (1896– ?)

Corner Store, 1932
Drypoint on paper, 8 x 12" (20.32 x 30.48 cm.)
Signed, Andrew R. Butler, lower right
Museum purchase, 1977
977-P-128

James D. BUTLER, (1945–)

Entertaining at the Studio
Oil on canvas, 38.25 x 49.75" (97.16 x 126.37 cm.)
Signed, J. D. Butler, lower right
Gift of the Friends of American Art, 1968
968-O-195

Mary BUTLER, (1865–1946)

Seascape #1
Oil on canvas, 36 x 41" (91.44 x 104.14 cm.)
Unsigned
Gift of the estate of Mary Butler, 1948
948-O-109

Max BUTLER, (1920–)

Eclipse and Dead Bird
Watercolor on paper, 30.5 x 23" (77.47 x 58.42 cm.)
Signed, Butler, lower right
Museum purchase, 1962
962-W-105

James E. BUTTERSWORTH, (1817–1894)

Ship: *Valparaiso*, ca. 1855
Oil on canvas, 24 x 36" (60.96 x 91.44 cm.)
Signed, J. E. Buttersworth, lower right
Museum purchase, 1928
S28-O-122

Borys BUZKIJ, (1938–)

Elegy No. 4, 1968
Watercolor on paper, 27 x 38" (68.58 x 96.52 cm.)
Unsigned
Museum purchase, 1969
969-W-105

Dennis BYNG, (active 20th century)

Cellist, 1956
Oil on canvas, 52 x 31" (132.08 x 78.74 cm.)
Signed, Byng, '56, lower right
Museum purchase, 1956
956-O-101

D. Gibson BYRD, (1923–)

Wild Blue Yonder Plus Twenty, 1964
Oil on canvas, 38 x 48" (96.52 x 121.92 cm.)
Unsigned
Museum purchase, 1965
965-O-154

John BYRUM, (active late 20th century)

(Untitled)
Portfolio of 53: Rip Off on the Last Millennium
Print on paper, 8.5 x 11" (21.59 x 27.94 cm.)
Signed, John Byrum, lower right
Gift of the William Busta Gallery, 1990
990-P-111.7

Paul CADMUS, (1904–)

Reclining Nude
Pen and ink on paper, 7.25 x 13" (18.42 x 33.02 cm.)
Signed, Cadmus, lower right
Gift of Albert E. Hise, 1979
979-D-101

YMCA Locker Room, 1934
Etching on paper, 10 x 16" (25.40 x 40.64 cm.)
Signed, Paul Cadmus, lower right
Gift of Albert E. Hise, 1979
979-P-157

John CAGE, (1912–1992)

Not Wanting To Say Anything About Marcel
Serigraph on plexiglass, 15 x 24.50 x 2.25" (38.10 x 62.23 x 5.72 cm.)
Unsigned
Gift of Arthur Feldman, 1992
992-P-117

(Untitled)
Serigraph on paper, 27.5 x 40" (69.85 x 101.60 cm.)
Signed, John Cage, lower right
Gift of Paul and Suzanne Donnelly Jenkins, 1990
990-P-105

Joseph Alexander CAIN, (1920–)

Homage to a Harlequin, 1965
Mixed media on paper, 40 x 30" (101.60 x 76.20 cm.)
Signed, Joseph Cain, '65, lower right
Museum purchase, 1965
965-W-132

Alexander CALDER, (1898–1976)

The High Sign, 1944
Watercolor on paper, 44 x 31" (111.76 x 78.64 cm.)
Signed, Calder, '44, lower left
Gift of Mr. and Mrs. Milton Lowenthal, 1954
954-W-106

Balloons, 1973
Offset lithograph on paper, 40 x 28.5" (101.60 x 72.39 cm.)
Signed, Calder, lower right
Gift of Dana Seman, 1980
980-P-112

McGovern
Silkscreen on paper, (3), 34.5 x 23.75" (87.63 x 60.33 cm.)
Signed, Calder, lower right
Gift of Arthur Feldman, 1991
991-P-173 — 991-P-175

Kenneth CALLAHAN, (1905–1986)

Solstice
Oil on board, 28.81 x 21.81" (73.18 x 55.40 cm.)
Signed, Kenneth Callahan, lower right
Gift of the estate of Helen Moyer, 1988
988-O-119

Mary CALLERY, (1903–1977)

Frieze
Serigraph on paper, 5 x 50" (12.70 x 127.00 cm.)
Signed, Mary Callery, lower right
Gift of Louis Held, 1965
965-P-188

Manolis CALLIYANNIS, (active 20th century)

Still Life
Oil on canvas, 32 x 40" (81.28 x 101.60 cm.)
Signed, Manolis Calliyannis, lower left
Gift of Mrs. Benjamin Weiss, 1971
971-O-102

Perry CALVIN, (1924–1976)

The Hucksters
Watercolor on paper, 21 x 27" (53.34 x 68.58 cm.)
Signed, Calvin, lower right
Gift of the Friends of American Art, 1950
950-W-101

Shirley Aley CAMPBELL, (1925–)

Five Figure Exercise, Opus I, 1970
Oil on canvas, 63 x 95" (160.02 x 241.30 cm.)
Signed, Shirley Aley Campbell, upper right and lower left
Gift of Mr. and Mrs. Joseph Erdelac, 1975
975-O-140

La Calle
Watercolor collage on paper, 40 x 30" (101.60 x 76.20 cm.)
Signed, Shirley Aley Campbell, lower left
Gift of the Friends of American Art, 1959
959-W-110

Wayne E. CAMPBELL, (active late 20th century)

Special Consensus, 1969
Silkscreen on paper, 26.5 x 20.25" (67.31 x 51.44 cm.)
Signed, Wayne E. Campbell, lower right
Gift of Reese and Marilyn Arnold Palley, 1991
991-P-165

Charles G. CANNON, (1925–)

Freighters, 1968
Oil on canvas, 23.5 x 35.5" (59.69 x 90.17 cm.)
Signed, C. G., '68, lower right
Museum purchase, 1970
970-O-117

Rhys CAPRAN, (1909–)

Animals
Charcoal and pen on paper, 8 x 7" (20.32 x 17.78 cm.)
Signed, Rhys Capran, lower right
Gift of Adolph Green, 1960
960-D-106

Brahma Bull
Charcoal on paper, 17 x 22" (43.18 x 55.88 cm.)
Signed, Rhys Capran, lower right
Gift of Samuel Browner, 1960
960-D-104

Cage - Not Wanting To Say Anything About Marcel

Cain - Homage to a Harlequin

Calder - The High Sign

Callahan - Solstice

Calvin - The Hucksters

Carlsen - The Surf

Clarence H. Carter - Yellow Blinds

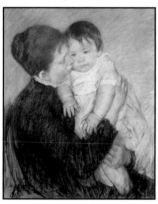

Cassatt - Agatha and Her Child

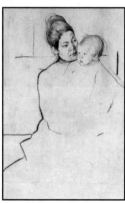

Cassatt - Gardiner Held by His Mother

Castellon - Strange Figure (961-O-138)

Sylvia CAREWE, (? –ca.1994)

Half Mist
Oil on canvas, 31 x 23" (78.74 x 58.42 cm.)
Signed, Carewe, lower right
Gift of Marvin Small, 1955
955-O-108

Soren Emil CARLSEN, (1853–1932)

The Surf, 1907
Oil on canvas, 64 x 74" (162.56 x 187.96 cm.)
Signed, Emil Carlsen, 1907, lower right
Museum purchase, 1923
923-O-102

Little Bridge, 1928
Oil on canvas, 25 x 25" (63.50 x 63.50 cm.)
Signed, Emil Carlsen, 1928, lower left
Gift of Dr. John J. McDonough, 1969
969-O-161

The Butler Institute's collection contains a
posthumous edition of six unsigned etchings
which are the gift of Elliot Weisenberg, 1980
980-P-101 — 980-P-106

John Fabian CARLSON, (1875–1945)

Sylvan Stream, 1916
Oil on canvas, 24 x 31" (60.96 x 78.74 cm.)
Signed, John F. Carlson, lower right
Museum purchase, 1921
921-O-101

Francis B. CARPENTER, (1830–1900)

Lincoln and His Cabinet, 1864
Engraving on paper, 20.5 x 32" (52.07 x 81.28 cm.)
Signed, F. B. C., 1864, lower left
Museum purchase, 1968
968-P-247

James CARROLL, (1934–)

Big A, 1967
Acrylic on canvas, 48.25 x 48" (122.56 x 121.92 cm.)
Unsigned
Gift of Leonard Bocour, 1976
976-O-121

Robert CARROLL, (1934–)

Horses, 1971
Etching on paper, 27.5 x 19.75" (69.85 x 50.17 cm.)
Signed, Carroll, 71, lower right
Gift of Ernest Kirkwood, 1974
974-P-104

Clarence Holbrook CARTER, (1904–)

Yellow Blinds, 1939
Watercolor on paper, 14 x 21" (35.56 x 53.34 cm.)
Signed, Clarence Carter, 39, lower right
Museum purchase, 1940
940-W-101

Circus Figure, 1933
Pastel on paper, 18 x 12" (45.72 x 30.48 cm.)
Signed, Clarence H. Carter, lower right
Museum purchase, 1969
969-W-104

The Picking of the Grapes, 1931
Aquatint on paper, 6.25 x 9.62" (15.88 x 24.45 cm.)
Signed, Clarence H. Carter, lower right
Gift of Berenice Kent, 1975
975-P-134

Meahala J. CARTER, (dates unknown)

Residence and Tomb of Washington
Charcoal on paper, 21 x 29" (53.34 x 73.66 cm.)
Signed, Meahala J. Carter, lower right
Museum purchase, 1973
973-D-101

John Williams CASILEAR, (1811–1893)

The Presidents of the United States
Steel engraving on paper, 14 x 10.5" (35.56 x 26.67 cm.)
Signed, J. W. C., lower left
Museum purchase, 1975
975-P-119

Victor CASSANELLI, (1920–)

Two Forms, 1972
Oil on canvas, 40 x 30" (101.60 x 76.20 cm.)
Unsigned
Gift of Victor Cassanelli, 1977
977-O-111

Mary Stevenson CASSATT, (1845–1926)

Agatha and Her Child, 1892–1893
Pastel on paper, 26 x 21" (66.04 x 53.34 cm.)
Signed, Mary Cassatt, lower left
Museum purchase, 1947
947-W-102

Gardiner Held by His Mother
Drypoint on paper, 7.75 x 5" (19.69 x 12.70 cm.)
Unsigned
Museum purchase, 1961
961-P-115

In the Opera Box #3
Aquatint on paper, 7.75 x 7" (19.69 x 17.78 cm.)
Signed, M. C., lower right
Museum purchase, 1961
961-P-116

Jeanette Smiling
Etching on paper, (V644), 8.75 x 5.75" (22.23 x 14.60 cm.)
Unsigned
Museum purchase, 1966
966-P-152

John CASTAGNO, (1930–)

Pin Wheel, 1971
Serigraph on paper, 29 x 33" (73.66 x 83.82 cm.)
Signed, Castagno, lower right
Gift of John Castagno, 1972
972-P-111

Frederico CASTELLON, (1914–1971)

Two Women
Lithograph on paper, 8 x 12" (20.32 x 30.48 cm.)
Signed, Castellon, lower right
Museum purchase, 1967
967-P-132

The Butler Institute's collection includes three
oils on canvas, one watercolor on paper, one
crayon on paper, and thirty-three drawings and

prints on paper which are the gift of P. Weber, 1961

961-O-137 — 961-O-139, 961-W-116, 961-D-149
961-D-122 — 961-D-147, 961-P-119 — 961-P-125

Elizabeth CATLETT, (1919–)

El Pueblo Español Firma por La Paz

Lithograph on paper, 12.25 x 16.37" (31.12 x 41.59 cm.)
Signed, E. Catlett, lower right
Museum purchase. 1995
995-P-101

George CATLIN, (1796–1872)

The North American Indian Portfolio, published in 1944, is the gift of William G. Barth, 1986
The twenty-five color lithographs on paper are imprinted *Catlin del — on stone by McGahey*, lower left, and *Day and Haghe, lithographers to the Queen*, lower right

Antelope Shooting

16.13 x 22.75" (40.96 x 57.79 cm.)
986-P-169.12

Archery of the Indians

16.13 x 22.75" (40.96 x 57.79 cm.)
986-P-169.6

Attacking the Grizzly Bear

16.13 x 22.75" (40.96 x 57.79 cm.)
986-P-169.25

Ball Play

16.13 x 22.75" (40.96 x 57.79 cm.)
986-P-169.19

Ball Players

16.13 x 22.75" (40.96 x 57.79 cm.)
986-P-169.15

Ball Playing Dance

16.13 x 22.75" (40.96 x 57.79 cm.)
986-P-169.24

Buffalo Bull Grazing

16.13 x 22.75" (40.96 x 57.79 cm.)
986-P-169.3

Buffalo Dance

16.13 x 22.75" (40.96 x 57.79 cm.)
986-P-169.20

Buffalo Hunt Under the White Wolfskin

16.13 x 22.75" (40.96 x 57.79 cm.)
986-P-169.7

Buffalo Hunt, Approaching on a Ravine

16.13 x 22.75" (40.96 x 57.79 cm.)
986-P-169.8

Buffalo Hunt Chase

16.13 x 22.75" (40.96 x 57.79 cm.)
986-P-169.1

Buffalo Hunt Chase

16.13 x 22.75" (40.96 x 57.79 cm.)
986-P-169.18

Buffalo Hunt Chase

16.13 x 22.75" (40.96 x 57.79 cm.)
986-P-169.9

Buffalo Hunt, Chasing Back

16.13 x 22.75" (40.96 x 57.79 cm.)
986-P-169.17

Buffalo Hunt on Snow Shoes

16.13 x 22.75" (40.96 x 57.79 cm.)
986-P-169.21

Buffalo Hunt, Surround

16.13 x 22.75" (40.96 x 57.79 cm.)
986-P-169.10

Buffalo Hunt, White Wolves Attacking a Buffalo

16.13 x 22.75" (40.96 x 57.79 cm.)
986-P-169.13

Catching a Wild Horse

16.13 x 22.75" (40.96 x 57.79 cm.)
986-P-169.14

Dying Buffalo Bull in Snow Drift

16.13 x 22.75" (40.96 x 57.79 cm.)
986-P-169.4

North American Indians

22.75 x 16.13" (57.79 x 40.96 cm.)
986-P-169.23

The Bear Hunt

16.13 x 22.75" (40.96 x 57.79 cm.)
986-P-169.2

The Snow Shoe Dance

16.13 x 22.75" (40.96 x 57.79 cm.)
986-P-169.16

Wi-Jun-Jon

22.75 x 16.13" (57.79 x 40.96 cm.)
986-P-169.22

Wild Horses at Play

16.13 x 22.75" (40.96 x 57.79 cm.)
986-P-169.11

Wounded Buffalo Bull

16.13 x 22.75" (40.96 x 57.79 cm.)
986-P-169.5

Elise CAVANNA, (1905–)

Descending Orange

Oil on canvas, 9 x 12" (22.86 x 30.48 cm.)
Unsigned
Gift of Samuel Browner, 1959
959-O-132

Therese E. CENSOR, (1908–)

The Wall

Ink and collage on paper, 10 x 14" (25.40 x 35.56 cm.)
Unsigned
Gift of Cecile Brunswick, 1978
978-D-104

Robert O. CHADEAYNE, (1897–1981)

Down Town

Copol medium on canvas, 24 x 30" (60.96 x 76.20 cm.)
Unsigned
Museum purchase, 1966
966-O-113

Readfield Maine, 1972

Oil on canvas, 30 x 40" (76.20 x 101.60 cm.)
Signed, Chadeayne, lower right
Museum purchase, 1972
972-O-120

Catlett - El Pueblo Español Firma por La Paz

Catlin - Ball Players

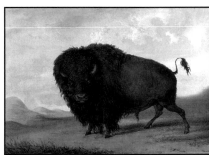

Catlin - Buffalo Bull Grazing

Catlin - Buffalo Dance

Catlin - North American Indians

Chafetz - Last Leaf

Chamberlain - (Untitled)

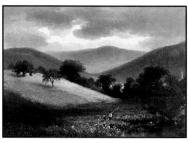

Champney - Landscape

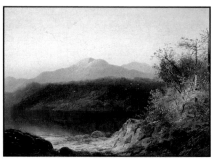

C. H. Chapin - Adirondack Mountains

Sidney CHAFETZ, (1922–)

Last Leaf, 1966
Etching on paper, (19/250), 12.5 x 7.5" (31.75 x 19.05 cm.)
Signed, Sidney Chafetz, 1966, lower right
Museum purchase, 1966
966-P-132

John CHAMBERLAIN, (1927–)

(Untitled), 1973
Offset lithograph and plastic on paper, 9 x 9" (22.86 x 22.86 cm.)
Signed, Chamberlain, lower center
Gift of Steven Feinstein, 1983
983-P-147

Benjamin CHAMPNEY, (1817–1907)

Landscape, 1878
Oil on canvas, 14 x 20" (35.56 x 50.80 cm.)
Signed, B. Champney, lower left
Museum purchase, 1967
967-O-137

CHANDLER, (dates unknown)

Adirondacks
Pastel on paper, 18 x 14" (45.72 x 35.56 cm.)
Signed, Chandler, lower right
Museum purchase, 1968
968-W-145

J. J. CHANT, (active late 19th century)

Evening Prayer, 1879
Steel engraving on paper, 21 x 17" (53.34 x 43.18 cm.)
Unsigned
Gift of Grace Heath Butler, 1971
971-P-125

C. H. CHAPIN, (active 1850–1874)

Adirondack Mountains
Oil on canvas, 12 x 22" (30.48 x 55.88 cm.)
Signed, C. H. Chapin, lower right
Gift of Mr. and Mrs. Paul Wick, 1963
963-O-127

Mountain Lake
Watercolor on paper, 22 x 30" (55.88 x 76.20 cm.)
Signed, C. H. Chapin, lower right
Museum purchase, 1975
975-W-102

Francis CHAPIN, (1899–1965)

Landscape
Watercolor on paper, 22 x 38.25" (55.88 x 97.16 cm.)
Signed, Francis Chapin, lower right
Gift of Dorothy Dennison Butler, 1969
969-W-114

Kentucky Derby, 1953
Lithograph on paper, 20 x 26" (50.80 x 66.04 cm.)
Signed, Francis Chapin, lower right
Museum purchase, 1989
989-P-113

J. Linton CHAPMAN, (active 19th century)

Landscape with Team and Carriage
Oil on canvas, 14.25 x 20.25" (36.20 x 51.44 cm.)
Signed, J. Linton Chapman, lower left
Museum purchase, 1969
969-O-138

Alonzo CHAPPEL, (1828–1887)

The following seven unsigned engravings on paper, all approximately 5.5 x 7.25" (13.97 x 18.42 cm.), are an anonymous gift, 1968

Death of Colonel Scammell at the Siege of Yorktown, 1859
968-P-318

Death of General Wolfe, 1857
968-P-317

John Trumbull, 1863
968-P-315

Patrick Henry Addressing the Virginia Assembly, 1856
968-P-316

Samuel F. B. Morse, 1872
968-P-314

Washington Allston, 1863
968-P-313

Washington Portrait, 1856
968-P-298

Jean CHARLOT, (1898–1979)

Arches, 1933
Colored lithograph on paper, 11 x 8.5" (27.94 x 21.59 cm.)
Signed, Jean Charlot, lower right
Gift of Jack Lord, 1973
973-P-113

Picture Book II, 1973
Colored lithographs on paper, (32), 8.5 x 11" (21.59 x 27.94 cm.)
Unsigned
Gift of Jack Lord, 1973
973-P-141

The following nine signed colored lithographs on paper of various sizes are a museum purchase, 1973

Idol, 1933
973-P-108

Malinche, 1933
973-P-107

Pastoras, 1933
973-P-114

Sacrifice of Isaac, 1933
973-P-110

The Petate, 1933
973-P-112

Tondo II, 1933
973-P-111

Tondo III, 1933
973-P-115

Woman Standing, Child on Back, 1933
973-P-106

Woman Washing, 1933
973-P-109

William Merritt CHASE, (1849–1916)

Did You Speak to Me?, 1900
Oil on canvas, 38 x 43" (96.52 x 109.22 cm.)
Signed, Wm. M. Chase, lower left
Museum purchase, 1921
921-O-102

Portrait, After Velasquez, 1881
Oil on canvas, 11.5 x 9.5" (29.21 x 24.13 cm.)
Unsigned
Gift of Francis E. Myers, II, 1959
959-O-106

Eduardo Arcenio CHAVEZ, (1917–)

Mirage, 1958
Oil on canvas, 36 x 60" (91.44 x 152.40 cm.)
Signed, Chavez, lower right
Museum purchase, 1959
959-O-102

Thornbush
Oil on canvas, 40 x 45" (101.60 x 114.30 cm.)
Signed, Chavez, lower right
Gift of Adolph Green, 1960
960-O-103

(Untitled)
Serigraph on paper, 18 x 11" (45.72 x 27.94 cm.)
Signed, Chavez, lower right
Gift of the Woodstock Art Association, 1956
956-P-102

CHECHEUTE, (active 20th century)

Looking at Sea
Watercolor on paper, 4.5 x 6.25" (11.43 x 15.88 cm.)
Signed, Checheute, lower left
Gift of Louis Held, 1965
965-W-126

Marvin CHERNEY, (1925–1967)

Joseph the Altar Boy
Oil on canvas, 24 x 24" (60.96 x 60.96 cm.)
Signed, M. Cherney, upper right
Museum purchase, 1962
962-O-108

Old Woman, 1960
Oil on canvas, 30 x 24" (76.20 x 60.96 cm.)
Signed, M. Cherney, 1960, upper right
Gift of A. S. Wilder, 1963
963-O-133

Portrait of a Boy, 1963
Pastel on paper, 23 x 20" (58.42 x 50.80 cm.)
Signed, M. Cherney, 63, "To Katherine Dyson w/Friendship,"
lower right
Gift of Katherine Warwick, 1968
968-D-116

The Mourner
Watercolor on paper, 26 x 18.5" (66.04 x 46.99 cm.)
Signed, M. Cherney, upper right
Gift of Mr. and Mrs. Bernhardt Crystal, 1960
960-D-109

Ann CHERNOW, (1936–)

Fishing Cove
Oil on canvas, 30 x 40" (76.20 x 101.60 cm.)
Signed, Chernow, lower right
Gift of Ann Chernow, 1968
968-O-213

Sad Heart at the Super Market, 1966
Oil on canvas, 36 x 23" (91.44 x 58.42 cm.)
Unsigned
Gift of Leonard Bocour, 1975
975-O-113

The following three signed serigraphs on paper,
30 x 20" (76.20 x 50.80 cm.), are the gift of H.
Lust, 1977
977-P-113, 977-P-112, and 977-P-111

Cassiopeia

Hercules

Ursa Major

Lee R. CHESNEY, Jr., (1920–)

Night Sea #2
Watercolor on paper, 22 x 34" (55.88 x 86.36 cm.)
Signed, Chesney, lower right
Museum purchase, 1959
959-W-103

Chen CHI, (1912–)

High Noon, New York, 1986
Watercolor on paper, 38 x 35" (96.52 x 88.90 cm.)
Signed, Chen Chi, 1986, lower left
Gift of Chen Chi, 1990
990-W-101

Birds Flying, 1955
Watercolor on paper, 13 x 52" (33.02 x 132.08 cm.)
Signed, Chen Chi, lower left
Museum purchase, 1955
955-W-104

Alan R. CHIARA, (1936–)

Jigsaw Pier, 1964
Watercolor on paper, 25.5 x 33" (64.77 x 83.82 cm.)
Signed, Chiara, lower left
Museum purchase, 1964
964-W-104

Albert W. CHRIST-JANER, (1910–1973)

Distant Mountains
Colored lithograph on paper, 18 x 29.5" (45.72 x 74.93 cm.)
Signed, Christ-Janer, lower right
Museum purchase, 1972
972-P-121

Dan CHRISTIANSEN, (1942–)

Mellow Yellow, 1981
Acrylic on canvas, 67 x 54.5" (170.18 x 138.43 cm.)
Unsigned
Museum purchase, 1985
985-O-110

Galena Territory #1, 1982
Lithograph on paper, (2/4), 42 x 30.75" (106.68 x 78.11 cm.)
Signed, Dan Christiansen, 1982, lower left
Museum purchase, 1989
989-P-104

Frederic Edwin CHURCH, (1826–1900)

In the Andes, 1878
Oil on canvas, 15.18 x 22.18" (38.57 x 56.35 cm.)
Signed, F. E. Church, lower left
Museum purchase, 1978
978-O-102

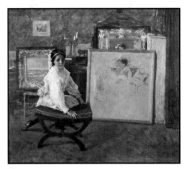
Chase - Did You Speak to Me?

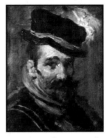
Chase - Portrait, After Velasquez

Chen Chi - High Noon, New York

Christiansen - Mellow Yellow

Church - In the Andes

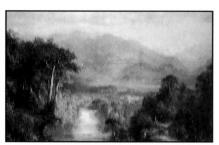
Church - The Heart of the Andes

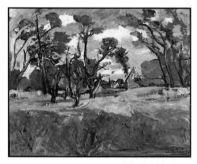
Cikovsky - The Grove

Close - Georgia

Darius Cobb - Fish on a Wall

Thomas Cole - Italian Landscape

The Heart of the Andes, 1862
Engraving on paper, 17.5 x 27" (44.45 x 68.58 cm.)
Signed, Ptd. by F. E. Church, lower left, Eng. by Wm. Forrest, lower right
Gift of Mr. and Mrs. Richard Ulrich, 1968
968-P-221

Sonia CHUSIT, (1926–)

Figure in the Studio
Watercolor on paper, 22 x 27" (55.88 x 68.58 cm.)
Signed, Chusit, lower right
Museum purchase, 1961
961-W-110

Nicolai CIKOVSKY, (1894–1984)

The Grove, 1943
Oil on canvas, 23 x 30" (58.42 x 76.20 cm.)
Signed, Nicolai Cikovsky, 1943, lower right
Gift of Mrs. William V. Miller, 1959
959-O-121

The Pasture
Oil on canvas, 20 x 24" (50.80 x 60.96 cm.)
Signed, Nicolai Cikovsky, lower right
Gift of Mrs. William V. Miller, 1959
959-O-122

Roland CLARK, (active 20th century)

End of Day
Chromolithograph on paper, 11.37 x 8" (28.89 x 20.32 cm.)
Signed, Roland Clark, lower right
Gift of Leona Cohen, 1992
992-P-113

Rex CLAWSON, (1930–)

The War Machine
Oil on panel, 40 x 30" (101.60 x 76.20 cm.)
Signed, Clawson, lower right
Gift of S. Goldberg, 1967
967-O-131

Paul Lewis CLEMENS, (1911–)

Circus at Night, 1938
Watercolor on paper, 10 x 17" (25.40 x 43.18 cm.)
Unsigned
Museum purchase, 1938
938-W-102

Carroll CLOAR, (1913–1993)

Forbidden Thicket
Oil on canvas, 24 x 32" (60.96 x 81.28 cm.)
Signed, Carroll Cloar, lower left
Museum purchase, 1956
956-O-102

Chuck CLOSE, (1940–)

Georgia, 1984
Watercolor on handmade paper pulp, 56 x 45" (142.24 x 114.30 cm.)
Signed, C. Close, lower right
Gift of the American Academy and Institute of Arts and Letters, 1986
986-W-109

Roger CLOUGH, (1935–)

View of West Philadelphia, 1970
Oil on canvas, 20.12 x 26.62" (51.12 x 67.63 cm.)
Signed, Clough, 70, lower right
Gift of S. Beryl Lush, 1971
971-O-106

Griffith B. COALE, (1890– ?)

The Spaniard, 1916
Oil on canvas, 39 x 38" (99.06 x 96.52 cm.)
Signed, Coale, 1916, lower left
Gift of C. M. Paul, 1957
957-O-103

Darius COBB, (1834–1919)

Fish on a Wall
Oil on canvas, 30 x 15" (76.20 x 38.10 cm.)
Signed, Darius Cobb, lower left
Museum purchase, 1957
957-O-104

Dipper Missing, published 1880
Chromolithograph on paper, 30.5 x 22.5" (77.47 x 57.15 cm.)
Unsigned
Museum purchase, 1975
975-P-122

Ruth COBB, (1914–)

The Talisman
Watercolor on paper, 29.5 x 21" (74.93 x 53.34 cm.)
Signed, Ruth Cobb, lower left
Museum purchase, 1966
966-W-107

William COGSWELL, (1819–1903)

Portrait of Joseph G. Butler, Jr., 1865
Oil on canvas, 25 x 22" (63.50 x 55.88 cm.)
Signed, W. Cogswell, 1865, lower right
Gift of Joseph G. Butler, III, 1951
951-O-112

Scottish Girl, ca. 1870
Oil on canvas, 44 x 32" (111.76 x 81.28 cm.)
Unsigned
Gift of Joseph G. Butler, III, 1977
977-O-142

Carmon COLANGELO, (active late 20th century)

The following two signed color lithographs on paper are the gift of Drs. Paul and Laura Mesaros, 1994

Lotto's Lantern, 1992
(3/8), 28.75 x 21" (73.03 x 53.34 cm.)
994-P-216

Rotation, 1990
(1/6), 28 x 22" (71.12 x 55.88 cm.)
994-P-215

Thomas COLE, (1801–1848)

Italian Landscape, 1839
Oil on canvas, 35 x 53" (88.90 x 134.62 cm.)
Signed, Thomas Cole, 1839, lower left center
Museum purchase, 1945
945-O-102

The following three engravings on paper, 15.12 x 22.75" (38.42 x 57.79 cm.), are the gift of Berenice Kent, 1970

The Voyage of Life, Childhood
970-P-155

The Voyage of Life, Manhood
970-P-156

The Voyage of Life, Old Age
970-P-157

Thomas Casilear COLE, (1888–1976)

Portrait of Dorothy Paris, 1921
Oil on canvas, 28 x 23" (71.12 x 58.42 cm.)
Signed, T. Casilear Cole, lower right
Gift of Dorothy Paris, 1969
969-O-116

Timothy COLE, (1931–)

Lowlands
Wood engraving on paper, 9 x 10.75" (22.86 x 27.31 cm.)
Signed, Timothy Cole, lower right
Gift of Mr. and Mrs. Edward E. Ford, 1968
970-P-111

Loring W. COLEMAN, (1918–)

Rural Pattern
Oil on hardboard, 48 x 60" (121.92 x 152.40 cm.)
Signed, Loring W. Coleman, lower left
Gift of Fanniebelle McVey Trippe, 1959
959-O-110

Warrington COLESCOTT, (1921–)

Dillinger, The Battle of Little Bohemia, II, 1965
Color collage, etching on paper, 19 x 27.5" (48.26 x 69.85 cm.)
Signed, Warr Colescott, 1965, lower right
Museum purchase, 1965
965-P-291

History of Print Making: S. W. Hayter Discovers Viscosity Printing, 1976
Etching on paper, 25 x 36" (63.50 x 91.44 cm.)
Signed, Warr Colescott, lower right
Gift of Vera List, 1977
977-P-117

William Francis COLLINS, (1925–)

Cult Member #37, 1975
Acrylic on canvas, 72 x 48" (182.88 x 121.92 cm.)
Signed, William Francis Collins, lower right
Gift of Leonard Bocour, 1975
975-O-111

Cult Member Transition #50, 1975
Acrylic on canvas, 44 x 42" (111.76 x 106.68 cm.)
Signed, William Francis Collins, lower right
Gift of Leonard Bocour, 1975
975-O-112

Samuel COLMAN, (1832–1920)

Caravan in the Desert, 1878
Oil on canvas, 25.5 x 52" (64.77 x 132.08 cm.)
Signed, Sam Colman, 1878, lower right
Museum purchase, 1947
947-O-102

Ora COLTMAN, (1860–ca. 1940)

Italianate Canal Scene with Bridge, 1918
Oil on canvas, 40 x 24" (101.60 x 60.96 cm.)
Signed, Ora Coltman, lower center
Gift of Mrs. Cyril P. Deibel, 1976
976-O-115

John N. COLTON, (1925–)

Red Satin, 1972
Paint on canvas, 26 x 16" (66.04 x 40.64 cm.)
Unsigned
Gift of Mr. and Mrs. Leonard Bocour, 1976
976-O-107

James R. COLWAY, (1920–)

The Farm Door
Oil on canvas, 24 x 18" (60.96 x 45.72 cm.)
Signed, James Colway, lower right
Museum purchase, 1969
969-O-117

Suetelle COMEN, (1926–)

Mood of Light and Darks, 1967
Watercolor on paper, 9.5 x 13" (24.13 x 33.02 cm.)
Signed, Suetelle, lower middle
Anonymous gift, 1968
968-W-138

The following nine signed drawings on paper of various sizes are the gift of Suetelle Comen, 1970

Dark Cliffs, 1970
970-D-120

Louis Held, 1968
970-D-116

Louis Held "The Collector," 1968
970-D-115

Nude Sitting Down
970-D-117

Nude with Uplifted Arms
970-D-118

Pensive Woman, 1969
970-D-114

Some Motive, 1970
970-D-119

Woman with Uplifted Arm, 1969
970-D-113

Womanhood, 1969
970-D-121

Robert F. CONOVER, (1920–)

Mountain, 1966
Relief print on paper, 20 x 30" (50.80 x 76.20 cm.)
Signed, Robert Conover, 1966, lower right
Gift of Associated American Artists, 1968
968-P-237

Thomas Casilear Cole - Portrait of Dorothy Paris

Colescott - Dillinger, The Battle of Little Bohemia, II

Colman - Caravan in the Desert

Coltman - Italianate Canal Scene with Bridge

Conover - Mountain

Cooper - Peace Memorial, Hiroshima

Cope - Fisherman's Accoutrements

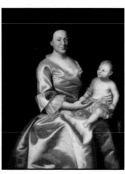

Copley - Portrait of Mrs. Daniel Rea and Child

Corbino - Boiler Maker's Picnic

Costigan - Woman, Goat at Brook (page 43)

Cottingham - Blues (page 43)

George CONRAD, (1916–)

Conversation
Oil on canvas, 36 x 48" (91.44 x 121.92 cm.)
Signed, Conrad, lower right
Gift of George Conrad, 1965
965-O-103

Mother and Child
Oil on canvas, 48 x 36" (121.92 x 91.44 cm.)
Signed, Conrad, lower right
Gift of George Conrad, 1968
968-O-217

George CONSTANT, (1892–1978)

Lonely Figure
Oil on canvas, 32 x 38" (81.28 x 96.52 cm.)
Signed, G. Constant, lower left
Gift of Mr. and Mrs. Samuel B. Brouner, 1956
956-O-103

Head, 1961
Lithograph on paper, 9.5 x 7" (24.13 x 17.78 cm.)
Signed, G. Constant, lower right
Gift of George Constant, 1961
961-P-117

August COOK, (1897–1980)

Summer in the Mountains
Wood engraving on paper, 4.75 x 10" (12.06 x 25.40 cm.)
Signed, August Cook, lower right
Museum purchase, 1967
967-P-186

Howard COOK, (1901–1980)

Southern Mountaineer, 1936
Aquatint on paper, 12 x 9" (30.48 x 22.86 cm.)
Signed, Howard Cook, imp. 1936, lower right
Gift of Louis Held, 1965
965-P-186

Martha Dale COOPE, (1916–)

Arch
Oil on canvas, 30 x 40" (76.20 x 101.60 cm.)
Unsigned
Museum purchase, 1965
965-O-168

Rogers Station, 1959
Oil on canvas, 23 x 29" (58.42 x 73.66 cm.)
Signed, Dale Coope, lower left
Museum purchase, 1960
960-O-125

Window, 1961
Mixed media on paper, 22 x 28" (55.88 x 71.12 cm.)
Signed, M. D. Coope, lower left
Museum purchase, 1964
964-W-117

Mario COOPER, (1905–)

Peace Memorial, Hiroshima
Watercolor on paper, 21 x 29" (53.34 x 73.66 cm.)
Signed, Mario Cooper, lower right
Gift of the National Academy of Design, 1957
957-W-112

George COPE, (1855–1929)

Fisherman's Accoutrements, 1887
Oil on canvas on board, 42 x 30" (106.68 x 76.20 cm.)
Signed, George Cope, lower right
Museum purchase, 1957
957-O-105

John Singleton COPLEY, (1737–1815)

Portrait of Mrs. Daniel Rea and Child, 1757
Oil on canvas, 49 x 39" (124.46 x 99.06 cm.)
Unsigned
Museum purchase, 1947
947-O-103

Jon CORBINO, (1905–1964)

Boiler Maker's Picnic, 1936
Oil on paper, 11 x 19" (27.94 x 48.26 cm.)
Signed, Jon Corbino, lower right
Museum purchase, 1938
938-W-103

Fisherman and Nets
Oil and ink on paper, 8.5 x 11.5" (21.59 x 29.21 cm.)
Signed, Jon Corbino, lower left
Gift of Louis Held, 1965
965-W-114

Thomas CORNELL, (1937–)

Revolutionary Head
Etching on paper, 12.5 x 10" (31.75 x 25.40 cm.)
Signed, Cornell, lower right
Museum purchase, 1972
972-P-119

Paul CORNOYER, (1864–1923)

Compiègne, France
Oil on canvas, 16 x 48" (40.64 x 121.92 cm.)
Unsigned
Gift of Lenore Spiering, 1966
966-O-104

The Grove
Oil on canvas, 24 x 18" (60.96 x 45.72 cm.)
Signed, Paul Cornoyer, lower left
Gift of Lenore Spiering in memory of Theodore and Frida M. Spiering, 1966
966-O-129

Dennis CORRIGAN, (1944–)

The following two signed chronaflex film prints on paper, 14.25 x 12" (36.20 x 30.48 cm.), are a museum purchase, 1973

Prince Albert, His Face, 1972
973-P-116

The Marion Davies Home Entertainment Unit, 1972
973-P-117

John E. COSTIGAN, (1888–1972)

Wood Interior, 1921
Oil on board, 20 x 20" (50.80 x 50.80 cm.)
Signed, Costigan, lower right
Gift of Mr. and Mrs. Joseph P. Sontich, 1978
978-O-103

Woman, Goat at Brook, 1962
Watercolor on paper, 21 x 26.5" (53.34 x 67.31 cm.)
Signed, J. E. Costigan, N.A., lower left
Gift of the Friends of American Art, 1962
962-W-107

Ida, The Artist's Wife, 1917
Pencil on paper, 13 x 12" (33.02 x 30.48 cm.)
Signed, J. E. Costigan, lower right
Gift of John E. Costigan, 1971
971-D-109

Mother and Child
Ink on paper, 14 x 9" (35.56 x 22.86 cm.)
Signed, J. E. Costigan, lower right
Museum purchase, 1959
959-D-127

Fall Plowing
Etching on paper, 8.25 x 12.75" (20.96 x 32.39 cm.)
Signed, J. E. Costigan, N.A., lower right
Museum purchase, 1967
967-P-103

Jackie
Etching on paper, 11.5 x 9.25" (29.21 x 23.50 cm.)
Signed, J. E. Costigan, N.A., lower right
Gift of Mrs. W. J. Sampson, Jr., 1977
977-P-103

The following three signed etchings on paper of
various sizes are the gift of James T. Villani,
1979

Figures with Cow
979-P-148

Mother—Child
979-P-162

Woman, Boy and Goats
979-P-146

Robert COTTINGHAM, (1935–)

Blues, 1989
Color aquatint on paper, (2/45), 26.5 x 26" (67.31 x 66.04 cm.)
Signed, Cottingham, lower right
Museum purchase, 1989
989-P-114

Lillian COTTON, (1901–1962)

Sahra
Oil on canvas, 33 x 28" (83.82 x 71.12 cm.)
Signed, Lillian Cotton, lower left
Gift of Chester G. Burden, 1963
963-O-111

Jack COUGHLIN, (1932–)

Owl in Flight, 1967
Etching on paper, 14.75 x 10.75" (37.47 x 27.31 cm.)
Signed, Jack Coughlin, lower right
Museum purchase, 1968
968-P-211

Eanger Irving COUSE, (1866–1936)

A Vision of the Past, 1913
Oil on canvas, 59 x 59" (149.86 x 149.86 cm.)
Signed, E. I. Couse, lower left
Museum purchase, 1919
919-O-501

Julia COUZENS, (active 20th century)

Mortal Lessons #18
Ink on paper, 44.25 x 30" (112.40 x 76.20 cm.)
Signed, J. Couzens, on reverse
Gift of Erle L. Flad, 1992
992-W-104

Russell COWLES, (1887–1979)

Orchard
Charcoal on paper, 17.5 x 23.5" (44.45 x 59.69 cm.)
Signed, Cowles, lower right
Gift of Louis Held, 1965
965-D-109

Albert Scott COX, (1863–1920)

Telescope, 1883
Oil on canvas, 20 x 27" (50.80 x 68.58 cm.)
Signed, Albert Scott Cox, lower left
Museum purchase, 1954
954-O-111

Allyn COX, (1896–1982)

The following two drawings, charcoal on paper,
are a museum purchase, 1966

Nude Study
17.5 x 15" (44.45 x 38.10 cm.)
966-D-106

Seated Soldier
15 x 22" (38.10 x 55.88 cm.)
966-D-107

John Rogers COX, (1915–)

The Meadow, 1947
Oil on canvas, 20 x 27" (50.80 x 68.58 cm.)
Signed, John Rogers Cox, 1947, lower right
Gift of the Friends of American Art, 1956
956-O-104

Kenyon COX, (1856–1919)

Landscape, 1885
Oil on panel, 30 x 18" (76.20 x 45.72 cm.)
Signed, Kenyon Cox, 1885, lower left
Gift of Allyn Cox, 1966
966-O-138

Douglas CRAFT, (1924–)

Edge of Quiet, 1967
Oil and acrylic on canvas, 65 x 40" (165.10 x 101.60 cm.)
Signed, D. Craft, 67, lower right
Gift of Douglas Craft, 1993
993-O-115

Charles CRAIG, (1846–1931)

On the Lookout, 1900
Oil on canvas, 30 x 50" (76.20 x 127.00 cm.)
Signed, Chas. Craig, lower right
Museum purchase, 1913
913-O-502

On the Trail, 1900
Oil on canvas, 30 x 50" (76.20 x 127.00 cm.)
Signed, Chas. Craig, 1900, lower right
Museum purchase, 1913
913-O-501

Couse - A Vision of the Past

Cowles - Orchard

Craft - Edge of Quiet

Craig - On the Lookout

Craig - On the Trail

Crawford - Meriah Smith Tod

Crawford - Portrait of David Tod

Creem - Yasuo Kuniyoshi

Cropsey - Sailing, (The Hudson at Tappan Zee)

Standing Indian, 1900
Oil on canvas, 16 x 12" (40.64 x 30.48 cm.)
Signed, Chas. Craig, 1900, lower right
Museum purchase, 1915
915-O-501

Charles CRANDALL, (? –1950)

Autumn Fields
Oil on canvas, 8 x 10" (20.32 x 25.40 cm.)
Signed, Charles Crandall, on reverse
Gift of the estate of Charles Crandall, 1951
951-O-127

Bruce CRANE, (1857–1937)

November Lowlands
Oil on canvas, 14 x 20" (35.56 x 50.80 cm.)
Signed, Bruce Crane, lower left
Museum purchase, 1958
958-O-112

John Claude CRAWFORD, (1838–1876)

Anna Dinello, ca. 1865
Oil on canvas, 12 x 10" (30.48 x 25.40 cm.)
Unsigned
Gift of the estate of Winifred Pendleton, 1962
962-O-118

George Tod
Oil on canvas, 30 x 25" (76.20 x 63.50 cm.)
Unsigned
Gift of Mrs. Lawrence, 1961
961-O-103

Meriah Smith Tod
Oil on canvas, 40 x 32" (101.60 x 81.28 cm.)
Unsigned
Gift of Mrs. Fred Tod, 1954
954-O-112

Minna Leitch, 1865
Oil on canvas, 15 x 12" oval (38.10 x 30.48 cm.)
Unsigned
Gift of Isabel Wilson, 1957
957-O-106

Portrait of a Woman
Oil on canvas, 23 x 19" oval (58.42 x 48.26 cm.)
Unsigned
Gift of Dorothy Dennison Butler, 1966
966-O-122

Portrait of David Tod
Oil on canvas, 39.5 x 31.5" (100.33 x 80.01 cm.)
Unsigned
Gift of John Stambaugh and Grace Wilkerson Stambaugh, 1921
921-O-104

Portrait of William Potter, ca. 1865
Oil on canvas, 25 x 20" (63.50 x 50.80 cm.)
Unsigned
Gift of Eva A. Scott, 1954
954-O-113

Rock of Ages
Oil on canvas, 49 x 29" (124.46 x 73.66 cm.)
Unsigned
Gift of Mrs. Charles Crandall, 1951
951-O-113

The following two oils on canvas are the gift of the estate of Charles Crandall, 1951

Mrs. Crandall as a Girl
24 x 20" oval (60.96 x 50.80 cm.)
951-O-102

Sarah Stambaugh Crandall
40 x 32" (101.60 x 81.28 cm.)
951-O-101

Beryl Thompson Miller CREEL, (active 20th century)

(Untitled)
Oil on canvas, 18 x 24" (45.72 x 60.96 cm.)
Signed, Beryl Miller, lower right
Gift of Gertrude Wagner, 1981
981-O-111

Tom CREEM, (active 20th century)

Yasuo Kuniyoshi
Lithograph on paper, 11 x 7.5" (27.94 x 19.05 cm.)
Signed, Tom Creem, lower right
Museum purchase, 1967
967-P-173

Celia CRIE, (active 20th century)

Lobster Shack #2, 1957
Woodblock on paper, 6 x 13.5" (15.24 x 34.29 cm.)
Signed, Celia Crie, S-57, lower right
Gift of Joseph G. Butler, III, 1975
975-P-112

Alfred D. CRIMI, (1900–1994)

Chroma–Rhythms, 1962
Watercolor on paper, 18 x 25" (45.72 x 63.50 cm.)
Signed, A. D. Crimi, lower right
Museum purchase, 1969
969-W-106

Francis CRISS, (1901–1974)

Still Life with Bust, 1931
Oil on canvas, 44 x 54" (111.76 x 137.16 cm.)
Signed, Criss, 31, lower right
Gift of Max Zurkow, 1957
957-O-107

Richard CRIST, (1909–)

Pool at Sully's, 1960
Woodcut on paper, 12 x 15" (30.48 x 38.10 cm.)
Signed, Richard Crist, lower right
Museum purchase, 1960
960-P-105

Scott L. CROFT, (1911–)

Landscape
Oil on canvas, 12 x 16" (30.48 x 40.64 cm.)
Signed, Croft, lower right
Gift of R. J. Welter, 1972
972-O-122

Jasper F. CROPSEY, (1823–1900)

Sailing, (The Hudson at Tappan Zee), 1883
Oil on canvas, 14 x 24" (35.56 x 60.96 cm.)
Signed, J. F. Cropsey, 1883, lower right
Museum purchase, 1946
946-O-104

Henry H. CROSS, (1837–1918)

Spotted Elk, Sioux, 1879
Oil on canvas, 35 x 29" (88.90 x 73.66 cm.)
Signed, Spotted Elk, Pocatello Sioux, from life, H. H. Cross,
1879, upper left
Museum purchase, 1920
920-O-501

Sitting Bull, Taronka-I-Yotahka, 1877
Oil on canvas, 13.5 x 10" (34.29 x 25.40 cm.)
Signed, H. H. Cross, upper right
Museum purchase, 1920
920-O-502

Linda CROSS, (1936–)

It Was All Good Way Back Then
Oil on canvas, 50 x 50" (127.00 x 127.00 cm.)
Signed, Linda Cross, lower right
Museum purchase, 1966
966-O-114

Roger L. CROSSGROVE, (1921–)

Double Floral, 1961
Watercolor on paper, 24 x 34.5" (60.96 x 87.63 cm.)
Unsigned
Museum purchase, 1965
965-W-130

Stephen CSOKA, (1897–1989)

The following two signed etchings on paper are
the gift of Louis Held, 1965

Landscape
5.5 x 7.5" (13.97 x 19.05 cm.)
965-P-198

Roadside Stand
6 x 8" (15.24 x 20.32 cm.)
965-P-139

Charles CSURI, (1923–)

Procession, 1956
Oil on canvas, 17 x 28" (43.18 x 71.12 cm.)
Signed, Csuri, 56, lower left
Gift of Harry Salpeter, 1962
962-O-107

Horses, 1959
Drawing on paper, 19 x 25" (48.26 x 63.50 cm.)
Signed, Csuri, 59, lower right
Museum purchase, 1959
959-D-102

Pat CUCARO, (1915–)

Angelique, 1966
Lithograph on paper, 14.5 x 11.75" (36.83 x 29.85 cm.)
Signed, Cucaro, lower left
Gift of Edward J. Cory, 1970
971-P-115

Charles CULVER, (1908–1967)

Beetle with Red Marking, 1948
Watercolor on paper, 22 x 30" (55.88 x 76.20 cm.)
Signed, C. Culver, 1948, lower right
Museum purchase, 1957
957-W-102

Landscape
Watercolor on paper, 23 x 15.5" (58.42 x 39.37 cm.)
Signed, C. Culver, lower left
Gift of Mrs. Ferdinand Cinelli, 1968
968-W-146

Russet Flowers
Watercolor on paper, 20.5 x 14" (52.07 x 35.56 cm.)
Signed, C. Culver, lower left
Gift of the Friends of American Art, 1963
963-W-102

Two Formosan Deer
Watercolor on paper, 26 x 40" (66.04 x 101.60 cm.)
Signed, C. Culver, lower left
Museum purchase, 1966
966-W-103

Two Formosan Deer
Silkscreen on paper, 18 x 26.75" (45.72 x 67.95 cm.)
Signed, Chas. Culver, lower left
Gift of Mrs. Charles Culver, 1971
971-P-102

Bruce CURRIE, (1911–)

Buildings at Night
Oil on canvas, 28 x 46" (71.12 x 116.84 cm.)
Signed, Bruce Currie, lower right
Museum purchase, 1954
954-O-114

Girl in a Yellow Skirt
Oil on canvas, 53 x 37" (134.62 x 93.98 cm.)
Signed, Bruce Currie, lower left
Museum purchase, 1958
958-O-117

Girl Drying Her Hair, 1961
Color woodcut on paper, 15 x 10" (38.10 x 25.40 cm.)
Signed, Bruce Currie, 1961, lower right
Museum purchase, 1961
961-P-110

Joseph Frank CURRIER, (1843–1909)

Self Portrait, 1887
Oil on canvas, 35.5 x 28.25" (90.17 x 71.76 cm.)
Unsigned
Bequest of H. H. Stambaugh, 1919
919-O-104

Nathaniel CURRIER, (1813–1888)

Death of Washington, Dec. 14, A.D., 1799
Lithograph on paper, 13.5 x 19" (34.29 x 48.26 cm.)
Unsigned
Museum purchase, 1974
974-P-102

Washington's Reception, 1845
Colored lithograph on paper, 13 x 9" (33.02 x 22.86 cm.)
Unsigned
Museum purchase, 1965
965-P-313

Nathaniel CURRIER, (1813–1888) and
J. Merritt IVES, (1824–1895)

Death of Harrison, 1841
Colored lithograph on paper, 8.25 x 12.5" (20.96 x 31.75 cm.)
Unsigned
Gift of Paul Shumacher, 1961
961-P-109

Henry H. Cross - Spotted Elk, Sioux

Cucaro - Angelique

Culver - Beetle with Red Marking

Joseph Frank Currier - Self Portrait

Nathaniel Currier and J. Merritt Ives - Death of Harrison

Curry - Sanctuary

Curry - End Run

Daingerfield - The Sunset Hour

Dali - Ace of Spades

Daphnis - Palace in Minos (page 47)

Margaret
Lithograph on paper. 11 x 15" (27.94 x 38.10 cm.)
Unsigned
Gift of Louis Held, 1967
967-P-116

The Trotting Gelding Frank with J. O. Nay, His Running Mate, 1884
Lithograph in oil color on paper, 19 x 29.87" (48.26 x 75.88 cm.)
Signed, ©1884 by Currier and Ives, lower right
Museum purchase, 1989
989-P-115

The following six lithographs on paper are the gift of Mrs. W. J. Sampson, Jr., 1977

An Ocean Steamer in a Heavy Gale
8 x 12.75" (30.32 x 32.39 cm.)
977-P-108

Burning of the Steamship *Golden Gate*, July 27, 1862
8 x 12.25" (20.32 x 31.12 cm.)
977-P-104

Clipper Ship in a Hurricane
9 x 12.5" (22.86 x 31.75 cm.)
977-P-107

God Bless Our Home
9.25 x 13.25" (23.50 x 33.66 cm.)
977-P-105

Midnight Race on the Mississippi
9 x 13" (22.86 x 33.02 cm.)
977-P-106

The Iron Steamship *Great Britain*
8 x 13" (20.32 x 33.02 cm.)
977-P-109

John Steuart CURRY, (1897–1946)

Sanctuary, 1936
Watercolor on paper, 14 x 21" (35.56 x 53.34 cm.)
Signed, John Steuart Curry, 1936, lower right
Museum purchase, 1941
941-W-106

End Run, 1942–46
Oil on canvas, 38 x 59.5" (96.52 x 151.13 cm.)
Signed, John Steuart Curry, 1942–46, lower left
Museum purchase, 1988
988-O-101

Sanctuary, 1944
Lithograph on paper, 14 x 18" (35.56 x 45.72 cm.)
Signed, John Steuart Curry, lower right
Gift of Albert E. Hise, 1979
979-P-155

Stallion and Jack Fighting, 1943
Lithograph on paper, 11.75 x 15.5" (29.85 x 39.37 cm.)
Signed, John Steuart Curry, lower right
Museum purchase, 1967
967-P-112

Gandy CURTIS, (active late 19th, early 20th century)

Mother's Pride
Oil on canvas, 12 x 16" (30.48 x 40.64 cm.)
Signed, C., lower left
Museum purchase, 1920
920-O-505

Stefano CUSUMANO, (1912–1975)

Eulogy, 1969
Oil on canvas, 42 x 36" (106.68 x 91.44 cm.)
Signed, S. Cusumano, lower right
Gift of the Friends of American Art, 1975
975-O-137

Eulogy, 1969
Pencil on paper, 21 x 16" (53.34 x 40.64 cm.)
Signed, S. Cusumano, upper right
Gift of the Friends of American Art, 1980
980-D-101

Virginia CUTHBERT, (1908–)

The Valley of the Rosas, Spain, 1961–62
Oil on canvas, 38 x 51.25" (96.52 x 130.18 cm.)
Signed, Virginia Cuthbert, lower right
Gift of Dorothy Dennison Butler, 1976
976-O-103

Ruth CYRIL, (active late 20th century)

Queen Anne's Lace, 1966
Etching on paper, 11.75 x 9.75" (29.85 x 24.77 cm.)
Signed, Cyril, lower right
Museum purchase, 1968
968-P-249

Elliott DAINGERFIELD, (1859–1932)

The Sunset Hour, 1919
Oil on canvas, 35.5 x 47.5" (90.17 x 120.65 cm.)
Unsigned
Museum purchase, 1922
922-O-101

Kenneth DALEY, (1941–)

Cascade, 1966
Etching on paper, (6/210), 23.75 x 18" (60.33 x 45.72 cm.)
Signed, Ken Daley, 1966, lower right
Museum purchase, 1967
967-P-167

Salvador DALI, (1904–1989)

The portfolio "Playing Card Suit" contains twelve signed lithographs on paper, 22.5 x 29.5" (57.15 x 74.93 cm.), which is the gift of Reese and Marilyn Arnold Palley, 1991

Ace of Clubs, 1971
991-P-133

Ace of Diamonds, 1971
991-P-144

Ace of Spades, 1971
991-P-140

Jack of Clubs, 1971
991-P-136

Jack of Diamonds, 1971
991-P-143

Jack of Spades, 1971
991-P-137

King of Clubs, 1971
991-P-134

King of Diamonds, 1971
991-P-141

King of Spades, 1971
991-P-139

Queen of Clubs, 1971
991-P-135

Queen of Diamonds, 1971
991-P-142

Queen of Spades, 1971
991-P-138

Nassos DAPHNIS, (1914–)

Palace in Minos, 1988
Enamel on canvas, 75 x 90" (190.50 x 228.60 cm.)
Unsigned
Gift of Alexander and Helen Avlonitis, 1994
994-O-101

The Three Graces 3–F–51, 1950
Oil on canvas, 56 x 42" (142.24 x 106.68 cm.)
Signed, N. Daphnis, 50, lower right
Gift of Alexander and Helen Avlonitis, 1993
993-O-118

Allan D'ARCANGELO, (1930–)

(Untitled), 1965
Serigraph on paper, 24 x 20" (60.96 x 50.80 cm.)
Signed, Allan D'Arcangelo, 1965, lower right
Gift of Arthur Feldman, 1991
991-P-187

(Untitled), 1979
Lithograph on paper, (4/6), 46 x 35" (116.84 x 88.90 cm.)
Signed, A. D'Arcangelo, 1979, lower right
Gift of Arthur Feldman, 1993
993-P-149

DARTEL, (active 20th century)

Flowers, 1968
Oil on canvas, 51 x 48" (129.54 x 121.92 cm.)
Unsigned
Gift of Stanley Bard, 1969
969-O-164

(Untitled)
Oil on canvas, 48 x 43.5" (121.92 x 110.49 cm.)
Unsigned
Gift of Stanley Bard, 1973
973-O-108

Robert Warren DASH, (1934–)

October Branch
Silkscreen on paper, (13/65), 28.5 x 22.5" (72.39 x 57.15 cm.)
Signed, Robert Dash, lower right
Gift of Robert Dash, 1978
978-P-129

Gyorgy DASKALOFF, (1923–)

Joseph Butler, 1977
(Ancestral Portrait)
Conte crayon on paper, 39 x 29" (99.06 x 73.66 cm.)
Signed, Daskaloff, lower left
Museum purchase, 1977
977-D-105

The following eight lithographs on paper, 26 x
19.75" (66.04 x 50.17 cm.), are the gift of
Dorothy Dennsion Butler, 1975
975-P-117.01 — 975-P-117.08

Visages: Portrait Horizontal Black and
White

Visages: Portrait Vertical Black and
White

Visages: Portrait Magenta Hair

Visages: Male Portrait Blue and Yellow

Visages: Female Portrait Purple Eye

Visages: Female Portrait Turquoise Hair

Visages: Female Against Blue Ground

Visages: Black and Pink Study Four
Heads

A. Mark DATZ, (1889–1990)

Evening Fantasy
Oil on canvas, 9.75 x 20.5" (24.77 x 52.07 cm.)
Signed, Mark Datz, lower right
Gift of Jack M. Hockett, 1977
977-O-153

Hudson River, 1966
Etching on paper, (4/10), 8 x 11" (20.32 x 27.94 cm.)
Signed, A. Mark Datz, lower right
Gift of Louis Held, 1966
966-P-146

Arthur Bowen DAVIES, (1862–1928)

Arethusa, 1901
Oil on canvas, 27.5 x 22.5" (69.85 x 57.15 cm.)
Signed, A. B. Davies, lower left
Museum purchase, 1923
923-O-103

Cinderella
Oil on canvas, 17 x 21.5" (43.18 x 54.61 cm.)
Unsigned
Gift of Mr. and Mrs. Solton Engel, 1955
955-O-109

Nude
Chalk on paper, 17 x 11.5" (43.18 x 29.21 cm.)
Signed, Arthur B. Davies, lower right
Gift of Arthur A. Marshall, 1991
991-D-134

Against Green, 1925
Soft grade aquatint on paper, (3 of 4 /25), 8 x 11.75" (20.32 x
29.85 cm.)
Signed, Arthur B. Davies, lower right
Museum purchase, 1966
966-P-155

Angled Beauty, 1918
Aquatint on paper, 8 x 11.87" (20.32 x 30.16 cm.)
Signed, Arthur B. Davies, lower left
Museum purchase, 1995
995-P-102

Fountain of Youth, 1919
Aquatint on paper, 13.25 x 17.25" (33.66 x 43.82 cm.)
Signed, Arthur B. Davies, lower right
Museum purchase, 1980
980-P-131

Daphnis - The Three Graces 3–F–51

D'Arcangelo - (Untitled) (991-P-187)

Davies - Arethusa

Davies - Nude

Davies - Angled Beauty

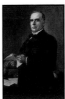

Cornelia C. Davis - Portrait of President William McKinley
(page 48)

Stuart Davis - Gloucester Harbor

Stuart Davis - Construction

Stuart Davis - Hotel Cafe

W. M. Davis - Drawing a Bead on a Woodchuck

DeHaven - Silvery Waters (page 49)

Adolf Dehn - Big Mountain (page 49)

Recurrence
Lithograph on paper, (#102, edition 25), 14 x 17.5" (35.56 x 44.45 cm.)
Signed, Arthur B. Davies, lower right
Museum purchase, 1966
966-P-154

Charles Harold DAVIS, (1856–1933)

Call of the West Wind, 1912
Oil on canvas, 40 x 30" (101.60 x 76.20 cm.)
Signed, C. H. Davis, lower left
Museum purchase, 1919
919-O-105

Cornelia Cassady DAVIS, (1870–1920)

Portrait of President William McKinley, 1899
Oil on canvas, 50 x 34" (127.00 x 86.36 cm.)
Signed, Cornelia Cassady Davis, lower right
Gift of Sir Malcolm Perks, 1968
968-O-199

Gladys Rockmore DAVIS, (1901–)

Pink Roses
Pastel on paper, 25 x 18" (63.50 x 45.72 cm.)
Signed, G. R. D., lower right
Museum purchase, 1944
944-W-101

Study of a Nude
Conte drawing on paper, 17 x 11.5" (43.18 x 29.21 cm.)
Signed, G. R. D., lower right
Museum purchase, 1962
962-D-152

Harry Allen DAVIS, (1914–)

A Mansion in Vevay
Acrylic on masonite, 34 x 46" (86.36 x 116.84 cm.)
Signed, Harry A. Davis, lower right
Museum purchase, 1978
978-O-119

End of an Era
Watercolor on paper, 20 x 30" (50.80 x 76.20 cm.)
Signed, Harry A. Davis, lower right
Museum purchase, 1961
961-W-105

Noel DAVIS, (1928–)

Turtle and Lagoon, 1953
Watercolor on paper, 14 x 19" (35.56 x 48.26 cm.)
Signed, Noel Davis, '53, lower right
Museum purchase, 1954
954-W-107

Landscape
Pencil on paper, 14 x 17.5" (35.56 x 44.45 cm.)
Signed, Noel Davis, lower center
Gift of Noel Davis, 1956
956-D-102

Old Lady in Wheel Chair, 1957
Pencil on paper, 18 x 14.5" (45.72 x 36.83 cm.)
Signed, Noel Davis, '57, lower right
Gift of Dorothy Dennison Butler, 1959
959-D-103

Stuart DAVIS, (1894–1964)

Gloucester Harbor, 1924
Watercolor and crayon on paper, 12.75 x 18" (32.39 x 45.72 cm.)
Signed, Stuart Davis, '24, lower right
Museum purchase, 1967
967-W-101

Construction
Serigraph on paper, (28/40), 12.5 x 15" (31.75 x 38.10 cm.)
Signed, Stuart Davis, lower right
Gift of Louis Held, 1965
965-P-180

Hotel Cafe, 1929
Lithograph on paper, (5/30), 10.25 x 7.75" (26.04 x 19.69 cm.)
Signed, Stuart Davis, lower right
Museum purchase, 1968
968-P-260

W. M. DAVIS, (1829– ?)

Drawing a Bead on a Woodchuck
Oil on canvas, 16.18 x 21.37" (41.11 x 54.29 cm.)
Signed, W. M. Davis, left center
Museum purchase, 1946
946-O-103

Worden DAY, (1916–1986)

Mandala VIII
Woodcut on paper, (137/200), 18.5 x 23.5" (46.99 x 59.69 cm.)
Signed, Worden Day, lower right
Museum purchase, 1964
964-P-121

Anthony DEBERNARDIN, (1889–1972)

From Across the Street Waving
Oil on canvas, 34.5 x 49.75" (87.63 x 126.37 cm.)
Unsigned
Gift of Lucy Ball Owsley, 1979
979-O-107

Mountain Lake with Boats
Oil on canvas, 26.75 x 24" (67.95 x 60.96 cm.)
Unsigned
Gift of Lucy Ball Owsley, 1982
982-O-101

Peter DECHAR, (1942–)

(Untitled), 1970
Lithograph on paper, 11 x 14" (27.94 x 35.56 cm.)
Signed, Dechar, 70, lower right
Gift of Arthur Feldman, 1991
991-P-182

Julio de DIEGO, (1900–1979)

Oriental Figures
Color serigraph on paper, 12 x 18" (30.48 x 45.72 cm.)
Signed, de Diego, lower left
Gift of the Woodstock Artists, 1968
968-P-310

Val DEEZIK, (1914–)

V. J. Day
Watercolor on paper, 19 x 30" (48.26 x 76.20 cm.)
Signed, V. Deezik, lower right
Museum purchase, 1948
948-W-102

Didi DEGLIN, (1929–)

Fallen Pegasus
Watercolor on paper, 26 x 36" (66.04 x 91.44 cm.)
Signed, Didi Deglin, lower right
Museum purchase, 1963
963-W-105

Franklin DeHAVEN, (1856–1934)

Silvery Waters, 1916
Oil on canvas, 39.5 x 49.5" (100.33 x 125.73 cm.)
Signed, DeHaven, lower left
Museum purchase, 1918
918-O-102

Adolf DEHN, (1895–1968)

Big Mountain, 1956
Casein on panel, 36 x 48" (91.44 x 121.92 cm.)
Signed, Adolf Dehn, lower left
Museum purchase, 1957
957-O-108

Italian Scene
Gouache on paper, 18 x 26" (45.72 x 66.04 cm.)
Signed, Adolf Dehn, lower right
Gift of Carl L. Dennison, 1978
978-W-110

Haitian Nights, 1962
Lithograph on paper, 14 x 18" (35.56 x 45.72 cm.)
Signed, Adolf Dehn, lower right
Museum purchase, 1962
962-P-111

Sacred Bull, 1961
Lithograph on paper, 14 x 18" (35.56 x 45.72 cm.)
Signed, Adolf Dehn, lower right
Museum purchase, 1967
967-P-194

The following two signed watercolors on paper
are the gift of Mrs. Adolf Dehn, 1991

Ohio Farm Near Lake Cowan
20 x 28.25" (50.80 x 71.76 cm.)
991-W-104

(Untitled)
20.12 x 27.25" (51.12 x 69.22 cm.)
991-W-103

The following three lithographs on paper of
various sizes are the gift of Adolf Dehn, 1962

Big Rock, 1961
962-P-127

Mountain
962-P-126

Three Heads
962-P-125

The Sketchbooks of Adolf Dehn,
1941–1967

The Butler Institute's collection includes one
hundred fourteen drawings on paper of various
sizes which are the gift of Mrs. Adolf Dehn,
1991
AD991-D-101 — AD991-D-214

Virginia DEHN, (active 20th century)

St. Germaine en-laye
Lithograph on paper, 15 x 18.5" (38.10 x 46.99 cm.)
Signed, Virginia Dehn, lower right
Gift of Virginia Dehn, 1980
980-P-128

Willem de KOONING, (1904–1988)

The Preacher, 1971
Lithograph on paper, (28/60), 29.87 x 22.25" (75.88 x 56.52
cm.)
Signed, de Kooning, lower right
Museum purchase, 1983
983-P-143

Amanda DeLEON, (1908–)

Christening
Casein on canvas, 30 x 20" (76.20 x 50.80 cm.)
Signed, A. DeLeon, lower left
Gift of Mr. and Mrs. Eugene Kilpatrick Perry, 1955
955-O-110

James DEL GROSSO, (active late 20th
century)

Louisville Slugger, 1992
Oil on canvas, 32 x 52" (81.28 x 132.08 cm.)
Unsigned
Gift of the Terminare Corporation, 1994
994-O-111

Joseph DEMARAIS, (active late 20th century)

What Kind of Irony, 1966
Etching on paper, (192/250), 10.5 x 24" (26.67 x 60.96 cm.)
Signed, Demarais, 66, lower right
Museum purchase, 1967
967-P-144

John Stockton De MARTELLY, (1903–1980)

Two Old Toms
Lithograph on paper, 11.25 x 8" (28.58 x 20.32 cm.)
Signed, John S. De Martelly, lower right
Museum purchase, 1967
967-P-135

Joseph de MARTINI, (1896– ?)

Coastal Scene
Oil on canvas, 10 x 12" (25.40 x 30.48 cm.)
Signed, Joseph de Martini, lower right
Gift of Mr. and Mrs. Nahum Tschacbasov, 1975
975-O-133

The Lighthouse
Oil on canvas, 9 x 12" (22.86 x 30.48 cm.)
Unsigned
Gift of Mr. and Mrs. Milton Lowenthal, 1955
955-O-111

The Haunted House
Oil on paper, 10 x 15" (25.40 x 38.10 cm.)
Unsigned
Gift of Mrs. Harold Weston, 1977
977-W-113

Dorothy DEMBOSKI, (1937–)

Blue Interior, 1960
Oil on canvas, 52 x 58" (132.08 x 147.32 cm.)
Signed, Demboski, 60, lower right
Museum purchase, 1960
960-O-111

Adolf Dehn - Italian Scene

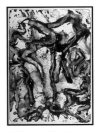
de Kooning - The Preacher

Del Grosso - Louisville Slugger

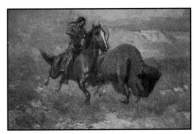
Deming - A Young Arapaho (page 50)

Deming - Indians Hunting Buffalo (page 50)

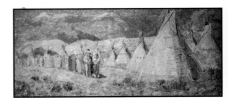
Deming - Medicine Lodge - (page 50)

Demuth - Two Figures (page 50)

DeNiro - Landscape

Dennison (Butler) - Professional Painters

Dennison (Butler) - The Yellow Pencil

Desch - The Blue Chinese Coat

Diao - Weld

Diebenkorn - Soft Ground V (page 51)

Edwin Willard DEMING, (1860–1942)

The following two signed oils on canvas, 12 x 18" (30.48 x 45.72 cm.), are a museum purchase, 1920

A Young Arapaho
920-O-503

The Pursuit
920-O-504

The following two signed oils on canvas are the gift of Dr. Bernard L. Pacella, 1969, 1970

Indians Hunting Buffalo
28 x 34" (71.12 x 86.36 cm.)
970-O-125

Medicine Lodge
28 x 69" (71.12 x 175.26 cm.)
969-O-155

Charles DEMUTH, (1883–1935)

Two Figures, ca. 1916
Watercolor on paper, 9 x 11.5" (22.86 x 29.21 cm.)
Signed, C. Demuth, lower left
Museum purchase, 1962
962-W-112

Robert DeNIRO, (1922–)

Landscape, 1978
Oil on canvas, 26 x 28" (66.04 x 71.12 cm.)
Signed, DeNiro, upper left
Gift of Virginia Zabriskie, 1991
991-O-224

Dorothy D. DENNISON, (Butler), (1908–1994)

Professional Painters, 1948
Oil on canvas, 40 x 50" (101.60 x 127.00 cm.)
Unsigned
Museum purchase, 1951
951-O-103

The Yellow Pencil, 1954
Oil on canvas, 40 x 24" (101.60 x 60.96 cm.)
Unsigned
Museum purchase, 1965
965-O-147

Judith's Fancy
Ink on paper, 7.5 x 13.5" (19.05 x 34.29 cm.)
Signed, Dorothy D. Butler, lower right
Gift of Louis Held, 1966
966-D-113

Josh, 1963
Lithograph on paper, (15/25), 14 x 18" (35.56 x 45.72 cm.)
Signed, Dorothy D. Dennison, lower right
Gift of "The Women," 1965
965-P-206

Starboard Boat, 1963
Colored lithograph on paper, 14 x 20" (35.56 x 50.80 cm.)
Signed, Dorothy D. Dennison, '63, lower right
Museum purchase, 1963
963-P-143

The following two signed lithographs on paper are the gift of Louis Held, 1969

Prince Edward Island, 1967
(3/20), 8 x 14" (20.32 x 35.56 cm.)
969-P-121

Show Off
(6/20), 13 x 7" (33.02 x 17.78 cm.)
969-P-120

Jan De RUTH, (1922–1991)

Two
Oil on canvas, 50 x 32" (127.00 x 81.28 cm.)
Signed, Jan De Ruth, lower left
Museum purchase, 1963
963-O-113

Femme En Chemise, 1965
Lithograph on paper, (51/250), 12 x 9" (30.48 x 22.86 cm.)
Signed, Jan De Ruth, lower right
Museum purchase, 1965
965-P-319

Reclining Nude
Sepia crayon on paper, 9 x 15.5" (22.86 x 39.37 cm.)
Signed, Jan De Ruth, lower right
Gift of Jan De Ruth, 1971
971-D-108

Frank H. DESCH, (1873–1934)

The Blue Chinese Coat, 1919
Oil on canvas, 32 x 26" (81.28 x 66.04 cm.)
Signed, Frank H. Desch, lower left
Museum purchase, 1923
923-O-104

John DETORE, (1902–1975)

Forest Stream, 1964
Watercolor on paper, 37 x 27" (93.98 x 68.58 cm.)
Unsigned
Museum purchase, 1964
964-W-101

Boris DEUTSCH, (1892– ?)

Chinese Girl, 1934
Crayon on paper, 15 x 13" (38.10 x 33.02 cm.)
Unsigned
Gift of Harry Salpeter, 1934
934-D-101

Themis DEVITIS, (1905–)

Portrait of H. Bella Schaeffer
Gouache on paper, 13 x 10" (33.02 x 25.40 cm.)
Signed, Devitis, lower left
Gift of Louis Held, 1969
969-W-111

Robert DeWEESE, (1920–)

The Search, 1963
Etching and drypoint on paper, 6 x 15" (15.24 x 38.10 cm.)
Signed, Robert DeWeese, 1963, lower right
Museum purchase, 1965
965-P-256

David DIAO, (1943–)

Weld
Acrylic on canvas, 92 x 135" (233.68 x 342.90 cm.)
Signed, Diao, lower left
Gift of Jayne Turk, 1992
992-O-110

Eleanor DICKINSON, (1931–)

My Father
Oil on canvas, 52 x 58" (132.08 x 147.32 cm.)
Signed, Dickinson, lower right
Museum purchase, 1960
960-O-110

Sidney E. DICKINSON, (1890–1980)

John J. McDonough, Portrait, 1957
Oil on canvas, 30 x 25" (76.20 x 63.50 cm.)
Signed, Sidney E. Dickinson, lower right
Gift of Dr. John J. McDonough, 1975
975-O-135

Richard DIEBENKORN, (1922–)

Soft Ground V, 1982
Drypoint on paper, (13/35), 40.5 x 26.5" (102.87 x 67.31 cm.)
Signed, R. D., lower right
Museum purchase, 1983
983-P-144

Charles DIETZ, (1910–)

Muchacho Triste
Watercolor on paper, 21.5 x 13" (54.61 x 33.02 cm.)
Signed, Dietz, lower right
Museum purchase, 1958
958-W-115

Alex P. DiGIACOMO, (1933–)

Times Passed
Watercolor on paper, 20.5 x 17" (52.07 x 43.18 cm.)
Signed, A. P. DiGiacomo, lower right
Museum purchase, 1976
976-W-103

Crabapple Tree, 1971
Pencil on paper, 14 x 10" (35.56 x 25.40 cm.)
Signed, A. P. DiGiacomo, lower right
Museum purchase, 1971
971-D-110

Phil DIKE, (1906–)

Echo from the Sea
Watercolor on paper, 22.5 x 28" (57.15 x 71.12 cm.)
Signed, Phil Dike, lower right
Museum purchase, 1959
959-W-102

Jim DINE, (1935–)

Art in Science
Silkscreen on paper, 40 x 25" (101.60 x 63.50 cm.)
Signed, Jim Dine, lower left
Anonymous gift, 1980
980-P-157

Quartet, 1986
Gravure, etching, and aquatint on paper, (40/50), 35.5 x 27.75"
(90.17 x 70.49 cm.)
Signed, J. D., lower left
Museum purchase, 1986
986-P-111

(Untitled), 1973
Lithograph on paper, 9 x 12" (22.86 x 30.48 cm.)
Signed, Dine, lower right
Gift of Steven Feinstein, 1983
983-P-148

Harvey DINNERSTEIN, (1928–)

Maggy, 1985
Oil on canvas, 74 x 36" (187.96 x 91.44 cm.)
Signed, H. Dinnerstein, lower left
Gift of Phil Desind, 1987
987-O-121

Boxing, 1985
Pastel on paper, 24 x 19.5" (60.96 x 49.53 cm.)
Signed, H. D., lower right
Museum purchase, 1988
988-D-102

Portrait of Phil Desind, 1989–90
Pastel on paper, 70 x 40" (177.80 x 101.60 cm.)
Signed, H. Dinnerstein, middle left
Museum purchase, 1989
989-D-102

Joe Dimaggio
Print reproduction on paper, 15 x 20" (38.10 x 50.80 cm.)
Unsigned by artist, signed by subject
Gift of Mr. and Mrs. Irwin Thomases, 1984
984-P-104

Nathaniel DIRK, (1896–1961)

Seascape
Watercolor on paper, 14 x 18" (35.56 x 45.72 cm.)
Signed, N. Dirk, lower left
Gift of Mrs. Harold Weston, 1977
977-W-117

Mary K. D'ISA, (1926–)

Mystic Morn
Watercolor on paper, 16 x 20" (40.64 x 50.80 cm.)
Signed, M. K. D'Isa, lower right
Museum purchase, 1973
973-W-105

WALT DISNEY PRODUCTIONS

Doves at Fountain, 1937
(Snow White and the Seven Dwarfs)
Celluloid painting, 10 x 12" (25.40 x 30.48 cm.)
Unsigned
Gift of Louis Held, 1979
979-W-108

Figaro, 1939
(Pinocchio)
Celluloid painting, 7.25 x 7.02" (18.42 x 17.84 cm.)
Unsigned
Gift of Louis Held, 1965
965-W-119

Mark Di SUVERO, (1933–)

(Untitled), 1973
Lithograph on paper, 9 x 12" (22.86 x 30.48 cm.)
Signed, Mark Di Suvero, lower left
Gift of Steven Feinstein, 1983
983-P-149

John B. DOBBS, (1931–)

Deodand #2
Oil on canvas, 40.25 x 36" (102.24 x 91.44 cm.)
Unsigned
Gift of Mr. and Mrs. Robert DeCormier, 1972
972-O-119

Dine - Quartet

Dinnerstein - Maggy

Dinnerstein - Portrait of Phil Desind

D'Isa - Mystic Morn

Walt Disney Productions - Figaro

Di Suvero - (Untitled)

Dobrotka - Brick, Cleveland

Dombek - Steel Mill South

Dotson - Portrait of Dave Dravecky

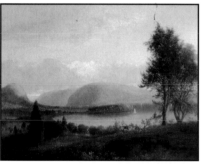
Doughty- Denning's Point, Hudson River

Dove - Ice and Clouds

Dowd - (And I Heard a Loud Voice) "Woe, Woe, Woe"
(page 53)

Alexander DOBKIN, (1908–1975)

Sienna
Oil on canvas, 43 x 23" (109.22 x 58.42 cm.)
Unsigned
Gift of David A. Teichman, 1957
957-O-109

Father and Child
Lithograph on paper, 21 x 15" (53.34 x 38.10 cm.)
Unsigned
Gift of Louis Held, 1965
965-P-154

Edward DOBROTKA, (1917–)

Brick, Cleveland, 1939
Watercolor on paper, 12 x 19" (30.48 x 48.26 cm.)
Unsigned
Museum purchase, 1940
940-W-102

William de Leftwich DODGE, (1867–1935)

Forgotten, 1933
Oil on burlap, 48.25 x 40.25" (122.56 x 102.24 cm.)
Signed, W. de L. Dodge, 1933, lower left
Gift of Leftwich D. Kimbrough, 1989
989-O-105

Stevan DOHANOS, (1907–1994)

The following three signed lithographs on paper
are a museum purchase, 1979

Departure
16 x 13" (40.64 x 33.02 cm.)
979-P-114

Shooting the Breeze
16 x 12" (40.64 x 30.48 cm.)
979-P-112

Which Comes First
15.5 x 12" (39.37 x 30.48 cm.)
979-P-113

George DOMBEK, (1944–)

San Francisco, 1978
Watercolor on paper, 13.75 x 17.75" (34.93 x 45.09 cm.)
Signed, Dombek, lower left
Gift of George Dombek, 1979
979-W-107

Steel Mill South, 1986
Watercolor, acrylic on paper, 30 x 42" (76.20 x 106.68 cm.)
Signed, Dombek, lower right
Museum purchase, 1988
988-W-103

Bruce DORFMAN, (1936–)

Early
Oil on canvas, 68 x 38" (172.72 x 96.52 cm.)
Unsigned
Museum purchase, 1972
972-O-117

Bill DOTSON, (1948–)

Portrait of Dave Dravecky, 1991
Pen and ink on paper, 61 x 32" (154.94 x 81.28 cm.)
Signed, Bill Dotson, lower right
Museum purchase, 1991
991-D-113

Portrait of Joseph G. Butler, III, 1981
Pen and ink on paper, 21 x 15.5" (53.34 x 39.37 cm.)
Signed, Bill Dotson, lower left
Gift of Bill Dotson, 1981
981-D-104

Youngstown's Own, 1982
Ink on paper, 36 x 24" (91.44 x 60.96 cm.)
Signed, Bill Dotson, lower left
Gift of Bill Dotson, 1983
983-D-101

Elvis
Lithograph on paper, 20.5 x 17" (52.07 x 43.18 cm.)
Signed, Bill Dotson, lower right
Gift of Judge and Mrs. William T. Bodoh, 1995
995-P-109

The following three signed lithographs on paper,
22 x 17" (55.88 x 43.18 cm.), are the gift of
Judge and Mrs. William T. Bodoh, 1995

Notre Dame Series
995-P-106 — 995-P-108

Saliba DOUAIHY, (1915–)

Chasm, 1974
Acrylic on canvas, 44 x 52" (111.76 x 132.08 cm.)
Signed, Douaihy, lower left
Gift of Saliba Douaihy, 1975
975-O-127

Gerard E. DOUDERA, (1932–)

Danville
Oil on canvas, 30 x 40" (76.20 x 101.60 cm.)
Signed, Doudera, lower right
Museum purchase, 1958
958-O-119

Thomas DOUGHTY, (1793–1856)

Denning's Point, Hudson River, ca. 1839
Oil on mounted canvas, 24 x 30" (60.96 x 76.20 cm.)
Unsigned
Anonymous gift, 1961
961-O-104

Arthur G. DOVE, (1880–1946)

Ice and Clouds, 1931
Oil on board, 19.5 x 26.75" (49.53 x 67.95 cm.)
Signed, Dove, lower right
Museum purchase, 1961
961-O-134

Douglas DOWD, (active late 20th century)

Portfolio—Meet Me in Kuwait, 1991
Etchings on paper, (9), 20.25 x 25.5" (51.44 x 64.77 cm.)
Museum purchase, 1993
993-P-164.1 — 993-P-164.9

Cannibal! Cannibal!

Options (But Which? Which?)

Babylon Ho!

Tidings

War Mother

Betrayal

Shell

(And I Heard a Loud Voice) "Woe, Woe, Woe"

Oracle

Edward J. DOWLING, (active 20th century)

SS *Joseph G. Butler Jr.*
Watercolor on paper, 20 x 25" (50.80 x 63.50 cm.)
Signed, Edward J. Dowling, lower left
Museum purchase, 1975
975-W-103

Dean DRAHOS, (1937–)

Crusade
Oil on canvas, 31 x 44" (78.74 x 111.76 cm.)
Signed, Dean Drahos, lower left
Museum purchase, 1961
961-O-124

Clement DREW, (1806–1889)

Ship: *Francis Johnson*
Oil on canvas, 30 x 40" (76.20 x 101.60 cm.)
Signed, C. Drew, lower right
Museum purchase, 1928
S28-O-103

Werner DREWES, (1899–1985)

Shimmering Waters, 1962
Color woodcut on paper, (194/210), 11.5 x 17.5" (29.21 x 44.45 cm.)
Signed, Drewes, 1962, lower right
Museum purchase, 1963
963-P-146

Rosalyn DREXSLER, (active 20th century)

(Untitled), 1972
Lithograph on paper, 41.25 x 29.5" (104.78 x 74.93 cm.)
Signed, Rosalyn Drexsler, lower left
Gift of Samuel S. Mandel, 1986
986-P-160

David DRIESBACH, (1922–)

Money Tree, 1966
Etching on paper, (53/100), 10 x 4" (25.40 x 10.16 cm.)
Signed, David Driesbach, lower right
Museum purchase, 1967
967-P-123

Seymour DRUMLEVITCH, (1923–)

Roman Aqueduct, 1952
Oil on canvas, 46 x 48" (116.84 x 121.92 cm.)
Unsigned
Museum purchase, 1954
954-O-115

Nancy DRYFOOS, (active 20th century)

Seated Woman
Engraving on paper, 22.25 x 17.75" (56.52 x 45.09 cm.)
Signed, Nancy Dryfoos, lower right
Gift of Donald Dryfoos, 1978
978-P-123

The following two signed block prints on paper are the gift of Donald Dryfoos, 1978

Comfort
10 x 8" (25.40 x 20.32 cm.)
978-P-120

Head of a Horse
8 x 10" (20.32 x 25.40 cm.)
978-P-121

Tanya DUANE, (active 20th century)

Interweaving Circles
Watercolor and collage on paper, 18 x 24" (45.72 x 60.96 cm.)
Signed, T. Duane, lower right
Gift of Louis Held, 1977
977-W-102

Peter Paul DUBANIEWICZ, (1913–)

Central City, Colorado
Watercolor on paper, 17 x 30" (43.18 x 76.20 cm.)
Signed, Peter Paul Dubaniewicz, lower right
Museum purchase, 1954
954-W-108

Ralph DUBIN, (1918–)

Portrait of O'Casey
Ink on paper, 26 x 20" (66.04 x 50.80 cm.)
Signed, Ralph Dubin, lower left
Gift of Louis Held, 1966
966-D-114

Victor DUBREUIL, (active 1886–1900)

The Eye of the Artist, ca. 1898
Oil on canvas, 10 x 14" (25.40 x 35.56 cm.)
Signed, V. Dubreuil, lower left
Museum purchase, 1967
967-O-148

Randy DUDLEY, (active 20th century)

Gowanus Canal, 1986
Oil on canvas, 35 x 51" (88.90 x 129.54 cm.)
Signed, Dudley, lower right
Gift of Charles Allen, 1987
987-O-119

Charles H. DUGAN, (active late 20th century)

East Side–West Side
Intaglio on paper, 18 x 24" (45.72 x 60.96 cm.)
Signed, Charles H. Dugan, lower right
Museum purchase, 1965
965-P-281

Robert S. DUNCANSON, (1821–1872)

Fall Fisherman
Oil on canvas, 30 x 40" (76.20 x 101.60 cm.)
Unsigned
Museum purchase, 1969
969-O-105

Nate DUNN, (1896–1983)

The Cove
Oil on canvas, 33 x 42" (83.82 x 106.68 cm.)
Unsigned
Museum purchase, 1958
958-O-155

Drew - Ship: *Francis Johnson*

Dubaniewicz - Central City, Colorado

Dubreuil - The Eye of the Artist

Dudley - Gowanus Canal

Duncanson - Fall Fisherman

Dunn - The Cove

Durand - The Trysting Tree

Duveneck - Portrait of a Boy

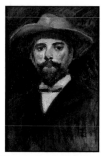
Duveneck - Portrait of Mr. Sharp

Eakins - The Coral Necklace

Eakins - Portrait of General George Cadwalader

Asher Brown DURAND, (1796–1886)

The Trysting Tree, 1868
Oil on canvas, 27.5 x 42" (69.85 x 106.68 cm.)
Signed, Durand, lower right
Museum purchase, 1979
979-O-117

William DURHAM, (1937–)

Curl
Silkscreen on paper, (28/45), 23.25 x 27.25" (59.06 x 69.22 cm.)
Signed, W. Durham, lower right
Gift of William Durham, 1978
978-P-135

Frank DUVENECK, (1848–1919)

Portrait of a Boy, 1872
Oil on canvas, 22 x 18" (55.88 x 45.72 cm.)
Unsigned
Museum purchase, 1920
920-O-104

Portrait of Mr. Sharp
Oil on canvas, 24 x 16" (60.96 x 40.64 cm.)
Unsigned
Gift of Mr. and Mrs. Sharp, 1913
913-O-101

The following two etchings on paper are a museum purchase, 1923

Grande Canal
13 x 21" (33.02 x 53.34 cm.)
923-P-101

Venice
13 x 10" (33.02 x 25.40 cm.)
923-P-102

Robert DVORAK, (1938–)

Constantine, 1965
Etching on paper, (172/250), 12.5 x 9.5" (31.75 x 24.13 cm.)
Signed, R. Dvorak, lower right
Gift of Associated American Artists, 1965
965-P-115

Mabel DWIGHT, (1876–1955)

Farmyard
Lithograph on paper, 12.25 x 15" (31.12 x 38.10 cm.)
Signed, Mabel Dwight, lower right
Museum purchase, 1973
973-P-105

Luis E. EADES, (1923–)

War Prisoners, 1957
Watercolor on paper, 18 x 26" (45.72 x 66.04 cm.)
Signed, Eades, '57, lower left
Museum purchase, 1958
958-W-102

Thomas Cowperthwait EAKINS, (1844–1916)

The Coral Necklace, 1904
Oil on canvas, 43 x 31" (109.22 x 78.74 cm.)
Signed, Eakins, 1904, right center
Museum purchase, 1958
958-O-101

Portrait of General George Cadwalader, 1878
Oil on canvas, 39 x 25" (99.06 x 63.50 cm.)
Unsigned
Museum purchase, 1945
945-O-103

Ralph EARL, (1751–1801)

The Striker Sisters, 1787
Oil on canvas, 37 x 27" (93.98 x 68.58 cm.)
Signed, R. Earl, 1787, lower left
Museum purchase, 1950
950-O-102

M. Mayer EARLBACHER, (active 20th century)

(Untitled)
Lithograph on paper, 24.25 x 30" (61.60 x 76.20 cm.)
Signed, M. Mayer Earlbacher, lower right
Gift of Arthur Feldman, 1991
991-P-186

Annie M. EASLEY, (active late 19th century)

Naval Battle of Santiago, American Victory on Water, ca. 1900
Oil on cardboard, 22 x 28" (55.88 x 71.12 cm.)
Signed, Annie M. Easley, lower right
Museum purchase, 1970
970-O-110

Seth EASTMAN, (1808–1875)

Hudson River with a Distant View of West Point, 1834
Oil on canvas, 33 x 50" (83.82 x 127.00 cm.)
Signed, Eastman, 1834, lower right
Museum purchase, 1968
968-O-174

William Joseph EASTMAN, (1881–1950)

Landscape
Distemper on paper, 16 x 14" (40.64 x 35.56 cm.)
Unsigned
Anonymous gift, 1961
961-W-114

Charles Warren EATON, (1857–1937)

A Village
Oil on canvas, 20 x 24" (50.80 x 60.96 cm.)
Signed, Chas. Warren Eaton, lower left
Gift of Mr. and Mrs. Harry L. Tepper, 1968
969-O-130

Pauline EATON, (1935–)

Spring Spectrum Square
Watercolor on paper, 29.5 x 29.5" (74.93 x 74.93 cm.)
Signed, Pauline Eaton, lower right
Museum purchase, 1979
979-W-105

Kerr EBY, (1889–1946)

Infantry, Chateau Theirry
Lithograph on paper, 9.5 x 12.5" (24.13 x 31.75 cm.)
Signed, Kerr Eby, lower right
Museum purchase, 1967
967-P-179

No. 1 Wall Street
Etching on paper, 19 x 13" (48.26 x 33.02 cm.)
Signed, Kerr Eby, lower right
Museum purchase, 1976
976-P-115

The following two signed etchings on paper are
the gift of Norman and June Krafft, 1980

Inlet
13.5 x 17" (34.29 x 43.18 cm.)
980-P-137

The Caissons Go Rolling Along
17.5 x 11" (44.45 x 27.94 cm.)
980-P-138

William Dean ECKERT, (1927–)

Foo Room, 1950
Oil on canvas, 24 x 28" (60.96 x 71.12 cm.)
Unsigned
Museum purchase, 1950
950-O-103

F. C. ECKMAIR, (1930–)

The following four signed woodcuts on paper are
a museum purchase, 1964, 1967

End of Procession
(6/8), 5 x 19" (12.70 x 48.26 cm.)
964-P-115

Parkside
(13/15), 10 x 11.5" (25.40 x 29.21 cm.)
964-P-116

Winter Silence
7 x 28" (17.78 x 71.12 cm.)
964-P-114

Winterscape
(artist's proof), 8.5 x 11" (21.59 x 27.94 cm.)
967-P-188

Don EDDY, (1944–)

(Untitled)
Lithograph on paper, 33 x 26" (83.82 x 66.04 cm.)
Signed, Don Eddy, lower right
Gift of Ana and Eric Baer, 1991
991-P-197

A. Clive EDWARDS, (active 20th century)

Clipper Ship *Flying Cloud*, ca. 1923
Watercolor and chines white on paper, 21.25 x 28.75" (53.98 x
73.03 cm.)
Signed, A. Clive Edwards, lower left
Gift of Joseph G. Butler, III, 1980
980-W-106

Benjamin EGGLESTON, (1867–1937)

Morning, 1916
Oil on board, 9.75 x 7.75" (24.77 x 19.69 cm.)
Signed, Eggleston, 16, lower right
Gift of Mrs. John F. Tyler, 1995
995-O-109

John W. EHNINGER, (1827–1889)

The Promising Colt
Wood engraving on paper, 9 x 13.75" (22.86 x 34.93 cm.)
Unsigned
Anonymous gift, 1963
963-P-106

Emma EHRENREICH, (1906–)

Milliner's Boutique
Oil on canvas, 22 x 30" (55.88 x 76.20 cm.)
Signed, Ehrenreich, lower right
Gift of Emma Ehrenreich, 1977
977-O-112

Forms Thru Space
Oil, ink, and casein on paper, 39 x 28" (99.06 x 71.12 cm.)
Signed, Ehrenreich, lower right
Gift of Emma Ehrenreich, 1977
977-W-104

Jacob EICHHOLTZ, (1776–1842)

Eliza Cook, ca. 1816
Oil on canvas, 29.25 x 24" (74.30 x 60.96 cm.)
Unsigned
Gift of Mrs. William L. Litle, 1979
979-O-104

Louis Michel EILSHEMIUS, (1864–1941)

Landscape with Nudes, 1918
Oil on canvas, 17.5 x 29.5" (44.45 x 74.93 cm.)
Signed, Eilshemius, lower right
Gift of Emil J. Arnold, 1958
958-O-153

Landscape
Oil on canvas, 10 x 8" (25.40 x 20.32 cm.)
Signed, Eilshemius, lower left
Gift of Samuel N. Tonkin and Sidney Freeman, 1955
955-O-112

Two Bathers, 1915
Oil on canvas, 17 x 27" (43.18 x 68.58 cm.)
Signed, Eilshemius, lower right
Gift of Joseph H. Hirshhorn, 1948
948-O-113

In the Catskills
Watercolor on paper, 20 x 12" (50.80 x 30.48 cm.)
Signed, Eilshemius, lower right
Gift of Joseph H. Hirshhorn, 1948
948-W-103

Margot EISEMAN, (active 20th century)

(Untitled)
Portfolio of 53: Rip Off on the Last Millennium
Print on paper, 8.5 x 11" (21.59 x 27.94 cm.)
Signed, Margot Eiseman, lower center
Gift of the William Busta Gallery, 1990
990-P-111.26

Evelyn EISGRAU, (active 20th century)

After Image #7
Oil on canvas, 40 x 30" (101.60 x 76.20 cm.)
Signed, Eisgrau, lower right
Gift of Sharon Bretton, 1978
978-O-110

Earl - The Striker Sisters (page 54)

Seth Eastman - Hudson River with a Distant View of West Point
(page 54)

Eddy - (Untitled)

Ehninger - The Promising Colt

Eichholtz - Eliza Cook

Eilshemius - Landscape with Nudes (page 55)

Enneking - Hillside and Pond

Enneking - Speckle Mountain

Erbe - Lipsync

Erbe - Lowy

Ernst - Abstraction

Ben EISNER, (active 20th century)

Sleeping Sailor, 1943
Drawing on paper, 13 x 10" (33.02 x 25.40 cm.)
Signed, Ben Eisner, 1943, lower right
Gift of Louis Held, 1965
965-D-125

Woman's Head, 1947
Pencil on paper, 12 x 8.5" (30.48 x 21.59 cm.)
Signed, Ben Eisner, 1947, lower left
Gift of Louis Held, 1965
965-D-124

Stuart ELDREDGE, (1902–1992)

Winter on Rockingham Road, 1953
Watercolor on paper, 18 x 23" (45.72 x 58.42 cm.)
Signed, S. Eldredge, lower right
Gift of Joseph G. Butler, III, 1954
954-W-109

Dean ELLIS, (1921–)

Intimate Conversation
Oil on canvas, 30 x 36" (76.20 x 91.44 cm.)
Unsigned
Museum purchase, 1949
949-O-104

Emily Schorr ELMAN, (active 20th century)

A Bouquet, 1957
Woodcut on paper, 13 x 13" (33.02 x 33.02 cm.)
Signed, Emily Schorr Elman, '57, lower right
Anonymous gift, 1961
961-P-107

Heidi ELSAESSER, (1939–1965)

(Untitled), 1960
Watercolor on paper, 27 x 38" (68.58 x 96.52 cm.)
Unsigned
Museum purchase, 1960
960-W-111

Akiba EMANUEL, (1925–)

Samson and Delilah
Ink on paper, 8.5 x 11" (21.59 x 27.94 cm.)
Unsigned
Gift of Henry Salpeter, 1957
957-D-104

Frank ENGLE, (active 20th century)

Spell on the Moon
Watercolor on paper, 19 x 28" (48.26 x 71.12 cm.)
Unsigned
Museum purchase, 1956
956-W-102

John Joseph ENNEKING, (1841–1916)

Hillside and Pond
Oil on canvas, 25 x 30" (63.50 x 76.20 cm.)
Unsigned
Gift of Dr. and Mrs. Albert B. Cinelli, 1991
991-O-111

Speckle Mountain, 1901
Oil on canvas, 24 x 29" (60.96 x 73.66 cm.)
Signed, Enneking, lower right
Museum purchase, 1929
929-O-102

George Pearce ENNIS, (1884–1936)

Tapping Furnace into Ladles
Oil on canvas, 34 x 40" (86.36 x 101.60 cm.)
Signed, Ennis, lower right
Museum purchase, 1953
953-O-105

Gary T. ERBE, (1944–)

Lipsync, 1983
Oil on canvas, 30 x 37" (76.20 x 93.98 cm.)
Signed, G. T. Erbe, lower right
Museum purchase and gift of Gary T. Erbe, 1985
985-O-105

The following seven signed works on paper are the gift of Gary T. Erbe, 1990, 1991, 1992

Fantasy in Pursuit
15.37 x 19" (39.05 x 48.26 cm.)
991-P-104

Joy Ride
13 x 11" (33.02 x 27.94 cm.)
990-P-108

Lowy
(1/15, artist's proof), 4.25 x 6.25" (10.80 x 15.88 cm.)
992-P-104

Lust
7.37 x 9.5" (18.73 x 24.13 cm.)
990-P-110

Mae West
(15/30), 10.87 x 7.87" (27.62 x 20.00 cm.)
990-P-109

Self Portrait
10.75 x 7.75" (27.31 x 19.69 cm.)
990-P-107

The Stalker
(14/22), 4 x 5.87" (10.16 x 14.92 cm.)
991-P-103

Jimmy ERNST, (1920–1984)

Abstraction, 1945
Oil on canvas, 12 x 15" (30.48 x 38.10 cm.)
Signed, Jimmy Ernst, 45, lower right
Gift of Richard and Geraldine Love, 1989
989-O-101

Black Isolation
Gouache on paper, 13 x 10" (33.02 x 25.40 cm.)
Signed, Jimmy Ernst, lower right
Gift of Louis Held, 1965
965-D-107

(Untitled), 1970
Silkscreen on paper, 40 x 30" (101.60 x 76.20 cm.)
Signed, Jimmy Ernst, 70, XIII/25, lower right
Gift of Arthur Feldman, 1991
991-P-178

Dominic ESPOSITO, (active 20th century)

Impression of the Artist
Oil on canvas, 20 x 17" (50.80 x 43.18 cm.)
Signed, Esposito, lower left
Gift of Dominic Esposito for the Louis Held Collection, 1977
977-O-113

George E. ESSIG, (1883–ca. 1970)

Beach Scene, (obverse)
A Grey Morning – Beach at Cape May,
(reverse)
Watercolor on paper, 13.5 x 27.87" (34.29 x 70.80 cm.)
Signed, Geo. E. Essig, lower right
Gift of Joseph G. Butler, III, 1968
968-W-137

Richard ESTES, (1932–)

Urban Landscape II/New York Pressing
Machinery, 1979
Silkscreen on paper, (87/100), 27.5 x 19.62" (69.85 x 49.85 cm.)
Signed, Richard Estes, lower right
Museum purchase, 1983
983-P-142

Anthony W. ETEROVICH, (1916–)

The Merry Bench
Oil on canvas, 30 x 44" (76.20 x 111.76 cm.)
Signed, A. W. Eterovich, lower left
Museum purchase, 1950
950-O-104

Stephen Morgan ETNIER, (1903–)

Accra Beach, 1953
Oil on canvas, 20 x 43" (50.80 x 109.22 cm.)
Signed, Etnier, lower left
Museum purchase, 1953
953-O-106

Howard Lee ETTER, (1931–)

Rock Island Line, 1973
Acrylic on panel, 24 x 30" (60.96 x 76.20 cm.)
Signed, Howard Etter, lower left
Gift of the Friends of American Art, 1975
975-O-123

Len G. EVERETT, (? –ca. 1994)

The Blue Coffee Pot
Oil on canvas, 20.25 x 24.25" (51.44 x 61.60 cm.)
Signed, Everett, lower left
Gift of Bernard E. Willie, 1978
978-O-115

Russell EVERETT, (1952–)

A Sign of the Times
Acrylic on canvas, 38 x 50" (96.52 x 127.00 cm.)
Signed, Everett, lower right
Museum purchase, 1976
976-O-133

Walker EVERETT, (1904–1968)

Columbus Circle in 1910, 1959
Oil on board, 18.75 x 24" (47.63 x 60.96 cm.)
Unsigned
Gift of Robert H. Luck, 1970
970-O-106

Philip EVERGOOD, (1901–1973)

Mother and Child, 1950
Oil on canvas, 20 x 16" (50.80 x 40.64 cm.)
Signed, Philip Evergood, 50, lower right
Museum purchase, 1950
950-O-105

Taming of the Tiger
Oil on canvas, 30 x 40" (76.20 x 101.60 cm.)
Signed, Philip Evergood, left center
Museum purchase, 1972
972-O-114

Cripple, 1950
Drawing on paper, 9.5 x 8.5" (24.13 x 21.59 cm.)
Signed, Philip Evergood, lower left
Gift of Louis Held, 1965
965-D-126

Nude Drawing, 1930
Drawing on paper, 10 x 9" (25.40 x 22.86 cm.)
Signed, Philip Evergood, lower right
Gift of Carl L. Dennison, 1953
953-D-101

City Lights
Lithograph on paper, 8.5 x 12" (21.59 x 30.48 cm.)
Signed, Philip Evergood, lower right
Gift of Louis Held, 1967
967-P-120

Still Life
Lithograph on paper, 11.5 x 16" (29.21 x 40.64 cm.)
Signed, Philip Evergood, lower right
Gift of Carl L. Dennison, 1953
953-P-105

Robert FABE, (1917–)

Winter Twilight, 1942
Watercolor on paper, 14 x 23" (35.56 x 58.42 cm.)
Signed, Robert Fabe, lower left
Museum purchase, 1943
943-W-102

Jacques FABERT, (1925–)

To Us Differently, 1968
Oil on canvas, 48 x 48" (121.92 x 121.92 cm.)
Signed, Jacques Fabert, lower right
Museum purchase, 1968
968-O-183

Ralph FABRI, (1894–1975)

Balconies of Taormina
Watercolor on paper, 18 x 31" (45.72 x 78.74 cm.)
Signed, Ralph Fabri, lower right
Museum purchase, 1968
968-W-131

George FADDIS, (1920–1985)

Discovery, 1955
Oil on canvas, 16 x 28" (40.64 x 71.12 cm.)
Unsigned
Museum purchase, 1955
955-O-113

Tattooed Dancers, 1956
Watercolor on paper, 15 x 25" (38.10 x 63.50 cm.)
Signed, Faddis, 56, lower right
Museum purchase, 1956
956-W-103

TV Antennas, 1961
Pencil and wash on paper, 6 x 9" (15.24 x 22.86 cm.)
Signed, Faddis, lower left
Gift of Albert E. Hise, 1979
979-D-108

Estes - Urban Landscape II/New York Pressing Machinery

Evergood - Mother and Child

Evergood - Taming of the Tiger

Fabri - Balconies of Taormina

Faddis - Tattooed Dancers

Fahlstrom - Eddy (Sylvie's Brother) in the Desert

Feininger - Hulks

Ferrer - El Sol Asombra

Ferrer - Oriente Tropical

Fiene - Colorado Hills

Oyvind FAHLSTROM, (1928–1976)

Eddy (Sylvie's Brother) in the Desert
New York International: Portfolio of Ten Prints, (210/225)
Serigraph on paper, 22 x 17" (55.88 x 43.18 cm.)
Signed, Oyvind Fahlstrom, lower right
Museum purchase, 1966
966-P-137.5

(Untitled), 1973
Serigraph on paper, 12 x 9" (30.48 x 22.86 cm.)
Signed, Oyvind Fahlstrom, lower right
Gift of Steven Feinstein, 1983
983-P-150

Noel FARESE, (active 20th century)

Karroo
Collagraph and etching on paper, 15.5 x 19.75" (39.37 x 50.17 cm.)
Signed, Noel Farese, lower right
Gift of Louis Held, 1978
978-P-106

Marilyn FARINACCI, (active late 20th century)

(Untitled)
Portfolio of 53: Rip Off on the Last Millennium
Print on paper, 8.5 x 11" (21.59 x 27.94 cm.)
Signed, M. Farinacci, lower right
Gift of the William Busta Gallery, 1990
990-P-111.36

Remo Michael FARRUGGIO, (1906–)

On the Way to Oaxaca, 1952
Oil on canvas, 32 x 40" (81.28 x 101.60 cm.)
Signed, Remo Farruggio, 52, lower right
Gift of Samuel N. Tonkin and Sydney Freedman, 1955
955-O-114

California Beach
Watercolor on paper, 20 x 30" (50.80 x 76.20 cm.)
Signed, R. Farruggio, lower right
Museum purchase, 1956
956-W-104

The White Doorway
Watercolor on paper, 20 x 26.5" (50.80 x 67.31 cm.)
Signed, Remo Farruggio, lower right
Gift of Sylvia Carewe, 1961
961-W-102

Standing Nude
Chalk on paper, 17.5 x 11.5" (44.45 x 29.21 cm.)
Signed, Remo M. Farruggio, lower left center
Gift of Mr. and Mrs. Robert Miller, 1959
959-D-104

Howard FECH, (active 20th century)

American Watchdogs
Etching on paper, 6 x 9" (15.24 x 22.86 cm.)
Signed, Howard Fech, lower right
Museum purchase, 1979
979-P-150

Marion FEDERE, (1938–)

Moon, 1968–69
Oil on canvas, 50 x 34" (127.00 x 86.36 cm.)
Signed, Federe, lower right
Gift of Marion Federe, 1972
972-O-110

Lionel FEININGER, (1871–1956)

Hulks
Drawing on paper, 9 x 14" (22.86 x 35.56 cm.)
Signed, Feininger, lower left
Museum purchase, 1953
953-D-102

Herbert E. FEIST, (active 20th century)

Still Life, 1963
Gouache on panel, 22 x 16" (55.88 x 40.64 cm.)
Signed, Feist, lower right
Gift of Louis Held, 1977
977-W-103

Carolyn S. FELDMAN, (1913–)

David and Bathsheba
Oil on canvas, 30 x 40" (76.20 x 101.60 cm.)
Signed, C. S. Feldman, lower left
Gift of H. M. Levy, 1967
967-O-154

John Nathaniel FENTON, (1912–1977)

Hassidic Dance II
Etching on paper, 8.75 x 11.87" (22.23 x 30.16 cm.)
Signed, John Fenton, lower right
Museum purchase, 1970
970-P-119

Rafael FERRER, (1933–)

El Sol Asombra, 1989
Oil on canvas, 60 x 72" (152.40 x 182.88 cm.)
Signed, Ferrer, lower left
Museum purchase, 1990
990-O-106

Oriente Tropical
Woodblock on paper, (36/36), 24 x 12" (60.96 x 30.48 cm.)
Signed, R. Ferrer, lower right
Museum purchase, 1992
992-P-124

Ernest FIENE, (1894–1965)

Colorado Hills, 1935
Watercolor on paper, 15 x 22" (38.10 x 55.88 cm.)
Signed, E. Fiene, 35, lower left
Museum purchase, 1963
963-W-112

Girl Asleep
Line etching on paper, 6 x 7" (15.24 x 17.78 cm.)
Signed, Ernest Fiene, lower right
Gift of Edith Halpert, 1948
948-P-103

St. Michael's in Brooklyn
Lithograph on paper, 13 x 16" (33.02 x 40.64 cm.)
Signed, Ernest Fiene, lower right
Museum purchase, 1973
973-P-103

The following three lithographs on paper of various sizes are the gift of Edith Halpert, 1948

Brooklyn Bridge, 1940
948-P-104

Notre Dame, 1929
948-P-102

Seated Nude, 1930
948-P-101

Michael R. FILMUS, (1943–)

Tyringham Valley
Watercolor on paper, 32 x 40" (81.28 x 101.60 cm.)
Signed, Michael Filmus, lower left
Museum purchase, 1976
976-W-102

Herbert L. FINK, (1921–)

Midsummer, 1966
Etching on paper, (36/250), 9 x 11" (22.86 x 27.94 cm.)
Signed, Herbert L. Fink, lower right
Museum purchase, 1966
966-P-133

Sheldon FINK, (1925–)

Antique Dealer, 1966
Lithograph on paper, (24/250), 9 x 12" (22.86 x 30.48 cm.)
Signed, Sheldon Fink, lower right
Museum purchase, 1966
966-P-131

Richard FISCUS, (active late 20th century)

Route #1, 1969
Silkscreen on paper, (42/98), 20 x 24" (50.80 x 60.96 cm.)
Signed, Fiscus, lower right
Gift of Reese and Marilyn Arnold Palley, 1991
991-P-163

Alvan FISHER, (1792–1863)

View Near Springfield, Mass., 1819
Oil on canvas, 32 x 44" (81.28 x 111.76 cm.)
Signed, A. Fisher, BINXIT, lower left
Museum purchase, 1979
979-O-116

Hugo Melville FISHER, (1876– ?)

Spring
Oil on board, 18 x 23" (45.72 x 58.42 cm.)
Signed, H. Melville Fisher, lower left
Anonymous gift, 1982
982-O-107

Joel A. FISHER, (1947–)

Late August
Casein on canvas, 24 x 28.5" (60.96 x 72.39 cm.)
Unsigned
Museum purchase, 1962
962-O-122

Friday
Mixed media on masonite, 19 x 46" (48.26 x 116.84 cm.)
Unsigned
Gift of Dr. John J. McDonough, 1965
965-O-160

Leonard Everett FISHER, (1924–)

An American Lament, 1964
Oil on canvas, 39.25 x 59.5" (99.70 x 151.13 cm.)
Signed, Leonard Everett Fisher, lower right
Gift of Capricorn Galleries, 1972
972-O-115

William Crothers FITLER, (1857–1911)

October Meadows
Oil on canvas, 8 x 10" (20.32 x 25.40 cm.)
Signed, W. Fitler, lower right
Gift of Charles Crandall, 1982
982-O-108

Louise FITZPATRICK, (1869–1928)

Evening
Oil on canvas, 14 x 16" (35.56 x 40.64 cm.)
Unsigned
Gift of Philip Evergood, 1948
948-O-111

Audrey FLACK, (1931–)

Davey Moore, 1993
Oil on canvas, 36.25 x 30.25" (92.08 x 76.84 cm.)
Signed, Audrey Flack, lower right
Gift of Mr. and Mrs. David M. Draime and Mr. and Mrs. David
Heimann, 1993
993-O-103

James Montgomery FLAGG, (1877–1960)

Gyle Mellott
Charcoal on paper, 14 x 11" (35.56 x 27.94 cm.)
Signed, James Montgomery Flagg, lower left
Museum purchase, 1971
971-D-112

Larry FLINT, (active 20th century)

White Mule in Landscape, 1939
Oil on masonite, 18 x 23" (45.72 x 58.42 cm.)
Signed, Larry Flint, lower left
Gift of John J. Benninger, 1977
977-O-162

Leroy FLINT, (1909–1991)

Sleepers
Etching on paper, 5.75 x 4.5" (14.61 x 11.43 cm.)
Signed, Leroy Flint, lower right
Gift of Albert E. Hise, 1979
979-P-130

Joseph FLOCH, (1895–1977)

Stairway, 1965
Lithograph on paper, 13 x 9.75" (33.02 x 24.77 cm.)
Signed, J. Floch, lower right
Museum purchase, 1965
965-P-318

Richard FLORSHEIM, (1916–1979)

Hulk
Lithograph on paper, (3/250), 14 x 10" (35.56 x 25.40 cm.)
Signed, R. Florsheim, lower right
Museum purchase, 1967
967-P-148

Shore Line, 1964
Lithograph on paper, 10 x 14" (25.40 x 35.56 cm.)
Signed, R. Florsheim, lower right
Museum purchase, 1964
964-P-125

Arthur L. FLORY, (1914–1972)

Dune Pattern
Woodblock on paper, 16 x 12" (40.64 x 30.48 cm.)
Signed, Arthur Flory, lower right
Museum purchase, 1953
953-P-106

Alvan Fisher - View Near Springfield, Mass.

Joel A. Fisher - Late August

Flack - Davey Moore

Flagg - Gyle Mellott

Florsheim - Hulk

Ford - Eden

Fortess - Fragment

Foster - From Hill to Hill

Francis - Still Life with Fruit

John FORD, (1950–)

Eden, 1991
Oil on canvas, 32 x 44" (81.28 x 111.76 cm.)
Signed, John Ford, on reverse
Gift of Erle L. Flad, 1992
992-O-105

Rob FOREMAN, (active 20th century)

Bass Bugging at Sunset, 1984
Oil on canvas, 22 x 28" (55.88 x 71.12 cm.)
Signed, Rob, lower right
Gift of Rob Foreman, 1985
985-O-104

Karl E. FORTESS, (1907–)

Fragment
Oil on canvas, 46 x 36" (116.84 x 91.44 cm.)
Signed, K. Fortess, lower left
Gift of Mr. and Mrs. Sam Golden, 1969
969-O-158

The following twelve signed oils on canvas of various sizes are the gift of Mrs. William V. Miller, 1957, 1959, 1960, 1961, 1963

Boat Landing
960-O-119

Construction with Portraits
961-O-147

Double Five
961-O-148

Green Landscape
957-O-110

Landscape
963-O-102

Landscape with Dead Tree
959-O-120

Man Made Forms in Landscape
957-O-133

Masks
961-O-149

Now, 1959
961-O-146

Romantic Landscape
957-O-134

Still Life
963-O-101

Still Life with Painting
963-O-130

Monument
Lithograph on paper, 14.25 x 8.25" (36.20 x 20.96 cm.)
Signed, K. Fortess, lower right
Gift of Louis Held, 1965
965-P-169

Tanks and Trees
Lithograph on paper, 14 x 10" (35.56 x 25.40 cm.)
Signed, K. Fortess, lower right
Museum purchase, 1953
953-P-107

Joseph FOSHKO, (1891– ?)

Harbor
Oil on canvas, 17 x 20" (43.18 x 50.80 cm.)
Signed, J. Foshko, lower right
Gift of Joseph H. Hirshhorn, 1948
948-O-112

Ben FOSTER, (1852–1926)

From Hill to Hill, 1916
Oil on canvas, 34.5 x 29" (87.63 x 73.66 cm.)
Signed, Ben Foster, lower left
Museum purchase, 1917
917-O-101

The Meadow Brook
Oil on canvas, 36 x 30" (91.44 x 76.20 cm.)
Signed, Ben Foster, lower left
Gift of William H. Hitchcock in memory of Grace J. Hitchcock, 1956
956-O-105

Hans FOY, (active 20th century)

Nude
Pencil on paper, 11 x 8.5" (27.94 x 21.59 cm.)
Signed, Hans Foy, lower right
Gift of Jack Hockett, 1977
977-D-109

John F. FRANCIS, (1808–1886)

Still Life with Fruit
Oil on canvas, 23.25 x 30" (59.06 x 76.20 cm.)
Signed, Francis, lower left
Gift of family and friends in memory of Grace Heath Butler, 1973
973-O-115

Christopher FRANKE, (active late 20th century)

(Untitled)
Portfolio of 53: Rip Off on the Last Millennium
Print on paper, 8.5 x 11" (19.00 x 27.94 cm.)
Signed, Christopher Franke, lower left
Gift of the William Busta Gallery, 1990
990-P-111.20

Max FRANKEL, (1909–1962)

Landscape, 1959
Watercolor on paper, 17.5 x 23.5" (44.45 x 59.69 cm.)
Signed, Frankel, 59, lower left
Gift of Harry Salpeter, 1963
963-W-113

Helen FRANKENTHALER, (1928–)

Viewpoint II, 1979
Acrylic on canvas, 81.25 x 94.5" (206.38 x 240.03 cm.)
Signed, Frankenthaler, lower right
Gift of Paul and Suzanne Donnelly Jenkins, 1989
989-O-108

Michael FRARY, (1918–)

Oil Construction on the Beach
Oil on canvas, 36 x 48" (91.44 x 121.92 cm.)
Unsigned
Museum purchase, 1955
955-O-115

Coast Town
Watercolor on paper, 21 x 29" (53.34 x 73.66 cm.)
Signed, Frary, lower right
Museum purchase, 1959
959-W-108

Antonio FRASCONI, (1919–)

The following two woodcuts on paper are a
museum purchase, 1966, 1967

Flowers, 1966
13 x 12" (33.02 x 30.48 cm.)
966-P-121

The Bird, 1966
18 x 18" (45.72 x 45.72 cm.)
967-P-155

The following three woodcuts on paper are the
gift of Louis Held, 1965

Albert Einstein (Princeton Print Club), 1951
12 x 9.5" (30.48 x 24.13 cm.)
965-P-138

Sunflower, 1951
(9/10), 15 x 22" (38.10 x 55.88 cm.)
965-P-187

Woman Picking Grapes, 1951
15.5 x 8.5" (39.37 x 21.59 cm.)
965-P-143

Frank FRATE, (active 20th century)

(Untitled)
Portfolio of 53: Rip Off on the Last Millennium
Print on paper, 8.5 x 11" (21.59 x 27.94 cm.)
Signed, Frank Frate, lower left
Gift of the William Busta Gallery, 1990
990-P-111.37

Elias FREDENSOHN, (1924–)

Head
Oil on masonite, 12 x 16" (30.48 x 40.64 cm.)
Signed, Elias, lower right
Gift of Leonard Bocour, 1975
975-O-105

David FREDENTHAL, (1914–1959)

Man Reading
Watercolor on paper, 15 x 17" (38.10 x 43.18 cm.)
Signed, David Fredenthal, lower right
Gift of Robert Tannahill, 1947
947-W-103

Ernest FREED, (1908–)

Last Judgement, 1964
Etching on paper, (3/50), 35.5 x 27.5" (90.17 x 69.85 cm.)
Signed, Ernest Freed, 64, lower right
Museum purchase, 1965
965-P-255

Maurice FREEDMAN, (1904– ca. 1985)

Birds of the Night
Oil on canvas, 30 x 40" (76.20 x 101.60 cm.)
Unsigned
Museum purchase, 1964
964-O-117

Mark FREEMAN, (1908–)

Reflections, 1962
Oil on board, 15.75 x 48" (40.01 x 121.92 cm.)
Signed, Mark Freeman, lower right
Gift of Stephen Freeman, 1977
977-O-114

White Light
Relief print on paper, (6/25), 17 x 20" (43.18 x 50.80 cm.)
Signed, Mark Freeman, lower right
Museum purchase, 1968
968-P-311

Linae FREI, (active 20th century)

Middle Earth
Oil on canvas, 36 x 48" (91.44 x 121.92 cm.)
Signed, Frei, lower right
Gift of Linae Frei, 1978
978-O-109

Robert FREIMARK, (1922–)

The War Mongers, 1955
Color woodcut on paper, 11 x 18" (27.94 x 45.72 cm.)
Signed, R. Freimark, 55, lower right
Museum purchase, 1957
957-P-104

Theodore FRIED, (1902–)

Boy with Musical Top
Oil on canvas, 30 x 24" (76.20 x 60.96 cm.)
Signed, T. Fried, lower right
Gift of Mr. and Mrs. Mortimer Kramerman, 1955
955-O-116

Miss Emily Francis, 1948
Oil on masonite, 27 x 31" (68.58 x 78.74 cm.)
Signed, T. Fried, lower right
Gift of Theodore Fried, 1977
977-O-115

Four Hands, 1971
Etching on paper, 8 x 5.5" (20.32 x 13.97 cm.)
Signed, T. Fried, lower right
Gift of Theodore Fried, 1978
978-P-118

Arnold FRIEDMAN, (1879–1946)

Blue River
Oil on canvas, 24 x 30" (60.96 x 76.20 cm.)
Unsigned
Gift of Mr. and Mrs. William V. Miller, 1958
958-O-107

Hayes FRIEDMAN, (active 20th century)

The Family
Oil on canvas, 66 x 66" (167.64 x 167.64 cm.)
Signed, H. F., left center
Gift of Jane Haslem Gallery, 1981
981-O-112

Martin FRIEDMAN, (1896–1980)

The Dancer
Ink on paper, 14 x 12" (35.56 x 30.48 cm.)
Unsigned
Museum purchase, 1959
959-D-119

Frankenthaler - Viewpoint II (page 60)

Frasconi - Flowers

Hayes Friedman - The Family

Martin Friedman - The Dancer

Frieseke - Good Morning

Fujita - Countryside Sketch

George Fuller - Gold and Old Lace

Gaertner - The Houses

Gamble - Ty Cobb; Navine Field

Frederick Carl FRIESEKE, (1874–1939)

Good Morning, ca. 1912 or 1913
Oil on canvas, 32 x 26" (81.28 x 66.04 cm.)
Signed, F. C. Frieseke, lower left
Museum purchase, 1959
959-O-126

Study of a Girl
Drawing on paper, 21 x 16.5" (53.34 x 41.91 cm.)
Signed, F. C. Frieseke, lower left
Museum purchase, 1968
968-D-121

Ann FROMAN, (1942–)

From Heaven to Earth, 1978
Conte crayon on paper, 24 x 19" (60.96 x 48.26 cm.)
Signed, Ann Froman, lower right
Gift of Martin P. Soloman, 1978
978-D-106

Stuart H. FROST, (1925–)

Symmetrical Still Life
Oil on canvas, 19 x 25" (48.26 x 63.50 cm.)
Unsigned
Gift of the Friends of American Art, 1960
960-O-112

Tsuguji FUJITA, (1888–1968)

The following two signed drawings, oil on paper,
11 x 9.25" (27.94 x 23.50 cm.), are the gift of
Amanda H. Hwang, 1995

Countryside Sketch
995-D-101

Sketch of a Short Hair Lady
995-D-102

George FULLER, (1822–1884)

Gold and Old Lace, 1867
Oil on canvas, 26 x 21" (66.04 x 53.34 cm.)
Signed, G. Fuller, lower left
Museum purchase, 1920
920-O-106

Sue FULLER, (1914–)

Modern Art Vassar College, 1965
Silkscreen on paper, (poster), 29" dia. (73.66 cm.)
Signed, Sue Fuller, lower left
Anonymous gift, 1980
980-P-150

Edwin L. FULWIDER, (1913–)

Trestles of Ophir
Color lithograph on paper, 15 x 8" (38.10 x 20.32 cm.)
Signed, Edwin Fulwider, lower right
Museum purchase, 1955
955-P-104

The Trestles of Ophir
Lithograph on paper, 18 x 13" (45.72 x 33.02 cm.)
Signed, Edwin L. Fulwider, lower right
Gift of Albert E. Hise, 1979
979-P-139

Carl GAERTNER, (1898–1953)

Bend at Newton Hook, 1952
Watercolor on paper, 18 x 30" (45.72 x 76.20 cm.)
Signed, Carl Gaertner, lower left
Gift of the Friends of American Art, 1952
952-W-101

Brook, 1952
Casein on paper, 11.5 x 17.5" (29.21 x 44.45 cm.)
Signed, Carl Gaertner, 1952, lower right
Gift of Mrs. Edward G. Perkins, 1969
969-W-115

Snow Scene
Watercolor on paper, 4.5 x 7" (11.43 x 17.78 cm.)
Signed, Carl Gaertner, lower right
Gift of Albert E. Hise, 1979
979-W-110

The Houses
Pencil on paper, 14 x 19" (35.56 x 48.26 cm.)
Signed, Carl Gaertner, lower left
Museum purchase, 1966
966-D-103

Roy C. GAMBLE, (1887– ?)

Ty Cobb; Navine Field
Oil on canvas, 8 x 32" (20.32 x 81.28 cm.)
Signed, Gamble, lower center
Museum purchase, 1991
991-O-115

Emil GANSO, (1895–1941)

Landscape
Watercolor on paper, 15 x 22" (38.10 x 55.88 cm.)
Signed, Ganso, lower right
Museum purchase, 1965
965-W-143

Landscape
Pastel on paper, 12 x 18" (30.48 x 45.72 cm.)
Signed, Ganso, lower right
Gift of Louis Held, 1966
966-W-119

Dark Street
Lithograph on paper, 10.5 x 13.25" (26.67 x 33.66 cm.)
Signed, Ganso, lower right
Gift of Louis Held, 1967
967-P-115

Farm and Church
Woodcut on paper, 8 x 10" (20.32 x 25.40 cm.)
Signed, Ganso, lower right
Gift of Louis Held, 1965
965-P-167

Daniel GARBER, (1880–1958)

Landscape
Oil on canvas, 28 x 30" (71.12 x 76.20 cm.)
Signed, Daniel Garber, lower right
Museum purchase, 1980
980-O-109

Gene GARNIER, (1929–)

Sunday Morning
Watercolor on paper, 19 x 24.5" (48.26 x 62.23 cm.)
Signed, G. Garnier, lower left
Museum purchase, 1963
963-W-107

Barbara GARRISON, (1931–)

The Voyage, 1974
Etching on paper, 17.5 x 11.75" (44.45 x 29.85 cm.)
Signed, Barbara Garrison, lower right
Gift of Brian Garrison, 1978
978-P-105

Walter Raymond GARVER, (1927–)

Spring on Peach Street, 1959
Oil on canvas, 29 x 39" (73.66 x 99.06 cm.)
Signed, W. Garver, 1959, lower left
Gift of Dr. John J. McDonough, 1963
963-O-118

Symbols, 1953
Oil on canvas, 28 x 22" (71.12 x 55.88 cm.)
Signed, Garver, lower left
Gift of the Friends of American Art, 1955
955-O-117

Jan GARY, (1925–)

Bobby's Day
Watercolor on paper, 22 x 30" (55.88 x 76.20 cm.)
Signed, Jan Gary, lower right
Museum purchase, 1966
966-W-109

Winter Willow, 1965
Woodblock on paper, (21/25), 11.5 x 16" (29.21 x 40.64 cm.)
Signed, Jan Gary, 1965, lower right
Museum purchase, 1967
967-P-191

Lee E. GASKINS, (1910–)

Salt Air
Watercolor on paper, 20 x 29" (50.80 x 73.66 cm.)
Signed, L. E. Gaskins, lower left
Museum purchase, 1966
966-W-105

Oronzo GASPARO, (1903–1969)

The following two signed oils on canvas are a gift of the estate of Oronzo Gasparo, 1974

Seated Figure with Still Life, 1943
59.5 x 44" (151.13 x 111.76 cm.)
974-O-105

Solitudine, 1944
60 x 45" (152.40 x 114.30 cm.)
974-O-106

The following groups of works are a gift of the estate of Oronzo Gasparo, 1974

Thirty-nine watercolors on paper, sixteen pastels on paper, sixty-four drawings, pen and ink on paper, fifty-two drawings, pencil on paper, seven drawings, charcoal on paper, 974-W-101

Nineteen lithographs on paper, 974-P-103

Fred GASSER, (active 20th century)

Woman on Couch
Oil on mat board, 13 x 16" (33.02 x 40.64 cm.)
Unsigned
Museum purchase, 1958
959-O-107

Henry Martin GASSER, (1909–1981)

Intersection
Watercolor on paper, 22 x 30" (55.88 x 76.20 cm.)
Signed, H. Gasser, lower right
Museum purchase, 1954
954-W-110

Mordi GASSNER, (1899–)

Elk: The Majesty of Nature
Lithograph on paper, 15.25 x 11.25" (38.74 x 28.58 cm.)
Signed, Mordi Gassner, lower right
Gift of Albert E. Hise, 1979
979-P-138

Lee GATCH, (1902–1968)

Vigil Lighters
Oil on canvas, 24 x 21" (60.96 x 53.34 cm.)
Signed, Gatch, lower right
Gift of Mr. and Mrs. Milton Lowenthal, 1955
955-O-118

Marion Thompson GATRELL, (1909–1984)

Cat in the Grass
Watercolor on paper, 21 x 33" (53.34 x 83.82 cm.)
Unsigned
Museum purchase, 1957
957-W-103

The following two signed lithographs on paper are the gift of Albert E. Hise, 1979

Paper Boy
20 x 15.5" (50.80 x 39.37 cm.)
979-P-137

Two Cats
12 x 18" (30.48 x 45.72)
979-P-136

Robert M. GATRELL, (1906–1982)

Magic Dreamer
Serigraph on paper, 11 x 17" (27.94 x 43.18 cm.)
Signed, R. M. Gatrell, lower right
Museum purchase, 1956
956-P-103

John Claude GAUGY, (active 20th century)

Le Masque d'Artan
Hand colored etching on paper, 12 x 10" (30.48 x 25.40 cm.)
Signed, John Claude Gaugy, lower left
Gift of Mr. and Mrs. Jonathan A. Levy, 1992
992-P-128

E. K. GAYNER, (active 20th century)

Water Maidens
Etching on paper, 12.5 x 26.5" (31.75 x 67.31 cm.)
Signed, E. K. Gayner, lower center
Gift of Louis Held, 1978
978-P-110

Coral GAYNES, (active 20th century)

Barrigona Palm
Encaustique on canvas, 12.5 x 16.5" (31.75 x 41.91 cm.)
Signed, Coral Gaynes, lower left
Gift of Penny Powers Stevens, 1978
978-O-114

Ganso - Landscape, 965-W-143 (page 62)

Garber - Landscape (page 62)

Fred Gasser - Woman on Couch

Henry Martin Gasser - Intersection

Getz - Monhegan Moment

Charles Dana Gibson - Lynn Fontanne

Charles Dana Gibson - Study of a Head

Robert Swain Gifford - Cliff Scene, Grand Manan (page 65)

Sanford R. Gifford - Study of a Coming Storm on Lake George
(page 65)

Madeleine Wormser GEKIERE, (1920–)

Head of a Girl
Oil on canvas, 30 x 26" (76.20 x 66.04 cm.)
Unsigned
Gift of Robert Gwathmey, 1948
948-O-124

Lily GELTMAN, (1903–)

South of France
Watercolor on paper, 15 x 22" (38.10 x 55.88 cm.)
Signed, L. Geltman, lower right
Gift of Mr. and Mrs. Harry Milgrom, 1978
978-W-106

Kathleen GEMBERLING, (1922–)

Winter Retreat, 1968
Oil on canvas, 55 x 50" (139.70 x 127.00 cm.)
Signed, Gemberling, 68, lower right
Gift of the Friends of American Art, 1969
969-O-136

Lillian GENTH, (1896–1953)

Study of Mother
Oil on canvas, 29 x 24" (73.66 x 60.96 cm.)
Signed, L. Genth, lower right
Gift of Edythe Haskell and Mrs. W. H. Bender, 1955
955-O-119

Herbert GENTRY, (1919–)

Hiver en Suede
Oil on canvas, 28.5 x 36" (72.39 x 91.44 cm.)
Signed, Gentry, lower right
Gift of Stanley Bard, 1973
973-O-107

Helen GERARDIA, (1903–1993)

First Frost
Oil on canvas, 57 x 45" (144.78 x 114.30 cm.)
Unsigned
Gift of Samuel Goldberg, 1965
965-O-104

The Mother
Oil on canvas, 30 x 24" (76.20 x 60.96 cm.)
Signed, Helen Gerardia, lower right
Gift of Louis Held, 1977
977-O-116

The following two signed oils on canvas are the
gift of Sylvia Berkowitz, 1956

Night Sail, 1954
28 x 22" (71.12 x 55.88 cm.)
956-O-109

Procession, 1953
30 x 24" (76.20 x 60.96 cm.)
956-O-108

Abstraction, Torso
Lithograph on paper, 14 x 11" (35.56 x 27.94 cm.)
Signed, Helen Gerardia, lower right
Gift of Samuel B. Cohn, 1954
954-P-102

Another Planet, 1964
Lithograph on paper, (6/25), 14 x 18" (35.56 x 45.72 cm.)
Signed, Helen Gerardia, lower right
Museum purchase, 1967
967-P-189

The Butler Institute's collection includes thirty-
six signed lithographs on paper of various sizes
which are an anonymous gift, 1969
969-P-128.1 — 969-P-128.6

Fernando GERASSI, (1899–)

The Sun is Never Alone
Oil on canvas, 30 x 40" (76.20 x 101.60 cm.)
Unsigned
Gift of Sylvia Carewe, 1955
955-O-120

Rosario GERBINO, (1900–1972)

Sunset–East River Drive
Oil on canvas, 11 x 28" (27.94 x 71.12 cm.)
Signed, Gerbino, lower right
Gift of the Rosario Gerbino family, 1973
974-O-101

Don GETZ, (active late 20th century)

Monhegan Moment
Acrylic on canvas, 38 x 60" (96.52 x 152.40 cm.)
Signed, Don Getz, AWS, lower left
Gift of Don Getz, 1993
993-O-102

Joseph M. GEYER, (1911–)

Hit and Run
Oil on canvas, 20 x 26" (50.80 x 66.04 cm.)
Signed, Joseph M. Geyer, lower right
Gift of John J. Benninger, 1977
977-O-166

Margarite GIBBONS, (1906–)

(Untitled)
Oil on canvas, 59.5 x 42" (151.13 x 106.68 cm.)
Signed, Gibbons, lower left
Gift of Stanley Bard, 1973
973-O-109

Benedict S. GIBSON, (1946–)

Dotted Glyph, 1976
Acrylic on canvas, 46 x 64" (116.84 x 162.56 cm.)
Unsigned
Museum purchase, 1977
977-O-147

Charles Dana GIBSON, (1867–1944)

Portrait of Anne Paul Owsley, 1940
Oil on canvas, 40 x 33.25" (101.60 x 84.46 cm.)
Unsigned
Gift of Mrs. Richard P. Owsley, 1977
977-O-104

Lynn Fontanne, 1921
Charcoal on board, 21.75 x 16.87" (55.25 x 42.86 cm.)
Signed, C. D. Gibson, lower center
Museum purchase, 1961
961-D-120

Study of a Head
Ink on paper, 23 x 15.5" (58.42 x 39.37 cm.)
Unsigned
Museum purchase, 1961
961-D-121

Robert Swain GIFFORD, (1840–1905)

Cliff Scene, Grand Manan, 1865
Oil on canvas, 21 x 27" (53.34 x 68.58 cm.)
Signed, R. Swain Gifford, lower right
Museum purchase, 1969
969-O-115

(Untitled), 1879
Etching on paper, 11 x 16" (27.94 x 40.64 cm.)
Signed, R. Swain Gifford, lower right
Museum purchase, 1974
974-P-106

Sanford Robinson GIFFORD, (1823–1880)

Study of a Coming Storm on Lake
George, 1863, (formerly: Storm in the Catskills)
Oil on canvas, 12 x 18" (30.48 x 45.72 cm.)
Signed, S. R. Gifford, lower right
Gift of Mr. and Mrs. Paul Wick, 1963
963-O-126

Ruth GIKOW, (1914–1982)

Demonstrators
Oil on canvas, 36 x 28" (91.44 x 71.12 cm.)
Signed, Gikow, lower right
Museum purchase, 1968
968-O-184

Figure
Oil on canvas, 20 x 16" (50.80 x 40.64 cm.)
Signed, Gikow, upper right
Gift of Mr. and Mrs. Leonard Seliger, 1958
958-O-125

The following three signed lithographs on paper
are a museum purchase, 1970

Girl's Head
11 x 8.5" (27.94 x 21.59 cm.)
970-P-166

Majorette
11 x 9.5" (27.94 x 24.13 cm.)
970-P-164

Three Children and Horse
11 x 8.5" (27.94 x 21.59 cm.)
970-P-165

Robert GILL, (1925–)

Whispers of Immortality
Oil on canvas, 34 x 50" (86.36 x 127.00 cm.)
Signed, Gill, lower left
Anonymous gift, 1972
972-O-108

Peter GILLERAN, (active 20th century)

Blue Still Life
Oil on canvas, 35.5 x 47" (90.17 x 119.38 cm.)
Unsigned
Museum purchase, 1982
982-O-175

Sam GILLIAM, (1933–)

Mars at Angles, 1978
Acrylic on polypropylene, 232 x 186" (589.28 x 472.44 cm.)
Signed, Gilliam, on reverse
Museum purchase, 1989
989-O-106

W. H. GILMORE, (active 20th century)

Old Mill in the Smokies, 1939
Woodcut on paper, 6.75 x 8" (17.15 x 20.32 cm.)
Signed, W. H. G., lower right
Gift of Albert E. Hise, 1979
979-P-129

Ira GLACKENS, (active 20th century)

The Communicant May 1962
Oil on canvas, 16 x 12" (40.64 x 30.48 cm.)
Signed, Ira, on reverse
Gift of the estate of George K. Bishop, 1988
988-O-104

Leena GLACKENS, (1913–1943)

Pioneer Life
Oil on canvas board, 13 x 16" (33.02 x 40.64 cm.)
Unsigned
Gift of the estate of George K. Bishop, 1988
988-O-105

William James GLACKENS, (1870–1938)

Still Life with Three Glasses, ca. mid-
1920s
Oil on canvas, 20 x 29" (50.80 x 73.66 cm.)
Signed, W. Glackens, lower left
Museum purchase, 1957
957-O-111

The following eight oils on canvas are a gift of
the estate of George K. Bishop, 1988

Bandstand
18 x 14" (45.72 x 35.56 cm.)
988-O-110

. . . . Bay Shore
10.75 x 15" (27.31 x 38.10 cm.)
988-O-109

Bridge
8 x 10" (20.32 x 25.40 cm.)
988-O-115

Freesia and Tulips, ca. 1915
15 x 12" (38.10 x 30.48 cm.)
988-O-113

Nude
27.25 x 20" (69.22 x 50.80 cm.)
988-O-112

Rockport, Mass., 1936
11.5 x 15" (29.21 x 38.10 cm.)
988-O-111

Seated Nude, (obverse)
Standing Nude, (reverse)
12 x 10" (30.48 x 25.40 cm.)
988-O-114

Shakespearean Actor
26 x 13.25" (66.04 x 33.66 cm.)
988-O-108

Joseph M. GLASCO, (1925–)

(Untitled), 1979
Acrylic on canvas with collage, 54 x 42" (137.16 x 106.68 cm.)
Signed, J. G., 1979, on reverse
Gift of Paul and Suzanne Donnelly Jenkins, 1991
991-O-221

Gikow - Demonstrators

Gilliam - Mars at Angles

William James Glackens - Still Life with Three Glasses

William James Glackens - Bandstand

William James Glackens - Freesia and Tulips

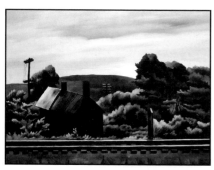

Gleitsmann - House by the Railroad

Grigory Gluckman - At the Court of Henry III

Godfrey - Skater

Goldberg - (Untitled)

Raphael GLEITSMANN, (1905–1995)

House by the Railroad
Oil on canvas, 35.25 x 48.5" (89.54 x 123.19 cm.)
Signed, Raphael Gleitsmann, lower right
Gift of Dr. John J. McDonough, 1972
972-O-123

The following two signed oils on canvas are a museum purchase, 1950, 1954

Merry-go-round
30 x 48" (76.20 x 121.92 cm.)
954-O-117

The Green Wall, 1949
33 x 40" (83.82 x 101.60 cm.)
950-O-107

Caboose on a Siding, 1939
Watercolor on paper, 21 x 25" (53.34 x 63.50 cm.)
Signed, Raphael Gleitsmann, lower right
Museum purchase, 1940
940-W-103

Dome, 1940–1946
Gouache on paper, 28 x 40" (71.12 x 101.60 cm.)
Signed, Raphael Gleitsmann, 1940–1946, lower right
Museum purchase, 1954
954-W-125

The Bridge
Watercolor on paper, 22 x 32" (55.88 x 81.28 cm.)
Signed, Raphael Gleitsmann, lower right
Museum purchase, 1954
954-W-111

Gateway, (France, 1944)
Ink on paper, 8.5 x 11.5" (21.59 x 29.21 cm.)
Signed, Raphael Gleitsmann, lower right
Gift of Joseph G. Butler, III, 1980
980-D-103

David GLINES, (1931–)

Winter Triptych, 1965
Etching on paper, (12/210), 11.5 x 24" (29.21 x 60.96 cm.)
Signed, David Glines, 1965, lower right
Museum purchase, 1966
966-P-147

Raymond GLOECKLER, (1928–)

Social Mogul, 1961
Woodcut on paper, (14/20), 36 x 20" (91.44 x 50.80 cm.)
Signed, Gloeckler, lower right
Museum purchase, 1965
965-P-284

Grigory GLUCKMAN, (1898–)

At the Court of Henry III, 1924–25
Oil on canvas, 53 x 35" (134.62 x 88.90 cm.)
Signed, Grigory Gluckman, Paris, 1924–25, lower right
Gift of Milch Galleries, 1960
960-O-120

M. GLUCKMAN, (1894– ?)

Landscape, 1965
Watercolor on paper, 7.25 x 7" (18.42 x 17.78 cm.)
Signed, M. Gluckman, 1965, lower right
Gift of Louis Held, 1968
968-W-125

Robert GODFREY, (1941–)

The Birdwatcher, 1984
Oil on canvas, 51 x 77.5" (129.54 x 196.85 cm.)
Signed, Godfrey, lower left
Gift of Robert Godfrey, 1985
985-O-108

Off Orchard Road, 1981
Gouache on board, 6.5 x 9.5" (16.51 x 24.13 cm.)
Signed, Godfrey, lower right
Gift of Theresa Abranovich-Godfrey, 1985
985-W-102

Skater
Glass matrix on paper, 15.62 x 15.62" (39.69 x 39.69 cm.)
Signed, Robert Godfrey, lower right
Museum purchase, 1993
993-P-148

Marion GODLEWSKI, (active 20th century)

Communion with Nature, 1955
Watercolor on paper, 21 x 39" (53.34 x 99.06 cm.)
Signed, M. Godlewski, 1955, lower left
Museum purchase, 1957
957-W-104

Augustus Frederick GOERTZ, III, (1948–)

Dance on the Patio
Oil on canvas, 22 x 28" (55.88 x 71.12 cm.)
Signed, Augustus Goertz, lower right
Gift of Louis Held, 1965
965-O-108

Richard Vernon GOETZ, (1915–1991)

The American
Oil on canvas, 20 x 24" (50.80 x 60.96 cm.)
Signed, R. V. Goetz, lower right
Museum purchase, 1968
968-O-185

Leah GOLD, (active late 20th century)

Oriental Figure
Woodcut and mixed media, 18 x 22" (45.72 x 55.88 cm.)
Signed, Leah Gold, lower right
Gift of Leah Gold, 1978
978-P-116

Michael GOLDBERG, (1924–)

(Untitled)
Oil on canvas, 11 x 12" (27.94 x 30.48 cm.)
Signed, Goldberg, lower right
Gift of Marilynn Meeker, 1986
986-O-112

Edith Dvorah GOLDSTEIN, (1939–)

Marine Parkway Bridge
Acrylic on canvas, 36 x 42" (91.44 x 106.68 cm.)
Signed, E. Goldstein, lower right
Museum purchase, 1975
975-O-121

Peter GOLFINOPOULOS, (1928–)

Grey Painting #4, 1961
Oil on canvas, 55 x 55" (139.70 x 139.70 cm.)
Unsigned
Gift of Dr. H. Meadows, 1976
976-O-101

The following four signed groups of drawings, charcoal on paper, five in each group, are the gift of Marietta Chicorel, 1976

Epic Suite
13 x 16" (33.02 x 40.64 cm.)
976-D-101, 976-D-102, 976-D-103, and 976-D-104

Joseph W. GOLINKIN, (1896–1977)

The following two signed lithographs on paper are a museum purchase, 1986

Hole in the Line
16 x 23.5" (40.64 x 59.69 cm.)
986-P-101

Tear 'im Apart
23 x 16" (58.42 x 40.64 cm.)
986-P-102

Xavier GONZALEZ, (1898– ?)

South Shore, 1959
Mixed media on canvas, 40 x 48" (101.60 x 121.92 cm.)
Unsigned
Gift of the American Academy of Art and Letters, Childe Hassam Fund, 1960
960-O-101

Joe GOODE, (1937–)

The following five signed groups of lithographs on paper, five works in each group, are the gift of Reese and Marilyn Arnold Palley, 1991

Floating Cards, 1969
22.5 x 30" (57.15 x 76.20 cm.)
991-P-152, 991-P-153, 991-P-154, 991-P-155, and 991-P-159

Bertram GOODMAN, (1904–)

Steel, 1950
Lithograph on paper, 15 x 8" (38.10 x 20.32 cm.)
Signed, Bertram Goodman, 1950, lower right
Museum purchase, 1953
953-P-101

Winter
Color lithograph on paper, 7 x 9" (17.78 x 22.86 cm.)
Signed, Bertram Goodman, lower right
Anonymous gift, 1948
948-P-105

Winter, 1947
Color lithograph on paper, 10 x 12" (25.40 x 30.48 cm)
Signed, Bertram Goodman, 47, lower right
Gift of Louis Held, 1965
965-P-153

The following two lithographs on paper are the gift of Louis Held, 1965

Greenwich Village
11 x 13" (27.94 x 33.02 cm.)
965-P-164

Maypole, 1947
12 x 6" (30.48 x 15.24 cm.)
965-P-148

Sidney GOODMAN, (1936–)

The Artist's Parents in the Store, 1973–75
Oil on canvas, 58.5 x 77" (148.59 x 195.58 cm.)
Signed, Goodman, lower right
Museum purchase, 1982
982-O-176

Parents, 1972
Charcoal on paper, 29 x 36" (73.66 x 91.44 cm.)
Signed, Goodman, lower right
Museum purchase, 1991
991-D-109

Robert GOODNOUGH, (1923–)

Movement, 1985
Acrylic on canvas, 64 x 120" (162.56 x 304.80 cm.)
Signed, Goodnough, 85, on reverse
Museum purchase, 1988
988-O-123

John L. GOODYEAR, (1930–)

Two Sided Movement
New York International: Portfolio of Ten Prints, (210/225)
Serigraph on vinyl with gold, 22 x 17" (55.88 x 43.18 cm.)
Unsigned
Museum purchase, 1966
966-P-137.1

John GORDON, (1923–)

The Morning News, 1966
Polymer on canvas, 57 x 57" (144.78 x 144.78 cm.)
Signed, Gordon, 3/15/66, lower right
Museum purchase, 1966
966-O-115

Maxwell GORDON, (1910–1982)

Interior
Oil on canvas, 10 x 12" (25.40 x 30.48 cm.)
Signed, Maxwell Gordon, lower right
Gift of Louis Held, 1965
965-O-134

They Came Here to Pause
Watercolor on paper, 13 x 19" (33.02 x 48.26 cm.)
Signed, Maxwell Gordon, lower left
Gift of Louis Held, 1965
965-W-104

Paul GORKA, (1931–)

Still Life
Oil on canvas, 40 x 47.75" (101.60 x 121.29 cm.)
Signed, Paul Gorka, lower left
Museum purchase, 1968
968-O-186

William D. GORMAN, (1925–)

and all the air and solemn stillness holds
Casein on paper, 17 x 28" (43.18 x 71.12 cm.)
Signed, Gorman, lower right
Museum purchase, 1961
961-W-109

Douglas W. GORSLINE, (1913–1985)

Brooklyn Local
Etching on paper, 8.25 x 7" (20.96 x 17.78 cm.)
Signed, Douglas W. Gorsline, lower right
Museum purchase, 1967
967-P-102

Golfinopoulos - Grey Painting #4 (page 66)

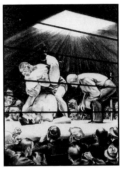
Golinkin - Tear 'im Apart

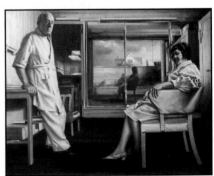
Sidney Goodman - The Artist's Parents in the Store

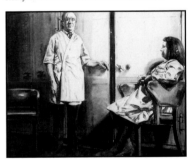
Sidney Goodman - Parents

Goodnough - Movement

Adolph Gottlieb - Seer

Graham - Pyle's Parlor

Adam Grant - Figures in a Circus Setting

Gordon Grant - Old Boats Never Die

Richard GOSMINSKI, (1927–)

Girl
Oil on canvas, 20 x 16" (50.80 x 40.64 cm.)
Signed, Gosminski, lower right
Gift of James Welsh, 1969
969-O-125

Byron GOTO, (active 20th century)

Oxidation
Brush and ink on paper, 19 x 8" (48.26 x 20.32 cm.)
Unsigned
Gift of Samuel Brouner, 1960
960-D-102

Joseph GOTO, (1920–1994)

Yellow and Black
Oil on canvas, 14 x 22" (35.56 x 55.88 cm.)
Unsigned
Gift of Mr. and Mrs. Robert Miller, 1959
959-O-129

Adolph GOTTLIEB, (1903–1974)

Seer, 1947
Oil on masonite, 30 x 24" (76.20 x 60.96 cm.)
Signed, Adolph Gottlieb, lower left
Gift of Samuel M. Kootz, 1947
947-O-114

Harry GOTTLIEB, (1895–1992)

Parachutes
Silkscreen on paper, 15.5 x 11" (39.37 x 27.94 cm.)
Signed, Harry Gottlieb, lower right
Gift of Louis Held, 1965
965-P-150

Harland J. GOUDIE, (active 20th century)

Eating and Drinking
Etching on paper, 18 x 23.5" (45.72 x 59.69 cm.)
Signed, H. J. Goudie, lower right
Museum purchase, 1954
954-P-101

Robert Alan GOUGH, (1931–)

Barn Pigeon, 1961
Oil on canvas, 22 x 14" (55.88 x 35.56 cm.)
Unsigned
Gift of the Friends of American Art, 1962
962-O-117

Dinner Bell, 1963
Pencil on paper, 13.5 x 10.5" (34.29 x 26.67 cm.)
Unsigned
Gift of Joseph G. Butler, III, 1966
966-D-112

Steve GRABER, (active late 20th century)

Oriole Hill
Graphite on paper, 18 x 27" (45.72 x 68.58 cm.)
Signed, Graber, lower right
Gift of Capricorn Galleries, 1995
995-D-103

Hans GRAEDER, (active 20th century)

The following three signed lithographs on paper, 23 x 34" (58.42 x 86.36 cm.), are the gift of Samuel S. Mandel, 1986

Cassandra
986-P-138

Night
986-P-137

Sorrow
986-P-156

Robert D. GRAHAM, (1936–)

Pyle's Parlor
Oil on canvas, 17 x 32.75" (43.18 x 83.19 cm.)
Signed, Graham, lower left
Museum purchase, 1974
974-O-112

Normandy Avenue, 1967
Polymer on canvas, 18 x 22" (45.72 x 55.88 cm.)
Signed, Graham, lower left
Gift of the Friends of American Art, 1968
968-O-194

Adam GRANT, (1924–)

Figures in a Circus Setting
Oil on canvas, 60 x 42" (152.40 x 106.68 cm.)
Signed, Adam Grant, lower right
Museum purchase, 1963
963-O-112

Mystic Marvels
Oil on canvas, 64 x 40" (162.56 x 101.60 cm.)
Signed, Adam Grant, lower left
Museum purchase, 1968
968-O-187

Bather
Acrylic on paper, 16.5 x 9.25" (41.91 x 23.50 cm.)
Signed, Adam Grant, lower right
Museum purchase, 1964
964-W-111

Bather
Mixed media on paper, 20 x 13" (50.80 x 33.02 cm.)
Signed, Adam Grant, lower right
Gift of Joseph G. Butler, III, 1980
980-D-194

Gordon GRANT, (1875–1962)

The Street Where I Lived
Watercolor on paper, 15 x 21" (38.10 x 53.34 cm.)
Signed, Gordon Grant from Grand Central, lower left
Gift of Dr. John J. McDonough, 1969
969-W-119

Drifting In
Etching on paper, 8.87 x 10.25" (22.54 x 26.04 cm.)
Signed, Gordon Grant, lower right
Gift of Paul Burke, 1993
993-P-165

Old Boats Never Die
Lithograph on paper, 9 x 12" (22.86 x 30.48 cm.)
Signed, Gordon Grant, lower right
Museum purchase, 1967
967-P-101

C. D. Graves - Indian with Scalp

Winter Harbor
Lithograph on paper, 9 x 12" (22.86 x 30.48 cm.)
Signed, Gordon Grant, lower right
Gift of Mr. and Mrs. Edward E. Ford, 1968
970-P-112

C. D. GRAVES, (active 19th century)

Indian with Scalp
Ink on paper, 20 x 29.75" (50.80 x 75.57 cm.)
Signed, Graves, lower right
Gift of The Association for the Advancement of American
Historical Art, 1975
975-D-115

Morris GRAVES, (1910–)

Young Woodpeckers
Watercolor on paper, 30.5 x 24.5" (77.47 x 62.23 cm.)
Signed, M. Graves, lower right
Gift of Mr. and Mrs. Milton Lowenthal, 1950
950-W-102

O. E. L. GRAVES, (1897– ?)

Lover's Dream
Oil on canvas, 18 x 22" (45.72 x 55.88 cm.)
Signed, O. E. L. Graves, lower right
Gift of Samuel Brouner, 1961
961-O-116

The following three signed oils on canvas are an
anonymous gift, 1958

Burst of Summer
48 x 24" (121.92 x 60.96 cm.)
958-O-131

Crowded Moon
48 x 36" (121.92 x 91.44 cm.)
958-O-130

Dappled with Damson
24 x 20" (60.96 x 50.80 cm.)
958-O-132

Cleve GRAY, (1918–)

Ceres
Color lithograph on paper, (43/50), 24 x 21.75" (60.96 x 55.25
cm.)
Signed, Gray, lower right
Museum purchase, 1968
968-P-320

Sante GRAZIANI, (1920–)

George Washington
Relief print on paper, 12 x 12" (30.48 x 30.48 cm.)
Signed, Sante Graziani, lower right
Museum purchase, 1965
965-P-285

Edmund W. GREACEN, (1877–1949)

The following two oils on canvas are a museum
purchase, 1918

Lady in Blue, 1916
40 x 36" (101.60 x 91.44 cm.)
918-O-104

Sidonie, 1918
82 x 40" (208.28 x 101.60 cm.)
918-O-103

Anthony Joseph GRECO, (1937–)

Self Portrait
Oil on canvas, 62 x 28" (157.48 x 71.12 cm.)
Unsigned
Museum purchase, 1961
961-O-122

Joseph GREEN, (1901–1981)

Pertaining to Painting
Oil on canvas, 25 x 39" (63.50 x 99.06 cm.)
Signed, J. Green, on reverse
Museum purchase, 1969
969-O-139

Sailor Beware!, 1952
Gouache on paperboard, 8.5 x 15.02" (21.59 x 38.16 cm.)
Signed, Jos. Green, on reverse
Gift of Dr. M. Metzger, 1989
989-W-106

Michael GREEN, Sr., (active 20th century)

(Untitled)
Portfolio of 53: Rip Off on the Last Millennium
Print on paper, 8.5 x 11" (21.59 x 27.94 cm.)
Signed, Green, lower right
Gift of the William Busta Gallery, 1990
990-P-111.40

Joseph GREENBERG, (1926–)

Ships and Mist
Oil on canvas, 40 x 48" (101.60 x 121.92 cm.)
Signed, J. Greenberg, lower right
Museum purchase, 1963
963-O-119

F. Douglas GREENBOWE, (1921–)

Spring Sun, 1947
Watercolor on paper, 19 x 25" (48.26 x 63.50 cm.)
Unsigned
Museum purchase, 1947
947-W-104

George GREENE, (1943–)

Divisions
Silkscreen on paper, 28 x 22" (71.12 x 55.88 cm.)
Signed, George Greene, lower right
Gift of George Greene, 1978
978-P-130

Gertrude GREENE, (1907–1956)

It Began in Sunlight
Oil on canvas, 40 x 30" (101.60 x 76.20 cm.)
Signed, Gertrude Greene, on reverse
Gift of Balcomb Greene, 1976
976-O-142

Marion GREENWOOD, (1909–1970)

Eastern Elegy
Oil on canvas, 40 x 26" (101.60 x 66.04 cm.)
Signed, Marion Greenwood, lower right
Museum purchase, 1956
956-O-106

Portrait Sketch: Julio De Diego, 1958
Pastel on paper, 21 x 17" (53.34 x 43.18 cm.)
Signed, Marion Greenwood, lower left
Museum purchase, 1959
959-W-113

Morris Graves - Young Woodpeckers

Gray - Ceres

Joseph Green - Pertaining to Painting

Michael Green, Sr. - (Untitled)

Greenwood - Suffering Child (page 69)

Grilley - Red and White Blues

Grillo - Abstraction (964-P-119)

Groll - Landscape

Grooms - Rose Selavy

Suffering Child
Watercolor on paper, 9.5 x 8" (24.13 x 20.32 cm.)
Signed, Marion Greenwood, lower right
Gift of Louis Held, 1965
965-W-121

The following three lithographs on paper are a museum purchase, 1962, 1963, 1966

Iberian Motif
10 x 14.5" (25.40 x 36.83 cm.)
963-P-142

Lament
18 x 14" (45.72 x 35.56 cm.)
962-P-108

Sisters, 1965
14 x 10" (35.56 x 25.40 cm.)
966-P-114

John W. GREGORY, (1903–)

Sunrise–End of Wharf, 1969
Lithograph on paper, 18 x 13.87" (45.72 x 35.24 cm.)
Signed, John W. Gregory, lower right
Gift of John Baglama, 1982
982-P-153

Estelle GREY, (active 20th century)

Trees, 1964
Oil on canvas, 53.25 x 49" (135.26 x 124.46 cm.)
Signed, E. Grey, lower right
Gift of Elizabeth Ashby, 1978
978-O-112

Martha and Arthur GRIDLEY, (active late 20th century)

(Untitled)
Portfolio of 53: Rip Off on the Last Millennium
Print on paper, 8.5 x 11" (21.59 x 27.94 cm.)
Signed, Martha, Arthur Gridley, upper right
Gift of the William Busta Gallery, 1990
990-P-111.52

Denny GRIFFITH, (1952–)

Number Nine, Mesa, 1975
Acrylic on canvas, 51.5 x 72" (130.81 x 182.88 cm.)
Unsigned
Museum purchase, 1975
975-O-124

Samuel W. GRIGGS, (active 1848–1898)

Speckled Trout, Caught, 1885
Oil relined on masonite, 18 x 27" (45.72 x 68.58 cm.)
Signed, S. W. Griggs, 85, lower right
Museum purchase, 1970
970-O-102

Robert GRILLEY, (1920–)

Red and White Blues, 1961
Oil on canvas, 30 x 20" (76.20 x 50.80 cm.)
Signed, R. Grilley, lower right
Museum purchase, 1967
967-O-117

John GRILLO, (1917–)

Abstraction, 1963
Color lithograph on paper, (19/20), 30.5 x 22.5" (77.47 x 57.15 cm.)
Signed, Grillo, lower right
Museum purchase, 1964
964-P-119

Abstraction, 1964
Lithograph on paper, 14 x 20" (35.56 x 50.80 cm.)
Signed, Grillo, 1964, lower right
Anonymous gift, 1964
971-P-105

Vincent GRIMALDI, (1929–)

Season of Meditation, 1962
Watercolor on paper, 10 x 13" (25.40 x 33.02 cm.)
Signed, Grimaldi, lower center
Gift of Louis Held, 1977
977-W-105

A. GRITCHENKO, (1883–1977)

Seascape
Oil on canvas, 25.5 x 32" (64.77 x 81.28 cm.)
Unsigned
Gift of Mrs. William V. Miller, 1963
963-O-109

Albert Leroy GROLL, (1868–1952)

Landscape
Oil on canvas, 12.5 x 15.5" (31.75 x 39.37 cm.)
Signed, Groll, lower right
Gift of Arthur B. Marshall, 1991
991-O-226

Symphony in Green
Oil on canvas, 10 x 16" (25.40 x 40.64 cm.)
Signed, A. Groll, lower right
Gift of Lenore Spiering, 1965
965-O-171

Red GROOMS, (1937–)

The following two signed etchings on paper are a museum purchase, 1985

Dallas 14, Jack 6, 1980
13.87 x 14" (35.24 x 35.56 cm.)
985-P-106

Rose Selavy, 1980
10.5 x 7.5" (26.67 x 19.05 cm.)
985-P-107

Mango Mango, 1973
Offset lithograph on paper. 40 x 29" (101.60 x 73.66 cm.)
Signed, Red Grooms, lower right
Gift of Dana Seman, 1980
980-P-115

Self Portrait with Liz, 1982
Color lithograph on paper, 16 x 12" (40.64 x 30.48 cm.)
Signed, Red Grooms, lower right
Museum purchase, 1988
988-P-106

The Guggenheim/Ten Independents, 1972
Lithograph on paper, 38.25 x 26" (97.16 x 66.04 cm.)
Unsigned
Gift of Samuel S. Mandel, 1986
986-P-140

(Untitled), 1973
Serigraph on paper, 9 x 12" (22.86 x 30.48 cm.)
Signed, Red Grooms, lower right
Gift of Steven Feinstein, 1983
983-P-151

William GROPPER, (1897–1977)

Youngstown Strike, ca. 1937
Oil on canvas, 20 x 40" (50.80 x 101.60 cm.)
Signed, Gropper, lower right
Museum purchase, 1985
985-O-106

Anniversary
Oil on canvas, 36 x 26" (91.44 x 66.04 cm.)
Signed, Gropper, lower left
Gift of Mr. and Mrs. William Gropper, 1969
969-O-154

Aggressors' Retribution, 1943
Watercolor on paper, 18 x 24" (45.72 x 60.96 cm.)
Signed, Gropper, 43, lower right
Gift of Joseph H. Hirshhorn, 1947
947-W-105

Student
Brush and ink on paper, 26 x 18.5" (66.04 x 46.99 cm.)
Signed, Gropper, lower right
Museum purchase, 1964
964-D-105

Backstage
Color lithograph on paper, 17 x 14" (43.18 x 35.56 cm.)
Signed, Gropper, lower right
Museum purchase, 1947
947-P-104

Diogonese
Lithograph on paper, 10.5 x 13.25" (26.67 x 33.66 cm.)
Signed, Gropper, lower right
Gift of William and Margaret Kinnick, 1986
986-P-105

Liberated Village
Lithograph on paper, 12 x 16.5" (30.48 x 41.91 cm.)
Signed, Wm. Gropper, lower right
Gift of Louis Held, 1965
965-P-157

Self Portrait
Lithograph on paper, 13 x 9" (33.02 x 22.86 cm.)
Signed, Wm. Gropper, lower right
Gift of Robert Gwathmey, 1948
948-P-106

Capriccio, 1953–1956
A Portfolio of fifty signed lithographs on paper,
14 x 10" (35.56 x 25.40 cm.), is the gift of
Sophie Gropper, 1963

A New Dawn
964-P-101.32

"All God's Children—"
964-P-101.38

Alone
964-P-101.25

Awakening
964-P-101.15

Black List
964-P-101.43

Crisis
964-P-101.2

Dictatorship
964-P-101.18

Dream
964-P-101.6

Echoes
964-P-101.28

Emancipation
964-P-101.23

Environment
964-P-101.31

Eruption
964-P-101.34

Falls of the Gods
964-P-101.21

Fantasy
964-P-101.14

Fate
964-P-101.9

Favor
964-P-101.33

Fear
964-P-101.45

First Step
964-P-101.13

Fledglings
964-P-101.17

Gossip Mongers
964-P-101.27

Grave Yard
964-P-101.5

Heroics
964-P-101.1

"I Gotta Gal—"
964-P-101.29

Informers
964-P-101.12

Intoxication
964-P-101.41

Justice
964-P-101.3

Ladder of Success
964-P-101.20

Logic
964-P-101.37

Lust
964-P-101.40

Masqueraders
964-P-101.48

Nostalgia
964-P-101.8

Gropper - Youngstown Strike

Gropper - Anniversary

Gropper - Agressors' Retribution

Gropper - Student

Gropper - Self Portrait

Chaim Gross - Nude

Chaim Gross - Male Torso

Sidney Gross - Composition # 10 (page 73)

Sidney Gross - Reflections (page 73)

Grosz - Resting (page 73)

Nuclear Gods
964-P-101.22

Patrioteers
964-P-101.24

Pegasus
964-P-101.10

Performance
964-P-101.11

Piece Work
964-P-101.39

Playmates
964-P-101.4

Politics
964-P-101.46

Psychosis
964-P-101.35

The Funny Men
964-P-101.30

The Have and the Havenots
964-P-101.19

The Horn Blowers
964-P-101.36

The Old Man
964-P-101.44

The Spinner
964-P-101.49

Time
964-P-101.26

Tornado
964-P-101.7

Uprooted
964-P-101.16

Vengeance
964-P-101.47

Visionary
964-P-101.42

Whither
964-P-101.50

The following portfolio of twelve etchings, 18.5 x 22.03" (46.99 x 55.96 cm.), are the gift of Sophie Gropper, 1985

Catastrophe
985-P-103.10

Check
985-P-103.4

Coffee Break
985-P-103.1

Dream
985-P-103.2

Duchess
985-P-103.11

Fantasy
985-P-103.7

Fisherman
985-P-103.5

Gourmet
985-P-103.12

Hasidim
985-P-103.8

Market on 38th Street
985-P-103.6

Rembrandt Lady
985-P-103.9

Tomorrow's Saint
985-P-103.3

The following five colored lithographs on paper are a museum purchase, 1947

Backstage
17 x 14" (43.18 x 35.56 cm.)
947-P-104

Red Cavalry
14 x 18" (35.56 x 45.72 cm.)
947-P-107

The Races
17 x 14" (43.18 x 35.56 cm.)
947-P-106

The Senate
14 x 18" (35.56 x 45.72 cm.)
947-P-103

Winter
17 x 14" (43.18 x 35.56 cm.)
947-P-105

Maurice GROSSMAN, (1903–)

The following two signed oils on canvas are the gift of Louis Held, 1965

Mandolin Player, 1949
16 x 12" (40.64 x 30.48 cm.)
965-O-137

Still Life
12 x 16" (30.48 x 40.64 cm.)
965-O-126

Still Life
Silkscreen on paper, 25 x 19.25" (63.50 x 48.90 cm.)
Signed, M. Grossman, lower right
Gift of Louis Held, 1965
965-P-177

Chaim GROSS, (1904–1991)

Nude, 1937
Watercolor and pencil on paper, 12 x 18" (30.48 x 45.72 cm.)
Signed, Chaim Gross, 37, lower right
Gift of Katherine Warwick, 1968
968-D-114

Male Torso
Pastel on paper, 18 x 12" (45.72 x 30.48 cm.)
Signed, Chaim Gross, lower right
Gift of Albert E. Hise, 1979
979-D-107

Mother and Child, 1965
Lithograph on paper, (18/125), 12 x 20" (30.48 x 50.80 cm.)
Signed, Chaim Gross, 65, lower right
Gift of Joseph G. Butler, III, 1965
965-P-315

Mother Playing
Ink on paper, 13 x 19" (33.02 x 48.26 cm.)
Signed, Chaim Gross, lower right
Gift of Renee Gross, 1958
958-D-107

The following two signed drawings on paper are the gift of Louis Held, 1965

Nude
Sepia wash on paper, 11.5 x 16" (29.21 x 40.64 cm.)
965-D-105

Nude
Pencil on paper, 11 x 18" (27.94 x 45.72 cm.)
968-D-112

The following two drawings on paper are the gift of Albert E. Hise, 1979

Nude Leaning on Elbow
13 x 18" (33.02 x 45.72 cm.)
979-D-106

Reclining Nude
11.75 x 18" (29.85 x 45.72 cm.)
979-D-105

The Song of Songs
Portfolio of five signed prints, 21 x 17" (53.34 x 43.18 cm.)
Gift of Leona Cohen, 1992
992-P-114

Sidney GROSS, (1921–1969)

Composition # 10, 1960
Oil on canvas, 84 x 65" (213.36 x 165.10 cm.)
Signed, Gross, 60, lower right
Gift of the Alpern Foundation in memory of Daniel Alpern, 1961
961-O-127

Reflections
Oil on canvas, 42 x 60" (106.68 x 152.40 cm.)
Signed, S. Gross, lower right
Museum purchase, 1953
953-O-117

George GROSZ, (1893–1959)

Resting, ca. 1939–1941
Oil on canvas, 20 x 26" (50.80 x 66.04 cm.)
Signed, Grosz, lower right
Gift of Joseph Cantor, 1960
960-O-123

John GROTH, (1908–1988)

Crossbow Tournament
Watercolor on paper, 26 x 39" (66.04 x 99.06 cm.)
Signed, John Groth, Crossbow Tournament at Gulbio, Italy, upper right
Museum purchase, 1960
960-W-102

Aaronel de Roy GRUBER, (active 20th century)

Interior and Suggested Outerim, 1968
Silkscreen serigraph on paper, 12 x 19" (30.48 x 48.26 cm.)
Signed, Aaronel de Roy Gruber, lower right
Gift of Mrs. Aaronel de Roy Gruber, 1969
969-P-113

Charles Paul GRUPPE, (1860–1940)

Landscape, (The Brook)
Oil on canvas, 7 x 10" (17.78 x 25.40 cm.)
Signed, C. P. Gruppe, lower left
Gift of the estate of Charles Crandall, 1951
951-O-104

It Sure is Jan, 1914
Watercolor on paper, 26 x 18" (66.04 x 45.72 cm.)
Unsigned
Museum purchase, 1918
918-W-101

Robert GUCCIONE, (1930–)

Fleur de Soir
Oil on canvas, 36 x 30" (91.44 x 76.20 cm.)
Signed, Guccione, middle right
Gift of Robert Guccione, 1994
994-O-124

David John GUE, (1836–1917)

Seascape
Oil on canvas, 8 x 10" (20.32 x 25.40 cm.)
Unsigned
Gift of the estate of Charles Crandall, 1951
951-O-124

Victor GUINTO, (active late 20th century)

Consumer 1
Portfolio of 53: Rip Off on the Last Millennium
Print on paper, 8.5 x 11" (21.59 x 27.94 cm.)
Signed, Victor Guinto, lower right
Gift of the William Busta Gallery, 1990
990-P-111.42

Lena GURR, (1897– ?)

Little Old New York, 1942
Oil on canvas, 33 x 27" (83.82 x 68.58 cm.)
Signed, Lena Gurr, lower right
Gift of Lena Gurr, 1981
981-O-106

Time Remembered, 1956–62
Oil on panel, 33 x 36" (83.82 x 91.44 cm.)
Signed, Lena Gurr, lower right
Gift of H. M. Levy, 1967
967-O-141

Moonlight
Colored woodcut, 8.5 x 9.5" (21.59 x 24.13 cm.)
Signed, Lena Gurr, lower right
Museum purchase, 1969
969-P-101

Sails on Fog
Silkscreen on paper, 13 x 18" (33.02 x 45.72 cm.)
Signed, Lena Gurr, lower right
Gift of Louis Held, 1965
965-P-151

Groth - Crossbow Tournament

Gruppe - Landscape, (The Brook)

Gruppe - It Sure is Jan

Guccione - Fleur de Soir

Gwathmey - Children Dancing

Gwathmey - Pick until the Rain Hits

Haacke - (Untitled)

Hailman - Spring

Hale - Hollyhocks

Robert GWATHMEY, (1903–1988)

Children Dancing
Oil on canvas, 32 x 40" (81.28 x 101.60 cm.)
Signed, Gwathmey, lower right
Museum purchase, 1948
948-O-114

Pick until the Rain Hits
Watercolor on paper, 22 x 9" (55.88 x 22.86 cm.)
Signed, Gwathmey, upper left
Gift of Mr. and Mrs. Milton Lowenthal, 1955
955-W-105

Children Playing
Silkscreen on paper, 12.5 x 15.5" (31.75 x 39.37 cm.)
Signed, Gwathmey, upper left
Museum purchase, 1960
960-P-107

Rural Home Front
Silkscreen on paper, 10 x 18" (25.40 x 45.72 cm.)
Signed, Gwathmey, lower right
Gift of Louis Held, 1965
965-P-174

Sewing and Singing
Serigraph on paper, 12 x 14" (30.48 x 35.56 cm.)
Signed, Gwathmey, upper left
Museum purchase, 1958
958-P-113

The following two signed silkscreens on paper are an anonymous gift, 1960

Female Figure
29.5 x 20" (74.93 x 50.80 cm.)
960-P-108

Parade
15 x 11.5" (38.10 x 29.21 cm.)
960-P-109

The following two signed silkscreens on paper are the gift of Joseph G. Butler, III, 1960

Hoeing Tobacco
13.5 x 10.5" (34.29 x 26.67 cm.)
960-P-102

Picking
13.5 x 9" (34.29 x 22.86 cm.)
960-P-103

Hans HAACKE, (1936–)

(Untitled), 1973
Serigraph on paper, 12 x 9" (30.48 X 22.86 cm.)
Unsigned
Gift of Steven Feinstein, 1983
983-P-152

George J. HABERGRITZ, (1909–)

Ornamental Horse, 1965-66
Acrylic on canvas, 35 x 70" (88.90 x 177.80 cm.)
Signed, Habergritz, lower right
Gift of Mr. and Mrs. Louis Haber, 1968
968-O-180

Nancy HAGIN, (1940–)

Mosquito Net, '76, 1976
Acrylic on canvas, 44 x 36" (111.76 x 91.44 cm.)
Unsigned
Gift of Nancy Hagin, 1977
977-O-149

Johanna K. W. HAILMAN, (1871–1958)

Spring, 1922
Oil on canvas, 40 x 40" (101.60 x 101.60 cm.)
Signed, Johanna K. W. Hailman, 1922, lower left
Museum purchase, 1933
933-O-101

Phillip Leslie HALE, (1865–1931)

Hollyhocks, ca. 1922–23
Oil on canvas, 36 x 24" (91.44 x 60.96 cm.)
Unsigned
Museum purchase, 1966
966-O-137

Sleeping Nude
Pencil on paper, 17 x 24" (43.18 x 60.96 cm.)
Unsigned
Museum purchase, 1966
966-D-115

Theodore HALKIN, (1924–)

Bull Fight
Oil on canvas, 12 x 40" (30.48 x 101.60 cm.)
Unsigned
Museum purchase, 1956
956-O-107

H. D. HALL, (active 19th century)

Mt. Vernon in the Olden Time,
Washington at Thirty Years Of Age
Engraving on paper, 24 x 29.75" (60.96 x 75.57 cm.)
Unsigned
Gift of Carl H. Seaborg, 1971
971-P-133

Mary Plant HALL, (active early 20th century)

Trees and Shore, ca. 1920
Oil on canvas, 9 x 13" (22.86 x 33.02 cm.)
Unsigned
Gift of Margaret Hall Coffey and John H. Hall, Jr., 1993
993-O-117

Susan HALL, (1943–)

Magician's Daughter
Watercolor and graphite on paper, 41.75 x 29.5" (106.05 x 74.93 cm.)
Signed, Susan Hall, lower right
Gift of Mr. and Mrs. David Levitt, 1990
990-W-105

Holiday, 1972
Colored pencil and ink on paper, 24 x 19" (60.96 x 48.26 cm.)
Signed, Susan Hall, lower right
Gift of Mr. and Mrs. David Levitt, 1990
990-D-102

The Glove Display, 1973
Watercolor over lithograph on paper, 19 x 17" (48.26 x 43.18 cm.)
Signed, Susan Hall, lower right
Gift of Mr. and Mrs. David Levitt, 1991
991-P-102

H. HALLETT & Co., (active 19th century)

George Washington, Martha Washington, ©1880
Chromolithographs on paper (2), 14 x 10" (35.56 X 25.40 cm.)
Unsigned
Gift of Sydna Smith, 1975
975-P-101.1 — 975-P-101.2

Hendricks A. HALLETT, (1847–1921)

Boston Periphery, 1880
Oil on canvas, 10 x 20" (25.40 x 50.80 cm.)
Signed, H. A. Hallett, 1880, lower right
Gift of Joseph G. Butler, III, 1964
964-O-118

Boston's Back Bay
Oil on canvas, 11.25 x 20.25" (28.58 x 51.44 cm.)
Unsigned
Museum purchase, 1968
968-O-198

S. HALPERT, (1884–1930)

The following four lithographs on paper of
various sizes are the gift of Edith Halpert, 1948

Boats–St. Tropez, 1930
948-P-107

Central Park, 1930
948-P-110

Dressmaker
948-P-109

Nude–Head Down
948-P-108

James HAMILTON, (1819–1878)

From Sail to Steam, ca. 1870's
Oil on canvas, 30 x 50" (76.20 x 127.00 cm.)
Signed, Hamilton, lower right
Museum purchase, 1968
968-O-215

Paul HAMLIN, (1909–)

West Virginia River Town, 1939
Watercolor on paper, 23 x 26" (58.46 x 66.04 cm.)
Signed, Paul Hamlin, lower right
Museum purchase, 1940
940-W-104

Frederick HAMMERSLEY, (1919–)

There
Oil on canvas, 49 x 40" (124.46 x 101.60 cm.)
Signed, Hammersley, on reverse
Museum purchase, 1961
961-O-125

William L. HANNEY, (active late 20th century)

All Together Now, 1975
Oil on canvas, 48 x 66" (121.92 x 167.64 cm.)
Unsigned
Museum purchase, 1976
976-O-131

Encroachment VI
Acrylic and pencil on paper, 30 x 42" (76.20 x 106.68 cm.)
Signed, Hanney, upper left
Museum purchase, 1980
980-W-103

Boyd HANNA, (active 20th century)

Saguaro
Woodcut on paper, 9.5 x 6" (24.13 x 15.24 cm.)
Signed, Boyd Hanna, lower right
Gift of Charles F. Fischer, 1984
984-P-106

Russell HARDER, Jr., (1943–)

Number Two
Acrylic on canvas, 59.75 x 59.75" (151.77 x 151.77 cm.)
Unsigned
Gift of Youngstown State University Student Art Show, 1971
971-O-107

Chester HARDING, (1792–1866)

The following two unsigned oils on canvas are
the gift of Mr. and Mrs. John Clancy, 1962

Portrait
35 x 28" oval (88.90 x 71.12 cm.)
962-O-110

Portrait
37 x 30" oval (93.98 x 76.20 cm.)
962-O-109

DeWitt HARDY, (1940–)

Figure
Watercolor on paper, 28 x 21.5" (71.12 x 54.61 cm.)
Unsigned
Museum purchase, 1969
969-W-107

Tom HARDY, (1921–)

Cormorant Rookery
Ink on paper, 12 x 19" (30.48 x 48.26 cm.)
Unsigned
Museum purchase, 1959
959-D-107

Deer, 1956
Ink on paper, 12 x 18.5" (30.48 x 46.99 cm.)
Signed, Tom Hardy, 1956, lower right
Gift of Kraushaar Galleries, 1959
959-D-126

Three Sketches, Sheep, 1956
Ink and watercolor on paper, 19.5 x 12.5" (49.53 x 31.75 cm.)
Signed, Tom Hardy, 1956, lower right
Gift of Dorothy Dennison Butler, 1963
963-D-104

Chuck HARGROVE, (active 20th century)

Triangulom, 1989
Oil on canvas, 44.13 x 59.75" (112.07 x 151.77 cm.)
Unsigned
Gift of William Marlieb, 1995
995-O-108

Linda HARKLESS, (active late 20th century)

The following two signed prints on paper, 8.5 x
11" (21.59 x 27.94 cm.), are the gift of the
William Busta Gallery, 1990

Broken Memories
Portfolio of 53: Rip Off on the Last Millennium
990-P-111.46

(Untitled)
Portfolio of 53: Rip Off on the Last Millennium
990-P-111.53

Hale - Sleeping Nude (page 74)

Hamilton - From Sail to Steam

Harder - Number Two

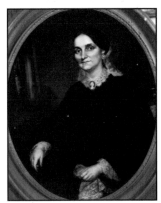

Harding - Portrait (962-O-110)

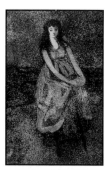

Lily Harmon - Summer Night

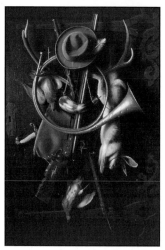

Harnett - After the Hunt

Birge Harrison - Bridge at Cos Cob

Birge Harrison - St. Michael's Church

George Overbury Hart - Springtime in New Orleans
(965-P-166)

Dwight HARMON, (1947–)

Hemet Lake, 1968
Watercolor on paper, 28 x 27.5" (71.12 x 69.85 cm.)
Unsigned
Museum purchase, 1969
969-W-108

Lily HARMON, (1912–)

Party Dress
Oil on canvas, 30 x 24" (76.20 x 60.96 cm.)
Signed, Lily Harmon, lower right
Museum purchase, 1950
950-O-106

Summer Night, 1965
Aquatint on paper, (48/250), 11.5 x 8" (29.21 x 20.32 cm.)
Signed, Lily Harmon, lower right
Museum purchase, 1965
965-P-320

William Michael HARNETT, (1848–1892)

After the Hunt, 1884
Oil on canvas, 55 x 40" (139.70 x 101.60 cm.)
Signed, W. M. Harnett, Munchen, 1884, lower left
Museum purchase, 1954
954-O-120

The Old Violin
Chromolithograph on paper, 35 x 24" (88.90 x 60.96 cm.)
Signed, William Harnett, lower left
Museum purchase, 1955
955-P-105

Robert M. HARPER, (1942–)

Lots of Boards, IV, 1975
Acrylic on canvas, 37.5 x 58" (95.25 x 147.32 cm.)
Signed, Bob Harper, 1975, lower right
Museum purchase, 1975
975-O-118

James HARRINGTON, (active 20th century)

Mervin Gules, ca. 1995
Oil on board, 48 x 40" (121.92 x 101.60 cm.)
Signed, Harrington, lower right
Gift of Capricorn Galleries, 1995
995-O-107

Jaye HARRIS, (active 20th century)

Variations in a Flower Theme
Oil on canvas, 24 x 18" (60.96 x 45.72 cm.)
Signed, J. Harris, lower right
Gift of the Friends of American Art, 1969
969-O-163

Birge HARRISON, (1854–1929)

The following two signed oils on canvas are a
museum purchase, 1919

Bridge at Cos Cob, 1915
29.5 x 39.5" (74.93 x 100.33 cm.)
919-O-107

St. Michael's Church, 1919
39.5 x 31.5" (100.33 x 80.01 cm.)
919-O-106

Thomas Alexander HARRISON, (1853–1930)

Girl in Cornfield, Le Mais, ca. 1887
Oil on canvas, 51 x 64" (129.54 x 162.56 cm.)
Unsigned
Gift of Franklin Biggs, 1976
976-O-130

Agnes HART, (? –1979)

Transition
Oil and sand on canvas, 30 x 24" (76.20 x 60.96 cm.)
Signed, Hart, lower right
Gift of Agnes Hart, 1978
978-O-106

Cityscape
Watercolor on paper, 15 x 23" (38.10 x 58.42 cm.)
Unsigned
Gift of Mr. and Mrs. Nahum Tschacbasov, 1972
972-W-109

Allen M. HART, (1925–)

Phoenix, 1963
Oil on canvas, 32 x 24" (81.28 x 60.96 cm.)
Signed, Hart, 1963, lower right
Gift of Mr. A. J. Shorin, 1966
966-O-102

George Overbury HART, (1868–1933)

The following two lithographs on paper are the
gift of Louis Held, 1965

Mammy Dere Comes De Candy Man
5.5 x 6.5" (13.97 x 16.51 cm.)
965-P-144

Springtime in New Orleans
12.5 x 9.5" (31.75 x 24.13 cm.)
965-P-166

The following eleven aquatints and line etchings
on paper of various sizes are the gift of Mrs. E.
Halpert, 1948

Dias de Fiesta, #1
948-P-113

Dias de Fiesta, #2
948-P-121

Early Morning Market
948-P-119

Garden Bois Jaland
948-P-117

Landscape—Santo Domingo 1
948-P-114

Market Plaza
948-P-111

Market Stand—Santo Domingo
948-P-112

Pig Market, Mexico
948-P-120

Shopkeeper's Daughter
948-P-118

Springtime—New Orleans
948-P-116

Tahiti Girls
948-P-115

Vincent A. HARTGEN, (1914–)

Path of Katahdin Moon
Watercolor on paper, 22 x 29" (55.88 x 73.66 cm.)
Signed, Vincent A. Hartgen, lower left
Gift of Herbert Chase, 1969
969-W-118

Marsden HARTLEY, (1877–1943)

Birds of the Bagaduce, 1939
Oil on board, 28 x 22" (71.12 x 55.88 cm.)
Signed, M. H., lower right
Museum purchase, 1957
957-O-113

Mt. Katahdin, 1939
Pencil on tan paper, 21 x 27" (53.34 x 68.58 cm.)
Unsigned
Museum purchase, 1958
959-D-101

Apples on Table, 1923
Lithograph on paper, 12.25 x 17.50" (31.12 x 44.45 cm.)
Signed, Marsden Hartley, 1923, lower right
Museum purchase, 1964
965-P-117

Bertram HARTMAN, (1882–1960)

The following two signed oils on canvas are the
gift of Mr. and Mrs. Nahum Tschacbasov, 1975

Flower Still Life
26 x 20" (66.04 x 50.80 cm.)
975-O-132

Winter Self Portrait
45 x 33" (114.30 x 83.82 cm.)
975-O-131

The following two oils on canvas are the gift of
Mr. and Mrs. Harry L. Tepper, 1969, 1970

Castle in Bavaria
24 x 20" (60.96 x 50.80 cm.)
969-O-128

Still Life
18 x 28" (45.72 x 71.12 cm.)
970-O-116

The following six watercolors on paper of
various sizes are the gift of Mr. and Mrs. Harry
L. Tepper, 1969, 1975

Cityscape, 1942, 1942
969-W-103

Brook
975-W-106

Farm
975-W-109

New York
975-W-105

Paris
975-W-108

Still Life, Grapes
975-W-107

The Butler Institute's collection contains three
groups of western oil sketches, all untitled, 8.5 x
10" (21.59 x 25.40 cm.), which are the gift of
Mr. and Mrs. Harry L. Tepper, 1975
975-O-128, 975-O-129, and 975-O-130

Robert L. HARTMAN, (1926–)

Enchanted Mountains
Watercolor on paper, 15 x 20" (38.10 x 50.80 cm.)
Signed, Hartman, lower left
Museum purchase, 1955
955-W-106

Rosella HARTMAN, (1894– ?)

Deer
Lithograph on paper, 13 x 9" (33.02 x 22.86 cm.)
Signed, Rosella Hartman, lower right
Museum purchase, 1964
964-P-118

Bunny HARVEY, (1946–)

Resonance Hunting and the Origins of
the Specious, 1988
Oil on canvas, 72 x 276" (182.88 x 701.04 cm.)
Unsigned
Gift of James Berry-Hill, 1995
995-O-115

William Stanley HASELTINE, (1835–1900)

Coppet, Lake Geneva, 1880
Watercolor on paper, 14 x 22" (35.56 x 55.88 cm.)
Signed, W. S. H., lower left
Gift of Helen Haseltine Plowden, 1952
952-W-102

Childe HASSAM, (1859–1935)

Manhattan's Misty Sunset, 1911
Oil on canvas, 18 x 32" (45.72 x 81.28 cm.)
Signed, Childe Hassam, Sept., 1911, lower left
Museum purchase, 1967
967-O-151

The following twenty-two lithographs on paper
are the gift of Mrs. Childe Hassam, 1940

Afternoon Shadows, 1918
7.5 x 11" (19.05 x 27.94 cm.)
940-P-122

Avenue of the Allies, 1918
14 x 7" (35.56 x 17.78 cm.)
940-P-105

Deshabelle, 1912
12 x 9" (30.48 x 22.86 cm.)
940-P-113

Inner Harbor, 1918
8 x 11.5" (20.32 x 29.21 cm.)
940-P-130

Joseph Pennell, 1917
15 x 11" (38.10 x 27.94 cm.)
940-P-112

Lafayette Street, 1918
15 x 11" (38.10 x 27.94 cm.)
940-P-124

Hartley - Birds of the Bagaduce

Hartley - Apples on Table

Harvey - Resonance Hunting and the Origins of the Specious

Haseltine - Coppet, Lake Geneva

Hassam - Manhattan's Misty Sunset

Hassam - Lafayette Street

Hassam - New York Skyline

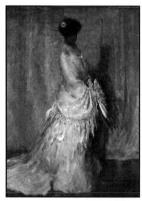

Charles Webster Hawthorne - Girl in Yellow Scarf

Charles Webster Hawthorne - The Adoration of the Mother

Charles Webster Hawthorne - Reflections, Sunny Morning, New Hampshire

Marion Campbell Hawthorne - French Street Scene

Hay - (Untitled) (page 79)

Land of Nod, 1918
9 x 11" (22.86 x 27.94 cm.)
940-P-123

Landscape Land of Nod, 1913
10 x 15" (25.40 x 38.10 cm.)
940-P-108

Little School House, 1918
9 x 12" (22.86 x 30.48 cm.)
940-P-118

Mrs. Hassam Knitting, 1918
12 x 9" (30.48 x 22.86 cm.)
940-P-110

New York Bouquet, 1917
11 x 6.5" (27.94 x 16.51 cm.)
940-P-109

New York Skyline, 1915
8.5 x 15" (21.59 x 38.10 cm.)
940-P-120

New York Skyline, Dark Buildings, 1918
9 x 14" (22.86 x 35.56 cm.)
940-P-106

North River, 1917
14 x 11" (35.56 x 27.94 cm.)
940-P-126

Nude
14 x 9.5" (35.56 x 24.13 cm.)
940-P-107

Red Cross Nurse
10 x 12" (25.40 x 30.48 cm.)
940-P-117

Return of the Fleet, 1918
10 x 14" (25.40 x 35.56 cm.)
940-P-116

St. Thomas, New York, 1918
11 x 8" (27.94 x 20.32 cm.)
940-P-125

Stone Fences, 1918
9 x 12" (22.86 x 30.48 cm.)
940-P-119

The Service Flag, 1915
9 x 6" (22.86 x 15.24 cm.)
940-P-128

The Spar Shop, 1918
11 x 12" (27.94 x 30.48 cm.)
940-P-127

The Wild Cherry Tree, 1913
8 x 12" (20.32 x 30.48 cm.)
940-P-111

The following seven etchings on paper are the gift of Mrs. Childe Hassam, 1940

Madonna of the North End, 1916
7 x 5" (17.78 x 12.70 cm.)
940-P-102

Moonrise at Sunset
5 x 7" (12.70 x 17.78 cm.)
940-P-101

Napoleon Girl, 1928
13 x 9" (33.02 x 22.86 cm.)
940-P-121

New York and the Hudson, 1919
10 x 15" (25.40 x 38.10 cm.)
940-P-114

The Beach, East Hampton, 1921
9 x 14" (22.86 x 35.56 cm.)
940-P-115

The Maidstone Beach Club, 1933
4.5 x 12" (11.43 x 30.48 cm.)
940-P-129

The Nymphs of the Garden, 1923
5 x 12" (12.70 x 30.48 cm.)
940-P-103

Donald R. HAUG, (1925–)

Q S T 4, 1968
Oil on canvas, 12 x 15" (30.48 x 38.10 cm.)
Signed, H. D., 1968, lower left
Museum purchase, 1970
970-O-105

Dudley S. HAWKINS, (1887– ?)

Early Shift, 1950
Oil on canvas, 24 x 30" (60.96 x 76.20 cm.)
Signed, Dudley S. Hawkins, lower right
Gift of Dudley S. Hawkins, 1962
962-O-105

Ted HAWKINS, (active 20th century)

San Jose
Aquatint on paper, 8 x 11" (20.32 x 27.94 cm.)
Signed, Ted Hawkins, lower right
Gift of Edward E. Ford, 1971
971-P-106

Charles Webster HAWTHORNE, (1872–1930)

Girl in Yellow Scarf, 1904
Oil on canvas, 40 x 30" (101.60 x 76.20 cm.)
Signed, C. Hawthorne, upper left
Museum purchase, 1967
967-O-142

The Adoration of the Mother
Oil on canvas, 60 x 48" (152.40 x 121.92 cm.)
Unsigned
Anonymous gift in memory of Mr. and Mrs. Harr, 1957
957-O-114

Reflections, Sunny Morning, New Hampshire
Watercolor on paper, 13.25 x 19.25" (33.66 x 48.90 cm.)
Signed, Charles Hawthorne, lower right
Museum purchase, 1985
985-W-101

Marion Campbell HAWTHORNE, (active early twentieth century)

French Street Scene
Watercolor on paper, 17.5 x 13" (44.45 x 33.02 cm.)
Signed, Marion C. Hawthorne, lower right
Gift of Marion Brenner, 1995
995-W-103

Alex HAY, (active 20th century)

(Untitled), 1973

Serigraph on paper, 12 x 9" (30.48 x 22.86 cm.)
Signed, Alex Hay, lower right
Gift of Steven Feinstein, 1983
983-P-153

Don HAZLITT, (1948–)

Blue Rod, 1989

Mixed oil and assemblage on canvas, 23 x 18.87" (58.42 x
47.94 cm.)
Signed, Don Hazlitt, 1989, on reverse
Gift of Erle L. Flad, 1992
992-O-104

Martin Johnson HEADE, (1819–1904)

Salt Marsh Hay

Oil on canvas, 13 x 26" (33.02 x 66.04 cm.)
Signed, M. J. Heade, lower left
Museum purchase, 1955
955-O-121

Sunset

Oil on canvas, 7 x 18" (17.78 x 45.72 cm.)
Signed, M. J. H., lower left
Gift of the Ernest Rosenfeld Foundation, 1958
958-O-141

William M. HEKKING, (1885–1970)

Fog Horn—Monhegan, 1930

Oil on canvas, 20 x 36" (50.80 x 91.44 cm.)
Signed, W. M. Hekking, lower right
Museum purchase, 1962
962-O-121

Bruce HELANDER, (1947–)

Station Stop, 1991

Watercolor and paper collage on paper, 16 x 11" (40.64 x 27.94
cm.)
Signed, Bruce Helander, lower right
Gift of Bruce Helander, 1992
992-W-102

Phillip HELD, (1920–)

Factory Building

Gouache on paper, 11 x 13.5" (27.94 x 34.29 cm.)
Signed, P. Held, lower right
Gift of Louis Held, 1965
965-W-109

Kansas Farmyard

Gouache on canvas, 11 x 15" (27.94 x 38.10 cm.)
Signed, Phillip Held, lower right
Gift of Louis Held, 1965
965-O-115

John Edward HELIKER, (1909–)

Funeral Procession

Oil on canvas, 9.5 x 8.5" (24.13 x 21.59 cm.)
Unsigned
Gift of Louis Held, 1965
965-O-141

The following three drawings, ink on paper, are a
museum purchase, 1959

Seated Man

11 x 8" (27.94 x 20.32 cm.)
959-D-110

Vermont Potato Digger

8.5 x 7" (21.59 x 17.78 cm.)
959-D-112

Woodchopper

10.5 x 7.5" (26.67 x 19.05 cm.)
959-D-111

HENDERSON, (active 19th century)

The *Monitor* and the *Merrimac*

Ink on paper, 20 x 30" (50.80 x 76.20 cm.)
Signed, H., lower left
Gift of the Association for the Advancement of American Art,
1975
975-P-114

Shirley HENDRICK, (active 20th century)

Woman Arranging Leaves

Oil on canvas, 11 x 9" (27.94 x 22.86 cm.)
Signed, S. Hendrick, lower right
Gift of Louis Held, 1965
965-O-125

Barkley Leonnard HENDRICKS, (1945–)

Tequila

Acrylic on canvas, 60 x 50" (152.40 x 127.00 cm.)
Signed, B. Hendricks, upper right
Museum purchase, 1980
980-O-110

Paul Lewis HENDRICKS, (1904–1956)

Storm Clouds

Watercolor on paper, 15 x 20" (38.10 x 50.80 cm.)
Signed, Paul Lewis Hendricks, lower right
Museum purchase, 1961
961-W-101

Robert HENRI, (1865–1929)

The Little Dancer, 1916–18

Oil on canvas, 40.5 x 32.5" (102.87 x 82.55 cm.)
Signed, Robert Henri, lower right
Museum purchase, 1920
920-O-107

E. L. HENRY, (1841–1919)

The Planet, 1904

Photogravure engraving on paper, 17.75 x 34" (45.09 x 86.36
cm.)
Signed, E. L. Henry, 1904, lower left
Gift of Mrs. W. J. Sampson, 1977
977-P-118

Harry HENSCHE, (1901–1992)

Sketch Portrait of Richard
Anuszkiewicz

Oil on canvas, 16 x 12" (40.64 x 30.48 cm.)
Signed, Hensche, lower right
Gift of Carol Jean Maringer, 1968
969-O-126

David HERSKOVITZ, (active mid-20th
century)

The following two unsigned drawings, brush and
ink on paper, 23.5 x 19" (59.69 x 48.26 cm.), are
a museum purchase, 1967

Pottery Porter, 1961

967-D-112

Heade - Salt Marsh Hay

Heade - Sunset

Held - Factory Building

Barkley Leonnard Hendricks - Tequila

Henri - The Little Dancer

Hertzi - (Untitled)

Hess - Dog

William Victor Higgins - Fiesta Day

Hild - Allegory #5

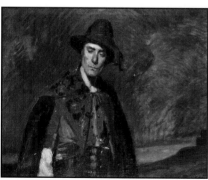

Hildebrandt - Sicilian Bandit

Two Sisters, 1960
967-D-111

Grace C. HERTLEIN, (1924–)

Leaves of Grass
Watercolor on paper, 25 x 19" (63.50 x 48.26 cm.)
Signed, G. C. H., lower right
Museum purchase, 1960
960-W-105

Joseph HERTZI, (active 20th century)

(Untitled)
Acrylic on masonite, 48 x 48" (121.92 x 121.92 cm.)
Unsigned
Gift of Mr. and Mrs. Ronald D. Cullen, 1981
981-O-107

J. N. HESS, (active late 19th century)

Dog, 1885
Oil on canvas, 28 x 39" (71.12 x 99.06 cm.)
Signed, J. N. Hess, 1885, lower left
Museum purchase, 1968
968-O-212

Henry James HEWAT, (1884– ?)

Basket of Fruit and Vegetable
Oil on canvas, 15 x 20" (38.10 x 50.80 cm.)
Unsigned
Gift of the estate of Charles Crandall, 1951
951-O-105

Erik HEYL, (active 20th century)

The following five signed drawings, ink and
watercolor on paper, 3.5 x 7" (8.89 x 15.88 cm.),
are a museum purchase, 1979
979-D-112 — 979-D-116

Fountain City

Granite State

Peerless

Troy

Winslow

Philip Burnham HICKEN, (1910–1985)

Of Things Marine
Serigraph on paper, 12 x 22" (30.48 x 55.88 cm.)
Signed, Hicken, lower right
Museum purchase, 1953
953-P-102

Eugene HIGGINS, (1874–1958)

Murderer
Watercolor and charcoal on paper, 10.5 x 14.5" (26.67 x 36.83
cm.)
Signed, Eugene Higgins, lower right
Gift of Mr. and Mrs. Nahum Tschacbasov, 1979
979-D-118

William Victor HIGGINS, (1884–1949)

Fiesta Day, 1918
Oil on canvas, 52 x 56" (132.08 x 142.24 cm.)
Signed, Victor Higgins, lower left
Museum purchase, 1920
920-O-506

Robert HILD, (1939–)

Allegory #5
Watercolor on paper, 19 x 27" (48.26 x 68.58 cm.)
Signed, Robert Hild, lower right
Museum purchase, 1968
968-W-114

Amish Visit, 1971
Watercolor on paper, 23 x 31" (58.42 x 78.74 cm.)
Unsigned
Museum purchase, 1971
971-W-103

The following two signed silkscreens on paper, 8
x 10" (20.32 x 25.40 cm.), are a museum
purchase, 1967, 1969

Sidersnake
967-P-156

"V" for the Amish
969-P-132

June HILDEBRAND, (1930–)

Contact Sheet, 1965
Silkscreen on paper, 10 x 8" (25.40 x 20.32 cm.)
Signed, June Hildebrand, lower right
Museum purchase, 1965
965-P-317

Howard Logan HILDEBRANDT, (1872–1958)

Sicilian Bandit, 1915
Oil on canvas, 30 x 39" (76.20 x 99.06 cm.)
Signed, Hildebrandt, lower right
Museum purchase, 1918
918-O-105

Hilaire HILER, (1898–1966)

The following two oils on canvas are the gift of
Mr. and Mrs. Nahum Tschacbasov, 1975

The Bridge
18.75 x 23.75" (47.63 x 60.33 cm.)
Unsigned
975-O-138

(Untitled), 1959
18 x 23" (45.72 x 58.42 cm.)
Signed, Hiler, lower right
975-O-139

Kingfisher, 1963
Opaque watercolor on paper, 10.5 x 17" (26.67 x 43.18 cm.)
Signed, Hiler, Paris, 1963, lower right
Gift of Mr. and Mrs. Milton Lowenthal, 1965
965-W-102

Edward Rufus HILL, (1852–1908)

White Mountains, 1886
Oil on canvas, 22 x 30" (55.88 x 76.20 cm.)
Signed, Edward Hill, 86, lower right
Gift of Mr. and Mrs. Paul Wick, 1963
963-O-123

J. W. HILL, (1812–1879)

Boston, 1857
Steel engraving on paper, 24.75 x 38.75" (62.87 x 98.43 cm.)
Unsigned
Museum purchase, 1967
967-P-124

Thomas HILL, (1829–1908)

Bridal Veil Falls, Yosemite, ca. 1870–84
Oil on canvas, 72 x 95" (182.88 x 241.30 cm.)
Signed, T. Hill, lower left
Museum purchase, 1969
969-O-109

HINGQUA PAINTER, (19th century)

Ship: *Flying Childers*, 1859
Oil on canvas, 25 x 32" (63.50 x 81.28 cm.)
Signed, Hong Kong, September, 1859, Hinqua Painter, lower middle
Museum purchase, 1928
S28-O-123

Charles B. HINMAN, (1932–)

Print Collage
New York International: Portfolio of Ten Prints, (210/225)
Serigraph and collage on paper, 22 x 17" (55.88 x 43.18 cm.)
Signed, Hinman, lower right
Museum purchase, 1966
966-P-137.3

Robert E. HINTSA, (active 20th century)

As I Remember
Watercolor on paper, 16.5 x 22" (41.91 x 55.88 cm.)
Signed, Hintsa, lower left
Museum purchase, 1973
973-W-101

Joseph HIRSCH, (1910–1981)

Invocation, 1966-69
Oil on canvas, 90 x 62" (228.60 x 157.48 cm.)
Signed, Joseph Hirsch, lower left
Museum purchase, 1969
969-O-152

Ball Game, 1978
Oil on canvas, 19 x 25" (48.26 x 63.50 cm.)
Signed, Joseph Hirsch, lower left
Museum purchase, 1988
988-O-122

Raphael Soyer and Karen, 1967
Charcoal on paper, 19.75 x 14.75" (50.17 x 37.47 cm.)
Signed, Joseph Hirsch, lower right
Gift of Mr. and Mrs. Carl Dennison, 1977
977-D-112

Ladies in Wading
Color lithograph on paper, 17.5 x 24.5" (44.45 x 62.23 cm.)
Signed, Joseph Hirsch, lower right
Museum purchase, 1967
967-P-171

The Crucifixion
Colored lithograph on paper, 21" dia., (53.34 cm.)
Signed, Joseph Hirsch, lower right
Museum purchase, 1969
969-P-115

The Model
Lithograph on paper, 22 x 9" (55.88 x 22.86 cm.)
Signed, Joseph Hirsch, lower left
Museum purchase, 1962
962-P-120

Albert HIRSCHFELD, (1903–)

The Late George Apley
Ink on paper, 14 x 15" (35.56 x 38.10 cm.)
Signed, Hirschfeld, lower right
Museum purchase, 1959
959-D-118

Milton HIRSCHL, (1917–1981)

Pied Piper, 1951
Woodcut on paper, 15 x 6" (38.10 x 15.24 cm.)
Signed, Milton Hirschl, 51, lower right
Museum purchase, 1951
951-P-104

Claude Raguet HIRST, (1855–1942)

Companions, ca. 1890
Watercolor on illustration board, 10 x 14.5" (25.40 x 36.83 cm.)
Signed, Claude Raguet Hirst, lower right
Museum purchase, 1968
968-W-123

Seascape, 1887
Oil on canvas, 9 x 14" (22.86 x 35.56 cm.)
Signed, Claude R. Hirst, NY, 87, lower left
Gift of Lois Comeau, 1985
986-O-101

Bluebird on a Branch, 1871
Watercolor on paper, 6.5 x 5.25" (16.51 x 13.34 cm.)
Signed, C. R. Hirst, 1871, lower right
Gift of Lois Comeau, 1985
986-W-101

Jacques HNIZDOVSKY, (1915–1985)

New York Subway, 1959
Oil on canvas, 24 x 36" (60.96 x 91.44 cm.)
Signed, Hnizdovsky, 1959, lower left
Museum purchase, 1960
960-O-108

Bouquet, 1964
Woodcut on paper, 15.5 x 19.5" (39.37 x 49.53 cm.)
Signed, Hnizdovsky, Bouquet woodcut, 1964, lower middle
Museum purchase, 1965
965-P-288

City Dwellings, 1962
Pen and ink on paper, 30 x 18" (76.20 x 45.72 cm.)
Signed, Hnizdovsky, 1962, lower middle
Museum purchase, 1962
962-D-155

The Field, 1962
Woodcut on paper, 23 x 38" (58.42 x 96.52 cm.)
Signed, J. Hnizdovsky, lower middle
Museum purchase, 1963
963-P-139

Helen HOCHS, (active 20th century)

Provincetown Interior, 1955
Ink on paper, 27 x 20.75" (68.58 x 52.71 cm.)
Signed, Helen Hochs, lower center
Gift of Jack M. Hackett, 1977
977-D-102

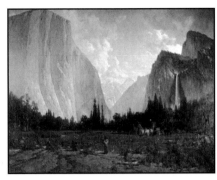

Thomas Hill - Bridal Veil Falls, Yosemite

Hinman - Print Collage

Hirsch - Invocation

Hirsch - Raphael Soyer and Karen

Hirschfeld - The Late George Apley

Hirst - Companions (page 81)

Hirst - Seascape (page 81)

Hoffy - Steamship *Constitution*

Hofmann - McSorley's

Hollingsworth - Boozers

Bill HOEY, (1930–)

Burning Grass, 1962
Oil on canvas, 24 x 30" (60.96 x 76.20 cm.)
Signed, Bill Hoey, 1962, lower right
Museum purchase, 1963
963-O-114

Arnold HOFFMAN, Jr., (1915–1991)

Interplay
Silkscreen on paper, 29 x 23" (73.66 x 58.42 cm.)
Signed, Arnold Hoffman, Jr., lower right
Museum purchase, 1978
978-P-137

Overlook
Silkscreen on paper, 33 x 26" (83.82 x 66.04 cm.)
Signed, Arnold Hoffman, Jr., lower right
Museum purchase, 1978
978-P-127

Irwin D. HOFFMAN, (1901–ca. 1993)

Banana Cutter
Oil on canvas, 30 x 24" (76.20 x 60.96 cm.)
Signed, Irwin D. Hoffman, lower middle
Gift of Victor Miller, 1953
953-O-108

The following two oils on canvas, 24 x 30"
(60.96 x 76.20 cm.), are the gift of Samuel S.
Goldberg, 1953, 1963

Mexican Band
953-O-107

Mexican Scene
963-O-118

Fiesta, 1933
Etching on paper, 9.5 x 12.5" (24.13 x 31.75 cm.)
Signed, Irwin D. Hoffman, lower right
Gift of Norman and June Krafft, 1980
980-P-136

Richard Peter HOFFMAN, (1911–)

Pennsylvania Dutch Farm
Watercolor on paper, 21 x 28" (53.34 x 71.12 cm.)
Unsigned
Museum purchase, 1955
955-W-107

J. D. HOFFY, (active 19th century)

Steamship *Constitution*
Lithograph on paper, 14 x 18" (35.56 x 45.72 cm.)
Unsigned
Museum purchase, 1970
970-P-117

Earl Francis HOFMANN, (active 20th century)

Changing City
Sepia and white ink on paper, 8 x 11" (20.32 x 27.94 cm.)
Signed, E. F. Hofmann, lower right
Museum purchase, 1961
961-D-101

McSorley's, 1938
Colored and white ink on paper, 8 x 11" (20.32 x 27.94 cm.)
Signed, E. Hofmann, 38, McSorley's Ale House, lower left
Museum purchase, 1961
961-D-102

Kate L. HOGUE, (1874–1964)

Across the Street
Oil on canvas, 8 x 10" (20.32 x 25.40 cm.)
Signed, Kate L. Hogue, lower right
Gift of the estate of Kate L. Hogue, 1964
964-O-112

Claus HOIE, (1911–)

St. John, V.I.
Watercolor on paper, 16 x 21" (40.64 x 53.34 cm.)
Signed, Claus Hoie, St. John, V.I., lower right
Gift of Harry Salpeter, 1963
963-W-114

Helen Elna HOKINSON, (1893–1949)

"After all dear, Harry Hansen couldn't
put it down until he'd finished it."
Ink on paper, 13.75 x 21" (34.93 x 53.34 cm.)
Signed, Helen E. Hokinson, lower right
Gift of Mrs. W. J. Sampson, 1977
977-D-101

Serge HOLLERBACH, (1923–)

Man with Folded Hands
Gouache on paper, 35 x 25" (88.90 x 63.50 cm.)
Signed, Hollerbach, lower right
Museum purchase, 1977
977-W-112

Ceylon HOLLINGSWORTH, (active late 19th
century)

The following two signed drawings, ink on
paper, are the gift of Mr. and Mrs. Irving Landau,
1981

Boozers, 1896
12.63 x 13.25" (32.08 x 33.66 cm.)
981-D-101

Spanking
11 x 8.5" (27.94 x 21.59 cm.)
981-D-102

Carl HOLTY, (1900–1973)

Flowers, 1947
Oil on canvas, 30 x 24" (76.20 x 60.96 cm.)
Signed, Carl Holty, lower right
Gift of Mr. and Mrs. Milton Lowenthal, 1965
965-O-177

Study–II
Acrylic on canvas, 11.75 x 7.75" (29.85 x 19.69 cm.)
Signed, Holty, lower right
Gift of Rita A. Orzel in memory of her father Casper Orzel,
1991
991-O-110

Winslow HOMER, (1836–1910)

Snap the Whip, 1872
Oil on canvas, 22 x 36" (55.88 x 91.44 cm.)
Signed, Homer, 1872, lower right
Museum purchase, 1919
919-O-108

Snap the Whip
Graphite pencil on tracing paper, 10 x 20" (25.40 x 50.80 cm.)
Unsigned
Museum purchase, 1941
941-D-102

Snap the Whip, 1873
Wood engraving on paper, 15.75 x 21.75" (40.01 x 55.25 cm.)
Unsigned
Museum purchase, 1963
963-P-131

Four Bullets or Off Duty
Pen and ink on paper, 8 x 14" (20.32 x 35.56 cm.)
Unsigned
Museum purchase, 1958
958-D-103

The following two etchings on paper are a museum purchase, 1958

Eight Bells, 1887
18.75 x 24.25" (47.63 x 61.60 cm.)
958-P-102

The Life Line, 1884
18.75 x 20.5" (47.63 x 52.07 cm.)
958-P-103

The following nineteen wood engravings on paper are an anonymous gift, 1963

1860–1870, 1870–71
13.5 x 20.5" (34.29 x 52.07 cm.)
963-P-129

At Sea–Signalling to a Passing Steamer
8.75 x 11.75" (22.23 x 29.85 cm.)
963-P-133

Bathing at Long Branch, "Oh, Ain't It Cold"
8.75 x 12" (22.23 x 30.48 cm.)
963-P-132

Dad's Coming, 1873
9.25 x 13.75" (23.50 x 34.93 cm.)
963-P-113

Holiday in Camp, 1865
9.75 x 13.75" (24.77 x 34.93 cm.)
963-P-122

Home-ward Bound, 1867
13.5 x 20.5" (34.29 x 52.07 cm.)
963-P-130

Low Tide, 1870
9 x 11.75" (22.86 x 29.85 cm.)
963-P-136

New York Academy of Design, At the Head of the Staircase, 1872–73
9.25 x 13.75" (23.50 x 34.93 cm.)
963-P-115

On the Bluff at Long Branch, 1873
13.75 x 9" (34.93 x 22.86 cm.)
963-P-107

On the Bluff at Long Branch, At the Bathing Hour, 1870
9 x 13.75" (22.86 x 34.93 cm.)
963-P-124

Ship Building, Gloucester Harbor, 1873
9.25 x 13.50" (23.50 x 34.29 cm.)
963-P-111

Spring Farm Work–Grafting, 1870
7 x 9" (17.78 x 22.86 cm.)
963-P-128

Spring Blossoms, 1870
9 x 14" (22.86 x 35.56 cm.)
963-P-126

Station House Lodgers, 1874
9.25 x 13.5" (23.50 x 34.29 cm.)
963-P-118

Tenth Commandment, 1870
11.5 x 9.5" (29.21 x 24.13 cm.)
963-P-137

The Dinner Horn, 1870
13.75 x 9" (34.93 x 22.86 cm.)
963-P-125

The Last Days of Harvest, 1873
9.25 x 13.25" (23.50 x 33.66 cm.)
963-P-114

The Nooning, 1873
9 x 13.75" (22.86 x 34.93 cm.)
963-P-108

Watch Tower, 1874
13.75 x 9.25" (34.93 x 23.50 cm.)
963-P-116

The following eleven wood engravings on paper are a museum purchase, 1963

A Clam Bake, Sea-Side Sketches, 1873
9.25 x 13.75" (23.50 x 34.93 cm.)
963-P-109

Battle of Bunker Hill, 1874–75
9 x 13.75" (22.86 x 34.93 cm.)
963-P-119

Chestnutting
12 x 9" (30.48 x 22.86 cm.)
963-P-135

Fireworks on the Night of the Fourth of July, 1868
9 x 13.75" (22.86 x 34.93 cm.)
963-P-123

Gloucester Harbor, 1873
9.25 x 14" (23.50 x 35.56 cm.)
963-P-110

High Tide
9 x 11.75" (22.86 x 29.85 cm.)
963-P-137

Noon Recess, 1873
9 x 13.75" (22.86 x 34.93 cm.)
963-P-120

The Morning Bell, 1873
9.25 x 13.5" (23.50 x 34.29 cm.)
963-P-112

The Robin's Note, 1870
9 x 9" (22.86 x 22.86 cm.)
963- P-134

The Wreck of the *Atlantic*, 1873
9.25 x 13.75" (23.50 x 34.93 cm.)
963-P-117

Waiting for a Bite, 1874
9 x 13.75" (22.86 x 34.93 cm.)
963-P-121

Homer - Snap the Whip (page 82)

Homer - Snap the Whip (963-P-131)

Homer - Snap the Whip (941-D-102) (page 82)

Homer - Four Bullets or Off Duty

Homer - Eight Bells

Homer - The Life Line

Homer - At Sea–Signalling to a Passing Steamer (page 83)

Homer - Fireworks on the Night of the Fourth of July, 1868 (page 83)

Homer - Waiting for a Bite (page 83)

Homer - A Country Store–Getting Weighed

Homer - Rebels Outside Yorktown

Homer - Winter at Sea, Taking in Sail . . .

A Country Store–Getting Weighed, 1871
Wood engraving on paper, 9 x 11.75" (22.86 x 29.85 cm.)
Unsigned
Anonymous gift, 1964
964-P-111

The following eight wood engravings on paper
are a museum purchase, 1964

Flirting, Sea-shore and Meadow, 1874
9.25 x 13.5" (23.50 x 34.29 cm.)
964-P-108

Our Outlying Picket, the Army of the
Potomac, 1862
7 x 9" (17.78 x 22.86 cm.)
964-P-103

Raid on a Sand Swallow, 1874
13.5 x 9" (34.29 x 22.86 cm.)
964-P-106

Rebels Outside Yorktown, 1862
11 x 9.25" (27.94 x 23.50 cm.)
964-P-104

Seesaw—Gloucester, Mass., 1874
9 x 13.75" (22.86 x 34.93 cm.)
964-P-110

Summit of Mount Washington, 1869
9 x 13.5" (22.86 x 34.29 cm.)
964-P-105

Winter at Sea, Taking in Sail . . ., 1869
9 x 13.75" (22.86 x 34.93 cm.)
964-P-109

Under the Falls, Catskill Mts., 1872
9 x 13.25" (22.86 x 33.66 cm.)
964-P-107

The following seventy-nine wood engravings on
paper are a museum purchase, 1965

A Bivouac Fire on the Potomac, 1861–62
14 x 20" (35.56 x 50.80 cm.)
965-P-241

A Merry Christmas and a Happy New
Year, 1859
14 x 20" (35.56 x 50.80 cm.)
965-P-236

A Parisian Ball–Dancing at the Casino,
1867
9 x 14" (22.86 x 35.56 cm.)
965-P-312

A Parisian Ball–Dancing at the Mabille,
Paris, 1867
9 x 14" (22.86 x 35.56 cm.)
965-P-301

A Shell in the Rebel Trenches, 1863
9 x 14" (22.86 x 35.56 cm.)
965-P-269

A Snow Slide in the City, 1860
9 x 14" (22.86 x 35.56 cm.)
965-P-209

Abraham Lincoln and President
Buchanan, 1861
11 x 9" (27.94 x 22.86 cm.)
965-P-111

Approach of the British Pirate *Alabama*,
1863
14 x 9" (35.56 x 22.86 cm.)
965-P-114

April Showers, 1859–60
6 x 9" (15.24 x 22.86 cm.)
965-P-212

Art Students in the Louvre Gallery, 1868
9 x 14" (22.86 x 35.56 cm.)
965-P-110

August in the Country, 1859–60
9 x 14" (22.86 x 35.56 cm.)
965-P-210

Beach at Long Branch–The Children's
Hour, 1874-75
9 x 13.5" (22.86 x 34.29 cm.)
965-P-297

Cadet Hop at West Point, 1859
9 x 14" (22.86 x 35.56 cm.)
965-P-107

Camping Out in the Adirondack Moun-
tains, 1874
9 x 14" (22.86 x 35.56 cm.)
965-P-302

Charge of the First Massachusetts
Regiment on a Rebel Rifle Pit near
Yorktown, 1862
7 x 9" (17.78 x 22.86 cm.)
965-P-248

Christmas Belles, 1869
9 x 13.5" (22.86 x 34.29 cm.)
965-P-108

Christmas Boxes in Camp, 1862
11 x 9" (27.94 x 22.86 cm.)
965-P-275

Christmas–Gathering Evergreens, 1858
6 x 9" (15.24 x 22.86 cm.)
965-P-226

Christmas Out of Doors, 1858
6 x 9" (15.24 x 22.86 cm.)
965-P-223

Crew of the U.S. Steam-sloop *Colorado*
Shipped at Boston, June, 1861, 1861
9 x 14" (22.86 x 35.56 cm.)
965-P-230

Driving Home the Corn, 1858
6 x 9" (15.24 x 22.86 cm.)
965-P-228

Fall Games–The Apple Bee, 1859
9 x 14" (22.86 x 35.56 cm.)
965-P-213

Filling Cartridges at the United States
Arsenal at Watertown, Mass., 1861
11 x 9" (27.94 x 22.86 cm.)
965-P-224

Great Fair . . . at Assembly Rooms, New
York . . ., 1861
13.5 x 20" (34.29 x 50.80 cm.)
965-P-105

Halt of a Wagon Train, 1864
13 x 20" (33.02 x 50.80 cm.)
965-P-270

Home from the War, 1863
9 x 14" (22.86 x 35.56 cm.)
965-P-268

Horse Racing at Saratoga, 1865
9 x 14" (22.86 x 35.56 cm.)
965-P-265

Husking the Corn in New England, 1858
9 x 14" (22.86 x 35.56 cm.)
965-P-221

Making Hay, 1872
9 x 14" (22.86 x 35.56 cm.)
965-P-295

March Winds, 1859
6 x 9" (15.24 x 22.86 cm.)
965-P-274

Meeting of Congress, Dec. 1857
13.5 x 20" (34.29 x 50.80 cm.)
965-P-262

New England Factory Life–Bell Time,
1868
9 x 14" (22.86 x 35.56 cm.)
965-P-294

News from the War, 1862
13 x 20" (33.02 x 50.80 cm.)
965-P-234

Our Next President, 1868
14 x 9" (35.56 x 22.86 cm.)
965-P-299

Pay-day in the Army . . ., 1863
13.5 x 20" (34.29 x 50.80 cm.)
965-P-271

Picknicking in the Woods, 1858
8 x 11" (20.32 x 27.94 cm.)
965-P-220

Post-Office of the Brooklyn Fair, 1864
14 x 9" (35.56 x 22.86 cm.)
965-P-267

Santa Claus and His Presents, 1858
6 x 9" (15.24 x 22.86 cm.)
965-P-222

Scene in Union Square, 1860
5 x 7" (12.70 x 17.78 cm.)
965-P-311

Seeing the Old Year Out, 1861
14 x 20" (35.56 x 50.80 cm.)
965-P-235

Sharpshooter on Picket Duty, 1862
9 x 14" (22.86 x 35.56 cm.)
965-P-204

Skating at Boston, 1859
9 x 14" (22.86 x 35.56 cm.)
965-P-276

Skating—Pond in the New York Central
Park, 1860
14 x 20" (35.56 x 50.80 cm.)
965-P-247

Spring in the City, 1858
9 x 14" (22.86 x 35.56 cm.)
965-P-217

St. Barnabas House, 1874
9 x 13.5" (22.86 x 34.29 cm.)
965-P-303

St. Valentine's Day . . . , 1868
13.5 x 9" (34.29 x 22.86 cm.)
965-P-298

Supreme Court, New York, 1869
9 x 13.5" (22.86 x 34.29 cm.)
965-P-296

Thanksgiving Day, (2)
(The Dinner, The Dance), 1858
14 x 9" (35.56 x 22.86 cm.)
965-P-113

Thanksgiving Day, 1860–The Two
Great Classes of Society, 1860
14 x 20" (35.56 x 50.80 cm.)
965-P-237

Thanksgiving Day, (2)
(Ways and Means, Arrival at the Old
Home), 1858
14 x 9" (35.56 x 22.86 cm.)
965-P-112

Thanksgiving Day in the Army–After
Dinner: Wishbone, 1865
9 x 14" (22.86 x 35.56 cm.)
965-P-266

Thanksgiving in Camp, 1862
9 x 14" (22.86 x 35.56 cm.)
965-P-216

The Bath at Newport, 1857–58
9 x 14" (22.86 x 35.56 cm.)
965-P-219

The Boston Common, 1857–58
9 x 14" (22.86 x 35.56 cm.)
965-P-218

The Chinese in New York, 1874
14 x 9" (35.56 x 22.86 cm.)
965-P-300

The Christmas Tree, 1858
6 x 9" (15.24 x 22.86 cm.)
965-P-273

The Christmas Tree, 1874
6 x 9" (15.24 x 22.86 cm.)
965-P-227

The Dance After the Husking, 1858
6 x 9" (15.24 x 22.86 cm.)
965-P-229

The Drive in the Central Park, 1860
13.5 x 20.5" (34.29 x 52.07 cm.)
965-P-103

Homer - A Bivouac Fire on the Potomac (page 84)

Homer - A Shell in the Rebel Trenches (page 84)

Homer - Approach of the British Pirate *Alabama* (page 84)

Homer - August in the Country (page 84)

Homer - Charge of the First Massachusetts Regiment . . . (page 84)

Homer - Halt of a Wagon Train

Homer - Skating—Pond in the New York Central Park (page 85)

Homer - Thanksgiving Day in the Army . . . Wishbone (page 85)

Homer - Thanksgiving in Camp (page 85)

Homer - . . . The Empty Sleeve at Newport

Homer - The Great Russian Ball. . .

Homer - The Seventy-ninth Regiment (Highlanders) New York State
Militia

. . . The Empty Sleeve at Newport, 1865
9 x 14" (22.86 x 35.56 cm.)
965-P-264

The Grand Review at Camp, near
Concord, Massachusetts, 1859
14 x 20" (35.56 x 50.80 cm.)
965-P-245

The Great Russian Ball . . ., 1863
13 x 20" (33.02 x 50.80 cm.)
965-P-307

The Match Between Sophs and Fresh-
men–The Opening (College Life), 1857
14 x 20" (35.56 x 50.80 cm.) 5 panels
965-P-239

The Morning Walk–Young Ladies'
School, Promenading the Avenue, 1868
9 x 13.5" (22.86 x 34.29 cm.)
965-P-304

The New Year–1869, 1869
9 x 13.5" (22.86 x 34.29 cm.)
965-P-106

The Russian Ball in the Summer–Rome,
1863
10.5 x 9" (26.67 x 22.86 cm.)
965-P-308

The Seventy-ninth Regiment (Highland-
ers) New York State Militia, 1860-61
9 x 14" (22.86 x 35.56 cm.)
965-P-232

The Sleighing Season, 1860
9 x 14" (22.86 x 35.56 cm.)
965-P-207

The Songs of War, 1861
14 x 20" (35.56 x 50.80 cm.)
965-P-238

The Surgeon at Work at the Rear During
an Engagement, 1862
9 x 14" (22.86 x 35.56 cm.)
965-P-215

The Union Cavalry and Artillery
Starting in Pursuit of the Rebels Up the
Yorktown Turnpike, 1862
9 x 14" (22.86 x 35.56 cm.)
965-P-214

The Union Meetings in the Open Air
Outside the Academy of Music, Dec.
19, 1859, 1860
11 x 9" (27.94 x 22.86 cm.)
965-P-225

The War for the Union, 1862 Bayonet
Charge, 1862
14 x 20" (35.56 x 50.80 cm.)
965-P-242

The War for the Union–A Cavalry
Charge, 1862
14 x 20" (35.56 x 50.80 cm.)
965-P-243

The War–Making Havelocks for the
Volunteers, 1861
11 x 9" (27.94 x 22.86 cm.)
965-P-231

Two are Company–Three are None, 1872
9 x 14" (22.86 x 35.56 cm.)
965-P-263

Winter–A Skating Scene, 1868
9 x 13.5" (22.86 x 34.29 cm.)
965-P-309

Winter Quarters in Camp. . ., 1863
9 x 14" (22.86 x 35.56 cm.)
965-P-310

Illustrations from The Mistress of the
Parsonage, 1860
Wood engravings on paper, (8 small prints)
965-P-233

The following six wood engravings on paper are
a museum purchase, 1967

A Boston Watering Cart
14 x 10" (35.56 x 25.40 cm.)
967-P-128

Emigrant Arrival at Constitution Wharf,
Boston, 1857
14 x 10" (35.56 x 25.40 cm.)
967-P-125

The Coolest Spot in New England—
Summit of Mount Washington, 1870
13.75 x 9" (34.93 x 22.86 cm.)
967-P-170

The Fountain on Boston Common, 1857
14 x 10" (35.56 x 25.40 cm.)
967-P-127

View of South Market St., Boston, 1857
14 x 10" (35.56 x 25.40 cm.)
967-P-126

What Shall We Do Next?, 1869
9 x 13.75" (22.86 x 34.93 cm.)
967-P-169

The following sixteen wood engravings on paper
are a museum purchase, 1968

A Quiet Day in the Woods, 1870
10.5 x 7.5" (26.67 x 19.05 cm.)
968-P-269

All in the Gay and Golden Weather,
1869
4.5 x 7" (11.43 x 17.78 cm.)
968-P-276

Blindman's Bluff, 1857
7 x 4.5" (17.78 x 11.43 cm.)
968-P-271

Deer Stalking in the Adirondacks in
Winter, 1871
12 x 9" (30.48 x 22.86 cm.)
968-P-278

Family Party Playing at Fox and Geese,
1857
7 x 4.5" (17.78 x 11.43 cm.)
968-P-272

Husking Party Finding the Red Ears,
1857
9.37 x 6.5" (23.82 x 16.51 cm.)
968-P-273

Low Tide, 1870
12 x 9" (30.48 x 22.86 cm.)
968-P-277

Lumbering In Winter, 1871
9 x 12" (22.86 x 30.48 cm.)
968-P-281

Summer in the Country, 1869
7 x 4.5" (17.78 x 11.43 cm.)
968-P-275

Swinging on a Birch Tree, 1867
4.5 x 7" (11.43 x 17.78 cm.)
968-P-266

The Beach at Long Branch, 1869
12.75 x 19.75" (32.39 x 50.17 cm.)
968-P-284

The Bird Catchers, 1867
7 x 4.5" (17.78 x 11.43 cm.)
968-P-268

The Fishing Party, 1869
12.5 x 9" (31.75 x 22.86 cm.)
968-P-280

The Last Load, 1869
7 x 4.5" (17.78 x 11.43 cm.)
968-P-274

The Picnic Excursion, 1869
9.12 x 6.5" (23.18 x 16.51 cm.)
968-P-282

The Strawberry Bed, 1868
4.5 x 7" (11.43 x 17.78 cm.)
968-P-265

The following five wood engravings on paper are
the gift of Gordon R. Allison, 1968

Chestnutting, 1870
9 x 16" (22.86 x 40.64 cm.)
968-P-279

Coasting Out of Doors, 1857
4.5 x 7" (11.43 x 17.78 cm.)
968-P-267

Thanksgiving Day–Hanging up the
Musket, 1865
14.25 x 9.25" (36.20 x 23.50 cm.)
968-P-305

Thanksgiving Day–The Church Porch,
1865
14 x 9.25" (35.56 x 23.50 cm.)
968-P-306

Watching the Crows, 1868
7 x 4.5" (17.78 x 11.43 cm.)
968-P-270

The following thirty-one wood engravings on
paper are a museum purchase, 1970

Army of the Potomac Sleeping on Their
Arms, 1864
16 x 22" (40.64 x 55.88 cm.)
970-P-144

. . . At Washington, . . . The Inaugural
Procession, (Lincoln's), 1861
11 x 16" (27.94 x 40.64 cm.)
970-P-132

Boston Street Characters, 1859
11 x 16" (27.94 x 40.64 cm.)
970-P-146

Captain Robert B. Forbes, 1859
11 x 16" (27.94 x 40.64 cm.)
970-P-147

Chime of 13 Bells, Christ Church,
Cambridge, 1860
11 x 16" (27.94 x 40.64 cm.)
970-P-123

Colonel Wilson of Wilson's Brigade, 1861
7 x 10.5" (17.78 x 26.67 cm.)
970-P-137

Corner of Winter, Washington and
Summer Streets, Boston, Mass., 1860
7 x 9.5" (17.78 x 24.13 cm.)
970-P-161

Expulsion of Negroes and Abolitionists
from Tremont Temple, Boston, 1860
10 x 8" (25.40 x 20.32 cm.)
970-P-124

Flag Office, Stringham, 1861
11 x 16" (27.94 x 40.64 cm.)
970-P-139

Floral Department of the Great Fair, 1864
11 x 16" (27.94 x 40.64 cm.)
970-P-143

Fourth of July on Boston Common, 1859
11 x 16" (27.94 x 40.64 cm.)
970-P-145

General Beauregard, 1861
11 x 16" (27.94 x 40.64 cm.)
970-P-135

General Thomas Swearing in the
Volunteers, 1861
11 x 16" (27.94 x 40.64 cm.)
970-P-134

Great Sumter Meeting in Union Square,
New York City, April 11,1863
11 x 16" (27.94 x 40.64 cm.)
970-P-140

Hon. Abraham Lincoln . . . , 1860
11 x 16" (27.94 x 40.64 cm.)
970-P-130

Hon. Eliha B. Washburne . . . , 1860
9.5 x 6.25" (24.13 x 15.88 cm.)
970-P-125

Hon. J. L. M. Curry . . . , 1860
11 x 16" (27.94 x 40.64 cm.)
970-P-128

May Day in the Country, 1859
11 x 16" (27.94 x 40.64 cm.)
970-P-126

Mdlle. Maria Piccolomini, 1858
11 x 16" (27.94 x 40.64 cm.)
970-P-122

Homer - The Sleighing Season (page 86)

Homer - The Surgeon at Work at the Rear . . . (page 86)

Homer - The War for the Union, 1862 Bayonet Charge (page 86)

Homer - The War for the Union—A Cavalry Charge (page 86)

Homer - Winter—A Skating Scene (page 86)

Homer - Winter Quarters in Camp . . . (page 86)

Homer - Chestnutting (page 87)

Homer - Coasting Out of Doors (page 87)

Homer - Expulsion . . . from Tremont Temple, Boston (page 87)

Homer - Hon. Abraham Lincoln (page 87)

Homer - The Late Chief-Justice Roger B. Taney

Our Women and the War, 1982
16 x 22" (40.64 x 55.88 cm.)
970-P-141

Presidents Buchanan and Lincoln
Entering the Senate Chamber . . . , 1861
8 x 11" (20.32 x 27.94 cm.)
970-P-133

The Aquarial Gardens . . . Boston, 1859
11 x 16" (27.94 x 40.64 cm.)
970-P-148

The Georgia Delegation in Congress,
1861
11 x 16" (27.94 x 40.64 cm.)
970-P-150

The Inaugural Procession, (Lincoln's). .
. At Washington, . . . , 1861
11 x 16" (27.94 x 40.64 cm.)
970-P-132

The Late Chief-Justice Roger B. Taney,
1860
11 x 16" (27.94 x 40.64 cm.)
970-P-129

The Late Dr. Murray
6.5 x 8" (16.51 x 20.32 cm.)
970-P-136

The Seceding Alabama Delegation in
Congress, 1861
11 x 16" (27.94 x 40.64 cm.)
970-P-131

The Seceding Mississippi Delegation,
1861
11 x 16" (27.94 x 40.64 cm.)
970-P-151

The Seceding South Carolina Delega-
tion, 1860
11 x 16" (27.94 x 40.64 cm.)
970-P-149

The Skating Season, 1862
11 x 16" (27.94 x 40.64 cm.)
970-P-142

U.S. Army Crossing Long Bridge over
the Potomac at 2 A.M. on May 24, 1861
11 x 16" (27.94 x 40.64 cm.)
970-P-138

Welcome to the Prince of Wales, 1860
11 x 16" (27.94 x 40.64 cm.)
970-P-127

The following two wood engravings on paper are
a museum purchase, 1972

The Family Record, 1875
13 x 9" (33.02 x 22.86 cm.)
972-P-117

A Winter Morning–Shovelling Out, 1871
9 x 11.75" (22.86 x 29.85 cm.)
972-P-116

The following ten wood engravings on paper are
a museum purchase, 1973

A Quiet Day in the Woods, 1870
10.5 x 7.5" (26.67 x 19.05 cm.)
973-P-125

Chestnutting, 1870
15 x 11" (38.10 x 27.94 cm.)
973-P-130

Danger Ahead, 1870
10.5 x 7.5" (26.67 x 19.05 cm.)
973-P-127

Gathering Berries, 1874
11 x 15.5" (27.94 x 39.37 cm.)
973-P-132

Picnicking in the Woods, 1869
8 x 11" (20.32 x 27.94 cm.)
973-P-126

Raid on a Sand-Swallow Colony–How
Many Eggs, 1874
16 x 11" (40.64 x 27.94 cm.)
973-P-134

Seesaw, Gloucester, Massachusetts, 1874
11 x 15.5" (27.94 x 39.37 cm.)
973-P-131

Summer in the Country, 1869
6 x 8" (15.24 x 20.32 cm.)
973-P-128

The Robin's Note, 1870
15 x 11"(38.10 x 27.94 cm.)
973-P-129

Waiting for a Bite, 1874
11 x 15.5" (27.94 x 39.37 cm.)
973-P-133

Boston Evening, Street Scene, 1857
Wood engraving on paper, 6.5 x 9.5" (16.51 x 24.13 cm.)
Anonymous gift, 1980
980-P-118

The Bright Side
Wood cut on paper, 2.75 x 3.75" (6.99 x 9.53 cm.)
Anonymous gift, 1980
980-P-120

Army Teamsters, 1866
Chromolithograph on paper, 17.75 x 28" (45.09 x 71.12 cm.)
Museum purchase, 1968
968-P-122

Civil War, 1864
Lithographs on paper, (set of 11), each 3.75 x 2.25" (9.53 x
5.72 cm.)
Museum purchase, 1965
965-P-102

Civil War, 1864
Lithographs on paper, (set of 12), each 3.75 x 2.25" (9.53 x
5.72 cm.)
Museum purchase, 1965
965-P-101

The following three collections of wood
engravings on paper are a museum purchase,
1969

Illustrations, 1866, 1870, 1871
969-P-111, 969-P-112, and 969-P-110

Winslow HOMER, (1836–1910), **and A.R. WAND**, (active 19th century)

Our Army Before Yorktown, Virginia, 1862
Wood engraving on paper, 14 x 20" (35.56 x 50.80 cm.)
Unsigned
Museum purchase, 1965
965-P-244

Gerrit HONDIUS, (1891–1970)

Fantasy
Oil on canvas, 30 x 24" (76.20 x 60.96 cm.)
Signed, Hondius, lower right
Gift of Paula Hondius, 1972
972-O-102

Figures
Oil on canvas, 24 x 30" (60.96 x 76.20 cm.)
Unsigned
Gift of Samuel B. Brouner, 1957
957-O-115

The following nine drawings on paper of various sizes are the gift of Paula Hondius, 1975

Birds
975-D-107

Dutch Acrobat
975-D-104

Harbour
975-D-103

Harlequin
975-D-105

Head of a Girl
975-D-101

Head of Man
975-D-109

Man and Woman
975-D-102

People Walking
975-D-106

Sad Clown
975-D-108

Walter HOOK, (1919–)

Banner of Medals, 1966
Opaque watercolor and collage on paper, 28.25 x 20.75" (71.76 x 52.71 cm.)
Signed, Walter Hook, 1966, lower right
Museum purchase, 1967
967-W-104

Before the Barn
Watercolor on paper, 20 x 28" (50.80 x 71.12 cm.)
Signed, Walter Hook, lower right
Museum purchase, 1958
958-W-108

Even Dozen, 1968
Watercolor on paper, 20 x 28.25" (50.80 x 71.76 cm.)
Signed, Walter Hook, lower left
Museum purchase, 1968
968-W-132

Ivan HOON, (1890– ?)

Quaker Valley Mine, 1938
Oil on masonite, 24 x 30" (60.96 x 76.20 cm.)
Signed, Ivan Hoon, upper left
Gift of John J. Benninger, 1977
977-O-165

Sunday Morning, 1939
Oil on canvas, 20 x 24" (50.80 x 60.96 cm.)
Signed, Ivan Hoon, upper left
Gift of John J. Benninger, 1977
977-O-164

James HOPE, (1818–1892)

Tower Gorge, 1871
Oil on canvas, 30 x 24" (76.20 x 60.96 cm.)
Signed, J. Hope, lower right
Museum purchase, 1968
968-O-157

Ernest HOPF, (1910–)

Normandy, 1942
Silkscreen on paper, 14 x 18" (35.56 x 45.72 cm.)
Unsigned
Gift of Louis Held, 1965
965-P-149

Edward HOPPER, (1882–1967)

Pennsylvania Coal Town, 1947
Oil on canvas, 28 x 40" (71.72 x 101.60 cm.)
Signed, Edward Hopper, lower left
Museum purchase, 1948
948-O-115

Shoshone Cliffs, Wy., 1941
Watercolor on paper, 20 x 25" (50.80 x 63.50 cm.)
Signed, Edward Hopper, lower right
Museum purchase, 1954
954-W-112

House in Charleston, S.C.
Charcoal on paper, 15 x 22" (38.10 x 55.88 cm.)
Signed, Edward Hopper, lower right
Museum purchase, 1959
959-D-121

American Landscape
Etching on paper, 7.25 x 12.25" (18.42 x 31.12 cm.)
Signed, Edward Hopper, lower right
Gift of Albert E. Hise, 1979
979-P-161

The Monhegan Boat
Etching on paper, 6.87 x 8.87" (17.46 x 22.54 cm.)
Signed, Edward Hopper, lower right
Gift of Mrs. Paul W. Schumacher in memory of Paul W. Schumacher, 1971
971-P-108

The following two etchings on paper are a museum purchase, 1955

East Side Interior, 1955
8 x 10" (20.32 x 25.40 cm.)
955-P-106

The Cat Boat
8 x 10" (20.32 x 25.40 cm.)
955-P-111

Hope - Tower Gorge

Hopper - Pennsylvania Coal Town

Hopper - Shoshone Cliffs, Wy.

Hopper - American Landscape

Hopper - The Monhegan Boat

Hopper - East Side Interior

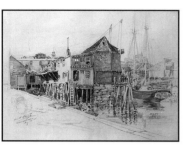
Hornby - Fishing Shack

Hudson - Monhegan Fish House

Humphrey - Loner

Willliam Morris Hunt - The Forge

William Morris Hunt - A Brown Study

The following two etchings on paper are a museum purchase, 1958

Cows and Rocks
7 x 8" (17.78 x 20.32 cm.)
958-P-109

Girl on a Bridge
7 x 9" (17.78 x 22.86 cm.)
958-P-110

Lester George HORNBY, (1882–1956)

Fishing Shack, 1905
Pencil on paper, 13 x 18" (33.02 x 45.72 cm.)
Signed, L. G. Hornby, Gloucester, Aug. 10, 05, lower left
Museum purchase, 1970
970-D-101

Faneuil Hall from Quincy Market, 1920
Etching on paper, 8.5 x 9.5" (21.59 x 24.13 cm.)
Signed, L. G. Hornby, lower right
Museum purchase, 1975
975-P-133

Amy HOSA, (active 20th century)

The Golden Agers, 1972
Watercolor on paper, 25 x 17.5" (63.50 x 44.45 cm.)
Signed, Amy Hosa, lower right
Museum purchase, 1973
973-W-106

Klindt HOULBERG, (1937–)

Winnebago Family, 1962
Intaglio print on paper, 18 x 23.5" (45.72 x 59.69 cm.)
Signed, Klindt Houlberg, 1962, lower right
Museum purchase, 1965
965-P-254

Russell F. HOUSMAN, (1928–)

Glaciers—Understructure
Oil on canvas, 36 x 24" (91.44 x 60.96 cm.)
Signed, Housman, lower left
Gift of Russell F. Housman, 1985
985-O-102

Thomas HOVENDEN, (1840–1895)

Helen Corson Hovenden
Pencil on gray paper, 11 x 7.25" (27.94 x 18.42 cm.)
Unsigned
Museum purchase, 1968
968-D-117

Charlotte HOWARD, (active 20th century)

Cats in Snow, 1951
Oil on canvas, 29 x 29" (73.66 x 73.66 cm.)
Signed, C. Howard, 51, lower left
Museum purchase, 1954
954-O-121

The Butler Institute's collection contains fourteen signed watercolors on paper of various sizes which are the gift of Charlotte Howard, 1991
991-W-146 — 991-W-159

The Butler Institute's collection contains twelve drawings, drypoint on paper of various sizes, which are the gift of Charlotte Howard, 1991
991-P-109 — 991-P-120

Michael HUBERT, (1939–)

Relegation for Tomorrow, 1966
Oil on panel, 31 x 40" (78.74 x 101.60 cm.)
Signed, Michael Hubert, lower right
Museum purchase, 1967
967-O-115

Robert E. HUCK, (1923–1961)

Italian Camera Men, 1955
Woodcut on paper, 15 x 23" (38.10 x 58.42 cm.)
Signed, Robert Huck, 1955, lower right
Museum purchase, 1956
956-P-104

Eric HUDSON, (1864–1932)

Monhegan Fish House
Oil on canvas, 28 x 34" (71.12 x 86.36 cm.)
Unsigned
Gift of Mrs. Eric Hudson, 1940
940-O-102

Gregory Stewart HULL, (1950–)

The Musician, 1984
Oil on canvas, 40 x 30" (101.60 x 76.20 cm.)
Signed, Hull, lower right
Gift of Gregory Stewart Hull, 1985
985-O-109

Ralph J. HUMPHREY, (1932–1990)

Loner
Casein and modeling paste on plywood, 60.25 x 37.25" (153.04 x 94.62 cm.)
Unsigned
Museum purchase, 1983
983-O-104

The Man with the Green Eyes
Oil on canvas board, 24 x 18" (60.96 x 45.72 cm.)
Unsigned
Gift of Lois Elser, 1994
994-O-118

(Untitled)
Oil on panel, 23.87 x 18.87" (60.64 x 47.94 cm.)
Signed, Humphrey, lower right
Gift of Paula Miller, 1985
985-O-101

Chet J. HUNT, (1913–)

Entrance to the Butler Institute of American Art, 1969
Drawing on paper, 10.5 x 12" (26.67 x 30.48 cm.)
Signed, C. J. Hunt, lower right
Gift of Chet J. Hunt, 1969
969-D-104

William Morris HUNT, (1824–1879)

The Forge
Oil on canvas, 26 x 20" (66.04 x 50.80 cm.)
Unsigned
Museum purchase, 1952
952-O-101

A Brown Study, ca. 1870
Wood engraving on paper, 13.75 x 9" (34.93 x 22.86 cm.)
Unsigned
Anonymous gift, 1963
963-P-105

Mel HUNTER, (1927–)

The following eleven color lithographs on paper, 22 x 30" (55.88 x 76.20 cm.), are the gift of Samuel S. Mandel, 1986

Appaloosa, 1974
986-P-147

Arabian, 1974
986-P-150

Country Games, 1972
986-P-139

Hunter–Jumper, 1972
986-P-154

Morgan
986-P-155

Pinto, 1974
986-P-146

Quarter Horse, 1974
986-P-152

Saddlebred
986-P-148

Standard Bred, 1974
986-P-151

Tennessee Walker, 1974
986-P-153

Thoroughbred, 1974
986-P-149

The Butler Institute's collection contains eighteen color lithographs on paper, 22 x 30" (55.88 x 76.20 cm.), which are the gift of Samuel S. Mandel, 1989
989-P-119 — 989-P-136

Lynne HUNTING, (ca. 1920–)

La Porte Abricot, 1962
Oil on unground masonite, 24 x 16" (60.96 x 40.64 cm.)
Unsigned
Gift of Lynne Hunting, 1962
962-O-124

Victoria Ebbels Hutson HUNTLEY, (1900–1971)

The following two signed lithographs on paper are the gift of Norman and June Krafft, 1980

Steam, 1958
12.5 x 19" (31.75 x 48.26 cm.)
980-P-148

Window
16 x 11.5" (40.64 x 29.21 cm.)
980-P-149

Peter HURD, (1904–1984)

Sermon from Revelations
Lithograph on paper, 10 x 13.5" (25.40 x 34.29 cm.)
Signed, Peter Hurd, lower right
Museum purchase, 1967
967-P-109

Harry HURWITZ, (1938–)

My Father
Ink and wash on paper, 7.75 x 7.75" (19.69 x 19.69 cm.)
Signed, Hurwitz, lower right
Museum purchase, 1963
963-D-101

Frank Townsend HUTCHENS, (1869–1937)

Entrance to the Forest
Oil on canvas, 25 x 21" (63.50 x 53.34 cm.)
Unsigned
Gift of the estate of Mrs. Arthur McGraw, 1951
951-O-106

Alfred Heber HUTTY, (1877–1954)

Berkshire Willows
Etching on paper, 11.5 x 14" (29.21 x 35.56 cm.)
Signed, Alfred Hutty, lower right
Gift of Charles Owsley, 1984
984-P-108

Trees
Etching on paper, 8 x 9.5" (20.32 x 24.13 cm.)
Signed, Alfred Hutty, lower right
Gift of the estate of Charles Crandall, 1951
951-P-102

Lori HYLER, (active late 20th century)

(Untitled)
Portfolio of 53: Rip Off on the Last Millennium
Print on paper, 8.5 x 11" (21.59 x 27.94 cm.)
Signed, Lori Hyler, lower right
Gift of the William Busta Gallery, 1990
990-P-111.23

ILLMAN BROTHERS, (active 19th century)

Washington at the Battle of Trenton
Steel engraving on paper, 21 x 17" (53.34 x 43.18 cm.)
Unsigned
Museum purchase, 1975
975-P-120

Robert INDIANA, (1928–)

Love Crosses, 1968
Serigraph on paper, 28.5 x 22.5" (72.39 x 57.15 cm.)
Signed, R. Indiana, 68, lower right
Museum purchase, 1969
969-P-116

George INNESS, (1825–1894)

Hazy Morning, Montclair, New Jersey, 1893
Oil on canvas, 30 x 50" (76.20 x 127.00 cm.)
Signed, G. Inness, 1893, lower right
Museum purchase, 1928
928-O-101

Durham, Connecticut, ca. 1880
Oil on canvas, 15.5 x 23.75" (39.37 x 60.32 cm.)
Signed, George Inness, lower right
Gift of the estate of Frances Hopper, 1970
970-O-111

Landscape
Watercolor on paper, 6.5 x 4.5" (16.51 x 11.43 cm.)
Unsigned
Gift of Sara Jane Peterson, 1989
989-W-105

Hunter - Appaloosa

Hurd - Sermon from Revelations

Illman Brothers - Washington at the Battle of Trenton

Indiana - Love Crosses

Inness - Hazy Morning, Montclair, New Jersey

Inness - Durham, Connecticut

Inness - Landscape (page 91)

Inness - Sunset in the Old Orchard, Montclair

Ipsen - Portrait of Joseph G. Butler as a Boy

Ipsen - White and Pure Gold

Ireland - Blue Room

Landscape with Sheep
Lithograph on paper, 12 x 10" (30.48 x 25.40 cm.)
Unsigned
Gift of the estate of Charles Crandall, 1951
951-P-103

Sunset in the Old Orchard, Montclair, 1894
Oil on canvas, 30 x 45" (76.20 x 114.30 cm.)
Signed, G. Inness, 1894, lower right
Gift of Dr. John J. McDonough, 1970
970-O-101

Thomas F. INSALACO, (active late 20th century)

Leslie at the Park, 1972–73
Oil on canvas, 68 x 56" (172.72 x 142.24 cm.)
Signed, Thomas F. Insalaco, lower right
Museum purchase, 1974
974-O-111

Ernest L. IPSEN, (1869–1951)

Mister Antonio, 1923
Oil on canvas, 86 x 44" (218.44 x 111.76 cm.)
Signed, E. L. Ipsen, 1923, lower left
Museum purchase, 1923
923-O-105

Portrait of Joseph G. Butler as a Boy, 1918
Oil on canvas, 32 x 25" (81.28 x 63.50 cm.)
Signed, E. L. Ipsen, 1918, upper left
Gift of Dr. Arthur B. McGraw, 1951
951-O-107

White and Pure Gold, 1915
Oil on canvas, 84 x 48" (213.36 x 121.92 cm.)
Signed, E. L. Ipsen, 1915, lower right
Museum purchase, 1921
921-O-105

Patrick IRELAND, (1935–)

Blue Room, (Rope Drawing #70), 1983
Pencil and ink on paper, 26 x 40" (66.04 x 101.60 cm.)
Signed, Patrick Ireland, 1983, lower right
Gift of Louis A. Zona, 1994
994-D-101

Nicholas ISAAK, Jr., (1944–)

Game Piece
Black and white etching on paper, 18 x 14" (45.72 x 35.56 cm.)
Signed, Nicholas Isaak, lower right
Museum purchase, 1969
969-P-105

Yukihisa ISOBE, (1936–)

(Untitled)
Silkscreen on paper, (poster, ed. 100), 16 x 20" (40.64 x 50.80 cm.)
Unsigned
Gift of American Federation of Arts, 1967
967-P-158

Ralph Shigeto IWAMOTO, (1927–)

Eastern Twilight, 1957
Oil on canvas, 36 x 50" (91.44 x 127.00 cm.)
Signed, Iwamoto, 57, lower right
Museum purchase, 1957
957-O-116

Kathryn JABLONSKI, (1936–)

Water Line
Oil on canvas, 24 x 36" (60.96 x 91.44 cm.)
Signed, Jablonski, upper left
Museum purchase, 1959
959-O-112

Billy Morrow JACKSON, (1926–)

Today Is
Oil on canvas, 42 x 66" (106.68 x 167.64 cm.)
Signed, B. M. Jackson, lower right
Museum purchase, 1966
966-O-116

Image
Watercolor on paper, 24 x 18" (60.96 x 45.72 cm.)
Signed, Bill Jackson, lower right
Gift of the Friends of American Art, 1963
963-W-111

Collection
Lithograph on paper, 20 x 12" (50.80 x 30.48 cm.)
Signed, B. M. Jackson, lower right
Museum purchase, 1965
965-P-205

Lee JACKSON, (1909–)

The Remnants Shop, ca. 1946
Oil on canvas, 20 x 16" (50.80 x 40.64 cm.)
Unsigned
Gift of Adele Jackson, 1969
969-O-118

Martin JACKSON, (1919–)

Toy Battle
Oil on canvas, 26 x 38" (66.04 x 96.52 cm.)
Signed, Martin Jackson, lower left
Museum purchase, 1953
953-O-116

Antonio JACOBSEN, (1850–1921)

Navahoe, Clyde Steamship Co., 1898
Oil on canvas, 22 x 36" (55.88 x 91.44 cm.)
Signed, A. Jacobsen, lower right
Museum purchase, 1968
968-O-161

Steamer *Kroonland,* (Red Star Line), 1903
Oil on canvas, 30 x 50" (76.20 x 127.00 cm.)
Signed, A. Jacobsen, lower left
Museum purchase, 1977
977-O-154

Bonnie JACOBSON, (active late 20th century)

(Untitled)
Portfolio of 53: Rip Off on the Last Millennium
Print on paper, 8.5 x 11" (21.59 x 27.94 cm.)
Signed, Bonnie Jacobson, lower right
Gift of the William Busta Gallery, 1990
990-P-111.43

Ellen T. JAGOW, (1920–)

Nature's Flags Flying, 1969
Oil on canvas, 36 x 36" (91.44 x 91.44 cm.)
Signed, Jagow, lower right
Museum purchase, 1969
969-O-131

Hazel JANICKI, (1918–1977)

Weavers of a Spell, 1950

Egg tempera on paper, 20 x 28" (50.80 x 71.12 cm.)
Signed, Hazel Janicki, 1950, lower right
Museum purchase, 1951
951-W-108

Fragment of a Portrait

Pencil and collage on paper, 16 x 24" (40.64 x 60.96 cm.)
Signed, Hazel Janicki, lower left
Museum purchase, 1973
973-D-103

James JARVAISE, (1925–)

Arrangement on a Blue Table

Oil on canvas, 37 x 58" (93.98 x 147.32 cm.)
Signed, Jarvaise, lower right
Museum purchase, 1955
955-O-122

William Martin JEAN, (active 20th century)

Domus Series V

Acrylic on linen, 48 x 48" (121.92 x 121.92 cm.)
Unsigned
Museum purchase, 1990
990-O-102

Elsie JECT-KEY, (active 20th century)

Variation on a Theme, 1966

Watercolor on paper, 26 x 23.25" (66.04 x 59.06 cm.)
Signed, Elsie Ject-Key, lower right
Museum purchase, 1967
967-W-106

Paul JENKINS, (1923–)

Side of St. George, 1968

Oil on canvas, 37 x 60" (93.98 x 152.40 cm.)
Signed, Paul Jenkins, lower left
Gift of David Kluger, 1968
968-O-205

Phenomena Anvil Compass, 1981–83

Acrylic on canvas, 75 x 150" (190.50 x 381.00 cm.)
Signed, Paul Jenkins, lower left
Gift of Paul Jenkins, 1984
984-O-102

Nadyne Herrick with Gulls and Sea, 1985

Acrylic and collage on paper, 22 x 29.5" (55.88 x 74.93 cm.)
Signed, Paul Jenkins, lower left
Gift of Paul and Suzanne Donnelly Jenkins, 1990
990-O-107

Phenomena Phoenix Overhead, 1969

Oil on canvas, 47 x 66.75" (119.38 x 169.55 cm.)
Signed, Jenkins, lower right
Gift of Dr. Robert Meadow, 1973
973-O-129

Phenomena Tantric Mantle, 1981

Collage on canvas, 41 x 78" (104.14 x 198.12 cm.)
Signed, Paul Jenkins, 1981, lower left
Gift of Max and Fran Weitzenhoffer, 1988
988-O-118

The following two signed acrylics on canvas are the gift of Paul and Suzanne Donnelly Jenkins, 1988

Phenomena Imago Mantle, 1974

50 x 53" (127.00 x 134.62 cm.)
988-O-125

Phenomena Windjammer Windbrace, 1973–74

50 x 75" (127.00 x 190.50 cm.)
988-O-124

Mandala Self-Portrait, 1981

Lithograph on stone with silkscreen on paper, (11/44), 38 x 29.25" (96.52 x 74.30 cm.)
Signed, Paul Jenkins, 11/44, 1981, lower left
Gift of Paul and Suzanne Donnelly Jenkins, 1991
991-P-127

Red Parrot, 1964

Lithograph on paper, (45/65), 32 x 22" (81.28 x 55.88 cm.)
Signed, Paul Jenkins, 45/65, 1964, lower left
Museum purchase, 1969
969-P-117

(Untitled), 1973

Colored lithograph on paper, 20.5 x 26" (52.07 x 66.04 cm.)
Signed, Paul Jenkins, lower right
Gift of Joseph G. Butler, III, 1975
975-P-116

(Untitled), 1981

Lithograph on paper, 38 x 29.5" (96.52 x 74.93 cm.)
Signed, Paul Jenkins, lower left
Gift of Paul Jenkins, 1984
984-P-101

(Untitled), 1976

Lithograph on paper, 40.25 x 27.62" (102.24 x 70.17 cm.)
Signed, Paul Jenkins, 1976, lower right
Gift of Paul and Suzanne Donnelly Jenkins, 1991
991-P-126

The following four signed lithographs on paper, 28 x 20" (71.12 x 50.80 cm.), (20/20), are the gift of Paul and Suzanne Donnelly Jenkins, 1990

Post Meridian Suite, 1966

990-P-103, 990-P-103.2, 990-P-103.3, and 990-P-103.4

The following two signed prints on paper, 19.75 x 13.75" (50.17 x 34.93 cm.), are the gift of Paul and Suzanne Donnelly Jenkins, 1991

As Above So Below, 1991

991-P-128

High Level of State One

991-P-129

The following two signed lithographs on paper, 41.5 x 29.5" (105.41 x 74.93 cm.), are the gift of Paul and Suzanne Donnelly Jenkins, 1993

(Untitled), (2), 1987

993-P-150 — 993-P-151

Alfred JENSEN, (1903–1981)

Faith in the Future

Silkscreen on paper, (76/100), 23.5 x 23.5" (59.69 x 59.69 cm.)
Signed, Alfred Jensen, lower right
Gift of American Fine Arts, 1967
967-P-154

Jean - Domus Series V

Jenkins - Side of St. George

Jenkins - Phenomena Anvil Compass

Jenkins- Nadyne Herrick with Gulls and Sea

Jenkins - Phenomena Phoenix Overhead

Jensen - Faith in the Future

Jewett - Ship: *Huntress*

Johns - Souvenir I

Johns - Summer

Eastman Johnson - Feather Duster Boy

Eastman Johnson - Joseph Warren

Sidney JEROME, (1923–)

Pennsylvania Coal Mine Country, 1958–1964
Oil on canvas, 19 x 23" (48.26 x 58.42 cm.)
Signed, Sidney Jerome, lower left and Sid Jerome, lower right
Gift of Margaret Jerome, 1977
977-O-117

Gypsy Festival
Ink on paper, 4.25 x 10.75" (10.80 x 27.31 cm.)
Signed, Sid Jerome, lower right
Gift of Margaret Jerome, 1978
978-D-107

W. S. JEWETT, (1823– ?)

Ship: *Huntress*, 1855
Oil on canvas, 28 x 42" (71.12 x 106.68 cm.)
Signed, W. S. Jewett, lower right
Museum purchase, 1928
S28-O-124

Jasper JOHNS, (1930–)

Recent Still Life, 1965
Lithograph on paper, (poster) 35 x 20" (88.90 x 50.80 cm.)
Signed, J. Johns, lower right
Anonymous gift, 1980
980-P-153

Souvenir I, 1972
Lithograph on paper, 38.5 x 29" (97.79 x 73.66 cm.)
Signed, J. Johns, 72, lower right
Museum purchase, 1984
984-P-107

Summer, 1985–1991
Lithograph on paper, (34/225), 16.25 x 11.25" (41.28 x 28.58 cm.)
Signed, Jasper Johns, 85–91, lower right
Museum purchase, 1991
991-P-107

Ben JOHNSON, (active 20th century)

The following two signed oils on canvas are the gift of Leonard Bocour, 1975

Lopidee Lipp
48.5 x 42" (123.19 x 106.68 cm.)
975-O-107

The Father Electric, 1975
50.25 x 42" (127.64 x 106.68 cm.)
975-O-106

Carolyn Lynn JOHNSON, (active 20th century)

Trickster Medicine
Intaglio on paper, 13 x 14" (33.02 x 35.56 cm.)
Signed, Johnson, lower right
Museum purchase, 1971
971-P-134

Eastman JOHNSON, (1824–1906)

Feather Duster Boy, ca. late 1860s–1870s
Oil on canvas, 22 x 16" (55.88 x 40.64 cm.)
Unsigned
Museum purchase, 1967
967-O-135

Joseph Warren, ca. 1863
Oil on canvas, 18 x 12" (45.72 x 30.48 cm.)
Signed, E. J., lower left
Museum purchase, 1966
966-O-125

Classic Head, 1854
Charcoal and chalk on paper, 15.5 x 11.5" (39.37 x 29.21 cm.)
Signed, E. Johnson, 1854, lower left
Museum purchase, 1965
965-D-132

Emily B. JOHNSON, (1908–)

Cluster, 1962
Watercolor on paper, 29 x 20.5" (73.66 x 52.07 cm.)
Signed, Emily B. Johnson, lower left
Museum purchase, 1964
964-W-105

Gregory JOHNSON, (1955–)

Chicago Park Bench Lady
Oil and pencil on birch panel, 12.5 x 18" (31.75 x 45.72 cm.)
Unsigned
Gift of Betty T. Werksman, 1983
983-O-106

Homer JOHNSON, (1925–)

Two Bathers
Watercolor on paper, 26 x 34" (66.04 x 86.36 cm.)
Signed, Homer Johnson, lower right
Gift of Edward Ford, 1972
972-W-104

Marshall JOHNSON, (1850–1915)

The *Constitution*, 1896
Photogravure on paper, 20.75 x 16.75" (52.71 x 42.55 cm.)
Unsigned
Anonymous gift, 1971
971-P-110

Ynez JOHNSTON, (1920–)

The Ivory Coast
Colored etching on paper, 15 x 11.5" (38.10 x 29.21 cm.)
Signed, Ynez Johnston, lower right
Museum purchase, 1958
958-P-111

Allen JONES, (1915–)

Self
New York International: Portfolio of Ten Prints, (210/225)
Serigraph on paper, 22 x 17" (55.88 x 43.18 cm.)
Signed, Allen Jones, lower right
Museum purchase, 1966
966-P-137.7

Hugh Bolton JONES, (1848–1927)

Stockbridge Meadows
Oil on canvas, 29 x 35" (73.66 x 88.90 cm.)
Signed, H. Bolton Jones, lower left
Gift of Dr. and Mrs. John J. McDonough, 1968
968-O-218

Joe JONES, (1909–1963)

We Demand, 1934
Oil on canvas, 48 x 36" (121.92 x 91.44 cm.)
Signed, Joe Jones, lower right
Gift of Sidney Freedman, 1948
948-O-110

Portrait–Henry Varnum Poor
Oil on canvas, 6 x 8" (15.24 x 20.32 cm.)
Unsigned
Gift of Louis Held, 1965
965-O-129

Harbor
Lithograph on paper, 9.25 x 12.5" (23.49 x 31.75 cm.)
Signed, Joe Jones, lower right
Gift of Louis Held, 1965
965-P-185

Head
Lithograph on paper, (7/16), 9 x 7.25" (22.86 x 18.41 cm.)
Signed, Joe Jones, lower right
Museum purchase, 1967
967-P-206

Joy Rider
Lithograph on paper, 16 x 12" (40.64 x 30.48 cm.)
Signed, Joe Jones, lower right
Gift of Mr. and Mrs. Nahum Tschacbasov, 1972
972-P-114

The following two color lithographs on paper, 8 x 32" (20.32 x 81.28 cm.), are a museum purchase, 1962

Beach Scene I
962-P-123

Beach Scene II
962-P-124

Alfred JONNIAUX, (1892– ?)

Tom of Whitechapel
Oil on canvas, 36 x 28" (91.44 x 71.12 cm.)
Signed, A. Jonniaux, lower left
Gift of Chase Gallery, 1967
967-O-138

Erne JOSEPH, (active 20th century)

Still Life with Black Duck, 1956
Oil on canvas, 48 x 37" (121.92 x 93.98 cm.)
Signed, Erne Joseph, lower right
Gift of Julian M. Bing, 1957
957-O-117

Donald JUDD, (1928–1994)

(Untitled), 1973
Photolithograph on paper, 9 x 12" (22.86 x 30.48 cm.)
Signed, Judd, lower right
Gift of Steven Feinstein, 1973
973-P-154

The following three signed etchings on paper are the gift of Marc A. Wyse, 1983

Woodcut Etchings, 1974
(6/70), 42 x 29.37" (106.68 x 74.59 cm.)
983-P-136

Woodcut Etchings, 1974
(67/70), 42 x 29.37" (106.68 x 74.59 cm.)
983-P-137

Woodcut Etchings, 1974
(66/70), 42 x 29.5" (106.68 x 74.93 cm.)
983-P-139

Jeanette A. JUDSON, (1912–)

Yellow Sky, 1965
Oil on canvas, 30 x 32" (76.20 x 81.28 cm.)
Unsigned
Gift of David Mann, 1967
967-O-114

Elaine JUHASZ, (1928–)

Coast of Textures, 1963
Aquatint on paper, 12 x 15" (30.48 x 38.10 cm.)
Signed, Elaine Juhasz, July, 63, lower right
Museum purchase, 1964
964-P-113

Mervin JULES, (1912–1994)

A Hit, ca. 1940
Color silkscreen on paper, 15.25 x 20" (38.73 x 50.80 cm.)
Signed, Jules, lower right
Museum purchase, 1990
990-P-106

Boy with Bird, 1964
Woodcut on paper, (23/250), 14 x 7.5" (35.56 x 19.05 cm.)
Signed, Jules, lower right
Museum purchase, 1964
964-P-124

The following two silkscreens on paper are the gift of Louis Held, 1965, 1966

Trio
11.5 x 13.5" (29.21 x 34.29 cm.)
965-P-155

Young Artist
7.5 x 12" (19.05 x 30.48 cm.)
966-P-151

George KACHMER, (1911–)

Boiler Houses
Watercolor on paper, 16 x 26" (40.64 x 66.04 cm.)
Signed, Kachmer, lower right
Museum purchase, 1955
955-W-108

Winter Along the Mills
Watercolor on paper, 14 x 21" (35.56 x 53.34 cm.)
Signed, Kachmer, lower right
Gift of the Federation of Women's Clubs, 1956
956-W-105

Dan KADISH, (active 20th century)

Silver Dephaeled
Acrylic on canvas, 55 x 68" (139.70 x 172.72 cm.)
Unsigned
Gift of Leonard Bocour, 1976
976-O-123

Charles S. KAELIN, (1858–1929)

Moored Boats, ca. 1919
Oil on canvas, 20 x 24" (50.80 x 60.96 cm.)
Signed, C. Kaelin, lower left
Museum purchase, 1965
965-O-172

Cape Ann Woods
Oil on canvas, 25 x 30" (63.50 x 76.20 cm.)
Signed, C. S. Kaelin, lower left
Gift of Robert and Paula Loos, 1991
991-O-106

Eastman Johnson - Classic Head (page 94)

Hugh Bolton Jones - Stockbridge Meadows (page 94)

Joe Jones - We Demand (page 94)

Judd - (Untitled)

Jules - A Hit

Kaelin - Moored Boats

Kaelin - Granite Shore

Kagy - C. W. A. Workers at the Stadium

Wolf Kahn - Near Pamet Beach

Kanovitz - (Untitled) (986-O-114)

Granite Shore
Oil on canvas, 20 x 24" (50.80 x 60.96 cm.)
Signed, C. S. Kaelin, lower left
Museum purchase, 1968
968-O-164

Rockport Dredge
Oil on canvas, 20 x 24" (50.80 x 60.96 cm.)
Signed, C. S. Kaelin, lower left
Museum purchase, 1968
968-O-163

Sunny Day in Rockport Harbor
Pastel on paper, 13 x 15.5" (33.02 x 39.37 cm.)
Unsigned
Gift of Julie Loos, 1991
991-D-104

The following two pastels on paper are the gift of
Robert and Paula Loos, 1991

Granite Shore (Rocky Coast)
14 x 16" (35.56 x 40.64 cm.)
991-D-110

Woodland Brook in Spring
14 x 15" (35.56 x 38.10 cm.)
991-D-111

The following two pastels on paper are the gift of
Lucille Wilson Loos, 1991

Kaelin's Brook
15.5 x 13" (39.37 x 33.02 cm.)
991-D-108

Rockport Harbor Sunset
13 x 16" (33.02 x 40.64 cm.)
991-D-107

Ruth Rita KAGAN, (active late 20th century)

Jamaica, 1967
Watercolor on paper, 20 x 29" (50.80 x 73.66 cm.)
Signed, R. R. K., lower right
Gift of Louis Held, 1968
968-W-139

The Butler Institute's collection contains eight
signed pastels on paper of various sizes which
are the gift of Ruth Rita Kagan, 1970

A Bit of New England Moon
970-D-112

My Model
970-D-107

My Model
970-D-108

Reflections
970-D-105

Standing Nude
970-D-106

The Cloud and the Moon
970-D-111

The Moon
970-D-110

The Native
970-D-109

Sheffield KAGY, (1907–1989)

The following three signed block prints on paper,
12.25 x 15.25" (31.11 x 38.73 cm.), are the gift
of the Youngstown Public Library, 1976

C. W. A. Workers at the City Lakefront,
1934
976-P-112

C. W. A. Workers at the Stadium, 1934
976-P-113

C. W. A. Workers on the Mall, 1934
976-P-114

Susan B. KAHN, (1924–)

Young Couple, 1964
Oil on canvas, 24 x 20" (60.96 x 50.80 cm.)
Signed, S. Kahn, 1964, lower left
Gift of Joseph Kahn, 1965
965-O-174

Wolf KAHN, (1927–)

Near Pamet Beach, 1956
Pastel on paper, 12 x 18" (30.48 x 45.72 cm.)
Signed, W. Kahn, 56, lower right
Gift of Louis Held, 1965
965-W-113

Tree in Landscape, 1969
Color lithograph on paper, (82/98), 22 x 30" (55.88 x 76.20
cm.)
Signed, W. Kahn, lower center
Gift of Reese and Marilyn Arnold Palley, 1991
991-P-162

Ben KAMIHIRA, (1925–)

Self Portrait
Oil on canvas, 20 x 16" (50.80 x 40.64 cm.)
Signed, Kamihira, lower right
Gift of Kennedy Gallery, 1969
969-O-151

Jeanette T. KANN, (active 20th century)

Railroad Yards, 1955
Watercolor on paper, 11 x 30" (27.94 x 76.20 cm.)
Signed, Jeanette T. Kann, 1955, lower right
Museum purchase, 1956
956-W-106

Howard KANOVITZ, (1929–)

(Untitled)
Pastel and oil on paper, 20 x 26" (50.80 x 66.04 cm.)
Unsigned
Gift of Marilynn Meeker, 1986
986-O-116

The following two oils on canvas are the gift of
Marilynn Meeker, 1986

(Untitled)
34 x 31" (86.36 x 78.74 cm.)
986-O-111

(Untitled)
25 x 18" (63.50 x 45.72 cm.)
986-O-114

The following two drawings, ink on paper, are the gift of Marilynn Meeker, 1986

(Untitled)
16.12 x 13.25" (40.95 x 33.65 cm.)
986-D-102

(Untitled)
16.5 x 13.62" (41.91 x 34.60 cm.)
986-D-103

Charles H. KAPITY, (active late 20th century)

The Circus, 1985
Acrylic and watercolor on paper, 15.25 x 22.25" (38.73 x 56.51 cm.)
Signed, Charles H. Kapity, O.W.S., 85, lower left
Gift of Charles H. Kapity, 1990
990-W-102

Joseph KAPLAN, (1900–1980)

Dark Cloud
Oil on canvas, 16 x 42" (40.64 x 106.68 cm.)
Signed, Joseph Kaplan, lower right
Museum purchase, 1949
949-O-107

Monhegan
Oil on canvas, 12 x 8" (30.48 x 20.32 cm.)
Signed, Joseph Kaplan, lower left center
Gift of Henry Salpeter, 1963
963-O-104

Highland Light
Casein on paper, 19 x 27" (48.26 x 68.58 cm.)
Signed, Joseph Kaplan, lower right
Museum purchase, 1951
951-W-101

Stanley KAPLAN, (1925–)

Home Run
Aquatint on paper, 16.5 x 13" (41.91 x 33.02 cm.)
Signed, Stanley Kaplan, lower right
Museum purchase, 1972
972-P-118

Albert KAPP, (active 20th century)

Provincetown Waterfront
Oil on canvas, 9 x 12" (22.86 x 30.48 cm.)
Signed, Albert Kapp, lower left
Gift of Mr. and Mrs. Albert Kapp, 1969
969-O-103

Paula KAPP, (active 20th century)

Shore Glasses
Oil on canvas, 36 x 24" (91.44 x 60.96 cm.)
Signed, Paula Kapp, lower right
Gift of Mr. and Mrs. Albert Kapp, 1969
969-O-101

Philip KAPPEL, (1901–1981)

Marine, 1927
Etching on paper, 9 x 6.5" (22.86 x 16.51 cm.)
Signed, Philip Kappel, lower right
Gift of Joseph G. Butler, III, 1959
959-P-101

Karl KAPPES, (1861–1943)

Summer Landscape
Oil on canvas board, 16 x 20" (40.64 x 50.80 cm.)
Signed, K. Kappes, lower left
Gift of Mrs. Walter Chapman, 1977
977-O-144

Richard Charles KARWOSKI, (1938–)

Apples and Peaches, 1977
Watercolor on paper, 22 x 30" (55.88 x 76.20 cm.)
Signed, Richard C. Karwoski, lower right
Gift of Richard C. Karwoski, 1980
980-W-104

Alexander Raymond KATZ, (1895–1974)

Ayen
Oil on canvas, 34 x 24" (86.36 x 60.96 cm.)
Signed, A. Raymond Katz, lower right
Gift of Emanuel Redfield, 1959
959-O-104

Shavout
Watercolor on paper, 24 x 18.5" (60.96 x 46.99 cm.)
Signed, A. Raymond Katz, lower left
Gift of Emanuel Redfield, 1959
959-W-101

Alex KATZ, (1927–)

Blue Umbrella #1, 1978
Lithograph on paper, 20 x 30" (50.80 x 76.20 cm.)
Signed, Alex Katz, lower left
Museum purchase, 1982
982-P-152

Morris KATZ, (active 20th century)

The following two signed oils on masonite, 24 x 20" (60.96 x 50.80 cm.), are the gift of Leonard Bocour, 1975

Bouquet, 1974
975-O-116

Daisies, 1974
975-O-115

Herbert KATZMAN, (1923–ca. 1994)

Marsden Hartley Before Portrait of a German Officer, 1983
Oil on canvas, 78 x 48" (198.12 x 121.92 cm.)
Signed, H. K., 83, lower right
Gift of the Daniel Roses Foundation, 1990
990-O-116

Marsden Hartley, 1989
Charcoal on paper, 43 x 29" (109.22 x 73.66 cm.)
Signed, H. K., 89, lower right
Museum purchase, 1994
994-D-102

Robert KAUFMAN, (1914–1959)

Philosopher, 1951
Oil on canvas, 22 x 18" (55.88 x 45.72 cm.)
Signed, Kaufman, lower right
Gift of the estate of Robert Kaufman, 1960
960-O-113

Kapity - The Circus

Albert Kapp - Provincetown Waterfront

Alex Katz - Blue Umbrella #1

Katzman - Marsden Hartley Before Portrait of a German Officer

Katzman - Marsden Hartley

Kaulback - Freedom's Light

Keith - An Autumnal Sunset on the Russian River

Keith - Woodland Scene

Keller - Crossing the Fiord, (Puerto Rico)

Keller - Ready to Clean the Catch, Perce

Keller - Three Turkeys

Margaret KAULBACK, (1899–1996)

Freedom's Light, 1965
Oil on canvas, 15 x 11.5" (38.10 x 29.21 cm.)
Signed, Peggy Kaulback, lower right
Gift of Susan and William Kaulback, 1971
971-O-113

Hilde B. KAYN, (1903–1950)

Consolation
Oil on canvas, 29 x 24" (73.66 x 60.96 cm.)
Signed, H. B. Kayn, lower right
Museum purchase, 1944
944-O-101

James KEARNS, (1924–)

Man on Stilts
Etching on paper, 14.75 x 8.75" (37.46 x 22.22 cm.)
Signed, J. Kearns, lower right
Museum purchase, 1968
968-P-213

William KEITH, (1839–1911)

An Autumnal Sunset on the Russian
River, 1878, (formerly Evening Glow)
Oil on canvas, 36 x 60" (91.44 x 152.40 cm.)
Signed, W. Keith, 78, lower right
Museum purchase, 1924
924-O-102

In The Gloaming
Oil on canvas, 10 x 14" (25.40 x 35.56 cm.)
Signed, W. Keith, lower left
Gift of the estate of John Tod, 1953
953-O-133

Landscape
Oil on canvas, 14.37 x 16" (36.51 x 40.64 cm.)
Signed, W. Keith, lower right
Gift of the estate of Nathan Bentley Folsom, 1984
984-O-109

The Shepard
Oil on canvas, 22 x 27" (55.88 x 68.58 cm.)
Signed, W. Keith, lower right
Gift of Mrs. Henry A. Butler, 1951
951-O-109

Woodland Scene
Oil on canvas, 19 x 26" (48.26 x 66.04 cm.)
Signed, W. Keith, lower left
Gift of Paul Wick, 1963
963-O-125

Henry G. KELLER, (1869–1949)

Crossing the Fiord, (Puerto Rico)
Watercolor on paper, 17 x 24" (43.18 x 60.96 cm.)
Signed, Keller, lower left
Gift of the estate of Maria Stoll, 1982
982-W-105

Landscape
Distemper on paper, 20 x 29" (50.80 x 73.66 cm.)
Unsigned
Anonymous gift, 1961
961-W-115

Ready to Clean the Catch, Perce, 1937
Watercolor on paper, 14 x 20" (35.56 x 50.80 cm.)
Signed, Keller, lower left
Museum purchase, 1939
939-W-101

Morning in the Stable
Etching on paper, 7 x 9" (17.78 x 22.86 cm.)
Unsigned
Gift of Louis Held, 1967
967-P-137

The Henry G. Keller Collection

The Butler Institute's collection includes forty
oils on canvas or board of various sizes which
are the gift of the estate of Henry G. Keller, 1981
HK981-O-101 — HK981-O-141

The Butler Institute's collection includes one-
hundred ten watercolors on paper or board of
various sizes which are the gift of the estate of
Henry G. Keller, 1981
HK981-W-101 — HK981-W-211

The Butler Institute's collection includes eight
drawings on paper of various sizes which are the
gift of the estate of Henry G. Keller, 1981
HK981-D-101 — HK981-D-108

E. C. KELLOGG, (active 19th century)

The Presidents of the United States
Hand tinted lithograph on paper, 14 x 10" (35.56 x 25.40 cm.)
Unsigned
Gift of Sydna Smith, 1975
975-P-102

Ellsworth KELLY, (1923–)

Lincoln Center Poster
Lithograph on paper, (15/100), 33 x 26" (83.82 x 66.04 cm.)
Unsigned
Museum purchase, 1967
967-P-153

(Untitled), 1973
Print on paper, 12 x 9" (30.48 x 22.86 cm.)
Signed, E. K., lower right
Gift of Steven Feinstein, 1983
983-P-155

Marie Tuicillo KELLY, (1916–)

The following four watercolors on paper are a
museum purchase, 1953, 1954, 1957, 1958

Three Kings, #11
21 x 15" (53.34 x 38.10 cm.)
953-W-105

Last Supper
19 x 27" (48.26 x 68.58 cm.)
954-W-113

The Ark
21 x 29" (53.34 x 73.66 cm.)
957-W-105

Beasts
22 x 30" (55.88 x 76.20 cm.)
958-W-105

Doris Wainwright KENNEDY, (1916–)

The Hunt, 1963
Watercolor and "duco" on paper, 22 x 36" (55.88 x 91.44 cm.)
Signed, Doris Wainwright Kennedy, lower right
Museum purchase, 1963
963-W-109

Dale KENNINGTON, (active late 20th century)

Barber Shop
Oil on canvas, 40 x 50" (101.60 x 127.00 cm.)
Signed, Kennington, lower right
Gift of Capricorn Galleries, 1995
995-O-106

Thomas Henry KENNY, (active 20th century)

Space Vehicle #1, 1968
Lithograph on paper, 22 x 26" (55.88 x 66.04 cm.)
Signed, Thomas Henry Kenny, lower right
Gift of Michael Kenny, 1968
968-P-123

John Frederick KENSETT, (1816–1872)

Bash Bish Falls, ca. 1855
Oil on canvas, 34 x 27" (86.36 x 68.58 cm.)
Signed, Kensett, lower left
Museum purchase, 1989
989-O-102

Rockwell KENT, (1882–1917)

Europa
Lithograph on paper, 13.5 x 9.5" (34.29 x 24.13 cm.)
Signed, Rockwell Kent, lower right
Gift of Louis Held, 1965
965-P-183

Deborah KEREW, (1916–1958)

The following eight signed oils on canvas are the
gift of Sylvia Carewe, 1961

Jugs and Carnations
25 x 30" (63.50 x 76.20 cm.)
961-O-112

Still Life with Candelabra
16 x 20" (40.64 x 50.80 cm.)
961-O-113

Still Life with Glass Bottle
12 x 30" (30.48 x 76.20 cm.)
961-O-114

Still Life with Pitcher
18 x 14" (45.72 x 35.56 cm.)
961-O-115

The Doorways
30 x 25" (76.20 x 63.50 cm.)
961-O-111

The Golden Vase
24 x 20" (60.96 x 50.80 cm.)
961-O-110

The White Pitcher
18 x 24" (45.72 x 60.96 cm.)
961-O-107

White Pitcher on Table
24 x 20" (60.96 x 50.80 cm.)
961-O-108

Shirley Wells KERRUISH, (1924–)

Amanda's Time, 1963
Shira gouache on paper, 17 x 30" (43.18 x 76.20 cm.)
Signed, Shirley Wells Kerruish, 63, lower right
Museum purchase, 1963
963-W-106

Dapple Grey
Ink on paper, 24 x 30" (60.96 x 76.20 cm.)
Unsigned
Museum purchase, 1959
960-D-101

Shirley KESSLER, (active 1963–)

Big City Rhythms
Acrylic on paper, 21.5 x 28" (54.61 x 71.12 cm.)
Signed, S. Kessler, lower left
Gift of Mr. and Mrs. Seymour L. Baldash, 1977
977-W-114

Riisoburo KIMURA, (1924–)

City 173, 117, 26, 23, 101
Five lithographs on paper, 30 x 22" (76.20 x 55.88 cm.)
Signed, Kimura, lower right
Gift of Samuel S. Mandel, 1986
986-P-135 and 986-P-142 — 986-P-145

Portfolio of Twenty Cities
Twenty lithographs on paper, 30 x 22" (76.20 x 55.88 cm.)
Signed, Kimura, lower right
Gift of Samuel S. Mandel, 1986
986-P-114 — 986-P-135, 986-P-142 — 986-P-145

Albert F. KING, (1854–1945)

Still Life
Oil on canvas, 18 x 24" (45.72 x 60.96 cm.)
Signed, A. F. King, lower right
Museum purchase, 1977
977-O-155

C. B. KING, (active early 19th century)

J-Aw-Beance—A Chippeway Chief,
(published, 1836)
Lithograph on paper, 21.5 x 15.75" (54.61 x 40.00 cm.)
Unsigned
Gift of Albert E. Hise, 1979
979-P-121

Huber KING, (active late 20th century)

(Untitled)
Oil on canvas, 24.12 x 34" (61.27 x 86.36 cm.)
Signed, Huber King, lower left
Gift of Patrick C. Pinney, 1991
991-O-147

Tony KING, (active late 20th century)

Mississippi, 1992
Oil on linen, 32 x 24" (81.28 x 60.96 cm.)
Signed, King, lower left
Gift of Erle L. Flad, 1995
995-O-105

Dong KINGMAN, (1911–)

Lighthouse, 1945
Watercolor on paper, 18 x 29" (45.72 x 73.66 cm.)
Signed, Kingman, 45, lower left
Gift of W. H. Wulf, 1945
945-W-103

Kennington - Barber Shop

Kensett - Bash Bish Falls

Kent - Europa

C. B. King - J-Aw-Beance—A Chippeway Chief

Kingman - Lighthhouse

Kinstler - Will Barnet

Kirschenbaum - The Playground

Kleeman - The Flying Scot

Robert E. Klein - Morning Light

Knaths - Rough Riders

Knight - Life is Sweet

Jonah KINIGSTEIN, (1924–)

The Centaur
Oil on canvas, 48 x 36" (121.92 x 91.44 cm.)
Unsigned
Museum purchase, 1954
954-O-122

Troy KINNEY, (1871–1938)

Ballet
Etching on paper, 15 x 18.25" (38.10 x 46.35 cm.)
Signed, Troy Kinney, lower right
Gift of Norman and June Krafft, 1980
980-P-141

William KINNICK, (1939–)

Collage VIII
Collage on canvas, 36.5 x 48" (92.71 x 121.92 cm.)
Unsigned
Museum purchase, 1965
965-O-169

Everett Raymond KINSTLER, (1926–)

Will Barnet, 1979
Oil on canvas, 50 x 40" (127.00 x 101.60 cm.)
Signed, Everett Raymond Kinstler, lower right
Gift of Everett Raymond Kinstler, 1993
993-O-112

Robert KIPNISS, (1931–)

Clouds
Lithograph on paper, 12.12 x 8.87" (30.79 x 22.54 cm.)
Signed, Kipniss, lower right
Museum purchase, 1970
970-P-120

Jules KIRSCHENBAUM, (1930–)

The Playground, 1954
Oil on canvas, 39 x 54" (99.06 x 137.16 cm.)
Signed, Jules Kirschenbaum, lower right
Museum purchase, 1957
957-O-118

Sand Dunes—Cape Cod, 1955
Pen and ink on parchment, 11.75 x 19.5" (29.84 x 49.53 cm.)
Signed, Jules Kirschenbaum, 1955, lower right
Museum purchase, 1962
962-D-151

Two Heads
Pencil on paper, 18 x 14" (45.72 x 35.56 cm.)
Signed, K., lower left
Museum purchase, 1959
959-D-116

Maurice KISH, (1898–)

Revolt of the Carousel
Oil on canvas, 25 x 30" (63.50 x 76.20 cm.)
Signed, Maurice Kish, lower left
Gift of Harold Levy, 1968
969-O-107

Ron KLEEMAN, (1937–)

The Flying Scot
Lithograph on paper, 23.75 x 33.5" (60.32 x 85.09 cm.)
Unsigned
Gift of Samuel S. Mandel, 1986
986-P-167

Albert KLEIN, (1918–)

Cortez Bay
Watercolor on paper, 15 x 22" (38.10 x 55.88 cm.)
Signed, A. Klein, lower left
Museum purchase, 1964
964-W-116

Robert E. KLEIN, (active 20th century)

Morning Light
Watercolor on paper, 22 x 30" (55.88 x 76.20 cm.)
Unsigned
Museum purchase, 1969
969-W-122

The following two drawings, ink on paper, are a museum purchase, 1969, 1971

Dead Gull
23 x 18" (58.42 x 45.72 cm.)
969-D-105

Falling Darkness
17 x 23" (43.18 x 58.42 cm.)
971-D-111

Frank KLEINHOLZ, (1901–)

Dreaming
Oil on canvas, 5 x 7" (12.70 x 17.78 cm.)
Unsigned
Gift of Louis Held, 1965
965-O-144

The following two lithographs on paper are the gift of Louis Held, 1965

Group on a Balcony
11 x 7.25" (27.94 x 18.41 cm.)
965-P-133

Street Scene
10 x 8" (25.40 x 20.32 cm.)
965-P-171

Bernard KLONIS, (1906–1957)

Vase of Flowers, 1942
Oil on canvas, 10.5 x 7.5" (26.67 x 19.05 cm.)
Signed, B. Klonis, 42, lower right
Gift of Louis Held, 1965
965-O-143

Otto Karl KNATHS, (1891–1971)

Rough Riders, 1951
Oil on canvas, 40 x 30" (101.60 x 76.20 cm.)
Signed, Karl Knaths, lower center
Gift of Emil Arnold, 1967
967-O-113

Xmas Greeting, 1970
Hand colored lithograph on paper, 13.5 x 19" (34.29 x 48.26 cm.)
Unsigned
Anonymous gift, 1971
971-P-111

Daniel Ridgway KNIGHT, (1840–1924)

Life is Sweet, ca. 1900–1915
Oil on canvas, 32.5 x 25.5" (82.55 x 64.77 cm.)
Signed, Ridgway Knight, Paris, lower left
Gift of the estate of Mrs. Robert Bentley, 1959
959-O-101

Joe KNOWLES, (1869–1942)

A Chief of the Nez Percé

Drypoint etching on paper, 5.75 x 4.37" (14.60 x 11.11 cm.)
Signed, Joe Knowles, lower left
Gift of Lyle and Janet Bramhall, 1990
990-P-101

George KOCAR, (1948–)

(Untitled)

Portfolio of 53: Rip Off on the Last Millennium
Print on paper, 8.5 x 11" (21.59 x 27.94 cm.)
Signed, Kocar, lower right
Gift of the William Busta Gallery, 1990
990-P-111.22

Edwin E. KOCH, (1915–)

Freight Door

Oil on canvas, 42 x 24" (106.68 x 60.96 cm.)
Signed, E. Koch, lower right
Gift of Louis Held, 1977
977-O-118

John KOCH, (1909–1978)

Music, 1956–57

Oil on canvas, 48 x 60" (121.92 x 152.40 cm.)
Signed, Koch, lower right
Museum purchase, 1962
962-O-112

Portrait of William Hitchcock, 1970

Oil on canvas, 40 x 34" (101.60 x 86.36 cm.)
Signed, Koch, lower left
Gift of Mr. and Mrs. George C. Wick, 1982
982-O-105

The following four signed drawings are the gift
of Mr. and Mrs. George C. Wick, 1982

Alabaster Lamp Base

11.75 x 8.5" (29.84 x 21.59 cm.)
982-D-102.a

Alabaster Lamp Base

10 x 8" (25.40 x 20.32 cm.)
982-D-102.b

Hitchcock Portrait

10 x 8" (25.40 x 20.32 cm.)
982-D-102.c

Hitchcock Portrait

10 x 8" (25.40 x 20.32 cm.)
982-D-102.d

Maryanne Feldhaus KOCH, (active 20th
century)

Dawns Dawning, 1955

Lithograph on paper 10 x 11.75" (25.40 x 29.84 cm.)
Signed, Maryanne Feldhaus Koch, lower right
Gift of Albert E. Hise, 1979
979-P-131

Philip KOCH, (active late 20th century)

Shadow Birches

Oil on canvas, 37 x 55" (93.98 x 139.70 cm.)
Signed, Philip Koch, lower right
Gift of Philip Koch, 1995
995-O-112

C. Catherine KOENIG, (1921–)

Duo, 1987

Pastel on paper, 35.75 x 57.5" (90.81 x 146.05 cm.)
Signed, C. Catherine Koenig, lower right
Gift of C. Catherine Koenig, 1991
991-P-106

Henry KOERNER, (1915–1991)

The Bench

Pen and ink on paper, 16 x 20" (40.64 x 50.80 cm.)
Signed, Koe, lower right
Museum purchase, 1963
963-D-103

Paul KOLESAR, (1919–)

Embryo

Watercolor on paper, 24 x 20" (60.96 x 50.80 cm.)
Signed, Kolesar, upper left
Museum purchase, 1965
965-W-133

August KOLLNER, (1813– ?)

Rocks in the Potomic (sic) River/at North
Mason's Island, 1839

Pencil and ink on paper, 7 x 8.25" (17.78 x 20.95 cm.)
Unsigned
Gift of Albert E. Hise, 1979
979-D-111

Joseph KONOPKA, (1932–)

Operation Sail

Acrylic on canvas, 36 x 72" (91.44 x 182.88 cm.)
Signed, Konopka, upper right
Gift of Joseph Konopka, 1979
979-O-103

Sunglasses

Acrylic on canvas, 36 x 42" (91.44 x 106.68 cm.)
Signed, Konopka, lower center
Gift of the Youngstown Polish Arts Club, 1979
979-O-102

David KONTAK, (active late 20th century)

(Untitled)

Portfolio of 53: Rip Off on the Last Millennium
Print on paper, 8.5 x 11" (21.59 x 27.94 cm.)
Signed, David Kontak, lower middle
Gift of the William Busta Gallery, 1990
990-P-111.49

Darell J. KOONS, (1924–)

Barn in June, 1967

Polymer on paper, 19 x 31" (48.26 x 78.74 cm.)
Signed, Darell Koons, 67, lower right
Anonymous gift, 1967
967-W-111

Benjamin KOPMAN, (1887–1965)

Connecticut Landscape

Oil on canvas, 22.5 x 27" (57.15 x 68.58 cm.)
Signed, Kopman, lower left center
Gift of Dr. and Mrs. James Rudel, 1954
954-O-125

Edwin E. Koch - Freight Door

John Koch - Music

John Koch - Portrait of William Hitchcock

Koerner - The Bench

Kollner - Rocks in the Potomic (sic) River/at North Mason's Island

Kraus - King of the Forest

Krebs - A Rainbow Tree

Kroll - Dancers in Repose

Kroll - Reclining Nude

Kronberg - La Premiere Danseuse (page 103)

The following two signed oils on canvas are the gift of Sidney Freeman and Samuel N. Tonkin, 1954

In an Artist's Studio, 1954
36 x 30" (91.44 x 76.20 cm.)
954-O-124

Midsummer Landscape, 1954
32 x 26" (81.28 x 66.04 cm.)
954-O-123

Landscape with Man, 1944
Watercolor gouache on paper, 11 x 14" (27.94 x 35.56 cm.)
Signed, Kopman, 44, lower right
Gift of Joseph H. Hirshhorn, 1948
948-W-109

Chaim KOPPELMAN, (1920–)

Intaglio Angel
Etching on paper, 10 x 8" (25.40 x 20.32 cm.)
Signed, Chaim Koppelman, lower right
Museum purchase, 1965
965-P-305

Ray J. KOSKI, (1910–)

Performers, 1946
Watercolor on paper, 14 x 21" (35.56 x 53.34 cm.)
Signed, Koski, 46, lower left
Museum purchase, 1947
947-W-109

Sigmund KOSLOW, (1913–)

The following two signed oils on canvas are the gift of Louis Held, 1965

Fall Landscape
7.5 x 11" (19.05 x 27.94 cm.)
965-O-136

October
7.5 x 15.5" (19.05 x 39.37 cm.)
965-O-123

George KOSMON, (active late 20th century)

Baptistry Railing, 1986
Lithograph on paper, 19 x 25" (48.26 x 63.50 cm.)
Signed, Kosman, 1986, lower right
Gift of James Corcoran, 1987
988-P-101

Allen KOSS, (1931–)

Sunday Morning
Oil on canvas, 32 x 46" (81.28 x 116.84 cm.)
Signed, Allen Koss, lower right
Museum purchase, 1967
967-O-119

Richard KOZLOW, (1926–)

Palermo
Oil on canvas, 16 x 19" (40.64 x 48.26 cm.)
Signed, Kozlow, lower right
Museum purchase, 1951
951-O-117

O. M. KRAUS, (active 19th century)

King of the Forest
Pen and ink on paper, 19 x 24" (48.26 x 60.96 cm.)
Signed, O. M. Kraus, lower center
Gift of William Froch, 1969
969-D-103

Glen KRAUSE, (1914–)

The Raven, 1953
Oil on canvas, 30 x 24" (76.20 x 60.96 cm.)
Signed, Krause, 53, lower right
Gift of Joseph G. Butler, III, 1954
954-O-126

Monhegan
Ink on paper, 12 x 33" (30.48 x 83.82 cm.)
Signed, Krause, lower right
Museum purchase, 1966
966-D-101

Nine Crows, 1961
Woodcut on paper, 15 x 28" (38.10 x 71.12 cm.)
Signed, Krause, 61, lower right
Museum purchase, 1961
961-P-128

Sleep, 1961
Lithograph on paper, 17 x 33" (43.18 x 83.82 cm.)
Signed, Krause, 61, lower right
Gift of Dorothy Dennison Butler, 1969
969-P-114

Rockne KREBS, (1938–)

A Rainbow Tree, 1970
Offset lithograph on paper, 17 x 22" (43.18 x 55.88 cm.)
Signed, Rockne Krebs, lower right
Museum purchase, 1982
982-P-154

Doris Barsky KREINDLER, (1901–1974)

The End of the Storm
Color etching on paper, (5/20), 11 x 16" (27.94 x 40.64 cm.)
Signed, Kreindler, lower right
Museum purchase, 1965
965-P-251

Leon KROLL, (1884–1974)

Dancers in Repose, 1946–48
Oil on canvas, 26 x 36" (66.04 x 91.44 cm.)
Signed, Leon Kroll, lower right
Gift of Joseph Kahn, 1965
965-O-175

Reclining Nude
Crayon on paper, 11 x 23" (27.94 x 58.42 cm.)
Signed, Leon Kroll, lower right
Gift of Joseph J. Hirshhorn, 1948
948-D-101

Two Girls
Crayon on paper, 18.5 x 24.5" (46.99 x 62.23 cm.)
Signed, Leon Kroll, lower right
Gift of Louis Held, 1965
965-P-110

Monique
Lithograph on paper, 15.75 x 12" (40.00 x 30.48 cm.)
Signed, Leon Kroll, lower right
Museum purchase, 1979
979-P-109

Louis KRONBERG, (1872–1965)

La Premiere Danseuse
Oil on canvas, 24 x 29" (60.96 x 73.66 cm.)
Signed, Louis Kronberg, lower right
Gift of Dr. John J. McDonough, 1973
973-O-126

The Ballet Girl, 1917
Oil on canvas, 24 x 18" (60.96 x 45.72 cm.)
Signed, L. Kronberg, lower left
Museum purchase, 1921
921-O-106

Herbert L. KRUCKMAN, (1904–)

The following two oils on canvas are the gift of
Louis Held, 1968, 1969

Portrait of Louis Held, 1969
24 x 17" (60.96 x 43.18 cm.)
969-O-142

Street Scene, Brooklyn, USA
28 x 36" (71.12 x 91.44 cm.)
968-O-196

Backyard, 1966
Casein on paper, 15 x 22" (38.10 x 55.88 cm.)
Signed, Kruckman, lower right
Gift of Selma Kruckman, 1970
970-W-105

Bathers
Watercolor on paper, 6.5 x 10" (16.51 x 25.40 cm.)
Signed, Kruckman, lower right
Gift of Louis Held, 1966
966-W-121

Power Shovel
Lithograph on paper, 10 x 8.5" (25.40 x 21.59 cm.)
Signed, Kruckman, lower right
Gift of Louis Held, 1965
965-P-191

Nicholas KRUSHENICK, (1929–)

(Untitled)
Paper collage on paper, 44 x 36" (111.76 x 91.44 cm.)
Unsigned
Anonymous gift, 1965
965-W-139

Poster, 1965
Silkscreen on paper, (42/100), 30.5 x 25" (77.47 x 63.50 cm.)
Signed, Nicholas Krushenick, lower left
Museum purchase, 1967
967-P-152

Howard KUH, (1899–)

(Untitled)
Oil on canvas, 26.25 x 48.25" (66.67 x 122.55 cm.)
Signed, Kuh, lower left
Gift of Dr. Nathaniel Schwartz, 1978
978-O-105

Otto KUHLER, (1894–1977)

The following five signed etchings on paper of
various sizes are a museum purchase, 1979

Allegheny River Lock and Dam 2
Under Construction, 1933
979-P-160

Construction Along the River
979-P-151

Construction on Site for Floating
Drydock of the Bethlehem Shipbuilding
Corp., Baltimore, MD
979-P-149

The Prettyboy Dam Under Construction
979-P-154

Washington Monument, Baltimore
979-P-152

Walt KUHN, (1877–1949)

Green Pom-Pom, 1944
Oil on canvas, 30 x 25" (76.20 x 63.50 cm.)
Signed, Walt Kuhn, lower right
Museum purchase, 1986
986-O-108

Clown, 1946
Watercolor on paper, 7.5 x 3.5" (19.05 x 8.89 cm.)
Signed, W. K., lower right
Gift of Mr. L. A. Fleischman, 1968
968-W-129

Clown with Top Hat
Ink on paper, 5 x 3.5" (12.70 x 8.89 cm.)
Unsigned
Gift of the Walt Kuhn Gallery, 1988
988-D-104

The following four colored lithographs on paper
are a museum purchase, 1967

Clown and Girl
7 x 5.75" (17.78 x 14.60 cm.)
967-P-160

Indian Fight
9.5 x 12.75" (24.13 x 32.38 cm.)
967-P-166

Officers and Indians
9.5 x 12.75" (24.13 x 32.38 cm.)
967-P-164

Riding Indians
9.75 x 12.75" (24.76 x 32.38 cm.)
967-P-165

Marguerite Elizabeth KUMM, (1900–1992)

The following four drypoint prints on paper of
various sizes are a museum purchase, 1952

Art Lovers
3 x 2" (7.62 x 5.08 cm.)
952-P-106

Happy Days
8 x 10" (20.32 x 25.40 cm.)
952-P-103

Museum Visitors
3 x 2" (7.62 x 5.08 cm.)
952-P-105

The Critics
3 x 2" (7.62 x 5.08 cm.)
952-P-104

Kruckman - Portrait of Louis Held

Krushenick - (Untitled)

Kuhn - Green Pom-Pom

Kuhn - Clown

Kumm - Museum Visitors

Kuniyoshi - Fruit in Bowl with Biscuits

Kuniyoshi - Carnival

Kuniyoshi - Circus Performer

Kuniyoshi - Wire Performer

Louis Kurz and Alexander Allison - Abraham Lincoln

Karen KUNC, (active 20th century)

A Jaded Nature
Woodblock on paper, (18/41), 45 x 30" (114.30 x 76.20 cm.)
Signed, Karen Kunc, lower right
Museum purchase, 1992
992-P-125

Yasuo KUNIYOSHI, (1889–1953)

Fruit in Bowl with Biscuits, ca. 1930
Pencil on paper, 12 x 16" (30.48 x 40.64 cm.)
Unsigned
Museum purchase, 1965
965-D-102

Cafe au Boulevard, Clichy, 1928
Lithograph on paper, 11.5 x 10.25" (29.21 x 26.03 cm.)
Signed, Y. Kuniyoshi, lower right
Museum purchase, 1986
986-P-110

Carnival, 1949
Lithograph on paper, (235), 15.62 x 9.5" (39.68 x 24.13 cm.)
Signed, Yasuo Kuniyoshi by S. M. Kuniyoshi, lower right
Museum purchase, 1968
968-P-262

Circus Performer
Lithograph on paper, 15 x 11" (38.10 x 27.94 cm.)
Signed, Y. Kuniyoshi, lower right
Gift of Edith Halpert, 1948
948-P-122

Girl Dressing, 1928
Lithograph on paper, (25/32), 9.25 x 6" (23.49 x 15.24 cm.)
Signed, Y. Kuniyoshi, 28, lower right
Museum purchase, 1966
966-P-139

Grapes, 1928
Lithograph on paper, (24/26), 9.25 x 13" (23.49 x 33.02 cm.)
Signed, Y. Kuniyoshi, 28, lower right
Gift of Louis Held, 1965
965-P-172

Still Life with Portrait, 1928
Lithograph on paper, 17 x 10.75" (43.18 x 27.30 cm.)
Signed, Y. Kuniyoshi, 28, lower right
Museum purchase, 1967
967-P-175

Wire Performer, 1938
Lithograph on paper, 15.87 x 11.87" (40.32 x 30.16 cm.)
Signed, "Yasuo Kuniyoshi" by S. M. Kuniyoshi, lower right
Museum purchase, 1968
968-P-259

Woman Undressing, 1928
Lithograph on paper, (18/30), 13 x 9" (33.02 x 22.86 cm.)
Signed, Y. Kuniyoshi, 28, lower right
Museum purchase, 1965
965-P-287

The following three signed lithographs on paper are the gift of Carl Dennison, 1975

Fruit, or Still Life with Pears
9.75 x 13.25" (24.76 x 33.65 cm.)
975-P-130

Girl in Feathered Hat
9.25 x 7" (23.49 x 17.78 cm.)
975-P-129

High Wire
17 x 12.5" (43.18 x 31.75 cm.)
975-P-131

The following two lithographs on paper are the gift of Louis Held, 1965

Interior with Dress Form
12.5 x 8.5" (31.75 x 21.59 cm.)
965-P-165

Three Dancers, 1937
14.25 x 11" (36.19 x 27.94 cm.)
965-P-170

Louis KURZ and Alexander ALLISON, (active 19th century)

Abraham Lincoln
Lithograph on paper, 27.75 x 22" (70.48 x 55.88 cm.)
Unsigned
Gift of the Youngstown Public Library, 1976
976-P-103

The following thirteen unsigned lithographs on paper are a museum purchase, 1972

Declaration of Independence
22 x 28" (55.88 x 71.12 cm.)
972-P-104

Paul Revere
12 x 18" (30.48 x 45.72 cm.)
972-P-112

Portrait of Benjamin Franklin
28 x 22" (71.12 x 55.88 cm.)
972-P-106

Portrait of George Washington
27 x 21" (68.58 x 53.34 cm.)
972-P-108

Portrait of Martha Washington
27 x 21" (68.58 x 53.34 cm.)
972-P-107

Revolutionary War Series, (seven prints)
12.5 x 18" (31.75 x 45.72 cm.)
972-P-113

Washington Entering Trenton
16 x 20" (40.64 x 50.80 cm.)
972-P-105

Yayoi KUSAMA, (1929–)

Dot Abstraction
Oil on canvas, 44 x 45" (111.76 x 114.30 cm.)
Unsigned
Gift of Mr. and Mrs. Harry L. Tepper, 1968
969-O-140

The Butler Institute's collection contains twenty-three pastels and watercolors on paper of various sizes which are the gift of Mr. and Mrs. Harry L. Tepper, 1968
975-W-111

Chester M. KWIECINSKI, (1924–)

Woods, 1961
Watercolor on paper, 21 x 29" (53.34 x 73.66 cm.)
Signed, Kwiecinski, lower right
Museum purchase, 1962
962-W-109

William LACHOWICZ, (active 20th century)

Signal
Oil on canvas, 42 x 20" (106.68 x 50.80 cm.)
Unsigned
Museum purchase, 1956
956-O-115

Robert LAESSIG, (1920–)

Spring Soliloquy, 1962
Watercolor on paper, 35 x 43.5" (88.90 x 110.49 cm.)
Signed, Robert Laessig, 62, lower right
Museum purchase, 1962
962-W-103

Sunflower #1, 1960
Watercolor on paper, 45 x 35" (114.30 x 88.90 cm.)
Signed, Robert Laessig, lower right
Museum purchase, 1960
960-W-108

John La FARGE, (1835–1910)

Kwannon Meditating on Human Life, 1894
Oil on canvas, 36 x 34" (91.44 x 86.36 cm.)
Signed, John La Farge, lower left
Museum purchase, 1918
918-O-106

Sketch for Portrait of Dickey Hunt: A Boy and His Dog, 1910
Pencil on paper, 4.87 x 4" (12.38 x 10.16 cm.)
Unsigned
Gift of Joseph G. Butler, III, 1981
981-D-105

LAFOSSE, (active late 20th century)

Young, '76
Lithograph on paper, 30 x 23.75" (76.20 x 60.32 cm.)
Unsigned
Museum purchase, 1971
971-P-124

Jack C. LAHRER, (active 20th century)

The Frosted Pitcher
Oil on canvas, 24 x 20" (60.96 x 50.80 cm.)
Signed, J. C. Lahrer, lower left
Gift of Jack C. Lahrer, 1983
983-O-109

Norman LALIBERTE, (active late 20th century)

The Future and Beyond, 1994
Acrylic on board, 40 x 30" (101.60 x 76.20 cm.)
Signed, Laliberte, lower left
Gift of Norman Laliberte, 1994
994-O-117

Vassili LAMBRINOS, (active 20th century)

Easter Parade
Oil on canvas, 25.5 x 35.5" (64.77 x 90.17 cm.)
Signed, V. Lambrinos, lower left
Gift of Vassili Lambrinos, 1974
974-O-104

Chet Harmon LaMORE, (1908–1980)

After the Harvest, 1938
Lithograph on paper, 13.75 x 17.5" (34.92 x 44.45 cm.)
Signed, Chet LaMore, lower right
Gift of Mr. and Mrs. Nahum Tschacbasov, 1975
975-P-128

Robert L. LANCASTER, (1924–)

Staccato for Dormers, 1953
Oil on canvas, 30 x 40" (76.20 x 101.60 cm.)
Signed, R. L. Lancaster, 53, lower right
Museum purchase, 1953
953-O-109

Ernest Albert LAND, (1918–)

Tailgate, 1971
Oil on canvas, 14 x 48" (35.56 x 121.92 cm.)
Signed, Ernest Albert Land, upper right
Museum purchase, 1972
972-O-118

Jacob LANDAU, (1917–)

Attica
Lithograph on paper, 22 x 30" (55.88 x 76.20 cm.)
Signed, Jacob Landau, lower right
Gift of Martin Barooshien, 1973
973-P-118

Bird of Prey, 1965
Woodcut on paper, (65/250), 11 x 9" (27.94 x 22.86 cm.)
Signed, Jacob Landau, lower right
Museum purchase, 1965
965-P-316

Lev LANDAU, (1896– ?)

Shoppers
Oil on canvas, 12 x 14" (30.48 x 35.56 cm.)
Signed, Lev Landau, upper left
Gift of Louis Held, 1965
965-O-132

Fitz Hugh LANE, (1804–1865)

Ship *Starlight*
Oil on canvas, 30 x 50" (76.20 x 127.00 cm.)
Unsigned
Museum purchase, 1928
S28-O-127

James M. LANG, (active 20th century)

(Untitled)
Portfolio of 53: Rip Off on the Last Millennium
Print on paper, 8.5 x 11" (21.59 x 27.94 cm.)
Signed, J. M. Lang, lower right
Gift of the William Busta Gallery, 1990
990-P-111.5

Edward LANING, (active 20th century)

Three Nudes, 1929
Oil on canvas, 30 x 25" (76.20 x 63.50 cm.)
Signed, Laning, 29, lower left
Gift of the estate of Mary Fife Laning, 1991
991-O-233

The following six drawings on paper of various sizes are the gift of the estate of Mary Fife Laning, 1991

La Farge - Kwannon Meditating on Human Life

La Farge - Sketch for Portrait of Dickey Hunt: A Boy and His Dog

Laliberte - The Future and Beyond

Jacob Landau - Bird of Prey

Lane - Ship *Starlight*

Laning - Three Nudes

Larson - Man of Honor

Robert Laurent - Nude Model

Lawman - Coal Tipple

Lawrence - The Street

Lawrence - Men at War

Etruscan Sarcophagi, 1988
991-D-141

Cassino, 1944
991-D-142

Gaeta, 1944
991-D-143

Victoire Portrait un Trophee
991-D-145

Tarquinia
991-D-146

The Trestle, 1934–35
991-D-144

Julius J. LANKES, (1884–1960)

The following two signed woodcuts on paper are
the gift of Norman and June Krafft, 1980

Barn and Silo
10.5 x 8" (26.67 x 20.32 cm.)
980-P-139

The Bee
8.5 x 6" (21.59 x 15.24 cm.)
980-P-140

Gerald LARING, (active late 20th century)

(Untitled)
Serigraph on paper, 30 x 36" (76.20 x 91.44 cm.)
Signed, Gerald Laring, lower right
Gift of Arthur Feldman, 1991
991-P-180

Eugene LARKIN, (1921–)

Yellow Vase, 1957
Serigraph on paper, 10 x 20" (25.40 x 50.80 cm.)
Signed, Eugene Larkin, © 1957, lower right
Museum purchase, 1959
959-P-102

Fran LARSEN, (1937–)

Midtown, 1969
Watercolor on paper, 36 x 26" (91.44 x 66.04 cm.)
Signed, Fran Larsen, lower right
Museum purchase, 1969
969-W-109

Carl H. LARSON, (1926–)

A Study in Time, 1962
Oil on canvas, 24 x 36" (60.96 x 91.44 cm.)
Signed, C. H. Larson, lower left
Museum purchase, 1962
962-O-123

Man of Honor, 1966
Oil on masonite, 24 x 36" (60.96 x 91.44 cm.)
Signed, C. H. Larson, lower left
Museum purchase, 1966
966-O-130

A Reasonable Prophet
Drawing on paper, 11.5 x 8.5" (29.21 x 21.59 cm.)
Signed, C. H. Larson, lower right
Museum purchase, 1965
965-D-131

Joe LASKER, (1919–)

Tuscan Town #2
Drawing on paper, 14 x 17" (35.56 x 43.18 cm.)
Signed, Joe Lasker, lower right
Museum purchase, 1959
959-D-109

Thanksgiving Dress
Sepia ink on paper, 11.5 x 8.5" (29.21 x 21.59 cm.)
Signed, Joe Lasker, lower right
Gift of Louis Held, 1965
965-D-115

Sidney LAUFMAN, (1891–1985)

The Pines
Oil on canvas, 30 x 40" (76.20 x 101.60 cm.)
Signed, Sidney Laufman, lower right
Museum purchase, 1954
954-O-127

John LAURENT, (1890– ?)

The following two aquatints on paper are the gift
of Louis Held, 1967

Bait Wharf, 1965
(6/20), 9 x 5" (22.86 x 12.70 cm.)
967-P-139

Sea Still Life, 1965
(11/20), 8 x 8.75" (20.32 x 22.22 cm.)
967-P-140

Robert LAURENT, (1890–1970)

Nude Model
Pen and ink on paper, 15 x 7.5" (38.10 x 19.05 cm.)
Signed, Laurent, lower left
Gift of Louis Held, 1965
965-D-108

Cynthia D. LAVELLE-PAHL, (active late 20th
century)

(Untitled)
Portfolio of 53: Rip Off on the Last Millennium
Print on paper, 8.5 x 11" (21.59 x 27.94 cm.)
Signed, Cynthia Lavelle-Pahl, lower right
Gift of the William Busta Gallery, 1990
990-P-111.8

Jasper H. LAWMAN, (1825–1906)

Coal Tipple, 1854
Oil on canvas, 30.75 x 40" (78.10 x 101.60 cm.)
Signed, J. H. Lawman, 1854, lower left
Museum purchase, 1967
967-O-105

Jacob LAWRENCE, (1917–)

The Street, 1957
Casein on paper, 30.5 x 22.25" (77.47 x 56.51 cm.)
Signed, Jacob Lawrence, lower right
Museum purchase, 1986
986-W-111

Men at War, 1947
Watercolor on paper, 16 x 20" (40.64 x 50.80 cm.)
Signed, Jacob Lawrence, 1947, lower right
Gift of Marvin Small, 1948
948-W-105

Self Portrait, 1965
Ink on paper, 18 x 14.5" (45.72 x 36.83 cm.)
Signed, Jacob Lawrence, lower right
Gift of Youngstown Chapter of Links, Inc., 1984
984-D-102

The Builders, 1974
Silkscreen on paper, 34 x 25.75" (86.36 x 65.40 cm.)
Signed, Jacob Lawrence, lower right
Museum purchase, 1986
986-P-107

Ernest LAWSON, (1873–1939)

Misty Day in March, 1917
Oil on canvas, 30 x 40" (76.20 x 101.60 cm.)
Signed, E. Lawson, lower right
Museum purchase, 1921
921-O-107

Wesley LEA, (1914–)

Gold in the Earth, 1956
Watercolor on paper, 19 x 27" (48.26 x 68.58 cm.)
Signed, Lea, 56, lower left
Museum purchase, 1958
958-W-106

Lonely Ruins, 1947
Oil on canvas, 18.5 x 24.5" (46.99 x 62.23 cm.)
Signed, Lea, lower right
Gift of Edith Halpert, 1947
947-O-105

Frederick LEACH, (1924–)

The Rider
Oil on canvas, 22 x 23" (55.88 x 58.42 cm.)
Signed, Leach, lower right
Gift of the Friends of American Art, 1963
963-O-121

Three Fisherman, 1957
Watercolor on paper, 21.75 x 28.5" (55.24 x 72.39 cm.)
Signed, Leach, lower right
Museum purchase, 1968
968-W-133

Ruth LEAF, (active 20th century)

In November
Intaglio on paper, 25.5 x 23.5" (64.77 x 59.69 cm.)
Signed, Ruth Leaf, lower right
Gift of Hersey Lerner, 1978
978-P-113

Percy A. LEASON, (1889–1959)

In the Catskills
Oil on board, 16 x 20" (40.64 x 50.80 cm.)
Signed, Leason, lower right
Gift of Max Leason, 1978
978-O-113

Rico LeBRUN, (1900–1964)

The Beggar, 1941
Watercolor on paper, 25 x 19" (63.50 x 48.26 cm.)
Signed, LeBrun, 1941, lower right
Gift of Mr. and Mrs. Milton Lowenthal, 1951
951-W-102

James LECHAY, (1907–)

Still Life, 1938
Oil on canvas, 20 x 26" (50.80 x 66.04 cm.)
Signed, James Lechay, lower right
Gift of Mr. and Mrs. Nahum Tschacbasov, 1975
975-O-134

Portrait
Pastel on paper, 23 x 17" (58.42 x 43.18 cm.)
Unsigned
Gift of Mr. and Mrs. Nahum Tschacbasov, 1972
972-D-101

Myron LECHAY, (1898–)

Girl on Beach, 1932
Watercolor on paper, 14.5 x 23" (36.83 x 58.42 cm.)
Signed, Myron Lechay, upper left
Gift of Mr. and Mrs. Nahum Tschacbasov, 1975
975-W-113

Charles LECLAIR, (1914–)

Chinese Greengrocer, 1955
Watercolor on paper, 22 x 30" (55.88 x 76.20 cm.)
Unsigned
Museum purchase, 1956
956-W-107

Catherine LEE, (1950–)

(Untitled), 1978
Oil on canvas, 36 x 36" (91.44 x 91.44 cm.)
Unsigned
Gift of Professor Sam Hunter, 1990
990-O-118

Doris LEE, (1905–1983)

Maytime, 1936
Pastel on paper, 22 x 27" (55.88 x 68.58 cm.)
Signed, Doris Lee, lower right
Museum purchase, 1940
940-W-105

Afternoon Tea
Lithograph on paper, 8 x 10.5" (20.32 x 26.67 cm.)
Signed, Doris Lee, lower right
Gift of Edward Dobroski, 1993
993-P-146

Apple Pickers
Lithograph on paper, 9 x 12" (22.86 x 30.48 cm.)
Signed, Doris Lee, lower right
Museum purchase, 1948
948-P-123

Fruits, 1966
Silkscreen on paper, 12 x 24" (30.48 x 60.96 cm.)
Signed, Doris Lee, lower right
Museum purchase, 1966
966-P-143

Thanksgiving
Lithograph on paper, 12 x 16" (30.48 x 40.64 cm.)
Signed, Doris Lee, lower right
Gift of Albert E. Hise, 1979
979-P-143

Mong Q. LEE, (1923–1960)

Boat #2
Watercolor on paper, 15 x 32" (38.10 x 81.28 cm.)
Signed, Mong Q. Lee, lower left
Museum purchase, 1959
959-W-109

Lawson - Misty Day in March

Leach - The Rider

LeBrun - The Beggar

Myron Lechay - Girl on Beach

Doris Lee - Maytime

Samuel M. Lee - Plantation Home on the Ohio River

Leichman - Sun Room

Leighton - A Barnyard Snow Scene

Lepore - (Untitled)

Lepper - Railroad Station

Samuel M. LEE, (? –1841)

Plantation Home on the Ohio River
Oil on canvas, 25 x 32" (63.50 x 81.28 cm.)
Unsigned
Museum purchase, 1968
968-O-171

Hilton LEECH, (1906–1969)

Feeding Gulls
Watercolor on paper, 21 x 27" (53.34 x 68.58 cm.)
Signed, Hilton Leech, lower right
Museum purchase, 1965
965-W-134

J. Harvey LEEDY, (1870–1947)

Swartz & Co. General Store
Oil on canvas, 28 x 40" (71.12 x 101.60 cm.)
Signed, J. Harvey Leedy, lower left
Gift of the estate of J. Harvey Leedy, 1947
947-O-106

Rita LEFF, (1907–)

Carnival
Woodcut on paper, 24 x 17.5" (60.96 x 44.45 cm.)
Signed, Rita Leff, lower right
Gift of Rita Leff, 1978
978-P-108

Sisters
Color woodcut on paper, 7.5 x 5.5" (19.05 x 13.97 cm.)
Signed, Rita Leff, lower right
Gift of Louis Held, 1965
965-P-132

Irving LEHMAN, (1900–1983)

Steeples
Oil on canvas, 34 x 12" (86.36 x 30.48 cm.)
Signed, I. Lehman, lower right
Gift of Harry Salpeter, 1963
963-O-108

Leonard LEHRER, (1935–)

Formal Garden
Black and white etching on paper, 11.75 x 3.62" (29.85 x 9.20 cm.)
Signed, L. Lehrer, lower right
Museum purchase, 1969
969-P-106

Seymour LEICHMAN, (1933–)

Sun Room, 1972
Oil on canvas, 50 x 60" (127.00 x 152.40 cm.)
Signed, Leichman, lower right
Museum purchase, 1973
973-O-116

(Untitled)
Lithograph on paper, 21 x 26.25" (53.34 x 66.67 cm.)
Signed, Leichman, lower right
Gift of Dorothy Dennison Butler, 1980
980-P-121

Fate Takes a Hand
Lithograph on paper, 24 x 18" (60.96 x 45.72 cm.)
Signed, Seymour Leichman, lower right
Gift of Dorothy Dennison Butler, 1970
970-P-108

Scott LEIGHTON, (1847–1898)

A Barnyard Snow Scene
Oil on canvas, 20 x 33" (50.80 x 83.82 cm.)
Signed, Scott Leighton, lower left
Museum purchase, 1968
968-O-208

Cows
Oil on canvas, 22.25 x 36.25" (56.52 x 92.07 cm.)
Signed, Scott Leighton, lower left
Museum purchase, 1968
968-O-197

Smuggler, ca. 1874
Lithograph on paper, 18 x 25.25" (45.72 x 64.13 cm.)
Signed, Scott Leighton, lower right
Museum purchase, 1968
968-P-283

William Johnson L'ENGLE, Jr., (1884–1957)

Latins
Watercolor on paper, 13 x 19" (33.02 x 48.26 cm.)
Signed, L'Engle, lower right
Gift of Mr. and Mrs. Harry Tepper, 1975
975-W-110

Annie LENNEY, (1910– ca. 1994)

Dancing Trees
Oil on canvas, 24 x 36" (60.96 x 91.44 cm.)
Unsigned
Gift of William Shannon, 1961
961-O-101

Michael LENSON, (1903–1971)

Drawing
Ink on paper, 9 x 7" (22.86 x 17.78 cm.)
Signed, Lenson, lower left
Gift of Mr. and Mrs. Irving White, 1961
961-D-108

Lillian LENT, (1926–)

Sleeping Bird Hill, 1963
Lithograph on paper, 14 x 11" (35.56 x 27.94 cm.)
Signed, Lillian Lent, lower right
Museum purchase, 1963
963-P-138

Norbert LENZ, (active 20th century)

(Untitled)
Acrylic on paper, 18.5" dia. (46.99 cm.)
Signed, Norbert Lenz, lower left
Gift of Mr. and Mrs. Joseph Erdelac, 1993
993-O-105

James LEPORE, (1931–)

(Untitled)
Acrylic on paper, 75 x 34" (190.50 x 86.36 cm.)
Unsigned
Museum purchase, 1988
988-O-127

Robert Lewis LEPPER, (1906–)

Railroad Station
Oil on canvas, 24 x 30" (60.96 x 76.20 cm.)
Signed, Robert Lepper, lower right
Gift of George Schmutz, 1949
949-O-108

Harold M. LeROY, (1905–ca. 1994)

The following four signed silkscreens on paper of various sizes are the gift of Harold M. LeRoy, 1974

Arrarat
974-P-110

At the Spanish Steps
974-P-109

Mod Cirque
974-P-108

Shades of Tiffany
974-P-107

Don LeRUD, (1932–)

Conformation VIII, 1967
Opaque watercolor on paper, 21 x 27" (53.34 x 68.58 cm.)
Signed, LeRud, 67, lower right
Museum purchase, 1967
967-W-109

Alfred LESLIE, (1927–)

View Over Holyoke, Massachusetts, 1983
Watercolor on paper, 36 x 53" (91.44 x 134.62 cm.)
Unsigned
Gift of Alfred Leslie, 1984
984-W-101

The following two signed etchings on paper, 70 x 46.62" (177.80 x 118.42 cm.), are the gift of Alfred Leslie and Pace Editions, New York, 1993

Hugh, 1992
993-P-145

Malena
993-P-144

R. Hayley LEVER, (1876–1968)

Pawling, NY
Oil on canvas, 10 x 12" (25.40 x 30.48 cm.)
Signed, Hayley Lever, lower left
Gift of Arthur A. Marshall, 1991
991-O-225

Julian LEVI, (1900–1982)

Beachcomber
Oil on canvas, 22 x 28" (55.88 x 71.12 cm.)
Signed, Julian Levi, lower left
Gift of Edith Halpert, 1954
954-O-128

Cassandra
Lithograph on paper, (12/25), 16.5 x 22.5" (41.91 x 57.15 cm.)
Signed, Julian Levi, lower right
Museum purchase, 1967
967-P-200

Morton LEVIN, (1923–)

Caryatid, 1966
Aquatint on paper, 15.75 x 9.5" (40.00 x 24.13 cm.)
Signed, Morton Levin, lower right
Museum purchase, 1967
967-P-145

The following two etchings on paper are a museum purchase, 1967

Barbute
(3/20), 9 x 9.75" (22.86 x 24.77 cm.)
967-P-204

Orpheus
(8/50), 16 x 19" (40.64 x 48.26 cm.)
967-P-205

Jack LEVINE, (1915–)

Carnival at Sunset, 1984
Oil on canvas, 60 x 48" (152.40 x 121.92 cm.)
Signed, J. Levine, lower right
Museum purchase, 1988
988-O-117

Funeral of a Policeman
Charcoal on paper, 19.75 x 25.5" (50.17 x 64.77 cm.)
Signed, J. Levine, lower left
Museum purchase, 1984
984-D-101

Office Figures
Pencil on paper, 10 x 6.5" (25.40 x 16.51 cm.)
Signed, J. Levine, lower right
Gift of Louis Held, 1965
965-D-122

Adam and Eve, 1965
Etching on paper, (72/100), 10 x 8" (25.40 x 20.32 cm.)
Signed, J. Levine, lower right
Museum purchase, 1965
965-P-201

Hillel
Etching on paper, (98/100), 10 x 8" (25.40 x 20.32 cm.)
Signed, J. Levine, lower right
Museum purchase, 1964
964-P-122

Maimonides, 1965
Aquatint on paper, (75/100), 10 x 8" (25.40 x 20.32 cm.)
Signed, J. Levine, lower right
Museum purchase, 1965
965-P-200

Rape of the Sabines
Etching on paper, (3/100), 8 x 10.25" (20.32 x 26.04 cm.)
Signed, J. Levine, lower right
Museum purchase, 1967
967-P-195

Les LEVINE, (1925–)

Culture Hero, 1970
Silkscreen on paper, (26 page book), 23.5 x 18" (56.69 x 45.72 cm.)
Unsigned
Gift of Reese and Marilyn Arnold Palley, 1991
991-P-156

Abraham F. LEVINSON, (1883–1946)

Man in Shirt Sleeves, Wearing Cap
Oil on canvas, 30 x 25" (76.20 x 63.50 cm.)
Signed, A. F. Levinson, left center
Gift of Teresa Jackson Weill, 1968
968-O-210

Boats in Dock
Watercolor on paper, 17 x 23" (43.18 x 58.42 cm.)
Signed, A. F. Levinson, lower right
Gift of Teresa Jackson Weill, 1968
968-W-141

Leslie - View Over Holyoke, Massachusetts

Leslie - Hugh

Levi - Beachcomber

Jack Levine - Carnival at Sunset

Jack Levine - Funeral of a Policeman

Edmond Lewis - Mirror Lake, Adirondacks

Martin Lewis - Rain on Murray Hill

Lewitt - (Untitled)

Libby - On the Spur

Lichtenstein - Weatherford's Surrender to Jackson

Sharon Bohm LEVY, (active 20th century)

Patchwork Wicker Interior, 1977
Silkscreen on paper, 17 x 19.5" (43.18 x 49.53 cm.)
Signed, Sharon Bohm Levy, lower right
Gift of Mr. and Mrs. Samuel Bohm, 1978
978-P-101

Edmond D. LEWIS, (1837–1910)

Mirror Lake, Adirondacks, 1870
Oil on canvas, 30 x 53" (76.20 x 134.62 cm.)
Signed, E. D. Lewis, lower left
Gift of Grace Heath Butler, 1968
968-O-216

Martin LEWIS, (1882–1962)

The following three signed prints on paper of
various sizes are a museum purchase, 1968, 1978

Passing Storm, 1919
978-P-125

Rain on Murray Hill
968-P-322

Rainy Day, Queens, 1931
978-P-124

Norman Wilfred LEWIS, (1902–1979)

Talking It Over
Lithograph on paper, 10.5 x 4.5" (26.67 x 11.43 cm.)
Signed, N. L., lower left
Gift of Louis Held, 1965
965-P-147

William Arthur LEWIS, (1918–)

A Winter's Day, 1957
Watercolor on paper, 13 x 29" (33.02 x 73.66 cm.)
Signed, William Lewis, 1957, lower right
Museum purchase, 1958
958-W-107

Sol LEWITT, (1928–)

(Untitled), 1973
Lithograph on paper, 8.87 x 8.87" (22.55 x 22.55 cm.)
Signed, Lewitt, on reverse
Gift of Steven Feinstein, 1983
983-P-156

William Charles LIBBY, (1919–1983)

On the Spur, 1962
Oil on canvas, 24 x 33" (60.96 x 83.82 cm.)
Unsigned
Gift of Joseph G. Butler, III, 1963
963-O-107

Non-Conformists
Oil on canvas, 24 x 40" (60.96 x 101.60 cm.)
Unsigned
Museum purchase, 1949
949-O-109

The following five lithographs on paper of
various sizes are a museum purchase, 1952,
1958, 1966

Day Dreams
952-P-108

Fire Scar
966-P-130

Moonlight
958-P-105

Off the Main Line
952-P-107

Semaphore
958-P-106

The following four etchings and lithographs on
paper of various sizes are the gift of Joseph G.
Butler, III, 1975, 1977, 1980

Currents
977-P-125

Fantasy
975-P-115

Moonlight
980-P-126

The Flame
975-P-114

Lewis Jean LIBERTE, (1896–1965)

Nocturne
Gouache on paper, 8.5 x 6.5" (21.59 x 16.51 cm.)
Signed, Liberte, lower left
Gift of Louis Held, 1965
965-W-116

The Butler Institute's collection contains twelve
drawings on paper of various sizes which are the
gift of Lewis Jean Liberte, 1968
968-D-122 — 968-D-133

Roy F. LICHTENSTEIN, (1923–)

Weatherford's Surrender to Jackson,
1953
Oil on canvas, 42 x 50" (106.68 x 127.00 cm.)
Signed, Lichtenstein, lower right
Gift of Samuel N. Tonkin and Sidney Freedman, 1955
955-O-123

The Explorer
Oil on canvas, 16 x 14" (40.64 x 35.56 cm.)
Signed, Lichtenstein, lower right
Gift of Mr. and Mrs. Robert Miller, 1959
959-O-128

The Straight Shooter
Oil on canvas, 16 x 13.5" (40.64 x 34.29 cm.)
Signed, Lichtenstein, lower right
Gift of Mr. and Mrs. Samuel Brouner, 1959
959-O-131

The Treaty of Traverse des Sioux
Oil on canvas, 28 x 42" (71.12 x 106.68 cm.)
Signed, Lichtenstein, lower right
Gift of Mr. and Mrs. Samuel Brouner, 1961
961-O-129

No Thank You
Six color poster on paper, 24 x 26" (60.96 x 66.04 cm.)
Signed, Lichtenstein, lower right
Gift of Roy F. Lichtenstein, 1990
990-P-137

(Untitled), 1973
Serigraph on paper, 12 x 9" (30.48 x 22.86 cm.)
Unsigned
Gift of Roy F. Lichtenstein, 1983
983-P-157

Janet LIEBOWITZ, (active 20th century)

Purple Space
Acrylic on canvas, 44 x 48" (111.76 x 121.92 cm.)
Unsigned
Gift of Leonard Bocour, 1970
970-O-122

Vera LILIENSTERN, (active 20th century)

Flowers, 1963
Oil on canvas, 24 x 20" (60.96 x 50.80 cm.)
Signed, Lilienstern, lower right
Gift of Chase Gallery, 1965
965-O-101

Russell T. LIMBACH, (1904–)

The following three signed lithographs on paper,
12.5 x 18.5" (31.75 x 46.99 cm.), are the gift of
the Youngstown Public Library, 1976

C. W. A. Workers at the Incinerator, 1934
976-P-104

C. W. A. Workers at the Patrick Henry
School, 1934
976-P-109

C. W. A. Workers Sawing Piles at the
Sewage Disposal Works, 1934
976-P-110

The following five signed lithographs on paper,
18.5 x 12.5" (46.99 x 31.75 cm.), are the gift of
the Youngstown Public Library, 1976

C. W. A. Workers on the City Water-
front, 1934
976-P-111

Painters at the Cleveland Post Office,
1934
976-P-105

Placing the Cornice of the Cleveland
Post Office, 1934
976-P-107

Plasterers in the Cleveland Post Office,
1934
976-P-108

Structural Steel Workers on the Cleve-
land Post Office, 1934
976-P-106

The following three signed lithographs on paper
of various sizes are the gift of Albert E. Hise,
1979

Locust Trees
979-P-135

The Hunter, Flaw Hunter
979-P-156

The Train
979-P-134

C. LINDEMAN, (active late 19th century)

Charlotte Tod, 1868
Oil on canvas, 40 x 32" (101.60 x 81.28 cm.)
Unsigned
Gift of Mrs. Fred Tod, 1954
954-O-129

Earl LINDEMAN, (active 20th century)

The following three signed lithographs on paper
are the gift of Paul and Suzanne Donnelly
Jenkins, 1991

(Untitled), 1985
30 x 22" (76.20 x 55.88 cm.)
991-P-122

(Untitled), 1985
30 x 22" (76.20 x 55.88 cm.)
991-P-123

Hot Jazz
35.5 x 29.62" (90.17 x 75.25 cm.)
991-P-124

Richard LINDNER, (1901–1978)

The following three signed lithographs on paper
are the gift of Mr. and Mrs. Joseph P. Sontich,
1980

Dog and Man
28 x 21.75" (71.12 x 55.25 cm.)
980-P-144

Girl with Hula Hoop
26.5 x 20.5" (67.31 x 52.07 cm.)
980-P-142

Man in Profile
28 x 19.75" (71.12 x 50.17 cm.)
980-P-143

The following three signed lithographs on paper
are the gift of Samuel S. Mandel, 1986

How It All Began
28 x 21.75" (71.12 x 55.25 cm.)
986-P-166

Second Avenue
24 x 18.75" (60.96 x 47.63 cm.)
986-P-165

Uptown
39.5 x 27.5" (100.33 x 69.85 cm.)
986-P-164

The Vancouver Art Gallery
Lithograph on paper, 29 x 20.25" (73.66 x 51.44 cm.)
Signed, Richard Lindner, lower right
Anonymous gift, 1980
980-P-156

Judith J. LINHARES, (1940–)

Travelers
Oil on canvas, 78.5 x 96.5" (199.39 x 245.11 cm.)
Signed, J. J., lower right
Gift of Erle L. Flad, 1992
992-O-106

Lichtenstein - The Treaty of Traverse des Sioux (page 110)

Limbach - C. W. A. Workers at the Patrick Henry School

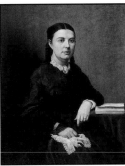
C. Lindeman - Charlotte Tod

Richard Lindner - Girl with Hula Hoop

Lipchitz - The Couple

Longo - Jules

Lotterman - Profile Nude

Lozowick - Into the Canyon

Lucioni - Landscape

Lucioni - Barn

Jacques LIPCHITZ, (1891–1973)

The Couple
Silkscreen on paper, (18/98), 17 x 21" (43.18 x 53.34 cm.)
Signed, Lipchitz, upper right
Gift of Louis Held, 1965
965-P-179

John L. LLOYD, (ca. 1883–1967)

Winter Landscape, 1923
Oil on canvas, 25 x 30" (63.50 x 76.20 cm.)
Signed, John L. Lloyd, lower right
Gift of the estate of Charles Crandall, 1951
982-O-106

Charles LOCKE, (1899–)

Furman St. North
Lithograph on paper, 8.5 x 6.75" (21.59 x 17.15 cm.)
Signed, Charles Locke, lower right
Gift of Louis Held, 1967
967-P-138

The following two signed lithographs on paper
of different sizes are a museum purchase, 1979

Critics
979-P-108

Intermission
979-P-115

Walter Ronald LOCKE, (1883– ?)

In Beaufort, South Carolina, 1931
Etching on paper, 16 x 13" (40.64 x 33.02 cm.)
Signed, W. R. Locke, lower right
Gift of Mrs. W. J. Sampson, 1977
977-P-110

George LOCKWOOD, (1929–)

Portrait of Redon
Colored wood engraving on paper, (40/50), 7 x 4.25" (17.78 x
10.80 cm.)
Signed, George Lockwood, lower right
Museum purchase, 1967
967-P-136

Michael LODERSTEDT, (active late 20th
century)

A Brief History of Art
Portfolio of 53: Rip Off on the Last Millennium
Print on paper, 8.5 x 11" (21.59 x 27.94 cm.)
Signed, imprint, L. M., lower right
Gift of the William Busta Gallery, 1990
990-P-111.12

John LONERGAN, (1897–1969)

Expectations
Lithograph on paper, 14 x 17.75" (35.56 x 45.09 cm.)
Signed, John Lonergan, lower right
Gift of Mr. and Mrs. Nahum Tschacbasov, 1975
975-P-127

Robert LONGO, (1953–)

Jules, 1988
Color lithograph with embossing on paper, (10/45), 30 x 15"
(76.20 x 38.10 cm.)
Signed, Robt. Longo, 88, lower right
Museum purchase, 1988
988-P-105

Harley LONNIE, (active 20th century)

Hopi Indian Altar
Watercolor on paper, 9 x 12" (22.86 x 30.48 cm.)
Unsigned
Gift of Albert E. Hise, 1979
979-W-109

Don LORD, (1929–)

Girard
Watercolor on paper, 22 x 27" (55.88 x 68.58 cm.)
Unsigned
Museum purchase, 1955
955-W-109

Sidney Roberts LORD, (active 20th century)

Bay View
Oil on canvas, 27 x 37" (68.58 x 93.98 cm.)
Signed, Sidney Roberts, lower right
Gift of Mr. and Mrs. John S. Miller, 1975
975-O-143

Hal LOTTERMAN, (1920–)

With Flowers, 1958
Oil on canvas, 40 x 30" (101.60 x 76.20 cm.)
Signed, Hal Lotterman, 58, upper left
Museum purchase, 1958
958-O-133

Profile Nude
Lacquer on cameo, 23.5 x 17" (59.69 x 43.18 cm.)
Unsigned
Gift of Hal Lotterman, 1960
960-D-108

Louis LOZOWICK, (1892–1973)

Into the Canyon, 1932
Lithograph on paper, 22.25 x 15.75" (56.52 x 40.01 cm.)
Signed, Louis Lozowick, 32, lower right
Museum purchase, 1978
978-P-126

Craig LUCAS, (active late 20th century)

Conduct of the Program
Portfolio of 53: Rip Off on the Last Millennium
Print on paper, 8.5 x 11" (21.59 x 27.94 cm.)
Signed, C. L., lower right
Gift of the William Busta Gallery, 1990
990-P-111.31

Luigi LUCIONI, (1900–)

Landscape, 1943
Oil on canvas, 6 x 12" (15.24 x 30.48 cm.)
Signed, L. Lucioni, 43, lower right
Gift of Louis Held, 1965
965-O-124

Barn, 1959
Etching on paper, 10.75 x 13.5" (27.31 x 34.29 cm.)
Signed, Luigi Lucioni, lower left
Gift of William and Margaret Kinnick, 1986
986-P-113

The following two etchings on paper of various
sizes are a museum purchase, 1965, 1966

Dominating Trees, 1965
965-P-116

The Enveloping Shadow, 1966
966-P-136

Eugene LUDINS, (1904–)

Utter Disrespect, 1966
Etching on paper, (126/150), 8 x 12" (20.32 x 30.48 cm.)
Signed, Eugene Ludins, lower right
Museum purchase, 1966
966-P-138

Ryah LUDINS, (active 20th century)

Dancing Figures
Oil and sand on canvas, 34 x 44" (86.36 x 111.76 cm.)
Signed, Ryah Ludins, lower right
Gift of Stanley Bard, 1967
967-O-101

George LUKS, (1867–1933)

The Cafe Francis, ca. 1909
Oil on canvas, 36 x 42" (91.44 x 106.68 cm.)
Signed, George Luks, lower left
Museum purchase, 1960
960-O-105

Sketch of George K. Bishop
Oil on canvas, 24 x 10" (60.96 x 25.40 cm.)
Unsigned
Gift of the estate of George K. Bishop, 1988
988-O-107

The following four signed drawings, pencil on paper, are a museum purchase, 1964, 1988

Traffic Cop and Mount
5.5 x 7.5" (13.97 x 19.05 cm.)
964-D-108

Yawning Waiter
6.25 x 4" (15.88 x 10.16 cm.)
964-D-107

Boxer
9.87 x 7.37" (25.08 x 18.73 cm.)
988-D-105

Polo Player
8.5 x 6.5" (21.59 x 16.51 cm.)
988-D-106

Harriet Randall LUMIS, (1870–1953)

Upland Pasture, ca. 1918
Oil on canvas, 24 x 28" (60.96 x 71.12 cm.)
Signed, Harriet R. Lumis, lower left
Gift of Richard H. Love Galleries, 1978
978-O-101

William LUMPKINS, (active late 20th century)

(Untitled), 1986
Watercolor on paper, 45 x 45" (114.30 x 114.30 cm.)
Signed, For P. and S., Aug., 1986, Santa Fe, W. Lumpkins, 86, lower right
Gift of Paul and Suzanne Donnelly Jenkins, 1991
991-W-160

Huc-Mazelet LUQUIENS, (1881–1961)

Puna, 1926
Etching on paper, 12.75 x 9.75" (32.39 x 24.77 cm.)
Signed, H. M. Luquiens, lower right
Gift of Mrs. W. J. Sampson, 1977
977-P-101

Nan LURIE, (active 20th century)

Kitchen Interior
Relief print on paper, 15.5 x 9.25" (39.37 x 23.50 cm.)
Signed, Nan Lurie, lower right
Gift of Joseph G. Butler, III, 1956
956-P-105

Dan LUTZ, (1906–1978)

Sunday in the Park
Brush, pen, and ink on paper, 17 x 22" (43.18 x 55.88 cm.)
Signed, Dan Lutz, lower left
Museum purchase, 1962
962-D-153

Minerva LYNCH, (1899– ?)

Flower Mood, 1941
Oil on canvas, 23 x 20" (58.42 x 50.80 cm.)
Unsigned
Museum purchase, 1941
941-O-102

Jane J. LYON, (1920–)

Bikini Heat, 1966
Acrylic on canvas, 50 x 48" (127.00 x 121.92 cm.)
Signed, Jane J. Lyon, 66, lower left
Museum purchase, 1966
966-O-108

William E. LYONS, (active 20th century)

Rough Day in Asheville
Photograph, 16 x 20" (40.64 x 50.80 cm.)
Unsigned
Museum purchase, 1992
992-P-184

Gregory LYSUN, (1924–)

Self Portrait and Things
Oil on canvas, 24 x 20" (60.96 x 50.80 cm.)
Signed, Gregory Lysun, lower right
Museum purchase, 1966
966-O-110

Guy MacCOY, (1904–)

Birds Feeding, 1946
Silkscreen on paper, 7 x 9" (17.78 x 22.86 cm.)
Signed, Guy MacCoy, 46, lower right
Gift of Louis Held, 1965
965-P-141

Covered Bridge, 1945
Silkscreen on paper, 11 x 14" (27.94 x 35.56 cm.)
Signed, Guy MacCoy, 45, lower right
Gift of Louis Held, 1965
965-P-175

Golden Warriors
Silkscreen on paper, 22.5 x 36" (57.15 x 91.44 cm.)
Signed, Guy MacCoy, lower right
Gift of John Baglama, 1992
992-P-105

Bruce MacDONALD, (1934–)

Nowhere
Oil on canvas, 20 x 24" (50.80 x 60.96 cm.)
Unsigned
Museum purchase, 1963
963-O-115

Luks - The Cafe Francis

Luks - Polo Player

Luks - Boxer

Lumis - Upland Pasture

Lurie - Kitchen Interior

Lynch - Flower Mood

Machetanz - Deep Snow

Macomer - Pandora

Maddick - (Untitled)

Magafan - Distant Mountain

Majore - Ultra

Maloney - The Park

Harry A. MacDONALD, (1919–)

Woman of Caserta, 1944
Pen and ink on paper, 17 x 11.5" (43.18 x 29.21 cm.)
Signed, H. A. MacDonald, 1944, lower right
Gift of Harry Salpeter Gallery, 1957
957-P-103

Fred MACHETANZ, (1908–)

Deep Snow, 1972
Oil on board, 22 x 28" (55.88 x 71.12 cm.)
Signed, F. Machetanz, lower right
Gift of Carl Dennison, 1979
979-O-124

Roy Vincent MacNICHOL, (1889– ?)

The following two signed oils on canvas, 29 x
39" (73.66 x 99.06 cm.), are the gift of J. S.
Ladson, 1957

Breton Fisherwomen, 1948
957-O-119

Haitian Interlude, 1948
957-O-135

M. L. MACOMER, (1861–1916)

Pandora
Oil on canvas, 40 x 30" (101.60 x 76.20 cm.)
Unsigned
Museum purchase, 1922
922-O-106

Russell MADDICK, (1941–)

(Untitled), 1971
Oil on canvas, 67.5 x 71" (171.45 x 180.34 cm.)
Unsigned
Museum purchase, 1971
971-O-115

New Blue, 1971
Watercolor on paper, 36 x 40.5" (91.44 x 102.87 cm.)
Unsigned
Museum purchase, 1971
971-W-102

Moishi, 1989
Mixed media on paper, (22/23), 29.25 x 29.5" (74.30 x 74.93
cm.)
Signed, R. Maddick, 89, lower right
Gift of Russell Maddick, 1991
991-P-105

Stephen MAGADA, (1925–1971)

Celebration
Oil on canvas, 26 x 40" (66.04 x 101.60 cm.)
Signed, Stephen, lower right
Museum purchase, 1954
954-O-131

After the Parade
Watercolor on paper, 15 x 22" (38.10 x 55.88 cm.)
Signed, Steven Magada, lower right
Museum purchase, 1953
953-W-106

The Park
Oil on canvas, 12 x 16" (30.48 x 40.64 cm.)
Unsigned
Gift of Paul and Suzanne Donnelly Jenkins, 1990
990-O-109

Ethel MAGAFAN, (1916–1993)

Distant Mountain
Oil on canvas, 23 x 33" (58.42 x 83.82 cm.)
Signed, Ethel Magafan, lower right
Gift of Adolph Green, 1960
960-O-104

Dark Image
Drawing on paper, 11 x 14" (27.94 x 35.56 cm.)
Signed, Ethel Magafan, lower right
Gift of Mr. and Mrs. Irving White, 1961
961-D-109

November Leaves
Etching on paper, 9.75 x 11.75" (24.77 x 29.85 cm.)
Signed, Ethel Magafan, lower right
Gift of Associated American Artists, 1968
968-P-240

Nude Searching for Prometheus
Drypoint on paper, 8 x 5.37" (20.32 x 13.65 cm.)
Signed, Ethel Magafan, lower right
Gift of Mr. and Mrs. Edward E. Ford, 1968
970-P-113

Winter Tree
Woodblock on paper, 19 x 9.5" (48.26 x 24.13 cm.)
Signed, Ethel Magafan, lower right
Museum purchase, 1958
958-P-101

F. D. MAHER, (active late 19th century)

Flying Squadron, ca. 1898
Chromolithograph on paper, 15.75 x 20" (40.01 x 50.80 cm.)
Unsigned
Museum purchase, 1975
975-P-121

Frank MAJORE, (active late 20th century)

Ultra, 1989
Cibachrome print on paper, 39.5 x 29.5" (100.33 x 74.93 cm.)
Signed, Majore, lower right
Museum purchase, 1992
992-P-119

Daniel MALONEY, (active late 20th century)

The Park
Oil on canvas, 12 x 16" (30.48 x 40.64 cm.)
Unsigned
Gift of Paul and Suzanne Donnelly Jenkins, 1990
990-O-109

The Pittsburgh Sisters, 1956
Oil and anthracite on panel, 14.5 x 11. 67" (36.83 x 29.65 cm.)
Signed, Maloney, lower right
Gift of Paul and Suzanne Donnelly Jenkins, 1991
991-O-220

Howard MANDEL, (1917–)

A Plenum of Birds
Casein on masonite, 48 x 29" (121.92 x 73.66 cm.)
Signed, Howard Mandel, lower right
Museum purchase, 1965
965-O-155

Woman Dining
Serigraph on paper, 16 x 10" (40.64 x 25.40 cm.)
Signed, Howard Mandel, lower right
Museum purchase, 1957
957-P-103

Beatrice M. MANDELMAN, (1912–)

Time of Winter
Oil and collage on canvas, 15 x 19" (38.10 x 48.26 cm.)
Signed, Mandelman, lower right
Gift of Mr. and Mrs. Irving White, 1961
961-O-130

Sylvia Plimack MANGOLD, (1938–)

Cropped Sunset with Plum Tree, 1981
Silkscreen on paper, 29.75 x 42" (75.57 x 106.68 cm.)
Signed, Sylvia Plimack Mangold, lower right
Gift of Marc A. Wyse, 1983
983-P-138

Tess MANILLA, (? –1994)

Ethereal Landscape
Oil on masonite, 24 x 28" (60.96 x 71.12 cm.)
Signed, Tess Manilla, lower right
Gift of Tess Manilla, 1981
981-O-105

Thomas R. MANLEY, (1853–1938)

A Street and Boulevard, West Side,
N.Y., 1891
Pen and ink on paper, 7.12 x 9.87" (18.10 x 25.08 cm.)
Signed, T. R. Manley, 1891
Gift of Sidney Hill, 1971
971-D-104

Joseph MANNING, (1928–)

Century of Time
Opaque watercolor on paper, 16.5 x 20.5" (41.91 x 52.07 cm.)
Signed, Joe Manning, lower left
Museum purchase, 1965
965-W-135

Wray MANNING, (1898–)

Afternoon Mail
Watercolor on paper, 22 x 30" (55.88 x 76.20 cm.)
Signed, Wray Manning, lower left
Museum purchase, 1950
950-W-103

Elsie MANVILLE, (1922–)

One Quart Berry Basket
Oil on canvas, 60 x 50" (152.40 x 127.00 cm.)
Signed, E. Manville, lower right
Gift of the Friends of American Art, 1978
978-O-117

Irving MARANTZ, (1912–1972)

The Drawing
Oil on canvas, 20 x 24" (50.80 x 60.96 cm.)
Signed, I. Marantz, lower right
Gift of the Living Arts Foundation, 1958
958-O-102

William MARCAVISH, (active 20th century)

Radio
Oil on canvas, 72 x 48" (182.88 x 121.92 cm.)
Unsigned
Museum purchase, 1973
973-O-103

MARCO, (active 20th century)

The following six drawings, ink on paper of
various sizes, are the gift of Mr. and Mrs. Irving
White, 1961

Lady and Man
961-D-115

Girl
961-D-116

Lady
961-D-118

(Untitled), 1954
961-D-114

(Untitled), 1954
961-D-106

Woman and Fish, 1954
961-D-119

The following six drawings, ink on paper of
various sizes, are the gift of Samuel Brouner,
1960, 1961

Head of a Girl, 1954
961-D-105

Nude Study
960-D-105

Seated Woman, 1954
961-D-103

Space Study
960-D-103

Two Girls, 1954
961-D-106

Young Man, 1954
961-D-104

Irving MARCUS, (1929–)

Giveaway, 1990
Oil pastel on paper, 28.5 x 24" (72.39 x 60.96 cm.)
Signed, Marcus, on reverse
Gift of Erle L. Flad, 1992
992-O-103

Marcia MARCUS, (1928–)

Dunes, 1967
Silkscreen on paper, (14/100), 17 x 23.5" (43.18 x 59.69 cm.)
Signed, Marcia Marcus, 67, lower right
Museum purchase, 1967
967-P-163

Dorie MARDER, (active late 20th century)

Rocks
Oil on canvas, 24 x 30" (60.96 x 76.20 cm.)
Signed, Marder, lower left
Gift of Leonard Bocour, 1975
975-O-108

De Hirsch MARGOLIES, (1899–1965)

(Untitled), 1957
Oil on paper, 17.67 x 23.75" (44.89 x 60.33 cm.)
Signed, De Hirsch Margolies, lower right
Gift of Marilynn Meeker, 1986
986-O-113

Mangold - Cropped Sunset with Plum Tree

Manley - A Street and Boulevard, West Side, N.Y.

Joseph Manning - Century of Time

Marantz - The Drawing

Irving Marcus - Giveaway

Maril - The Farm (page 116)

Marin - Schooner Yachts, Deer Isle, Maine

Maringer - Light of the World

Marisol - Chief Joseph Special

Markham - July 4, 1936

Marsh - The Normandie

Marsh - Two Girls on Boardwalk

The following four signed gouaches on paper are the gift of Mr. and Mrs. Nahum Tschacbasov, 1975, 1979

Basin for Little Boats, 1946
22 x 30.5" (55.88 x 77.47 cm.)
979-W-112

Dancer, 1955
23.75 x 17.75" (60.33 x 45.09 cm.)
975-W-114

Sailboats, 1957
17.5 x 22" (45.45 x 55.88 cm.)
975-W-116

Sailboats, Sun and Moon
14.75 x 22" (37.47 x 55.88 cm.)
975-W-115

Joseph MARGULIES, (1896–1986)

Contemplation, 1966
Etching on paper, (145/250), 9 x 7.25" (22.86 x 18.42 cm.)
Signed, Joseph Margulies, lower right
Museum purchase, 1966
966-P-122

Herman MARIL, (1908–1986)

The Farm, 1936
Serigraph on paper, 11.5 x 12.5" (29.21 x 31.75 cm.)
Signed, Herman Maril, in print
Gift of Albert E. Hise, 1979
979-P-132

John MARIN, (1870–1953)

Schooner Yachts, Deer Isle, Maine, 1928
Watercolor on paper, 16 x 22" (40.64 x 55.88 cm.)
Signed, Marin, 28, lower right
Museum purchase, 1967
967-W-119

Les Gondoliers, Venezia, 1907
Etching on paper, 5 x 7" (12.70 x 17.78 cm.)
Signed, Marin, 07, lower left
Museum purchase, 1968
968-P-261

Carol Jean MARINGER, (1933–)

Cosmic Light, 1972
Oil on canvas, 36 x 46" (91.44 x 116.84 cm.)
Signed, C. Maringer, upper left
Museum purchase, 1973
973-O-102

Light of the World, 1959
Oil on canvas, 28 x 26" (71.12 x 66.04 cm.)
Signed, Maringer, upper left
Museum purchase, 1960
960-O-122

Mystic Reader, 1956
Oil on canvas, 28 x 40" (71.12 x 101.60 cm.)
Signed, Maringer, upper left
Gift of the Waldhorns, 1959
959-O-117

MARISOL, (1930–)

Saca al Lengua, 1972
Lithograph on paper, (50/110), 41 x 29.25" (104.14 x 74.30 cm.)
Signed, Marisol, 1972, left center
Gift of Arthur Feldman, 1991
991-P-185

The following two signed lithographs on paper are the gift of Marc A. Wyse, 1983

Chief Joseph, 1980
41 x 31" (104.14 x 78.74 cm.)
983-P-112

Chief Joseph Special, 1980
41 x 31" (104.14 x 78.74 cm.)
983-P-113

Bendor MARK, (1912–)

The following two signed oils on canvas are the gift of Bernard Marcus, 1972

Colonialism, 1954
20 x 24" (50.80 x 60.96 cm.)
972-O-106

The Eagle, 1954
20 x 24" (50.80 x 60.96 cm.)
972-O-105

Henry MARK, (active 20th century)

Horse and Bird
Watercolor on paper, 4 x 6" (10.16 x 15.24 cm.)
Signed, Henry Mark, lower middle
Gift of Louis Held, 1965
965-W-127

The following two silkscreens on paper, 13.5 x 10.5" (34.29 x 26.67 cm.), are the gift of Louis Held, 1965

Mandolin Player
965-P-189

Woman with String
965-P-190

Kyra MARKHAM, (1891– ?)

July 4, 1936, 1936
Lithograph on paper, (11/25), 16 x 13.75" (40.64 x 34.93 cm.)
Signed, Kyra Markham, 36, lower right
Museum purchase, 1988
988-P-110

Reginald MARSH, (1898–1954)

The Normandie, 1938
Watercolor on paper, 30 x 50" (76.20 x 127.00 cm.)
Signed, Reginald Marsh, lower right
Museum purchase, 1962
962-W-115

Two Girls on Boardwalk, 1934
Tempera on canvas, 16 x 12" (40.64 x 30.48 cm.)
Signed, Reginald Marsh, lower right
Museum purchase, 1962
962-O-129

Shopping Bound, 1943
Oil on canvas, 12 x 9" (30.48 x 22.86 cm.)
Unsigned
Gift of Louis Held, 1965
965-O-131

Along the Waterfront, 1939
Watercolor on paper, 14 x 20" (35.56 x 50.80 cm.)
Signed, Reginald Marsh, lower right
Museum purchase, 1940
940-W-106

The following works are the gift of the estate of
Felicia Meyer Marsh, 1979

Lehigh Valley
Watercolor on paper, 14 x 20" (35.56 x 50.80 cm.)
Unsigned
979-W-101

People Standing at Bar
Ink and chalk on paper, 22.5 x 30.5" (57.15 x 77.47 cm.)
Unsigned
979-D-101

Two Girls, 1954
Maroger on panel, 11.87 x 2" (30.15 x 5.08 cm.)
Signed, R. M., lower right
979-O-112

Two Girls on Ferry Boat, ca. 1948
Watercolor on paper, 21.37 x 29.37" (54.29 x 74.61 cm.)
Signed, R. M., lower right
979-W-102

20th Century Limited, 1931
Etching on paper, 4.75 x 11.5" (12.07 x 29.21 cm.)
Signed, Reginald Marsh, lower right
Gift of Mrs. W. J. Sampson, 1977
977-P-102

Kenneth Hayes Miller
Etching on paper, 6.25 x 4.25" (15.88 x 10.80 cm.)
Unsigned
Museum purchase, 1965
965-P-124

New York Skyline, 1947
Wash on paper, 22.12 x 30.62" (56.20 x 77.79 cm.)
Signed, Reginald Marsh, 47, lower right
Gift of Drs. Paul and Laura Mesaros, 1991
991-D-105

Switch Yards, Erie Yards
Lithograph on paper, 13 x 16.75" (33.02 x 42.55 cm.)
Signed, Reginald Marsh, lower right
Gift of Albert E. Hise, 1979
979-P-142

(Untitled), 1949
(League Print—Two Girls Standing)
Engraving on paper, 9.75 x 7.87" (24.77 x 20.00 cm.)
Signed, Reginald Marsh, lower right
Gift of Carl Seaborg, 1974
974-P-101

The following four etchings on paper are the gift
of Louis Held, 1965

Bread Line, 1929
(21/50), 5 x 9" (12.70 x 22.86 cm.)
965-P-160

Gaiety Burlesque, 1929
7 x 11" (17.78 x 27.94 cm.)
965-P-161

Second Avenue El, 1929
7 x 9" (17.78 x 22.86 cm.)
965-P-159

Tattoo, Haircut and Shave
10 x 10" (25.40 x 25.40 cm.)
965-P-158

Fletcher MARTIN, (1904–1979)

Bullfight, 1956
Oil on canvas, 32 x 42" (81.28 x 106.68 cm.)
Signed, Fletcher Martin, 1956, upper left
Museum purchase, 1957
957-O-120

High Pass
Ink on paper, 8.5 x 11.5" (21.59 x 29.21 cm.)
Signed, Fletcher Martin, lower right
Gift of Joseph G. Butler, III, 1963
963-D-105

Christmas Card
Silkscreen on paper, 17 x 14.5" (43.18 x 36.83 cm.)
Unsigned
Gift of Joseph G. Butler, III, 1980
980-P-127

Girl with Mother
Lithograph on paper, 20 x 15" (50.80 x 38.10 cm.)
Signed, Fletcher Martin, lower right
Museum purchase, 1965
965-P-282

Passenger
Silkscreen on paper, 22 x 12" (55.88 x 30.48 cm.)
Signed, Fletcher Martin, lower right
Museum purchase, 1966
966-P-149

Sun Woman #1
Silkscreen on paper, 14 x 9.75" (35.56 x 24.77 cm.)
Signed, Fletcher Martin, lower right
Museum purchase, 1967
967-P-121

Young Mother
Lithograph on paper, 13 x 7" (33.02 x 17.78 cm.)
Signed, Fletcher Martin, lower middle
Museum purchase, 1952
952-P-109

Homer Dodge MARTIN, (1836–1897)

Newport Landscape, 1892
Oil on canvas, 18 x 30" (45.72 x 76.20 cm.)
Signed, Martin, lower right
Museum purchase, 1923
923-O-106

Keith MARTIN, (1911–1983)

Frontier, 1958
Watercolor on paper, 22 x 27" (55.88 x 69.58 cm.)
Signed, Martin, 1958, lower right
Museum purchase, 1958
958-W-104

Stephen MARTIN, (1936–)

Lone Tree
Woodcut on paper, (157/200), 26 x 19" (66.04 x 48.26 cm.)
Signed, Stephen Martin, lower right
Museum purchase, 1964
964-P-120

Marsh - Shopping Bound

Marsh - Along the Waterfront

Marsh - New York Skyline

Marsh - Tattoo, Haircut and Shave

Fletcher Martin - Bullfight

Homer Dodge Martin - Newport Landscape

Giovanni Martino - Lauriston St.

Frank H. Mason - The Old Philosopher

Max Mason - Spring Training Batter

Mathews - Bouquet

Matson - Tea Time

Matteson - John Elliot Preaching to the Indians (page 119)

Antonio Pietro MARTINO, (1902–)

Jefferson Street, Manayunk
Oil on canvas, 13 x 16.5" (33.02 x 41.91 cm.)
Signed, Antonio P. Martino, lower left
Gift of Antonio Pietro Martino, 1971
971-O-112

Winter Landscape
Oil on canvas, 28 x 23" (71.12 x 58.42 cm.)
Signed, Antonio P. Martino, lower left
Gift of Mr. and Mrs. Harry L. Tepper, 1968
969-O-129

The Cathedral, 1960
Watercolor on paper, 21 x 28" (53.34 x 71.12 cm.)
Signed, Antonio P. Martino, lower right
Museum purchase, 1962
962-W-102

Giovanni MARTINO, (1908–)

Lauriston St.
Oil on canvas, 24 x 36" (60.96 x 91.44 cm.)
Signed, Giovanni Martino, lower right
Museum purchase, 1967
967-O-120

Grape Hill, Manayunk
Watercolor on paper, 18 x 26" (45.72 x 66.04 cm.)
Signed, Giovanni Martino, lower right
Gift of the National Academy of Design, 1955
955-W-110

Schweig Langsdorf MARTYL, (1918–)

Landscape
Watercolor on paper, 10 x 14" (25.40 x 35.56 cm.)
Signed, Martyl, lower left
Gift of Joseph H. Hirshhorn, 1948
948-W-106

Marcia MARX, (active 20th century)

Musical Chairs
Lithograph on paper, 22.5 x 30" (57.15 x 76.20 cm.)
Signed, Marcia Marx, lower right
Gift of Samuel S. Mandel, 1986
986-P-136

Robert MARX, (1925–)

Faces, 1965
Etching on paper, (112/250), 10 x 12.5" (25.40 x 31.75 cm.)
Signed, Marx, lower right
Museum purchase, 1966
966-P-119

(Untitled)
Etching on paper, 12.75 x 9.25" (32.39 x 23.50 cm.)
Signed, Marx, lower right
Gift of William and Margaret Kinnick, 1986
986-P-110

Frank H. MASON, (1921–)

The Old Philosopher, 1953
Oil on canvas, 75 x 59" (190.50 x 149.86 cm.)
Unsigned
Gift of Frank H. Mason, 1963
963-O-128

Max MASON, (active late 20th century)

The following four signed oils on canvas, 56 x 53.75" (142.24 x 136.53 cm.), are a museum purchase, 1990

Spring Training Batter, 1990
56 x 53.87" (142.24 x 136.83 cm.)
990-O-114

Spring Training Catcher, 1990
56 x 51.75" (142,24 x 131.45 cm.)
990-O-113

Spring Training Fielder, 1989
65 x 55.87" (165.10 x 141.91 cm.)
990-O-115

Spring Training Pitcher, 1990
56 x 53.75" (142.24 x 136.53 cm.)
990-O-112

The following two signed lithographs on paper, 13 x 11.5" (33.02 x 29.21 cm.), are a museum purchase, 1995

23
995-P-110 — 995-P-111

Phillip Lindsay MASON, (1939–)

God Bless the Child Who's Got His Own, 1968
Lithograph on paper, 13 x 10" (33.02 x 25.40 cm.)
Signed, Mason, lower right
Gift of Phillip Lindsay Mason, 1981
981-P-102

Gregory MASUROVSKY, (1929–)

Nude, 1967
Etching on paper, 9.5 x 8" (24.13 x 20.32 cm.)
Signed, Gregory Masurovsky, 1967, lower right
Museum purchase, 1967
968-P-251

William T. MATHEWS, (1821–1905)

Bouquet, 1887
Oil on canvas, 13.5 x 9.75" (34.29 x 24.77 cm.)
Signed, W. T. Mathews, lower left
Gift of Albert E. Hise, 1979
979-O-118

Craig MATIS, (active late 20th century)

(Untitled)
Portfolio of 53: Rip Off on the Last Millennium
Print on paper, 8.5 x 14" (21.59 x 35.56 cm.)
Signed, Craig Matis, lower right
Gift of the William Busta Gallery, 1990
990-P-111.16

Greta MATSON, (1915–)

Tea Time, 1942
Oil on canvas, 30 x 25" (76.20 x 63.50 cm.)
Signed, Greta Matson, lower left
Gift of Greta Matson, 1981
981-O-104

Antonio MATTEI, (1900–)

Winter Burial, 1937
Oil on canvas, 17 x 35" (43.18 x 88.90 cm.)
Signed, Tony Mattei, 37, lower left
Museum purchase, 1941
941-O-103

Tompkins H. MATTESON, (1813–1884)

John Elliot Preaching to the Indians, 1849
Oil on canvas, 53 x 67" (134.62 x 170.18 cm.)
Unsigned
Museum purchase, 1961
961-O-102

Vincent MATTEUCCI, (active 20th century)

The following two signed untitled drawings, ink on paper of different sizes, are the gift of Mr. and Mrs. Joseph Erdelac, 1993
993-D-102 — 993-D-103

Gene E. MATTHEWS, (1931–)

Landscape, 1964
Watercolor on paper, 22 x 30" (55.88 x 76.20 cm.)
Signed, Matthews, 1964, lower right
Museum purchase, 1964
964-W-103

Henry MATTSON, (1887–1971)

The Wave
Oil on canvas, 20 x 24" (50.80 x 60.96 cm.)
Signed, Mattson, lower left
Gift of Mr. and Mrs. Milton Lowenthal, 1948
948-O-116

Jan MATULKA, (1890–1972)

Stone Bridge
Watercolor on paper, 12 x 18.75" (30.48 x 47.63 cm.)
Signed, Matulka, lower right
Gift of Louis Held, 1967
967-W-103

George Eric MAUNSBACH, (1890–ca. 1994)

Self Portrait
Oil on canvas, 16 x 20" (40.64 x 50.80 cm.)
Signed, Maunsbach, lower right
Gift of Jack M. Hockett, 1977
977-O-150

Alfred Henry MAURER, (1868–1932)

Flowers in a Green Vase, 1928
Gouache and pencil on paper, 21.5 x 18" (54.61 x 45.72 cm.)
Signed, To E. Weyher/28, A. H. Maurer, upper right
Museum purchase, 1996
996-W-101

Female Nude
Pencil on paper, 11 x 16.75" (27.94 x 42.55 cm.)
Signed, A. H. Maurer, upper left
Gift of Mr. and Mrs. Nahum Tschacbasov, 1979
979-D-119

Peter MAX, (1937–)

Mondrian Ladies, 1993
Acrylic on canvas, 36 x 48" (91.44 x 121.92 cm.)
Signed, MAX, upper right
Gift of Gil Michaels, 1994
994-O-113

John MAXWELL, (1909–)

Skyline, 1960
Oil and tempera on canvas, 13 x 16.25" (33.02 x 41.28 cm.)
Unsigned
Museum purchase, 1964
964-O-110

Winter Forms
Watercolor on paper, 20 x 35" (50.80 x 88.90 cm.)
Unsigned
Museum purchase, 1957
957-W-107

Bena Frank MAYER, (1898–1991)

Glen
Watercolor on paper, 31.5 x 22" (80.01 x 55.88 cm.)
Signed, Bena Frank Mayer, lower right
Gift of Ralph Mayer, 1978
978-W-112

Henrik Martin MAYER, (1908–)

Barometer Falling, 1948
Watercolor on paper, 12 x 27" (30.48 x 68.58 cm.)
Signed, Henrik Mayer, 48, lower right
Museum purchase, 1949
949-W-101

Ralph MAYER, (1895–1979)

The Sand Mountain #2
Oil on canvas, 25 x 17" (63.50 x 43.18 cm.)
Signed, Ralph Mayer, lower left
Gift of Bena Frank Meyer, 1978
978-O-116

John McAULIFFE, (1830–1900)

Colonel Jim Douglas and His Trotting Mares
Oil on paper, 14 x 21" (35.56 x 53.34 cm.)
Signed, J. McAuliffe, lower right
Museum purchase, 1965
965-O-149

Charles F. McCALL, (1887– ?)

Great Blondin Crosses Federal Street, 1947
Oil on canvas, 38 x 48" (96.52 x 121.92 cm.)
Signed, C. F. McCall, 1947, lower right
Gift of Charles F. McCall, 1951
951-O-114

Henry McCARTER, (1866–1942)

Landscape with Building
Oil on canvas, 30 x 36" (76.20 x 91.44 cm.)
Unsigned
Gift of Franklin C. Watkins, 1955
955-O-126

Senator Eugene McCARTHY, (1916–)

The following two signed lithographs on paper are the gift of Reese and Marilyn Arnold Palley, 1991

Great Seal XIV/XXXVIII
23.5 x 30" (59.69 x 76.20 cm.)
991-P-167

Love It or Leave It XXII/XXV
23 x 30" (58.42 x 76.20 cm.)
991-P-168

Lorraine C. McCARTY, (1920–)

Flight Simulator
Acrylic on canvas, 48 x 48" (121.92 x 121.92 cm.)
Unsigned
Museum purchase, 1967
967-O-121

Matulka - Stone Bridge

Maurer - Flowers in a Green Vase

Maurer - Female Nude

Max - Mondrian Ladies

McAuliffe - Colonel Jim Douglas and His Trotting Mares

McCarthy - Great Seal XIV/XXXVIII

McCloskey - Mills

McClure - Wind and Clouds

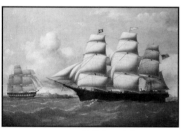

McFarlane - Ship: *Alice Couce*

McNickle - A More Than Even Trade

McNickle - Butler Institute Courtyard

Quentin L. McCHRISTY, (1921–1994)

The Angry Men

Watercolor on paper, 17 x 24" (43.18 x 60.96 cm.)
Unsigned
Gift of the Friends of American Art, 1960
960-W-110

Robert John McCLELLAN, (1906–)

Heads

Lithograph on paper, (8/100), 13 x 14" (33.02 x 35.56 cm.)
Signed, McClellan, lower right
Museum purchase, 1967
968-P-312

Martha McCLOSKEY, (active 20th century)

Houses

Oil on canvas, 30 x 31.12" (76.20 x 79.06 cm.)
Signed, McCloskey, lower right
Gift of Martha McCloskey, 1969
969-O-156

Mills, 1936

Watercolor on paper, 18 x 22" (45.72 x 55.88 cm.)
Signed, Martha McCloskey, 1936, lower right
Museum purchase, 1945
945-W-104

Frank McCLURE, (active 20th century)

The following three signed linoleum prints on paper are the gift of Frank McClure, 1972

A Far Horizon

12 x 20" (30.48 x 50.80 cm.)
972-P-102

Flowers in the Window

20 x 40" (50.80 x 101.60 cm.)
972-P-103

Wind and Clouds

18 x 14" (45.72 x 35.56 cm.)
972-P-101

Robert E. McDONOUGH, (active late 20th century)

Words for a Daughter

Portfolio of 53: Rip Off on the Last Millennium
Print on paper, 8.5 x 11" (21.59 x 27.94 cm.)
Signed, Robert E. McDonough, lower right
Gift of the William Busta Gallery, 1990
990-P-111.21

Michael J. McEWAN, (active late 20th century)

Breaking Storm Clouds, 1990

Oil on canvas, 46 x 52" (116.84 x 132.08 cm.)
Signed, M. McEwan, lower left
Gift of Michael J. McEwan, 1991
991-O-146

Duncan McFARLANE, (active mid–19th century)

Ship: *Alice Couce*, 1861

Oil on canvas, 24 x 36" (60.96 x 91.44 cm.)
Signed, D. McFarlane, 1861, lower left
Museum purchase, 1928
S28-O-106

Henry Lee McFEE, (1886–1953)

Still Life with Duck

Oil on canvas, 24 x 30" (60.96 x 76.20 cm.)
Signed, McFee, lower right
Museum purchase, 1960
960-O-102

John McGUIGAN, (active late 19th century)

Millcreek Autumn Scene, 1898

Oil on canvas, 32 x 22" (81.28 x 55.88 cm.)
Unsigned
Museum purchase, 1950
950-O-115

Renee McKAY, (active late 20th century)

Don Quixote

Ink on paper, 7.5 x 10.25" (19.05 x 26.04 cm.)
Signed, Renee McKay, lower right
Gift of D. Paris, 1979
979-D-117

Marybeth McKENZIE, (1946–)

Standing Nude

Oil on canvas, 46 x 32" (116.84 x 81.28 cm.)
Signed, McKenzie, lower right
Museum purchase, 1992
992-O-116

Don McKINNEY, (active 20th century)

Western Fence with Wooden Panels

Acrylic on masonite, 72 x 48" (182.88 x 121.92 cm.)
Unsigned
Gift of the Friends of American Art, 1981
981-O-110

Thomas G. McNICKLE, (1944–)

A More Than Even Trade

Acrylic on canvas, 72 x 60" (182.88 x 152.40 cm.)
Signed, Thomas G. McNickle, lower right
Gift of Thomas G. McNickle, 1994
994-O-103

E. M., (Ways of Knowing)

Watercolor on paper, triptych, 26 x 40.62" (66.04 x 103.19 cm.)
Signed, Thomas G. McNickle, lower right
Gift of Thomas G. McNickle, 1993
993-W-102

Butler Institute Courtyard

Watercolor on paper, 19.25 x 27.5" (48.90 x 69.85 cm.)
Signed, Thomas G. McNickle, lower right
Gift of Thomas G. McNickle, 1983
983-W-101

The Butler Institute of American Art, 1981

Watercolor on paper, 19.75 x 27.75" (50.17 x 70.49 cm.)
Signed, Thomas G. McNickle, lower right
Gift of Thomas G. McNickle, 1982
982-W-107

John C. McRAE, (dates unknown)

The Marriage of Pocahontas

Engraving on paper, 28 x 38" (71.12 x 96.52 cm.)
Unsigned
Gift of George R. Hann, 1971
971-P-126

J. Jay McVICKER, (1911–)

Tropical Washday
Aquatint on paper, 11.75 x 19" (29.85 x 48.26 cm.)
Signed, J. Jay McVicker, lower right
Museum purchase, 1979
979-P-116

Roger MEDEARIS, (1920–)

The Heritage
Lithograph on paper, 15.5 x 33.5" (39.37 x 85.09 cm.)
Signed, Roger Medearis, lower right
Gift of Roger Medearis, 1978
978-P-102

Thomas MEEHAN, (1923–)

Day of Mountain Flowers
Oil on canvas, 18 x 48" (45.72 x 121.92 cm.)
Unsigned
Gift of the Friends of American Art, 1953
953-O-110

Dean Jackson MEEKER, (1920–)

Icarus, 1961
Lithograph on paper, 28 x 20" (71.12 x 50.80 cm.)
Signed, Dean Meeker, imp. 61, lower right
Museum purchase, 1962
962-P-101

Joseph John Paul MEERT, (1905–)

Man in Thought
Gouache on paper, 24.5 x 16" (62.23 x 40.64 cm.)
Signed, Joseph Meert, lower right
Gift of Mr. and Mrs. Samuel Brouner, 1961
961-W-112

Harry MEIERS, (active 20th century)

Kennybunk Boatyard
Watercolor on paper, 15 x 20" (38.10 x 50.80 cm.)
Signed, Meiers, lower right
Museum purchase, 1973
973-W-104

Walter MEIGS, (1918–)

Huts in the Rocks
Oil on canvas, 45 x 48" (114.30 x 121.92 cm.)
Signed, Meigs, lower right
Museum purchase, 1957
957-O-121

Gari MELCHERS, (1860–1932)

In My Garden, 1900
Oil on canvas, 41 x 40" (104.14 x 101.60 cm.)
Signed, Gari Melchers, lower left
Museum purchase, 1922
922-O-102

Doris MELTZER, (1908–)

Sunday Outing, 1940
Serigraph on paper, 12 x 17.25" (30.48 x 43.82 cm.)
Signed, Doris Meltzer, on reverse
Gift of Albert E. Hise, 1979
979-P-128

Jack MENDENHALL, (1937–)

Romantic Dining Room, 1977
Oil on canvas, 63 x 77" (160.02 x 195.58 cm.)
Unsigned
Museum purchase, 1977
977-O-148

Sigmund Joseph MENKES, (1896–1986)

Barn Yard
Oil on canvas, 26 x 32" (66.04 x 81.28 cm.)
Unsigned
Gift of Mrs. William V. Miller, 1960
960-O-115

Bouquet
Oil on canvas, 35 x 24" (88.90 x 60.96 cm.)
Signed, Menkes, lower right
Gift of Mr. and Mrs. Frederick Serger, 1955
955-O-124

Seated Figure
Watercolor on paper, 15.5 x 11.5" (39.37 x 29.21 cm.)
Signed, Menkes, lower right
Museum purchase, 1962
962-W-101

Woodstock Summer Day
Oil on canvas, 25.5 x 32" (64.77 x 81.28 cm.)
Signed, Menkes, lower right
Gift of Mrs. William V. Miller , 1959
959-O-119

Yolanda MERCHANT, (active late 20th century)

The following two signed oils on paper are the gift of Yolanda Merchant, 1994

Golfers Study, 1981
19 x 24" (48.26 x 60.96 cm.)
994-O-105

Golfers Study, 1981
19 x 24" (48.26 x 60.96 cm.)
994-O-106

Ray MERVA, (active 20th century)

Pilgrimage, 1975
Oil on canvas, 36 x 50" (91.44 x 127.00 cm.)
Signed, Merva, lower center
Gift of Leonard Bocour, 1976
976-O-118

George Jo MESS, (1878–1962)

The following two signed aquatints on paper are the gift of Norman and June Krafft, 1980

Ice House
5.75 x 4.5" (14.61 x 11.43 cm.)
980-P-146

Weather Vane
8 x 15.25" (20.32 x 38.74 cm.)
980-P-147

Fred L. MESSERSMITH, (1924–)

Conneaut Harbor
Watercolor on paper, 19.5 x 26.5" (49.53 x 67.31 cm.)
Signed, Messersmith, lower right
Museum purchase, 1958
958-W-113

Medearis - The Heritage

Meiers - Kennybunk Boatyard

Melchers - In My Garden

Meltzer - Sunday Outing

Mendenhall - Romantic Dining Room

Menkes - Bouquet

Metcalf - Spring Landscape, Giverny

Meurer - A Doughboy's Equipment

Meurer - The Old Master's Violin

Mielatz - Bridges and Barges

Millar - Algiers

Willard Leroy METCALF, (1858–1925)

Spring Landscape, Giverny, 1887
Oil on canvas, 19.5 x 25.75" (49.53 x 65.41 cm.)
Signed, W. L. Metcalf, 1887, lower left
Gift of Dr. John J. McDonough, 1973
973-O-127

The Professor
Pencil and wash on paper, 17 x 18" (43.18 x 45.72 cm.)
Signed, To my friend Waler, Willard L. Metcalf, lower right
Gift of Joseph G. Butler, III, 1951
951-D-102

Evelyn B. METZGER, (1911–)

Iris and Poppies, 1963
Oil on masonite, 36 x 24" (91.44 x 60.96 cm.)
Unsigned
Gift of Chase Gallery, 1965
965-O-102

Charles A. MEURER, (1865–1955)

A Doughboy's Equipment, 1921
Oil on canvas, 68 x 40" (172.72 x 101.60 cm.)
Signed, C. A. Meurer, lower right
Gift of Elmer G. Engel, 1959
959-O-130

The Old Master's Violin, 1923
Oil on canvas, 22 x 30" (55.88 x 76.20 cm.)
Signed, C. A. Meurer, lower right
Museum purchase, 1964
964-O-114

Sally MEWHINNEY, (active 20th century)

Cafeteria, 1942
Lithograph on paper, (3/16), 13.5 x 11" (34.29 x 27.94 cm.)
Signed, Sally Mewhinney, 42, lower right
Gift of Louis Held, 1965
965-P-127

William MEYEROWITZ, (1898–1981)

The Horse Show
Oil on canvas, 15 x 35" (38.10 x 88.90 cm.)
Signed, Wm. Meyerowitz, lower right
Gift of William Meyerowitz, 1974
974-O-102

Mother and Child
Etching on paper, 7.5 x 5.25" (19.05 x 13.34 cm.)
Signed, Wm. Meyerowitz, lower right
Gift of Louis Held, 1965
965-P-197

Delbert MICHEL, (1938–)

Butterfly and Flowers #1, 1968
Watercolor on paper, 29.5 x 23.5" (74.93 x 59.69 cm.)
Signed, Delbert Michel, lower left
Museum purchase, 1968
968-W-134

Peggy MIDENER, (active 20th century)

East Jordan by Moonlight
Oil on canvas, 28 x 17" (71.12 x 43.18 cm.)
Unsigned
Museum purchase, 1956
956-O-116

Charles F. W. MIELATZ, (1864–1919)

Bridges and Barges, 1913
Etching on paper, 12 x 9" (30.48 x 22.86 cm.)
Signed, Mielatz, lower right
Museum purchase, 1977
977-P-127

Robert MIHALY, (active late 20th century)

Landscape #2
Portfolio of 53: Rip Off on the Last Millennium
Print on paper, 8.5 x 11" (21.59 x 27.94 cm.)
Signed, Robert Mihaly, lower right
Gift of the William Busta Gallery, 1990
990-P-111.45

Addison Thomas MILLAR, (1860–1913)

Algiers
Oil on canvas, 16 x 12" (40.64 x 30.48 cm.)
Unsigned
Gift of Mrs. Griswold Hurlbert, 1973
973-O-111

The following five signed works are the gift of
the estate of Lorena Coale, 1986

Algerian Street Scene
Watercolor on paper, 5.5 x 6.75" (13.97 x 17.15 cm.)
986-W-102

Dutch Canal and Windmill
Watercolor on board, 23.5 x 14" (59.69 x 35.56 cm.)
986-W-103

Rue Porte Neuve, Alger
Oil on wood panel, 7.5 x 6" (19.05 x 15.24 cm.)
986-O-104

Seascape, 1884
Oil on canvas lined on board, 14 x 30" (35.56 x 76.20 cm.)
986-O-103

Street Life, Alger
Watercolor on board, 15.5 x 21.5" (39.37 x 54.61 cm.)
986-W-104

Oak Trees
Etching on paper, 10 x 8" (25.40 x 20.32 cm.)
Signed, Addison T. Millar, lower left
Gift of Mrs. Griswold Hurlbert, 1973
973-P-102

Barse MILLER, (1904–1973)

Bristol Mills, 1939
Watercolor on paper, 18 x 28" (45.72 x 71.12 cm.)
Signed, Barse Miller, 39, lower middle
Museum purchase, 1939
939-W-103

Jane Else MILLER, (active late 20th century)

Man at Window Reading Paper, 1979
Acrylic on canvas, 40 x 36" (101.60 x 91.44 cm.)
Signed, Jane Else Miller, lower right
Gift of the Friends of American Art , 1979
979-O-119

Janet Cailor MILLER, (active 20th century)

French Fish Market, 1957
Oil on canvas, 36 x 26" (91.44 x 66.04 cm.)
Signed, Cailor, lower left
Gift of Dr. John J. McDonough, 1980
980-O-112

Joan MILLER, (1930–)

Tone Poem
Etching on paper, 18 x 24" (45.72 x 60.96 cm.)
Signed, Joan Miller, lower right
Gift of Joan Miller, 1978
978-P-107

Kenneth Hayes MILLER, (1876–1952)

By the Window, 1928
Oil on canvas, 24 x 20" (60.96 x 50.80 cm.)
Signed, Hayes Miller, 28, lower left
Museum purchase, 1991
991-O-108

Nude by the Sea
Oil on canvas, 25 x 18" (63.50 x 45.72 cm.)
Signed, Hayes Miller, lower left
Gift of Mrs. Grant Sanger, 1955
955-O-125

Woman at Keyboard, 1923
Oil on canvas, 24 x 20" (60.96 x 50.80 cm.)
Signed, Hayes Miller, lower right
Gift of Virginia Zabriskie, 1991
991-O-227

Sunbath
Etching on paper, 6.37 x 4.62" (16.19 x 11.75 cm.)
Signed, Hayes Miller, lower right
Gift of the estate of Frank J. Marzano, 1988
988-P-112

Thomas MILLER, (1913–)

Old Barn
Watercolor on paper, 14 x 20" (35.56 x 50.80 cm.)
Unsigned
Museum purchase, 1943
943-W-103

Gibbs MILLIKEN, (1935–)

Cryptic Stone, 1965
Acrylic intaglio on paper, 10 x 12" (25.40 x 30.48 cm.)
Signed, Milliken, 65, lower right
Museum purchase, 1965
965-P-260

Dissolving Skeleton, 1963
Lithograph on paper, 9 x 10.5" (22.86 x 26.67 cm.)
Signed, Gibbs Milliken, 1963, lower right
Museum purchase, 1965
965-P-259

Edward MILLMAN, (1907–1964)

Abstraction
Oil on canvas, 48 x 40" (121.92 x 101.60 cm.)
Signed, Edward Millman, lower right
Gift of Mrs. Edward Millman, 1967
967-O-153

Philippine Reminiscences, 1947
Oil on canvas, 50 x 30" (127.00 x 76.20 cm.)
Signed, Edward Millman, 47, lower left
Gift of Samuel N. Tonkin, 1953
953-O-112

Tagalog Imagery, 1948
Oil on canvas, 36 x 28" (91.44 x 71.12 cm.)
Signed, Edward Millman, 48, lower right
Gift of Sidney Freedman, 1953
953-O-111

Charles MILLS, (1856–1956)

Alexander Doyle Executing the Sculptured Head of Artist Charles Mills
Oil on canvas, 27 x 30" (68.58 x 76.20 cm.)
Unsigned
Gift of Mrs. Willard E. Closs, 1974
974-O-120

David MINK, (1910–)

Winter on Bolivar Road, 1939
Watercolor on paper, 24 x 18" (60.96 x 45.72 cm.)
Signed, Dave Mink, 39, lower left
Museum purchase, 1940
940-W-107

Joan MITCHELL, (1926–1992)

Untitled, ca. 1950s
Oil on canvas, 17 x 16" (43.18 x 40.64 cm.)
Signed, J. Mitchell, lower right
Gift of Marilynn Meeker, 1986
986-O-115

Ann MITTLEMAN, (1898– ?)

The following four works are the gift of Louis Held, 1966

Giant Crab, 1955
Gouache on paper, 6.5 x 6.75" (16.51 x 17.15 cm.)
966-W-117

J, 1955
Oil on paper, 8 x 13.5" (20.32 x 34.29 cm.)
966-O-134

Oriental Landscape, 1954
Gouache on paper, 8.5 x 13.5" (21.59 x 34.29 cm.)
966-W-116

Spring
Watercolor on paper, 9 x 12" (22.86 x 30.48 cm.)
966-W-118

Louis Charles MOELLER, (1855–1930)

A Political Discussion
Oil on canvas, 19 x 25.5" (48.26 x 64.77 cm.)
Signed, Louis Moeller, lower right
Museum purchase, 1975
975-O-126

Maude MOHERMAN, (active late 19th century)

The following two works are the gift of Mr. and Mrs. Stan Hewitt, 1978

Lilacs, 1891
Oil on canvas, 20 x 26" (50.80 x 66.04 cm.)
Signed, Maude Moherman, 1891, lower right
978-O-120

Pansies
Watercolor on paper, 5 x 24" (12.70 x 60.96 cm.)
Unsigned
978-W-114

Cheri MOHN, (1936–)

Corner Painting
Oil on canvas, 35 x 47.5" (88.90 x 120.65 cm.)
Signed, Cheri Mohn, lower right
Museum purchase, 1970
970-O-114

Kenneth Hayes Miller - By the Window

Kenneth Hayes Miller - Woman at Keyboard

Mitchell - Untitled

Moeller - A Political Discussion

Moherman - Lilacs

Mora - The Fortune Teller

Edward Moran - New Castle on the Delaware

Thomas S. Moran - An Arizona Sunset Near the Grand Canyon

Thomas S. Moran - Summer Storm

Morehouse - Chisos Mountains

Henry D. Morse - Fox and Quail (page 125)

Maurice MOLARSKY, (1885–1950)

Fruit with Blue Vase
Oil on panel, 10 x 12" (25.40 x 30.48 cm.)
Unsigned
Museum purchase, 1924
924-O-104

Hans MOLLER, (1905–)

Connecticut Coast, 1973
Acrylic on canvas, 40 x 50" (101.60 x 127.00 cm.)
Signed, Moller, lower right
Museum purchase, 1978
978-O-118

The following two woodcuts on paper are the gift of Louis Held, 1965

Don Quixote, 1948
(18/20), 8 x 10" (20.32 x 25.40 cm.)
965-P-156

Fencing, 1948
(18/25), 9 x 11.5" (22.86 x 29.21 cm.)
965-P-146

Paul MOMMER, (1899– ?)

Head
Oil on canvas, 17 x 10.5" (43.18 x 26.67 cm.)
Signed, P. Mommer, lower right
Gift of Louis Held, 1965
965-O-121

Ernest O. MONDORF, (1924–)

Fisherman #6, 1967
Etching on paper, (artist's proof), 11 x 12.5" (27.94 x 31.75 cm.)
Signed, Ernest O. Mondorf, 1967, lower right
Museum purchase, 1967
967-P-198

Donald MONTANO, (1933–)

Transilience, 1962
Oil on canvas, 60 x 66" (152.40 x 167.64 cm.)
Unsigned
Museum purchase, 1964
964-O-104

Martha MOORE, (1908–1982)

Guitarist
Oil on canvas, 50 x 38" (127.00 x 96.52 cm.)
Signed, Martha Moore, lower left
Gift of Louis Burnett, 1983
983-O-102

F. Luis MORA, (1874–1940)

The Fortune Teller, 1905
Oil on canvas, 59.5 x 47.5" (151.13 x 120.65 cm.)
Signed, F. Luis Mora, 1905, lower left
Museum purchase, 1919
919-O-109

Edward MORAN, (1829–1901)

New Castle on the Delaware, 1857
Oil on canvas, 40 x 60" (101.60 x 152.40 cm.)
Signed, E. Moran, lower left
Museum purchase, 1976
976-O-113

Thomas S. MORAN, (1837–1926)

An Arizona Sunset Near the Grand Canyon, 1898
Oil on canvas, 20 x 30" (50.80 x 76.20 cm.)
Signed, Moran, 1898, lower right
Museum purchase, 1958
958-O-128

Mountain Scene
Oil on board, 9.5 x 12.5" (24.13 x 31.75 cm.)
Signed, Moran, lower right
Museum purchase, 1969
969-O-124

Summer Storm, 1903
Oil on canvas, 24 x 36" (60.96 x 91.44 cm.)
Signed, Thomas S. Moran, 1903, lower right
Gift of Alexander J. Revnik, 1969
969-O-121

The following two signed etchings on paper are a museum purchase, 1973

January Thaw
15 x 17" (38.10 x 43.18 cm.)
973-P-119

The Much Resounding Sea, 1886
29 x 31" (73.66 x 78.74 cm.)
973-P-124

The Rockies, 1887
Etching on paper, 11.5 x 8.03" (29.21 x 20.40 cm.)
Signed, Moran, 1887, lower left
Museum purchase, 1968
968-P-296

William MOREHOUSE, (active 20th century)

Chisos Mountains
Oil on linen, 30 x 24" (76.20 x 60.96 cm.)
Unsigned
Gift of Erle L. Flad, 1995
995-O-104

Patricia MORRIS, (1927–)

Palisades, 1958
Watercolor on paper, 15.5 x 33" (39.37 x 83.82 cm.)
Signed, P. Morris, 58, lower right
Museum purchase, 1959
959-W-105

Robert MORRIS, (1931–)

(Untitled), 1973
Photolithograph on paper, 9 x 12" (22.86 x 30.48 cm.)
Signed, R. Morris, lower right
Gift of Steven Feinstein, 1983
983-P-158

War Memorial
Lithograph on paper, 24 x 42.25" (60.96 x 107.32)
Signed, Morris, lower right
Gift of Arthur Feldman, 1991
991-P-179

Robert E. MORROW, (1917–)

Jason
Watercolor on paper, 29 x 18" (73.66 x 45.72 cm.)
Signed, R. Morrow, lower right
Museum purchase, 1950
950-W-104

Philip MORSBERGER, (1933–)

Robert Goldsand, Pianist
Oil on canvas, 62 x 46" (157.48 x 116.84 cm.)
Signed, Morsberger, lower left
Museum purchase, 1967
967-O-122

Valley Falls, WV
Oil on canvas, 18 x 24" (45.72 x 60.96 cm.)
Signed, Morsberger, lower left
Gift of Philip Morsberger, 1969
969-O-127

Dune Girl, 1969
Mixed media on wallboard, 58 x 47" (147.32 x 119.38 cm.)
Signed, Morsberger, 1969, lower right
Gift of Philip Morsberger, 1975
975-O-123.9

Assassination
Etching on paper, 6.5 x 9.5" (16.51 x 24.13 cm.)
Signed, Morsberger, lower right
Gift of Philip Morsberger, 1975
975-P-123

The Butler Institute's collection also contains
nineteen drawings on paper and twenty-eight oils
on canvas which are the gift of Philip
Morsberger, 1975
975-D-110 and 975-O-117

Henry D. MORSE, (1826–1888)

Fox and Quail, 1872
Oil on canvas, 30 x 42" (76.20 x 106.68 cm.)
Signed, H. D. Morse, 1872, lower right
Museum purchase, 1967
967-O-128

Attributed to Samuel F. B. MORSE, (1791–
1872)

The Lace Cap
Oil on canvas, 29 x 23" (73.66 x 58.42 cm.)
Unsigned
Museum purchase, 1945
945-O-104

August MOSCA, (1907–)

The following two oils on canvas are the gift of
Harry Salpeter, 1966

Artist in His Studio, #1, 1965
76 x 48" (193.04 x 121.92 cm.)
966-O-123

The Yellow Robe
28 x 22" (71.12 x 55.88 cm.)
966-O-128

Seated Figure, 1953
Ink on paper, 9 x 8" (22.86 x 20.32 cm.)
Signed, August Mosca, 1953, lower left
Museum purchase, 1958
958-D-106

Anna Mary (Grandma) MOSES, (1860–1961)

Cold, So Cold, 1942
Oil on canvas, 9 x 12" (22.86 x 30.48 cm.)
Signed, Moses, lower right
Gift of Louis Held, 1965
965-O-128

Henry MOSLER, (1841–1920)

Girl with Prayer Book in Landscape,
1893
Oil on wood panel, 12.75 x 9.5" (32.39 x 24.13 cm.)
Signed, Henry Mosler, lower left
Gift of R. W. Ramsdell, 1978
978-O-107

Tom MOSSER, (active 20th century)

Barasso, 1994
Watercolor on paper, 33.25 x 26.25" (84.46 x 66.68 cm.)
Signed, Tom Mosser, 94, lower left
Museum purchase, 1994
994-W-101

Robert MOTHERWELL, (1915–1991)

Mexican Past, 1990
Acrylic on canvas, 72 x 144" (182.88 x 365.76 cm.)
Signed, R. M., 90, upper right
Museum purchase and gift of the Dedalus Foundation, 1994
994-O-119

French Door V, 1974
Acrylic and paper collage on board, 72 x 24" (182.88 x 60.96
cm.)
Signed, Motherwell, 28 Aug., 74, upper left
Museum purchase and gift of the Dedalus Foundation, 1994
994-O-120

Collage with Ocher and Black, 1953
Oil and collage on canvas, 30 x 19.75" (76.20 x 50.17 cm.)
Signed, Robert Motherwell, 1953, upper right
Gift of Mr. and Mrs. James A. Roemer, 1994
994-O-104

Night Music Opus #9, 1988
Collage of rice paper and acrylic on canvas, 32.25 x 26.25"
(81.92 x 66.68 cm.)
Signed, R. M., 88, upper left
Museum purchase and gift of the Dedalus Foundation, 1994
994-O-121

(Untitled), Brushy Elegy, 1980
Oil on paper, 23 x 29" (58.42 x 73.66 cm.)
Signed, R. M., 80, lower left
Museum purchase and gift of the Dedalus Foundation, 1994
994-D-126

American–LaFrance Variations III, 1984
Ten color lithographs on paper, (39/70), 48 x 30.75" (121.92 x
78.11 cm.)
Signed, Motherwell, lower right
Museum purchase, 1988
988-P-109

Roots of Abstract Art in America
Offset lithograph on paper, 22.25 x 17" (56.52 x 43.18 cm.)
Signed, Motherwell, lower right
Anonymous gift, 1980
980-P-152

Lithograph
New York International: Portfolio of Ten Prints, (210/225)
Lithograph on paper, 22 x 17" (55.88 x 43.18 cm.)
Signed, Motherwell, lower right
Museum purchase, 1966
966-P-137.4

Samuel F. B. Morse (attributed) - The Lace Cap

Moses - Cold, So Cold

Motherwell - Mexican Past

Motherwell - French Door V

Motherwell - Collage with Ocher and Black

Motherwell - Night Music Opus #9

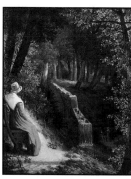

Mount - Landscape with Figures

Murch - The Wall

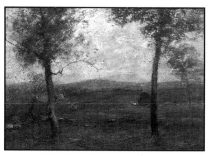

Murphy - An Old Farm

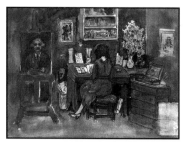

Jerome Myers - Studio Interior

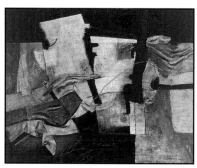

Naberezny - Collage with Black–Red

Charles MOTTRAM, (? –1850)

The Two Farewells, published 1850
(from a painting by G. H. Boughton)
Engraving on paper, 27 x 38" (68.58 x 96.52 cm.)
Unsigned
Gift of Sydna Smith, 1975
975-P-103

William Sidney MOUNT, (1807–1868)

Landscape with Figures
Oil on wood, 19 x 15.5" (48.26 x 39.37 cm.)
Unsigned
Museum purchase, 1966
966-O-121

Music is Contagious, 1849
Steel engraving on paper, 14.75 x 18.75" (37.47 x 47.63 cm.)
Unsigned
Museum purchase, 1970
970-P-167

Seong MOY, (1921–)

Winter's Path, 1965
Woodcut on paper, (125/210), 32 x 12" (81.28 x 30.48 cm.)
Signed, S. Moy, 65, imprint, lower right
Museum purchase, 1965
965-P-292

Roy MOYER, (1921–)

Turnips, 1962
Oil on canvas, 24 x 30" (60.96 x 76.20 cm.)
Signed, Moyer, lower center
Gift of Dr. Karl Lunde, 1977
977-O-120

Edward MUELLER, (active 20th century)

The following three silkscreens on paper of various sizes are a museum purchase, 1968

USS *Constitution*, 1962
968-P-321

Porch
968-P-214

Summit Street
968-P-215

John MUENCH, (1914–1993)

Coastal Signals, 1959
Lithograph on paper, 14 x 17" (35.56 x 43.18 cm.)
Signed, Muench, lower right
Museum purchase, 1959
959-P-103

Charles MUNDAY, (active 20th century)

Reflections, 1974
Watercolor on paper, 26 x 40" (66.04 x 101.60 cm.)
Signed, Munday, lower right
Museum purchase, 1974
974-W-102

Walter MURCH, (1907–1968)

The Wall, 1959
Oil on canvas, 21.25 x 31" (53.98 x 78.74 cm.)
Unsigned
Museum purchase, 1968
968-O-177

J. Francis MURPHY, (1853–1921)

An Old Farm, 1918
Oil on canvas, 23 x 35" (58.42 x 88.90 cm.)
Signed, J. Francis Murphy, 1918, lower right
Museum purchase, 1918
918-O-107

Richard D. MURRAY, (active 20th century)

Today's Enigma, 1946
Oil on canvas, 42 x 54.25" (106.68 x 137.80 cm.)
Signed, R. D. M., lower left
Gift of Richard D. Murray, 1989
989-O-104

Isaac Lane MUSE, (1906–)

Nude
Silkscreen on paper, 16 x 9" (40.64 x 22.86 cm.)
Signed, Muse, lower middle
Gift of Louis Held, 1965
965-P-137

Jack Frederick MYERS, (1927–)

Two from a Flea Market, 1979
Egg tempera on masonite, 30 x 48" (76.20 x 121.92 cm.)
Signed, Jack Frederick Myers, lower right
Museum purchase, 1979
979-O-109

Jerome MYERS, (1867–1940)

Studio Interior, ca. 1918
Varnished watercolor on paper, 11.5 x 15" (29.21 x 38.10 cm.)
Unsigned
Museum purchase, 1965
965-W-147

Old New York House
Color etching on paper, 10 x 12" (25.40 x 30.48 cm.)
Signed, Jerome Myers, lower right
Museum purchase, 1979
979-P-106

Pursuit of Pleasure
Lithograph on paper, 12 x 16" (30.48 x 40.64 cm.)
Signed, Jerome Myers, lower right
Museum purchase, 1979
979-P-107

Self Portrait
Etching on paper, 11 x 7.75" (27.94 x 19.69 cm.)
Signed, Jerome Myers, lower right
Museum purchase, 1968
968-P-124

Six Women
Etching on paper, (18/50), 7.5 x 10" (19.05 x 25.40 cm.)
Signed, Jerome Myers, imprint, lower right
Museum purchase, 1967
967-P-141

Jon NABEREZNY, (1921–)

Collage with Black–Red, 1967
Oil and collage on canvas, 49 x 61" (124.46 x 154.94 cm.)
Signed, Naberezny, lower right
Museum purchase, 1967
967-O-132

Crucifix
Oil on canvas, 41 x 48" (104.14 x 121.92 cm.)
Unsigned
Museum purchase, 1957
957-O-132

Dave Dravecki, 1991
Pencil on paper, 40 x 30" (101.60 x 76.20 cm.)
Signed, Naberezny, lower right
Gift of Jon Naberezny, 1991
991-D-137

Drawing #30, 1973
Pencil on paper, 28.5 x 22" (72.39 x 55.88 cm.)
Signed, Naberezny, lower right
Museum purchase, 1973
973-D-105

Fred NAGLER, (1891–1983)

Head of Christ, 1952
Oil on wood, 10.25 x 8.25" (26.04 x 20.96 cm.)
Signed, F. N., lower right
Gift of Fred Nagler, 1979
979-O-111

Nativity, 1949
Oil on board, 24.5 x 16.25" (62.23 x 41.28 cm.)
Signed, F. Nagler, lower right
Gift of Margaret Tempest, 1962
962-O-119

The Nativity, 1945
Drawing on paper, 9 x 13.5" (22.86 x 34.29 cm.)
Signed, Fred, 45, lower right
Museum purchase, 1951
951-D-103

George A. NAMA, (1939–)

Interior #2, 1961
Oil on paper, 30 x 39" (76.20 x 99.06 cm.)
Signed, Nama, 61, lower left
Museum purchase, 1963
963-W-108

Guiseppe NAPOLI, (active 20th century)

Head of Man, 1956
Drawing on paper, 7 x 5" (17.78 x 12.70 cm.)
Signed, Guiseppe Napoli, 1956, lower middle
Gift of Louis Held, 1965
965-D-127

Thomas W. NASON, (1889–1971)

Haystacks, 1949
Wood engraving on paper 6.5 x 9" (16.51 x 22.86 cm.)
Signed, T. W. Nason, 1949, lower right
Museum purchase, 1967
967-P-110

Offshore Islands–Maine, 1954
Engraving on paper, (No. 843), 6.75 x 11.75" (17.15 x 29.85 cm.)
Signed, T. W. Nason, lower right
Museum purchase, 1968
968-P-323

Thomas NAST, (1840–1902)

The Baltimore Incident, April 19, 1861, 1893
Ink on paper, 18 x 18" (45.72 x 45.72 cm.)
Signed, The Nast, lower right
Museum purchase, 1970
970-D-124

The Drummer Boy, 1863
Wood engraving on paper, 16 x 11" (40.64 x 27.94 cm.)
Unsigned
Museum purchase, 1980
980-P-119

The Rebels Shelling the New York Militia in the Main Street of Carlisle, Pennsylvania, 1863
Woodblock etching on paper, 11.25 x 16" (28.58 x 40.64 cm.)
Unsigned
Gift of Sam D. Pipino, 1994
994-P-211

Ellen NATHAN, (1937–)

Arecibo I, 1961
Woodcut on paper, (8/30), 14.5 x 20" (36.83 x 50.80 cm.)
Signed, Ellen Nathan, 1961, lower right
Museum purchase, 1962
962-P-122

Robert NATKIN, (1930–)

(Untitled)
Acrylic on canvas, 79.5 x 83" (201.93 x 210.82 cm.)
Unsigned
Gift of Dr. Herbert Meadow, 1974
974-O-117

(Untitled)
Serigraph on paper, 42.25 x 79" (107.32 x 200.66 cm.)
Unsigned
Gift of Arthur Feldman, 1992
992-P-116

The following five signed lithographs on paper of various sizes are the gift of Marc A. Wyse, 1983

Color Bath Series Oval, 1980
983-P-117

Face Series, 1980
983-P-115

Face Series, 1981
983-P-114

Homage to Louis Sullivan and Frank Lloyd Wright Series, 1981
983-P-116

Little Appola Series, 1982
983-P-140

Jim NAWARA, (1945–)

Turn and Bank
Oil on canvas, 44.5 x 41" (113.03 x 104.14 cm.)
Unsigned
Museum purchase, 1972
972-O-116

John NEAGLE, (1796–1865)

Portrait of Joseph Tagert, 1848
Oil on canvas, 50 x 40" (127.00 x 101.60 cm.)
Signed, J. Neagle, 1848, lower left
Museum purchase, 1954
954-O-132

Nama - Interior #2

Nast - The Rebels Shelling the New York Militia in the Main Street of Carlisle, Pennsylvania

Natkin - (Untitled) (974-O-117)

Neagle - Portrait of Joseph Tagert

Neff - Circus at the Edge of a City

Nehlig - The Survivor

Robert A. Nelson - Bicycle Warriors

William H. de Beauvoir Nelson - Old Pelham Courthouse

Nesbitt - Three Iris on Pink

Nevelson - Being One

Barbara NECHIS, (1937–)

Hill People
Watercolor on paper, 14.25 x 21" (36.20 x 53.34 cm.)
Signed, B. Nechis, lower left
Gift of Louis Held, 1978
978-W-107

Edith NEFF, (1943–)

Circus at the Edge of a City, ca. 1992
Oil on linen, 64 x 74" (162.56 x 187.96 cm.)
Signed, Neff, on reverse
Gift of Phyllis Fleming and Walter and Nancy Herman, 1994
994-O-115

Victor NEHLIG, (1830–1909)

The Survivor
Oil on mounted canvas, 20.25 x 30.25" (51.44 x 76.84 cm.)
Signed, Nehlig, lower right
Gift of J. Welch, 1967
967-O-129

Yehuda NEIMAN, (active 20th century)

(Untitled)
Oil on canvas, 44.5 x 63.75" (113.03 x 161.93 cm.)
Unsigned
Gift of Stanley Bard, 1973
973-O-106

Donald NELSON, (active 20th century)

Eagle's Nest
Watercolor on paper, 19 x 26" (48.26 x 66.04 cm.)
Unsigned
Museum purchase, 1970
970-W-110

Robert A. NELSON, (1925–)

Bicycle Warriors, 1963
Oil on canvas, 58 x 54" (147.32 x 137.16 cm.)
Unsigned
Museum purchase, 1963
963-O-116

Lincoln–Grant, 1965
Oil and collage on canvas, 56 x 64" (142.24 x 162.56 cm.)
Unsigned
Museum purchase, 1966
966-O-117

Watermelon Crypt
Oil on canvas, 58 x 58" (147.32 x 147.32 cm.)
Unsigned
Museum purchase, 1961
961-O-121

Icarus, 1961
Watercolor on paper, 34 x 21" (86.36 x 53.34 cm.)
Signed, Nelson, R. A., 1961, lower right
Gift of the Friends of American Art, 1961
961-W-111

Colt's Giant Balloon, 1966
Drawing on paper, 26 x 34" (66.04 x 86.36 cm.)
Signed, Nelson, R. A., 1966, lower right
Museum purchase, 1966
966-D-105

Angel, 1964
Lithograph on paper, 20 x 12.5" (50.80 x 31.75 cm.)
Signed, Nelson, Robt. A., 1964, lower right
Gift of George Faddis, 1968
968-P-216

Two Knights, 1961
Lithograph on paper, (6/10), 22 x 32" (55.88 x 81.28 cm.)
Signed, Nelson, R. A., 1961, lower right
Museum purchase, 1962
962-P-106

The following two lithographs on paper are a museum purchase, 1967

Haileyville #1, 1964
27.5 x 19" (69.85 x 48.26 cm.)
967-P-113

Typewriter Washington, 1966
28 x 20.5" (71.12 x 52.07 cm.)
967-P-114

William H. de Beauvoir NELSON, (1861–1920)

Old Pelham Courthouse, 1916
Watercolor on paper, 17 x 14" (43.18 x 35.56 cm.)
Signed, W. H. Nelson, 1916, lower left
Museum purchase, 1921
921-W-101

Timothy A. NERO, (active late 20th century)

(Untitled)
Portfolio of 53: Rip Off on the Last Millennium
Print on paper, 8.5 x 11" (21.59 x 27.94 cm.)
Signed, Timothy A. Nero, lower right
Gift of the William Busta Gallery, 1990
990-P-111.2

Lowell Blair NESBITT, (1933–)

Three Iris on Pink, 1979
Oil on canvas, 76 x 116" (193.04 x 294.64 cm.)
Unsigned
Gift of John Glenn Avrett, 1982
982-O-177

The following eight signed lithographs on paper, 22 x 29.75" (55.88 x 75.57 cm.), are the gift of Reese and Marilyn Arnold Palley, 1991

Moon Shot
991-P-132, 991-P-145 — 991-P-151

Barbara NEUSTADT, (1922–)

Streambed, 1970
Intaglio on paper, 9.75 x 15" (24.77 x 38.10 cm.)
Signed, B. Neustadt, 1970, lower right
Museum purchase, 1970
970-P-107

Louise NEVELSON, (1900–1988)

Being One, ca. 1953–55, printed 1965–66
Etching on paper, (2/20), 28.25 x 22" (71.76 x 55.88 cm.)
Signed, Louise Nevelson, lower right
Museum purchase, 1988
988-P-102

Composition (B.107), 1974
Serigraph on paper, 32.25 x 26" (81.92 x 66.04 cm.)
Signed, L. N., lower right
Museum purchase, 1980
980-P-123

(Untitled), 1973
Silkscreen on paper, 12 x 9" (30.48 x 22.86 cm.)
Signed, Louise Nevelson, lower right
Gift of Steven Feinstein, 1983
983-P-159

Alan NEWBERG, (active late 20th century)

The Dark Side of Spring, (Xipe), 1977
Acrylic on canvas, 48 x 104" (121.92 x 264.16 cm.)
Signed, Alan Newberg, lower right
Museum purchase, 1979
979-O-108

George Glenn NEWELL, (1870–1947)

By the Drover's Inn, 1917
Oil on canvas, 36 x 48" (91.44 x 121.92 cm.)
Signed, Glenn Newell, 1917, lower left
Museum purchase, 1917
917-O-103

Unconquered, 1919
Oil on canvas, 47 x 51" (119.38 x 129.54 cm.)
Signed, G. Glenn Newell, lower right
Museum purchase, 1921
921-O-108

Caroline NEWHOUSE, (1910–)

Floral Still Life
Oil on canvas, 37 x 22" (93.98 x 55.88 cm.)
Signed, C. Newhouse, lower left
Gift of T. Newhouse, 1967
968-O-167

Beatrice F. NEWMAN, (active 20th century)

Public at the Pub, 1954
Woodblock on paper, 11 x 20" (27.94 x 50.80 cm.)
Signed, Beebs, 12/54, lower right
Museum purchase, 1955
955-P-107

Elias NEWMAN, (1903–)

Clouds over Lands End, Rockport
Casein on paper, 10 x 13" (25.40 x 33.02 cm.)
Signed, Elias Newman, lower left
Gift of Mrs. L. J. Newman, 1978
978-W-101

Portrait of Milton Avery, 1954
Watercolor on paper, 25 x 19" (63.50 x 48.26 cm.)
Signed, Elias Newman, upper right
Gift of Mr. and Mrs. Marcel H. Steiglitz, 1955
955-W-111

Don NICE, (1932–)

Buffalo, V/V, 1976
Lithograph on paper, 31.5 x 47.5" (80.01 x 120.65 cm.)
Signed, Nice, 76, lower right
Gift of Arthur Feldman, 1991
991-P-157

Thomas A. NICHOLAS, (1934–)

The Sierra Nevada, 1961
Watercolor on paper, 13.5 x 19.5" (34.29 x 49.53 cm.)
Signed, Tom Nicholas, lower left
Museum purchase, 1962
962-W-104

Thomas J. NICHOLL, (1850–1931)

Experidon, 1884
Oil on panel, 10 x 8" (25.40 x 20.32 cm.)
Signed, T. J. Nicholl, lower right
Gift of the estate of Charles Crandall, 1951
951-O-129

Mahoning Club Encampment
Oil on canvas, 26 x 15" (66.04 x 38.10 cm.)
Unsigned
Anonymous gift, 1931
931-O-101

Lanterman's Falls
Pastel on paper, 14.5 x 21" (36.83 x 53.34 cm.)
Signed, T. J. Nicholl, lower left
Gift of Dr. and Mrs. John Noll, 1975
975-D-112

Lanterman's Falls
Charcoal and paint on paper, 6 x 8.75" (15.24 x 22.23 cm.)
Signed, T. J. Nicholl, lower right
Gift of George Kelley, 1975
975-D-111

William NICHOLLS, (active 20th century)

After Rain, Thiensville Creek, 1982
Acrylic on canvas, 54 x 76" (137.16 x 193.04 cm.)
Signed, W. Nicholls, 82, lower left
Gift of the Terminare Corporation, 1994
994-O-112

Dale NICHOLS, (1904–)

Partners
Lithograph on paper, 9.5 x 13.25" (24.13 x 33.66 cm.)
Signed, Dale Nichols, lower right
Museum purchase, 1967
967-P-129

James C. NICOLL, (1846–1918)

Near Point Judith, 1893
Etching on paper, 4.5 x 7" (11.43 x 17.78 cm.)
Signed, J. C. Nicoll, lower left
Museum purchase, 1962
962-P-117

Edmund E. NIEMANN, (active 20th century)

Nocturnal, 1975
Acrylic and watercolor on paper, 17.5 x 23" (44.45 x 58.42 cm.)
Signed, E. E. Niemann, lower right
Gift of Vivienne Niemann, 1978
978-W-109

Robert Hogg NISBET, (1879–1961)

Emerald Robe, 1914
Oil on canvas, 42 x 54" (106.68 x 137.16 cm.)
Unsigned
Museum purchase, 1918
918-O-112

Summer Landscape by Lake
Oil on canvas, 24 x 30" (60.96 x 76.20 cm.)
Signed, Robert H. Nisbet, lower right
Gift of Jack C. Lahrer, 1983
983-O-110

Newell - By the Drover's Inn

Elias Newman - Portrait of Milton Avery

Nice - Buffalo, V/V

Nicholl - Lanterman's Falls (975-D-111)

Nisbet - Emerald Robe

Nobili - Blue Metropolis

Nolan - Untitled PG—0070

Novotny - National Monument, USA

Nyme - The Storm

Ochtman - Summer Morning (917-O-104)

Oestreich - Company of Fishes

Dorian Leaver NISENSON, (active late 20th century)

Dahlgren

Silkscreen on paper, (42/62), 18 x 18" (45.72 x 45.72 cm.)
Signed, Dorian Nisenson, lower right
Gift of Dorian Leaver Nisenson, 1978
978-P-132

Louise NOBILI, (1917–)

Blue Metropolis

Leaf and polymer on canvas, 42 x 48" (106.68 x 121.92 cm.)
Unsigned
Gift of Sarah Edna Cinelli, 1961
961-O-128

G. Kenneth NOLAN, (1924–)

(Untitled), 1973

Lithograph on paper, 9 x 12" (22.86 x 30.48 cm.)
Signed. G. K. N., stamped on reverse
Gift of Steven Feinstein, 1983
983-P-160

Untitled PG–0070, 1978

Handmade paper print, 25.25 x 30" (64.14 x 76.20 cm.)
Signed, G. K. N., stamp and seal, lower right
Gift of Paul and Suzanne Donnelly Jenkins, 1990
990-P-104

E. NOORDHOF-SMITH, (active 20th century)

Figure Representing the Arts

India ink on paper, 13.25 x 10" (33.66 x 25.40 cm.)
Signed, E. Noordhof-Smith, lower right
Gift of Albert E. Hise, 1979
979-D-109

Tom NORTON, (active late 20th century)

(Untitled), 1969

Silkscreen on paper, 18 x 24" (45.72 x 60.96 cm.)
Signed, Tom Norton, 69, lower right
Gift of Reese and Marilyn Arnold Palley, 1991
991-P-166

Elmer L. NOVOTNY, (1909–)

National Monument, USA

Oil on masonite, 48 x 36" (121.92 x 91.44 cm.)
Signed, E. L. Novotny, lower right
Gift of Elmer L. Novotny, 1965
965-O-105

Wingaersheek Beach

Watercolor on paper, 20 x 26" (50.80 x 66.04 cm.)
Signed, E. L. Novotny, lower right
Gift of the Friends of American Art, 1958
958-W-110

Joseph NYME, (1908–)

The Storm

Watercolor on paper, 12 x 15" (30.48 x 38.10 cm.)
Signed, Nyme, lower right
Museum purchase, 1938
938-W-104

Violet OAKLEY, (1874–1961)

Portrait of John Paul Hitchcock

Oil on canvas, 42 x 36" (106.68 x 91.44 cm.)
Signed, Violet Oakley, upper left
Gift of William J. Hitchcock, 1970
970-O-119

Leonard OCHTMAN, (1854–1934)

Summer Morning, 1916

Oil on canvas, 24 x 30" (60.96 x 76.20 cm.)
Signed, Leonard Ochtman, 1916, lower left
Museum purchase, 1917
917-O-104

Summer Morning, 1916

Oil on canvas, 12 x 15" (30.48 x 38.10 cm.)
Signed, Leonard Ochtman, 1916, lower left
Gift of J. W. Porter, 1950
950-O-116

Thom O'CONNOR, (1937–)

Bierce

Lithograph on paper, 12 x 16" (30.48 x 40.64 cm.)
Signed, Thom O'Connor, lower right
Museum purchase, 1968
968-P-264

Magician, 1966

Lithograph on paper, (76/250), 13 x 9" (33.02 x 22.86 cm.)
Signed, Thom O'Connor, lower right
Museum purchase, 1966
966-P-135

Nelson E. OESTREICH, (1932–)

Company of Fishes, 1963

Oil on canvas, 36 x 48" (91.44 x 121.92 cm.)
Signed, Oestreich, lower right
Museum purchase, 1963
963-P-132

Swamp Flowers, 1971

Watercolor on paper, 13 x 23" (33.02 x 58.42 cm.)
Signed, Oestreich, lower right
Museum purchase, 1971
971-W-104

Old Whiteface, 1967

Color woodblock on paper, 10.5 x 12" (26.67 x 30.48 cm.)
Signed, Oestreich, 67, lower right
Museum purchase, 1967
967-P-181

Pena's Stretch, 1990

Woodcut on paper, 14.75 x 20.5" (37.47 x 52.07 cm.)
Signed, Oestreich, 1990, lower right
Gift of Mr. and Mrs. Nelson E. Oestreich, 1990
990-P-112

Pigeon, 1966

Color woodcut on paper, (6/9), 13 x 19" (33.02 x 48.26 cm.)
Signed, Oestreich, 66, lower right
Museum purchase, 1966
966-P-141

River Bird and Flowers, 1965

Woodcut on paper, (8/8), 9 x 7" (22.86 x 17.78 cm.)
Signed, N. E. Oestreich, 65, lower right
Museum purchase, 1965
965-P-280

Youngstown, Ohio circa 1880, 1979

Woodblock on paper, 22.5 x 11.25" (57.15 x 28.58 cm.)
Signed, Oestreich, lower right
Gift of Joseph G. Butler, III, 1979
979-P-118

City Reflections, 1962
Etching on paper, 12 x 16" (30.48 x 40.64 cm.)
Signed, Oestreich, lower right
Museum purchase, 1962
962-P-115

The following two signed color woodcuts on paper, 14.87 x 7.25" (37.79 x 18.42 cm.), are the gift of Mr. and Mrs. Nelson E. Oestreich, 1992

Winter Night at the Butler, #1, 1992
992-P-102

Winter Night at the Butler, #2, 1992
992-P-103

Eliot O'HARA, (1890–1969)

Cape Porpoise Harbor, 1941
Watercolor on paper, 11 x 22" (27.94 x 55.88 cm.)
Signed, Eliot O'Hara, 1941, lower right
Museum purchase, 1941
941-W-107

Frederick James O'HARA, (1904–1980)

Mandrill
Relief print on paper, 29 x 20.5" (73.66 x 52.07 cm.)
Signed, Frederick O'Hara, lower right
Museum purchase, 1970
970-P-160

Arthur OKAMURA, (1932–)

Image #29, 1957
Oil on canvas, 50.5 x 40" (128.27 x 101.60 cm.)
Signed, Okamura, lower right
Gift of Mr. and Mrs. Joseph P. Sontich, 1979
979-O-101

Georgia O'KEEFFE, (1887–1986)

Cottonwood III, 1944
Oil on canvas, 19.5 x 29.25" (49.53 x 74.30 cm.)
Unsigned
Museum purchase, 1990
990-O-111

Claes OLDENBERG, (1929–)

Bat Spinning at the Speed of Light–State I, 1975
Lithograph on paper, (14/14), 38 x 25.02" (96.52 x 63.57 cm.)
Signed, C. O., lower right
Museum purchase, 1988
988-P-104

(Untitled), 1973
Lithograph on paper, 12 x 9" (30.48 x 22.86 cm.)
Signed, C. O., lower left
Gift of Steven Feinstein, 1983
983-P-161

Elizabeth OLDS, (1897– ?)

Street Corner
Oil on canvas, 9 x 13" (22.86 x 33.02 cm.)
Signed, Elizabeth Olds, lower left
Gift of Louis Held, 1965
965-O-133

Burlesque
Lithograph on paper, 14.5 x 10.5" (36.83 x 26.67 cm.)
Signed, Elizabeth Olds, lower right
Gift of Joseph G. Butler, III, 1963
963-P-102

Ivan G. OLINSKY, (1878–1962)

Portrait of J. G. Butler, Jr., 1920
Oil on canvas, 51 x 41" (129.54 x 104.14 cm.)
Signed, Ivan G. Olinsky, upper right
Gift of Jonathan Wainer, 1920
920-O-108

Portrait of Mrs. J. G. Butler, Jr., 1929
Oil on canvas, 51 x 41" (129.54 x 104.14 cm.)
Signed, Ivan G. Olinsky, upper left
Museum purchase, 1929
929-O-103

Portrait of Judge John W. Ford
Oil on canvas, 40 x 36" (101.60 x 91.44 cm.)
Signed, Ivan G. Olinsky, upper left
Gift of the Ford Family, 1969
969-O-146

Portrait of Mr. E. L. Ford
Oil on canvas, 46.12 x 34.5" (117.16 x 87.63 cm.)
Signed, Ivan G. Olinsky, upper left
Gift of Mrs. Benjamin Agler, 1971
971-O-110

Portrait of H. H. Stambaugh, 1919
Oil on canvas, 36 x 30" (91.44 x 76.20 cm.)
Unsigned
Gift of the estate of H. H. Stambaugh, 1919
919-O-110

Springtime, 1918
Oil on canvas, 49 x 39" (124.46 x 99.06 cm.)
Signed, Ivan G. Olinsky, lower right
Museum purchase, 1920
920-O-109

The following three signed oils on canvas are the gift of Mr. and Mrs. Edward E. Ford, 1969

Portrait of Dorothy Brandt Ford
40 x 32" (101.60 x 81.28 cm.)
969-O-145

Portrait, Mr. E. L. Ford
30 x 25" (76.20 x 63.50 cm.)
969-O-148

Portrait of Mrs. E. L. Ford
(Blanche Butler Ford)
51 x 41" (129.54 x 104.14 cm.)
969-O-147

Portrait of Joseph G. Butler, Jr.
Pastel on paper, 16.5 x 12.5" (41.91 x 31.75 cm.)
Signed, Ivan G. Olinsky, lower right
Gift of Blanche Agler, 1972
972-D-102

Joseph G. Butler, Jr.
Charcoal on paper, 16 x 12.5" (40.64 x 31.75 cm.)
Signed, Ivan G. Olinsky, lower right
Gift of the Ford Family, 1970
970-D-123

The following two drawings, charcoal on paper, 17 x 13" (43.18 x 33.02 cm.), are the gift of Mrs. Henry A. Butler, 1958

Portrait Study of Joseph G. Butler, Jr.
958-D-101 and 958-D-102

Eliot O'Hara - Cape Porpoise Harbor

O'Keeffe - Cottonwood III

Oldenburg - Bat Spinning at the Speed of Light–State I

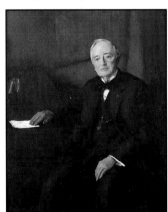
Olinsky - Portrait of J. G. Butler, Jr.

Olinsky - Portrait of Mrs. J. G. Butler, Jr.

Olson - The Wheat Field

Omiros - Composition in Blue

Dennis Oppenheim - And the Mind Grew Fingers

Orr - The Storm

Louisa McMahan Osborne - Johnstown Flood

Ossorio - The Swimmers

Nathan J. OLIVEIRA, (1928–)

Landscape, 1955, 1955
Watercolor on paper, 20 x 40" (50.80 x 101.60 cm.)
Signed, Oliveira, 55, upper right
Museum purchase, 1956
956-W-108

Rick OLSON, (1950–)

The Wheat Field, 1988
Pastel on paper, 20 x 52" (50.80 x 132.08 cm.)
Signed, Rick Olson, lower right
Gift of Rick Olson, 1991
991-D-102

OMIROS, (active 20th century)

Composition in Blue, 1967–70
Oil on canvas, 72 x 160" (182.88 x 406.40 cm.)
Signed, Omiros, upper right
Gift of Chen Chi, 1991
991-O-101

Charles OPPENHEIM, (1890– ?)

Girl in Red Dress
Oil on canvas, 24 x 20" (60.96 x 50.80 cm.)
Unsigned
Gift of Charles Oppenheim, 1967
967-O-147

Dennis OPPENHEIM, (active 20th century)

And the Mind Grew Fingers
Mixed media on paper, (4 panels), each 38 x 50" (96.52 x 127.00 cm.)
Signed, Dennis Oppenheim, 1984, lower right
Museum purchase, 1996
996-D-101

The following three signed lithographs on paper, 41 x 29" (104.14 x 73.66 cm.), are a gift of Dennis Oppenheim, 1995

Dream Lines
995-P-114

Rainbow Pass/Color Mix 3/8
995-P-113

Silver Disk Landing Field
995-P-112

Lily ORLOFF, (1908–1957)

Mother and Child
Oil on canvas, 39 x 28" (99.06 x 71.12 cm.)
Signed, Orloff, lower right
Gift of Chase Galleries, 1963
963-O-110

Elliot ORR, (1904–)

The Storm, 1936
Oil on panel, 16 x 20" (40.64 x 50.80 cm.)
Signed, Elliot Orr, lower right
Museum purchase and gift of the Richard Florsheim Art Fund, 1991
991-O-103

The Butler Institute's collection includes the following works which are the gift of Elliot Orr, 1991
One hundred signed oils on canvas
991-O-118 — 991-O-217

Forty-one signed watercolors on paper
991-W-105 — 991-W-145

Seventeen signed prints and drawings on paper
991-D-113 — 991-D-129

J. O. OSBORNE, (active early 19th century)

The following two signed oils on canvas, 27 x 22" (68.58 x 55.88 cm.), are the gift of Mrs. W. J. Sampson, 1977

Portrait of Hannah Wick, 1845
977-O-102

Portrait of Henry Wick, 1845
977-O-101

Louisa McMahan OSBORNE, (active late 19th century)

Johnstown Flood, 1885
Oil on canvas, 29 x 46.25" (73.66 x 117.48 cm.)
Signed, Louisa McMahan Osborne, on reverse
Museum purchase, 1971
971-O-108

Richard OSBORNE, (active late 20th century)

November, 69
Oil on canvas, 25 x 55.5" (63.50 x 140.97 cm.)
Signed, R. Osborne, lower left
Museum purchase, 1973
973-O-101

Joseph B. O'SICKEY, (1918–)

Dining Table and Window, 1973
Oil on canvas, 61 x 70" (154.94 x 177.80 cm.)
Signed, O'Sickey, lower right
Gift of the Friends of American Art, 1974
974-O-109

Alfonso OSSORIO, (1916–)

The Swimmers
Watercolor on paper, 34 x 24" (86.36 x 60.96 cm.)
Unsigned
Gift of Dr. Bernard Brodsky, 1959
959-W-111

Edmund H. OSTHAUS, (1858–1928)

Family Portrait
Watercolor on paper, 10.25 x 14.25" (26.04 x 36.20 cm.)
Signed, Edm. H. Osthaus, lower right
Gift of Mrs. Henry A. Butler, 1967
967-W-116

Jerry OTT, (1947–)

The following three signed lithographs on paper of various sizes are the gift of Marc A. Wyse, 1983

Connie, 1978
(87/90), 24 x 31" (60.96 x 78.74 cm.)
983-P-123

Susan, 1981
28 x 39.5" (71.12 x 100.33 cm.)
983-P-118

(Untitled), 1980
8.5 x 10.25" (21.59 x 26.04 cm.)
983-P-101

William PACHNER, (1915–)

Variations on Avignon Pieta #2
Oil on canvas, 46 x 48" (116.84 x 121.92 cm.)
Signed, Pachner, lower right
Museum purchase, 1959
959-O-109

Portrait, 1961
Pen and ink on paper, 13 x 10" (33.02 x 25.40 cm.)
Signed, Pachner, lower left
Museum purchase, 1962
962-D-150

Harry PACKMAN, (1913–)

Sunday Morning
Oil on canvas, 34 x 47" (86.36 x 119.38 cm.)
Signed, Packman, lower right
Museum purchase, 1952
952-O-102

Nam June PAIK, (1932–)

(Untitled), 1973
Lithograph on paper, 12 x 9" (30.48 x 22.86 cm.)
Signed, Paik, lower right
Gift of Steven Feinstein, 1983
983-P-162

Guy PALAZZOLA, (1919–1978)

The following two oils on canvas are a museum purchase, 1957, 1958

Family Tree
36 x 48" (91.44 x 121.92 cm.)
957-O-122

Prometheus Rebound
35 x 48" (88.90 x 121.92 cm.)
958-O-118

PALMER, (active early 20th century)

Joseph G. Butler, Jr.
Pen and ink on paper, 27 x 21" (68.58 x 53.34 cm.)
Signed, Palmer, lower middle
Museum purchase, 1926
926-D-101

Richard PANTELL, (1951–)

Two Sided Street, 1986
Etching on paper, 15.75 x 19" (40.01 x 48.26 cm.)
Signed, Richard Pantell, lower right
Gift of Paramour Fine Arts, 1987
987-P-101

Peter PAONE, (1936–)

Two Sail Boats, 1969
Gouache on paper, 15.5 x 20.5" (39.37 x 52.07 cm.)
Signed, Paone, lower right
Museum purchase, 1973
973-W-103

Frederick PAPSDORF, (1887– ?)

Farm Scene, 1940
Oil on canvas, 12 x 18" (30.48 x 45.72 cm.)
Signed, Papsdorf, 1940, lower right
Gift of Robert Tannahill, 1947
947-O-109

Flowers in Vase, 1944
Oil on canvas, 24 x 20" (60.96 x 50.80 cm.)
Signed, Papsdorf, lower right
Gift of Mr. and Mrs. Milton Lowenthal, 1954
954-O-133

Phil PARADISE, (1905–)

Return from Pasture, 1941
Watercolor on paper, 18 x 24" (45.72 x 60.96 cm.)
Signed, Phil Paradise, lower left
Gift of Katherine R. Donaldson, 1970
970-W-101

Malcolm Stephens PARCELL, (1896–1987)

Portrait, My Mother, 1918
Oil on canvas, 47 x 63" (119.38 x 160.02 cm.)
Signed, Malcolm Parcell, lower right
Museum purchase, 1923
923-O-107

The Old Doorway
Oil on canvas, 21 x 30" (53.34 x 76.20 cm.)
Signed, Malcolm Parcell, lower right
Gift of Dr. and Mrs. C. R. Clark, 1954
954-O-134

Albert L. PARELLA, (1909–)

Race at Southern Park Circa 1928, 1978
Watercolor and collage on paper, 8 x 22" (20.32 x 55.88 cm.)
Signed, Parella, lower left
Gift of Albert L. Parella, 1988
988-W-101

Thistle and Juniper, Grampians, Scotland, 1976
Watercolor on paper, 19 x 26" (48.26 x 66.04 cm.)
Signed, Albert Parella, lower right
Gift of the Friends of American Art, 1976
976-W-104

The following three signed watercolors on paper of various sizes are a museum purchase, 1954, 1965, 1967

Another Time, 1966
967-W-115

Swamp Tree
954-W-115

View from the Bridge
965-W-141

Dorothy PARIS, (1899– ?)

Mexican Women in Courtyard
Oil on canvas, 16 x 14" (40.64 x 35.56 cm.)
Signed, D. Paris, lower right
Gift of Louis Held, 1968
968-O-181

The following three signed oils on canvas of various sizes are the gift of Jack Hockett, 1968, 1977

Nocturnal
977-O-122

The Death of a Saint
977-O-121

The Garden–Jordan
968-O-179

Osthaus - Family Portrait (page 132)

Paik - (Untitled)

Papsdorf - Farm Scene

Parcell - Portrait, My Mother

Parella - View from the Bridge

Paris - Mexican Women in Courtyard

Catherine Burchfield Parker - Late Afternoon Sunflowers

Ray Parker - (Untitled) (986-O-117)

Pascin - Trois Petites Filles

Paxton - Sylvia

Paxton - The Beach at Chatham

Anna Claypoole Peale - Still Life (page 135)

The following three signed woodcuts on paper of various sizes are the gift of Louis Held, 1968

The Gentle Bird, 1967
968-P-233

Woman with Cat, 1967
968-P-232

Young Girl, 1967
968-P-231

Bill PARKER, (1922–)

(Untitled), 1960
Oil on canvas, 23.5 x 32" (59.69 x 81.28 cm.)
Signed, B. P., 60, lower right
Gift of Gerold Frank, 1974
975-O-103

Catherine Burchfield PARKER, (active 20th century)

Late Afternoon Sunflowers
Watercolor on paper, 29.5 x 21.5" (74.93 x 54.61 cm.)
Signed, Catherine B. Parker, lower right
Museum purchase, 1988
988-W-102

Study on Pearl Street
Pen, ink, and graphite on paper, 24 x 18" (60.96 x 45.72 cm.)
Signed, Catherine B. Parker, lower right
Gift of Catherine Burchfield Parker, 1988
988-D-101

Mary PARKER, (active 20th century)

Spatial
Oil on canvas, 40 x 30" (101.60 x 76.20 cm.)
Signed, Mary Parker, lower right
Gift of the Department of Art, Western Carolina University, 1992
992-O-114

Ray PARKER, (1922–)

(Untitled), 1977
Oil on paper, 22 x 30" (55.88 x 76.20 cm.)
Signed, R. P., 1977, lower left
Museum purchase, 1986
986-O-117

(Untitled)
Lithograph on paper, (23/100), 11 x 14.25" (27.94 x 36.20 cm.)
Unsigned
Gift of Arthur Feldman, 1991
991-P-183

Charles PARNESS, (1945–)

Play Ball, 1989
Oil on canvas, 60 x 40" (152.40 x 101.60 cm.)
Signed, Parness, 89, lower right
Museum purchase, 1990
990-O-105

Tom PARRISH, (1933–)

Structure
Oil on canvas, 34.5 x 60" (87.63 x 152.40 cm.)
Unsigned
Museum purchase, 1965
965-O-156

De Witt PARSHALL, (1864–1956)

The Old Willows, 1908–09
Oil on canvas, 24 x 32" (60.96 x 81.28 cm.)
Signed, De Witt Parshall, lower left
Gift of Allen S. Wilder, 1963
963-O-134

Charles PARSONS, (1821–1910)

Baltimore and Havana Steamship Line
Color lithograph on paper, 17.5 x 35" (44.45 x 88.90 cm.)
Unsigned
Museum purchase, 1968
968-P-227

Jules PASCIN, (1885–1930)

Trois Petites Filles, 1919
Etching on paper, 4 x 5" (10.16 x 12.70 cm.)
Signed, Pascin, lower right
Museum purchase, 1965
965-P-250

Douglas PASEK, (1933–)

Quiet Cove
Opaque watercolor on paper, 17.5 x 24" (44.45 x 60.96 cm.)
Signed, Pasek, lower right
Museum purchase, 1965
965-W-136

Robert Charles PATTERSON, (1878–1958)

Turning the Buoy
Oil on canvas, 30 x 40" (76.20 x 101.60 cm.)
Signed, Robert Charles Patterson, lower left
Museum purchase, 1980
980-O-101

Paul PATTON, (active 20th century)

See You at the Butler
Oil on canvas, 20 x 30" (50.80 x 76.20 cm.)
Signed, P. Patton, lower right
Museum purchase, 1992
992-O-102

Jon PAUL, (active 20th century)

Blue Chance
Acrylic on canvas, 64.75 x 57.25" (164.47 x 145.42 cm.)
Unsigned
Gift of Leonard Bocour, 1976
976-O-117

Josephine PAUL, (1908–)

Tomorrow is Sunday, 1946
Oil on canvas, 24 x 16" (60.96 x 40.64 cm.)
Signed, Jo Paul, 46, lower left
Museum purchase, 1948
948-O-117

William McGregor PAXTON, (1869–1941)

Sylvia, 1908
Oil on canvas, 49 x 39.5" (124.46 x 100.33 cm.)
Signed, Paxton, 1908, upper right
Museum purchase, 1917
917-O-105

The Beach at Chatham, ca. 1915
Oil on canvas, 40 x 50" (101.60 x 127.00 cm.)
Signed, Paxton, lower right
Gift of Richard Owsley, 1977
977-O-105

Robert PEAK, (active late 20th century)

Wilt Chamberlain and John Havlicek
Lithograph on paper, 15 x 20" (38.10 x 50.80 cm.)
Signed, R. Peak, lower right, signed by subjects
Gift of Mr. and Mrs. Irwin Thomases, 1984
984-P-105

Anna Claypoole PEALE, (1791–1878)

Still Life
Oil on canvas, 26 x 40" (66.04 x 101.60 cm.)
Unsigned
Gift of C. M. Paul, 1957
957-O-123

Charles Willson PEALE, (1741–1827)

Portrait of Mr. Thomas Russell, ca. 1784
Oil on canvas, 30.25 x 25.25" (76.84 x 64.14 cm.)
Unsigned
Museum purchase, 1969
969-O-112

Portrait of Mrs. Thomas Russell, ca. 1784
Oil on canvas, 30.25 x 25.25" (76.84 x 64.14 cm.)
Unsigned
Museum purchase, 1969
969-O-111

Washington Portrait, 1787
Engraving on paper, 6 x 4.75" (15.24 x 12.07 cm.)
Unsigned
Museum purchase, 1968
968-P-299

James PEALE, (1749–1831)

Still Life with Grapes and Apples on a Plate
Oil on canvas, 16 x 22" (40.64 x 55.88 cm.)
Unsigned
Museum purchase, 1945
945-O-105

Washington Portrait, © 1884
Hand tinted lithograph on paper, 4.25 x 3" (10.80 x 7.62 cm.)
Signed, Jas. Peale, lower left
Museum purchase, 1968
968-P-301

Rembrandt PEALE, (1778–1860)

Porthole Portrait of George Washington, 1795
Oil on canvas, 36 x 29" (91.44 x 73.66 cm.)
Signed, Rembrandt Peale, lower left
Museum purchase, 1957
957-O-124

The Court of Death
Lithograph on paper, 21 x 30" (53.34 x 76.20 cm.)
Unsigned
Gift of the Youngstown Public Library, 1976
976-P-102

Moses P. PEARL, (1917–)

The Pass-over
Watercolor on paper, 30 x 36" (76.20 x 91.44 cm.)
Signed, Pearl, lower left
Gift of the Friends of American Art, 1957
957-W-108

Philip PEARLSTEIN, (1924–)

Portrait of Mrs. Florence S. Beecher, 1988
Oil on canvas, 30 x 40" (76.20 x 101.60 cm.)
Signed, Pearlstein, lower right
Museum purchase, 1988
988-O-116

View of Assisi, #5, 1958
Watercolor on paper, 25.56 x 29.12" (64.92 x 73.98 cm.)
Signed, Pearlstein, lower center
Gift of Philip Pearlstein, 1992
992-W-103

Nude, 1970
Lithograph on paper, (38/50), 30 x 22" (76.20 x 55.88 cm.)
Signed, Philip Pearlstein, lower right
Gift of Arthur Feldman, 1991
991-P-158

Nude with Rocker
Lithograph on paper, 23 x 24" (58.42 x 60.96 cm.)
Signed, Philip Pearlstein, lower right
Museum purchase, 1980
980-P-122

Nude Seated on Stool
Lithograph on paper, (90/150), 24 x 18" (60.96 x 45.72 cm.)
Signed, Philip Pearlstein, lower left
Gift of Judah Rubinstein, 1995
995-P-105

(Untitled)
Lithograph on paper, 20 x 25" (50.80 x 63.50 cm.)
Signed, Philip Pearlstein, lower left
Gift of Mr. and Mrs. David M. Draime, 1990
990-P-102

Henry PEARSON, (1914–)

Osiris
Lithograph on paper, 22.5 x 22.5" (57.15 x 57.15 cm.)
Signed, Henry Pearson, lower right
Museum purchase, 1966
966-P-148

John PEARSON, (1940–)

Circle–Section Series, Invert PC
Silkscreen on paper, 19 x 25" (48.26 x 63.50 cm.)
Signed, J. Pearson, 1984, lower right
Gift of Adele Silver, 1992
992-P-121

Mondrian Series
Lithographs on paper, (4), 22 x 22" (55.88 x 55.88 cm.)
Unsigned
Gift of Ana and Eric Baer, 1991
991-P-193 — 991-P-196

Mariam PECK, (1910–)

Early Autumn
Watercolor on paper, 22 x 30" (55.88 x 76.20 cm.)
Unsigned
Museum purchase, 1950
950-W-105

Waldo PEIRCE, (1884–1970)

Milkweed, 1947
Oil on canvas, 30 x 20" (76.20 x 50.80 cm.)
Signed, W. P., 47, right center
Museum purchase, 1974
974-O-107

Charles Willson Peale - Portrait of Mr. Thomas Russell

Charles Willson Peale - Portrait of Mrs. Thomas Russell

James Peale - Still Life with Grapes and Apples on a Plate

Rembrandt Peale - Porthole Portrait of George Washington

Pearlstein - Portrait of Mrs. Florence S. Beecher

Pearlstein - View of Assisi, #5

John Pearson - Circle–Section Series, Invert PC (page 135)

Pellew - Viewing Constable

Péne du Bois - Trapeze Performers

Pennell - Grand Central Station Concourse

Pepper - (Untitled)

Pereira - View

Haunted House
Watercolor on paper, 18 x 23" (45.72 x 58.42 cm.)
Unsigned
Museum purchase, 1947
947-W-106

Christopher PEKOC, (active 20th century)

After the Storm
Lithograph on paper, 21 x 29" (53.34 x 73.66 cm.)
Signed, Pekoc, upper right
Gift of Ana and Eric Baer, 1991
991-P-200

John Clifford PELLEW, (1903–)

Viewing Constable
Watercolor on paper, 20.5 x 26.5" (52.07 x 67.31 cm.)
Signed, Pellew, lower right
Museum purchase, 1963
963-W-103

Albert PELS, (1910–)

The following four oils on canvas of various
sizes are the gift of Albert Pels, 1973

Follow the Leader
973-O-125

Mother and Child
973-O-124

(Untitled)
973-O-122

(Untitled)
973-O-123

Guy PÉNE du BOIS, (1884–1958)

Trapeze Performers, ca. 1930s
Oil on canvas, 25 x 20" (63.50 x 50.80 cm.)
Signed, Guy Péne du Bois, lower left
Museum purchase, 1964
964-O-113

Man and Woman on Bench, 1931
Drawing on paper, 14.25 x 11" (36.20 x 27.94 cm.)
Signed, Guy Péne du Bois, 31, lower right
Gift of Milch Galleries, 1964
964-D-103

Two Men Standing, 1938
Ink on paper, 14.5 x 11" (36.83 x 27.94 cm.)
Signed, Guy Péne du Bois, 38, lower left
Museum purchase, 1964
964-D-102

Joseph PENNELL, (1857–1926)

Pittsburgh No. 2
Etching on paper, 9 x 12" (22.86 x 30.48 cm.)
Signed, J. Pennell, lower center
Gift of Charles H. Owsley, 1984
984-P-109

The following four signed etchings on paper of
various sizes are a museum purchase, 1968,
1970, 1977

Chelsea Church and Whistler's House
970-P-101

Flat Iron Building
968-P-324

Grand Central Station Concourse
977-P-126

Stock Yards, Chicago
968-P-325

John Ritto PENNIMAN, (1782–1841)

Spencer Nolen, 1806
Oil on wood, 29 x 23.67" (73.66 x 60.14 cm.)
Unsigned
Gift of Mr. and Mrs. Kurt Albrecht, 1976
976-O-102

Harper PENNINGTON, (1854–1920)

Nude
Pastel on paper, 15.5 x 11" (39.37 x 27.94 cm.)
Unsigned
Museum purchase, 1956
956-W-111

Beverly PEPPER, (1924–)

(Untitled)
Oil on paper, 39.5 x 27.5" (100.33 x 69.85 cm.)
Signed, Beverly Pepper, lower right
Gift of Professor Sam Hunter, 1993
993-O-120

Irene Rice PEREIRA, (1907–1971)

View
Oil on canvas, 20.5 x 18.5" (52.07 x 46.99 cm.)
Signed, I. Rice Pereira, lower right
Gift of Robert Gwathmey, 1953
953-O-113

Celestial Beings
White ink on paper, 25.25 x 19.25" (64.14 x 48.90 cm.)
Signed, I. Rice Pereira, lower right
Gift of Harold M. Levy, 1967
967-D-110

Robert PERINE, (1922–)

Tripscape, 1972
Watercolor on paper, 35.5 x 60" (90.17 x 152.40 cm.)
Signed, Robert Perine, lower left
Museum purchase, 1972
972-W-108

Granville PERKINS, (1830–1895)

Off Bannegat Light–New Jersey Coast
Watercolor on paper, 17 x 22" (43.18 x 55.88 cm.)
Signed, Granville Perkins, lower left
Gift of Mrs. W. J. Sampson, 1977
977-W-101

Philip PERKINS, (1907–1970)

Aphrodite or Mae West, 1944
Oil on canvas, 50 x 30" (127.00 x 76.20 cm.)
Signed, Perkins, lower right
Gift of Dr. Henry Ostberg, 1978
978-O-104

Jack PERLMUTTER, (1920–)

Elevated Station
Color lithograph on paper, 13 x 42.5" (33.02 x 107.95 cm.)
Signed, J. Perlmutter, lower right
Museum purchase, 1956
956-P-106

James PERNOTTO, (1950–)

Zip, Slam, Crash, 1977
Oil, cut paper, glitter, colored pencil, and rhroplex on canvas
80 x 15" (203.20 x 38.10 cm.)
Unsigned
Gift of James Pernotto, 1984
984-O-105

Technician Beard, 1984
Graphite on handmade paper, 24 x 18.5" (60.96 x 46.99 cm.)
Signed, James Pernotto, lower right
Gift of James Pernotto, 1986
986-D-101

Council Rock, 1987
Reduction woodblock on paper, 24 x 36" (60.96 x 91.44 cm.)
Signed, Jim Pernotto, lower right
Gift of James Pernotto, 1989
989-P-102

Tongues of Fire, 1987
Reduction woodblock on paper, 24 x 36" (60.96 x 91.44 cm.)
Signed, Jim Pernotto, 1987, lower right
Gift of James Pernotto, 1989
989-P-103

Minor Artists Borrow/Major Artists Steal
Portfolio of 53: Rip Off on the Last Millennium
Print on paper, 8.5 x 11" (21.59 x 27.94 cm.)
Unsigned
Gift of the William Busta Gallery, 1990
990-P-111.15

Simmons PERSONS, (1906–)

Bright Day
Watercolor on paper, 15.5 x 24.5" (39.37 x 62.23 cm.)
Unsigned
Gift of Mrs. Graham Bennett, 1958
958-W-116

George PETER, (1922–)

Seated Nude
Oil on canvas, 26 x 22" (66.04 x 55.88 cm.)
Signed, George Peter, lower right
Gift of Chase Gallery, 1966
966-O-106

Gabor PETERDI, (1915–)

Pacific X, (The Current)
Oil on canvas, 42.75 x 34.5" (108.59 x 87.63 cm.)
Signed, Peterdi, lower right
Gift of Drs. Paul and Laura Mesaros, 1992
992-O-111

(Untitled)
Etching on paper, 22 x 30" (55.88 x 76.20 cm.)
Signed, Peterdi, lower right
Gift of Arthur Feldman, 1991
991-P-177

Robert PETERSEN, (active 20th century)

The following signed lithographs on paper, 30.25 x 43" (76.84 x 109.22 cm.), are the gift of Marc A. Wyse, 1983

Chart Series, 1977
983-P-124 — 983-P-129

Legend Series, 1977
983-P-119

Margaret PETERSON, (1940–)

Stereotyped Triad
Oil on canvas, 60 x 50" (152.40 x 127.00 cm.)
Signed, Peterson, lower center
Museum purchase, 1969
969-O-132

Norton PETERSON, (1916–)

Coke Oven
Watercolor on paper, 21 x 21" (53.34 x 53.34 cm.)
Signed, Norton Peterson, lower right
Gift of the Friends of American Art, 1966
966-W-111

Ruth PETLOCK, (active 20th century)

Kowloon
Watercolor collage on paper, 20 x 29.25" (50.80 x 74.30 cm.)
Signed, Ruth Petlock, lower right
Museum purchase, 1969
969-W-110

John Frederick PETO, (1854–1907)

Book, Mug, Candlestick and Pipe
Oil on canvas, 12.25 x 16" (31.12 x 40.64 cm.)
Signed, J. F. Peto, lower left
Museum purchase, 1967
967-O-102

Peter J. PETRONY, (1912–)

Dawn on the Rocks, 1970
Acrylic on masonite, 12 x 16" (30.48 x 40.64 cm.)
Signed, Petrony, lower right
Gift of Peter J. Petrony, 1977
977-O-143

Milan V. PETROVIC, (1893– ?)

Venice
Watercolor on board, 22 x 30" (55.88 x 76.20 cm.)
Signed, Milan Petrovic, lower right
Gift of Blanche Lewis in memory of Dr. John S. Lewis, Jr., 1977
977-P-119

Gary E. PETTIGREW, (1935–)

Judy and Harvey: Exchange, 1975
Watercolor on paper, 16.25 x 26" (41.28 x 66.04 cm.)
Signed, Pettigrew, lower right
Museum purchase, 1975
975-W-104

Jane PETTUS, (1908–)

Woman Peeling Apples
Oil on canvas, 39 x 30" (99.06 x 76.20 cm.)
Signed, J. Pettus, lower left
Gift of Thomas Pettus, 1967
967-O-130

Robert PHILIPP, (1895–1981)

The following four signed oils on canvas of various sizes are the gift of Mrs.William V. Miller, 1960, 1963, 1958, 1959

Girl in Red Robe
960-O-118

In Vermont
963-O-105

Granville Perkins - Off Bannegat Light—New Jersey Coast (page 136

Pernotto - Technician Beard

Peterdi - Pacific X, (The Current)

Peto - Book, Mug, Candlestick and Pipe

Pettigrew - Judy and Harvey: Exchange

Philipp - Girl in Red Robe

Bert Greer Phillips - Apache

Pickering - Some Grow Up

Pike - Umberto's Boys

Pippin - Zachariah

Pittman - Mantel Arrnagement

Pleissner - Quai aux Fleurs (page 139)

Lola–Lady in Black
958-O-108

Still Life #3
959-O-123

Bert Greer PHILLIPS, (1868–1956)

Apache
Oil on paperboard, 12 x 9" (30.48 x 22.86 cm.)
Signed, Bert Phillips, Taos, NM, lower right
Museum purchase, 1920
920-O-507

Gray–Buffalo
Oil on panel, 12 x 9" (30.48 x 22.86 cm.)
Signed, Bert Phillips, Taos, NM, upper left
Museum purchase, 1920
920-O-508

Harriet S. PHILLIPS, (1849–1928)

(Untitled), 1917
Etching on paper, 11 x 6.5" (27.94 x 16.51 cm.)
Signed, H. Phillips, lower right
Gift of Jerold Meyer, 1972
972-P-109

Joseph PICCILLO, (1941–)

Policy Makers III, 1967
Oil on canvas, 66 x 73" (167.64 x 185.42 cm.)
Signed, Joseph Piccillo, 1967, right center
Gift of Joseph Piccillo, 1969
969-O-143

George PICKEN, (1898–1971)

Near Verdun
Lithograph on paper, 10.5 x 17.25" (26.67 x 43.82 cm.)
Signed, George Picken, lower right
Gift of Harry Salpeter Gallery, 1967
967-P-172

Vinton PICKENS, (active 20th century)

Race Day, Kelani Valley, (Ceylon), ca. 1964
Oil on canvas, 48 x 60" (121.92 x 152.40 cm.)
Signed, Pickens, lower right
Gift of Chase Gallery, 1966
966-O-107

H. Douglas PICKERING, (1921–1991)

Some Grow Up, 1947
Oil on canvas, 25 x 32" (63.50 x 81.28 cm.)
Signed, H. Douglas Pickering, 1947, upper left
Museum purchase, 1949
949-O-110

Pomegranate, 1961
Woodblock on paper, 31 x 36" (78.74 x 91.44 cm.)
Signed, H. Douglas Pickering, lower right
Museum purchase, 1962
962-P-105

Edna Wagner PIERSOL, (1931–)

Spacious Skies
Watercolor on paper, 27 x 37" (68.58 x 93.98 cm.)
Signed, Edna Wagner Piersol, lower right
Gift of the Friends of American Art, 1970
970-W-106

John PIKE, (1911–1980)

Umberto's Boys
Watercolor on paper, 24 x 33" (60.96 x 83.82 cm.)
Signed, John Pike, lower right
Gift of Dr. John J. McDonough, 1974
974-W-103

Paul F. PINZARRONE, (1951–)

(Untitled)
Spray paint on canvas, 38 x 42" (96.52 x 106.68 cm.)
Unsigned
Museum purchase, 1975
975-O-120

Horace PIPPIN, (1888–1946)

Zachariah, 1943
Oil on canvas, 11 x 14" (27.94 x 35.56 cm.)
Signed, H. Pippin, 1943, lower right
Museum purchase, 1951
951-O-120

Anthony PISCIOTTA, (1913–)

Yellow Moon
Oil on canvas, 14 x 10" (35.56 x 25.40 cm.)
Unsigned
Gift of Louis Held, 1965
965-O-122

Hobson PITTMAN, (1900–1972)

Mantel Arrangement, 1954
Oil on canvas, 30 x 46" (76.20 x 116.84 cm.)
Signed, Pittman, lower left
Museum purchase, 1955
955-O-142

Interior in Charleston
Pastel on paper, 18 x 24" (45.72 x 60.96 cm.)
Signed, Hobson Pittman, lower left
Anonymous gift, 1955
955-W-112

Nine P.M.
Pastel on paper, 12 x 19" (30.48 x 48.26 cm.)
Signed, H. Pittman, lower left
Museum purchase, 1941
941-W-108

Winter Night, ca. 1935
Woodblock on paper, 9 x 12" (22.86 x 30.48 cm.)
Signed, Hobson Pittman, lower right
Museum purchase, 1964
964-P-123

Henry C. PITZ, (1895–1976)

Hotel Lobby
Watercolor on paper, 20 x 24" (50.80 x 60.96 cm.)
Signed, Henry C. Pitz, lower right
Museum purchase, 1953
953-W-107

Joseph PLAVCAN, (1908–1981)

Coal Yard, 1965
Oil on masonite, 24 x 36" (60.96 x 91.44 cm.)
Unsigned
Museum purchase, 1965
965-O-161

Ogden W. PLEISSNER, (1905–1983)

Quai aux Fleurs
Watercolor on paper, 21 x 30" (53.34 x 76.20 cm.)
Signed, Pleissner, lower left
Museum purchase, 1964
964-W-115

Salmon Guide
Etching on paper, 10 x 8" (25.40 x 20.32 cm.)
Signed, Ogden W. Pleissner, lower right
Museum purchase, 1967
967-P-177

Gloria Joy PLEVIN, (1934–)

View from the Studio: Cottonwoods,
1988
Watercolor on paper, 28.75 x 20" (73.03 x 50.80 cm.)
Signed, Gloria Plevin, lower right
Gift of Gloria Plevin, 1993
993-W-105

Carolyn G. PLOCHMANN, (1926–)

Barriers
Oil on canvas, 34 x 32" (86.36 x 81.28 cm.)
Unsigned
Museum purchase, 1952
952-O-103

Andrew Jackson POE, (1851–1919)

The following two signed oils on canvas are a
museum purchase, 1950

Ohio River Landscape
28 x 38" (71.12 x 96.52 cm.)
950-O-109

Pennsylvania Station in Cleveland
34 x 60" (86.36 x 152.40 cm.)
950-O-108

Charles POLLOCK, (active 20th century)

Rome #10, 1963
Oil on canvas, 66.75 x 55.25" (169.55 x 140.34 cm.)
Unsigned
Gift of Mr. and Mrs. James A. Roemer, 1994
994-O-114

Reginald Murray POLLACK, (1924–)

Bird Woman
Silkscreen on paper, 7 x 10" (17.78 x 25.40 cm.)
Signed, Pollack, lower right
Gift of Louis Held, 1965
965-P-192

Elsie Lower POMEROY, (1882– ?)

A Melting Snow, 1935
Watercolor on paper, 15 x 21" (38.10 x 53.34 cm.)
Signed, Elsie Lower Pomeroy, 1935, lower left
Gift of the Friends of American Art, 1942
942-W-101

Suzanne POOL, (1937–)

Ediface, Avis and Uranus, 1960
Color woodblock on paper, 11.5 x 23.5" (29.21 x 59.69 cm.)
Signed, Suzanne Pool, lower right
Museum purchase, 1960
960-P-106

Eugene Alonzo POOLE, (1841–1913)

Fall Landscape, 1907
Oil on canvas, 14 x 18" (35.56 x 45.72 cm.)
Unsigned
Museum purchase, 1915
915-O-101

Joseph Green Butler, Sr.
Oil on canvas, 27 x 22" (68.58 x 55.88 cm.)
Unsigned
Gift of Joseph G. Butler, III, 1954
954-O-158

The following two signed oils on canvas, 27 x
22" (68.58 x 55.88 cm.), are the gift of Judge and
Mrs. John W. Ford, 1951, 1954

Portrait of Temperance Orwig Butler
951-O-119

Temperance Orwig Butler
(Mrs. Joseph G. Butler, Sr.)
954-O-159

Anne POOR, (1918–)

Switch House
Oil on canvas, 29 x 36" (73.66 x 91.44 cm.)
Signed, Anne Poor, lower left
Gift of Chaim Gross, 1962
962-O-111

Henry Varnum POOR, (1888–1970)

Midsummer, 1966
Oil on mounted canvas, 24 x 30" (60.96 x 76.20 cm.)
Signed, H. V. Poor, lower left
Gift of Mrs. Francis O. Hooper, 1967
967-O-150

James PORTER, (active early 20th century)

Trees in Light Green Woods, ca. 1925
Oil on board, 7 x 6" (17.78 x 15.24 cm.)
Signed, J. P., lower left
Gift of Zell Draz, 1982
982-O-102

Martha POSNER-DOERINGER, (active late 20th century)

The Secret Marriage
Portfolio of 53: Rip Off on the Last Millennium
Print on paper, 8.5 x 11" (21.59 x 27.94 cm.)
Signed, Posner, lower right
Gift of the William Busta Gallery, 1990
990-P-111.35

Edward POTTHAST, (1857–1927)

Afternoon Fun
Oil on canvas, 24 x 30" (60.96 x 76.20 cm.)
Signed, E. Potthast, lower right
Museum purchase, 1989
989-O-103

Nathaniel J. POUSETTE-DART, (1886–1965)

Kitchen Window
Watercolor on paper, 8.5 x 5.5" (21.59 x 13.97 cm.)
Unsigned
Gift of Louis Held, 1965
965-W-128

Charles Pollock - Rome #10

Poole - Portrait of Temperance Orwig Butler

Henry Varnum Poor - Midsummer

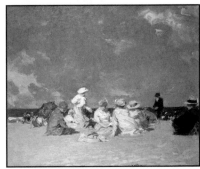
Pottast - Afternoon Fun

Pousette-Dart - Kitchen Window

Powers - The Greek Slave

Pozzatti - Yesterday

Charles E. Prendergast - The Offering

Maurice Brazil Prendergast - Sunset and Sea Fog

Prestopino - Afternoon Sun

Leslie POWELL, (1906–)

Provincetown Steeple
Oil on canvas, 32 x 22" (81.28 x 55.88 cm.)
Signed, L. Powell, lower right
Gift of Dorothy Paris, 1977
977-O-123

Totems
Silkscreen on paper, 20 x 26" (50.80 x 66.04 cm.)
Signed, L. Powell, lower right
Gift of Dorothy Paris, 1977
977-P-116

Hiram POWERS, (1805–1873)

The Greek Slave
Engraving on paper, 7.25 x 5" (18.42 x 12.70 cm.)
Signed, Hiram Powers, lower left
Museum purchase, 1968
968-P-128

Rudy O. POZZATTI, (1925–)

Yesterday
Oil on canvas, 40 x 18" (101.60 x 45.72 cm.)
Signed, Pozzatti, lower right
Museum purchase, 1950
950-O-110

The Denial
Watercolor on paper, 21 x 28" (53.34 x 71.12 cm.)
Signed, Pozzatti, lower right
Museum purchase, 1952
952-W-104

Carnivale, 1960
Color woodcut on paper, 18 x 24" (45.72 x 60.96 cm.)
Signed, Rudy Pozzatti, 1960, lower right
Museum purchase, 1962
962-P-107

Four Kings, 1961
Etching on paper, 23.5 x 17.5" (59.69 x 44.45 cm.)
Signed, Rudy Pozzatti, 1961, lower right
Museum purchase, 1965
965-P-252

David PRATT, (1918–)

Sleepers in the Swamp
Watercolor on paper, 21 x 29" (53.34 x 73.66 cm.)
Signed, David Pratt, lower right
Museum purchase, 1954
954-W-116

Charles E. PRENDERGAST, (1863–1948)

The Offering, ca. 1916–17
Plaster and tempera on panel, 20 x 25" (50.80 x 63.50 cm.)
Signed, C. P., left center
Gift of Dr. John J. McDonough, 1972
972-O-124

Maurice Brazil PRENDERGAST, (1858–1924)

Sunset and Sea Fog, ca. 1918–23
Oil on canvas, 18 x 29" (45.72 x 73.66 cm.)
Signed, Prendergast, lower right
Museum purchase, 1955
955-O-128

Joseph PRESSER, (1909–1967)

Conversation
Watercolor on paper, 22 x 16.5" (55.88 x 41.91 cm.)
Signed, J. Presser, lower right
Gift of Mr. and Mrs. Nahum Tschacbasov, 1972
972-W-101

Three Clowns and Bird, 1950
Ink and gouache on paper, 14.25 x 9.75" (36.20 x 24.77 cm.)
Signed, Presser, lower right
Gift of Agnes Hart Presser, 1977
977-W-106

Gregorio PRESTOPINO, (1907–1984)

Afternoon Sun
Oil on canvas, 31 x 38" (78.74 x 96.52 cm.)
Unsigned
Museum purchase, 1958
958-O-116

Workingman's Lunch
Ink on paper, 26 x 20" (66.04 x 50.80 cm.)
Unsigned
Gift of Katherine Warwick, 1968
968-D-115

The following two signed drawings, ink on paper of different sizes, are the gift of Louis Held, 1965

Machinist
965-D-103

Winter
965-D-106

Ray PROHASKA, (1901–1981)

Deep Pool, ca. 1960
Watercolor on paper, 22 x 30" (55.88 x 76.20 cm.)
Signed, Ray Prohaska, lower left
Gift of Chase Gallery, 1963
963-W-101

Albert E. PROOM, (1933–)

San Francisco Hillscape, 1966
Oil on canvas, 18 x 24" (45.72 x 60.96 cm.)
Signed, Al Proom, on reverse
Museum purchase, 1969
969-O-133

Leonard PYTLAK, (1910–)

Skating
Silkscreen on paper, 6 x 9" (15.24 x 22.86 cm.)
Signed, L. Pytlak, lower left
Anonymous gift, 1967
967-P-122

The following three silkscreens on paper of various sizes are the gift of Louis Held, 1965, 1977

Angels at Puebla No. 2
965-P-173

Ballet Dancers
977-P-124

Girl with Flowers
965-P-134

Helen QUAT, (1918–)

Crevasse
Etching on paper, 23.75 x 9.75" (60.33 x 24.77 cm.)
Signed, Helen Quat, lower right
Gift of Leon Quat, 1978
978-P-109

Edward QUINCY, (1903–)

Dancer and Musicians
Oil on canvas, 7.5 x 9" (19.05 x 22.86 cm.)
Signed, Quincy, lower right
Gift of Louis Held, 1965
965-O-135

Noel J. QUINN, (1915–)

Harbor Pattern
Watercolor on paper, 19 x 27" (48.26 x 68.58 cm.)
Unsigned
Museum purchase, 1958
958-W-109

Norman Scott QUINN, (1939–)

Milk Cap Man, 1948
Plastic, cloth, and acrylic on canvas, 18 x 14" (45.72 x 35.56 cm.)
Signed, Quinn, lower right
Gift of John Hink, 1984
984-O-108

William QUINN, (1929–)

Italian Still Life
Oil on canvas, 18 x 27.5" (45.72 x 69.85 cm.)
Signed, William Quinn, lower left
Gift of the Friends of American Art, 1959
959-O-116

Luis QUINTANILLA, (1895– ?)

Garden Boy
Dry point on paper, 13 x 10" (33.02 x 25.40 cm.)
Signed, Luis Quintanilla, lower right
Gift of Mr. and Mrs. Edward E. Ford, 1970
970-P-114

Thomas Charles QUIRK, Jr., (1922–)

Vigil at the Beach, 1957
Oil on canvas, 28 x 47" (71.12 x 119.38 cm.)
Signed, Quirk, 1957, lower left
Museum purchase, 1957
957-O-125

Winter Sleep, 1962
Drawing on paper, 11 x 8" (27.94 x 20.32 cm.)
Signed, Quirk, MCMLXII, lower right
Museum purchase, 1962
962-D-154

Walter QUIRT, (1902–1968)

Composition
Oil on paper, 30 x 40" (76.20 x 101.60 cm.)
Signed, Quirt, lower right
Gift of Samuel B. Brouner, 1957
957-O-126

(Untitled)
Mixed media on mounted cloth, 16 x 20" (40.64 x 50.80 cm.)
Signed, Quirt, lower right
Gift of Samuel S. Goldberg, 1980
980-O-106

The following two signed drawings on paper, 30 x 26" (76.20 x 66.04 cm.), are the gift of Benjamin Weiss, 1970

Two of Eleanor, 1958
971-D-102

Figure, 1958
971-D-101

Andre RACZ, (1916–)

Mother and Child, 1949
Etching on paper, 18.5 x 11.5" (46.99 x 29.21 cm.)
Signed, Andre Racz, 49, lower right
Museum purchase, 1959
959-P-106

William RADAWEC, (active late 20th century)

(Untitled)
Portfolio of 53: Rip Off on the Last Millennium
Print on paper, 8.5 x 11" (21.59 x 27.94 cm.)
Signed, Radawec, lower right
Gift of the William Busta Gallery, 1990
990-P-111.3

Dan RADIN, (1929–)

Water Quarry
Oil on canvas, 48 x 40" (121.92 x 101.60 cm.)
Unsigned
Museum purchase, 1961
961-O-120

Joseph RAFFAEL, (1933–)

Paper Mill, 1974
Oil on canvas, 83 x 120" (210.82 x 304.80 cm.)
Signed, Raffael, on reverse
Museum purchase, 1992
992-O-112

Winter Rose, 1991
Watercolor on paper, 57 x 38" (144.78 x 96.52 cm.)
Signed, Raffael, lower right
Gift of the Hoffman/Greenwald family: Nancy Hoffman, Rebecca Greenwald, and Peter Greenwald, 1993
993-W-104

Journey, 1981
Color lithograph on paper, 39 x 16.75" (99.06 x 42.55 cm.)
Signed, Raffael, lower left
Gift of Robert E. Kohler, Jr., 1990
990-P-113

William RAKOCY, (1924–)

Limestone Open Pit Mine, 1958
Oil on canvas, 28 x 44" (71.12 x 111.76 cm.)
Signed, Ro, 58, lower right
Gift of Charles D. Arnott, 1991
991-O-113

Landscape with Blue–Violet, 1954
Watercolor on paper, 23 x 33" (58.42 x 83.82 cm.)
Signed, Rakocy, 54, PA Turnpike, lower right
Gift of Federated Women's Clubs, 1954
954-W-117

John RAMAGE, (ca. 1748–1802)

Washington Portrait, 1789
Engraving on paper, 7 x 5" (17.84 x 12.70 cm.)
Unsigned
Museum purchase, 1968
968-P-302

Quirk - Vigil at the Beach

Quirt - Composition

Raffael - Paper Mill

Raffael - Winter Rose

Rakocy - Limestone Open Pit Mine

Ramage - Washington Portrait

Ranger - Long Pond

Ranney - On the Wing

Rattner - Figures in Flames

Rauschenberg - Arcanum IX

Ray - # One (red) (991-P-171)

Mel (Melvin John) RAMOS, (1935–)

The following two signed lithographs on paper, 24 x 32" (60.96 x 81.28 cm.), are the gift of Reese and Marilyn Arnold Palley, 1969, 1991

Girl with Jaguar, 1969
969-P-161

Girl with Antelope, 1991
991-P-160

Henry Ward RANGER, (1858–1916)

Long Pond, 1907
Oil on canvas, 28 x 35" (71.12 x 88.90 cm.)
Signed, Henry Ranger, lower right
Museum purchase, 1918
918-O-108

William Tylee RANNEY, (1813–1857)

On the Wing, ca. 1850
Oil on canvas, 32 x 45" (81.28 x 114.30 cm.)
Unsigned
Museum purchase
964-O-102

The Trapper's Last Shot
Steel engraving on paper, 19 x 23.5" (48.26 x 59.69 cm.)
Unsigned
Museum purchase, 1972
972-P-115

Nancy S. RANSON, (1905– ca. 1994)

Monhegan Fog
Oil on canvas, 24 x 30" (60.96 x 76.20 cm.)
Signed, Nancy Ranson, lower right
Gift of Nancy S. Ranson, 1977
977-O-124

Joseph RASKOB, (dates unknown)

Burlesque
Serigraph on paper, 21 x 17.5" (53.34 x 44.45 cm.)
Signed, Joseph Raskob, lower middle
Anonymous gift, 1971
971-P-112

George RATKAI, (1907–)

Thanksgiving Children, 1948
Oil on canvas, 40 x 74" (101.60 x 187.96 cm.)
Unsigned
Gift of George Ratkai, 1955
955-O-129

The Revelers
Watercolor on paper, 26 x 32" (66.04 x 81.28 cm.)
Signed, G. Ratkai, lower middle
Museum purchase, 1956
956-W-112

Abraham RATTNER, (1895–1978)

Figures in Flames, 1961
Oil on masonite, 51 x 38" (129.54 x 96.52 cm.)
Signed, Rattner, lower left
Museum purchase, 1969
969-O-153

Mother and Child
Pencil on paper, 16 x 9.5" (40.64 x 24.13 cm.)
Signed, Rattner, lower left
Museum purchase, 1959
959-D-124

Robert RAUSCHENBERG, (1925–)

The following six signed silkscreen silk collages on paper are the gift of Marc A. Wyse, 1983

Arcanum II, 1981
(71/85), 22.75 x 15.75" (57.79 x 40.01 cm.)
983-P-105

Arcanum IX, 1981
(74/85), 22.75 x 15.75" (57.79 x 40.01 cm.)
983-P-104

Arcanum V, 1981
(78/85), 22.5 x 15.5" (57.15 x 39.37 cm.)
983-P-102

Arcanum VI, 1981
(77/85), 22.75 x 15.75" (57.79 x 40.01 cm.)
983-P-103

Arcanum X, 1981
(74/85), 22.5 x 15.37" (57.15 x 39.05 cm.)
983-P-106

Arcanum XII, 1981
(77/85), 22.5 x 15.75" (57.15 x 40.01 cm.)
983-P-107

Centennial Certificate, Metropolitan Museum of Art, 1970
Lithograph on paper, (poster), 40.5 x 26" (102.87 x 66.04 cm.)
Signed, Rauschenberg, lower right
Gift of Eric C. Hulmer, 1981
981-P-167

Rays, 1973
Offset lithograph on paper, (68/95), 53 x 39" (134.62 x 99.06 cm.)
Signed, Rauschenberg, lower left
Gift of Marc A. Wyse, 1983
983-P-120

Support, 1973
Silkscreen on paper, 29.75 x 22" (75.57 x 55.88 cm.)
Signed, Rauschenberg, lower right
Gift of Dana Seman, 1980
980-P-113

(Untitled), 1973
Offset lithograph on paper, 12 x 9" (30.48 x 22.86 cm.)
Signed, Rauschenberg, lower left
Gift of Steven Feinstein, 1983
983-P-163

Man RAY, (1890–1977)

The following three signed lithographs on paper are the gift of Reese and Marilyn Arnold Palley, 1991

One (green)
(60/125I), 25.5 x 19.75" (64.77 x 50.17 cm.)
991-P-169

One (red)
(20/125 IV), 25.5 x 19.75" (64.77 x 50.17 cm.)
991-P-171

Woman with Hands
(47/100), 25.75 x 19" (65.41 x 48.26 cm.)
991-P-170

Omar RAYO, (active 20th century)

The New York Public Library
Print and embossing on paper, 30.5 x 22" (77.47 x 55.88 cm.)
Signed, Omar Rayo, lower left
Gift of American Federation of Art, 1967
967-P-157

T. Buchanan READ, (1822–1872)

General on a Horse
Oil on canvas, 14 x 11" (35.56 x 27.94 cm.)
Signed, T. Buchanan Read, lower right
Museum purchase, 1968
968-O-207

Daniel L. RECZEK, (active 20th century)

Pines, 1958
Watercolor collage on paper, 18 x 28" (45.72 x 71.12 cm.)
Signed, Reczek, 58, lower left
Museum purchase, 1961
961-W-113

Alex S. REDEIN, (1912–)

City View
Oil on canvas, 50 x 30" (127.00 x 76.20 cm.)
Unsigned
Gift of Samuel N. Tonkin and Sidney Freedman, 1955
955-O-130

Edward Willis REDFIELD, (1868–1965)

Laurel Run, 1916
Oil on canvas, 38 x 50" (96.52 x 127.00 cm.)
Signed, E. W. Redfield, lower right
Museum purchase, 1922
922-O-103

Catherine REDMOND, (active late 20th century)

Afternoon Light: Simultaneous and Sequential, 1987
Oil on canvas, 72 x 84" (182.88 x 213.36 cm.)
Signed, C. Redmond, lower right
Museum purchase, 1988
988-O-129

Allen C. REDWOOD, (1844–1922)

The following two signed drawings, ink and wash on paper, 7 x 5" (17.78 x 12.70 cm.), are the gift of Berry-Hill Galleries, Inc., 1967

Two Figures
967-D-109.a

Two Figures
967-D-109.b

David REED, (1946–)

(Untitled), 1982–85
Mixed media on canvas, 24 x 54" (60.96 x 137.16 cm.)
Signed, 214, David Reed, 1982-85, on reverse
Gift of Paul and Suzanne Donnelly Jenkins, 1991
991-O-223

Doel REED, (1894–1985)

Black Mesa
Casein on paper, 20.5 x 29" (52.07 x 73.66 cm.)
Signed, Doel Reed, lower right
Museum purchase, 1965
965-W-129

Ghosts, Cimarron River
Drawing on paper, 15 x 20" (38.10 x 50.80 cm.)
Signed, Doel Reed, lower right
Museum purchase, 1952
952-D-101

Winterscape
Lithograph on paper, 15 x 22.25" (38.10 x 56.52 cm.)
Signed, Doel Reed, lower right
Museum purchase, 1979
979-P-117

Woman with Landscape
Aquatint on paper, 10 x 17" (25.40 x 43.18 cm.)
Signed, Doel Reed, lower right
Museum purchase, 1952
952-P-110

Anton REFREGIER, (1905–1979)

Boy Drawing, 1948
Oil on canvas, 24 x 36" (60.96 x 91.44 cm.)
Signed, A. Refregier, 1948, upper right
Gift of Dr. Bernard Brodsky, 1960
960-O-124

Fence, 1949
Oil on canvas, 40.5 x 17.5" (102.87 x 44.45 cm.)
Signed, A. Refregier, 1949, upper right
Gift of Dr. Bernard Brodsky, 1958
958-O-158

(Untitled)
Watercolor on paper, 15 x 11" (38.10 x 27.94 cm.)
Signed, A. Refregier, lower right
Gift of Mr. and Mrs. L. Seliger, 1958
958-W-111

Boy with Mask
Lithograph on paper, 14.25 x 10" (36.20 x 25.40 cm.)
Signed, Anton Refregier, lower right
Museum purchase, 1968
968-P-250

Donald T. REGAN, (1920–)

Williamsburg
Oil on canvas, 24 x 30" (60.96 x 76.20 cm.)
Unsigned
Gift of Donald T. Regan, 1995
995-O-114

Sophy REGENSBURG, (1885–1974)

Black Eyed Susans
Casein on canvas, 14 x 12" (35.56 x 30.48 cm.)
Signed, Sophy Regensburg, lower right
Gift of Mary Regensburg Feist, 1987
987-W-114

Gustav REHBERGER, (1910–)

Jack Dempsey vs. Gene Tunney
Lithograph on paper, 15 x 20" (38.10 x 50.80 cm.)
Signed, Rehberger, lower right
Gift of Mr. and Mrs. Irwin Thomases, 1984
984-P-103

Noel REIFEL, (active late 20th century)

(Untitled)
Portfolio of 53: Rip Off on the Last Millennium
Print on paper, 8.5 x 14" (21.59 x 35.56 cm.)
Signed, Noel Reifel, lower right
Gift of the William Busta Gallery, 1990
990-P-111.34

Redfield - Laurel Run

Redmond - Afternoon Light: Simultaneous and Sequential

Redwood - Two Figures (967-D-109.a)

Refregier - Boy Drawing

Regan - Williamsburg

Rehberger - Jack Dempsey vs. Gene Tunney

Reindel - Field and Forest

Ad F. Reinhardt - Abstract Print

Remington - Quadra

Ribak - Old Boat

Addison T. Richards - Seascape

William Trost Richards - Lands End, Cornwall

Edna REINDEL, (1900–)

Field and Forest
Line etching on paper, 7 x 9" (17.78 x 22.86 cm.)
Signed, Reindel, lower right
Museum purchase, 1943
943-P-107

J. G. Butler
Etching on paper, 5.25 x 4.5" (13.34 x 11.43 cm.)
Signed, Reindel, lower right
Gift of Charles William Butler, II, 1992
992-P-115

Ad F. REINHARDT, (1913–1967)

Abstract Print
New York International: Portfolio of Ten Prints, (210/225)
Serigraph on plexiglass, 12.5 x 12" (31.75 x 30.48 cm.)
Signed, A.R., lower right
Museum purchase, 1966
966-P-137.6

Charles Stanley REINHART, (1844–1896)

Varnishing Day at the Academy, ca. 1873
Wood engraving on paper, 9 x 13.5" (22.86 x 34.29 cm.)
Unsigned
Anonymous gift, 1963
963-P-104

Philip REISMAN, (1904–1992)

Second Front Meeting, 1943
Watercolor on paper, 12 x 20.25" (30.48 x 51.44 cm.)
Signed, P. Reisman, 43, lower right
Gift of Louis Held, 1965
965-W-108

Pencil Seller, 1964
Wash on paper, 14 x 10" (35.56 x 25.40 cm.)
Signed, Philip Reisman, lower right
Gift of Louis Held, 1978
978-D-101

Deborah REMINGTON, (1935–)

Quadra, 1989
Lithograph on paper, 20 x 30" (50.80 x 76.20 cm.)
Signed, Remington, 1989, lower left
Gift of Ana and Eric Baer, 1991
991-P-205

Jim RENTZ, (active late 20th century)

The following two signed serigraphs on paper,
12 x 18" (30.48 x 45.72 cm.), are a museum
purchase, 1973

Quiet Night
973-P-139

White Picket Fence
973-P-140

Lili RETHI, (1939–)

World Trade Center
Lithograph on paper, 9.5 x 11" (24.13 x 27.94 cm.)
Signed, Rethi, lower right
Museum purchase, 1969
969-P-107

Grant REYNARD, (1887–1967)

Robert Frost
Lithograph on paper, 17.5 x 12.75" (44.45 x 32.39 cm.)
Signed, Grant Reynard, lower left
Museum purchase, 1979
979-P-110

Louis RIBAK, (1902–1980)

Old Boat
Oil on canvas, 12.75 x 22" (32.39 x 55.88 cm.)
Signed, Ribak, lower right
Gift of Mr. and Mrs. Nahum Tschacbasov, 1972
972-O-107

Jerri RICCI, (1916–)

A Side Street
Watercolor on paper, 19 x 27" (48.26 x 68.58 cm.)
Signed, Jerri Ricci, lower right
Museum purchase, 1953
953-W-108

Daniel RICE and **James B. CLARK**, (active
19th century)

Pee-Chee-Kir: A Chippeway Chief
Lithograph on paper, 21.5 x 15" (54.61 x 38.10 cm.)
Unsigned
Gift of Albert E. Hise, 1979
979-P-120

Harry A. RICH (active 20th century)

Tulips
Watercolor on paper, 9 x 13.5" (22.86 x 34.29 cm.)
Signed, Rich, lower right
Museum purchase, 1965
965-W-110

Addison T. RICHARDS, (1820–1900)

Seascape, 1889
Watercolor on paper, 16 x 29" (40.64 x 73.66 cm.)
Signed, T. Richards, lower left
Museum purchase, 1976
976-W-101

William Trost RICHARDS, (1833–1905)

Lands End, Cornwall, 1888
Oil on canvas, 62 x 50" (157.48 x 127.00 cm.)
Signed, Wm. T. Richards, lower left
Museum purchase, 1919
919-O-111

The following six signed oils on canvas are a gift
of the estate of Mrs. William T. Brewster, 1954

Conanicut Shore, ca. 1895
9 x 16" (22.86 x 40.64 cm.)
954-O-135

Icart Bay, Sark, ca. 1890
9 x 16" (22.86 x 40.64 cm.)
954-O-153

Icart Point, Guernsey, ca. 1890
9 x 16" (22.86 x 40.64 cm.)
954-O-155

Landscape, ca. 1855–60
10.5 x 15" (26.67 x 38.10 cm.)
954-O-156

Landscape, ca. 1855–60
11.5 x 12" (29.21 x 30.48 cm.)
954-O-157

Near Germantown, Pa., ca. 1860
12 x 12" (30.48 x 30.48 cm.)
954-O-136

The following three unsigned works are the gift of the estate of Mrs. William T. Brewster, 1954

Near Newport
Wash on paper, 8.5 x 13" (21.59 x 33.02 cm.)
954-D-102

Near Newport, R.I., ca. 1875–80
Watercolor on paper, 7 x 13.5" (17.78 x 34.29 cm.)
954-W-124

New Jersey Shore, ca. 1865
Drawing on paper, 8 x 13.5" (20.32 x 34.29 cm.)
954-D-108

The following three signed drawings, pencil on paper, are a gift of the estate of Mrs. William T. Brewster, 1954

Landscape Sketch, ca. 1865
9 x 14" (22.86 x 35.56 cm.)
954-D-105

Rocks
6.5 x 13" (16.51 x 33.02 cm.)
954-D-107

Seascape
8.5 x 13.5" (21.59 x 34.29 cm.)
954-D-106

Lance RICHBOURG, (active late 20th century)

Roberto Clemente, 1989
Oil on canvas, 64 x 48" (162.56 x 121.92 cm.)
Unsigned
Museum purchase, 1991
991-O-219

Celebration of 1974 World Series Victory in Oakland, 1986
Chalk, powder, pigments, glue, sequins, and watercolor on paper, 30.25 x 22" (76.84 x 55.88 cm.)
Signed, Lance Richbourg, lower right
Museum purchase, 1986
986-W-110

Dr. Louis Zona with Portrait of Roberto Clemente by Lance Richbourg, 1991
Watercolor on paper, 30 x 21" (76.20 x 53.34 cm.)
Signed, Lance Richbourg, 91, lower right
Museum purchase, 1991
991-W-101

Edward (Jeff) Pfeffer, 1988
Watercolor on paper, 66 x 52" (167.64 x 132.08 cm.)
Signed, Lance Richbourg, 1988, lower right
Museum purchase, 1989
989-W-102

Wallace "Bud" Smith vs. Joe Brown, August 24, 1956
Ink on paper, 30 x 23" (76.20 x 58.42 cm.)
Signed, Richbourg, lower right
Gift of Dr. and Mrs. Albert B. Cinelli, 1993
993-D-101

Lou Boudreau's Slide, 1993
Sepia drawing on paper, 26 x 18" (66.04 x 45.72 cm.)
Signed, Lance Richbourg, 1993, lower right
Gift of Lance Richbourg, 1994
994-D-103

James RICHTER, (active 20th century)

Woodland Fantasy, 1967
Casein on paper, 12 x 14.25" (30.48 x 36.20 cm.)
Signed, J. Richter, lower left
Gift of Louis Held, 1977
977-W-107

Robert RIGGS, (1896–1970)

Accident Ward
Lithograph on paper, 20 x 23.5" (50.80 x 59.69 cm.)
Signed, Robert Riggs, lower right
Gift of Dr. William H. Evans, 1975
975-P-124

Children's Ward
Lithograph on paper, 14.02 x 19" (35.62 x 48.26 cm.)
Signed, Robert Riggs, lower right
Gift of Capricorn Galleries, 1970
970-P-153

One Punch Knock Out
Lithograph on paper, 14.5 x 19.5" (36.83 x 49.53 cm.)
Signed, Robert Riggs, lower right
Museum purchase, 1953
953-P-103

The Pool
Lithograph on paper, 14.02 x 19.5" (35.62 x 49.53 cm.)
Signed, Robert Riggs, lower right
Gift of Capricorn Galleries, 1970
970-P-154

RIKON, (active 20th century)

The Struggle of Life, 1976
Oil on canvas, 12 x 8" (30.48 x 20.32 cm.)
Signed, Rikon, lower right
Gift of Louis Held, 1977
977-O-151

Art RILEY, (1911–)

Copper Country, 1962
Watercolor on paper, 22 x 30" (55.88 x 76.20 cm.)
Signed, Art Riley, lower right
Museum purchase, 1963
963-W-104

Bridgit RILEY, (active 20th century)

(Untitled)
Lithograph on paper, 49 x 32" (124.46 x 81.28 cm.)
Signed, B. Riley, lower right
Gift of Ana and Eric Baer, 1991
991-P-198

Anthony RIPPORTELLA, (active 20th century)

Still Life with Lemons
Oil on canvas, 24 x 20" (60.96 x 50.80 cm.)
Unsigned
Gift of Leonard Bocour, 1975
975-O-114

William Trost Richards - Near Newport

Richbourg - Celebration of 1974 World Series Victory in Oakland

Richbourg - Edward (Jeff) Pfeffer

Riggs - One Punch Knockout

Art Riley - Copper Country

Alexander Hay Ritchie - First Blow for Liberty

Ritman - Jullien

Rittenberg - Caroline Augusta

Rivers - Garbage

Rivers - Last Civil War Veteran

Luigi RIST, (1888–1960)

Pears
Lithograph on paper, 9.02 x 7.02" (22.92 x 17.84 cm.)
Signed, Luigi Rist, lower right
Museum purchase, 1970
970-P-169

Peperone
Woodblock on paper, 10 x 13" (25.40 x 33.02 cm.)
Signed, Luigi Rist, lower right
Museum purchase, 1955
955-P-108

Strawflowers
Color block print on paper, 10 x 14" (25.40 x 35.56 cm.)
Signed, Luigi Rist, lower right
Museum purchase, 1965
965-P-203

The following two color silkscreens on paper are
a museum purchase, 1956

Fish and Mushroom
10 x 14" (25.40 x 35.56 cm.)
956-P-108

Potato Shoots
10 x 7.5" (25.40 x 19.05 cm.)
956-P-107

Alexander Hay RITCHIE, (1822–1895)

First Blow for Liberty
Steel engraving on paper, 27.75 x 35.75" (70.49 x 90.81 cm.)
Unsigned
Museum purchase, 1975
975-P-118

Charles RITCHIE, (active late 20th century)

Daffodils with Astronomical Chart, 1995
Watercolor on paper, 5.25 x 5.5" (13.34 x 13.97 cm.)
Unsigned
Museum purchase, 1995
995-W-105

Louis RITMAN, (1898–1963)

Jullien
Oil on canvas, 56.5 x 52" (143.51 x 132.08 cm.)
Signed, Ritman, lower left
Gift of the estate of Louis Ritman, 1973
973-O-113

Henry R. RITTENBERG, (1879–1969)

Caroline Augusta, 1918
Oil on canvas, 59.5 x 38" (151.13 x 96.52 cm.)
Signed, Rittenberg, upper left
Museum purchase, 1918
918-O-109

Larry RIVERS, (1923–)

Garbage, 1974
Oil and airbrush on canvas, 90 x 90" (228.60 x 228.60 cm.)
Signed, Larry Rivers, lower left
Gift of Professor and Mrs. Sam Hunter, 1988
988-O-130

Last Civil War Veteran, 1970
Silkscreen and collage on paper, 28.75 x 19.75" (73.03 x 50.17 cm.)
Signed, Rivers, lower right
Museum purchase, 1971
971-P-103

Living at the Movies, 1970
Photolithograph on paper, 24.5 x 35" (62.23 x 88.90 cm.)
Signed, Rivers, lower right
Gift of Dana Seman, 1980
980-P-111

The Bird and the Circle, 1957
Hand colored lithograph on paper, (15, 2-2-III), 13 x 17"
(33.02 x 43.18 cm.)
Signed, Rivers, 57, lower right
Gift of Louis Held, 1965
965-P-181

(Untitled), 1973
Lithograph on paper, 9 x 12" (22.86 x 30.48 cm.)
Signed, Rivers, lower right
Gift of Steven Feinstein, 1983
983-P-164

Donald ROBERTS, (1923–)

Trochlea, May 1961
Oil on canvas, 35 x 42" (88.90 x 106.68 cm.)
Unsigned
Museum purchase, 1961
961-O-123

Priscilla W. ROBERTS, (1916–)

Dance Program
Oil on panel, 12.5 x 13.5" (31.75 x 34.29 cm.)
Signed, P. Roberts, lower right
Gift of Dr. John J. McDonough, 1966
966-O-133

Richard ROBERTS, (1925–)

Ohio Evening
Watercolor on paper, 18 x 25" (45.72 x 63.50 cm.)
Unsigned
Museum purchase, 1954
954-W-118

Linda ROBERTSON, (active 20th century)

Summer–1957, 1957
Oil on canvas, 62 x 40" (157.48 x 101.60 cm.)
Signed, L. Robertson, lower left
Museum purchase, 1958
958-O-123

Red ROBIN, (1913–)

Arabs, 1940
Watercolor on paper, 4 x 5" (10.16 x 12.70 cm.)
Signed, Red Robin, lower left
Gift of Louis Held, 1965
965-W-125

Boardman ROBINSON, (1876–1952)

Society Dame
Watercolor on paper, 10 x 7.5" (25.40 x 19.05 cm.)
Signed, Boardman Robinson, lower right
Gift of Louis Held, 1965
965-W-117

Horse Auction
Lithograph on paper, 8 x 11.75" (20.32 x 29.85 cm.)
Signed, Boardman Robinson, lower right
Museum purchase, 1967
967-P-111

The Brothers Karamazov
Ink wash on paper, 14 x 12" (35.56 x 30.48 cm.)
Signed, Boardman Robinson, lower right
Gift of George Vander Sluis, 1963
963-D-102

Theodore ROBINSON, (1852–1896)

Watching the Cows, 1892
Oil on canvas, 16 x 26" (40.64 x 66.04 cm.)
Signed, Th. Robinson, 1892, lower left
Museum purchase, 1961
961-O-132

View of Segovia
Watercolor on paper, 14 x 17" (35.56 x 43.18 cm.)
Signed, Th. Robinson, lower left
Museum purchase, 1965
965-W-145

George RODRIQUE, (1944–)

The Cajun Beauty
Oil on canvas, 36 x 24" (91.44 x 60.96 cm.)
Signed, Rodrique, lower left
Gift of Lynne M. Kortenhaus, 1976
976-O-135

Severin ROESEN, (active 1848–1871)

Still Life with Strawberries
Oil on canvas, 21.12 x 29.87" (53.66 x 75.88 cm.)
Unsigned
Museum purchase, 1993
993-O-119

Charles B. ROGERS, (1911–)

Wild Fowl at Sundown
Lithograph on paper, 7 x 9.75" (17.78 x 24.77 cm.)
Signed, Charles B. Rogers, lower right
Gift of Mr. and Mrs. Edward E. Ford, 1971
971-P-107

Jane ROGERS, (1896– ?)

Brothers, 1940
Oil on canvas, 40 x 34" (101.60 x 86.36 cm.)
Signed, Jane Rogers, 1940, lower right
Gift of Jane Rogers, 1969
969-O-159

The following five lithographs on paper of various sizes are the gift of Louis Held, 1967, 1974

Doorway, 1931
967-P-117

Jesse Owens
974-P-111.f

Nude
974-P-111.b

Portrait of M. Robert Rogers
974-P-111.c

Woman Reading
974-P-111.e

The following two etchings on paper of different sizes are the gift of Louis Held, 1974

Kroll Family Portrait
974-P-111.a

Woods
974-P-111.d

Arsen ROJE, (active late 20th century)

To Have and Have Not
Oil on canvas, 63 x 75.5" (160.02 x 191.77 cm.)
Unsigned
Museum purchase, 1994
994-O-108

Shirley ROMAN, (active 20th century)

Restless Tide
Etching on paper, 17.75 x 27.75" (45.09 x 70.49 cm.)
Signed, Shirley Roman, lower right
Gift of Lauri Roman Barnfeld, 1978
978-P-115

Emanuel ROMANO, (1897– ?)

The following two signed oils on canvas are the gift of P. Weber, 1961

Child
30 x 25" (76.20 x 63.50 cm.)
961-O-140

Girl in Blue Chair
59 x 40" (149.86 x 101.60 cm.)
961-O-141

Umberto ROMANO, (1906–1983)

Chanson D'Amour
Color lithograph on paper, (14/100), 19.5 x 26.75" (49.53 x 67.95 cm.)
Signed, Umberto Romano, lower right
Museum purchase, 1967
967-P-161

Roman Warriors
Lithograph on paper, 10 x 14" (25.40 x 35.56 cm.)
Signed, Umberto Romano, lower right
Museum purchase, 1965
965-P-261

Frederick RONDEL, (1826–1892)

The Picnic, ca. 1864–66
Oil on canvas, 19.5 x 34" (49.53 x 86.36 cm.)
Signed, F. Rondel, lower left
Museum purchase, 1965
965-O-167

Charles ROSEN, (1878–1950)

Winter Sunlight, 1917
Oil on canvas, 42 x 52" (106.88 x 132.08 cm.)
Signed, Charles Rosen, lower right
Museum purchase, 1920
920-O-111

Samuel ROSENBERG, (1896–1972)

The Patriarch, 1947
Oil on canvas, 24 x 20" (60.96 x 50.80 cm.)
Unsigned
Museum purchase, 1948
948-O-125

Theodore Robinson - Watching the Cows

Theodore Robinson - View of Segovia

Roesen - Still Life with Strawberries

Roje - To Have and Have Not

Rondel - The Picnic

Rosenquist - Gold Trash Can

Rosenquist - Horizontal Bar

James M. Ross - Uncompleted Bridge

Ruellan - Fatherhood (page 149)

Ralph ROSENBORG, (1910–)

American Landscape: Two Blue Trees, 1972, 1972
Oil on canvas, 20 x 30" (50.80 x 76.20 cm.)
Signed, Rosenborg, lower right
Gift of Ralph Rosenborg, 1979
979-O-115

James ROSENQUIST, (1933–)

Gold Trash Can, 1977
Lithograph on paper, 21 x 14.25" (53.34 x 36.20 cm.)
Signed, Rosenquist, 77, lower right
Anonymous gift, 1988
988-P-107

Horizontal Bar, 1973
Lithograph on paper, 22 x 30" (55.88 x 76.20 cm.)
Signed, Rosenquist, lower right
Gift of Dana Seman, 1980
980-P-109

(Untitled)
Serigraph on paper, 9 x 12" (22.86 x 30.48 cm.)
Signed, Rosenquist, lower center
Gift of Steven Feinstein, 1983
983-P-165

Somewhere to Light
New York International: Portfolio of Ten Prints, (210/225)
Serigraph on paper, 17 x 22" (43.18 x 55.88 cm.)
Signed, James Rosenquist, lower right
Museum purchase, 1966
966-P-137.9

Doris Kay ROSENTHAL, (ca. 1900–1971)

Back Stage–Brownsville
Oil on canvas, 24 x 30" (60.96 x 76.20 cm.)
Unsigned
Gift of the estate of Doris Kay Rosenthal, 1976
976-O-110

Permanentes
Oil on canvas, 24 x 32" (60.96 x 81.28 cm.)
Signed, Doris Rosenthal, lower left
Gift of the estate of Doris Kay Rosenthal, 1976
976-O-111

Finca San Juan
Watercolor on paper, 20 x 14 .5" (50.80 x 36.83 cm.)
Signed, Doris Kay Rosenthal, lower right
Museum purchase, 1951
951-W-106

Martin ROSENTHAL, (1899–1974)

Buildings, 1971
Watercolor on paper, 12.25 x 30" (31.12 x 76.20 cm.)
Signed, Martin Rosenthal, 71, upper right
Gift of Rosalind Leonard, 1975
975-W-101

Seymour ROSENTHAL, (1921–)

Candle Vendor
Lithograph on paper, 17 x 13" (43.18 x 33.02 cm.)
Signed, Seymour Rosenthal, lower right
Museum purchase, 1971
971-P-123

Charles ROSS, (active late 20th century)

Solar Burn Sign of Gemini, 1979
Painted boards, 49 x 63" (124.46 x 160.02 cm.)
Unsigned
Gift of Alan Sonfist, The Alliance for Environmental Art and Architecture, 1992
992-O-108

James M. ROSS, (1931–)

Uncompleted Bridge, 1954
Watercolor on paper, 20 x 28" (50.80 x 71.12 cm.)
Signed, Ross, 54, lower right
Museum purchase, 1955
955-W-113

John ROSS, (1921–)

Ascent, 1966
Color lithograph on paper, (53/100), 17.5 x 12.5" (44.45 x 31.75 cm.)
Signed, John Ross, lower right
Museum purchase, 1966
966-P-150

Michael ROSS, (active 20th century)

Parallel Lines Never Meet
Casein on paper, 18 x 23.5" (45.72 x 59.69 cm.)
Signed, Ross, lower right
Gift of Harold M. Levy Gallery, 1968
968-W-136

Ernest D. ROTH, (1879–1964)

Campo San Boldo, 1924
Etching on paper, 9.25 x 10.5" (23.50 x 26.67 cm.)
Signed, Ernest D. Roth, 1924, lower middle
Museum purchase, 1967
967-P-178

Anna Fell ROTHSTEIN, (1890– ?)

The following two signed oils on canvas are the gift of Anna Fell Rothstein, 1968, 1957

Black Spider Woman
26 x 37.5" (66.04 x 95.25 cm.)
968-O-158

Masks
32 x 43" (81.28 x 109.22 cm.)
957-O-127

Betty RUBENSTEIN, (active 20th century)

Isadora Returns, 1960
Drawing on paper, 19.5 x 13.5" (49.53 x 34.29 cm.)
Signed, B. Rubenstein, lower right
Gift of Betty Rubenstein, 1970
970-P-122

Lewis RUBENSTEIN, (1908–)

Sea Gleaners, 1966
Lithograph on paper, (50/250), 10 x 14" (25.40 x 35.56 cm.)
Signed, Lewis Rubenstein, lower right
Museum purchase, 1966
966-P-134

Ronald L. RUBLE, (1935–)

I Rode a White Horse, 1974
Lithograph on paper, 19.75 x 26.5" (50.17 x 67.31 cm.)
Signed, Ruble, lower right
Gift of John Baglama, 1980
980-P-145

Of Mountains and Elephants, 1974
Etching on paper, 22.25 x 15.75" (56.52 x 40.01 cm.)
Signed, Ruble, lower right
Gift of Frank Marzano, 1980
980-P-162

Andrée RUELLAN, (1905–)

Fatherhood
Pencil on paper, 9 x 10" (22.86 x 25.40 cm.)
Signed, Andrée Ruellan, lower right
Gift of Louis Held, 1967
967-D-102

On the Quai, Arles
Drawing on paper, 14.5 x 20.5" (36.83 x 52.07 cm.)
Unsigned
Museum purchase, 1959
959-D-108

Duet
Lithograph on paper, 8 x 11.5" (20.32 x 29.21 cm.)
Signed, Andrée Ruellan, lower right
Museum purchase, 1967
967-P-133

Andrew RUSH, (1931–)

Idyll Settimello
Dry point on paper, 8.75 x 10.87" (22.23 x 27.62 cm.)
Signed, Andrew Rush, lower right
Gift of Associated American Artists, 1968
968-P-239

Eugene N. RUTKOWSKI, (1936–)

Melchizedek, 1970
Drawing on paper, 23.25 x 29.75" (59.06 x 75.57 cm.)
Signed, Rutkowski, 70, lower left
Gift of the Polish Arts Club, 1971
971-D-103

Albert P. RYDER, (1847–1917)

Roadside Meeting, 1901
Oil on canvas, 15 x 12" (38.10 x 30.48 cm.)
Signed, A. P. Ryder, lower right
Museum purchase, 1917
917-O-106

Chauncey F. RYDER, (1868–1949)

Lincoln Mountain Road
Oil on canvas, 28 x 36" (71.12 x 91.44 cm.)
Signed, Chauncey F. Ryder, lower right
Gift of Fanniebelle Trippe, 1954
954-O-137

The Path Down the Mountains, 1912
Oil on canvas, 31.5 x 39.5" (80.01 x 100.33 cm.)
Signed, Chauncey F. Ryder, lower right
Museum purchase, 1918
918-O-110

Robert SABO, (1949–)

Barbra
Oil on canvas, 36 x 48" (91.44 x 121.92 cm.)
Unsigned
Museum purchase, 1966
966-O-131

John, 1971
Oil on canvas, 30 x 30" (76.20 x 76.20 cm.)
Unsigned
Museum purchase, 1971
971-O-116

Soul Poster, 1967
Oil on canvas, 72 x 52" (182.88 x 132.08 cm.)
Unsigned
Museum purchase, 1967
967-O-133

Donald SAFF, (1937–)

Urbino Notte, 1966
Etching on paper, (96/210), 19.5 x 18" (49.53 x 45.72 cm.)
Signed, Saff, 66, lower right
Museum purchase, 1967
967-P-180

SAHLIN, (1885– ?)

The following two watercolors on paper are the
gift of Mr. and Mrs. Gordon King, 1964, 1965

Indians—Silvia, Columbia
18.25 x 13.75" (46.36 x 34.93 cm.)
964-W-110

Temuca, Honduras
17.5 x 14.5" (44.45 x 36.83 cm.)
965-W-140

Samuel SALKO, (1888–)

Old and Destitute
Drawing on paper, 11.5 x 7" (29.21 x 17.78 cm.)
Signed, S. Salko, lower left
Museum purchase, 1952
952-D-102

Mary Ellen May SALO, (active late 20th
century)

The following two signed prints on paper, 8.5 x
11" (21.59 x 27.94 cm.), are the gift of the
William Busta Gallery, 1990

(Untitled), (2)
Portfolio of 53: Rip Off on the Last Millennium
990-P-111.25 and 990-P-111.44

Anthony J. SALVATORE, (1938–1994)

The following two signed pastels on canvas
board, 20 x 16" (50.80 x 40.64 cm.), are the gift
of Eleanor Beecher Flad, 1991

Habakkuk 2: 1-4
991-D-131

Habakkuk 2: 4, 5
991-D-130

Albert P. Ryder - Roadside Meeting

Chauncey F. Ryder - Lincoln Mountain Road

Sabo - John

Saff - Urbino Notte

Salvatore - Habakkuk 2: 1-4 (page 149)

Sample - Port-au-Prince, Market Place

Sample - The Milk Sledge

Sargent - Mrs. Knowles and Her Children

Sargent - Mermaid Study

The Butler Institute's collection includes six signed drawings on paper, 17 x 14" (43.18 x 35.56 cm.), which are the gift of James Jeswald, 1995
995-D-107 — 995-D-112

Paul SAMPLE, (1896–1974)

Port-au-Prince, Market Place
Oil on canvas, 30 x 40" (76.20 x 101.60 cm.)
Signed, Paul Sample, lower right
Museum purchase, 1963
963-O-129

The Milk Sledge, 1938
Watercolor on paper, 14.5 x 22" (36.83 x 55.88 cm.)
Signed, Paul Sample, lower right
Museum purchase, 1939
939-W-102

The Slope Near the Bridge
Lithograph on paper, 8.87 x 12.87" (22.54 x 32.70 cm.)
Signed, Paul Sample, lower left
Gift of Mr. and Mrs. Edward E. Ford, 1968
970-P-115

Paul F. SAMUELSON, (1924–)

Mansion Doorway, 1948
Watercolor on paper, 29 x 21" (73.66 x 53.34 cm.)
Signed, Paul Samuelson, 1948, lower left
Museum purchase, 1949
949-W-102

Alice SANDS, (1914–)

Cabaret, 1968
Oil on canvas, 36 x 38" (91.44 x 96.52 cm.)
Signed, Sands, lower right
Museum purchase, 1968
968-O-188

Gillian SANLANDS, (1906–)

Night–Manhattan, 1962
Etching on paper, (4/10), 13 x 18" (33.02 x 45.72 cm.)
Signed, Sanlands, 62, lower right
Museum purchase, 1965
965-P-257

John Singer SARGENT, (1859–1925)

Mrs. Knowles and Her Children, 1902
Oil on canvas, 72 x 59.5" (182.88 x 151.13 cm.)
Signed, John S. Sargent, upper right
Museum purchase, 1929
929-O-104

Mermaid Study
Drawing on paper, 8 x 12" (20.32 x 30.48 cm.)
Signed, John Sargent, lower right
Museum purchase, 1949
949-D-101

Paul SARKISIAN, (1928–)

Ancient Facade
Oil on canvas, 58 x 30" (147.32 x 76.20 cm.)
Signed, Sarkisian, lower left
Museum purchase, 1959
959-O-114

(Untitled)
Offset lithograph on paper, 34 x 24" (86.36 x 60.96 cm.)
Unsigned
Gift of Samuel S. Mandel, 1986
986-P-168

Sarkis SARKISIAN, (1909–1977)

Archaic Rock, 1953
Watercolor on paper, 26 x 39" (66.04 x 99.06 cm.)
Signed, Sarkis, 53, lower right
Museum purchase, 1955
955-W-114

Robert SARSONY, (1938–)

Color from Autumn, 1971
Oil on canvas, 20 x 40" (50.80 x 101.60 cm.)
Signed, Robert Sarsony, lower right
Gift of Robert Sarsony and Capricorn Galleries, 1972
972-O-104

John SARTAIN, (1808–1897)

Irene
Steel engraving on paper, 20 x 24" (50.80 x 60.96 cm.)
Signed, John Sartain, lower right
Gift of Patrick Vacaro, 1971
971-P-135

Conwell SAVAGE, (1907–)

Dunes
Ink on paper, 5.75 x 7.75" (14.61 x 19.69 cm.)
Signed, Conwell Savage, lower right
Gift of Louis Held, 1978
978-P-105

Elizabeth B. SAVAGE, (active late 20th century)

Dunes Under the Sun
Watercolor on paper, 12.5 x 8.75" (31.75 x 22.23 cm.)
Signed, E. B. Savage, lower left
Gift of Conwell Savage, 1978
978-W-102

W. Lee SAVAGE, (1928–)

Girl with Her Arm Up
Oil on canvas, 36 x 30" (91.44 x 76.20 cm.)
Signed, W. L. S., lower right
Museum purchase, 1962
962-O-126

Angelo SAVELLI, (1911–)

Above, 1965
Lithograph on paper, 19.5 x 30.5" (49.53 x 77.47 cm.)
Signed, Savelli, lower right
Gift of Associated American Artists, 1968
968-P-236

Italo SCANGA, (active late 20th century)

Figs, 1991
Color photo lithograph on paper, 29 x 22.5" (73.66 x 57.15 cm.)
Signed, Italo Scanga, 1991, lower right
Museum purchase, 1992
992-P-126

Henri-Bella SCHAEFER, (1908–)

Pineapples
Oil on canvas, 17 x 22" (43.18 x 55.88 cm.)
Signed, Bella Schaefer, lower left
Gift of Louis Held, 1965
965-O-116

Alice Pauline SCHAFER, (1899–1980)

Going to St. Ives
Woodblock on paper, (8/40), 14 x 18.5" (35.56 x 46.99 cm.)
Signed, Alice Pauline Schafer, lower right
Museum purchase, 1967
967-P-192

Cecil SCHAPIRO, (active late 20th century)

Red, White, and Blue
Watercolor on paper, 20.62 x 18.62" (52.39 x 47.31 cm.)
Signed, Cecil Schapiro, lower left
Gift of Cecil Schapiro in memory of Rebecca Hornstein
Schapiro, 1968
968-W-142

Anthony Joseph SCHEPIS, (1927–)

Closures/blue-green, 1974
Oil on canvas, 58 x 58" (147.32 x 147.32 cm.)
Signed, Anthony Schepis, 74, lower right
Museum purchase, 1974
974-O-113

Nancy SCHERMER, (1931–)

Norvig, 1966
Watercolor collage on paper, 16 x 7.5" (40.64 x 19.05 cm.)
Unsigned
Museum purchase, 1966
966-W-114

Harry SCHEUCH, (1907–)

Cheap Lumber, 1940
Oil on canvas, 24 x 33" (60.96 x 83.82 cm.)
Signed, H. Scheuch, 1940, lower right
Museum purchase, 1942
942-O-101

Point Breeze, Pittsburgh, 1952
Oil on canvas, 30 x 40" (76.20 x 101.60 cm.)
Unsigned
Gift of Joseph G. Butler, III, 1954
954-O-138

Carl SCHMITT, (1889– ca. 1970)

Lanterman Falls
Oil on canvas, 25 x 30" (63.50 x 76.20 cm.)
Unsigned
Museum purchase, 1921
921-O-109

Portrait of H. K. Wick, 1917
Oil on canvas, 28 x 23" (71.12 x 58.42 cm.)
Unsigned
Gift of Mrs. H. K. Wick, 1917
934-O-101

The Hermit
Oil on canvas, 20 x 16" (50.80 x 40.64 cm.)
Signed, Carl Schmitt, lower left
Gift of Mrs. Griswold Hurlbert, 1973
973-O-110

Portrait of James W. Porter, 1909
Oil on canvas, 4.87 x 4.62" (12.38 x 11.75 cm.)
Signed, C. S., Dec., 1909, right center
Gift of Marian Roller Chilson, 1988
988-O-121

The following three unsigned oils on canvas or
board are the gift of the estate of Lorena Coale,
1986

Portrait Study
14.5 x 10.12" (36.83 x 25.72 cm.)
986-O-105

Victory Day, 1952
20 x 24" (50.80 x 60.96 cm.)
986-O-106

Victory Day, 1952
20 x 26" (50.80 x 66.04 cm.)
986-O-107

The following four signed watercolors on paper,
board, or wood panel are the gift of the estate of
Lorena Coale, 1986

Dutch Peasant on Sandy Beach, 1906
8 x 6" (20.32 x 15.24 cm.)
986-W-108

Head of Man, 1906
8.5 x 6.5" (21.59 x 16.51 cm.)
986-W-105

Profile of a Monk
7 x 5" oval (17.78 x 12.70 cm.)
986-W-107

Profile of Old Man
10 x 5" oval (25.40 x 12.70 cm.)
986-W-106

Warren, Ohio, 1913
Pastel on paper, 10.25 x 7.25" (26.04 x 18.42 cm.)
Signed, Schmitt, upper left
Gift of the estate of Almira A. Wick, 1981
981-D-103

Julian SCHNABEL, (1951–)

The Ball of Wax Gets Religion
Oil on paper, 50 x 38" (127.00 x 96.52 cm.)
Signed, Julian Schnabel, lower left
Museum purchase, 1985
985-O-107

Jo Anne SCHNEIDER, (1919–)

Lobster
Oil on canvas, 30 x 40" (76.20 x 101.60 cm.)
Signed, Jo Anne Schneider, lower left
Gift of Jo Anne Schneider and the Students Assistance Fund,
1955
955-O-132

Moment of Glory
Oil on canvas, 22 x 28" (55.88 x 71.12 cm.)
Signed, Jo Anne Schneider, lower right
Gift of Peter Corn, 1961
961-O-105

Paul Sarkisian - Ancient Facade (page 150)

Savelli - Above (page 150)

Scanga - Figs (page 150)

Schmitt - The Hermit

Schnabel - The Ball of Wax Gets Religion

Schneider - Home Run Queen

Schonzeit - Three Inch Brush

Schrag - Autumn Sky with White Cloud

Schreckengost - Blackout

John White Allen Scott - View of Conway Valley, New Hampshire

L. E. SCHNEIDER, (active late 20th century)

Home Run Queen
Ink on paper, 19 x 13.5" (48.26 x 34.29 cm.)
Signed, L. E. Schneider lower right
Gift of Mr. and Mrs. Joseph Erdelac, 1990
990-D-101

William SCHOCK, (1913–1976)

Carousel
Pencil on paper, 19 x 24" (48.26 x 60.96 cm.)
Signed, Schock, lower left
Anonymous gift, 1973
973-D-104

Lisa SCHONBERG, (active late 20th century)

(Untitled)
Portfolio of 53: Rip Off on the Last Millennium
Print on paper, 8.5 x 11" (21.59 x 27.94 cm.)
Signed, L. Schonberg, lower right
Gift of the William Busta Gallery, 1990
990-P-111.47

Benjamin SCHONZEIT, (1942–)

Three Inch Brush, 1981
Oil on linen, 60 x 48" (152.40 x 121.92 cm.)
Unsigned
Gift of James Uffeiman, 1994
994-O-122

Justin SCHORR, (1928–)

The Audience
Oil on canvas, 50.5 x 72" (128.27 x 182.88 cm.)
Unsigned
Gift of Justin Schorr, 1972
972-O-111

Karl SCHRAG, (1912–)

Autumn Sky with White Cloud
Watercolor on paper, 22 x 26" (55.88 x 66.04 cm.)
Signed, Karl Schrag, lower right
Museum purchase, 1970
970-W-107

Windswept Coast
Etching on paper, 21.5 x 27.5" (54.61 x 69.85 cm.)
Signed, Karl Schrag, lower right
Museum purchase, 1959
959-P-104

Viktor SCHRECKENGOST, (1906–)

Blackout
Watercolor on paper, 21 x 29.5" (53.34 x 74.93 cm.)
Signed, Viktor Schreckengost, lower right
Gift of Viktor Schreckengost, 1966
966-W-112

George SCHREIBER, (1904–1977)

Tide, 1966
Oil on canvas, 12 x 14" (30.48 x 35.56 cm.)
Signed, Schreiber, lower right
Gift of Lewis M. Helm, 1976
976-O-144

Equilibrium
Lithograph on paper, 13.5 x 9.5" (34.29 x 24.13 cm.)
Signed, Schreiber, lower right
Museum purchase, 1967
967-P-108

Albert SCHRODER, (1929–)

Victoriana
Oil on panel, 10 x 18" (25.40 x 45.72 cm.)
Signed, A. Schroder, lower right
Museum purchase, 1967
967-O-149

George SCHWACHA, (1908–1986)

Market Place
Oil on canvas, 24 x 36" (60.96 x 91.44 cm.)
Signed, Geo. Schwacha, lower left
Museum purchase, 1955
955-O-133

Aubrey E. SCHWARTZ, (1928–)

Albert Pinkham Ryder
Lithograph on paper, 16.75 x 14.5" (42.55 x 36.83 cm.)
Signed, Aubrey Schwartz, lower right
Museum purchase, 1971
971-P-132

The following two signed etchings on paper, 15
x 12" (38.10 x 30.48 cm.), are a museum
purchase, 1963, 1965

Elm, 1963
963-P-147

Elm
965-P-293

Joseph SCHWARZ, (active late 20th century)

Mourning the Child
Oil on canvas, 40 x 28" (101.60 x 71.12 cm.)
Unsigned
Museum purchase, 1955
955-O-134

H. Winfield SCOTT, (1910–)

Western Scene–Illustration
Oil on canvas, 20 x 42" (50.80 x 106.68 cm.)
Signed, H. W. Scott, lower right
Gift of Mr. and Mrs. Joseph P. Sontich, 1982
982-O-110

John White Allen SCOTT, (1815–1907)

View of Conway Valley, New Hampshire, ca. 1865
Oil on canvas, 30 x 50" (76.20 x 127.00 cm.)
Unsigned
Museum purchase, 1968
968-O-155

Michael L. SCOTT, (1952–)

Dying Giants
Oil on linen, 66.5 x 70.25" (168.91 x 178.44 cm.)
Signed, Michael Scott, lower right
Gift of Margaret Minster, 1992
992-O-101

Jonathan A. SCOVILLE, III, (1937–)

Clouds, 1974
Oil on masonite, 18 x 23.75" (45.72 x 60.33 cm.)
Signed, Jonathan A. Scoville, III, 1974, lower right
Gift of Leonard Bocour, 1976
976-O-120

Peter SCULTHORPE, (active late 20th century)

Draft Horse
Lithograph on paper, 7.5 x 6" (19.05 x 15.24 cm.)
Signed, P. Sculthorpe, lower right
Museum purchase, 1995
995-P-103

Hive House
Color lithograph on paper, (3/14), 6.87 x 5" (17.46 x 12.70 cm.)
Signed, P. Sculthorpe, lower right
Gift of Ron Jaworski, 1993
993-P-162

Seldomridge Farm
Lithograph on paper, 7 x 16.75" (17.78 x 42.55 cm.)
Signed, P. Sculthorpe, lower right
Museum purchase, 1995
995-P-104

Dorothy R. SEDER, (active 20th century)

Founding Fathers
Watercolor on paper, 12 x 16" (30.48 x 40.64 cm.)
Signed, Dorothy Seder, lower right
Museum purchase, 1947
947-W-107

George SEGAL, (1924–)

Remembrance of Marcel, 1973
Offset lithograph on paper, 7 x 7" (17.78 x 17.78 cm.)
Signed, G. Segal, lower right
Gift of Steven Feinstein, 1983
983-P-166

Richard SEGALMAN, (active late 20th century)

Late Afternoon, 1990
Pastel on paper, 22 x 30" (55.88 x 76.20 cm.)
Signed, Segalman, lower right
Gift of Richard Segalman, 1991
991-D-101

Nobuo SEKINE, (active late 20th century)

(Untitled), 1988
Mixed media on paper, 31.62 x 25.62" (80.33 x 65.09 cm.)
Unsigned
Gift of Professor Sam Hunter, 1990
990-W-104

Dixie SELDEN, (1868–1935)

Cityscape
Oil on canvas, 22.5 x 28.5" (57.15 x 72.39 cm.)
Signed, Selden, lower right
Gift of Mrs. William V. Miller, 1961
961-O-145

Ruth SELWITZ, (active 20th century)

Leslie and Bunny, 1964
Oil on canvas, 42 x 57" (106.68 x 144.78 cm.)
Unsigned
Museum purchase, 1964
964-O-107

John SEMON, (1852–1917)

Late Summer Landscape
Oil on canvas, 24 x 36" (60.96 x 91.44 cm.)
Signed, J. Semon, lower right
Gift of E. J. Petrequin, 1981
981-O-116

Zoltan SEPESHY, (1898–1974)

Up North in Michigan
Watercolor on paper, 15 x 19" (38.10 x 48.26 cm.)
Signed, Sepeshy, lower right
Museum purchase, 1941
941-W-109

Julianne SERAPHINE, (active late 20th century)

The following two signed etchings on paper, 26 x 19.87" (66.04 x 50.48 cm.), are the gift of Samuel S. Mandel, 1986

Asturius No. 1
986-P-162

Asturius No. 2
986-P-163

Frederick SERGER, (1889–1965)

The following thirteen oils on canvas of various sizes are an anonymous gift, 1955

Artist and Model
955-O-135

Bread, Fruit and Wine
955-O-149

Good Earth
955-O-161

Idle Hour
955-O-158

Kitchen Table
955-O-152

Peasant Bride
955-O-157

Pinecone and White Mountains
955-O-154

Pink Fan
955-O-156

Red Gladiolas
955-O-162

Still Life in Red and Green
955-O-153

Sunflowers
955-O-159

Tomato Plant
955-O-155

Woman in White
955-O-151

Sculthorpe - Hive House

Segal - Remembrance of Marcel

Selden - Cityscape

Semon - Late Summer Landscape

Serra - (Untitled)

Shahn - Inside Looking Out

Shahn - Our House in Skowhegan, 1967

Shahn - Man

Shahn - Gandhi

Shahn - Four and a Half Men

Richard SERRA, (1939–)

(Untitled)
Lithograph on paper, 9.56 x 9.12" (24.28 x 23.18 cm.)
Signed, Serra, lower right
Gift of Steven Feinstein, 1983
983-P-167

Daniel SERRA-BADUE, (1914–)

Self-Portrait at Age 48, 1962
Lithograph on paper, 13.5 x 17" (34.29 x 43.18 cm.)
Signed, Daniel Serra-Badue, lower right
Museum purchase, 1973
973-P-136

Albert SERWAZI, (1905–)

The following four signed oils on canvas of
various sizes are a gift of Albert Serwazi, 1976

Gertrude Trimming Flowers, 1970
976-O-140

Girl in Large Hat, 1957
976-O-138

Manasquan Inlet, 1956
976-O-141

Still Life with Guitar, 1971
976-O-139

Alfred SESSLER, (1909–1963)

The Year Eleven, 1953–60
Oil on canvas, 18 x 24" (45.72 x 60.96 cm.)
Signed, Sessler, 1953–1960, lower left
Museum purchase, 1960
960-O-107

Donald SEXAUER, (1932–)

To Fly, To Fly, 1967
Etching on paper, 13.75 x 9.5" (34.93 x 24.13 cm.)
Signed, Sexauer, 67, lower right
Museum purchase, 1968
969-P-109

Woman, 1967
Etching on paper, 13.75 x 9.75" (34.93 x 24.77 cm.)
Signed, Sexauer, 67, lower right
Museum purchase, 1968
968-P-248

Ralph E. SHAFFER, (1941–)

The Fantasy Flight, 1967
Oil on canvas, 16 x 20" (40.64 x 50.80 cm.)
Signed, Shaffer, lower right
Gift of the Friends of American Art, 1968
968-O-193

Ben SHAHN, (1898–1969)

Inside Looking Out, 1953
Casein on paper, 17 x 15" (43.18 x 38.10 cm.)
Signed, Ben Shahn, lower right
Museum purchase, 1953
954-W-120

Our House in Skowhegan, 1967, 1967
Watercolor on paper, 26 x 40" (66.04 x 101.60 cm.)
Signed, Ben Shahn, lower right
Museum purchase, 1968
968-W-140

Man
Drawing on paper, 6 x 9" (15.24 x 22.86 cm.)
Signed, Ben Shahn, lower right
Gift of Louis Held, 1965
965-D-120

All That's Beautiful
Silkscreen on paper, 25.5 x 38.25" (64.77 x 97.16 cm.)
Signed, Ben Shahn, center right
Gift of Carl Dennison, 1975
975-P-132

For the Sake of a Single Verse
A portfolio of lithographs on paper of various sizes is a
museum purchase, 1968
968-P-255

Gandhi, 1965
Silkscreen on paper, 25.25 x 29.5" (64.14 x 74.93 cm.)
Signed, Ben Shahn, lower right
Gift of Dorothy Dennison Butler, 1979
979-P-105

Lute and Molecules #1, 1958
Hand colored silkscreen on paper, 27 x 40.5" (68.58 x 102.87
cm.)
Signed, Ben Shahn, lower right
Museum purchase, 1959
959-P-107

The following two silkscreens on paper are the
gift of P. Weber, 1961

Four and a Half Men, 1937
15 x 12" (38.10 x 30.48 cm.)
961-P-126

Two Figures
14.25 x 11.5" (36.20 x 29.21 cm.)
961-P-127

Clara SHAINESS, (active late 20th century)

The Moon Watches
Oil on masonite, 22.5 x 48" (57.15 x 121.92 cm.)
Signed, Shainess, lower right
Gift of Dr. Natalie Shainess, 1978
978-O-108

Mardi Gras
Collage on paper, 21 x 13.25" (53.34 x 33.66 cm.)
Signed, Shainess, lower left
Gift of Dr. Natalie Shainess, 1978
978-W-104

Cecil SHAPIRO, (active late 20th century)

Breaking Clouds
Collage on paper, 19.5 x 26" (49.53 x 66.04 cm.)
Signed, Cecil Shapiro, lower left
Gift of Richard Feinman, 1977
977-W-111

David SHAPIRO, (1944–)

The following three signed silkscreens on paper
are the gift of Marc A. Wyse, 1983

Bely II, 1979
17 x 14" (43.18 x 35.56 cm.)
983-P-110

Subtle Body, 1981
(31/35), 26 x 20.5" (66.04 x 52.07 cm.)
983-P-131

Suki II, 1979
(34/35), 25 x 20" (63.50 x 50.80 cm.)
983-P-130

The following two signed hand colored lithographs on paper are the gift of Marc A. Wyse, 1983

Birnham Wood, 1979
(32/35), 10.5 x 9" (26.67 x 22.86 cm.)
983-P-121

Poignancy of Things, 1979
(28/35), 21 x 17.5" (53.34 x 44.45 cm.)
983-P-109

Joseph Henry SHARP, (1859–1953)

Ration Day at the Reservation
Oil on canvas, 40 x 55" (101.60 x 139.70 cm.)
Signed, J. H. Sharp, lower right
Museum purchase, 1921
921-O-504

Sketch for Ration Day at the Reservation
Oil on canvas board, 10 x 14" (25.40 x 35.56 cm.)
Signed, J. H. Sharp, lower right
Museum purchase, 1913
913-O-534

Young Chief's Mission
Oil on canvas, 36 x 40" (91.44 x 101.60 cm.)
Signed, J. H. Sharp, lower right
Museum purchase, 1921
921-O-503

Late Summer Flowers
Oil on canvas, 37 x 41" (93.98 x 104.14 cm.)
Signed, J. H. Sharp, lower left
Gift of Dr. John J. McDonough, 1976
976-O-145

The following two signed oils on canvas are the gift of Mrs. Ralston Thompson, 1980

La Neophyte, 1883
40 x 30" (101.60 x 76.20 cm.)
980-O-103

Along the River
22 x 30.25" (55.88 x 76.84 cm.)
980-O-102

Portrait of the Artist's Mother, 1888–90
Pastel on paper, 25 x 20" (63.50 x 50.80 cm.)
Signed, J. H. Sharp, lower right
Gift of Ralston Thompson, 1946
946-W-103

Indian Figure
Monotype on paper, 12 x 9" (30.48 x 22.86 cm.)
Signed, J. H. Sharp, lower right
Gift of Douglas Worcester, 1973
973-P-135

The following twenty-three signed oils on canvas, 18 x 12" (45.72 x 30.48 cm.), are a museum purchase, 1913

Big Plume, 1902 (Blackfoot)
913-O-532

Bill Jones, (Gros Ventre)
913-O-530

Birds-all-over-the-ground, (Crow)
913-O-519

Chief Big Medicine, 1900, (Crow)
913-O-515

Chief Deaf Bull, (Crow)
913-O-518

Chief Elk Horn, "Big Brave," (Blackfoot)
913-O-528

Chief Little Plume, 1902, (Blackfoot)
913-O-507

Chief Louison, "Red Owl," 1902, (Flathead)
913-O-541

Chief Mo-y-se, 1902, (Flathead)
913-O-508

Chief Two Leggins, (Crow)
913-O-503

Chiz Chile, (Navaho)
913-O-517

Custer's Scout, "Curley," (Crow)
913-O-522

Daughter of Chief Little Chief, (Cheyenne)
913-O-516

Hatalie-nez, "Tall Singer," (Navaho)
913-O-526

Little Whirlwind Cheyenne, (Lame Deer, MT)
913-O-531

Long Soldier, (Sioux)
913-O-523

Mourning Eagle, (Blackfoot)
913-O-520

Red Cloud
913-O-533

Silver Water, 1898
913-O-506

Strikes His Enemy Pretty
913-O-510

Tailfeathers, (Blackfoot)
913-O-512

White Swan, (Crow)
913-O-527

Wife of Chief Little Wolf, (Cheyenne)
913-O-529

The following seven signed oils on canvas, 14 x 10" (35.56 x 25.40 cm.), are a museum purchase, 1913

Bull Thigh, (Cheyenne)
913-O-504

Chief Big Nose, 1898, (Southern Cheyenne)
913-O-539

Chief Short Bull, (Sioux)
913-O-514

David Shapiro - Birnham Wood

Sharp - Ration Day at the Reservation

Sharp - Young Chief's Mission

Sharp - Late Summer Flowers

Shaw - Landscape with Cattle (page 156)

Sheeler - Steam Turbine

Sheppard - Mr. Mack's Fighter's Gym

Shevlin - The Executive

Shillinglaw - The Apartment

Shinn - Dancer in White Before the Footlights

Shinn - The Christ Story (976-W-105)

Chief Two Moons, (Cheyenne)
913-O-538

Lady Pretty Blanket, 1902, (Blackfoot)
913-O-536

Rose in the Dawn, (Sioux, Pine Bluff, SD)
913-O-535

Wolf Ear, (Sioux)
913-O-537

The following three signed oils on canvas, 13 x 9" (33.02 x 22.86 cm.), are a museum purchase, 1913

Chief Little Wolf, (Cheyenne, Lame Deer, MT)
913-O-511

Chief Rocky Bear, (Sioux, Pine Ridge, SD)
913-O-509

Ogalalla Sioux, "Indian Scout"
913-O-505

The following three signed oils on canvas are a museum purchase, 1913

Sun Feather, 1898, (Pueblo)
13 x 10" (33.02 x 25.40 cm.)
913-O-540

Two Dogs, (Sioux, Pine Ridge, SD)
16 x 12" (40.64 x 30.48 cm.)
913-O-525

Walks the Country, (Sioux, Pine Ridge, SD)
12 x 9" (30.48 x 22.86 cm.)
913-O-524

Paul SHAUB, (1923–)

Return, 1961
Chiaroscuro wood cut on paper, 15.25 x 22" (38.74 x 55.88 cm.)
Signed, Paul Shaub, lower right
Museum purchase, 1961
961-P-108

Joshua SHAW, (1776–1860)

Landscape with Cattle, 1818
Oil on canvas, 31 x 41" (78.74 x 104.14 cm.)
Signed, J. Shaw, lower right
Museum purchase, 1961
961-O-117

Sigmund SHAWKEY, (1914–)

Bus Stop, 1960
Watercolor on paper, 22 x 30" (55.88 x 76.20 cm.)
Signed, Shawkey, 60, lower right
Museum purchase, 1960
960-W-104

Barclay SHEAKS, (1928–)

Evening Mooring, 1966
Opaque acrylic on paper, 17.25 x 23.75" (43.82 x 60.33 cm.)
Signed, Barclay Sheaks, 66, lower left
Museum purchase, 1967
967-W-105

Charles SHEELER, (1883–1965)

Steam Turbine, 1938
Oil on canvas, 22 x 18" (55.88 x 45.72 cm.)
Signed, Sheeler, lower right
Museum purchase, 1950
950-O-111

Joseph S. SHEPPARD, (1930–)

Mr. Mack's Fighter's Gym, 1963
Oil on canvas, 52 x 52" (132.08 x 132.08 cm.)
Signed, Sheppard, lower right
Museum purchase, 1963
963-O-117

Beggar, 1962
Ink and watercolor on paper, 8.5 x 12" (21.59 x 30.48 cm.)
Signed, Sheppard, lower right
Gift of Joseph S. Sheppard, 1963
963-D-107

Neil SHEVLIN, (1931–)

The Executive
Oil on canvas, 46 x 58.5" (116.84 x 148.59 cm.)
Signed, N. Shevlin, lower left
Museum purchase, 1965
965-O-159

Fawn SHILLINGLAW, (active late 20th century)

The Apartment, 1987
Watercolor on paper, 20 x 28" (50.80 x 71.12 cm.)
Signed, Fawn, lower right
Gift of Fawn Shillinglaw, 1994
994-W-354

Paul SHIMON, (1922–)

Ports of Call
Tempera and opaque watercolor on paper, 34 x 28" (86.36 x 71.12 cm.)
Signed, Shimon, middle left
Gift of Louis Held, 1969
969-W-112

Everett SHINN, (1876–1953)

Dancer in White Before the Footlights, 1910, (retouched by artist, 1952)
Oil on canvas, 35 x 39" (88.90 x 99.06 cm.)
Signed, Everett Shinn, lower left
Museum purchase, 1957
957-O-128

The Christ Story, 1943
Watercolor on board, 12.5 x 13.5" (31.75 x 34.29 cm.)
Unsigned
Gift of Carl Dennison, 1976
976-W-105

The Christ Story, 1943
Watercolor on board, 12 x 13.5" (30.48 x 34.29 cm.)
Signed, Everett Shinn, lower right
Gift of Carl Dennison, 1976
976-W-106

Alley Cats, 1923
Conte crayon and watercolor on board 24.5 x 19.5" (62.23 x 49.53 cm.)
Signed, Everett Shinn, lower left
Gift of Louis Held, 1965
965-D-114

George E. SHIRAS, (active early 20th century)

The following three signed watercolors on paper are the gift of Elizabeth D. Reis, 1972

Birch Tree, 1906
18.5 x 15" (46.99 x 38.10 cm.)
972-W-105

Roadway, 1906
18.5 x 15.25" (46.99 x 38.74 cm.)
972-W-107

Woodland Stream, 1906
17 x 23" (43.18 x 58.42 cm.)
972-W-106

Guy SHIVELY, (active late 20th century)

Retired Bike Parts, 1977
Oil on canvas, 30.5 x 50.5" (77.47 x 128.27 cm.)
Signed, Guy Shively, lower right
Museum purchase, 1977
977-O-159

Harry SHOKLER, (1896– ?)

Skyline
Silkscreen on paper, 14 x 18" (35.56 x 45.72 cm.)
Signed, Harry Shokler, upper left
Gift of Louis Held, 1965
965-P-135

Harry SHOULBERG, (1903–)

Flowers with White Vase
Oil on canvas, 36 x 22" (91.44 x 55.88 cm.)
Signed, Shoulberg, lower left
Gift of Leonard Bocour, 1975
975-O-109

Rockport Harbour
Oil on canvas, 28 x 22" (71.12 x 55.88 cm.)
Signed, Shoulberg, lower left
Gift of Mr. and Mrs. Sam Golden, 1969
969-O-144

Lily SHUFF, (1906–)

The Swamp
Woodblock print on paper, 13 x 16.5" (33.02 x 41.91 cm.)
Signed, Lily Shuff, lower right
Museum purchase, 1967
967-P-187

Will SHUSTER, (1893– ?)

The following two signed etchings on paper, (4 x 3" (10.16 x 7.62 cm.), are the gift of Albert E. Hise, 1979

La Noria, 1929
979-P-127

San Miguel Church, 1929
979-P-126

Maurice SIEVAN, (1898–1981)

Ginga, 1961
Oil on canvas, 46 x 34" (116.84 x 86.36 cm.)
Signed, Sievan, lower right
Anonymous gift, 1965
965-O-176

Land Seascape
Oil on canvas, 16 x 22" (40.64 x 55.88 cm.)
Signed, Sievan, lower left
Gift of Louis Held, 1965
965-O-117

View in Hampton Bays
Oil on canvas, 16 x 20" (40.64 x 50.80 cm.)
Signed, Sievan, lower right
Gift of Mr. and Mrs. Israel David Orr, 1958
958-O-159

Violet SIGISMUND, (active late 20th century)

Inlet
Oil on canvas, 16 x 20" (40.64 x 50.80 cm.)
Signed, Violet Sigismund, lower right
Gift of Louis Held, 1977
977-O-125

Burton Philip SILVERMAN, (1928–)

The Etcher, 1981
Oil on canvas, 31 x 35" (78.74 x 88.90 cm.)
Signed, Silverman, lower left
Gift of the Henry Ward Ranger Fund, 1987
987-O-120

Nude
Charcoal on paper, 9.5 x 16.5" (24.13 x 41.91 cm.)
Signed, B. Silverman, lower left
Gift of Harry Kulkowitz, 1968
969-D-102

Harvey SILVERMAN, (1945–)

Two Girls
Oil on canvas, 40 x 50" (101.60 x 127.00 cm.)
Signed, Silverman, lower right
Museum purchase, 1965
965-O-158

Mel SILVERMAN, (1931–1966)

The following two etchings on paper are a museum purchase, 1959, 1967

Coney Island
14.5 x 35.5" (36.83 x 90.17 cm.)
959-P-105

The Pier, 1960
13.75 x 33.75" (34.93 x 85.73 cm.)
967-P-159

Wilma SIMONTON, (1915–)

Still Life
Oil on canvas, 28 x 24" (71.12 x 60.96 cm.)
Unsigned
Museum purchase, 1952
952-O-104

Clyde SINGER, (1908–)

An Incident in the Life of David Blythe, 1955
Oil on canvas, 22 x 28" (55.88 x 71.12 cm.)
Signed, C. Singer, lower left
Museum purchase, 1965
965-O-150

8th Ave., Night, 1969
Casein on panel, 22 x 29" (55.88 x 73.66 cm.)
Signed, C. Singer, center right
Gift of Mr. and Mrs. Joseph Erdelac, 1987
987-W-105

Shinn - Alley Cats (page 156)

Shively - Retired Bike Parts

Burton Philip Silverman - The Etcher

Burton Philip Silverman - Nude

Singer - An Incident in the Life of David Blythe

Singer - Minor League

Singer - Selections from the Permanent Collection

Singer - 5th Ave. at 97th St.

Singer - Parade

Singer - McSorley's on Sunday

Boys Fishing, 1958
Oil on canvas 12 x 16" (30.48 x 40.64 cm.)
Signed, C. Singer, lower right
Gift of Jane A. Altdoerfler, 1988
988-O-128

Defeated Theater, 1952
Oil on canvas, 30 x 48" (76.20 x 121.92 cm.)
Signed, Singer, 52, lower left
Museum purchase, 1954
954-O-139

Minor League, 1946
Oil on canvas, 40 x 50" (101.60 x 127.00 cm.)
Signed, Singer, lower right
Gift of the Friends of American Art, 1975
975-O-142

Rev. Jessey LeRoy Miller, 1950
Oil on canvas, 32 x 27" (81.28 x 68.58 cm.)
Signed, C. Singer, 50, lower right
Gift of Grace Evangelical Lutheran Church, 1993
993-O-109

Selections from the Permanent Collection, 1951
Oil on canvas, 14 x 26" (35.56 x 66.04 cm.)
Signed, Singer, 51, lower left
Museum purchase, 1953
953-O-114

Self Portrait on 20 Year Old Palette, 1969
Oil on masonite, 16 x 12" (40.64 x 30.48 cm.)
Signed, C. Singer, lower left
Gift of Drs. Paul and Laura Mesaros, 1983
983-O-112

Stormy Weather, 1941
Oil on canvas, 21 x 35.5" (53.34 x 90.17 cm.)
Signed, C. Singer, 41, lower left,
Museum purchase, 1942
942-O-102

The Melder Anne Furnace, 1950
Oil on canvas, 10 x 14" (25.40 x 35.56 cm.)
Signed, Singer, 50, lower right
Museum purchase, 1989
989-O-107

The following two signed oils on canvas are the gift of Arthur and Phyllis Stambler, 1993

Forward Pass, 1981
20 x 24" (50.80 x 60.96 cm.)
993-O-108

Fumble at Midfield, 1979
25 x 30" (63.50 x 76.20 cm.)
993-O-107

The following eighteen signed oils on canvas or board are the gift of Mr. and Mrs. Joseph Erdelac, 1987

5th Ave. at 97th St., 1970
24 x 18" (60.96 x 45.72 cm.)
987-O-105

Art Auction, 1952
17 x 23" (43.18 x 58.42 cm.)
987-O-115

Beatniks, 1960
24 x 12" (60.96 x 30.48 cm.)
987-O-111

Checkup in Subway, 1956
23 x 13" (58.42 x 33.02 cm.)
987-O-114

Ferryboat to Staten, 1962
18 x 24" (45.72 x 60.96 cm.)
987-O-110

Flowers that Bloom at Night, 1964
39 x 26.5" (99.06 x 67.31 cm.)
987-O-117

Green Front, 1960
25 x 30" (63.50 x 76.20 cm.)
987-O-113

In Penn Station, 1963
34 x 20" (86.36 x 50.80 cm.)
987-O-109

Madison Square Park, Morning
32 x 40" (81.28 x 101.60 cm.)
987-O-106

McSorley's Back Wall, 1967
24 x 30" (60.96 x 76.20 cm.)
987-O-107

McSorley's–No Women Permitted, 1970
38 x 30" (96.52 x 76.20 cm.)
987-O-104

One Way, 1966
37 x 16" (93.98 x 40.64 cm.)
987-O-108

P. J. Clark's Corner, 1969
40 x 26" (101.60 x 66.04 cm.)
987-O-101

Parade, 1965
40 x 50" (101.60 x 127.00 cm.)
987-O-118

Standees, McSorley's, 1967
30 x 24" (76.20 x 60.96 cm.)
987-O-103

Subway Entrance, 1964
36 x 24" (91.44 x 60.96 cm.)
987-O-116

Vendor at Battery, 1967
24 x 20" (60.96 x 50.80 cm.)
987-O-102

Voice in the Park, 1960
22 x 36" (55.88 x 91.44 cm.)
987-O-112

The following two signed caseins on paper are the gift of William and Margaret Kinnick, 1986

Art Students League Student, 1963
18 x 13.75" (45.72 x 34.93 cm.)
986-W-112

East Federal, 1962
28 x 20" (71.12 x 50.80 cm.)
986-W-113

McSorley's on Sunday, 1934
Watercolor on paper, 15.75 x 20.25" (40.01 x 51.44 cm.)
Signed, Singer, N.Y.C., lower right
Gift of Drs. Paul and Laura Mesaros, 1982
982-W-106

Memorial Day, 1965, 1965
Casein on paper, 26 x 28" (66.04 x 71.12 cm.)
Signed, C. Singer, lower left
Museum purchase, 1966
966-W-101

Winter Along the Hudson, 1934
Watercolor on paper, 15 x 20" (38.10 x 50.80 cm.)
Signed, Singer, N.Y., 3-34, lower right
Museum purchase, 1940
940-W-108

The following twelve signed watercolors, casein
on paper or panel, are the gift of Mr. and Mrs.
Joseph Erdelac, 1987

At the Whitney, 1970
16 x 20" (40.64 x 50.80 cm.)
987-W-101

Bagels and Hot Chestnuts, 1970
12 x 11" (30.48 x 27.94 cm.)
987-W-103

Barricade, 1970
28 x 32" (71.12 x 81.28 cm.)
987-W-102

Dancers, 1962
27 x 20" (68.58 x 50.80 cm.)
987-W-110

Encounter–Central Park, Night, 1960
12.25 x 18.25" (31.12 x 46.36 cm.)
987-W-111

Impromptu Flowers, 1966
15 x 19" (38.10 x 48.26 cm.)
987-W-107

In Central Park, 1963
16 x 20" (40.64 x 50.80 cm.)
987-W-109

No Left Turns, 1969
35 x 19" (88.90 x 48.26 cm.)
987-W-104

Old House in New York, 1959
12 x 9" (30.48 x 22.86 cm.)
987-W-113

Student, Red Umbrella, 1967
19 x 15" (48.26 x 38.10 cm.)
987-W-106

Subway, 14th St. Station, 1960
15 x 20" (38.10 x 50.80 cm.)
987-W-112

Three Girls in Phone Booth, 1965
24 x 18" (60.96 x 45.72 cm.)
987-W-108

Mitchell SIPORIN, (1910–1976)

Conflagration at the Museum
Watercolor on paper, 27 x 40" (68.58 x 101.60 cm.)
Signed, Mitchell Siporin, lower right
Museum purchase, 1960
960-W-109

Clara SITNEY, (active 20th century)

Sheridan Square at Night, 1940
Oil on canvas, 16 x 12" (40.64 x 30.48 cm.)
Signed, C. Sitney, 1940, lower left
Gift of Louis Held, 1965
965-O-120

Robert SIVARD, (1914–1990)

Yellow House, Ponce, P.R., 1967
Oil on panel, 24 x 24" (60.96 x 60.96 cm.)
Signed, Sivard, lower right
Museum purchase, 1967
967-O-116

David P. SKEGGS, (1924–1973)

Reveille
Woodblock on paper, 23 x 17" (58.42 x 43.18 cm.)
Unsigned
Museum purchase, 1953
953-P-104

Liz SKLEPKO, (1943–)

Silver Bridge, Mill Creek Park, Young-
stown, OH, 1964
Aquatint on paper, 10 x 17.5" (25.40 x 44.45 cm.)
Signed, Liz Sklepko, lower right
Museum purchase, 1964
964-P-112

Audrey SKOUDAS, (active late 20th century)

(Untitled), 1979
Lithograph on paper, 23 x 29" (58.42 x 73.66 cm.)
Signed, Audrey Skoudas Pearson, 79, lower right
Gift of Ana and Eric Baer, 1991
991-P-204

(Untitled), 1984
Lithograph on paper, 41 x 32" (104.14 x 81.28 cm.)
Signed, Audrey Skoudas, 1984, lower right
Gift of Ana and Eric Baer, 1991
991-P-203

John SLOAN, (1871–1951)

Recruiting in Union Square, 1909
Oil on canvas, 26 x 32" (66.04 x 81.28 cm.)
Signed, John Sloan, lower left
Museum purchase, 1954
954-O-140

Nude on Blue, ca. 1930
Oil on canvas, 16 x 20" (40.64 x 50.80 cm.)
Signed, John Sloan, lower right
Museum purchase, 1961
961-O-133

Nude, Pink Striped Coverlet, 1927
Oil on board, 13.5 x 15" (34.29 x 38.10 cm.)
Signed, John Sloan, lower right
Gift of Mr. and Mrs. Carl Dennison, 1977
977-O-161

The Telephone, 1906
Crayon and ink on paper, 16.75 x 14" (42.55 x 35.56 cm.)
Signed, John Sloan, 06, lower left
Gift of Louis Held, 1965
965-D-117

Singer - Three Girls in Phone Booth

Sloan - Recruiting in Union Square

Sloan - Nude on Blue

Sloan - Nude, Pink Striped Coverlet

Sloan - The Telephone

Smillie - French Beach

Allan Smith, Jr. - Sheep Washing in the Reserve

Allen Smith - Elizabeth Swain Brown Powers

Clarice Smith - Front Runner

Gary Earnest Smith - Three Women Gathering Pumpkins

The following two signed etchings on paper are a museum purchase, 1952

Buses in Washington Square, 1925
8 x 10" (20.32 x 25.40 cm.)
952-P-112

Turning Out the Light
5 x 7" (12.70 x 17.78 cm.)
952-P-111

The following five signed etchings on paper are a museum purchase, 1965

Copyist at the Metropolitan, 1910
7.5 x 8.5" (19.05 x 21.59 cm.)
965-P-121

Kraushaar's, 1926
4 x 5" (10.16 x 12.70 cm.)
965-P-119

Long Prone Nude, 1931
4.25 x 13.5" (10.80 x 34.29 cm.)
965-P-125

McSorley's Back Room, 1916
5 x 7" (12.70 x 17.78 cm.)
965-P-122

Robert Henri, 1905
6.5 x 4.5" (16.51 x 11.43 cm.)
965-P-123

The following three signed etchings on paper are a museum purchase, 1967

Bandit's Cave, 1910
7 x 5" (17.78 x 12.70 cm.)
967-P-143

Nude and Newspapers, 1927
5.5 x 6.75" (13.97 x 17.15 cm.)
967-P-176

Sisters at the Window, 1923
5 x 4" (12.70 x 10.16 cm.)
967-P-190

The following four signed etchings on paper are a museum purchase, 1968

Fifth Avenue Critics
4.5 x 6.75" (11.43 x 17.15 cm.)
968-P-228

Mother, 1906
8.75 x 7.25" (22.23 x 18.42 cm.)
968-P-257

Return From Toil, 1915
4 x 5.75" (10.16 x 14.61 cm.)
968-P-258

Women's Page, 1905
5 x 7" (12.70 x 17.78 cm.)
968-P-229

Wake on the Ferry
Etching on paper, 4.87 x 7" (12.39 x 17.78 cm.)
Signed, John Sloan, lower right
Museum purchase, 1969
969-P-119

Will Larymore SMEDLEY, (1871–ca. 1950)

Brook in the Woods
Oil on canvas, 14 x 17" (35.56 x 43.18 cm.)
Signed, W. Larymore Smedley, lower right
Gift of the estate of Charles Crandall, 1971
971-O-111

Enid SMILEY, (active late 20th century)

East River Fog, 1984
Oil on canvas, 38 x 27" (96.52 x 68.58 cm.)
Signed, Enid Smiley, on reverse
Gift of Enid Smiley, 1986
986-O-110

George H. SMILLIE, (1840–1921)

French Beach, 1884
Oil on canvas, 9 x 16" (22.86 x 40.64 cm.)
Signed, Geo. H. Smillie, lower left
Museum purchase, 1968
968-O-203

Allan SMITH, Jr., (1810–1890)

Sheep Washing in the Reserve, 1851
Oil on canvas, 45.5 x 40" (115.57 x 101.60 cm.)
Signed, Allan Smith, Jr., 1851, lower right
Gift of James Berry-Hill and museum purchase, 1996
996-O-101

Allen SMITH, (1810–1890)

James Scovil
Oil on mounted canvas, 36 x 28" (91.44 x 71.12 cm.)
Unsigned
Museum purchase, 1965
966-O-101

The following two oils on canvas are the gift of Mrs. E. L. Powers, 1948

Elizabeth Swain Brown Powers, 1872
35 x 28" (88.90 x 71.12 cm.)
948-O-119

William Powers, 1872
34 x 28" (86.36 x 71.12 cm.)
948-O-120

Andre SMITH, (1880–1959)

Santa Maria della Salute
Etching on paper, 12 x 7.5" (30.48 x 19.05 cm.)
Signed, Andre Smith, lower center
Gift of Blanche Lewis, 1977
977-P-121

Clarice SMITH, (active late 20th century)

Front Runner, 1990
Oil on canvas, 40 x 37.75" (101.60 x 95.89 cm.)
Signed, C. Smith, lower left
Museum purchase, 1991
991-O-218

Gary Earnest SMITH, (active late 20th century)

Three Women Gathering Pumpkins
Oil on canvas, 78 x 78" (198.12 x 198.12 cm.)
Signed, Gary Earnest Smith, lower right
Gift of Bob Sweeney, 1993
993-O-116

Gladys Nelson SMITH, (1890–1980)

Cottage Door Garden

Oil on canvas, 22 x 18"(55.88 x 45.72 cm.)
Signed, Gladys Nelson Smith, lower right
Gift of Josephine Nelson, 1987
988-O-103

Henry Pember SMITH, (1854–1907)

Landscape

Oil on canvas, 22 x 30" (55.88 x 76.20 cm.)
Signed, Henry P. Smith, lower right
Museum purchase, 1969
969-O-137

Houghton Cranford SMITH, (active late 20th century)

Cloudy Day

Oil on canvas, 18 x 32" (45.72 x 81.28 cm.)
Signed, Houghton Cranford Smith, lower right
Gift of Houghton Cranford Smith, 1976
976-O-109

Jacob Getlar SMITH, (1898–1959)

The Peasant, 1927

Oil on canvas, 40 x 32" (101.60 x 81.28 cm.)
Signed, Jacob Getlar Smith, lower left
Gift of Mr. and Mrs. H. Kroll, 1948
948-O-118

Joe W. SMITH, (active late 20th century)

Tribute to Theolonius II, 1975

Acrylic on canvas, 65 x 65" (165.10 x 165.10 cm.)
Signed, Joe Smith, lower right
Gift of William Pfaus, 1984
984-O-101

Lawrence Beall SMITH, (1909–)

Forest Flight

Lithograph on paper, 8.75 x 12" (22.23 x 30.48 cm.)
Signed, Lawrence Beall Smith, lower right
Gift of Edward Dobroski, 1993
993-P-147

Harbor Scene

Black and white lithograph on paper, 10 x 14" (25.40 x 35.56 cm.)
Signed, Lawrence Beall Smith, lower right
Museum purchase, 1969
969-P-108

Moishe SMITH, (1929–1993)

Rapallo, 1965

Etching on paper, 8.5 x 11" (21.59 x 27.94 cm.)
Signed, Moishe, 65, lower right
Museum purchase, 1965
965-P-249

R. A. SMITH, (active late 20th century)

Mother and Child III, 1965

Silkscreen on paper, 12 x 9" (30.48 x 22.86 cm.)
Signed, R. A. Smith, lower right
Gift of Salzer Galleries, 1966
966-P-115

Russell SMITH, (1812–1896)

Seascape, 1867

Oil on canvas, 34 x 56" (86.36 x 142.24 cm.)
Signed, Russell Smith, 1867, lower left
Museum purchase, 1968
968-O-175

Steven SMITH, (active late 20th century)

(Untitled)

Portfolio of 53: Rip Off on the Last Millennium
Print on paper, 8.5 x 14" (21.59 x 35.56 cm.)
Signed, Smith, on reverse
Gift of the William Busta Gallery, 1990
990-P-111.48

Walter Granville SMITH, (1870–1938)

Sail Boats

Oil on canvas, 12 x 16" (30.48 x 40.64 cm.)
Signed, W. Granville Smith, lower left
Gift of the estate of Charles Crandall, 1951
951-O-116

The Willows, 1911

Oil on canvas, 36.5 x 49.5" (92.71 x 125.73 cm.)
Signed, W. Granville Smith, 1911, lower left
Museum purchase, 1922
922-O-104

Ethel L. SMUL, (1897– ?)

Pagan Offering, 1955

Oil on canvas, 32 x 28" (81.28 x 71.12 cm.)
Signed, Ethel L. Smul, lower left
Gift of Teresa Jackson Weill, 1968
968-O-211

Henry Bayley SNELL, (1858–1943)

The Canal

Oil on canvas, 7 x 9" (17.78 x 22.86 cm.)
Signed, Henry B. Snell, lower right
Gift of the estate of Charles Crandall, 1951
951-O-115

David SNOOK, (active late 20th century)

Still Life

Oil on canvas, 16 x 20" (40.64 x 50.80 cm.)
Signed, Snook, lower right
Gift of Louis Held, 1965
965-O-113

Francis SNOWE, (active late 19th century)

Passing through the Shenandoah Valley, 1876

Oil on canvas, 26 x 40" (66.04 x 101.60 cm.)
Signed, Francis Snowe, lower left
Museum purchase, 1973
973-O-114

Sergio SOAVE, (active late 20th century)

The following two hand colored signed etchings on paper, 19.5 x 15.5" (49.53 x 39.37 cm.), artist's proofs, are the gift of Drs. Paul and Laura Mesaros, 1994

The Formative Years, 1994

994-P-214

The Passing of the Torch, 1994

994-P-213

Henry Pember Smith - Landscape

Russell Smith - Seascape

Walter Granville Smith - Sail Boats

Walter Granville Smith - The Willows

Snowe - Passing through the Shenandoah Valley

Soleri - Winged Angel

Solomon - Bird Key Bay

Sommer - (Untitled)

Sommer - Brandywine Farm

Sonnier - (Untitled)

Sonntag - Landscape

Sasson SOFFER, (1925–)

Conquest, 1965
Oil on canvas, 55 x 48" (139.70 x 121.92 cm.)
Signed, Sasson Soffer, 1965, lower right
Gift of Mrs. Stanley Bard, 1969
969-O-166

Miron SOKOLE, (1901–)

The following two oils on canvas, 24 x 30"
(60.96 x 76.20 cm.), are the gift of Mrs. William
V. Miller, 1960

Discourse on War
960-O-116

Main Street—Verplanck
960-O-117

Paolo SOLERI, (1919–)

Winged Angel, 1960
Lithograph on paper, 38 x 25" (96.52 x 63.50 cm.)
Signed, Paolo Soleri, lower right
Gift of Reese and Marilyn Arnold Palley, 1991
991-P-172

Joseph SOLMAN, (1909–)

The Redhead
Oil on canvas, 24 x 16" (60.96 x 40.64 cm.)
Signed, J. S., middle left
Gift of Emil Arnold, 1967
967-O-109

(Untitled), 1973
Monotype on paper, 12 x 17" (30.48 x 43.18 cm.)
Signed, Joseph Solman, lower right
Gift of Louis Held, 1978
978-P-112

Syd SOLOMON, (1917–)

Bird Key Bay
Watercolor on paper, 20 x 30" (50.80 x 76.20 cm.)
Signed, Syd Solomon, lower right
Museum purchase, 1957
957-W-109

Syd Solomon, Retrospective Exhibition
Offset lithograph on paper, 32 x 22" (81.28 x 55.88 cm.)
Signed, Syd Solomon, upper left
Museum purchase, 1980
980-P-158

William SOMMER, (1867–1949)

(Untitled)
Oil on canvas, 23.75 x 20" (60.33 x 50.80 cm.)
Signed, William Sommer, lower right
Gift of Mr. and Mrs. Joseph Erdelac, 1991
991-O-228

Boy Convalescing, 1904
Watercolor on paper, 26 x 20" (66.04 x 50.80 cm.)
Unsigned
Gift of Maurice I. Rappaport, 1968
968-W-121

Brandywine Farm
Watercolor on paper, 15.25 x 19.75" (38.74 x 50.17 cm.)
Unsigned
Gift of Mr. and Mrs. Joseph Erdelac, 1991
991-W-161

Frankie, 1929
Pen and watercolor on paper, 14.25 x 12.5" (36.20 x 31.75 cm.)
Signed, Wm. Sommer, 1929, lower left
Gift of Mr. and Mrs. Joseph Erdelac, 1967
967-W-102

The Butler Institute's collection contains twenty-
four watercolors on paper of various sizes which
are an anonymous gift, 1950
950-W-102, 950-W-106 — 950-W-127, 950-W-131

The following two drawings on paper are an
anonymous gift, 1950

The Glass
9 x 6" (22.86 x 15.24 cm.)
950-D-102

The Tree
9 x 12" (22.86 x 30.48 cm.)
950-D-103

The Butler Institute's collection contains two
untitled drawings, ink on paper, of different sizes
which are the gift of Mr. and Mrs. Joseph
Erdelac, 1991
991-D-139 and 991-D-140

(Untitled)
Lithograph on paper, 17 x 13.25" (43.18 x 33.66 cm.)
Signed, Wm. Sommer, lower right
Gift of Arthur Feldman, 1991
991-P-181

Miriam SOMMERBURG, (1910–1980)

Rising Woman
Colored lithograph on paper, 16 x 16.62" (40.64 x 42.23 cm.)
Signed, Miriam Sommerburg, lower right
Gift of Miriam Sommerburg, 1970
970-P-118

The Butler Institute's collection contains ten
sculptural woodcuts on paper of various sizes
which are the gift of Sascha Sommerburg, 1971
971-P-104.1 — 971-P-104.10

Jack SONNENBERG, (1925–)

Of Minos
Lithograph on paper, 18.25 x 27.62" (46.36 x 70.17 cm.)
Signed, J. Sonnenberg, lower right
Gift of Associated American Artists, 1968
968-P-238

Keith SONNIER, (1941–)

(Untitled)
Offset lithograph on paper, 9 x 12" (22.86 x 30.48 cm.)
Signed, K. S., center right
Gift of Steven Feinstein, 1983
983-P-168

William Louis SONNTAG, (1822–1900)

Landscape
Oil on canvas, 32 x 48" (81.28 x 121.92 cm.)
Signed, Sonntag, lower left
Gift of Mr. and Mrs. Joseph P. Sontich, 1970
970-O-123

Sunset
Oil on canvas, 16 x 23" (40.64 x 58.42 cm.)
Unsigned
Museum purchase, 1968
968-O-156

Mountain Landscape
Oil on canvas, 33 x 56" (83.82 x 142.24 cm.)
Unsigned
Museum purchase, 1967
967-O-107

SORIANA, (active 20th century)

Louis Held, 1938
Drawing on paper, 11 x 8" (27.94 x 20.32 cm.)
Signed, Soriana, lower right
Gift of Louis Held, 1965
965-D-137

Steven SORMAN, (1948–)

Ice Finding Tundra Lupine, 1975
Lithograph on paper, 38 x 25" (96.52 x 63.50 cm.)
Signed, Steven Sorman, lower center
Gift of James Pernotto, 1985
985-P-102

Isaac SOYER, (1902–1981)

Enchanted One
Lithograph on paper, 14.25 x 12" (36.20 x 30.48 cm.)
Signed, Isaac Soyer, lower right
Museum purchase, 1973
973-P-104

Moses SOYER, (1899–1974)

Reclining Nude
Oil on canvas, 20 x 26" (50.80 x 66.04 cm.)
Signed, M. Soyer, lower left
Gift of Mr. and Mrs. Nahum Tschacbasov, 1955
955-O-136

Seated Nude
Oil on canvas, 16 x 10" (40.64 x 25.40 cm.)
Signed, M. Soyer, upper right
Gift of Mr. and Mrs. Nahum Tschacbasov, 1979
979-O-121

Standing Figure
Oil on canvas, 23 x 10" (58.42 x 25.40 cm.)
Signed, M. Soyer, lower left
Gift of Emil J. Arnold, 1958
958-O-157

Young Actress, 1962
Oil on canvas, 30 x 30" (76.20 x 76.20 cm.)
Signed, M. Soyer, upper right
Gift of Ida Soyer, 1963
963-O-106

Raphael SOYER, (1899–1987)

My Friends, 1948
Oil on canvas, 70 x 60" (177.80 x 152.40 cm.)
Signed, Raphael Soyer, 1948, lower right
Gift of Raphael Soyer, 1963
963-O-103

Study for the Avenue of the Americas, 1971
Watercolor on paper, 17.75 x 15" (45.09 x 38.10 cm.)
Signed, Raphael Soyer, lower right
Gift of Drs. Paul and Laura Mesaros, 1994
994-W-349

Figures of Girls
Drawing on paper, 15 x 21" (38.10 x 53.34 cm.)
Signed, Raphael Soyer, lower right
Gift of Frank Kleinholz in memory of Leah Kleinholz, 1947
947-D-101

The following six drawings on paper are the gift of Emil Arnold, 1967

Girl with Stick
16.5 x 11.5" (41.91 x 29.21 cm.)
967-D-103

Nude
16 x 12" (40.64 x 30.48 cm.)
967-D-105

Nude
16 x 10" (40.64 x 25.40 cm.)
967-D-108

Seated Nude
18 x 14" (45.72 x 35.56 cm.)
967-D-104

Standing Nude
17 x 10" (43.18 x 25.40 cm.)
967-D-107

Three Figures
16 x 11" (40.64 x 27.94 cm.)
967-D-106

The following six drawings, pencil on paper, are the gift of Drs. Paul and Laura Mesaros, 1994

Female with Hands on Chin
9 x 4" (22.86 x 10.16 cm.)
994-D-122

Female with Hands on Head
11 x 10" (27.94 x 25.40 cm.)
994-D-123

Female with Hands on Lap
10 x 8" (25.40 x 20.32 cm.)
994-D-124

Nude Rising, 1964
15 x 14.5" (38.10 x 36.83 cm.)
994-D-120

Nude with Arms Behind Her Back
13 x 7" (33.02 x 17.78 cm.)
994-D-125

Study for Homage to Thomas Eakins, 1964
18 x 14" (45.72 x 35.56 cm.)
994-D-121

Self Portrait
Etching on paper, 3.75 x 2" (9.53 x 5.08 cm.)
Signed, Raphael Soyer, lower right
Museum purchase, 1968
968-P-220

Pedestrians, 1963
Etching on paper, 14.75 x 11" (37.47 x 27.94 cm.)
Signed, Raphael Soyer, lower right
Gift of Drs. Paul and Laura Mesaros, 1986
986-P-103

The following forty-one signed etchings on paper are the gift of Drs. Paul and Laura Mesaros, 1994

Couple in Interior, 1963
9.75 x 7.75" (24.77 x 19.69 cm.)
994-P-145

Sonntag - Sunset (page 162)

Sonntag - Mountain Landscape

Sorman - Ice Finding Tundra Lupine

Isaac Soyer - Enchanted One

Moses Soyer - Reclining Nude

Moses Soyer - Standing Figure

Moses Soyer - Young Actress (page 163)

Raphael Soyer - My Friends (page 163)

Raphael Soyer - Study for the Avenue of the Americas (page 163)

Raphael Soyer - Girl with Stick (page 163)

Raphael Soyer - Self Portrait (page 163) (968-P-220)

Raphael Soyer - Pedestrians (page 163)

Couple Walking
13.75 x 11" (34.93 x 27.94 cm.)
994-P-191

Eighth Avenue, 1980
11 x 6.37" (27.94 x 16.19 cm.)
994-P-184

Embracing Couple
13.75 x 11" (34.93 x 27.94 cm.)
994-P-192

Furnished Room, 1937
7 x 8.75" (17.78 x 22.23 cm.)
994-P-121

Girl in Black Stockings, 1967
18 x 16.5" (45.72 x 41.91 cm.)
994-P-168

Girl with Parted Lips, 1962
9.75 x 7.75" (24.77 x 19.69 cm.)
994-P-146

Greek Girl #2, 1966
10.75 x 8.5" (27.31 x 21.59 cm.)
994-P-162

Greek Girl #3, 1966
7 x 5.25" (17.78 x 13.34 cm.)
994-P-163

Greek Girl #3, 1966
7 x 5.25" (17.78 x 13.34 cm.)
994-P-164

Interior with Figure, 1963
10 x 8" (25.40 x 20.32 cm.)
994-P-147

Intimate Interior, 1978
8" dia. (20.32 cm.)
994-P-182

Lipstick, 1963
9.75 x 7.75" (24.77 x 19.69 cm.)
994-P-148

Nude Studies, 1963
7.75 x 9.75" (19.69 x 24.77 cm.)
994-P-149

Nude with Screen
9 x 6" (22.86 x 15.24 cm.)
994-P-196

Passer-By, ca. 1935
9.25 x 7" (23.50 x 17.78 cm.)
994-P-186

Pedestrian, 1963
9.75 x 7.75" (24.77 x 19.69 cm.)
994-P-150

Pedestrians, 1963
9.75 x 7.75" (24.77 x 19.69 cm.)
994-P-151

Pensive Girl, 1963
9.75 x 7.75" (24.77 x 19.69 cm.)
994-P-152

Portrait, 1974
7.75" dia. (19.69 cm.)
994-P-177

Portrait of a Girl
10.5" dia. (26.67 cm.)
994-P-197

Seated Nude
15.5 x 15" (39.37 x 38.10 cm.)
994-P-200

Seated Woman, 1963
9.75 x 7.75" (24.77 x 19.69 cm.)
994-P-153

Self Portrait, 1974
6.87 x 4.87" (17.46 x 12.38 cm.)
994-P-178

Self Portrait, 1977
4.75 x 3.5" (12.07 x 8.89 cm.)
994-P-181

Self Portrait with Glasses
7.5 x 6" (19.05 x 15.24 cm.)
994-P-201

Self Portrait with Wife, 1964
7.87 x 9.75" (20.00 x 24.77 cm.)
994-P-161

Sleeping Girl, 1945
4 x 4.87" (10.16 x 12.38 cm.)
994-P-131

Sleeping Girl, ca. 1945
4.5 x 8.75" (11.43 x 22.23 cm.)
994-P-187

Studies, 1975
14.75 x 11.62" (37.47 x 29.53 cm.)
994-P-179

The Artist's Parents, 1963
7.75 x 9.75" (19.69 x 24.77 cm.)
994-P-154

The Artist's Parents, 1963
7.25 x 7.75" (18.42 x 19.69 cm.)
994-P-155

The Bather, 1978
8.75 x 5.37" (22.23 x 13.65 cm.)
994-P-183

Two Women Undressing
14 x 9.25" (35.56 x 23.50 cm.)
994-P-205

Woman Shading Her Eyes, 1954
9.75 x 7.75" (24.77 x 19.69 cm.)
994-P-156

Woman Toweling Her Face
14 x 9.5" (35.56 x 24.13 cm.)
994-P-207

Woman with a Cross, 1963
9.75 x 7.75" (24.77 x 19.69 cm.)
994-P-157

Woman at Table, 1963
9.75 x 7.75" (24.77 x 19.69 cm.)
994-P-158

Young Dancers, 1966
17 x 13" (43.18 x 33.02 cm.)
994-P-167

Young Mother
13.5 x 11" (34.39 x 27.94 cm.)
994-P-209

Young Women, 1963
9.75 x 7.75" (24.77 x 19.69 cm.)
994-P-159

Japanese Girl
Lithograph on paper, 10 x 17" (25.40 x 43.18 cm.)
Signed, Raphael Soyer, lower right
Museum purchase, 1967
967-P-150

Seamstress
Lithograph on paper, 9.75 x 11.75" (24.77 x 29.85 cm.)
Signed, Raphael Soyer, lower right
Museum purchase, 1967
967-P-130

The following fifty-four signed lithographs on paper are the gift of Drs. Paul and Laura Mesaros, 1994

A Couple, ca. 1946
13 x 9.75" (33.02 x 24.77 cm.)
994-P-188

After the Rehearsal
17 x 14" (43.18 x 35.56 cm.)
994-P-190

Before the Mirror, ca. 1930
9.75 x 7" (24.77 x 17.78 cm.)
994-P-185

Boy and Girl, 1954
12 x 7.5" (30.48 x 19.05 cm.)
994-P-132

Casting Office, 1945
9.75 x 12.75" (24.77 x 32.39 cm.)
994-P-130

Conversation, 1931–1932
11 x 15" (27.94 x 38.10 cm.)
994-P-117

Girl Combing Hair
10.5 x 8" (26.67 x 20.32 cm.)
994-P-193

Girl Combing Her Hair
20 x 15.75" (50.80 x 40.01 cm.)
994-P-194

Girl Looking Left
13 x 11.75" (33.02 x 29.85 cm.)
994-P-195

Girl with Parted Lips, 1962
13.5 x 10" (34.29 x 25.40 cm.)
994-P-143

Head of a Girl, 1960
14 x 11.12" (35.56 x 28.26 cm.)
994-P-141

In Studio, 1935
13.5 x 9.5" (34.29 x 24.13 cm.)
994-P-120

Mother and Child, 1964
17.75 x 14" (45.09 x 35.56 cm.)
994-P-160

Mother and Child, 1966
16 x 22" (40.64 x 55.88 cm.)
994-P-165

Mother and Child, 1967
16.75 x 10.62" (42.55 x 26.97 cm.)
994-P-169

My Studio, 1944
12.25 x 9.5" (31.12 x 24.13 cm.)
994-P-128

Nude in Interior, 1954
12.25 x 9.25" (31.12 x 23.50 cm.)
994-P-133

Odalisque, 1920
15.25 x 13.12" (38.74 x 33.32 cm.)
994-P-115

Portrait of Isaac Bashevis Singer
18 x 15" (45.72 x 38.10 cm.)
994-P-198

Portrait of Joan, 1967
14.75 x 10.5" (37.47 x 26.67 cm.)
994-P-170

Pregnant Woman
21 x 15.5" (53.34 x 39.37 cm.)
994-P-199

Protected, 1938
13.37 x 6.25" (33.96 x 15.88 cm.)
994-P-123

Railroad Waiting Room, 1954
12 x 9.5" (30.48 x 24.13 cm.)
994-P-134

Rosemary Mayer, 1976
14.5 x 10.75" (36.83 x 27.31 cm.)
994-P-180

Self Portrait, 1933
13.25 x 9.75" (33.66 x 24.77 cm.)
994-P-119

Self Portrait, 1954
10 x 7" (25.40 x 17.78 cm.)
994-P-135

Self Portrait, 1956
12 x 9" (30.48 x 22.86 cm.)
994-P-139

Self Portrait, 1967
10 x 8.25" (25.40 x 20.96 cm.)
994-P-171

Self Portrait, 1969
13.94 x 11.62" (35.41 x 29.53 cm.)
994-P-174

Self Portrait with Greek Writing on Stone
16 x 12" (40.64 x 30.48 cm.)
994-P-202

Self Portrait with Model, 1959–1960
14 x 11.5" (35.56 x 29.21 cm.)
994-P-140

Springtime, 1938
14 x 17.25" (35.56 x 43.82 cm.)
994-P-124

Raffael Soyer - Before the Mirror

Raffael Soyer - Casting Office

Raffael Soyer - Girl Combing Her Hair

Raffael Soyer - Railroad Waiting Room

Raffael Soyer - Self Portrait with Model

Raffael Soyer - The Dancer (page 166)

Raffael Soyer - The John Reed Club: The Committee

Raffael Soyer - The Seamstress

Raffael Soyer - The Window

Raffael Soyer - Working Girls Going Home

Spalatin - Chiapas I

Spalatin - Chronos I

Street Scene #1, 1968
19 x 15.12" (48.26 x 38.42 cm.)
994-P-172

Studies with Self Portrait, 1966
21 x 24" (53.34 x 60.96 cm.)
994-P-166

The Dancer, ca. 1955
13 x 8.75" (33.02 x 22.23 cm.)
994-P-189

The Immigrants, 1969
16 x 15" (40.64 x 38.10 cm.)
994-P-175

The John Reed Club: The Committee,
1932
7.25 x 10" (18.42 x 25.40 cm.)
994-P-118

The Laundress, 1941–1942
14.5 x 10.75" (36.83 x 27.31 cm.)
994-P-126

The Model, 1944
11.75 x 7.75" (29.85 x 19.69 cm.)
994-P-129

The Pier, 1969
14.5 x 14" (36.83 x 35.56 cm.)
994-P-176

The Screen, 1962
18.5 x 14" (46.99 x 35.56 cm.)
994-P-144

The Seamstress, 1954
9 x 11.75" (22.86 x 29.85 cm.)
994-P-136

The Window, 1954
11 x 9.5" (27.94 x 24.13 cm.)
994-P-137

Three Figures
20 x 14.5" (50.80 x 36.83 cm.)
994-P-203

Three Women of the Evening
24 x 16" (60.96 x 40.64 cm.)
994-P-204

Two Friends, 1968
14.12 x 9.12" (35.88 x 23.18 cm.)
994-P-173

Unemployment
14.5 x 12.5" (36.83 x 31.75 cm.)
994-P-206

Union Square, 1929–1930
7.12 x 8.75" (18.10 x 22.23 cm.)
994-P-116

Waiting, 1942
7.12 x 8.75" (18.10 x 22.25 cm.)
994-P-127

Waitresses, 1954
11.5 x 9.5" (29.21 x 24.13 cm.)
994-P-138

Woman with Child on Back
17.5 x 10" (44.45 x 25.40 cm.)
994-P-208

Working Girls Going Home, 1937
11.25 x 9.37" (28.58 x 23.81 cm.)
994-P-122

Young Girl, 1961
14.25 x 10" (36.20 x 25.40 cm.)
994-P-142

Young Model, 1940
12 x 9.75" (30.48 x 24.77 cm.)
994-P-125

Marko SPALATIN, (active late 20th century)

The following signed serigraphs on paper, a portfolio of eight, 29.12 x 23.12" (73.98 x 58.74 cm.), dated 1986, are the gift of Marko Spalatin, 1994

Chiapas I — Chiapas VIII
994-P-107.1 — 994-P-107.8

The following signed serigraphs on paper, a portfolio of eight, 29 x 25.12" (73.66 x 63.82 cm.), dated 1991, are the gift of Marko Spalatin, 1994

Chronos I — Chronos VIII
994-P-104.1 — 994-P-104.8

The following signed serigraphs on paper, a portfolio of eight, 29 x 23.25" (73.66 x 59.06 cm.), dated 1983, are the gift of Marko Spalatin, 1994

Hexagon I — Hexagon VIII
994-P-110.1 — 994-P-110.8

The following signed serigraphs on paper, a portfolio of nine, 30 x 25.12" (76.20 x 63.82 cm.), dated 1981, are the gift of Marko Spalatin, 1994

Hydroid I — Hydroid IX
994-P-112.1 — 994-P-112.9

The following signed serigraphs on paper, a portfolio of eight, 29 x 25.12" (73.66 x 63.82 cm.), dated 1991, are the gift of Marko Spalatin, 1994

Matrix I — Matrix VIII
994-P-102.1 — 994-P-102.8

The following signed serigraphs on paper, a portfolio of four, 29.12 x 23.12" (73.98 x 58.74 cm.), dated 1986, are the gift of Marko Spalatin, 1994

Mistral I — Mistral IV
994-P-108.1 — 994-P-108.4

The following signed serigraphs on paper, a portfolio of twelve, 30 x 25.12" (76.20 x 63.82 cm.), dated 1982, are the gift of Marko Spalatin, 1994

Nautica I — Nautica XII
994-P-111.1 — 994-P-111.12

The following signed serigraphs on paper, a portfolio of eight, 23.12 x 29" (58.74 x 73.66 cm.), dated 1987, are the gift of Marko Spalatin, 1994

Nebula I — Nebula VIII
994-P-109.1 — 994-P-109.8

The following signed serigraphs on paper, a portfolio of six, 29 x 25.12" (73.66 x 63.82 cm.), dated 1985, are the gift of Marko Spalatin, 1994

Orikus I — Orikus VI
994-P-106.1 — 994-P-106.6

The following signed serigraphs on paper, a portfolio of eight, 25.12 x 30" (63.82 x 76.20 cm.), dated 1979, are the gift of Marko Spalatin, 1994

Parnasos I — Parnasos VIII
994-P-114.1 — 994-P-114.8

The following signed serigraphs on paper, a portfolio of eight, 29 x 25.12" (73.66 x 63.82 cm.), dated 1993, are the gift of Marko Spalatin, 1994

Pulsar I — Pulsar VIII
994-P-101.1 — 994-P-101.8

The following signed serigraphs on paper, a portfolio of eight, 29 x 25.12" (73.66 x 63.82 cm.), dated 1989, are the gift of Marko Spalatin, 1994

Quantum I — Quantum VIII
994-P-103.1 — 994-P-103.8

The following signed serigraphs on paper, a portfolio of eight, 29.12 x 23.12" (73.98 x 58.74 cm.), dated 1984, are the gift of Marko Spalatin, 1994

Rhombus I — Rhombus VIII
994-P-105.1 — 994-P-105.8

The following signed serigraphs on paper, a portfolio of four, 30 x 25.12" (76.20 x 63.82 cm.), dated 1980, are the gift of Marko Spalatin, 1994

Uxmal I — Uxmal IV
994-P-113.1 — 994-P-113.4

Gene SPARKMAN, (1941–)

Scarlet October, 1988
Pastel on paper, 39.25 x 59" (99.70 x 149.86 cm.)
Signed, G. Sparkman, lower left
Gift of Gene Sparkman, 1991
991-D-103

Amy SPARKS, (active late 20th century)

Sam's Food City
Portfolio of 53: Rip Off on the Last Millennium
Print on paper, 8.5 x 11" (21.59 x 27.94 cm.)
Signed, Amy Sparks, lower right
Gift of the William Busta Gallery, 1990
990-P-111.14

Arthur Watson SPARKS, (1870–1919)

Woman Sewing in Garden
Oil on canvas, 13.75 x 10.5" (34.93 x 26.67 cm.)
Unsigned
Gift of Dr. John J. McDonough, 1969
969-O-162

W. W. SPEER, (active late 20th century)

Sea and Boats, Rockport, Mass.
Oil on canvas, 19.75 x 24" (50.17 x 60.96 cm.)
Signed, W. W. Speer, lower left
Museum purchase, 1975
975-O-102

Eugene SPEICHER, (1883–1962)

Portrait of a Lady, 1947
Oil on canvas, 42 x 32" (106.68 x 81.28 cm.)
Signed, Eugene Speicher, 47, upper right
Gift of Larry Flint, 1960
960-O-114

Portrait of Grace H. Butler, 1950
Oil on canvas, 43 x 39" (109.22 x 99.06 cm.)
Signed, Eugene Speicher, 50, upper left
Museum purchase, 1950
950-O-112

Head
Pencil on paper, 10 x 8" (25.40 x 20.32 cm.)
Signed, Eugene Speicher, lower right
Museum purchase, 1959
959-D-105

Francis SPEIGHT, (1896–1989)

End of the Street
Oil on canvas, 17.5 x 34" (44.45 x 86.36 cm.)
Signed, Francis Speight, lower left
Museum purchase, 1946
946-O-106

Niles SPENCER, (1893–1952)

The Watch Factory, 1950
Oil on canvas, 28 x 42" (71.12 x 106.68 cm.)
Signed, Niles Spencer, lower left
Museum purchase, 1950
950-O-113

Jug and Gravy Boat, 1930
Gouache on paper, 23 x 14.5" (58.42 x 36.83 cm.)
Unsigned
Museum purchase, 1967
967-W-117

Provincetown, 1930
Brush and ink on paper, 13 x 16" (33.02 x 40.64 cm.)
Signed, Spencer, lower right
Museum purchase, 1966
966-D-102

White Factory, Paris, 1928
Crayon on paper, 14.5 x 11.5" (36.83 x 29.21 cm.)
Unsigned
Museum purchase, 1966
966-D-104

R. B. SPENCER, (active late 19th–early 20th century)

Ship: *Competitor*
Oil on canvas, 24 x 36" (60.96 x 91.44 cm.)
Signed, R. B. Spencer, lower right
Museum purchase, 1928
S28-O-108

Arthur Watson Sparks - Woman Sewing in Garden

Speicher - Portrait of a Lady

Speicher - Portrait of Grace H. Butler

Speight - End of the Street

Niles Spencer - The Watch Factory

Niles Spencer - Jug and Gravy Boat

Stamos - Abstraction

Stanczak - Reminiscent

Stankiewicz - (Untitled)

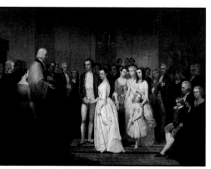

Stearns - The Marriage of Washington

Louis SPITZ, (active late 20th century)

Variations on Eve
Silkscreen on paper, 27 x 21" (68.58 x 53.34 cm.)
Signed, Louis Spitz, lower right
Gift of Louis Spitz, 1978
978-P-133

Carl SPRINCHORN, (active late 20th century)

Lady with Fan
Charcoal on paper, 14.5 x 9.25" (36.83 x 23.50 cm.)
Signed, Carl Sprinchorn, lower left
Gift of Virginia Zabriskie, 1991
991-D-132

Lumberjack
Crayon on paper, 9 x 11" (22.86 x 27.94 cm.)
Signed, Carl Sprinchorn, lower left
Gift of Virginia Zabriskie, 1991
991-D-133

Robert SPRINGFELS, (active late 20th century)

Composition #33
Oil on canvas, 49 x 36" (124.46 x 91.44 cm.)
Signed, Springfels, lower right
Museum purchase, 1968
968-O-189

Benton SPRUANCE, (1904–1967)

Bird Shapes, 1961
Color lithograph on paper, 15 x 26" (38.10 x 66.04 cm.)
Signed, Spruance, 61, lower right
Museum purchase, 1962
962-P-118

Return of the Hero, 1955
Lithograph on paper, 16 x 22" (40.64 x 55.88 cm.)
Signed, Spruance, 55, lower right
Museum purchase, 1955
955-P-109

The Artist–at Stone, 1942
Lithograph on paper, 14 x 19" (35.56 x 48.26 cm.)
Signed, Spruance, lower right
Museum purchase, 1973
973-P-118

Theodorus STAMOS, (1922–)

Abstraction, 1946
Oil on canvas, 16 x 20" (40.64 x 50.80 cm.)
Signed, Stamos, 46, lower left
Gift of George Poindexter, 1955
955-O-137

West Side Artists–New York, 1964
Lithograph on paper, 38 x 24" (96.52 x 60.96 cm.)
Signed, Stamos, lower right
Museum purchase, 1980
980-P-154

Julian STANCZAK, (1928–)

Reminiscent
Oil on canvas, 72 x 53.5" (182.88 x 135.89 cm.)
Unsigned
Museum purchase, 1965
965-O-157

Richard P. STANKIEWICZ, (1922–1983)

(Untitled), 1973
Lithograph on paper, 12 x 9" (30.48 x 22.86 cm.)
Signed, R. Stankiewicz, lower left
Gift of Steven Feinstein, 1983
983-P-169

Francis STANSBURY, (1900–)

Rockport Harbour, 1967
Opaque watercolor on paper, 15 x 21" (38.10 x 53.34 cm.)
Unsigned
Museum purchase, 1967
967-W-114

Samuel Ward STANTON, (1870–1912)

The following two drawings, ink on paper, are a museum purchase, 1976

Badger State
8.5 x 13.5" (21.59 x 34.29 cm.)
976-D-106

Great Lakes Propeller *Badger State*, 1862
12.5 x 18.5" (31.75 x 46.99 cm.)
976-D-105

Junius Brutus STEARNS, (1810–1885)

The Marriage of Washington, 1849
Oil on canvas, 40 x 55" (101.60 x 139.70 cm.)
Signed, Stearns, 1849, lower right
Museum purchase, 1966
966-O-135

Life of George Washington, 1854
Colored lithograph on paper, 17.25 x 23.5" (43.82 x 59.69 cm.)
Unsigned
Museum purchase, 1966
966-P-145

Gordon STEELE, (1906–1961)

Construction #2
Oil on canvas, 23 x 43" (58.42 x 109.22 cm.)
Unsigned
Museum purchase, 1960
960-O-109

J. L. STEG, (1922–)

Ascent of the Red Balloon
Color collage and intaglio on paper, 30 x 9" (76.20 x 22.86 cm.)
Signed, J. L. Steg, lower right
Museum purchase, 1967
967-P-162

Moonscape, 1963
Lithograph on paper, 24 x 38" (60.96 x 96.52 cm.)
Signed, J. L. Steg, 63, lower right
Museum purchase, 1963
963-P-140

Susan STEIG, (active late 20th century)

Window and Summer Shoes, 1975
Oil on canvas, 20 x 22" (50.80 x 55.88 cm.)
Signed, S. S., lower right
Gift of Susan Steig, 1979
979-O-123

Harve STEIN, (1904–)

Suzanne

Watercolor on paper, 20 x 16" (50.80 x 40.64 cm.)
Signed, Harve Stein, lower right
Gift of Dr. John J. McDonough, 1969
969-W-123

Saul STEINBERG, (1914–)

Sam's Art

New York International: Portfolio of Ten Prints, (210/225)
Lithograph on paper, 22 x 17" (55.88 x 43.18 cm.)
Signed, S. S., lower right
Museum purchase, 1966
966-P-137.2

Joseph S. STELLA, (1879–1946)

Steel Worker, 1908

Charcoal on paper, 23.5 x 17" (59.69 x 43.18 cm.)
Signed, J. S. Stella, lower left
Gift of Carl Dennison, 1975
975-D-113

Janine STERN, (active late 20th century)

A Place Where Water Can Be Obtained, 1989

Color pencil on roofing paper, 65.5 x 65" (166.37 x 165.10 cm.)
Signed, Janine Stern, lower right
Museum purchase, 1992
992-D-101

Rosalyn STERN, (active late 20th century)

Secret Forest

Color etching on paper, 17.75 x 15" (45.09 x 38.10 cm.)
Signed, Rosalyn Stern, lower right
Gift of Donald Pierce, 1978
978-P-119

Harry STERNBERG, (1904–)

Fascism

Serigraph on paper, 18.75 x 23" (47.63 x 58.42 cm.)
Signed, H. Sternberg, lower right
Gift of Albert E. Hise, 1979
979-P-159

Harlequin

Silkscreen on paper, 17.75 x 4.5" (45.09 x 11.43 cm.)
Unsigned
Gift of Louis Held, 1967
967-P-119

Albert STERNER, (1863–1946)

Girl on Bed

Conte crayon on paper, 8 x 11" (20.32 x 27.94 cm.)
Signed, Sterner, lower left
Museum purchase, 1965
965-D-129

Edward John STEVENS, Jr., (1923–1988)

Island Madonna, 1946

Gouache on paper, 21 x 18" (53.34 x 45.72 cm.)
Signed, Edward John Stevens, Jr., 1946, lower right
Gift of Mr. and Mrs. Milton Lowenthal, 1951
951-W-104

Jungle Bird, 1946

Etching on paper, 12 x 9" (30.48 x 22.86 cm.)
Signed, Edward John Stevens, Jr., 1946, lower right
Gift of Louis Held, 1965
965-P-136

Beulah STEVENSON, (1880–1965)

Still Life, 1948

Oil on masonite, 28 x 22" (71.12 x 55.88 cm.)
Signed, Beulah Stevenson, lower left
Gift of Dorothy Paris, 1977
977-O-126

Twins, (From Canyon Rd. de Corba), 1948

Oil on canvas board, 16 x 20" (40.64 x 50.80 cm.)
Signed, Beulah Stevenson, lower left
Gift of Jack M. Hockett, 1977
977-O-127

The Butler Institute's collection contains eight etchings on paper of various sizes which are the gift of Louis Held, 1966
966-P-101 — 966-P-103
966-P-107 — 966-P-108
966-P-110 — 966-P-112

The Butler Institute's collection contains five lithographs on paper of various sizes which are the gift of Louis Held, 1966
966-P-104 — 966-P-106
966-P-109
966-P-113

John STICKNEY, (active late 20th century)

(Untitled)

Portfolio of 53: Rip Off on the Last Millennium
Print on paper, 8.5 x 11" (21.59 x 27.94 cm.)
Signed, John Stickney, on reverse
Gift of the William Busta Gallery, 1990
990-P-111.28

Rolf STOLL, (1892–1978)

Australian Pines by Lake Worth, 1964

Oil on canvas, 24 x 30" (60.96 x 76.20 cm.)
Signed, Rolf Stoll, lower left
Gift of Mrs. Rolf Stoll, 1981
981-O-115

Segorian Gypsy

Oil on canvas, 45 x 33" (114.30 x 83.82 cm.)
Signed, Rolf Stoll, lower left
Gift of Frank S. Morris, 1958
958-O-161

The following two oils on board are the gift of Mrs. Rolf Stoll, 1981

Ballerina

30 x 25" (76.20 x 63.50 cm.)
981-O-101

Lilies and Snapdragons

18 x 22" (45.72 x 55.88 cm.)
981-O-102

Still Life with Amaryllis

Mixed media on panel, 30 x 24" (76.20 x 60.96 cm.)
Signed, Rolf Stoll, upper left
Gift of Mrs. Rolf Stoll, 1981
981-O-114

Steinberg - Sam's Art

Stella - Steel Worker

Janine Stern - A Place Where Water Can Be Obtained

Stevens - Island Madonna

Stoll - Segorian Gypsy

Strater - Birch and Hemlocks

Street - Portrait of a Man

Stuart - Portrait of Mr. Webb

Stubbs - *Oneida*

Sully - Mother and Child

The following three works are a gift of the estate of Maria Stoll, 1982

Basque Village, 1926
Watercolor on paper, 11.75 x 17" (29.85 x 43.18 cm.)
Signed, Rolf Stoll, lower left
982-W-104

Granada Gypsy, 1926
Mixed media on board, 13.5 x 11.75" (34.29 x 29.85 cm.)
Signed, Rolf Stoll, lower left
982-W-103

Melancholy Adalusia, 1926, 1929
Watercolor and pencil on paper, 12 x 18" (30.48 x 45.72 cm.)
Signed, Rolf Stoll, lower right
982-W-102

William E. STONE, (1895–1982)

East Side Bar, 1946
Oil on canvas, 28 x 32" (71.12 x 81.28 cm.)
Signed, W. E. Stone, lower right
Gift of the Friends of American Art, 1947
947-O-113

Main and Mechanic
Watercolor on paper, 19 x 25" (48.26 x 63.50 cm.)
Signed, W. E. Stone, lower right
Museum purchase, 1956
956-W-109

William E. STORY, (1925–)

Geryon
Oil on canvas, 42 x 34" (106.68 x 86.36 cm.)
Unsigned
Museum purchase, 1957
957-O-129

Gregory STRACHOV, (active late 20th century)

Morning Granite, 1987
Watercolor on paper, 22 x 30" (55.88 x 76.20 cm.)
Signed, Strachov, lower right
Museum purchase, 1989
989-W-104

Henry STRATER, (1896–1987)

Birch and Hemlocks, 1925
Oil on canvas, 30 x 30" (76.20 x 76.20 cm.)
Signed, Strater, lower right
Gift of Robert Marston, 1966
966-O-105

Robert STREET, (1796–1865)

Portrait of a Man, 1856
Oil on canvas, 30 x 25" (76.20 x 63.50 cm.)
Unsigned
Museum purchase, 1966
966-O-120

Gilbert STUART, (1755–1828)

Portrait of Mr. Webb, ca. 1787
Oil on canvas, 29 x 24" oval (73.66 x 60.96 cm.)
Unsigned
Museum purchase, 1921
921-O-110

William P. STUBBS, (1842–1909)

Oneida, 1855
Oil on canvas, 22 x 36" (55.88 x 91.44 cm.)
Signed, W. P. Stubbs, lower left
Museum purchase, 1968
968-O-162

Jack STUPPIN, (active late 20th century)

Firestone Oak, 1993
Acrylic on canvas, 30 x 20" (76.20 x 50.80 cm.)
Signed, Jack Stuppin, 1993, lower right
Gift of Erle L. Flad, 1995
995-O-102

Joy STUTTMAN, (1929–)

The following two works on paper, 6 x 4" (15.24 x 10.16 cm.), are the gift of Mr. and Mrs. Irving White, 1961

Abstraction, 1952
961-P-103 — 961-P-104

Ed SULLIVAN, (active late 20th century)

Chimney Sweep
Ink on paper, 17.25 x 9.5" (43.82 x 24.13 cm.)
Signed, Sullivan, lower right
Gift of Eleanor Beecher Flad, 1991
991-D-112

Thomas SULLY, (1783–1872)

Mother and Child, 1827
Oil on canvas, 26.5 x 43.5" (67.31 x 110.49 cm.)
Unsigned
Gift of Dr. John J. McDonough, 1970
970-O-121

Portrait – Elizabeth Wignal, 1814
Oil on mounted canvas, 23.75 x 17.75" (60.33 x 45.09 cm.)
Signed, T. S., 1814, lower right
Museum purchase, 1929
929-O-105

Martin SUMERS, (1922–)

31 Rue Miller
Oil on panel, 30 x 40" (76.20 x 101.60 cm.)
Signed, Martin Sumers, upper left
Gift of Mr. and Mrs. Irwin Lefcourt, 1967
967-O-140

Parade of the Possessed
Oil on masonite, 36.5 x 48.5" (92.71 x 123.19 cm.)
Signed, Martin Sumers, upper left
Gift of Leonard Bocour, 1968
969-O-157

Pink Lady, 1969
Oil on masonite, 36 x 24" (91.44 x 60.96 cm.)
Signed, Martin Sumers, on reverse
Gift of Mr. and Mrs. Leonard Bocour, 1976
976-O-108

Carl SUNDBERG, (1928–)

Resurrection, 1970
Enamel and gold on steel, 36 x 16" (91.44 x 40.60 cm.)
Unsigned
Museum purchase, 1970
970-O-107

Exhibition Poster, 1970
Serigraph on paper, 13.5 x 8.5" (34.29 x 21.59 cm.)
Signed, Carl Sundberg, lower right
Anonymous gift, 1971
971-P-113

Milt SURREY, (1922–)

Tropical Night, 1969
Oil on canvas, 40 x 20" (101.60 x 50.80 cm.)
Signed, Surrey, lower right
Gift of Milt Surrey, 1971
971-O-105

Diana W. SUTHERLAND, (active late 20th century)

Smoke Hole, 1973
Acrylic on canvas, 41 x 72" (104.14 x 182.88 cm.)
Unsigned
Museum purchase, 1973
973-O-117

Donald SUTPHIN, (1926–)

Duomo, 1961
Color woodcut on paper, 8 x 10" (20.32 x 25.40 cm.)
Signed, Sutphin, 1961, lower right
Gift of Collectors of American Art, 1963
963-P-101

SWANN, (active 20th century)

The following two signed etchings on paper are a museum purchase, 1979

Fort McHenry, Baltimore
9 x 13.75" (22.86 x 34.93 cm.)
979-P-153

Liberty Ship, 1944
9.75 x 13.75" (24.77 x 34.93 cm.)
979-P-147

Megan SWEENEY, (active late 20th century)

(Untitled)
Portfolio of 53: Rip Off on the Last Millennium
Print on paper, 8.5 x 11" (21.59 x 27.94 cm.)
Signed, M. Sweeney, lower right
Gift of the William Busta Gallery, 1990
990-P-111.29

Gardner SYMONS, (1863–1930)

Silence and Evening Light
Oil on canvas, 50 x 60" (127.00 x 152.40 cm.)
Signed, Gardner Symons, lower right
Museum purchase, 1919
919-O-112

Augustus Vincent TACK, (1870–1949)

Figures and Evening Sky
Oil on canvas, 18 x 12" (45.72 x 30.48 cm.)
Signed, Augustus Vincent Tack, lower left
Gift of Mr. and Mrs. Solton Engle, 1955
955-O-138

Seaside Scene
Oil on canvas, 24 x 18" (60.96 x 45.72 cm.)
Signed, Augustus Vincent Tack, lower right
Gift of Mr. and Mrs. Solton Engle, 1955
955-O-139

Arthur Fitzwilliam TAIT, (1819–1905)

Barnyard, 1860
Oil on canvas, 16 x 26" (40.64 x 66.04 cm.)
Signed, A. F. Tait, 1860, lower right
Museum purchase, 1948
948-O-121

Reuben TAM, (1916–)

Flounder, 1947
Oil on canvas, 18 x 24" (45.72 x 60.96 cm.)
Signed, Tam, '47, lower right
Museum purchase, 1947
947-O-110

Canon, 1943
Serigraph on paper, 13 x 19.75" (33.02 x 50.17 cm.)
Signed, Reuben Tam, lower right
Gift of Albert E. Hise, 1979
979-P-140

Sandi Knell TAMNY, (active late 20th century)

(Untitled)
Portfolio of 53: Rip Off on the Last Millennium
Print on paper, 8.5 x 11" (21.59 x 27.94 cm.)
Signed, Sandi Knell Tamny, lower left
Gift of the William Busta Gallery, 1990
990-P-111.41

Chuzo TAMOTZU, (1891–1975)

Horse and Wagon
Watercolor on paper, 12.5 x 15.75" (31.75 x 40.01 cm.)
Signed, Chuzo Tamotzu, lower right
Gift of Mr. and Mrs. Nahum Tschacbasov, 1975
975-W-112

Edmund C. TARBELL, (1862–1938)

Equestrian Figures, 1927
Pencil on paper, 8.5 x 11.5" (21.59 x 29.21 cm.)
Signed, Tarbell, 1927, lower right
Museum purchase, 1965
965-D-134

Lady in Profile
Etching on paper, 12.62 x 10" (32.05 x 25.40 cm.)
Signed, Edmund C. Tarbell, lower left
Museum purchase, 1968
968-P-256

Florence TATE, (dates unknown)

Edinburg–The Talbotts
Etching on paper, 10 x 7.5" (25.40 x 19.05 cm.)
Signed, Florence Tate, lower right
Gift of Albert E. Hise, 1979
979-P-124

Helene TATERKA, (active 20th century)

Magic Forest
Mixed media and collage on paper, 21 x 29.25" (53.54 x 74.30 cm.)
Signed, Taterka, lower left
Gift of Michael Taterka, 1978
978-W-105

Sully - Portrait – Elizabeth Wignal (page 170)

Symons - Silence and Evening Light

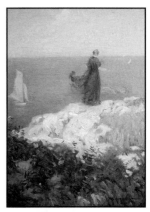

Tack - Seaside Scene

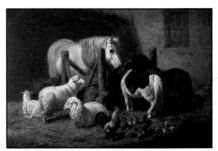

Tait - Barnyard

Tarbell - Equestrian Figures

Taubes - The Burning Bush

Tecau - Rebrum

Thayer - Meditation

Bill Thompson - Four New Tires

Ralston Thompson - Altar

Frederic TAUBES, (1900–)

The Burning Bush, 1944
Oil on canvas, 30.25 x 30" (76.84 x 76.20 cm.)
Signed, Taubes, lower left
Gift of Timothy E. Taubes, 1983
983-O-101

John TAYLOR, (active 20th century)

New Town, 1950
Lithograph on paper, 12.5 x 18" (31.75 x 45.72 cm.)
Signed, John Taylor, lower right
Gift of Joseph G. Butler, III, 1980
980-P-124

Prentiss TAYLOR, (1907–)

The Spanish Steps from Above, 1966
Lithograph on paper, 13.75 x 18.75" (34.93 x 47.63 cm.)
Signed, Prentiss Taylor, lower right
Museum purchase, 1968
968-P-241

Ron TAYLOR, (active late 20th century)

Blacksburg Hills
Oil on canvas, 45 x 55" (114.30 x 139.70 cm.)
Signed, Taylor, lower right
Gift of Ron Taylor, 1992
992-O-113

Ruth P. TAYLOR, (1900–)

Napeaque Dunes
(Beach—Hampton Scene), 1940
Watercolor on paper, 17.5 x 22.5" (44.45 x 57.15 cm.)
Signed, Ruth P. Taylor, lower right
Gift of Ruth P. Taylor, 1978
978-W-103

Apple Tree, 1942
Woodcut on paper, 5.5 x 7.5" (13.97 x 19.05 cm.)
Signed, Ruth P. Taylor, lower right
Gift of Ruth P. Taylor, 1978
978-P-114

Orchard Grass, 1956
Woodblock on paper, 19.5 x 11.5" (49.53 x 29.21 cm.)
Signed, Ruth P. Taylor, lower right
Gift of Ruth P. Taylor, 1978
978-P-111

Troy TECAU, (active late 20th century)

Rebrum, 1992
Oil on basswood panel, 84 x 60" (213.36 x 152.40 cm.)
Unsigned
Museum purchase, 1994
994-O-107

Sabina TEICHMAN, (1905–1983)

Travail
Oil on canvas, 34 x 27" (86.36 x 68.58 cm.)
Signed, Sabina Teichman, lower right
Museum purchase, 1958
958-O-104

Nude Study
Ink on paper, 14.25 x 10.5" (36.20 x 26.67 cm.)
Signed, Sabina Teichman, lower left
Museum purchase, 1964
964-D-106

The Nest
Lithograph on paper, 14.5 x 11" (36.83 x 27.94 cm.)
Signed, Sabina Teichman, lower middle
Museum purchase, 1964
964-P-117

Jefferson TESTER, (1900–)

Eastside
Oil on canvas, 13.5 x 6.5" (34.29 x 16.51 cm.)
Signed, Tester, lower left
Gift of Louis Held, 1965
965-O-139

Lee TETER, (active late 20th century)

Reflections, 1988
Lithograph on paper, 19 x 25.5" (48.26 x 64.77 cm.)
Signed, ©1988, Lee Teter, lower right
Gift of the Vietnam Veterans of America, 1992
992-P-106

John TEYRAL, (1912–)

Algerian Soldiers, 1944
Oil on canvas, 38 x 29" (96.52 x 73.66 cm.)
Signed, Teyral, 1944, upper left
Museum purchase, 1945
945-O-106

Abbott Handerson THAYER, (1849–1921)

Meditation, 1903
Oil on canvas, 24 x 19" (60.96 x 48.26 cm.)
Signed, Abbott H. Thayer, 1903, upper right
Museum purchase, 1922
922-O-107

Valfred P. THELIN, (1934–)

Harbor Lights, 1964
Opaque watercolor on paper, 28.5 x 38.5" (72.39 x 97.79 cm.)
Signed, Val, lower left
Museum purchase, 1964
964-W-108

Ronald THOMASON, (active 20th century)

The following two signed lithographs on paper
are the gift of Baker Collector Gallery, 1970

Bypassed
13 x 17.25" (33.02 x 43.82 cm.)
970-P-159

Sand Pasture
10.75 x 15" (27.31 x 38.10 cm.)
970-P-158

Bill THOMPSON, (1926–)

Four New Tires
Acrylic on wood, 31 x 31" (78.74 x 78.74 cm.)
Signed, Bill Thompson, on reverse
Gift of Bill Thompson, 1993
993-O-114

Ralston THOMPSON, (1904–1977)

The following seven unsigned oils on canvas are
the gift of Mrs. Ralston Thompson, 1977

Altar
37 x 49" (93.98 x 124.46 cm.)
977-O-133

Coastal Images
36 x 48" (91.44 x 121.92 cm.)
977-O-134

Guadalupe
26 x 44" (66.04 x 111.76 cm.)
977-O-132

Harbor
29.5 x 39.5" (74.93 x 100.33 cm.)
977-O-136

Music Flowers
24 x 32" (60.96 x 81.28 cm.)
977-O-137

Sunday Afternoon, Summer
30 x 40" (76.20 x 101.60 cm.)
977-O-138

Tidal Pool, No. 1
36 x 48" (91.44 x 121.92 cm.)
977-O-135

The Grudge
Watercolor on paper, 17 x 27" (43.18 x 68.58 cm.)
Unsigned
Museum purchase, 1948
948-W-107

The following two unsigned watercolors, casein on paper, are the gift of Mrs. Ralston Thompson, 1977

Acapulco
22 x 28" (55.88 x 71.12 cm.)
977-W-109

Taxco Wash Woman
22.25 x 29" (56.52 x 73.66 cm.)
977-W-108

Evening No. 2
Drawing on paper, 14 x 19" (35.56 x 48.26 cm.)
Signed, Ralston Thompson, lower right
Gift of the Friends of American Art, 1946
946-D-101

The Garden, No. 4
Ink wash on paper, 22 x 31" (55.88 x 78.74 cm.)
Unsigned
Gift of Mrs. Ralston Thompson, 1977
977-D-103

The following two signed drawings, ink on paper, are the gift of Joseph G. Butler, III, 1977

American Constant
15.25 x 20.75" (38.74 x 52.71 cm.)
977-D-111

Ohio Farm
9 x 12" (22.86 x 30.48 cm.)
977-D-106

William THOMSON, (1931–)

Fire Fighter, 1962
Watercolor on paper, 24 x 36" (60.96 x 91.44 cm.)
Unsigned
Museum purchase, 1962
962-W-106

William THON, (1906–)

Sunburst
Watercolor on paper, 21 x 29" (53.34 x 73.66 cm.)
Signed, Thon, lower right
Museum purchase, 1956
956-W-110

Freeman THORP, (1844–1922)

Chauncey Andrews, 1890
Oil on canvas, 30 x 25" (76.20 x 63.50 cm.)
Signed, Thorp, 1890, lower left
Gift of Leslie Bruce and sister, 1955
955-O-140

Arthur THRALL, (1926–)

Ceremonial Document
Etching on paper, (21/30), 22 x 14" (55.88 x 35.56 cm.)
Signed, Arthur Thrall, lower right
Museum purchase, 1965
965-P-202

Donald THRALL, (1918–)

Entrance, 1949
Watercolor on paper, 18 x 25" (45.72 x 63.50 cm.)
Signed, D. Thrall, 1949, lower left
Museum purchase, 1950
950-W-128

Walasse TING, (1929–)

Fireworks
Lithograph on paper, 15 x 22" (38.10 x 55.88 cm.)
Signed, Ting, upper left
Museum purchase, 1992
992-P-122

Victor TISCHLER, (1890–1951)

Slope, 1942
Oil on canvas, 20 x 24" (50.80 x 60.96 cm.)
Signed, V. Tischler, lower left
Gift of Mr. and Mrs. Frederick Serger, 1956
956-O-110

Mark TOBEY, (1890–1976)

The Renaissance of a Flower
Lithograph on paper, (14/22), 25.75 x 19.62" (65.41 x 49.83 cm.)
Signed, Tobey, lower right
Museum purchase, 1983
983-P-141

The following two signed lithographs on paper are the gift of Paul and Suzanne Donnelly Jenkins, 1991

(Untitled), 1970
22 x 18" (55.88 x 45.72 cm.)
991-P-130

(Untitled)
25.25 x 19.5" (64.14 x 49.53 cm.)
991-P-131

Jennings TOFEL, (1892–1959)

Self Portrait
Oil on canvas, 22 x 18" (55.88 x 45.72 cm.)
Signed, Tofel, lower right
Gift of Joseph H. Hirshhorn, 1948
948-O-122

Thon - Sunburst

Thorp - Chauncey Andrews

Ting - Fireworks

Tobey - The Renaissance of a Flower

Tobey - (Untitled) (991-P-130)

Toney - Elevated at 125th Street

Trapp - Back Door to Heaven

Travis - South Pacific Bouquet

Treaster - Cellar Stairs

Marjorie TOMCHUK, (1933–)

Midwest Gothic
Etching on paper, (55/100), 27.75 x 20" (70.49 x 50.80 cm.)
Signed, M. Tomchuk, lower right
Museum purchase, 1976
976-P-118

Van Veet TOMPKINS, (active 20th century)

The following two signed oils on canvas are the
gift of Mrs. William V. Miller, 1961

August, 1933
30 x 24" (76.20 x 60.96 cm.)
961-O-144

Midnight, 1938
24 x 30" (60.96 x 76.20 cm.)
961-O-143

Anthony TONEY, (1913–)

Discontinuity, 1974
Oil on canvas, 60 x 50" (152.40 x 127.00 cm.)
Signed, Toney, lower left
Gift of the Ranger Fund, 1981
981-O-103

Elevated at 125th Street, 1955
Oil on canvas, 17 x 20" (43.18 x 50.80 cm.)
Signed, Toney, '55, lower left
Gift of Louis Held, 1965
965-O-119

Atlantic City, 1943
Pen and ink on paper, 8 x 11" (20.32 x 27.94 cm.)
Signed, Toney, 43, lower right
Gift of Louis Held, 1965
965-D-104

Washing Down, 1943
Pen and ink on paper, 9.5 x 13.5" (24.13 x 34.29 cm.)
Signed, Toney, 43, lower right
Gift of Harry Salpeter Gallery, 1957
957-D-102

Frank Anderson TRAPP, (1922–)

Back Door to Heaven, 1941
Oil on canvas, 24 x 30" (60.96 x 76.20 cm.)
Signed, Frank A. Trapp, lower right
Gift of Paul and Suzanne Donnelly Jenkins, 1991
991-O-112

Circus, 1949-50
Oil on panel, 46 x 70" (116.84 x 177.80 cm.)
Unsigned
Gift of Frank Anderson Trapp, 1991
991-O-114

Paul B. TRAVIS, (1891–1975)

South Pacific Bouquet
Oil on canvas, 35 x 25" (88.90 x 63.50 cm.)
Unsigned
Gift of the Friends of American Art, 1946
946-O-108

War in the Sky
Watercolor on paper, 20 x 26.5" (50.80 x 67.31 cm.)
Unsigned
Gift of Anna Fell Rothstein, 1958
958-W-101

Studio Window
Lithograph on paper, 11.75 x 9" (29.85 x 22.86 cm.)
Signed, Paul B. Travis, lower right
Gift of Joseph G. Butler, III, 1980
980-P-125

Leonard TRAWICK, (active late 20th century)

The following two signed lithographs on paper,
8.5 x 11" (21.59 x 27.94 cm.), are the gift of the
William Busta Gallery, 1990

Head of Coleridge
Portfolio of 53: Rip Off on the Last Millennium
990-P-111.39

(Untitled)
Portfolio of 53: Rip Off on the Last Millennium
990-P-111.17

Richard A. TREASTER, (1932–)

Cellar Stairs, 1963
Watercolor on paper, 18 x 26.5" (45.72 x 67.31 cm.)
Signed, Treaster, '63, upper right
Museum purchase, 1964
964-W-107

Sketch of School Window
Watercolor on paper, 14 x 5" (35.56 x 12.70 cm.)
Signed, Treaster, lower left
Gift of Richard A. Treaster, 1995
995-W-101

Harry E. TREUSCH, (active 20th century)

Watermelon, 1955
Oil on canvas, 30 x 24" (76.20 x 60.96 cm.)
Signed, T., 1955, lower right
Museum purchase, 1958
958-O-121

Marco A. TRICCA, (1880–1969)

Landscape in the Manner of Cézanne
Oil on canvas, 22 x 30" (55.88 x 76.20 cm.)
Signed, M. A. Tricca, lower left
Gift of Ernestina Tricca, 1974
974-O-119

Abram TROMKA, (1896–1954)

Landscape
Oil on canvas, 34 x 28" (86.36 x 71.12 cm.)
Signed, Tromka, lower right
Gift of David Teichman, 1958
958-O-105

Laughing Man
Oil on canvas, 11 x 9" (27.94 x 22.86 cm.)
Signed, Tromka, upper left
Gift of Louis Held, 1965
965-O-127

Steel Town, ca. 1948
Oil on canvas, 30 x 36" (76.20 x 91.44 cm.)
Signed, Tromka, lower right
Gift of Mrs. Abram Tromka, 1964
964-O-103

John TRUMBULL, (1756–1843)

Washington Portrait, (The Father of Our Country)
Public Ledger Portrait
Engraving on paper, 10 x 9.25" (25.40 x 23.50 cm.)
Unsigned
Museum purchase, 1968
968-P-297

The Battle of Bunker Hill near Boston
Engraving on paper, 19.5 x 29.75" (49.53 x 75.57 cm.)
Unsigned
Museum purchase, 1971
971-P-101

Dwight William TRYON, (1849–1925)

Autumn Evening, 1913
Oil on canvas, 19 x 29" (48.26 x 73.66 cm.)
Signed, D. W. Tryon, 1913, lower left
Gift of the estate of H. H. Stambaugh, 1919
919-O-113

Nahum TSCHACBASOV, (1899–1984)

Green Nude by the Sea, 1941
Oil on canvas, 20 x 24" (50.80 x 60.96 cm.)
Signed, Tschacbasov, lower right
Gift of Dr. Bernard Kronenberg, 1958
958-O-126

Portrait of a Young Girl, 1968
Oil on canvas, 36 x 30" (91.44 x 76.20 cm.)
Signed, Tschacbasov, 68, lower left
Gift of Stanley Bard, 1969
969-O-167

The Bride, 1961
Oil on canvas, 48 x 37" (121.92 x 93.98 cm.)
Signed, Tschacbasov, 61, lower right
Gift of Mr. and Mrs. Nahum Tschacbasov, 1963
963-O-135

The Voyage, 1963
Oil on canvas, 30 x 40" (76.20 x 101.60 cm.)
Signed, Tschacbasov, '63, lower right
Gift of Mr. and Mrs. Nahum Tschacbasov, 1965
966-O-103

(Untitled), 1970
Oil on canvas, 30 x 40" (76.20 x 101.60 cm.)
Signed, Tschacbasov, upper left
Gift of Dr. George Conrad, 1971
972-O-101

Woman with Fan, 1944
Oil on canvas, 30 x 24" (76.20 x 60.96 cm.)
Signed, Tschacbasov, 44, upper right
Gift of Mr. and Mrs. Roy R. Neuberger, 1947
947-O-111

Young Girl with Birds, 1948
Oil on canvas, 12 x 9" (30.48 x 22.86 cm.)
Signed, Tschacbasov, 48, lower left
Gift of Mr. and Mrs. Charles Segal, 1955
955-O-141

The following eleven oils on canvas of various sizes are the gift of Samuel B. Cohen, 1953

Child with Doll, 1945
953-O-121

Egyptian Lady, 1945
953-O-129

Family with Flowers, 1944
953-O-130

Girl with Goat, 1946
953-O-131

Mother and Child
953-O-128

Oklahoma Landscape, 1944
953-O-132

On the Half Shell, 1945
953-O-141

Seascape, 1946
953-O-126

The Party Dress, 1947
953-O-123

Woman with Mirror, 1946
953-O-127

Xanadu, 1943
953-O-115

Group of Children
Pastel and acrylic on paper, 28 x 39.5" (71.12 x 100.33 cm.)
Signed, Tschacbasov, lower right
Gift of American Library Color Slide Co., Inc., 1980
980-W-105

Sunset, 1943
Watercolor on paper, 14 x 11" (35.56 x 27.94 cm.)
Signed, Tschacbasov, '43, lower right
Gift of Joseph H. Hirshhorn, 1948
948-W-108

Veranda in the Iceberg, 1975
Watercolor on paper, 28 x 22" (71.12 x 55.88 cm.)
Signed, Tschacbasov, lower right
Gift of Jonathan A. Berg, 1982
982-W-101

Fish Underwater, 1947
Etching on paper, 12 x 10" (30.48 x 25.40 cm.)
Signed, Tschacbasov, '47, lower right
Gift of Louis Held, 1965
965-P-168

The following three works on paper, etching, color woodcut, and oil are the gift of Mr. and Mrs. Irving White, 1961

Bird and Fish
961-P-101

Caprae
961-P-105

Profiles
961-O-167

Portfolio of Fifty Original Etchings
Aquatints and etchings on paper, various sizes
Gift of Mr. and Mrs. Nahum Tschacbasov, 1968
968-P-125

S. S. TUCKERMAN, (1830–1904)

Brig Becalmed—Gloucester Harbor, Mass.
Oil on canvas, 12 x 16" (30.48 x 40.64 cm.)
Signed, S. S. Tuckerman, lower left
Museum purchase, 1968
968-O-173

Trumbull - Washington Portrait, (The Father of Our Country)

Trumbull - The Battle of Bunker Hill near Boston

Tryon - Autumn Evening

Tschacbasov - Green Nude by the Sea

Tuckerman - Brig Becalmed—Gloucester Harbor, Mass.

Tudor - The Football Game

Twachtman - Landscape

Twitty - Points of View IV

Twombly - (Untitled)

Tworkov - T. L. No. VI

Unidentified Artist - Isaac Powers Farm and Mine

Rosamond TUDOR, (1878–1949)

The Football Game
Etching on canvas, 7.5 x 11.25" (19.05 x 28.58 cm.)
Signed, Tudor, lower left in plate, Rosamond Tudor, lower right
Gift of The Albany Gallery, 1988
988-P-108

Charles Yardley TURNER, (1850–1918)

Indian Girl
Oil on canvas, 26 x 22" (66.04 x 55.88 cm.)
Signed, Turner, lower right
Gift of Mrs. Charles F. Owsley, 1961
962-O-106

The following two oils on canvas, 30 x 20"
(76.20 x 50.80 cm.), are a gift of the estate of
Charles Yardley Turner, 1919

The Brave, 1910
919-O-504

The Squaw, 1910
919-O-503

John Henry TWACHTMAN, (1853–1902)

Landscape, 1889
Oil on canvas, 20 x 29" (50.80 x 73.66 cm.)
Signed, J. H. Twachtman, lower left
Museum purchase, 1937
937-O-101

Dock at Newport, 1893
Etching on paper, 4.75 x 6.75" (12.07 x 17.15 cm.)
Signed, J. H. T., lower right
Museum purchase, 1962
962-P-116

Stanley J. TWARDOWICZ, (1917–)

#35, 1968, 1968
Acrylic on canvas, 40 x 30" (101.60 x 76.20 cm.)
Signed, S. Twardowicz, lower left
Gift of Benjamin Weiss, 1971
971-O-103

Elliot TWERY, (1923–)

The Big City, 1958
Ink on paper, 16 x 22" (40.64 x 55.88 cm.)
Signed, Twery, '58, lower right
Museum purchase, 1959
959-D-117

James W. TWITTY, (1916–)

Points of View IV, 1989
Acrylic on linen, 60 x 60" (152.40 x 152.40 cm.)
Signed, Twitty, lower right
Gift of the Harmon-Meek Gallery, 1991
991-O-107

Cy TWOMBLY, (1928–)

(Untitled), 1973
Lithograph on paper, 12 x 9" (30.48 x 22.86 cm.)
Signed, C. T., on reverse
Gift of Steven Feinstein, 1983
983-P-170

Jack TWORKOV, (active late 20th century)

T. L. No. VI, 1978
Lithograph on paper, 15 x 19" (38.10 x 48.26 cm.)
Signed, Tworkov, 78, lower right
Gift of Ana and Eric Baer, 1992
992-P-120

Ansei UCHIMA, (1921–)

By the Lake, 1961
Woodblock on paper, 18.5 x 10.5" (46.99 x 26.67 cm.)
Signed, A. Uchima, 1961, lower right
Museum purchase, 1962
962-P-102

Michael J. ULICHNEY, (active late 20th
century)

Steve's Dream, 1981
Acrylic on canvas, 52 x 40" (132.08 x 101.60 cm.)
Signed, Michael Ulichney, '81, lower right
Museum purchase, 1981
981-O-109

Richard ULRICH, (1939–)

Praise to Lepore, 1964
Oil on canvas, 36 x 48" (91.44 x 121.92 cm.)
Unsigned
Museum purchase, 1964
964-O-116

Nancy UNDERHILL, (active late 20th century)

Nose Dive
Portfolio of 53: Rip Off on the Last Millennium
Print on paper, 8.5 x 14" (21.59 x 35.56 cm.)
Signed, Nancy Underhill, lower right
Gift of the William Busta Gallery, 1990
990-P-111.11

UNIDENTIFIED ARTISTS

Georgie C. Dickson
Oil on canvas, 24 x 34" (60.96 x 86.36 cm.)
Unsigned
Museum purchase, 1977
977-O-157

Girl in Green Dress
Oil on canvas, 17.25 x 13.25" (43.82 x 33.66 cm.)
Unsigned
Gift of Blanche Lewis, 1977
977-O-145

Half-nude by the Sea
Tempera on board, 13.75 x 9.37" (34.93 x 23.81 cm.)
Unsigned
Gift of Zell Draz, 1982
982-O-103

Harbor, Milwaukee, 1875
Oil on canvas, 8.75 x 16" (22.23 x 40.64 cm.)
Signed, J. R. S., lower right
Gift of Bernice H. Kent, 1968
968-O-206

Isaac Powers Farm and Mine, ca. 1800
Oil on canvas, 37 x 50" (93.98 x 127.00 cm.)
Unsigned
Gift of Sydna E. Smith, 1977
977-O-140

James Reed Clark
Oil on canvas, 22.12 x 17.12" (56.18 x 43.48 cm.)
Unsigned
Gift of Mrs. William L. Litle, 1979
979-O-105

Man in Yellow Vest, ca. 1850
Oil on canvas, 25 x 30" (63.50 x 76.20 cm.)
Unsigned
Museum purchase, 1967
967-O-124

Man with Ledger, ca. 1835
Oil on canvas, 33 x 26" (83.82 x 66.04 cm.)
Unsigned
Gift of Edith Halpert, 1952
952-O-106

Midshipman, ca. 1850
Oil on canvas, 26 x 20" (66.04 x 50.80 cm.)
Unsigned
Museum purchase, 1965
965-O-146

Portrait of Anne Alison (Reed) Clark
Oil on canvas, 30.25 x 25.25" (76.84 x 64.14 cm.)
Unsigned
Gift of Mrs. William L. Litle, 1976
976-O-137

Portrait of General William Tecumseh Sherman
Oil on canvas, 30 x 25.25" (76.20 x 64.14 cm.)
Unsigned
Gift of Grace Butler McGraw, 1923
923-O-136

Portrait of John Stambaugh
Oil on canvas, 28 x 22" (71.12 x 55.88 cm.)
Unsigned
Gift of Mrs. W. J. Fritz, 1968
968-O-166

Portrait of Wick Ancestor, ca. 1800
Oil on canvas, 32 x 24" (81.28 x 60.96 cm.)
Unsigned
Gift of the estate of Almira A. Wick, 1981
981-O-113

Portrait
Oil on canvas, 30 x 25" (76.20 x 63.50 cm.)
Unsigned
Museum purchase, 1965
965-O-145

Ship: *Castine*
Oil on canvas, 30 x 44" (76.20 x 111.76 cm.)
Unsigned
Museum purchase, 1929
S29-O-102

Ship: *Hermaphrodite* Brig
Oil on canvas, 22 x 27" (55.88 x 68.58 cm.)
Unsigned
Museum purchase, 1928
S28-O-117

Ship: *Great Republic*
Oil on canvas, 28 x 39" (71.12 x 99.06 cm.)
Signed, O. M. G., lower right
Museum purchase, 1928
S29-O-107

Ship: *Jacob Jones*
Oil on canvas, 18 x 35" (45.72 x 88.90 cm.)
Unsigned
Museum purchase, 1928
S28-O-115

Ship: *Oneida*
Oil on canvas, 24 x 30" (60.96 x 76.20 cm.)
Unsigned
Museum purchase, 1928
S28-O-114

Ship: *Queen Victoria*, Off the Azores
Oil on canvas, 29 x 37" (73.66 x 93.98 cm.)
Unsigned
Museum purchase, 1928
S28-O-116

Ship: *Susan Howland*
Oil on canvas, 30 x 42" (76.20 x 106.68 cm.)
Unsigned
Museum purchase, 1929
S29-O-101

Still Life–Currants, ca. 1890
Oil on canvas, 13.5 x 18" (34.29 x 45.72 cm.)
Unsigned
Museum purchase, 1968
968-O-168

The Judge's Watch, ca. 1911
Oil on canvas, 38 x 30" (96.52 x 76.20 cm.)
Unsigned
Gift of the estate of Charles R. Truesdale, 1977
977-O-107

Woman with Apple, ca. 1835
Oil on canvas, 33 x 26" (83.82 x 66.04 cm.)
Unsigned
Gift of Edith Halpert, 1952
952-O-105

Heavy Nude Figure
Watercolor on paper, 14 x 12" (35.56 x 30.48 cm.)
Unsigned
Gift of Louis Held, 1965
965-W-118

Portrait of Blanche Butler Ford
Watercolor on paper, 19.5 x 15.5" (49.53 x 39.37 cm.)
Unsigned
Gift of Joseph G. Butler, III, 1980
980-W-102

(Untitled), (Indians and Pottery)
Watercolor on paper, 11 x 9" (27.94 x 22.86 cm.)
Unsigned
Gift of Harry Winter, 1992
992-W-105

Still Life, ca. 1800
Pastel on paper, 8 x 10" (20.32 x 25.40 cm.)
Unsigned
Gift of Paul Magriel, 1962
962-W-111

Head and Hand, 1944
Drawing on paper, 10 x 9" (25.40 x 22.86 cm.)
Signed, N. L., July 29, '44, lower right
Gift of Louis Held, 1965
965-D-118

Unidentified Artist - Ship: *Great Republic*

Unidentified Artist - Ship: *Jacob Jones*

Unidentified Artist - Ship: *Queen Victoria*, Off the Azores

Unidentified Artist - Woman with Apple

Unidentified Artist - Head and Hand

Unidentified Artist - Caloric Ship *Ericcson*...

Unidentfied Artist - *"Old Ironsides"*

Unidentified Artist - Ship: *Stonington*

Unidentified Artist - Steamer: *Manhattan*

Patrick F. Vaccaro - Carnival B

Louis Held Caricature
Drawing on paper, 11 x 8" (27.94 x 20.32 cm.)
Unsigned
Gift of Louis Held, 1965
965-D-123

Caloric Ship *Ericcson*—Passing the Battery, New York
Color lithograph on paper, 13 x 20" (33.02 x 50.80 cm.)
Unsigned
Museum purchase, 1968
968-P-226

Four Ships
Engravings on paper, various sizes
Unsigned
Museum purchase, 1967
967-P-201

George Washington
Steel engraving on paper, 19 x 13" (48.26 x 33.02 cm.)
Unsigned
Museum purchase, 1965
965-P-314

"Old Ironsides"
Hand colored engraving on paper, 14 x 17.5" (35.56 x 44.45 cm.)
Unsigned
Museum purchase, 1967
967-P-203

Se-Quo-Yah
Lithograph on paper, 21.5 x 15" (54.61 x 38.10 cm.)
Unsigned
Gift of Albert E. Hise, 1979
979-P-119

Ship: *Red Jacket*
Hand colored lithograph on paper, 9 x 6.5" (22.86 x 16.51 cm.)
Unsigned
Gift of Joseph G. Butler, III, 1961
961-P-118

Ship: *Stonington*
Hand colored lithograph on paper, 18.25 x 33.25" (46.36 x 84.46 cm.)
Unsigned
Museum purchase, 1967
967-P-202

Steamer: *Manhattan*
Color lithograph on paper, 15 x 24" (38.10 x 60.96 cm.)
Unsigned
Museum purchase, 1968
968-P-223

The Arkansas Traveler
Color engraving on paper, 22 x 28" (55.88 x 71.12 cm.)
Unsigned
Museum purchase, 1968
968-P-242

Twin Screw Steamship, *City of Paris*
Lithograph on paper, 33.62 x 46.25" (85.39 x 117.48 cm.)
Unsigned
Museum purchase, 1969
969-P-102

Ulysses S. Grant
Steel engraving on paper, 13.75 x 9.87" (34.93 x 25.07 cm.)
Unsigned
Museum purchase, 1968
968-P-309

Water Works, Centre Square, Philadelphia
Etching on paper, 5.5 x 7.5" (13.97 x 19.05 cm.)
Unsigned
Gift of Richard A. Ulrich, 1968
968-P-222

Richard T. UPTON, (active 20th century)

The following two signed posters, silkscreen on paper, are an anonymous gift, 1980

Richard Upton, 1971
35 x 22" (88.90 x 55.88 cm.)
980-P-151

Richard Upton
34 x 22" (86.36 x 55.88 cm.)
980-P-155

James URMSTON, (active 20th century)

Studio Still Life, 1962
Oil on canvas, 45 x 36" (114.30 x 91.44 cm.)
Unsigned
Museum purchase, 1962
962-O-116

Douglas UTTER, (active late 20th century)

The following two signed prints on paper, 8.5 x 11" (21.59 x 27.94 cm.), are the gift of the William Busta Gallery, 1990

(Untitled)
Portfolio of 53: Rip Off on the Last Millennium
990-P-111.9

(Untitled)
Portfolio of 53: Rip Off on the Last Millennium
990-P-111.10

Patrick F. VACCARO, (1920–)

Some Birds, 1961
Watercolor on paper, 11 x 16" (27.94 x 40.64 cm.)
Signed, Pat Vaccaro, '61, lower left
Museum purchase, 1962
962-W-110

Carnival B, 1954
Serigraph on paper, 8 x 16" (20.32 x 40.64 cm.)
Signed, Pat Vaccaro, 1954, lower right
Museum purchase, 1955
955-P-110

Crucified, 1963
Serigraph on paper, (1/36), 10 x 14" (25.40 x 35.56 cm.)
Signed, Pat Vaccaro, lower middle
Museum purchase, 1964
964-P-102

Eclipse #2, 1954
Serigraph on paper, 16 x 8" (40.64 x 20.32 cm.)
Signed, Pat, '54, lower right
Museum purchase, 1957
957-P-105

Mono Suite Fodicol – 7, 1991
Serigraph on paper, 10 x 10" (25.40 x 25.40 cm.)
Signed, Pat Vaccaro, 1991, lower right
Gift of Patrick F. Vaccaro, 1994
994-P-210

My Kind of Circus, 1958
Serigraph on paper, 14.5 x 10.5" (36.83 x 26.67 cm.)
Signed, Pat Vaccaro, 1958, lower right
Museum purchase, 1958
958-P-112

Noah and the Ark, 1954
Woodcut on paper, 6.62 x 16.62" (16.81 x 42.21 cm.)
Signed, Pat Vaccaro, lower right
Gift of Dr. M. Metzger, 1989
989-P-138

Obsessed–'67, 1967
Silkscreen on paper, 14 x 8.5" (35.56 x 21.59 cm.)
Signed, Pat Vaccaro, 1967, lower right
Museum purchase, 1967
967-P-185

The Marchers, 1966, 1966
Silkscreen on paper, 15 x 10" (38.10 x 25.40 cm.)
Signed, Pat Vaccaro, 1966, lower middle
Museum purchase, 1966
966-P-142

The Flag, 1966
Serigraph on paper, 11 x 15" (27.94 x 38.10 cm.)
Signed, Pat Vaccaro, 1966, lower left
Museum purchase, 1969
969-P-131

The following two signed silkscreens on paper
are the gift of Joseph G. Butler, III, 1978

Illusion XIV
14.5 x 10.5" (36.83 x 26.67 cm.)
978-P-103

The Five, 1968
10.5 x 14" (26.67 x 35.56 cm.)
978-P-104

James VALERIO, (1939–)

Ruth and Cecil Him, 1982
Oil on canvas, 92.25 x 80.25" (234.32 x 203.84 cm.)
Unsigned
Museum purchase, 1991
991-O-234

Seated Model, 1983
Oil on canvas, 82 x 72" (208.28 x 182.88 cm.)
Unsigned
Gift of Mr. and Mrs. Paul DeRosa, 1993
993-O-121

Greg, 1982
Lithograph on paper, 30 x 22" (76.20 x 55.88 cm.)
Signed, James Valerio, '82, lower right
Museum purchase, 1989
989-P-117

Biron VALIER, (1943–)

Signals #5, 1965
Acrylic polymer on canvas, 45 x 45" (114.30 x 114.30 cm.)
Signed, Biron Valier, 1965, lower left
Museum purchase, 1966
966-O-111

Al VAN AUKER, (active 20th century)

Railroad Cars, 1942
Watercolor on paper, 14.25 x 22.25" (36.20 x 56.52 cm.)
Signed, Al Van Auker, lower right
Gift of Blanche Lewis, 1977
977-W-118

Clarence VAN DUZER, (active 20th century)

Pieta
Oil on canvas, 30 x 42" (76.20 x 106.68 cm.)
Signed, Van Duzer, lower left
Museum purchase, 1956
956-O-112

Cock VAN GENT, (1925–)

Drawing No. 1, 1953
Drawing on paper, 12 x 24" (30.48 x 60.96 cm.)
Unsigned
Museum purchase, 1954
954-D-103

Drawing No. 2
Drawing on paper, 12 x 6" (30.48 x 15.24 cm.)
Signed, Cock Van Gent, lower right
Museum purchase, 1954
954-D-104

Beth VAN HOESSEN, (1926–)

Pine, 1964
Etching on paper, 15.5 x 12.5" (39.37 x 31.75 cm.)
Signed, Beth Van Hoessen, 1964, lower right
Museum purchase, 1965
965-P-306

Abigail VAN SCOTER, (1941–)

Apples on Table
Oil on canvas, 31 x 48" (78.74 x 121.92 cm.)
Unsigned
Museum purchase, 1967
967-O-118

Phillip Dale VANDERWEG, (1943–)

Studio Screening #4, 1974
Mixed media on canvas, 39.5 x 50" (100.33 x 127.00 cm.)
Signed, Vanderweg, lower right
Gift of Leonard Bocour, 1976
976-O-124

Gloria VANDERBILT, (active 20th century)

The following three signed lithographs on paper
are the gift of Samuel S. Mandel, 1986

House
24 x 31" (60.96 x 78.74 cm.)
986-P-157

Summer
31 x 24" (78.74 x 60.96 cm.)
986-P-158

Tiger Lilies
31 x 24" (78.74 x 60.96 cm.)
986-P-159

Nicholas VASILIEFF, (1892–1970)

Landscape, 1953
Oil on canvas, 30 x 40" (76.20 x 101.60 cm.)
Signed, N. Vasilieff, lower right
Gift of Samuel N. Tonkin, 1954
954-O-142

Still Life with Blue Fish, 1952
Oil on canvas, 28 x 34" (71.12 x 86.36 cm.)
Signed, N. Vasilieff, lower right
Gift of Norman Scheider, 1954
954-O-143

Valerio - Ruth and Cecil Him

Valerio - Seated Model

Van Auker - Railroad Cars

Vedder - Cliffs of Volterra (page 180)

Vedder - Little Shrine Subiaco (page 180)

Vedder - Pines and Cabbages, Rome

Vickrey - Blue Ribbon

Vickrey - Late Afternoon

Vincente - Beginning

Vogel - Ex–Ray Vision

Woman with Child, 1951
Oil on canvas, 10 x 8" (25.40 x 20.32 cm.)
Signed, Vasilieff, lower right
Gift of Louis Held, 1965
965-O-130

Paul VAZQUEZ, (1933–)

Fruits and Flowers
Oil on canvas, 50 x 58" (127.00 x 147.32 cm.)
Unsigned
Museum purchase, 1958
958-O-120

Elihu VEDDER, (1836–1923)

Cliffs of Volterra, 1860
Oil on panel, 12 x 25" (30.48 x 63.50 cm.)
Signed, V., lower right
Gift of the American Academy of Arts and Letters, 1955
955-O-145

Little Shrine Subiaco
Oil on panel, 9 x 4.5" (22.86 x 11.43 cm.)
Signed, Elihu Vedder, on reverse
Gift of the American Academy of Arts and Letters, 1955
955-O-144

Tivoli Near Rome, ca. 1870
Oil on canvas mounted on board, 10 x 4" (25.40 x 10.16 cm.)
Unsigned
Gift of the American Academy of Arts and Letters, 1955
955-O-143

Nile Journey, 1890
Pastels on paper, (3 drawings), 12.5 x 7.5" (31.75 x 19.05 cm.)
Signed, E. Vedder, lower left
Gift of the American Academy of Arts and Letters, 1955
955-W-118

Pines and Cabbages, Rome, ca. 1911
Pastel on paper, 10 x 13" (25.40 x 33.02 cm.)
Unsigned
Gift of the American Academy of Arts and Letters, 1955
955-W-117

Stuyvesant VAN VEEN, (1910–)

Tivoli
Acrylic and oil on panel, 29.5 x 22.5" (74.93 x 57.15 cm.)
Signed, Stuyvesant, lower right
Gift of Stuyvesant Van Veen, 1977
977-O-139

Anthony VELONIS, (1911–)

The following three signed silkscreens on paper are the gift of Louis Held, 1965

Local Stop
6.5 x 8.5" (16.51 x 21.59 cm.)
965-P-196

Ships at Anchor
7.5 x 9.5" (19.05 x 24.13 cm.)
965-P-194

Washington Square
6.25 x 8.5" (15.88 x 21.59 cm.)
965-P-126

Robert R. VICKREY, (1926–)

Blue Ribbon, 1988
Egg tempera on gessoed panel, 30.25 x 43.5" (76.84 x 110.49 cm.)
Signed, Robert Vickrey, lower left
Gift of William Meek, 1991
991-O-109

Late Afternoon, 1958
Oil on canvas, 26 x 36.5" (66.04 x 92.71 cm.)
Signed, Robert Vickrey, lower left
Museum purchase, 1958
958-O-151

Woman in Thought
Drawing on paper, 10.37 x 18.37" (26.34 x 46.66 cm.)
Signed, Robert Vickrey, lower left
Museum purchase, 1968
968-D-120

Robert VIENCEK, (active 20th century)

Ribbon of Moonlight
Oil on wood, 22.5 x 23" (57.15 x 58.42 cm.)
Unsigned
Gift of Robert Viencek, 1994
994-O-102

Estaban VINCENTE, (1903–)

Beginning
Silkscreen on paper, (8/9), 26 x 33" (66.04 x 83.82 cm.)
Signed, Estaban Vincente, lower right
Gift of Estaban Vincente, 1978
978-P-136

(Untitled)
Lithograph on paper, 11.5 x 15.25" (29.21 x 38.74 cm.)
Signed, Estaban Vincente, lower right
Gift of Dr. and Mrs. Leonard Kornblee, 1985
985-P-108

Hank (Henry P.) VIRGONA, (1929–)

Embassy Staffs, 1974
Etching on paper, 7 x 12.5" (17.78 x 31.75 cm.)
Signed, Virgona, lower right
Gift of Gaspar Vaccaro, 1978
978-P-122

Martha VISSER'T HOOFT, (1906–)

Plurality, 1949
Watercolor on paper, 10 x 17" (25.40 x 43.18 cm.)
Signed, Visser't Hooft, '49, lower right
Gift of Louis Held, 1965
965-W-105

Douglas D. VOGEL, (active 20th century)

Ex–Ray Vision, 1967–68
Acrylic with objects on canvas, 22 x 12 x 9" (55.88 x 30.48 x 22.86 cm.)
Signed, Douglas D. Vogel, 1967-68, Boulder, Colo., lower right
Gift of Paul and Suzanne Donnelly Jenkins, 1991
991-O-222

Nick VOGLEIN, (1926–1980)

Top of the Hill
Opaque watercolor on paper, 19.5 x 29.5" (49.53 x 74.93 cm.)
Unsigned
Museum purchase, 1965
965-W-131

Edward Charles VOLKERT, (1871–1935)

Entering the Pasture
Oil on canvas, 8 x 11" (20.32 x 27.94 cm.)
Signed, Edw. C. Volkert, lower right
Gift of the estate of Charles Crandall, 1951
951-O-111

John VON WICHT, (1888–1970)

The Moon
Lithograph on paper, 10 x 7.5" (25.40 x 19.05 cm.)
Signed, V. Wicht, lower right
Gift of Louis Held, 1965
965-P-140

Robert William VONNOH, (1858–1933)

In Flanders Field – Where Soldiers
Sleep and Poppies Grow, 1890, ©1914
(Originally - Coquelicots (Poppies); later, Flanders—Where
Soldiers Sleep and Poppies Grow, Flanders, In Flanders'
Fields, and A Poppy Field)
Oil on canvas, 58 x 104" (147.32 x 264.16 cm.)
Signed, 1914, Robert Vonnoh, lower right
Museum purchase, 1919
919-O-114

Joseph E. WAGNER, (1917–)

The Morning of November 1st
Watercolor on paper, 13 x 14" (33.02 x 35.56 cm.)
Signed, W., lower right
Museum purchase, 1941
941-W-110

Stella WAITZKIN, (active late 20th century)

(Untitled)
Oil on canvas, 36 x 29.75" (91.44 x 75.57 cm.)
Unsigned
Gift of Stanley Bard, 1973
973-O-105

Samuel WALDO, (1783–1861)

Portrait of an Old Lady
Oil on canvas, 33 x 25" (83.82 x 63.50 cm.)
Unsigned
Museum purchase, 1969
969-O-114

O. J. WALDRON, (active early 20th century)

Ship: *City of Philadelphia*
Oil on canvas, 28 x 45" (71.12 x 114.30 cm.)
Signed, O. J. Waldron, lower left
Museum purchase, 1928
S28-O-109

George C. WALES, (1868–1940)

Winged Racer, 1924
Etching on paper, 10 x 7.5" (25.40 x 19.05 cm.)
Signed, G. C. W., lower left
Gift of Joseph G. Butler, III, 1975
975-P-113

Clay WALKER, (1924–)

Security of the Mother, 1959
Watercolor on paper, 29.5 x 37" (74.93 x 93.98 cm.)
Signed, Walker, '59, lower left
Museum purchase, 1959
959-W-104

James A. WALKER, (1921–1987)

Print No. 94
Serigraph on paper, 26 x 21" (66.04 x 53.34 cm.)
Signed, James A. Walker, lower right
Museum purchase, 1968
968-P-326

Print No. 124
Serigraph on paper, 32 x 39" (81.28 x 99.06 cm.)
Signed, James A. Walker, lower right
Museum purchase, 1977
977-P-122

Peter WALKER, (1946–)

Grandmother's Predictions, 1974
Oil on canvas, 60 x 108" (152.40 x 274.32 cm.)
Signed, Peter Walker, lower right
Museum purchase, 1974
974-O-110

Route Six Four Seconds, 1968
Acrylic on canvas, 72 x 54" (182.88 x 137.16 cm.)
Signed, Peter Walker, lower right
Gift of Dr. Harvey C. Sands, 1975
975-O-144

Abraham WALKOWITZ, (1880–1965)

Panel of Three Drawings of Isadora
Duncan
Watercolor on paper, 13 x 26" (33.02 x 66.04 cm.)
Signed, A. Walkowitz, lower left
Gift of Frank Kleinholz, 1947
947-W-108

(Untitled)
Watercolor on paper, 11 x 15.25" (27.94 x 38.74 cm.)
Unsigned
Gift of Zabrieski Galleries, 1995
995-W-102

Isadora Duncan
Drawing on paper, 7 x 2.5" (17.78 x 6.35 cm.)
Signed, A. Walkowitz, lower middle
Gift of Louis Held, 1965
965-D-116

Three Movements
Ink on paper, (3 panels), each 6.75 x 2.5" (17.15 x 6.35 cm.)
Signed, A. Walkowitz, lower right
Gift of Louis Held, 1966
966-D-108

The Butler Institute's collection includes three
drawings on paper of various sizes which are the
gift of Zabrieski Galleries, 1995
995-D-104 — 995-D-106

Alfred Bryan WALL, (1861–1937)

Landscape with Sheep
Oil on canvas, 30 x 21" (76.20 x 53.34 cm.)
Signed, A. Bryan Wall, lower right
Museum purchase, 1919
919-O-117

Mill Creek Park
Oil on canvas, 27.25 x 36" (69.22 x 91.44 cm.)
Signed, A. Bryan Wall, lower left
Gift of the estate of Helen Boyd, 1968
968-O-201

Vonnoh - In Flanders Field – Where Soldiers Sleep and Poppies Grow

Wagner - The Morning of November 1st

O. J. Waldron - Ship: *City of Philadelphia*

Walkowitz - Panel of Three Drawings of Isadora Duncan

Walkowitz - (Untitled)

Walkowitz - Isadora Duncan

Walters - Ship: *Euphrasia*

Walusis - Rope–A–Dope

Warhol - Paul Jenkins

Warhol - Watson Powell, Sr., The American Man

Warhol - Pete Rose

Watkins - Face to Face

Alfred S. WALL, (1809–1871)

Snow
Oil on canvas, 24 x 42" (60.96 x 106.68 cm.)
Signed, A. S. Wall, lower right
Gift of J. B. Laughlin, 1920
920-O-112

Sue WALL, (1950–)

Red Brick Building
Acrylic on canvas, 12 x 18" (30.48 x 45.72 cm.)
Signed, Sue Wall, lower left
Gift of Mr. and Mrs. Joseph Erdelac, 1976
976-O-104

WALLICK, (active 20th century)

Louis Held, 1941
Ink on paper, 10 x 13.5" (25.40 x 34.29 cm.)
Signed, Wallick, 5/21/41, lower left
Gift of Louis Held, 1965
965-D-111

Samuel WALTERS, (active early 19th century)

Ship: *Euphrasia*, 1831
Oil on canvas, 23 x 35" (58.42 x 88.90 cm.)
Unsigned
Museum purchase, 1928
S28-O-111

Ship: *Oglethorpe*, 1832
Oil on canvas, 12 x 16" (30.48 x 40.64 cm.)
Signed, S. Walters, 1832, lower right
Museum purchase, 1928
S28-O-125

Ship: Privateer *Jamaica*, 1829
Oil on canvas, 26 x 44" (66.04 x 111.76 cm.)
Unsigned
Museum purchase, 1928
S28-O-110

Harry Franklin WALTMAN, (1871–1957)

Vermont Woods in Winter, 1918
Oil on canvas, 39 x 32" (99.06 x 81.28 cm.)
Signed, Waltman, 1918, lower right
Museum purchase, 1919
919-O-115

Michael WALUSIS, (active latter 20th century)

Rope–A–Dope
Serigraph on paper, 26 x 20" (66.04 x 50.80 cm.)
Unsigned
Gift of the Friends of American Art, 1981
981-P-101

Marge WANSKY, (1944–)

Oliver
Watercolor on paper, 16 x 18.5" (40.64 x 46.99 cm.)
Unsigned
Museum purchase, 1965
965-W-142

Andy WARHOL, (1931–1987)

Paul Jenkins, 1979
Acrylic and silkscreen on canvas, 40 x 40" (101.60 x 101.60 cm.)
Signed, Andy Warhol, on reverse
Gift of Paul and Suzanne Donnelly Jenkins, 1986
986-O-109

Watson Powell, Sr., The American Man, 1964
Silkscreen on canvas, 3 panels, each 16 x 16" (40.64 x 40.64 cm.)
Unsigned
Gift of Carl Dennison, 1984
984-P-102

Pete Rose, 1985
12 color screen print on two-ply white lenox paper, 39.87 x 31.5" (101.27 x 80.01 cm.)
Signed, Andy Warhol, lower right
Museum purchase, 1991
991-P-101

(Untitled), 1973
Xerox copy, 11 x 8.5" (27.94 x 21.59 cm.)
Signed, Andy Warhol, on reverse
Gift of Steven Feinstein, 1983
983-P-171

WARREN, (active mid-19th century)

Launching of the *Great Republic*, 1853
Hand colored lithograph on paper, 8.5 x 10.5" (21.59 x 26.67 cm.)
Unsigned
Gift of Joseph G. Butler, III, 1976
976-P-116

Ferdinand WARREN, (1899–1981)

Gentle Breeze
Oil on canvas, 12 x 20" (30.48 x 50.80 cm.)
Signed, Ferdinand Warren, lower right
Museum purchase, 1945
945-O-107

Lunar Magic
Watercolor on paper, 20 x 28" (50.80 x 71.12 cm.)
Signed, Ferdinand Warren, lower middle
Museum purchase, 1954
954-W-119

Abel George WARSHAWSKY, (1884–1962)

Diane at the Bath
Oil on canvas, 50.5 x 66" (128.27 x 167.64 cm.)
Signed, A. G. Warshawsky, lower right
Gift of T. Y. Bigelson, 1975
975-O-141

Harry Clement WATERSTON, (1909–)

(Untitled)
Watercolor on paper, 15 x 22" (38.10 x 55.88 cm.)
Signed, Waterston, lower right
Gift of Harry Clement Waterston, 1979
979-W-104

Franklin WATKINS, (1894–1972)

Face to Face
Oil on canvas, 29 x 39" (73.66 x 99.06 cm.)
Unsigned
Gift of Mrs. Richard Harkness, 1977
977-O-158

Portrait of Joseph G. Butler, III, 1955
Oil on canvas, 43 x 31" (109.22 x 78.74 cm.)
Signed, Watkins, lower right
Museum purchase, 1955
955-O-146

Alfred R. WAUD, (1828–1891)

The Ride of Collins Grave

Ink wash on paper, 11.5 x 8.25" (29.21 x 20.96 cm.)
Signed, A. R. W., lower left
Museum purchase, 1978
978-D-102

Frederick Judd WAUGH, (1861–1940)

Breakers at Floodtide, 1909

Oil on canvas, 35 x 40" (88.90 x 101.60 cm.)
Signed, Waugh, lower right
Museum purchase, 1919
919-O-116

Albert M. WEARSTLER, (1893–1954)

The Little Herring Fleet

Watercolor on paper, 13.5 x 18" (34.29 x 45.72 cm.)
Unsigned
Gift of P. J. Thompson, 1943
943-W-104

White Faces at Ridgely #2, 1952

Watercolor on paper, 16 x 22" (40.64 x 55.88 cm.)
Signed, Albert M. Wearstler, 1952, lower right
Museum purchase, 1955
955-W-115

Frank (Francis H.) WEBB, (1927–)

Golden Sea Fields

Watercolor on paper, 22 x 30" (55.88 x 76.20 cm.)
Signed, Frank Webb, lower left
Gift of Dr. and Mrs. Henry Sisek, 1973
973-W-102

Albert J. WEBER, (1919–)

Bull

Watercolor on paper, 22.5 x 30.5" (57.15 x 77.47 cm.)
Signed, A. Weber, lower left
Museum purchase, 1959
959-W-106

Spanish Landscape

Watercolor on paper, 23 x 35" (58.42 x 88.90 cm.)
Signed, A. Weber, lower right
Museum purchase, 1961
961-W-107

Max WEBER, (1881–1961)

Reclining Nude, 1945

Ink wash on paper, 4.5 x 5" (11.43 x 12.70 cm.)
Signed, Max Weber, 1945, lower left
Museum purchase, 1959
959-D-123

Barrere Little Symphony

Lithograph on paper, 7 x 9.5" (17.78 x 24.13 cm.)
Signed, Max Weber, lower right
Gift of Louis Held, 1967
967-P-118

Reclining Figure, 1956

Silkscreen on paper, 18 x 24" (45.72 x 60.96 cm.)
Signed, Max Weber, 1956, lower right
Gift of Louis Held, 1965
965-P-178

Paul WEBER, (1823–1916)

Rocky Landscape with Waterfall, 1861

Oil on canvas, 37 x 53.5" (93.98 x 135.89 cm.)
Signed, Paul Weber, lower left
Gift of Mrs. Cyril P. Deibel, 1976
976-O-116

William WEGMAN, (1943–)

Endless Column, 1989

Woodblock on paper, (26/40), 24.25 x 18" (61.60 x 45.72 cm.)
Signed, William Wegman, '89, lower right
Museum purchase, 1992
992-P-123

Walt WEIDENBACHER, (1907–)

In Zero, 1968

Oil on canvas, 36 x 36" (91.44 x 91.44 cm.)
Signed, Walt Weidenbacher, Cin'ti, Ohio, on reverse
Museum purchase, 1968
968-O-190

W. H. WEIDMAN, (active 20th century)

Sunset at the Golden Gate, ca. 1935

Oil on canvas, 39.5 x 25" (100.33 x 63.50 cm.)
Unsigned
Museum purchase, 1949
949-O-111

Erika WEIHS, (1917–)

Mother and Son

Acrylic wash on paper, 14.5 x 19.5" (36.83 x 49.53 cm.)
Signed, E. Weihs, upper right
Gift of Tom Weihs, 1978
978-D-103

Bernard WEINER, (active 20th century)

Bronx Lights

Oil on canvas, 21 x 42" (53.34 x 106.68 cm.)
Signed, Weiner, lower right
Museum purchase, 1958
958-O-124

Julian Alden WEIR, (1852–1919)

The Oldest Inhabitant, 1876

Oil on canvas, 65.5 x 32" (166.37 x 81.28 cm.)
Signed, J. A. Weir, upper left
Museum purchase, 1922
922-O-105

The Builders

Watercolor on paper, 15 x 10.5" (38.10 x 26.67 cm.)
Signed, J. Alden Weir, lower right
Gift of Mr. and Mrs. Edward E. Ford, 1968
971-W-101

The Carpenter Shop, 1891

Etching on paper, 7.87 x 6" (20.00 x 15.24 cm.)
Signed, Caro Weir Ely imprint, lower right
Museum purchase, 1968
968-P-263

John Ferguson WEIR, (1841–1926)

Christmas Bell, 1860

Oil on canvas, 16 x 10.5" (40.64 x 26.67 cm.)
Signed, J. F. Weir, 1860, lower right
Gift of the Rosenfeld Foundation, 1958
958-O-145

Waugh - Breakers at Floodtide

Max Weber - Reclining Figure

Paul Weber - Rocky Landscape with Waterfall

Wegman - Endless Column

Julien Alden Weir - The Oldest Inhabitant

John Ferguson Weir - Halloween

Robert W. Weir - St. Nicholas

Weiss - Yesterday–A Variation

Welliver - Briggs Meadow

Benjamin West - The Sepulchre

Halloween

Oil on canvas, 16 x 10.5" (40.64 x 26.67 cm.)
Signed, John F. Weir, lower right
Gift of the Rosenfeld Foundation, 1958
958-O-146

Robert W. WEIR, (1803–1889)

St. Nicholas, 1838

(Formerly, The Night Before Christmas)
Oil on wood panel, 30 x 25" (76.20 x 63.50 cm.)
Signed, Robert W. Weir, West Point, 1838, lower left
Gift of Sidney Hill, 1962
962-O-101

Donald L. WEISMANN, (1914–)

Ground–Air Control

Oil on canvas, 33 x 40" (83.82 x 101.60 cm.)
Unsigned
Museum purchase, 1957
957-O-130

Blanche WEISS, (active latter 20th century)

Yesterday–A Variation

Acrylic on paper, 26.5 x 36" (67.31 x 91.44 cm.)
Signed, Weiss, lower right
Gift of the Friends of American Art, 1978
978-W-115

Neil WELLIVER, (1929–)

Briggs Meadow, 1977

Watercolor on paper, 29.5 x 30.25" (74.93 x 76.84 cm.)
Signed, Welliver, lower right
Museum purchase, 1979
979-W-106

Charles WELLS, (1935–)

Alban Berg, 1966

Etching on paper, 17.75 x 14.5" (45.09 x 36.83 cm.)
Signed, Wells, 1966, lower right
Museum purchase, 1967
967-P-168

Hemingway

Etching on paper, 19 x 13" (48.26 x 33.02 cm.)
Signed, Wells, lower right
Museum purchase, 1968
968-P-219

Lee WELLS, (1921–)

Contrast

Aquarelle and tempera on paper, 21 x 30" (53.34 x 76.20 cm.)
Signed, Lee Wells, lower right
Museum purchase, 1966
966-W-110

Stow WENGENROTH, (1906–1978)

Shore Contrast, ca. 1930–40

Watercolor on paper, 15 x 20" (38.10 x 50.80 cm.)
Signed, Stow Wengenroth, lower right
Museum purchase, 1978
978-W-113

Country Scene

Lithograph on paper, 9 x 13.5" (22.86 x 34.29 cm.)
Signed, Stow Wengenroth, lower right
Museum purchase, 1962
962-P-113

The following four signed lithographs on paper
are a museum purchase, 1966

Along the Coast, 1966

10 x 16" (25.40 x 40.64 cm.)
966-P-126

Flowers, 1966

11 x 16" (27.94 x 40.64 cm.)
966-P-123

Vermont Pasture, 1966

10 x 16" (25.40 x 40.64 cm.)
966-P-127

Winter Visitor, 1966

10.25 x 16" (26.04 x 40.64 cm.)
966-P-128

Evelyn E. WENTZ, (1915–)

Universe

Watercolor on paper, 15 x 19" (38.10 x 48.26 cm.)
Unsigned
Museum purchase, 1950
950-W-129

Anita WESCHLER, (active 20th century)

Chevrons, Hearts & Ribbons No. 9, 1962

Mixed media on paper, 8.5 x 11" (21.59 x 27.94 cm.)
Unsigned
Gift of Louis Held, 1978
978-W-108

Paul WESCOTT, (1904–1971)

The Harbor

Oil on canvas, 28 x 40" (71.12 x 101.60 cm.)
Signed, Paul Wescott, lower right
Museum purchase, 1959
959-O-111

Benjamin WEST, (1738–1820)

The Sepulchre, 1782

Gouache on paper, 18.5 x 14" (46.99 x 35.56 cm.)
Signed, B. West, 1782, lower left
Museum purchase, 1968
968-W-122

Clifford Bateman WEST, (1916–)

Man Smoking Pipe

Ink on paper, 8.25 x 6.75" (20.96 x 17.15 cm.)
Signed, Clifford West, lower right
Gift of Albert E. Hise, 1979
979-D-110

The Spectators, 1941

Lithograph on paper, 9.25 x 11" (23.50 x 27.94 cm.)
Signed, Clifford B. West, lower right
Gift of Albert E. Hise, 1979
979-P-133

Harold WESTON, (1894–1972)

Breakers, 1960

Oil on canvas, 30 x 36" (76.20 x 91.44 cm.)
Signed, Weston, lower left
Gift of Babcock Galleries, 1962
962-O-103

Reclining Nude, 1932
Oil on canvas, 15 x 34" (38.10 x 86.36 cm.)
Signed, Weston, lower left
Gift of Jack M. Hockett, 1977
977-O-128

John WHEAT, (1920–)

Arena
Watercolor on gessoed cardboard, 19.5 x 29.5" (49.53 x 74.93 cm.)
Signed, J. Wheat, lower right
Museum purchase, 1966
966-W-104

Tank Laager, 1968
Watercolor and acrylic on paper, 10 x 21" (25.40 x 53.34 cm.)
Signed, J. Wheat, lower right
Museum purchase, 1970
970-W-109

William WHEELER, (active late 20th century)

Mississippi, 1992
Acrylic on canvas, 38 x 32" (96.52 x 81.28 cm.)
Signed, Wheeler, 10/1/92, lower left
Gift of Erle L. Flad, 1995
995-O-103

Paul A. WHERRY, (active 20th century)

Composition #3
Oil on canvas, 32 x 24" (81.28 x 60.96 cm.)
Signed, Wherry, upper left
Museum purchase, 1956
956-O-113

Charlotte WHINSTON, (1895–1976)

Rhythm
Casein on paper, 29.25 x 21" (74.30 x 53.34 cm.)
Signed, Whinston, lower right
Gift of the Artists Welfare Fund, 1977
977-W-110

The following two signed drawings, ink on paper, are the gift of the Artists Welfare Fund, 1977

Ships
17 x 22" (43.18 x 55.88 cm.)
977-D-107

Undersea Form
17.5 x 23" (44.45 x 58.42 cm.)
977-D-110

James Abbott McNeill WHISTLER, (1834–1903)

The Thames from Battersea Bridge, 1863
(Attributed to James Abbott McNeill Whistler)
Oil on canvas, 16 x 24.5" (40.64 x 62.23 cm.)
Signed, Whistler, lower left
Museum purchase, 1958
958-O-152

Volcano
Oil on canvas, 12 x 16" (30.48 x 40.64 cm.)
Unsigned
Museum purchase, 1956
956-O-118

Rotherhithe, 1860
Etching on paper, 11 x 8" (27.94 x 20.32 cm.)
Signed, Whistler, 1860, lower left
Anonymous gift, 1960
960-P-101

Hurlingham
Etching and drypoint on paper, 5.5 x 7.37" (13.97 x 18.72 cm.)
Unsigned
Gift of Blanche Lewis in memory of Dr. John S. Lewis, 1977
977-P-120

The following four etchings on paper are a museum purchase, 1961

La Retaneuse
4.5 x 3.5" (11.43 x 8.89 cm.)
961-P-111

La Marchande de Moutarde, 1858
6 x 3.5" (15.24 x 8.89 cm.)
961-P-113

Newspaper Stall, Rue de Siene
3.25 x 7.75" (8.26 x 19.69 cm.)
961-P-112

Seymour Seated
5.25 x 3.75" (13.34 x 9.53 cm.)
961-P-114

The following two etchings on paper are a museum purchase, 1918

Bridge
6.5 x 9" (16.51 x 22.86 cm.)
918-P-101

Mon Viel Ami Seymour Haden
5 x 6" (12.70 x 15.24 cm.)
918-P-102

The Swan Brewery, Chelsea
Etching on paper, 2.5 x 4" (6.35 x 10.16 cm.)
Unsigned
Museum purchase, 1966
966-P-153

Chelsea Bridge
Etching on paper, 5.5 x 8" (13.97 x 20.32 cm.)
Unsigned
Museum purchase, 1968
968-P-217

The following two etchings on paper are a museum purchase, 1970

Billingsgate
6 x 9" (15.24 x 22.86 cm.)
970-P-162

St. James Street–London
11 x 6" (27.94 x 15.24 cm.)
970-P-163

The following two lithographs on paper are a museum purchase, 1966

Little Court, 1887
8.5 x 4.25" (21.59 x 10.80 cm.)
966-P-118

Victorian Club
9.25 x 6" (23.50 x 15.24 cm.)
966-P-117

Attributed to Whistler - The Thames from Battersea Bridge

Whistler - Rotherhithe

Whistler - La Marchande de Moutarde

Whistler - Mon Viel Ami Seymour Haden

Whistler - St. James Street–London

Whiting - Location Unknown

Whittredge - Landscape Near Rome

Whorf - Keeper of the Bell

Wiggins - Sheep

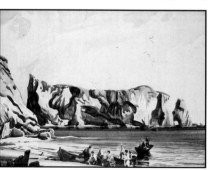

Wilcox - Perce Rock, Gaspé

In the Louvre
Lithograph on paper, 9.75 x 6.25" (24.77 x 15.88 cm.)
Signed, Whistler, lower right
Museum purchase, 1968
968-P-308

Charles WHITE, (1918–1979)

The following two unsigned lithographs on paper
are the gift of Louis Held, 1965

Hope for the Future, 1945
13.25 x 10.5" (33.66 x 26.67 cm.)
965-P-142

We Have Been Believers, 1949
15.5 x 13" (39.37 x 33.02 cm.)
965-P-152

Doris WHITE, (1924–)

Night in Silence
Watercolor on paper, 36 x 28" (91.44 x 71.12 cm.)
Signed, Doris White, lower right
Museum purchase, 1964
964-W-102

Night Port
Watercolor on paper, 20 x 28" (50.80 x 71.12 cm.)
Signed, Doris White, lower right
Museum purchase, 1961
961-W-108

Quiet Street
Watercolor on paper, 22 x 29" (55.88 x 73.66 cm.)
Signed, Doris White, lower left
Museum purchase, 1960
960-W-103

Randy Lee WHITE, (active late 20th century)

Homage Amor, 1986
Monotype with hand painting on paper, 29.5 x 24.5" (74.93 x
62.23 cm.)
Signed, Homage Amor, St. Maarten, June 23, 1986, R. Lee
White, lower right and left
Gift of Paul and Suzanne Donnelly Jenkins, 1991
991-P-125

Robert WHITE, (1868–1947)

Landscape with Figure
Oil on canvas, 19 x 20" (48.26 x 50.80 cm.)
Unsigned
Gift of Hobson Pittman, 1955
955-O-147

Valerie Mathews WHITFORD, (active 20th century)

Sailboat
Oil on canvas, 24 x 24" (60.96 x 60.96 cm.)
Signed, Valerie Mathews Whitford, lower center
Gift of Mr. and Mrs. Jere D. Lustig, 1988
988-O-126

J. T. WHITING, (active late 19th century)

Location Unknown, 1875
Oil on mounted canvas, 13.75 x 17.75" (34.93 x 45.09 cm.)
Signed, J. T. Whiting, 1875, lower right
Gift of the Golonka Family, 1967
967-O-127

Robert WHITMAN, (1935–)

(Untitled), 1973
Lithograph on paper, 9 x 18" (22.86 x 45.72 cm.)
Signed, R. Whitman, lower right
Gift of Steven Feinstein, 1983
983-P-172

Worthington WHITTREDGE, (1820–1910)

Landscape Near Rome, 1858
Oil on canvas, 33.5 x 54" (85.09 x 137.16 cm.)
Signed, W. Whittredge, Rome, lower right
Museum purchase, 1965
965-O-107

John WHORF, (1903–1956)

Keeper of the Bell
Watercolor on paper, 22 x 30" (55.88 x 76.20 cm.)
Signed, John Whorf, lower right
Museum purchase, 1946
946-W-105

Scene in Barbados
Watercolor on paper, 30 x 40" (76.20 x 101.60 cm.)
Signed, John Whorf, lower right
Gift of F. C. Schang, 1953
953-W-110

Amos WHYTE, (dates unknown)

Boys on a Barge
Oil on canvas, 22 x 28" (55.88 x 71.12 cm.)
Unsigned
Museum purchase, 1969
969-O-104

James L. WICK, Jr., (dates unknown)

Chippy Bell
Oil on canvas board, 24 x 18" (60.96 x 45.72 cm.)
Signed, J. L. Wick, Jr., lower right
Gift of Mrs. W. J. Sampson, 1977
977-O-103

J. Carlton WIGGINS, (1848–1932)

Sheep
Oil on canvas, 12 x 16" (30.48 x 40.64 cm.)
Signed, J. Carlton Wiggins, lower left
Museum purchase, 1949
949-O-105

Frank N. WILCOX, (1887–1964)

Rocky Stream
Watercolor on paper, 13 x 19.5" (33.02 x 49.53 cm.)
Signed, Wilcox, lower right
Gift of Joseph G. Butler, III, 1965
965-W-137

Early Wayfarers
Watercolor on paper, 17 x 22" (43.18 x 55.88 cm.)
Signed, Wilcox, lower right
Gift of Don Lord, 1969
969-W-116

Perce Rock, Gaspé, 1940
Watercolor on paper, 22 x 30" (55.88 x 76.20 cm.)
Signed, Wilcox, lower left
Gift of Mrs. Frank N. Wilcox, 1969
969-W-121

The Lock Stairs at Akron, OH, 1942
Watercolor on paper, 15 x 22" (38.10 x 55.88 cm.)
Signed, Wilcox, lower right
Gift of the Junior League of Youngstown, 1969
969-W-117

Low Bridge, Ohio Canal Series
Drypoint on paper, 5.5 x 7" (13.97 x 17.78 cm.)
Signed, Frank N. Wilcox, lower right
Museum purchase, 1969
969-P-130

Carla WILCZAK, (active late 20th century)

(Untitled)
Portfolio of 53: Rip Off on the Last Millennium
Print on paper, 5.5 x 8.5" (13.97 x 21.59 cm.)
Signed, Carla Wilczak, lower right
Gift of the William Busta Gallery, 1990
990-P-111.32

John WILDE, (1919–)

The Lady and the Shoeshine Boy, 1968
Oil on canvas, 45 x 35" (114.30 x 88.90 cm.)
Unsigned
Museum purchase, 1969
969-O-134

Irving Ramsey WILES, (1861–1948)

Portrait–Mrs. Ed F. Clark and Children, 1920
Oil on canvas, 63 x 46" (160.02 x 116.84 cm.)
Signed, Irving R. Wiles, 1920, lower right
Gift of Mr. and Mrs. E. F. Clark, 1950
950-O-117

Portrait of Mrs. Anne H. Gilbert, 1903
Oil on canvas, 37 x 31" (93.98 x 78.74 cm.)
Signed, Irving R. Wiles, lower right
Museum purchase, 1921
921-O-111

Bill WILLIAMS, (1950–)

Drop Kick, 1991
Oil on canvas, 20 x 30" (50.80 x 76.20 cm.)
Signed, Bill Williams, © 1991, lower right
Gift of Mr. and Mrs. David M. Draime, 1992
992-O-119

Donald D. WILLIAMS, (active 20th century)

Righteous Fox, 1989
Acrylic on canvas, 56 x 50" (142.24 x 127.00 cm.)
Unsigned
Gift of Donald D. Williams, 1990
990-O-101

Regen Tropfen X, 1985
Acrylic on canvas, 67.25 x 47.75" (170.82 x 121.29 cm.)
Signed, D. Williams, lower right
Gift of Louise Strader, 1986
986-O-102

Yukahama Kanaut Breast Stroke
Acrylic on canvas, 53.5 x 53" (135.89 x 134.62 cm.)
Unsigned
Museum purchase, 1973
973-O-128

Marie WILNER, (active 20th century)

The following two signed oils on paper are the
gift of Marie Wilner, 1977

Meditation
13 x 11" (33.02 x 27.94 cm.)
977-O-129

The Blessing
22 x 18" (55.88 x 45.72 cm.)
977-O-131

Alexander WILSON, (1766–1813)

White Headed Eagle
Hand colored engraving on paper, 10 x 13" (25.40 x 33.02 cm.)
Signed, Drawn from nature, A. Wilson, lower left
Gift of James Welsh, 1965
965-P-199

Kay WILSON, (1937–)

Self Portrait
Oil on canvas, 36 x 24" (91.44 x 60.96 cm.)
Unsigned
Museum purchase, 1970
970-O-115

Reginald WILSON, (1909–)

Lemon and Glass
Serigraph on paper, 9 x 12" (22.86 x 30.48 cm.)
Signed, R. Wilson, lower right
Museum purchase, 1954
954-P-102

Sol WILSON, (1896–1974)

Seashore Street
Oil on canvas, 40 x 50" (101.60 x 127.00 cm.)
Signed, Sol Wilson, lower left
Gift of Sol Wilson, 1962
962-O-128

Schooner and Scow
Oil on canvas, 20 x 30" (50.80 x 76.20 cm.)
Signed, Sol Wilson, lower left
Gift of David A. Teichman, 1958
958-O-106

Wharf in Winter
Oil on canvas, 20 x 30" (50.80 x 76.20 cm.)
Signed, Sol Wilson, lower right
Museum purchase, 1948
948-O-123

Fisherman
Oil on canvas, 8 x 6" (20.32 x 15.24 cm.)
Signed, Sol Wilson, lower right
Gift of Louis Held, 1965
965-O-140

Sketch for Schooner and Scow
Pen and ink on paper, 5 x 8" (12.70 x 20.32 cm.)
Signed, Sol Wilson, lower left
Gift of Sol Wilson, 1965
965-D-101

Wharf
Pencil on paper, 8 x 10.5" (20.32 x 26.67 cm.)
Signed, Sol Wilson, lower right
Gift of Louis Held, 1965
965-D-119

Wiles - Portrait—Mrs. Ed F. Clark and Children

Wiles - Portrait of Mrs. Anne H. Gilbert

Donald D. Williams - Righteous Fox

Alexander Wilson - White Headed Eagle

Sol Wilson - Seashore Street

Sol Wilson - Wharf in Winter

Winslow - In the Studio, June, 1980

Witkin - The Madonna Della Baggies

Witt - Landscape

Wolff - Girl with Toys

Grant Wood - In the Spring (page 189)

Evening on Bridge
Lithograph on paper, 9.5 x 14" (24.13 x 35.56 cm.)
Signed, Sol Wilson, lower right
Museum purchase, 1965
965-P-286

Hodgins Dock
Serigraph on paper, 12.5 x 20" (31.75 x 50.80 cm.)
Signed, Sol Wilson, lower right
Museum purchase, 1958
958-P-114

Morning Shift
Silkscreen on paper, 13 x 17" (33.02 x 43.18 cm.)
Signed, Sol Wilson, lower middle
Gift of Joseph G. Butler, III, 1966
966-P-116

Thomas WILSON, (1931–)

Quiet Corner
Oil on canvas, 25 x 30" (63.50 x 76.20 cm.)
Signed, Wilson, lower middle
Museum purchase, 1968
968-O-191

Richard WILT, (1915–1981)

Shambattle
Oil on canvas, 30 x 36" (76.20 x 91.44 cm.)
Signed, Richard Wilt, on reverse
Museum purchase, 1950
950-O-114

Circus Triptych, 1962
Watercolor on paper, 30 x 58" (76.20 x 147.32 cm.)
Signed, Richard Wilt, 1962, upper middle
Museum purchase, 1953
953-W-109

The Hillside, 1953
Watercolor on paper, 20.5 x 28.5" (52.07 x 72.39 cm.)
Signed, Richard Wilt, lower right
Gift of Joseph G. Butler, III, 1964
964-W-112

William WIMAN, (1940–)

Still Life with Floating Banana, 1972
Oil on canvas, 45 x 60" (114.30 x 152.40 cm.)
Unsigned
Museum purchase, 1974
974-O-114

John WINSLOW, (1938–)

In the Studio, June, 1980, 1980
Oil on canvas, 60 x 82" (152.40 x 208.28 cm.)
Signed, Winslow, lower left
Museum purchase, 1982
982-O-104

Andrew WINTER, (1893–1958)

The Wreck at Lobster Cove
Oil on canvas, 30 x 40" (76.20 x 101.60 cm.)
Signed, A. Winter, lower right
Museum purchase, 1968
968-O-202

Denny WINTERS, (1907–)

Moonlight, 1963
Acrylic and collage on canvas, 34 x 42" (86.36 x 106.68 cm.)
Signed, Winters, lower right
Museum purchase, 1964
964-O-109

Jerome WITKIN, (1939–)

The Madonna Della Baggies, 1977
(Portrait of Felice Dulberg)
Oil on canvas, 60 x 48" (152.40 x 121.92 cm.)
Signed, Witkin, lower right
Museum purchase, 1980
980-O-107

John Henry WITT, (1840–1901)

Landscape
Oil on canvas, 28 x 50" (71.12 x 127.00 cm.)
Signed, J. H. Witt, lower right
Museum purchase, 1969
969-O-106

Robert E. WOIDE, (1927–)

Still Life in Black, 1949
Watercolor on paper, 17 x 28" (43.18 x 71.12 cm.)
Signed, Woide, '49, lower right
Museum purchase, 1950
950-W-130

Helen WOLF, (1912–)

Summer Harvest
Oil on canvas, 32 x 34" (81.28 x 86.36 cm.)
Signed, Helen Wolf, lower left
Gift of Helen Wolf, 1969
969-O-119

Theodore WOLFF, (1926–)

Girl with Toys, 1968
Oil on canvas, 50 x 48" (127.00 x 121.92 cm.)
Signed, Th. Wolff, lower right
Museum purchase, 1969
969-O-135

Joseph WOLINS, (1915–)

The Jester
Oil on canvas, 36 x 28" (91.44 x 71.12 cm.)
Signed, Jos. Wolins, lower left
Gift of Mrs. Joseph Wolins, 1977
977-O-130

Frederick WONG, (1929–)

Rain on Park South
Watercolor on paper, 41 x 13" (104.14 x 33.02 cm.)
Signed, Frederick Wong, lower left
Museum purchase, 1960
960-W-107

Tyrus WONG, (1910–)

Abandoned Orchard
Watercolor on paper, 13 x 28" (33.02 x 71.12 cm.)
Signed, Tyrus Wong, lower right
Museum purchase, 1957
957-W-110

Grant WOOD, (1892–1942)

In the Spring, 1939
Pencil on paper, 18 x 24" (45.72 x 60.96 cm.)
Signed, Grant Wood, 1939, lower right
Museum purchase, 1942
942-D-101

Farmscape
Lithograph on paper, 9 x 12" (22.86 x 30.48 cm.)
Signed, Grant Wood, lower right
Museum purchase, 1967
967-P-183

In the Spring, 1939
Lithograph on paper, 12 x 15.5" (30.48 x 39.37 cm.)
Signed, Grant Wood, lower right
Museum purchase, 1985
985-P-104

Midnight Alarm
Lithograph on paper, 12 x 7" (30.48 x 17.78 cm.)
Signed, Grant Wood, lower middle
Museum purchase, 1962
962-P-112

July Fifteenth, 1939
Lithograph on paper, 9 x 12" (28.58 x 30.48 cm.)
Signed, Grant Wood, lower right
Gift of Eleanor Beecher Flad, 1991
991-P-106

Wild Flowers
Lithograph on paper, 11.25 x 16.25" (28.58 x 41.28 cm.)
Signed, Grant Wood, lower right
Gift of Albert E. Hise, 1979
979-P-145

Kenneth A. WOOD, (active 20th century)

Painters and Helpers, 1959
Oil on panel, 24 x 48" (60.96 x 121.92 cm.)
Signed, Kenneth A. Wood, lower right
Gift of Kenneth A. Wood, 1990
990-O-104

Robert E. WOOD, (1926–)

Summer Haze, 1967
Watercolor on paper, 21.5 x 29.5" (54.61 x 74.93 cm.)
Signed, Robert E. Wood, 1967, lower right
Museum purchase, 1967
967-W-107

Ralph WOODBURN, (active 20th century)

Portrait of Joseph G. Butler, Jr.
Drawing on paper, 13 x 10" (33.02 x 25.40 cm.)
Signed, Woodburn, lower right
Gift of Roland A. Luhman, 1955
955-D-101

R. C. WOODVILLE, (1825–1856)

Mexican News, 1851
Steel engraving on paper, 28.5 x 20.5" (72.39 x 52.07 cm.)
Unsigned
Museum purchase, 1967
967-P-142

The Card Players
Engraving on paper, 9 x 11.25" (22.86 x 28.58 cm.)
Signed, Ptd. by R. C. Woodville, lower left, Eng. by Chas.
Burt, lower right
Gift of Mr. and Mrs. Richard A. Ulrich, 1968
968-P-230

Howard L. WORNER, (1913–)

United Slabbing Mill, Somisa, San
Nicolas, 1969
Watercolor on paper, 20 x 29" (50.80 x 73.66 cm.)
Signed, Howard L. Worner, lower right
Gift of Wean United, 1969
969-W-120

The Butler, 1993
Watercolor on paper, 21 x 28" (53.34 x 71.12 cm.)
Signed, Howard L. Worner, A.W.S., lower right
Gift of Howard L, Worner, 1993
993-W-103

The Wean Collection

Maine Coast, Arcadia National Park,
1989
Acrylic on canvas board, 20.25 x 28.25" (51.44 x 71.76 cm.)
Unsigned
Gift of the Danieli Corporation, 1994
994-O-110

The Butler Institute's collection includes two-
hundred fifty signed watercolors on paper which
are the gift of the Danieli Corporation, 1994
994-W-102 — 994-W-352

The Butler Institute's collection includes fifteen
signed drawings which are the gift of the Danieli
Corporation, 1994
994-D-105 — 994-D-119

Edith Stevenson WRIGHT, (active late 19th
century)

Josephine Butler Ford as a Young Girl,
1905
Oil on canvas, 72 x 37" (182.88 x 93.98 cm.)
Signed, Edith S. Stevenson, lower right
Gift of Mrs. Benjamin Agler, 1976
979-O-106

Portrait of Thomas H. Wells, Sr. , 1906
Oil on canvas, 30 x 25" (76.20 x 63.50 cm.)
Signed, Edith P. Stevenson, 1906, upper left
Gift of Mr. Thomas H. Wells, III, 1955
955-O-163

Joseph WRIGHT, (1756–1793)

Washington Portrait, 1784
Engraving on paper, 6.75 x 4.75" (17.15 x 12.07 cm.)
Unsigned
Museum purchase, 1968
968-P-300

R. Stephens WRIGHT, (1903–)

Kennebunk Port, Maine, 1936
Drypoint on paper, 11 x 16" (27.94 x 40.64 cm.)
Signed, R. Stephens Wright, lower right
Gift of Mrs. R. Stephens Wright, 1976
976-P-101

Alexander Helwig WYANT, (1836–1892)

Lake Champlain, ca. 1868
Oil on canvas, 15 x 25" (38.10 x 63.50 cm.)
Signed, Wyant, lower left
Museum purchase, 1947
947-O-112

Grant Wood - July Fifteenth

Woodburn - Portrait of Joseph G. Butler, Jr.

Woodville - Mexican News

Worner - Matiricus Rock (994-W-351)

Worner - Steel Mills, Youngstown, Ohio (994-W-176)

Joseph Wright - Washington Portrait

Wyant - Lake Champlain

Wyeth - The General Knox Mansion

Yamamoto - South Pole

Yao - (Untitled)

Yates - Mountain Stream

Yektai - Portrait of Paul Jenkins

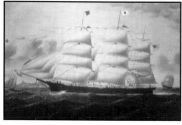

Yorke - Ship: *Dexter*

Environs of a City
Oil on canvas, 15 x 25" (30.48 x 63.50 cm.)
Signed, A. H. Wyant, lower left
Gift of William Hitchcock, 1964
964-O-115

Andrew N. WYETH, (1917–)

The General Knox Mansion, 1941
Watercolor on paper, 19 x 29.25" (48.26 x 74.30 cm.)
Signed, Andrew N. Wyeth, 1941, lower left
Museum purchase, 1942
942-W-102

Richard WYNN, (1928–)

Safari, 1963
Oil on canvas, 24 x 34" (60.96 x 86.36 cm.)
Signed, Richard Wynn, 1963, middle right
Museum purchase, 1964
964-O-106

Jud YALKUT, (active late 20th century)

To Yves Tanguy—Alleys of Imaginary Cities
Portfolio of 53: Rip Off on the Last Millennium
Print on paper, 8.5 x 11" (21.59 x 27.94 cm.)
Signed, Yalkut, lower right
Gift of the William Busta Gallery, 1991
991-P-111.1

Taro YAMAMOTO, (1919–)

South Pole, 1961
Oil on canvas, 60 x 54" (152.40 x 137.16 cm.)
Unsigned
Gift of Emil Arnold, 1967
967-O-111

Chris YAMBAR, (active late 20th century)

Mr. Clyde Singer, 1994
Acrylic and spray paint on masonite, 24 x 24" (60.96 x 60.96 cm.)
Signed, Chris Yambar, 94, lower right
Gift of Chris Yambar, 1994
994-O-116

C. J. YAO, (active late 20th century)

(Untitled), 1982
Lithograph on paper, 19.25 x 21.5" (48.90 x 54.61 cm.)
Signed, C. J. Yao, lower right
Gift of Marc A. Wyse, 1983
983-P-132

Richard YARDE, (active 20th century)

Garvey's Ghost
Oil on canvas, 61 x 18.5" (154.94 x 46.99 cm.)
Unsigned
Gift of Leonard Bocour, 1976
976-O-122

Cullen YATES, (1866–1945)

Mountain Stream, 1912
Oil on canvas, 39 x 35" (99.06 x 88.90 cm.)
Signed, Cullen Yates, lower right
Museum purchase, 1918
918-O-111

Manoucher YEKTAI, (1922–)

Portrait of Paul Jenkins, 1960–61
Oil on canvas, 57 x 40" (144.78 x 101.60 cm.)
Signed, Yektai, '60–61, lower left
Gift of Paul and Suzanne Donnelly Jenkins, 1990
990-O-108

Thomas YERXA, (1923–)

City Child, 1957
Oil on canvas, 40 x 30" (101.60 x 76.20 cm.)
Signed, Yerxa, '57, lower left
Museum purchase, 1957
957-O-131

Delmer J. YOAKUM, (1915–)

Old Reliable, 1967
Oil on canvas, 30 x 25" (76.20 x 63.50 cm.)
Signed, Yoakum, lower right
Museum purchase, 1968
968-O-192

W. H. YORKE, (active late 19th century)

Ship: *Dexter*
Oil on canvas, 24 x 36" (60.96 x 91.44 cm.)
Unsigned
Museum purchase, 1928
S28-O-112

Ship: *Huguenot of Boston*, 1870
Oil on canvas, 24 x 36" (60.96 x 91.44 cm.)
Signed, W. H. Yorke, Liverpool, lower left
Museum purchase, 1928
S28-O-113

Fred J. YOST, (1888–1968)

Las Cruces Mountains, 1945
Watercolor on paper, 21 x 28" (53.34 x 71.12 cm.)
Signed, Fred Yost, '45, lower right
Museum purchase, 1945
945-W-105

Beach Scene
Drawing on paper, 8 x 11" (20.32 x 27.94 cm.)
Signed, Fred Yost, lower right
Museum purchase, 1952
952-D-103

Fulton St. Dock
Lithograph on paper, 9.5 x 13.5" (24.13 x 34.29 cm.)
Signed, Fred Yost, lower right
Gift of Mrs. Henry A. Butler, 1960
960-P-104

Rio Grande Canyon, N.M.
Lithograph on paper, 10 x 13.75" (25.40 x 34.93 cm.)
Signed, Fred Yost, lower right
Gift of Jean Webb, 1968
968-P-253

The following two lithographs on paper, 10 x 14" (25.40 x 35.56 cm.), are a museum purchase, 1948

Idaho Night
948-P-125

Seal Rocks
948-P-124

Adja YUNKERS, (1900–1983)

Sun Drops–Petrified, 1975
Etching on paper, 39 x 33.5" (99.06 x 85.09 cm.)
Signed, Adja Yunkers, 75, lower right
Museum purchase, 1989
989-P-118

The following five signed etchings on paper are
the gift of Marc A. Wyse, 1983

Echo II in Pink, 1977
(50/50), 44.5 x 29.75" (113.03 x 75.57 cm.)
983-P-108

Red Echo, 1976
(30/40), 39.75 x 29.37" (100.97 x 74.56 cm.)
983-P-135

Sun Drops Petrified Black, 1975
(49/50), 45.62 x 36.5" (115.87 x 92.71 cm.)
983-P-122

The King in Black, 1977
44 x 29.75" (111.76 x 75.57 cm.)
983-P-134

The Sky Hides All Its Birds, 1976
(44/50), 41.75 x 30.75" (106.05 x 78.11 cm.)
983-P-133

Dave YUST, (active late 20th century)

The following four signed lithographs on paper
are the gift of Mr. and Mrs. Gordon L. Dalby,
1991

Alpha Inclusion, (Cool), 1982
(29/30), 30 x 30" (76.20 x 76.20 cm.)
991-P-191

Alpha Inclusion, (Warm), 1982
(29/30), 30 x 30" (76.20 x 76.20 cm.)
991-P-190

Circular Composition #120
(25/60), 28.5 x 28" (72.39 x 71.12 cm.)
991-P-189

Circular Composition #121
(25/60), 28.5 x 28" (72.39 x 71.12 cm.)
991-P-188

Athanasios ZACHARIAS, (1927–)

Water Image, 1966
Acrylic on canvas, 50.5 x 47.5" (128.27 x 120.65 cm.)
Signed, Athos Zacharias, lower right
Gift of Leonard Bocour, 1976
976-O-119

Jack ZAJAC, (1929–)

(Untitled)
Oil on canvas, 40 x 60.25" (101.60 x 153.04 cm.)
Signed, Zajac, lower right
Gift of Jack Zajac, 1972
972-O-113

Resurrection, 1960
Etching on paper, 11.75 x 15.5" (29.85 x 39.37 cm.)
Signed, Jack Zajac, 1960, lower right
Museum purchase, 1961
961-P-106

Karl ZERBE, (1903–1972)

Ruins, Brantome
Watercolor on paper, 17 x 24" (43.18 x 60.96 cm.)
Unsigned
Gift of the American Academy of Arts and Letters, 1946
946-W-106

George ZETZER, (active 20th century)

Market Place, Mexico
Watercolor on paper, 15 x 12.5" (38.10 x 31.75 cm.)
Signed, George Zetzer, lower right
Museum purchase, 1957
957-W-111

Irene ZEVON, (1918–)

Figures in Space, 1963
Oil on canvas, 30 x 40" (76.20 x 101.60 cm.)
Signed, Zevon, '63, lower right
Gift of Stanley Bard, 1969
969-O-165

Taurus Contemplating Repose, 1959
Oil on canvas, 32 x 48" (81.28 x 121.92 cm.)
Signed, Irene Zevon, upper right
Gift of Irene Zevon, 1959
959-O-108

Fred ZIMMER, (1923–)

Landscape
Watercolor on paper, 25 x 37" (63.50 x 93.98 cm.)
Signed, Fred Zimmer, lower right
Museum purchase, 1959
959-W-107

Kathleen M. ZIMMERMAN, (1923–)

Decanter with Plants
Oil on canvas, 24 x 30" (60.96 x 76.20 cm.)
Signed, K. Zimmerman, lower right
Gift of Charles J. Oppenheim, 1976
976-O-125

Nicola V. ZIROLI, (1908–)

N. Ziroli
Watercolor on paper, 18 x 15" (45.72 x 38.10 cm.)
Signed, N. Ziroli, lower left
Museum purchase, 1955
955-W-116

Florence M. ZLOWE, (1933–)

Bowl of Flowers
Ink on paper, 17 x 20" (43.18 x 50.80 cm.)
Signed, Zlowe, lower right
Gift of Mr. and Mrs. Irwin Zlowe, 1977
977-D-108

Elise, 1968
Pen and ink on paper, 13 x 11" (33.02 x 27.94 cm.)
Signed, Zlowe, lower left
Gift of William J. Ober, 1969
969-D-101

Richard ZOELLNER, (1908–)

Jockey, 1937
Oil on canvas, 24 x 18" (60.96 x 45.72 cm.)
Signed, Zoellner, lower right
Gift of John J. Benninger, 1977
977-O-163

Yunkers - Sun Drops–Petrified

Zajac - (Untitled)

Zerbe - Ruins, Brantome

Zoellner - Jockey

Zorach - Chinese Figure

Zorach - Marguerite

Zuniga - Yucateca con Fruta

Louis A. ZONA, (1944–)

Man Series IV, 1973
Mixed media on paper, 40 x 26" (101.60 x 66.04 cm.)
Signed, Zona, lower left
Museum purchase, 1973
973-D-106

Dhimitri ZONIA, (1921–)

Delta Queen, 1975
Acrylic on canvas, 24 x 36" (60.96 x 91.44 cm.)
Signed, Dhimitri Zonia, lower left
Museum purchase, 1975
975-O-122

William ZORACH, (1887–1966)

Chinese Figure, 1929
Watercolor on paper, 20 x 14" (50.80 x 35.56 cm.)
Signed, Zorach, 1929, lower right
Museum purchase, 1965
965-W-146

Marguerite
Pencil on paper, 18.5 x 14" (46.99 x 35.56 cm.)
Signed, William Zorach, lower right
Museum purchase, 1959
959-D-122

Milford ZORNES, (1908–)

The Coal Jetty, 1935
Watercolor on paper, 15 x 21" (38.10 x 53.34 cm.)
Signed, Milford Zornes, 1935, lower left
Museum purchase, 1937
937-W-101

Kazimieras ZOROMSKIS, (active 20th century)

TDS #158, 1977
Oil on canvas, 24 x 20" (60.96 x 50.80 cm.)
Unsigned
Gift of D. Paris, 1979
979-O-120

ZSISSLY (Malvin Marr Albright), (1897–)

The Captain's House, 1939
Watercolor on paper, 13 x 19" (33.02 x 48.26 cm.)
Signed, Zsissly, 39, lower right
Museum purchase, 1946
946-W-107

Victoria
Lithograph on paper, 11.5 x 16.5" (29.21 x 41.91 cm.)
Signed, Zsissly, lower right
Gift of Albert E. Hise, 1979
979-P-144

Victoria
Lithograph on paper. 8.5 x 13" (21.59 x 33.02 cm.)
Signed, Zsissly, lower right
Museum purchase, 1970
970-P-102

Jacques ZUCKER, (1900–1981)

Head, 1953
Red chalk on paper, 13.5 x 10" (34.29 x 25.40 cm.)
Signed, Taxco, 1953, Jacques Zucker, lower right
Gift of Samuel Brouner, 1959
959-D-125

Man's Head
Sepia crayon on paper, 17.5 x 12" (44.45 x 30.48 cm.)
Signed, J. Zucker, on reverse
Gift of Jacques Zucker, 1971
971-D-106

Murray ZUCKER, (1920–)

La Mancha, 1973
Pencil on paper, 16 x 24" (40.64 x 60.96 cm.)
Signed, Zucker, '73, lower right
Gift of Linda J. Lehrer, 1977
977-D-104

Sandor ZUGOR, (1923–)

Images, 1974
Collagraph on paper, 12 x 17" (30.48 x 43.18 cm.)
Signed, Sandor Zugor, lower right
Gift of Sandor Zugor, 1977
977-P-123

Francisco ZUNIGA, (active 20th century)

Yucateca con Fruta, 1974
Offset lithograph on paper, 27 x 19.25" (68.58 x 48.90 cm.)
Signed, Zia, 1974, lower right
Gift of Dana Seman, 1980
980-P-114

ZVI, (Thomas Wilson), (1931–)

The Promise I
Oil on canvas, 14 x 18" (35.56 x 45.72 cm.)
Signed, Zvi, lower right
Gift of Earl Cohen, 1967
967-O-106

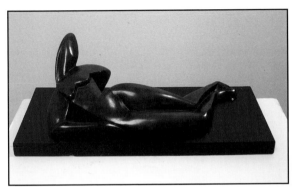

Archipenko - Reclining Figure

Eakins - Horse Skeleton

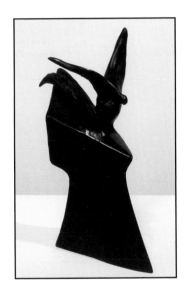

Hunt - The Flight of the Night—The Horses of Anahita

Sculpture

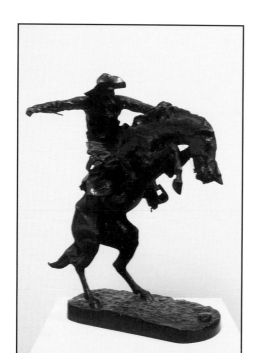

Remington - The Bronco Buster

Binder - Fertility Goddess

Rhind - Indian Scout

Beling - Seedling

Drum - Untitled #3

Gross - Lot's Wife

Ferrer - Vendaval Baricua

Hostetler - Cape Woman

Davis - Harmonic Grid XXX

Grooms - Fran Tarkenton

Hutchinson - O is for Old Spice

Hutchinson - Y is for Yellowstone

Kur - Portrait of a Young Girl

Jenkins - Phenomena Meditation Mandala

Komisar - Rhapsody on a Theme by F. Scott Key

Jones - Odyssey

Lakofsky - Horned Animal

Lynds - Stele CIV

Mills - Prodigal Son

Rhoades - (Untitled)

Naberezny - Prophet

Nevelson - Untitled

Schomberg - After the Game

Rhind - Apollo

Rhind - Minerva

Schreckengost - Ziamba

Unidentified Artist - Eagle

Taino - Bone Carving

Stix - Horse

Taino - Clay Sculpture

Zajac - Falling Waters

Segall - Potiphar's Wife

Margo ALLEN, (1895–1988)

Mexican Indian
Terra cotta, 10" h. (25.40 cm.)
Gift of Margo Allen, 1946
946-S-101

Irving AMEN, (1918–)

Protectors
Bronze, 9" h. (22.86 cm.)
Gift of the Irving Amen Studio, 1980
980-S-106

Victim
Bronze, 15" h. (38.10 cm.)
Gift of the Irving Amen Studio, 1980
980-S-105

Alexander ARCHIPENKO, (1887–1964)

Reclining Figure, 1913
Bronze, 4.12" h. (10.47 cm.)
Gift of Jere and Deborah Lustig, 1994
994-S-101

Tony ARMENI, (1957–)

Illegal Alien, 1982
Acrylic lacquer on steel, 124" h. (314.96 cm.)
Gift of Dr. and Mrs. Bertram Katz, 1982
982-S-101

John BALDWIN, (1922–1987)

Protest
Metal, 23.5" h. (59.69 cm.)
Museum purchase, 1973
973-S-101

John BALSEY, (1944–)

Commander-in-Chief, Wintergreen Home
Mixed material, 29" h. (73.66 cm.)
Museum purchase, 1966
966-S-101

Helen BELING, (1914–)

Seedling
Plaster, 64" h. (162.56 cm.)
Gift of Norman Schneider, 1955
955-S-101

Erwin BINDER, (1934–1993)

The following six sculptures are the gift of Eliane Alfred, 1984, 1986, 1988, and 1994

Fertility Goddess
Orange onyx on black marble base, 22" h. (55.88 cm.)
984-S-101

La Tierra
Onyx, 13" h. (33.02 cm.)
986-S-101

Life
Bronze, 26" h. (66.04 cm.)
988-S-103

The Caress
Bronze, 28" h. (71.12 cm.)
994-S-102

The Knife of Edge
Black marble, 25" h. (63.50 cm.)
988-S-104

The Rock Lady
Onyx on black marble base, 20.5" h. (52.07 cm.)
986-S-102

Edward Marshall BOEHM, (active late 20th century)

Young and Spirited
(American Bald Eagle)
Ceramic, 9.5" h. (24.13 cm.)
Gift of Strouss Department Store, 1976
976-S-102

Paul BOGATAY, (1905–)

Brahma Bull
Ceramic, 5" h. (12.70 cm.)
Museum purchase, 1957
957-S-101

The following two sculptures are the gift of the Junior League, 1946, 1948

Figure
Ceramic, 7" h. (17.78 cm.)
948-S-101

Zebra
Ceramic, 7" h. (17.78 cm.)
946-S-102

William B. BOWIE, (1926–1994)

Hivaro, 1964
Steel and brass, 35" h. (88.90 cm.)
Museum purchase, 1965
965-S-101

Jack CARLTON, (active 20th century)

JMS Temporary Town
Welded metal, 23" h. (58.42 cm.)
Museum purchase, 1961
961-S-102

Edward CAROME, (1927–)

Perceiving is Feeling
Plastic, 19.87" h. (50.47 cm.)
Museum purchase, 1977
977-S-101

Muriel CASTANIS, (1926–)

Untitled–85
Cloth and epoxy resin, 74" h. (187.96 cm.)
Gift of the Terminare Corporation, 1994
994-S-107

Ivan CHERMAYEFF, (1932–)

Vertical Angles
Polished stainless steel, two pieces, each 95" h. (243.30 cm.)
Gift of General Fireproofing Company, 1971
971-S-102

Ruth COCHRAN, (active 20th century)

Desire for Escape
Metal, 29.5" h. (74.93 cm.)
Museum purchase, 1956
956-S-101

M. R. COINER, (1934–)

Angel
Welded metal, 37" h. (93.98 cm.)
Museum purchase, 1962
962-S-101

Janet COLEMAN, (active 20th century)

Lovers
Bronze, 12" h. (30.48 cm.)
Gift of Janet Coleman, 1980
980-S-110

Claude CONOVER, (1907–)

Head from Granite Boulder
Granite, 12.5" h. (31.75 cm.)
Museum purchase, 1956
956-S-102

Bea CROLL, (active 20th century)

Bear
Ceramic, 11" h. (27.94 cm.)
Gift of Louis Held, 1967
967-S-104

Earl CUNNINGHAM, (active 20th century)

(Untitled)
Wood, 52" h. (132.08 cm.)
Museum purchase, 1960
960-S-103

Malcolm DASHIELL, (active 20th century)

Woman in Pink Marble
Marble, 21" l. (53.34 cm.)
Museum purchase, 1956
956-S-103

David E. DAVIS, (active 20th century)

Harmonic Grid XXX, 1974
Corten steel, 93" h. (236.22 cm.)
Gift of Mr. and Mrs. Joseph Erdelac, 1992
992-S-104

DOOLITTLE FOUNDRY

Bell
Brass, (2) 24" h. (60.96 cm.)
Gift of Mr. and Mrs. Maury Young, 1993
993-S-218

Dennis DOROGI, (1935–)

Monument to a Woman
Wood, 47" h. (119.38 cm.)
Museum purchase, 1961
961-S-101

Standing Torso
Wood, 27" h. (68.58 cm.)
Museum purchase, 1959
959-S-102

Don DRUM, (1935–)

Untitled #3, 1969
Aluminum, 14" h. (35.56 cm.)
Museum purchase, 1970
970-S-101

Gerald DUMLAO, (1935–)

Bronze Bird
Bronze, 6" h. (15.24 cm.)
Museum purchase, 1964
964-S-102

Thomas EAKINS, (1844–1916)

Horse Skeleton, 1878
Bronze, 11" h. (27.94 cm.)
Museum purchase, 1966
966-S-104

Edris ECKHARDT, (1905–)

Convoy
Ceramic, 10" h. (25.40 cm.)
Gift of the Junior League, 1950
950-S-101

George ELWELL, (dates unknown)

Hunters in the Snow
Metal wire, 20" h. (50.80 cm.)
Museum purchase, 1956
956-S-104

George FADDIS, (1920–1985)

Pasiphae, 1964
Slate, 8" h. (20.32 cm.)
Museum purchase, 1964
964-S-105

V. Dentato Circuitous
Sheet metal, 11" h. (27.94 cm.)
Museum purchase, 1965
965-S-103

Maybelle Muttart FALARDEAU, (active 20th century)

Song of David
Ceramic, 18" h. (45.72 cm.)
Museum purchase, 1955
955-S-105

Rafael FERRER, (1933–)

Vendaval Baricua, 1979
Mixed media, 85" h. (215.90 cm.)
Gift of Marsha Fogel, 1994
994-S-109

John B. FLANNAGAN, (1895–1942)

Young Fawn
Bronze, 14.5" h. (36.83 cm.)
Gift of Emil Arnold, 1958
958-S-104

Jon FORDYCE, (active 20th century)

Novum
Steel, 37" h. (93.98 cm.)
Museum purchase, 1980
980-S-101

James FRIEND, (1938–)

Organist
Iron, 5" h. (12.70 cm.)
Museum purchase, 1969
969-S-102

Robert GARCIA, (active late 20th century)

A Proud Mother, 1982
Alabaster, 18" h. (45.72 cm.)
Gift of Eleanor Beecher Flad, 1995
995-S-102

Dorothy GETZ, (1901–)

Seated Figure
Bronze, 7.5" h. (19.05 cm.)
Museum purchase, 1964
964-S-103

M. E. GOSLEE, (1915–)

Beastie
Stoneware, 11.5" h. (29.21 cm.)
Museum purchase, 1963
963-S-103

Bird Form
Stoneware, 13" h. (33.02 cm.)
Museum purchase, 1966
966-S-102

Red GROOMS, (1937–)

Fran Tarkenton, 1979
Painted vinyl, aluminum armature, polyester stuffing, 96" h.
(243.84 cm.)
Signed, Red Grooms, lower right
Museum purchase, 1988

Chaim GROSS, (1904–1991)

Lot's Wife
Lignum vitae, 36" h. (91.44 cm.)
Museum purchase, 1958
958-S-102

Minna HARKAVY, (1895–)

Nude, 1954
Bronze, 10" h. (25.40 cm.)
Gift of Mr. and Mrs. Nahum Tschacbasov, 1970
970-S-105

Hubert HARTMAN, Jr., (active 20th century)

Burden
Wood, 25" h. (63.50 cm.)
Museum purchase, 1959
959-S-103

Everett HAYCOCK, (1923–)

Flapper Type
Welded metal, 27" h. (68.58 cm.)
Museum purchase, 1962
962-S-102

Harold W. HILL, (1933–1988)

Torso, 1963
Plastic, 19.5" h. (49.53 cm.)
Gift of Mr. and Mrs. Nahum Tschacbasov, 1970
970-S-106

Ralph HOSPODAR, (? –1980)

Ride of the Valkyrie
Metal, 34" h. (86.36 cm.)
Museum purchase, 1960
960-S-101

David HOSTETLER, (1927–)

Cape Woman
Bronze, 40.5" h. (102.87 cm.)
Museum purchase, 1971
971-S-101

Fallen Woman
Bronze, 16" l. (40.64 cm.)
Museum purchase, 1971
971-S-101

Walter HULL, (active 20th century)

Gull
Brass, 10" h. (25.40 cm.)
Museum purchase, 1958
958-S-103

William Morris HUNT, (1824–1879)

The Flight of the Night—The Horses of Anahita
Bronze, 19.5" h. (49.53 cm.)
Gift of the Friends of American Art, 1978
978-S-102

Anna Hyatt HUNTINGTON, (1876–1973)

Elephant Running
Bronze, 7.5" h. (19.05 cm.)
Gift of Anna Hyatt Huntington, 1936
936-S-101

Peter HUTCHINSON, (1932–)

The following two signed mixed media sculptures are a museum purchase, 1993

O is for Old Spice, 1991
21.75" h. (55.25 cm.)
993-S-213

Y is for Yellowstone, 1991
27.75" h. (70.49 cm.)
993-S-214

David HYSELL, (1934–)

Girl Donning Stockings
Bronze, 5" h. (12.70 cm.)
Museum purchase, 1962
962-S-103

C. Gilbert JAMES, Jr., (active 20th century)

Eagle Form
Metal, 30" h. (76.20 cm.)
Gift of C. Gilbert James, Jr., 1971
971-S-103

Paul JENKINS, (1923–)

Phenomena Meditation Mandala
Bronze and wood, 23.5" h. (59.69 cm.)
Gift of Paul and Suzanne Donnelly Jenkins, 1988
988-S-105

Kate Tod JOHNSTONE, (active 20th century)

Running Free
Bronze, 6" h. (15.24 cm.)
Gift of the estate of Marguerite H. Tod, 1981
981-S-102

Touch Me, 1979
Bronze, 15.5" h. (39.37 cm.)
Museum purchase, 1981
981-S-101

Jack JOLLEY, (active 20th century)

Foundations
Fired clay, 12.5" h. (31.75 cm.)
Museum purchase, 1979
979-S-101

Jane Manus JONAS, (active 20th century)

Bachelor Pad
Steel, 18" h. (45.72 cm.)
Gift of Jane Manus Jonas, 1976
976-S-105

Roger JONES, (active late 20th century)

Odyssey, 1994
Painted steel, 13' h. (396.24 cm.)
Museum purchase, 1994
994-S-105

J. Wallace KELLEY, (1894– ?)

St. Francis
Cast concrete, 59" h. (149.86 cm.)
Gift of Venice Lamb, 1962
962-S-105

Susan KEMENYFFY, (1941–)

Flower Lady
Ceramic, 56" h. (142.24 cm.)
Gift of the Friends of American Art, 1976
976-S-102

Milton KOMISAR, (active late 20th century)

Rhapsody on a Theme by F. Scott Key,
1987
Plexoglas, 72" h. (182.88 cm.)
Gift of the David Bermant Foundation, 1994
994-S-103

Carl KRABILL, (1930–)

Sculptural Form
Ceramic, 16" h. (40.64 cm.)
Museum purchase, 1962
962-S-104

Csaba A. KUR, (1926–)

Bust of Joseph G. Butler, III, 1970
Marble, 26.5 h. (67.31 cm.)
Gift of Csaba A. Kur, 1970
971-S-104

Portrait of a Young Girl
Bronze, 18" h. (45.72 cm.)
Gift of Dr. and Mrs. Joseph A. Fagarty, 1987
987-S-101

Bernice KUSSOY, (1934–)

Three Musicians
Metal, 46" h. (116.84 cm.)
Museum purchase, 1958
958-S-101

Charles LAKOFSKY, (1922–)

Horned Animal
Ceramic, 10.5" h. (26.67 cm.)
Museum purchase, 1957
957-S-102

Alan LANDIS, (1937–)

Symbols
Metal, 15" h. (38.10 cm.)
Museum purchase, 1967
967-S-101

Anthony J. LAUK, (1908–)

Monk at Prayer, 1953
Limestone, 15" h. (38.10 cm.)
Gift of Mr. and Mrs. Leslie M. Swope, 1968
968-S-115

Michael J. LOWE, (1920–)

(Untitled), 1970
Wood and metal, 18" h. (45.72 cm.)
Museum purchase, 1972
972-S-102

Clyde LYNDS, (active late 20th century)

Stele CIV, 1982
Concrete with fiber optic elements, 85" h. (215.90 cm.)
Museum purchase, 1994
994-S-108

Phil MAKOFF, (active 20th century)

Standing Figure
Wood, 56" h. (142.24 cm.)
Museum purchase, 1961
961-S-103

Irving MARANTZ, (1918–)

Man with a Stick
Bronze, 9.5" h. (24.13 cm.)
Gift of Mr. and Mrs. Nahum Tschacbasov, 1980
980-S-104

Lawrence MARCELL, (1931–)

Woman of the Sea
Bronze, 45" h. (114.30 cm.)
Museum purchase, 1963
963-S-102

Michael Patrick McCONNELL, (1948–)

Model for a Monument
Bronze, 12" h. (30.48 cm.)
Museum purchase, 1976
976-S-101

Elizabeth C. McFAYDEN, (1925–)

Amneris
Ceramic, 19" h. (48.26 cm.)
Museum purchase, 1954
954-S-103

William McVEY, (1905–)

Twiggy
Metal, 5" h. (12.70 cm.)
Museum purchase, 1968
968-S-113

Hines METZ, (active 20th century)

Persepolis
Alabaster, 10" h. (25.40 cm.)
Gift of J. B. Martinson, 1967
967-S-110

Richard M. MILLER, (1922–)

Head
Alabaster, 18" h. (45.72 cm.)
Museum purchase, 1954
954-S-101

John the Baptist
Wood, 10" h. (25.40 cm.)
Museum purchase, 1955
955-S-102

Linda, 1969
Bronze, 12.5" h. (31.75 cm.)
Museum purchase, 1970
970-S-102

Roy N. MILLS, (1908–)

Prodigal Son
Wood, 20.5" h. (52.07 cm.)
Museum purchase, 1956
956-S-105

Torso
Wood, 20.5" h. (52.07 cm.)
Museum purchase, 1954
954-S-102

L. E. MOLL, (1925–)

Robed Figure
Bronze, 10" h. (25.40 cm.)
Museum purchase, 1963
963-S-101

Helen Bosart MORGAN, (1902–)

And He Saw It Was Good
Metal, 25" h. (63.50 cm.)
Gift of Helen Bosart Morgan, 1973
973-S-102

Robert MULLEN, (active 20th century)

Cube Over Allamont Hills
Painted wood, 16" dia. (40.64 cm.)
Gift of Robert Mullen, 1975
975-S-101

Jon NABEREZNY, (1921–)

Prophet
Limestone, 16" h. (40.64 cm.)
Museum purchase, 1956
956-S-106

Louise NEVELSON, (1900–1988)

Untitled, 1958
Painted wood construction, 21" h. (53.34 cm.)
Signed and dated on reverse
Museum purchase and gift of Mr. and Mrs. J. J. Cafaro, 1989
989-S-101

Mike NEVELSON, (1922–)

Head and Torso
Wood, 9" h. (22.86 cm.)
Gift of Louis Held, 1967
967-S-109

Woman, 1946
Wood, 20.5" h. (52.07 cm.)
Gift of Louis Held, 1967
967-S-103

Marian OWCZARSKI, (1932–)

Paderewski
Welded steel, 29" h. (73.66 cm.)
Gift of the Youngstown Polish Arts Club, 1979
979-S-102

Anita PARK, (active 20th century)

The Dream
Marble, 14" h. (35.56 cm.)
Museum purchase, 1959
959-S-101

Richard L. PARSONS, (1942–)

Charging Bear
Fiberglass, 47" h. (119.38 cm.)
Museum purchase, 1975
975-S-102

Miska PETERSHAM, (1888–1959)

Monkey
Stoneware, 18" h. (45.72 cm.)
Museum purchase, 1950
950-S-103

Richard PHILLIPS, (active 20th century)

(Untitled), 1989
Leather, latex, suede, and lace, 53" h. (134.62 cm.)
Gift of Professor Sam Hunter, 1993
993-S-216

Eleanor POMPILI, (active 20th century)

Fish
Ceramic, 11" h. (27.94 cm.)
Museum purchase, 1955
955-S-104

Ruth RANDALL, (1896– ?)

Llama
Ceramic, 17" h. (43.18 cm.)
Gift of the Friends of American Art, 1950
950-S-102

Frederick REMINGTON, (1861–1909)

The Bronco Buster, 1895
(Casting #245)
Bronze, 22.5" h. (57.15 cm.)
Signed, Copyright by Frederick Remington, Roman Bronze Wks.
Anonymous gift, 1955
955-S-103

J. Massy RHIND, (1860–1936)

Apollo
Marble, 90" h. (228.60 cm.)
Signed, Massy Rhind, base
Museum purchase, 1919
919-S-101

Authority
Bronze, 14" h. (35.56 cm.)
Museum purchase, 1922
922-S-102

Bust of Mr. Joseph G. Butler, Jr.
Bronze, 32" h. (81.28 cm.)
Gift of Fellow Directors of the American Iron and Steel Institute, 1921
921-S-102

Commemorative Tablet
Bronze, 27" h. (68.58 cm.)
Gift of Youngstown Federation of Women's Clubs, 1920
920-S-102

Indian Scout
Bronze, 72" h. (182.88 cm.)
Museum purchase, 1921
921-S-101

Minerva
Marble, 80" h. (203.20 cm.)
Signed, Massy Rhind, base
Museum purchase, 1919
919-S-102

Theodore Roosevelt
Bronze, 13" h. (33.02 cm.)
Museum purchase, 1920
920-S-101

Wisdom
Bronze, 14" h. (35.56 cm.)
Museum purchase, 1922
922-S-101

George RHOADES, (active 20th century)

(Untitled), 1986
Mixed media with electric motor, 38" h. (96.52 cm.)
Gift of the Terminare Corporation, 1994
994-S-106

Ingeborg RICHTER, (active 20th century)

Optogon
Plastic and metal, 11.5" h. (29.21 cm.)
Gift of the Friends of American Art, 1972
972-S-101

Stanley ROCKLAND, (active 20th century)

Eagle
Wood, 16" h. (40.64 cm.)
Museum purchase, 1977
977-S-103

John ROGERS, (1896– ?)

Parting Promise
Plaster, 21.5" h. (54.61 cm.)
Museum purchase, 1975
975-S-104

The Tap on the Window
Plaster, 19.5" h. (49.53 cm.)
Museum purchase, 1975
975-S-103

John ROOD, (1906–1974)

Sleeping Head, 1941
Orange wood, 7" h. (17.78 cm.)
Gift of Louis Held, 1966
966-S-102

A. Thomas SCHOMBERG. (active 20th century)

After the Game, 1995
Bronze, 21" h. (53.34 cm.)
Museum purchase, 1995
995-S-101

Viktor SCHRECKENGOST, (1906–)

Ziamba
Marble, 11" h. (27.94 cm.)
Gift of the Junior League, 1948
948-S-102

Robert SEGALL, (active 20th century)

Potiphar's Wife, 1988
Wood and mixed media, 41" h. (104.14 cm.)
Gift of Clara Segall, 1991
991-S-101

Rene SHAPSHAK, (1899–1985)

The City, 1964
Steel, 33.5" h. (85.09 cm.)
Gift of Mr. and Mrs. Nahum Tschacbasov, 1970
970-S-107

Roy W. SHODD, (1893–1971)

American Flag
Wood inlaid marquetry, 21.75" h. (55.25 cm.)
Gift of Roy W. Shodd, 1969
969-S-103

Lorna SIMPSON, (active 20th century)

III, 1994
Mixed media, 13.5" h. (34.29 cm.)
Gift of Louis A. Zona, 1994
994-S-104

Arlie SINAIKO, (1902–ca. 1994)

The Prophet
Bronze, 17" h. (43.18 cm.)
Gift of Arlie Sinaiko, 1969
969-S-105

Linda Thern SMITH, (active 20th century)

Quivers
Clay and wire, three pieces, each 24" h. (60.96 cm.)
Gift of Linda Thern Smith, 1980
980-S-102

Robert C. SMITH, (active 20th century)

Prophet
Vinyl, 18" h. (45.72 cm.)
Museum purchase, 1961
961-S-104

Gery SPINOSA, (active 20th century)

Ascension
Porcelain, 8.75" h. (22.23 cm.)
Museum purchase, 1974
974-S-101

Charles STEVENS, (1926–)

American Girl
Polychromed mahogany, 30" h. (76.20 cm.)
Gift of Mr. and Mrs. Irwin Leftcourt, 1967
967-S-111

Marguerite STIX, (1907–1975)

Horse
Bronze, 19" h. (48.26 cm.)
Gift of Mrs. Milton Weill, 1975
975-S-104

Jazz
Bronze, 19" h. (48.26 cm.)
Gift of Mrs. Milton Weill, 1961
961-S-106

Woman Holding Slipper, 1960
Bronze, 15" h. (38.10 cm.)
Gift of Mrs. Milton Weill, 1975
975-S-103

Irma STOLOFF, (active 20th century)

Head of a Young Negro
Bronze, 13" h. (33.02 cm.)
Gift of Dr. Charles Stoloff, 1968
968-S-114

TAINO

The Taino collection, sculptures and carvings made by the Taino Indians, an extinct aboriginal Arawakan people of the Greater Antilles and Bahamas, are the gift of Paul Burke, 1993

Bone Carvings, ca. 500—1500 A.D.
The following bone carvings range in size from .875" h. to 11" h. (2.22 to 27.94 cm.)
993-S-151 — 993-S-172

Clay Sculpture, ca. 500—1500 A.D.
The following clay sculptures, bowls and pots, range in size from 2.62" to 9.25" h. (6.66 to 23.50 cm.)
993-S-173 — 993-S-211

Stone Sculpture
The following stone sculptures range in size from 2" to 5.5" h. (5.08 to 13.97 cm.)
993-S-107 — 993-S-150

Wood Mortar and Pestle, ca. 500–1500 A.D.
10.75" h. (27.31 cm.)
993-S-212.1 — 993-S-212.2

TISON, (Tan De La Plante), (1922–)

To the Four Winds
Steel, bronze, aluminum alloys, 12" h. (30.48 cm.)
Museum purchase, 1966
966-S-103

UNIDENTIFIED ARTISTS

Crouching Woman, ca. 1940
Wood, 5.5" h. (13.97 cm.)
Gift of Louis Held, 1967
967-S-107

Eagle, ca. 1825
Wood, 24.5" h. (62.23 cm.)
Museum purchase, 1965
965-S-102

Flying Eagle
Hammered copper, 15" h. (38.10 cm.)
Gift of Dorothy Dennison Butler, 1967
967-S-102

Giraffe, ca. 1940
Welded wire, 12" h. (30.48 cm.)
Gift of Louis Held, 1967
967-S-105

Little Girl Knitting
White alabaster with black marble base, 11" h. (27.94 cm.)
Gift of Mr. and Mrs. Arthur Einstein, 1978
978-S-101

Navy Brass Bell
Brass, 20" h. (50.80 cm.)
Gift of Mr. and Mrs. Maury Young, 1993
993-S-217

Warrior
Bronze, 18.5" h. (46.99 cm.)
Gift of Louis Held, 1967
967-S-106

Woman
Bronze, 11" h. (27.94 cm.)
Gift of Louis Held, 1967
967-S-108

Marco VACCHER, (active 20th century)

Moon Knight on a Mechanized Mare, 1969
Construction, 12" h. (30.48 cm.)
Museum purchase, 1970
970-S-103

Hans VAN DE BOVENKAMP, (1938–)

(Untitled)
Bronze, 22.75" h. (57.79 cm.)
Gift of Mr. and Mrs. Nahum Tschacbasov, 1975
975-S-105

Anne G. VAN KLEECK, (active 20th century)

Bather
Marble, 33" h. (83.82 cm.)
Museum purchase, 1957
957-S-103

Ellen WALTERS, (1928–)

Ruffed Grouse
Ceramic, 8" h. (20.32 cm.)
Museum purchase, 1954
954-S-104

Jane WASEY, (1912–ca. 1994)

Sleeping Child
Granite with marble base, 11.5" h. (29.21 cm.)
Gift of Dr. Bernard Brodsky, 1961
961-S-105

Mary T. WAWRYTKO, (active 20th century)

Kate
Bronze, 21.5" h. (54.61 cm.)
Museum purchase, 1978
978-S-101

Robert WICK, (1935–)

Mask of Sherry
Bronze, 12" h. (30.48 cm.)
Museum purchase, 1969
969-S-101

Jack ZAJAC, (1929–)

Falling Waters
Bronze, 102 x 30.75" (259.08 x 78.11 cm.)
Museum purchase and gift of Jack Zajac, 1972
972-S-103

John M. ZEILMAN, (1932–)

Warrior #1
Welded steel, 16" h. (40.64 cm.)
Museum purchase, 1964
964-S-101

Frey - Red Buddha

Ceramic

Faddis - Circus Poster

Steven and Susan Kemenyffy - Gold Lady II

Steven Kemenyffy - Vase

Mills - Plate

Ross - Compote

Schreckengost - Butternut Vase

Takaezu - Bottle

Susan ABROMOVITZ, (active 20th century)

Puzzle Jar
Ceramic, 11.5" h. (29.21 cm.)
Gift of the Junior League, 1977
977-C-104

Leon APPLEBAUM, (active 20th century)

Sand Blasted Bowl
Enamel and glass, 6.5" h. (16.51 cm.)
Museum purchase, 1980
980-E-106

Jean E. APPLEBY, (active 20th century)

Celestial Womb II
Ceramic, 8" h. (20.32 cm.)
Museum purchase, 1980
980-C-105

Elizabeth ASH, (1936–)

Box
Stoneware, 10" h. (25.40 cm.)
Gift of the Friends of American Art, 1964
964-C-108

Arthur E. BAGGS, (1886– ?)

Bean Pot
Ceramic. 6" h. (15.24 cm.)
Gift of Mr. and Mrs. Joseph G. Butler, III, 1946
946-C-101

Celadon Bottle
Ceramic, 8" h. (20.32 cm.)
Gift of the Junior League, 1942
942-C-102

Joan BARON, (active 20th century)

Salt Ware
Porcelain, 7.5" h. (19.05 cm.)
Museum purchase, 1972
972-C-102

David BARR, (1936–)

Hub Pot
Stoneware, 11" h. (27.94 cm.)
Museum purchase, 1966
966-C-101

Kenneth Francis BATES, (1924–)

Green Bowl
Enamel on copper, 7.75" dia. (19.69 cm.)
Gift of Mrs. John Tyler, 1983
983-E-103

The following four enamel pieces are a museum
purchase, 1953, 1955, 1956, 1957

Marine Fantasy
11.25" dia. (28.58 cm.)
957-E-101

Message
9" dia. (22.86 cm.)
956-E-101

Siesta
6" h. (15.24 cm.)
955-E-101

Still Life with Fruit
9" dia. (22.86 cm.)
953-E-101

James K. BELL, (active 20th century)

Ceremonial Bottle
Clay, 18" h. (45.72 cm.)
Gift of the Friends of American Art, 1978
978-C-101

Emily BETZ, (active 20th century)

Bowl
Enamel, 11.25 dia. (28.58 cm.)
Gift of the Friends of American Art, 1957
957-E-105

Linda BIEHL, (active 20th century)

Slab Vase
Ceramic, 12" h. (30.48 cm.)
Museum purchase, 1974
974-C-104

David BLACK, (1928–)

Apple Pot
Stoneware, 18" h. (45.72 cm.)
Museum purchase, 1958
958-C-101

Totem Pot
Stoneware, 13" h. (33.02 cm.)
Museum purchase, 1959
959-C-101

Antonio M. BLACKBURN, (active 20th
century)

Bowl
Ceramic, 12" dia. (30.48 cm.)
Museum purchase, 1958
958-C-102

Lawrence BLAZEY, (1902–)

Jar with Copper Glaze
Stoneware, 9.5" h. (24.13 cm.)
Museum purchase, 1969
969-C-101

Reticulated Vase, 1969
Ceramic, 9" h. (22.86 cm.)
Gift of the Friends of American Art, 1970
970-C-101

James BROWN, (1932–)

(Untitled), 1985
Ceramic, 19.75" l. (50.16 cm.)
Anonymous gift, 1991
991-C-101

Jerry L. CAPLAN, (1922–)

Split Plate
Clay, 21.75" l. x 5.25" w. (55.25 x 13.34 cm.)
Gift of the Friends of American Art, 1983
983-C-101

Three Torsos
Raku, 13.75" h. (34.93 cm.)
Museum purchase, 1977
977-C-101

Barbara COFFMAN, (1924–)

Plate, 1968
Enamel, 8" dia. (20.32 cm.)
Museum purchase, 1968
968-E-110

Sarah E. COHEN, (active 20th century)

Green and Black Bowl
Enamel, 3.02" dia. (7.68 cm.)
Museum purchase, 1973
973-E-101

Fern COLE, (active 20th century)

The following three enamel pieces are a museum
purchase, 1956, 1957, 1958

Bird Tray
10" dia. (25.40 cm.)
958-E-103

Mardi Gras
41" l. (104.14 cm.)
956-E-105

The Red Face
5.5" dia. (13.97 cm.)
957-E-103

Claude CONOVER, (1907–)

Brown Striped Bottle
Ceramic, 13.5 x 12" (34.29 x 30.48 cm.)
Museum purchase, 1963
963-C-103

Red Plate, 1964
Ceramic, 8" dia. (20.32 cm.)
Gift of the Junior League, 1965
965-C-101

Eleanor COTTRELL, (1903–)

Blue Compote, 1964
Ceramic, 9.5" dia. (24.13 cm.)
Museum purchase, 1965
965-C-108

Hobart E. COWLES, (1923–)

Plate–Copper Blue, Bird Motif
Ceramic, 14" dia. (35.56 cm.)
Museum purchase, 1951
951-C-101

Hazel CROSE, (1900–1965)

The following two ceramic pieces are a museum
purchase, 1960

Bottle, Fish Design, 1960
17.5" h. (44.45 cm.)
960-C-109

Fish Plaque, 1960
24" l. x 11.5" w. (60.96 x 29.21 cm.)
960-C-110

Virginia DIEDRICHS, (active 20th century)

(Untitled)
Glass, 7" h. (17.78 cm.)
Museum purchase, 1973
973-E-103

Jack EARL, (1934–)

Bowl
Stoneware, 6.5" h. (16.51 cm.)
Gift of the Friends of American Art, 1963
963-C-108

Edris ECKHARDT, (1905–)

Phoenix—Shadow Box
Stained glass, 8" l. x 3.5" w. (20.32 x 8.89 cm.)
Museum purchase, 1957
957-E-104

Sylvan EINSTEIN, (active 20th century)

Shadows
Mosaic, 21" l. x 45" w. (53.34 x 114.30 cm.)
Museum purchase, 1958
958-C-104

Marguerite EISENBERG, (1902–)

Outing in the Sun
Enamel box, 3.5" l. x 5" w. (8.89 x 12.70 cm.)
Museum purchase, 1960
960-E-101

Robert ENGLE, (1920–)

Brick Design Bottle, 1964
Ceramic, 14" h. (35.56 cm.)
Gift of the Friends of American Art, 1965
965-C-102

George FADDIS, (1920–1985)

Circus Poster
Enamel, 14" h. (55.56 cm.)
Gift of the Friends of American Art, 1958
958-E-108

Red Bowl
Enamel, 5" dia. (12.70 cm.)
Museum purchase, 1953
953-E-110

Dorothy FASIG, (active 20th century)

Word Pot—Peace
Ceramic, 13.5" h. (34.29 cm.)
Museum purchase, 1972
972-C-103

Florence FILLOUS, (active 20th century)

The following two ceramic pieces are the gift of
the Friends of American Art, 1956

Bottle
6" h. (15.24 cm.)
956-C-106

Bowl
5" h. (12.70 cm.)
956-C-109

Bernie FLAGG, (1929–)

Flowers and Pot, 1967
Ceramic, 15" h. (38.10 cm.)
Museum purchase, 1968
968-C-111

Viola FREY, (1933–)

Red Buddha, 1994
Painted ceramic, 25" dia. (63.50 x 15.24 cm.)
Gift of Nancy Hoffman, Peter N. Greenwald, and Rebecca
Hoffman-Greenwald, 1994
994-C-101

Joseph FRY, (active late 20th century)

Bible Studies
Stoneware, 15.5" h. (39.37 cm.)
Museum purchase, 1980
980-C-101

M. E. GOSLEE, (1915–)

Bird Form
Ceramic, 15" l. (38.10 cm.)
Gift of the Junior League, 1959
959-C-106

Rare Bird
Ceramic, 19 h. (48.26 cm.)
Museum purchase, 1966
966-C-10

Gretchen GOSS, (active 20th century)

One Hundred Over Another
Enamel, cloisonne, and string, 10.62" dia. (26.97 cm.)
Museum purchase, 1981
981-E-103

Susanne Stephenson GROVES, (1935–)

Bottle
Ceramic, 52" h. (132.08 cm.)
Museum purchase, 1961
961-C-108

Maya GRUZITIS, (active 20th century)

Porcelain Form
Porcelain, 7.5" h. (19.05 cm.)
Museum purchase, 1974
974-C-105

Margaret HANDEL, (active 20th century)

Ruffle Bowl
Clay, 18" dia. (45.72 cm.)
Museum purchase, 1979
979-C-105

Elliptical Urn
Stoneware, 16" h. (40.64 cm.)
Museum purchase, 1980
980-C-103

William HARPER, (1944–)

Body Box #1, 1969
Enamel and plastic, 4" h. (10.16 cm.)
Museum purchase, 1970
970-E-102

Robert HASSELLE, (active 20th century)

Lidded Jar
Stoneware, 12.87" h. (32.70 cm.)
Gift of the Friends of American Art, Charles Law Memorial,
1977
977-C-106

Hal HASSLESCHWERT, (1930–)

Pendant
Champleve enamel, 2" dia. (5.08 cm.)
Museum purchase, 1964
964-E-106

Pill Box
Enamel on silver, 2" dia. (5.08 cm.)
Museum purchase, 1963
963-E-104

Dick HAY, (1942–)

Bottle
Stone, 11" h. (27.94 cm.)
Museum purchase, 1967
967-C-101

Storage Jar
Stoneware, 29" h. (73.66 cm.)
Museum purchase, 1969
969-C-106

Alfred HINGLEY, (active 20th century)

Goblet
Glass, 8" h. (20.32 cm.)
Gift of Anna Fell Rothstein, 1959
959-E-107

Peggy HITCHCOCK, (active 20th century)

Levity for Three
Enamel, 8" dia. (20.32 cm.)
Museum purchase, 1981
981-E-104

Claude HORAN, (active 20th century)

Glaze Slipped Bottle
Ceramic, 13" h. (33.02 cm.)
Anonymous gift, 1946
946-C-103

Ralph HOSPODAR, (? –1980)

Vase
Stoneware, 16" h. (40.64 cm.)
Museum purchase, 1960
960-C-105

Harold Wesley HUNSICKER, (active 20th
century)

Decanter Set
Ceramic, 17" h. (43.18 cm.)
Museum purchase, 1957
957-C-106

Vase
Ceramic, 11" h. (27.94 cm.)
Gift of the Junior League, 1943
943-C-101

El JAHR, (dates unknown)

Bowl—One Way
Ceramic, 17" dia. (43.18 cm.)
Museum purchase, 1972
972-C-101

Charles Bartley JEFFREY, (1910–)

Christ and the Evangelists
Enamel, 7" l. (17.78 cm.)
Museum purchase, 1956
956-E-104

The Sisters
Enamel, 3" h. (7.62 cm.)
Museum purchase, 1956
956-E-102

Jan JONES, (1917–)

Bowl
Stoneware, 21" dia. (53.34 cm.)
Museum purchase, 1964
964-C-101

Gene KANGAS, (1944–)

Printed Bottle, 1967
Glass, 6" h. (15.24 cm.)
Gift of the Friends of American Art, 1968
968-E-114

Gene KELLY, (active 20th century)

Stoneware Planter
Ceramic, 19" dia. (48.26 cm.)
Museum purchase, 1958
958-C-105

Steven KEMENYFFY, (1937–)

Short Vase
Ceramic, 32" h. (81.28 cm.)
Museum purchase, 1972
972-C-105

Steven, (1937–), **and Susan KEMENYFFY**, (1941–)

Gold Lady II
Clay, 60.5" h. (153.67 cm.)
Museum purchase, 1979
979-C-106

Susan KEMENYFFY, (1941–)

Raku Platter
Ceramic, 20" dia. (50.80 cm.)
Museum purchase, 1974
974-C-102

Josephine KERR, (ca. 1910–)

The following two enamel pieces are a museum purchase, 1970

Enamel Bowl, 1967
5.25" dia. (13.34 cm.)
970-E-105

Enamel Tray, 1967
5.75" dia. (14.61 cm.)
970-C-106

Brenda KERSHAW, (1948–)

Bottle, 1964
Brown glaze slab, 7" h. (15.24 cm.)
Museum purchase, 1965
965-C-110

Kathy KOOP, (active 20th century)

Trace Tea Set
Clay, pot: 11" h., cup: 2.75" h. (27.94 and 6.99 cm.)
Anonymous gift, 1982
982-C-101

Howard KOTTLER, (1930–)

American Supperware
Porcelain and leather covers, 10.75" dia. (27.31 cm.)
Museum purchase, 1974
974-C-103

Square Bottle
Stoneware, 17" h. (43.18 cm.)
Museum purchase, 1963
963-C-102

Carl KRABILL, (1930–)

Branch Vase
Ceramic, 16" h. (40.64 cm.)
Museum purchase, 1961
961-C-104

Eva KWONG, (1954–)

Cone of Light
Ceramic, 10.5" h. (26.67 cm.)
Museum purchase, 1981
981-C-101

Dominick LABINO, (1910–)

Cobalt Blue Glass Vase
Enamel, 12" h. (30.48 cm.)
Museum purchase, 1968
968-E-113

Di–Chronic Form
Enamel, 9" h. (22.86 cm.)
Museum purchase, 1969
969-E-104

(Untitled)
Enamel, 6" h. (15.24 cm.)
Gift of Ernest Kirkwood, 1972
972-E-106

Charles LAKOFSKY, (1922–)

Brown Bowl
Ceramic, 8" dia. (20.32 cm.)
Museum purchase, 1960
960-C-103

Bowl
Ceramic, 8" dia. (20.32 cm.)
Museum purchase, 1954
954-C-102

Bowl
Ceramic, 8" dia. (20.32 cm.)
Museum purchase, 1974
974-C-101

The following ceramic pieces are a museum purchase, 1953

Bottle
7" h. (17.78 cm.)
953-C-112

Tea Set
Pitcher, 9" h. (22.86 cm.), creamer, 4" (10.16 cm.), sugar bowl 2.75" h. (6.98 cm.)
953-C-111

The following three ceramic pieces are a museum purchase, 1955

Bowl
8" dia. (20.32 cm.)
955-C-107

Covered Jar
7" h. (17.78 cm.)
955-C-106

Jar
13" h. (33.02 cm.)
955-C-102

The following three ceramic pieces are a museum purchase, 1958

Covered Porcelain Jar
5" dia. (12.70 cm.)
958-C-106

Porcelain Bowl
7.5" dia. (19.05 cm.)
958-C-109

Porcelain Bowl
7.5" dia. (19.05 cm.)
958-C-110

Frances LENHERT, (active 20th century)

Hoagie
Ceramic, 5" w. x 15.5" l. (12.70 x 39.37 cm.)
Gift of the Junior League, 1971
971-C-101

Luke LIETZKE, (1909–)

Porcelain Vase–Loops
Ceramic, 7" h. (17.78 cm.)
Museum purchase, 1950
950-C-105

The following two ceramic pieces are a gift of the Junior League, 1950

Porcelain Bowl–Doodles
4" h. x 7" dia., (10.16 x 17.78 cm.)
950-C-106

Porcelain Bowl–Stripes
6.87" h. x 6.75" dia. (17.46 x 17.15 cm.)
950-C-101

Luke, (1909–), **and Rolland LIETZKE**, (active 20th century)

Porcelain Vase
Ceramic, 10.75" h. (27.31 cm.)
Gift of the Junior League, 1946
946-C-102

Henry LIN, (1918–)

The following stoneware pieces are a museum purchase, 1959, 1961, 1963, 1967

Bowl
Stoneware, 14" dia. (35.56 cm.)
967-C-102

Plate
Stoneware, 12" dia. (30.48 cm.)
961-C-101

Bowl
Stoneware, 8" dia. (20.32 cm.)
959-C-103

Vase, 1961
Stoneware, 18" h. (45.72 cm.)
963-C-101

Edgar LITTLEFIELD, (1905–)

The following pieces are a museum purchase,
1963, 1966

Compote
Stoneware, 10" h. (25.40 cm.)
966-C-103

Vase, 1962
Stoneware, 11.5" h. (29.21 cm.)
963-C-105

Marilyn LYSOHIR, (active 20th century)

American Woman
Ceramic, 19" h. (48.26 cm.)
Museum purchase, 1973
973-C-101

Norman MAGDEN, (1934–)

Cup
Enamel on copper, 2.5 h. (6.35 cm.)
Museum purchase, 1964
964-E-102

Procession of Royals
Enamel, 6" h. (15.24 cm.)
Museum purchase, 1958
958-E-10

The Ecclesiastical
Enamel panel, 21" l. (53.34 cm.)
Museum purchase, 1962
962-E-102

Triptych, 1964
Cloisonne, 12" l. x 10.5" w. (30.48 x 26.67 cm.)
Museum purchase, 1965
965-E-104

Phillip MAKOFF, (active 20th century)

The following glass pieces are a museum
purchase, 1975, 1976

Vase No. 1
11.25" h. (28.58 cm.)
976-E-105

Vase with White Spots
7.5" h. (19.05 cm.)
975-E-102

Catherine MALLOY, (1919–)

Covered Bowl
Stoneware, 10" h. x 7" dia. (25.40 x 17.78 cm.)
Museum purhcase, 1966
966-C-104

Dorothea MANBECK, (1907–)

The following ceramic pieces are a museum
purchase, 1951, 1953

Bowl
Ceramic, 7.5" dia. (19.05 cm.)
951-C-103

Red Jar
Ceramic, 8" h. (20.32 cm.)
953-C-103

Charles MARCH, (1931–)

Cuff Links
Silver and Niello, .05" dia. (1.27 cm.)
Musuem purchase, 1961
961-E-105

Ruth MARKUS, (1924–)

Waiting
Enamel, 8" dia. (20.32 cm.)
Museum purchase, 1968
968-E-109

Tony MARTIN, (dates unknown)

Porcelain Bottle
Porcelain with ash glaze, 12" h. (30.48 cm.)
Museum purchase, 1980
980-C-104

Jack MASON, (1927–)

Green and Brown Bottle
Stoneware, 22" h. (55.88 cm.)
Museum purchase, 1969
969-C-107

Patriotic Eagle Bottle, 1969
Ceramic, 22.5" h. (57.15 cm.)
Museum purchase, 1970
970-C-104

The Queen's Domain
Ceramic, 12" h. (30.48 cm.)
Museum purchase, 1967
967-C-103

Allan MAXWELL, (dates unknown)

Bottle
Raku vase, 10" h. (25.40 cm.)
Gift of the Junior League, 1976
976-C-101

Mary Ellen McDERMOTT, (1919–)

Apostles
Enamel, 40" h. (101.60 cm.)
Museum purchase, 1954
954-E-103

Harrison McINTOSH, (dates unknown)

Covered Jar
Ceramic, 10" h. (25.40 cm.)
Gift of Carl H. Seaberg, 1971
971-C-103

Leza S. McVEY, (1907–1984)

Bottle and Stopper
Ceramic, 23" h. (58.42 cm.)
Museum purchase, 1957
957-C-102

Robert MIHALY, (dates unknown)

Deco Delight #16
Ceramic, 8" h. (20.32 cm.)
Museum purchase, 1976
976-C-103

Steve MIKOLA, (1939–)

Ladies Before Gentlemen
Clay, 10" h. (25.40 cm.)
Gift of the Junior League, 1979
979-C-101

The following two pieces are a museum
purchase, 1973

Decorative Bottle
Ceramic, 7" h. (17.78 cm.)
973-C-102

Decorative Compote
Ceramic, 9" h. (22.86 cm.)
973-C-105

Roy N. MILLS, (1908–)

Plate
Ceramic, 15" dia. (38.10 cm.)
Museum purchase, 1952
952-C-101

R. A. MINCK, (1932–)

Bowl #19
Ceramic, 10" h. (25.40 cm.)
Museum purchase, 1966
966-C-105

Charles MOSGO, (dates unknown)

Bottle
Ceramic, 15" h. (38.10 cm.)
Museum purchase, 1955
955-C-108

Covered Bowl
Ceramic, 9" dia. (22.86 cm.)
Museum purchase, 1955
955-C-103

Vase
Ceramic, 11" h. (55.88 cm.)
Museum purchase, 1956
956-C-102

Sherwin MOSS, (dates unknown)

Pottery II
Weed pot, 12.75" h. (32.39 cm.)
Museum purchase, 1976
976-C-102

Barbara MUENGER, (1943–)

Lawn Pot
Ceramic, 31" h. (78.74 cm.)
Museum purchase, 1968
968-C-116

Jo NATKO, (1913–)

Red Clay Bowl
Ceramic, 14" dia. (35.56 cm.)
Gift of the Junior League, 1948
948-C-101

Bowl
Enamel, 12" dia. (30.48 cm.)
Museum purchae, 1954
954-E-101

Norma OLSEN, (dates unknown)

Small Dish, 1964
Porcelain, 6" dia. (15.24 x 5.08 cm.)
Museum purchase, 1965
965-C-103

Jane PARSHALL, (1916–)

Ovoid Bowl
Stoneware, 6.5" h. (16.51 cm.)
Museum purchase, 1954
954-C-104

PARSHALL and CHASEK, (dates unknown)

Oval Weed Pot
Ceramic stoneware, 11" h. (27.94 cm.)
Museum purchase, 1964
964-C-103

James Edward PECK, (1907–)

Alhambra
Enamel jewelry, 2" dia. (5.08 cm.)
Museum purchase, 1953
953-E-113

Intervention
Enamel jewelry, 2.5" dia. (6.35 cm.)
Museum purchase, 1953
953-E-104

Shelikof
Enamel jewelry, 3.25" dia. (8.26 cm.)
Museum purchase, 1953
953-E-114

Miriam PECK, (1910–1984)

Abstract
Enamel plate, 8" dia. (20.32 cm.)
Museum purchase, 1950
950-E-108

Abstract
Enamel, 8" l. (20.32 cm.)
Museum purchase, 1950
950-E-102

Black Magic
Enamel plate, 8" dia. (20.32 cm.)
Museum purchase, 1953
953-E-115

From the Sea
Enamel, 7" w. (17.78 cm.)
Museum purchase, 1950
950-E-107

Tray for Ebony Table
Enamel, 8" l. (30.32 cm.)
Museum purchase, 1953
953-E-105

Lyle PERKINS, (dates unknown)

Sculptural Vase
Stoneware, 27" h. (68.58 cm.)
Museum purchase, 1960
960-C-108

James PETERS, (1937–)

Closed Form Pot
Ceramic, 9.5 h. (24.13 cm.
Museum purchase, 1962
962-C-103

Miska PETERSHAM, (1888–1959)

Buttressed Vase
Stoneware, 16" h. (40.64 cm.)
Museum purchase, 1960
960-C-102

Compote
Stoneware, 13" dia. (33.02 cm.)
Museum purchase, 1964
964-C-104

Compote
Stoneware, 8" h. (20.32 cm.)
Museum purchase, 1966
966-C-107

White Bottle, 1964
Ceramic, 21" h. (53.34 cm.)
Museum purchase, 1965
965-C-106

Ronald PIVOVAR, (dates unknwon)

Covered Jar with Rope Handles
Ceramic, 21" h. (53.34 cm.)
Museum purchase, 1972
972-C-104

Joy PRAZNIK, (dates unknwon)

Branch Bottle
Ceramic, 11.5" h. (29.21 cm.)
Museum purchase, 1956
967-C-104

John F. PUSKAS, (dates unknown)

Studio Interior No. 1
Cloisonne, 16.5" w. x 20" l. (41.91 x 50.80 cm.)
Museum purchase, 1975
975-E-101

Geff REED, (1943–)

Slab Bowl
Ceramic, 11" dia. (27.94 cm.)
Museum purchase, 1968
968-C-115

Christopher RICHARD, (active 20th century)

Lidded Vessel
Clay and wood, 32" h. (81.28 cm.)
Museum purchase, 1982
982-C-102

Harry S. RICHARDSON, (active 20th century)

Decorated Bowl
Ceramic, 12" dia. (30.48 cm.)
Museum purchase, 1953
953-C-106

Decorated Plate
Ceramic, 14.5" dia. (36.83 cm.)
Museum purchase, 1953
953-C-102

George ROBY, (1944–)

78—6
Clay, 15" h. (38.10 cm.)
Museum purchase, 1979
979-C-104

Frank Woodworth ROOD, (1921–)

Cylindrical Jar
Stoneware, 21" h. (53.34 cm.)
Museum purchase, 1953
953-C-107

ROOKWOOD POTTERY

Yellow Glazed Vase, 1922
Glazed porcelain, 7" h. (17.78 cm.)
Gift of Carl H. Seaborg, 1971
971-C-102

Frank ROSS, (1928–)

Compote
Stoneware, 12" h. (30.48 cm.)
Museum purchase, 1967
967-C-107

Edwin SCHEIER, (1910–)

Black Vase
Ceramic, 21.5" h. (54.61 cm.)
Museum purchase, 1967
967-C-105

Richard SCHNEIDER, (1937–)

Three Star Rope Pot
Ceramic, 22.5" h. (57.15 cm.)
Museum purchase, 1973
973-C-104

Viktor SCHRECKENGOST, (1906–)

Butternut Vase
Ceramic, 19" (45.72 cm.)
Museum purchase, 1950
950-C-104

Foliage
Ceramic, 21.5" (54.61 cm.)
Museum purchase, 1957
957-C-107

Harry SCHULKE, (active 20th century)

Apple Bowl
Ceramic, 9" (22.86 cm.)
Museum purchase, 1950
950-C-103

Norman SCHULMAN, (1924–)

Lidded Jar
Ceramic, 8.5" h. (21.59 cm.)
Museum purchase, 1962
962-C-104

Temmoku Bowl
Stoneware, 6" dia. (15.24 cm.)
Museum purchase, 1960
960-C-107

Vase
Stoneware, 15" h. (38.10 cm.)
Museum purchase, 1959
959-C-104

Thomas SELLERS, (active 20th century)

Vase
Ceramic, 9" (22.86 cm.)
Gift of the Junior League, 1953
953-C-108

Arthur SENNETT, (active 20th century)

Casserole
Stoneware, 10" dia. (25.40 cm.)
Museum purchase, 1980
980-C-102

Thomas SHAFER, (1937–)

Covered Jar
Ceramic, 18.5" h. (46.99 cm.)
Gift of the Friends of American Art, 1968
969-C-105

Cad 'Oro (bottle)
Ceramic, 11" h. (27.94 cm.)
Museum purchase, 1968
968-C-117

Floy SHAFFER, (1922–)

Brown Pot and Eight Cups
Ceramic, pot 8.5: h. (21.59 cm.), cups 3.5" h. (8.89 cm.)
Museum purchase, 1962
962-C-110

Covered Jar
Ceramic, 8.5" h. (21.59 cm.)
Museum purchase, 1962
962-C-105

Footed Pot
Stoneware, 52" h. (132.08 cm.)
Gift of the Junior League, 1963
963-C109

Red Mottled Bowl
Ceramic, 5" dia. (12.70 cm.)
Museum purchase, 1962
962-C-109

Paul J. SIRES, (1955–)

Raku Bowl, 1978
Clay, 10.5" dia. (26.67 cm.)
Museum purchase, 1979
979-C-103

Peter SLUSARSKI, (1916–)

Slab Vase
Ceramic, 18" h. (45.72 cm.)
Museum purchase, 1966
966-C-108

Drew SMITH, (active late 20th century)

Vase Red
Glass, 4" h. (10.16 cm.)
Museum purchase, 1976
976-E-104

Paul SOLDNER, (1921–)

Bottle
Ceramic, 27" h. (68.58 cm.)
Museum purchase, 1956
956-C-108

Bottle
Ceramic, 13" h. (33.02 cm.)
Museum purchase, 1956
956-C-103

Bottle
Ceramic, 16" h. (40.64 cm.)
Museum purchase, 1956
956-C-107

Richard SPANGLE, (1916–)

Red Jar
Ceramic, 6" h., (15.24 cm.)
Museum purchase, 1962
962-C-106

White Jar
Stoneware, 8.5" h. (21.59 cm.)
Museum purchase, 1967
967-C-108

Mark SPEZZA, (active 20th century)

Mixing Bowl
Porcelain, 6" h. (15.24 cm.)
Museum purchase, 1977
977-C-102

John STEPHENSON, (1929–)

Impression of the News, 1964
Ceramic, 12.25" dia. (31.12 cm.)
Museum purchase, 1965
965-C-107

Sectional Pot
Ceramic, 15" dia. (38.10 cm.)
Museum purchase, 1960
960-C-106

Susanne Groves STEPHENSON, (1935–)

Bottle, Green and Rust
Ceramic, 11" h. (27.94 cm.)
Museum purchase, 1962
962-C-107

Jar, Ash, Red and White
Ceramic, 11" h. (27.94 cm.)
Museum purchase, 1968
968-C-112

STEUBEN GLASS WORKS

Bowl
Glass, 7" dia. (17.78 cm.)
Museum purchase, 1983
983-E-102

Norman STEWART, (1940–)

Garden Pot
Ceramic, 21" h. (53.34 cm.)
Museum purchase, 1966
966-C-109

Bottle, 1968
Glass, 7" h. (17.78 cm.)
Museum purchase, 1969
969-E-102

Bottle
Stoneware, 8" h. (20.32 cm.)
Museum purchase, 1966
966-C-110

Toshiko TAKAEZU, (1922–)

Bottle
Stoneware, 8" dia. (20.32 cm.)
Museum purchase, 1961
961-C-106

Bowl
Stoneware, 11" dia. (27.94 cm.)
Museum purchase, 1960
960-C-104

Plate
Stoneware, 14" dia. (35.56 cm.)
Museum purchase, 1962
962-C-108

Pot
Stoneware, 6.5" h. (16.51 cm.)
Museum purchase, 1963
963-C-107

Two Spouted Bottle
Stoneware, 12.5" h. (31.75 cm.)
Museum purchase, 1957
957-C-108

Anthony VAIKSNORAS, (1918–1973)

The following two enamel plaques are a museum purchase, 1948

Ghoules
4" h. x 5" w. (10.16 x 12.70 cm.)
948-E-102

Rasores
12" h. x 23" w. (30.48 x 58.42 cm.)
948-E-103

Ann VAN KLEECK, (active 20th century)

Spiney Pot
Stoneware, 13.5" h (34.29 cm.)
Museum purchase, 1959
959-C-105

Paul VOLCKENING, (1928–)

Bottle
Ceramic, 24" h. (60.96 cm.)
Museum purchase, 1961
961-C-102

Stella WAITZKIN, (active 20th century)

Abstraction
Glass, 13" w. (33.02 cm.)
Museum purchae, 1973
973-E-106

Mary Francis WARREN, (active 20th century)

Fish Pot
Ceramic, 16" h. (60.64 cm.)
Museum purchase, 1977
977-C-105

Evelyn WENTZ, (1915–)

Bowl
Enamel, 7.5" dia. (19.05 cm.)
Museum purchase, 1955
955-E-104

Elizabeth WHITE, (1913–)

Eat Not of the Fruit
Enamel, 12" h. (30.48 cm.)
Museum purchase, 1967
967-E-106

Edward WINTER, (1908–1976)

Footed Bowl, Gold Crackle, 1964
Enamel on copper, 8" h. (20.32 cm.)
Museum purchase, 1965
965-E-109

Gourds
Enamel, 30" h. (76.20 cm.)
Museum purchase, 1953
953-E-109

Thelma Frazier WINTER, (1905–)

Hen and Rooster, 1964
Enamel plaque, 15.5" dia. (39.37 cm.)
Museum purchase, 1965
965-E-105

Rose Anna Tendler WORTH, (active 20th century)

Plate
Enamel, 11" dia. (27.94 cm.)
Museum purchase, 1978
978-E-102

Robert WRIGHT, (active 20th century)

Brain
Enamel, 7.5 dia. (19.05 cm.)
Museum purchase, 1969
969-E-103

Mary Ann WURST, (1943–)

Double Faced Jar, 1969
Ceramic, 18" h. (45.72 cm.)
Museum purchase, 1970
970-C-103

Brent YOUNG, (active 20th century)

Fossil Fantasy: Fish and Fly, 1978
Glass, 8.5" h. (21.59 cm.)
Museum purchase, 1979
979-C-102

Joe ZELLER, (active 20th century)

Erosion of Spring
Ceramic plaster, 18.5" dia. (46.99 cm.)
Museum purchase, 1981
981-C-102

Robert ZERLIN, (active 20th century)

Bowl, Maze Design
Ceramic, 8" h. (20.32 cm.)
Museum purchase, 1955
955-C-105

Centaur Horse - from the George Breckner Collection

Americana

A. Margaretta ARCHAMBAULT, (1856–1956)

Calvin Coolidge, 1923–25
Oil miniature, 3 x 2.25" oval (7.62 x 6.72 cm.)
Signed, Archambault, 1924, upper left
Museum purchase, 1925
M25-O-102

Clara Louise BELL, (1886– ?)

Warren G. Harding, 1931
Oil miniature, 3 x 2.5" oval (7.62 x 5.72 cm.)
Signed, Clara Louise Bell, center right
Museum purchase, 1925
M25-O-101

Herbert Clark Hoover, 1930
Oil miniature, 3 x 2.25" oval (7.62 x 5.72 cm.)
Signed, Clara Louise Bell, center right
Museum purchase, 1930
M30-O-101

Lyndon Baines Johnson, 1969
Oil miniature, 3 x 2.25" oval (7.62 x 5.72 cm.)
Signed, Clara Louise Bell, center right
Museum purchase, 1969
M69-O-101

John Fitzgerald Kennedy, 1965
Oil miniature, 3 x 2.25" oval (7.72 x 5.72 cm.)
Signed, Clara Louise Bell, center right
Museum purchase, 1965
M65-O-101

Franklin Delano Roosevelt
Oil miniature, 3 x 2.25" oval (7.62 x 5.72 cm.)
Signed, Clara Louise Bell, center right
Museum purchase, 1950
M50-O-101

Sarah E. COWAN, (? –1958)

Harry S. Truman, 1954
Oil miniature, 3 x 2.25" oval (7.62 x 5.72 cm.)
Signed, Sarah E. Cowan, middle right
Museum purchase, 1954
M54-O-101

Dorothy DECKER, (active late 20th century)

George Herbert Walker Bush, 1989
Oil on formica, 3 x 2.25" oval (7.62 x 5.72 cm.)
Signed, Decker, center right
Museum purchase, 1989
989-O-109

Gerald Rudolph Ford, 1984
Oil on formica, 3.12 x 2.5" oval (7.94 x 6.35 cm.)
Signed, Decker, center left
Museum purchase, 1984
984-O-107

James Earl Carter, 1984
Oil on formica, 2.5 x 3" oval (6.35 x 7.62 cm.)
Signed, Decker, center left
Museum purchase, 1984
984-O-110

Willliam Jefferson Clinton, 1993
Oil on formica, 3.25 x 2.5" oval (8.26 x 6.35 cm.)
Signed, Decker, center left
Museum purchase, 1993
993-O-104

John Fitzgerald Kennedy, 1985
Oil on formica, 3.25 x 2.5" oval (8.26 x 6.35 cm.)
Signed, Decker, center left
Museum purchase, 1985
985-O-112

Lyndon Baines Johnson, 1985
Oil on formica, 3.25 x 2.5" oval (8.26 x 6.35 cm.)
Signed, Decker, center left
Museum purchase, 1985
985-O-113

Richard Milhous Nixon, 1984
Oil on formica, 3.12 x 2.5" oval (7.94 x 6.35 cm.)
Signed, Decker, center left
Museum purchase, 1985
985-O-106

Ronald Wilson Reagan, 1985
Oil on formica, 2.37 x 2.87" oval (6.03 x 7.30 cm.)
Signed, Decker, center left
Museum purchase, 1985
985-O-103

Alexandrina Robertson HARRIS, (1886– ?)

Dwight David Eisenhower, 1954
Oil on canvas, 3.25 x 2.5" oval (8.26 x 6.35 cm.)
Unsigned
Museum purchase, 1954
M54-O-102

William KIRKGAARD, (dates unknown)

The Butler Institute's collection includes seventeen watercolor miniatures which are the gift of Lillie M. Kirkgaard, 1970

Anne ALLER OVERSTREET, (active 20th century)

Castilleja Miniate, 1976
Oil on board, 3.75 x 1.75" (9.52 x 4.45 cm.)
Signed, Anne Aller Overstreet, 76, lower right
Gift of Robert K. Smith, 1995
995-O-110

(Untitled)
Oil on board, 3.75 x 1.75" (9.52 x 4.45 cm.)
Signed, Anne Aller Overstreet, lower right
Gift of Robert K. Smith, 1995
995-O-111

A. J. ROWELL, (1856– ?)

The following twenty-nine signed oil miniatures, 3 x 2.25" oval (7.62 x 5.72 cm.), are a museum purchase, 1920
M20-O-101.1 — M20-O-101.30

John Adams, 1914

John Quincy Adams, 1914

Chester Alan Arthur, 1918

James Buchanan, 1917

Grover Cleveland, 1918

Calvin Coolidge, 1919

Millard Fillmore, 1916

James Abram Garfield, 1918

Ulysses Simpson Grant, 1917

Warren Gamaliel Harding, 1919

Benjamin Harrison, 1918

William Henry Harrison, 1916

Rutherford Birchard Hayes, 1918

Herbert Clark Hoover, 1919

Andrew Jackson, 1915

Thomas Jefferson, 1914

Andrew Johnson, 1917

Abraham Lincoln, 1917

James Madison, 1914

William McKinley, 1918

James Monroe, 1915

Franklin Pierce, 1917

James Knox Polk, 1916

Theodore Roosevelt, 1919

Zachary Taylor, 1916

John Tyler, 1916

Martin Van Buren, 1915

George Washington, 1914–19

Woodrow Wilson, 1919

Paul SALTARELLI, (active late 20th century)

William Jefferson Clinton
Oil on board, 3 x 2.25" (7.62 x 5.72 cm.)
Unsigned
Museum purchase, 1993
993-O-106

James TOOGOOD, (active late 20th century)

William Jefferson Clinton, 1994
Oil on paper, 3.25 x 2.5" (8.26 x 6.35 cm.)
Signed, James Toogood, lower right
Museum purchase, 1995
995-O-101

The Butler Institute's collection includes six baseballs which are the gift of Mr. and Mrs. John R. McPhee, 1993
993-S-106, signed by Willie Stargell and Chuck Tanner
993-S-102, signed by Connie Mack and Al Simmons
993-S-101, signed by Honus Wagner to Johnny McPhee
993-S-105, signed by Eddie Rommel, Luis Aparicio, and Nelson Fox
993-S-104, signed by Harvey Kuen, Al Kaline, and John Honochick
993-S-103, signed by Mickey Mantle, Yogi Berra, Bill Dickey, Gene Woodling, Gil McDougald, and Hank Bauer

The Butler Institute collection includes ninety-two silver mugs which are the gift of George Bowman, Jr., 1992
992-S-101 — 992-S-193

The Cartoon Collection

The Butler Institute's collection includes more than 250 cartoons done in 1929–1930 which are the gift of Joseph G. Butler, III. A partial list of cartoonists includes Gene Ahern, C. D. Batchelor, Branner, A. W. Brewerton, R. M. Brinkerhoff, T. Brown, Webb Brown, Jack Callahan, J. T. Cargill, Nate Collier, Wood Cowan, Roy Crane, Harry Grant Dart, Billy DeBeck, J. N. Ding, Walt Disney, J. H. Donahey, Edmund Duffy, Edwina Dumm, Carl Ed, Gus Edson, W. J. Enright, Bud Fisher, Fitzpatrick, Charles H. Forbell, R. B. Fuller, Chester Garde, Gar, T. S. Geisel (Dr. Seuss), Rube Goldberg, Grant E. Hamilton, Scott E. Hamilton, Ethel Hays, Ned Hilton, C. C. Hungerford, Rollin Kirby, Norman Lynd, Gus Mager, Marcus, Marge, Windsor McKay, George McManus, Willard Mullin, Jimmy Murphy, Fred Neher, Frederick Burr Opper, Charles Plumb, Robert Ripley, Herb Roth, Fred O. Seibel, Shoemaker, Dorman H. Smith, Sidney Smith, Cliff Sterrett, Tousey, H. T. Webster, Russ Westover, Gaar Williams, Gluyas Williams, and J. R. Williams

Photographs

The Butler Institute's collection includes The Charles A. Leedy Collection of Movie Stills, more than 5,700 motion picture still photographs dating from 1916 to 1945, which are the gift of Mr. and Mrs. George Kelley, 1976.

The Butler Institute's collection includes an incomplete set of the Native American photogravures by E. S. Curtis and a small collection of Native American pottery and artifacts.

The Butler Institute's collection includes 106 glass bells of various sizes, shapes, and types which are the gift of Fanniebelle McVey Trippe, 1955. These bells were frequently produced and given as wedding gifts and were referred to as the Lady and Gentlemen bells.

The George Brechner Collection

The Butler Institute of American Art branch museum in Salem, Ohio houses the George Brechner Collection of Americana which is on permanent loan to The Butler Institute of American Art.

Ship Models

George E. WOODSIDE, (1867– ?)

Commodore Perry's Flagship *Niagara*
Wood model, 22" l. x 14" h. (55.88 x 35.56 cm.)
Museum purchase, 1928
928-M-102

USS *Constitution, "Old Ironsides"*
Wood model, 41" l. x 28" h. (104.14 x 71.12 cm.)
Museum purchase, 1928
928-M-101

Flying Cloud
Wood model, 37" l. x 24" h. (93.98 x 60.96 cm.)
Museum purchase, 1928
929-M-103

The *Red Jacket*
Wood model, 46" l. x 26" h. (116.84 x 66.04 cm.)
Museum purchase, 1928
929-M-102

The *Great Republic*
Wood model, 58" l. x 36" h. (147.32 x 91.44 cm.)
Museum purchase, 1928
929-M-101

South Street, New York City, 1852
Wood model to scale, 47 x 31" (119.38 x 78.74 cm.)
Museum purchase, 1946
946-M-101

The *Wanderer*, (Taking a Sperm Whale)
Wood model to scale, 43 x 43" (109.22 x 109.22 cm.)
Museum purchase, 1951
951-M-101